Eclectic Collecting

Eclectic Collecting

Art from Burma
in the
Denison Museum

edited by
ALEXANDRA GREEN

photography by Jens Johansen

UNIVERSITY OF HAWAI'I PRESS
HONOLULU

First published by
NUS Press
National University of Singapore
AS3-01-02, 3 Arts Link
Singapore 117569

Published in North America by
University of Hawai'i Press
2840 Kolowalu Street
Honolulu, HI 96822
www.uhpress.hawaii.edu

Library of Congress Cataloging-in-Publication Data

Eclectic collecting : art from Burma in the Denison Museum /
edited by Alexandra Green.
p. cm.
Includes bibliographical references and index.
ISBN 978-0-8248-3311-4 (hardcover : alk. paper)

1. Textile fabrics – Burma – Catalogs. 2. Textile fabrics –
Ohio – Granville – Catalogs. 3. Denison Museum – Catalogs.
I. Green, Alexandra. II. Title: Art from Burma in the Denison Museum.

NK8977.6.A1E26 2008
709.591'07477154—dc22 2008008441

Designed by Alden Prepress Services Pvt. Ltd
Printed in Malaysia

Contents

Foreword

During academic year 2004–2005, Denison University commissioned a ceremonial mace to be used in faculty processions at formal convocations of the college. Carved of black walnut harvested from the campus almost fifty years ago and topped and trimmed in silver, the mace visually represents the theme "Rooted at Denison, branches to the world." Nothing better illustrates the meaning in this message than the college's collection of Burmese art, for the first time thoroughly pictured, described, and evaluated in this catalogue.

Having completed its 175th year, Denison has a long and distinguished history of sending its students, its graduates, and its faculty into the world. Initially, Denison graduates populated the learned professions of the American frontier. Graduates and early professors moved on from Granville to become the founders or early leaders of colleges and universities from the Ohio River to the Pacific Ocean. By the 1840s, Denisonians were overseas too, often as representatives of the American Baptist denomination with which the college was connected during its first 125 years. In time, graduates would spread across the globe in the service of enterprise, of government, and of humanitarianism.

Today, in a world made smaller by communications, transportation, and trade, Denison's liberal arts curriculum especially seeks to acquaint students with the globe's diverse peoples and cultures. We are pleased that a large number of Denison students pursue off-campus international study as part of their undergraduate degree program and that today's student body enrolls men and women from more than three dozen nations. Denison faculty, too, represent a variety of national origins, and many professors have come to see their disciplines in a global context. Not surprisingly, graduates of the college are frequently engaged internationalists. The Chairman of the Foreign Relations Committee of the United States Senate and the Deputy Secretary General of the United Nations International Atomic Energy Agency are both Denison graduates. So is the former Executive Director of Oxfam America, an arm of the international NGO that addresses poverty, hunger, and social justice issues worldwide.

Denison was not much more than a decade old when the dispersion of its graduates to faraway places began to bring them into immediate contact with other peoples, cultures, and religions. For over a century, a long string of Denisonians involved in Christian missions found themselves living for longer or shorter periods in Southeast Asia.

Frequently, Denisonians manifested their interest in what they discovered by returning to this country with troves of cultural artifacts: textiles, lacquerware, and religious items, in particular. Over time, many of these materials made their way into the hands of the college, forming the core of a collection of Burmese art that Denison augmented with purchases.

Now, in the twenty-first century, we have a different view of this material than the one likely

held by the original collectors. Far from being souvenirs of travel or examples of the "exotic," Denison's Burmese art collection is a cultural treasure, providing an educational resource for students, scholars, and the public that offers both cross-cultural and historical insights. This catalogue both makes this collection more accessible and underscores the commitment of Denison to serve as a grateful and thoughtful steward of this resource.

As Denison students and faculty engage with the materials in this collection, we expect them to become better prepared to be constructive participants in a world community.

DALE T. KNOBEL
President
Denison University

Editor's note

This catalogue celebrates the collection of Burmese art at Denison University. Gathered by Baptist missionaries, United States governmental employees, diplomats, and other people interested in Burma, and augmented by judicious purchases, the collection holds over 1,500 objects ranging from textiles to silver, bronze, lacquer, ivory, and wood. The textiles form the largest part of this group of objects, and as a result, the volume focuses primarily upon this aspect of the collection.

Many options presented themselves when considering how to produce a catalogue of the Denison collection. After starting to explore writing the entire volume myself, I rapidly decided that inviting people with expertise in the various art forms found in the collection was the best way to proceed. Once this was determined and the contributors had agreed to write for the catalogue, I decided to encourage the various authors to use a methodology of their choice. Not only would the catalogue be an opportunity to explore, in more detail than is often possible, the histories and cultures of the peoples living in Burma, but it would also demonstrate the variety of theoretical approaches to the study of textiles. In keeping with the volume as a compendium of disparate articles, I have deliberately preserved a format and organization that is not heavily standardized.

ALEXANDRA GREEN

decorative effect (e.g. Catalogue no. 2.15). Supplementary warp weaving is also used, but much more rarely in Karenic textiles.

All groups, most noticeably the Paku and the Pwo on women's shirts, also sometimes decorate textiles with embroidery of geometric or naturalistic designs. Stitches used vary, but frequently include stem stitch and chain stitch. Job's tears (*Coix lachrymi* seeds) are often stitched onto women's shirts in particular, mostly by the Pwo and Sgaw Karen. Appliqué is also used, particularly in the form of red felt or rick-rack braid stitched onto Paku Karen women's shirts.

Products of weaving and their uses

Women weave blankets, bags, and clothing for themselves and their families, and sometimes for local sale. Karenic clothing items produced on backstrap looms include skirt-cloths for men and women, tunic-style shirts for men and women, shift dresses for young girls, and head-cloths. The limiting width of the cloth produced by a backstrap loom means that skirt-cloths, shirts, and dresses alike are usually constructed from two widths of cloth stitched together (often decoratively) along their length. Skirt-cloths are occasionally made from three fabric widths (Figure 2.4), while head-cloths consist of a single width. Tailoring is not a characteristic of traditional Karenic styles, with shirts and dresses being unshaped rectangles consisting of two pieces folded in half and stitched along their lengths, leaving holes for the neck and arms. Nonetheless, tailored garments made from Karenic cloth either for foreigners such as missionaries or with strong influences from them or their North American/ European-style clothes, do exist, and Denison University has a number of interesting examples of such hybrid style items (see Catalogue nos. 2.27 and 2.28). Denison also has some even more unusual— for materials, techniques, and styles—apparently hybrid items (see Catalogue nos. 2.29 and 2.30).

With the exception of Karenic shoulder bags, traditional-style items woven on backstrap looms are today increasingly less likely to be worn on an everyday basis among many Karenic groups, even amongst more conservatively dressed women. Certainly, in most Karenic groups, many men have long since ceased to wear traditional shirts and skirt-cloths on an everyday basis, wearing instead either ubiquitous Burmese printed cotton skirt-cloths,

Shan-style wide pants, or jeans with a T-shirt, and only wearing traditional style clothing—and even then usually only the shirt—on special occasions including, for Christians, Sunday church-going. For women too, while it is by no means a set rule and while it varies significantly with group, locality, and degree of remoteness, traditional-style clothing is increasingly often worn only on special occasions. On an everyday basis, many women wear instead the ubiquitous, mass-produced, printed, mock *batik* lightweight cotton skirt-cloths, together with a T-shirt. In such a setting, the traditional-style, backstrap-woven skirt-cloths and shirts or dresses take on particular meaning as signifiers of both ethnic and religious (and age-related; see discussion below) identity and associated cultural histories and values. They also cost more and in some cases (e.g. women's head-cloths) become heirloom objects.

Hand woven Karenic textiles do still retain a significant degree of cultural meaning and importance within the contexts of their production and use. Indeed, as I have argued elsewhere,[32] recent political and cultural upheaval has altered and occasionally enhanced the meanings of traditional textiles in certain settings. But what of the cultural significance of Karenic textiles in the past, when the Denison University items were being made and collected? The most well known, which still pertains amongst Sgaw and Pwo groups, is the change in female traditional style dress on marriage (or, sometimes, puberty or adulthood), in which a girl who wore a simple shift dress assumes instead the more elaborately decorated and darker skirt-cloth, shirt, and head-cloth of an adult/married woman (Catalogue no. 2.26).[33] Beyond this example, documentation is sparse, but early sources hint at a complexity of meanings and rituals involved with the production, wearing, and exchange of textiles, including taboos and secrecy associated in some places with traditional dyeing techniques.[34] Furthermore, bags have been and remain a traditional token of affection or esteem ceremonially gifted to visitors or senior community members.

KARENIC STYLES
"Karen" bags
All Karenic peoples bar some of the northern groups have traditionally woven shoulder bags on backstrap looms. Karenic bags are woven in various colors, with red the most common ground color (although

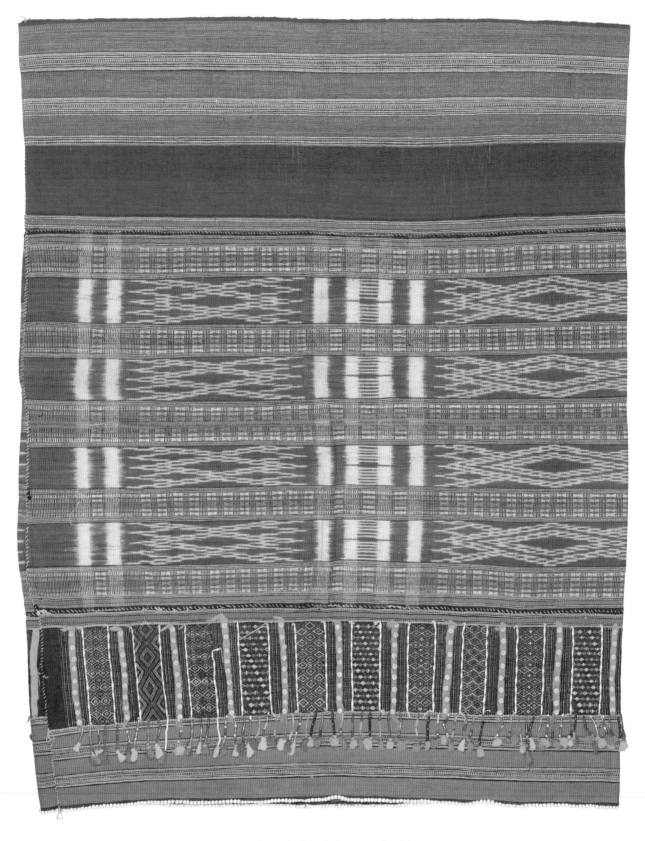

FIGURE 2.4 A three-panel Karen woman's skirt-cloth (*ni*) decorated with warp *ikat*, warp striping, supplementary weft, embroidery, tassels, and seeds. *Probably Sgaw Karen. Late nineteenth to early twentieth century. See Catalogue no. 2.17.*

see Catalogue nos. 2.3 and 2.6), and simple warp striping the most frequently seen decorative technique. They also, however, exhibit most other textile techniques used by the Karenic groups, including discontinuous supplementary weft in polychrome geometric and/or figurative designs. Much more rarely, one of Denison's numerous Karen bags (Figure 2.5) incorporates warp *ikat* python-skin patterning similar to that found in many Karen women's skirt-cloths. The supplementary weft on bags may, as with other, non-Karenic groups, sometimes be used to depict script (Catalogue no. 2.2 and Catalogue no. 2.4). Embroidery also sometimes appears on bags (e.g. Catalogue no. 2.5).

Northern Karenic/Karenni groups

As noted above, the Northern Karenic/Karenni groups are generally poorly represented in the Denison (and other) collections. Probably only the Bwe (Bghai), whatever that term may mean (see above and Catalogue no. 2.7), are represented by their textiles at Denison (see Figure 2.6, and Catalogue nos. 2.8 and 2.9). The Bwe originate in southwestern Karenni State, southern Shan State, and the Toungoo area. Traditionally, the more northerly Bwe men wore short trousers, whereas those further south wore a loose tunic: hence the early ethnonyms "Pant Bghai" and "Tunic Bghai".[35] The men's tunics typically incorporate warp stripes of red or burgundy, and supplementary weft patterning in a similar color. Bwe women are described[36] as wearing tunic shirts and skirt-cloths

similar to those of the Paku Karen (Catalogue no. 2.13), a style that in some ways is resonant of similar forms produced throughout southwestern Karenni State.[37]

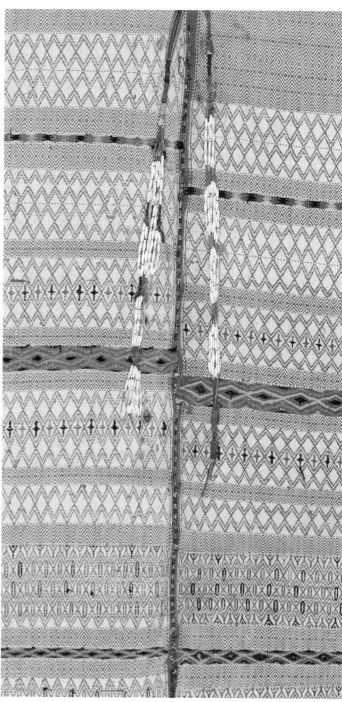

FIGURE 2.6 Detail of an undyed cotton Bwe Karen man's burial robe (*hse*) with mostly red continuous supplementary weft patterning.
Early to mid twentieth century. See Catalogue no. 2.7.

FIGURE 2.5 Detail of a Karen bag (*hteu*) decorated with warp striping, colored seam stitching, and warp *ikat* using natural dyes.
Probably Sgaw Karen. Circa 1920. See Catalogue no. 2.1.

The textiles of other northern Karenic peoples are not represented at all in Denison's collections, although for comparison it is worth briefly summarizing characteristics of the traditional dress of the two groups whose textiles (or photographic images) are most likely to be found in museum collections:

- Kayah (Karenni, or Red Karen): The men traditionally wore (but do so no longer) short, warp-striped trousers and Shan-style jackets.[38] Traditionally dressed women (Figures 2.1 and 2.2) still wear a black (or red striped) breast-cloth covering one or both breasts; a red or black warp-striped, short (one backstrap loom width) skirt-cloth fastened around the waist with a plain cotton strip functioning as a purse and belt; a red, warp-striped head-cloth (also worn as a shawl); large numbers of lacquered cotton knee-rings; silver coin belts, sashes, or necklaces; and large silver ear-plugs and pendants.
- Kayan Kangkaw/Kayan Ke-Kongdu (Padaung, or "Long Neck"): The men's traditional (and no longer worn) dress centers on short trousers, as with the Bwe and the Kayah. The women, however, are most notable for their coiled brass neck-band that give the impression of an elongated neck, worn together with a white (or black) tunic-style shirt, and an above-the-knee, warp-striped skirt-cloth. This style of female dress is still worn in Burma and in refugee Kayan Kangkaw villages in northwest Thailand.

Paku Karen

Paku items at Denison include typical married women's blouses, embroidered and ornamented with rick-rack braid or felt (Figure 2.7). An item not illustrated here (DU 1975.45) is probably a Paku married woman's shirt, although it is labeled by the museum as simply "Karen". It is made of black velvet (demonstrating the commercial nature of the cloth usually used for this style of woman's shirt) ornamented with polychrome embroidery, sequins, and rick-rack braid. In addition, Denison has an undyed "scarf" with fringing at one end, which is actually a Paku man's head-cloth (P67.115), and an item suggested by the museum documentation to be a sash, but which is actually a male shirt from the Toungoo area, taken apart in the middle and the ends then sewn together to make a very long piece

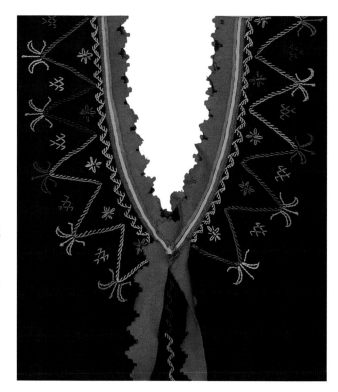

FIGURE 2.7 Detail of a Paku Karen woman's shirt made of black cotton with red felt trims and polychrome embroidery.
Mid twentieth century. See Catalogue no. 2.11.

(length approximately 225 cm), like a table runner (P67.113).

Denison also has two notable Paku or probably Paku women's skirt-cloths, one of which is of a classically typical style (Catalogue no. 2.13), and the other being a particularly unusual form (Catalogue no. 2.12).

Pwo groups

Denison has several items that are definitely or probably Pwo Karen, all of which are typical Pwo married women's blouses. Most incorporate embroidery, Job's tears, and appliquéd strips (e.g. Figure 2.8 and Catalogue no. 2.22). Traditionally, Pwo women would have worn these styles of shirt with a striped or more elaborately decorated skirt-cloth, not dissimilar to Sgaw or generically "Karen" styles (see below).

The other Pwo sub-group, the Pa-O, is represented at Denison by just one piece—a length of undyed cotton fabric. Pa-O men generally wear Shan-style pants, while the women traditionally dress in a long black tunic and black skirt-cloth, with bright color visible only in the narrow trims around the neck and armholes (often orange or turquoise) and in the Turkish towel-style head-cloth.

2.19 Woman's skirt-cloth

2.20 Detail of a woman's skirt-cloth

2.19 Woman's skirt-cloth (*ni*)
Burma; Karen, Sgaw Karen. Early twentieth century.
Cotton and natural dyes. L 99.37 cm.
Gift of Mrs. Hillis Howie. DU 1975.48.
This is a beautiful, warp-faced, backstrap-woven skirt-cloth decorated with broad and narrow warp stripes and, centrally, six narrow bands of python-skin pattern in warp *ikat*. The whole effect is muted and soft because of the use of natural rather than chemical dyes.

2.20 Woman's skirt-cloth (*ni*)
Burma. Karen, Sgaw Karen. Early twentieth century.
Cotton and natural dyes. L 120.65 cm.
Gift of Gertrude Anderson. DU 1968.247.
This warp-faced, backstrap-woven skirt-cloth is decorated with broad

and narrow warp stripes and, centrally, four bands of python-skin pattern in warp *ikat*. The appearance of the skirt is muted and soft due to the use of natural rather than chemical dyes.

2.21 Woman's shirt (*hse*)
Burma, Lower Burma. Karen, Pwo Karen. Mid twentieth century.
Cotton and seeds. L 59.69 cm,
W 69.85 cm.
Gift of Walter and Henry Sutton.
DU 2001.30.
This shirt consists of warp-faced, indigo-dyed cotton cloth woven on a backstrap loom and stitched together using, in this case, undyed cotton, the ends of which are allowed to hang free to form tassels at the neck and armholes. The whole ensemble is then

ornamented with rows of alternating blocks of red embroidery and patterns formed by stitching Job's tears (*Coix lachrymi* seeds) to the cloth. Other examples of this type of shirt utilize polychrome embroidery (see Catalogue no. 2.22), rather than the simple mixture of colors seen here.

This style of woman's shirt is typical of Pwo Karen items of this period, although Job's tears and embroidery are both also used by Sgaw and Paku groups. This is a form still commonly produced amongst Karen in Thailand, and as such is an interesting example of both the subjectivity of applying specific ethnic ascriptions to textiles and of the changes in reality and/or perception that

Sandra Dudley

may occur over significant time periods, especially when the peoples concerned have been undergoing migration (either forced or voluntary). For example, in 1998 I showed photographs of shirts like this to Karen weavers in refugee camps in Thailand, and they could not countenance that this item was from Burma. Instead, they insisted that it must have been made by Thai Karen. Were it a piece from today, they may well be right; their error of judgement with an older item is due not to ignorance but to real shifts in group locations, styles, techniques, and perceptions of self and other groups, over time.[42]

2.22 Woman's shirt (*hse*)
Burma, Lower Burma; Karen, Pwo Karen. Mid twentieth century.
Cotton and seeds. L 73.66 cm, W 73.6 cm.
Gift of Walter and Henry Sutton. DU 2001.32.
This shirt is composed of warp-faced, indigo-dyed cotton cloth stitched together using, in this case, blue cotton, with the addition of red cotton edge binding, the ends of which are allowed to hang free to form tassels. The whole is then ornamented with rows of alternating blocks of red, white, and yellow cross-stitch embroidery and patterns formed by stitching Job's tears (*Coix lachrymi* seeds) to the cloth. At the lower end there is an appliqué of a strip of red cotton cloth.

2.23 Woman's shirt (*hse*)
Burma, Lower Burma; Karen, probably Pwo Karen. Late nineteenth or early twentieth century.
Cotton and seeds. L 69.21 cm, W 76.2 cm.
Gift of Reverend and Mrs. Erville Sowards. DU 1971.506.
This shirt is made from warp-faced, indigo-dyed cotton cloth

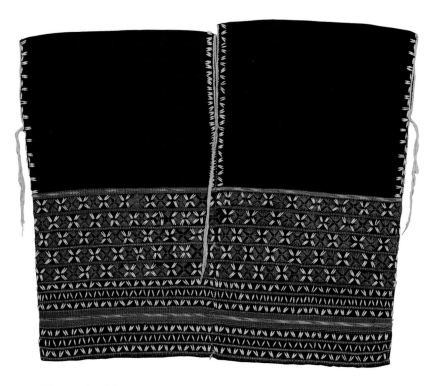

2.21 Woman's shirt

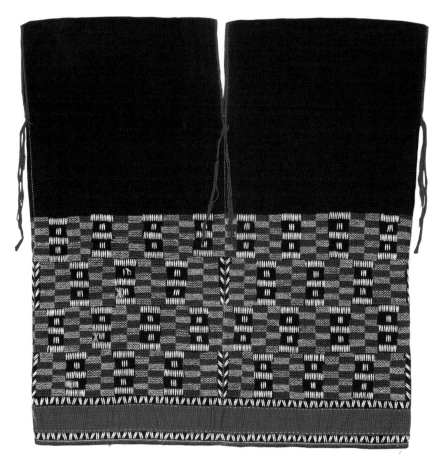

2.22 Woman's shirt

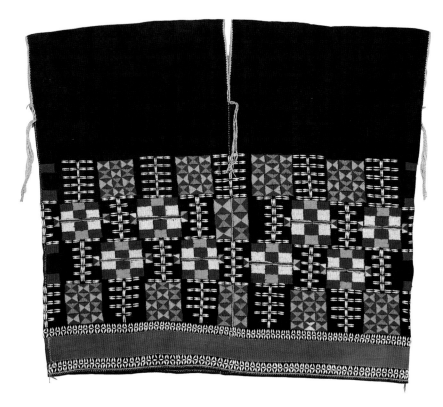

2.23 Woman's shirt

2.24 Man's shirt (*hse*)
Burma; Karen. Late nineteenth or early twentieth century.
Cotton. L 100.64 cm, W 74.93 cm.
Gift of Mrs. Hillis Howie. DU 1975.49.
This man's shirt is made of finely woven, warp-faced undyed cotton, with red (and some black) continuous supplementary weft patterning along the lower third of the piece, red (and some black) discontinuous supplementary weft patterning at the outside edges, and red tasseling.

Interestingly, despite the quality of the fabric, the two backstrap-woven pieces from which the shirt is made are not the same in number and thickness of red supplementary weft bands, so that when the two pieces were stitched together to form a garment, each side of the garment has a slightly different pattern. This may be deliberate (see Catalogue no. 2.7), or it may be the result of either two individuals weaving the fabric strips simultaneously, or simply of one weaver not referring to the first piece when weaving the second.

which has been stitched together using, in this case, undyed cotton, the ends of which are allowed to hang free to form tassels. The lower two-thirds are ornamented with rows of alternating blocks of dense red, white, and yellow embroidery and patterns formed by stitching Job's tears (*Coix lachrymi* seeds) to the cloth. At the lower end there is an appliqué of a strip of red cotton cloth.

2.25 Woman's shirt (*hse*)
Burma; Karen. Late nineteenth or early twentieth century.
Cotton. L 81.28 cm, W 55.88 cm.
Gift of Walter and Henry Sutton. DU 2001.41.
This is an unusual shirt of a form not often seen. The black cloth is, with the exception of the beaded lower edge, wholly decorated with polychrome, hand-embroidered linear and circular designs. Embroidery is most notably a feature of Paku Karen women's shirts (see Catalogue no. 2.11), but this shirt is not of that style. Here it is almost as if the embroidery has been used to emulate—more faintly and tremulously—the

2.24 Detail of a man's shirt

Sandra Dudley

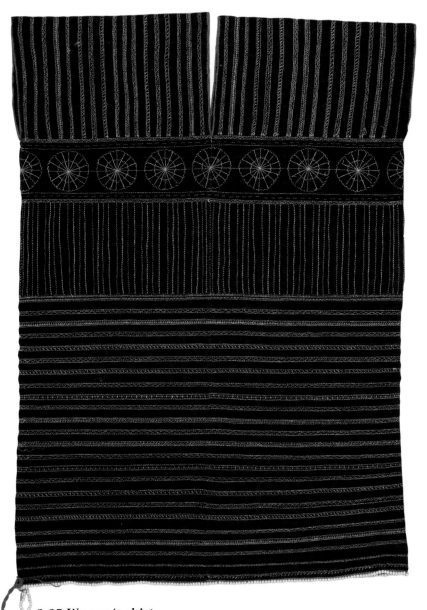

2.25 Woman's shirt

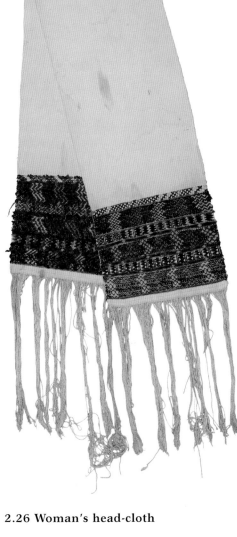

2.26 Woman's head-cloth

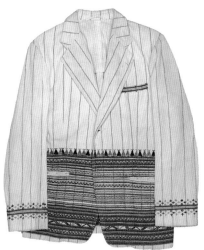

2.27 Man's jacket

supplementary weft seen on, especially, Sgaw Karen shirts.

2.26 Woman's head-cloth
(*hko peu ki*)
Burma; Karen. 1915–1930.
Cotton. L 140.97 cm, W 25.4 cm;
Fringe: L 33.02 cm.
Gift of John F. Marshall. DU 1970.28.
The ground cloth of this head-cloth is composed of undyed, backstrap loom-woven, warp-faced plain cotton with fringes at both ends. Each end is also decorated with a panel of green,

orange, red, and black geometric patterns executed in discontinuous supplementary weft. In many areas, such items were traditionally heirloom objects and were ceremonially placed on a girl's head on her wedding day.

2.27 Man's jacket
Burma, Bassein; Karen. Early twentieth century.
Cotton. L 74.93 cm.
Gift of Mrs. T.F. Holbert. P67.291.
The tailored style of this man's jacket is wholly European/North

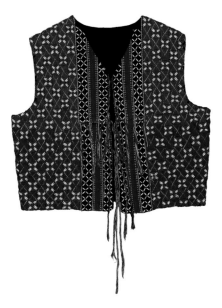

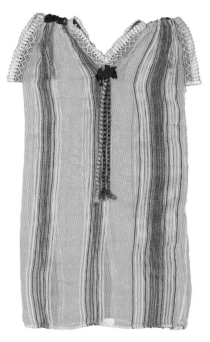

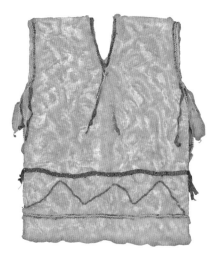

2.28 Woman's jacket

American, and is not characteristic of traditional Karenic styles. However, the jacket fabric is clearly Karen, with its narrow, red warp striping and lower panel of red and black narrow geometric patterns in continuous and discontinuous supplementary weft.

2.28 Woman's jacket
Burma; Karen, possibly Pwo Karen.
Cotton. L 45.72 cm, W 55.8 cm.
Purchase from Mrs. Erville Sowards.
DU 1975.2.
This pretty little jacket with its short tailored bodice has no resemblance to any traditional Karenic clothing form. However, as with Catalogue no. 2.27, this item is clearly Karen in production. It is of black indigo cloth, decorated all over with thick panels of dense, red embroidery, interspersed and overlaid with patterns created with Job's tears. There are also vertical, narrow appliqué strips of red felt on each side. The style of embroidery may indicate that the item is Pwo Karen in origin.

2.29 Girl's shirt-style dress

2.29 Girl's shirt-style dress (*hse*)
Burma; Karen. Late nineteenth or early twentieth century.
Cotton and other fibers. L 99.06 cm, W 58.42 cm.
Gift of John F. Marshall. DU 1970.32.
In some ways, this appears like a Sgaw or Pwo Karen girl's tunic dress: its simple shape and warp striping on a pale background echo such a form. The lace trim around neck and armholes, however, together with the fact that the fabric is of a fine, translucent gauze, and with the additional plaited, hair-like tassels in front, are unique and wholly out of keeping with conventional Karenic style. It is almost as if the item was altered by the missionary collector or made to order for a fancy dress event or other purpose.

2.30 Woman's shirt (*hse*)
Burma, possibly Bassein district; Karen. Circa 1930.
Velvet. L 68.58 cm, W 52.07 cm.
Gift of Mrs. Erville Sowards.
DU 1970.14.

2.30 Woman's shirt

This extraordinary Karen-style top has been made not using the usual cotton, but instead with purchased, crushed white velvet, trimmed with down, silver braid, silver sequins, rick-rack braid, and orange grosgrain ribbon. Like the base fabric, all the trimmings are likely to have been purchased specially in a market. This is poignant as well as striking when one learns that the shirt was made for presentation to the wife of a touring British colonial official. When she refused to accept the gift, it was given instead to Genevieve Sowards, wife of the Reverend Erville Sowards, a missionary based at Bassein. The uniqueness of this article, together with its originally intended recipient, imply that a great deal of thought went into its construction—either to try to make it more attractive to a British woman with the use of velvet and various trims, or at the least to make it particularly unusual and special. One can only imagine the disappointment and hurt that must have been felt when the gift was refused by its intended recipient.

NOTES

1. J.G. Scott, *Burma: A Handbook of Practical Information.* London: Alexander Moring Ltd., 1911, p. 120.

2. In this, I follow scholars such as J. Matisoff, "Linguistic diversity and language contact" in J. McKinnon and W. Bhruksasri (eds.), *Highlanders of Thailand*, Singapore: Oxford University Press, 1986.

3. S. Dudley, "Displacement and identity: Karenni refugees in Thailand," unpublished DPhil thesis, University of Oxford, 2000.

4. There is a tradition within the extant literature of insisting that the Pa-O do not acknowledge their Karen identity; see Scott, 1911, p. 126; Dudley, 2000.

5. "Sgaw" is not necessarily a single, homogenous category: in reality, there are often said to be many Sgaw sub-groups other than the Paku. As with other categories, however, precise definitions and sub-groupings vary considerably with different informants and authorities.

6. "Pakenyo" is the self-referent term; "Paku" is the term used by the Kayah and others to refer to the Pakenyo. "Pakenyo" is also sometimes said to refer generally to the Sgaw family (e.g. F.K. Lehman, "Who are the Karen, and if so, why? Karen ethno-history and a formal theory of ethnicity" in C.F. Keyes (ed.), *Ethnic Adaptation and Identity. The Karen on the Thai Frontier with Burma*, Philadelphia: Institute for the Study of Human Issues, 1979). In my own field research, I found that the Karen/Paku distinction is vague, and that when speaking with non-Paku Karenni, most of the Paku refer to themselves not as "Paku" (or "Pakenyo"), but as "Karen". Importantly, however, Paku describe themselves as like, but *not the same as*, the Sgaw Karen, although the languages are virtually identical (Dudley, 2000; c.f. Lehman's statement that "Paku" refers to all Sgaw [1979, p. 238]).

7. Lehman does not describe all the groups given in this table. On the other hand, he includes four not named here: the Northern and Southern Bre, the Zayein (or Sawngtung Karen), and the Geba (Gheba) (F.K. Lehman, "Burma: Kayah society as a function of the Shan-Burma-Karen context" in J. H. Steward (ed.), *Contemporary Change in Traditional Societies. II: Asian Rural Societies*, Urbana, IL: University of Illinois Press, 1967, p. 68). My own informants did not talk about these groups.

8. The Kayan as a whole are usually, but incorrectly, referred to by non-Kayan as the "Padaung", a Shan (Tai) term that strictly refers only to the "Long-Neck" Kayan. Kayan self-referent terms generally use descriptions of traditional residence patterns to distinguish between sub-groups.

9. "Padaung" is a Shan term meaning "copper neck", a reference to the brass neck-rings worn by the women.

10. Matisoff, 1986; R.B. Jones, *Karen Linguistic Studies.* Berkeley: University of California Press, Berkeley, 1961. Note, however, that Luce argues the Kayan languages are not a part of the Bwe subgroup (G. Luce, "Introduction to the comparative study of Karen languages," *Journal of the Burma Research Society*, vol. 42, no. 1, 1959, pp. 1–18).

11. Dudley, 2000.

12. Examples of US anthropological collections include the Smithsonian Institution's National Museum of Natural History and Man's 1960s collections made by William Sturtevant and Brian Peacock. Note too that UK collections include recent as well as early anthropological collections, such as those made by myself in Karenni refugee camps in the late 1990s for the University of Oxford's Pitt Rivers Museum and for the Brighton Museum and Art Gallery.

13. For an overview of significant collections of Burma textiles in the USA, UK and Europe, and Australasia, see the appendix in E. Dell and S. Dudley (eds.), *Textiles from Burma,* London: Philip Wilson Publishers, 2003.

14. Mariano, personal communication, 1996. For more on the history of missionary activity in Burma, see also A. Battander, "Burma," in *The Catholic Encyclopaedia*, The Encyclopaedia Press, 1913; C. Bennet, "Journal of Mr Bennet," *Baptist Missionary Magazine*, vol. 29, 1848, pp. 413–17; A.H. Judson, *Account of the American Baptist Mission to the Burman Empire*: *In a Series of Letters, Addressed to a Gentleman in London,* London: J. Butterworth and Son, 1823; J. Schendel, "Christian missionaries in Upper Burma, 1853–85," *South East Asia Research* vol. 7, no. 1, 1999, pp. 61–91; Matthias U Shwe, *Tali takha: "The Light": History of the Catholic Church in Burma and in Kayan Land,* Rangoon: Catholic Presses, 1976; H. Trager, *Burma Through Alien Eyes: Missionary Views of the Burmese in the Nineteenth Century,* New York: Praeger, 1966.

15. H.I. Marshall, *The Karen People of Burma: A Study in Anthropology and Ethnology.* Bangkok: White Lotus, 1997 (1922), p. 301.

16. American Baptist Foreign Mission Society *Annual Report 1919*, cited in Marshall, 1997 (1922), p. 300.

17. Missionary development of Karenic scripts happened early and was inspired by evangelical objectives, with the completion in 1853 of Dr. Francis Mason's translation of the Bible into Sgaw Karen, and very soon thereafter the Reverend D.L. Brayton's Bible in Pwo Karen. See Marshall, 1997 (1922).

18. These Peabody Essex items include pieces collected by the famous, first American Baptist missionary to Burma, Adoniram Judson (although it should be noted that Judson himself actually worked mainly with Burmans rather than with Karenic groups).

19. See the map of American Baptist mission stations in the 1911 revised edition of the American Baptist Foreign Mission Society's Historical Series booklet *Missions in Burma*.

20. This supposition is based on oral histories given to the author by Karenni informants and on contemporary denominational demographics, as well as on the relative absence of Karenni Karenic groups in American Baptist missionary collections.

21. There are of course numerous exceptions and many additional denominations, including Anglican, Seventh Day Adventist, and Methodist.

22. C.f. J.G. Scott and J.P. Hardiman, *Gazetteer of Upper Burma and the Shan States*, Vol. I, Pts. I and II, Rangoon: Government Printing, 1900, p. 524.

23. C.f. Dudley, 2000 and S. Dudley, "Diversity, identity and modernity in exile: 'traditional' Karenni clothing," in A. Green and T.R. Blurton (eds.), *Burma: Art and Archaeology*, London: British Museum Press, 2002, pp. 143–51.
24. Dudley, 2000.
25. Karenic looms are all examples of the type Ling Roth calls "Indonesian looms" (H. Ling Roth, *Studies in Primitive Looms,* Carlton: Ruth Bean, 1977, p. 64). Note that Ling Roth describes and illustrates an Iban loom in the Horniman Museum (London, UK) which incorporates an additional, heddle-lifter rod like the Kayan looms referred to here (Ling Roth, p. 67).
26. Naw Paw Wah (name changed), personal communication, 1997.
27. Many of these villages were forcibly relocated by the Burmese Army in 1996, and as a result women from these villages are no longer able to grow, spin, and weave their own cotton.
28. A Burmese unit of weight. One *petha* is equivalent to approximately 1.66 kilograms.
29. Personal communications, 1996. Note that S. Fraser-Lu (*Handwoven Textiles of South-East Asia*, Singapore: Oxford University Press, 1988, p. 31, citing W. Warming and M. Gaworski, *The World of Indonesian Textiles,* Tokyo: Kodansha, 1981), states that overnight burial in the mud of a nearby lake is used by women in Amarsai in West Timor, and that this works because the iron salts in the mud act as a mordant. It is likely that similar salts in local Karenic soils also act in this way.
30. Reds can be produced in a number of ways, including from the bark of the *dta-pwin-maw* tree (Daw Kraw Aw village), the sap of a tree called *saw-lee-maw* (Daw Mi Ku), the bark of the *hkree-maw* tree (Daw Ngo Say), or a mixture of *tha-ley-seh* fruit, *pleh-ngey-hpah* bark and *p-oh-hpah* bark, pounded and boiled together. These Kayah terms have yet to be equated with Burmese and/or Latin equivalents, but already indicate the potential range of species and method that might be used in different localities. At least one of the barks is likely to be that of sappanwood (*Caesalpinia sappan*), and another may be morinda (*Morinda citrifolia*). The fruit mentioned may be the seeds of the annatto (*Bixa orellana*). The leaves of teak trees and betel nut trees both produce a reddish brown dye, which is also likely to have been used in Karenic areas. Note that, in Kayah, *seh* = fruit; *leh* = leaf; *maw* = tree; and *hpah* = bark. Note too that in 1900 Scott and Hardiman published research by T.H. Giles on Kayah dyes, including the claims (1) that the Kayah do—or did then—use indigo, and (2) that they were unique in Karenni and Shan State for artificially stimulating the production of insect lac (Scott and Hardiman, 1900, pp. 396–99).
31. Marshall, 1997 (1922), p. 38.
32. Dudley, 2000, 2002.
33. There are descriptions too of the tradition, for some Karenic peoples at least, that at his wedding the groom changes from old clothes into a new suit woven for him by his prospective bride (P. Lewis and E. Lewis, *People of the Golden Triangle*, London: Thames and Hudson, 1984, p. 88).
34. Fraser-Lu, 1988, p. 27, citing M. Campbell, *From the Hands of the Hills*, Bangkok: Media Transasia, 1981, p. 88.
35. A.R. McMahon, *The Karens of the Golden Chersonese*. London: Walter W.G. Beatson, 1876, p. 301.
36. Marshall 1997 (1922), p. 39.
37. C.f. "transitional" skirt-cloths in Dudley, 2002.
38. H.R. Spearman, *British Burma Gazetteer*, Volume II. Rangoon: Government Press, 1880, p. 243.
39. H.I. Marshall, *The Karen People of Burma: A Study in Anthropology and Ethnology.* Bangkok: White Lotus, 1997 (1922), p. 38.
40. H.R. Spearman, *British Burma Gazetteer*, Volume II. Rangoon: Government Press, 1880, p. 120.
41. Marshall, 1997 (1922), p. 36.
42. See S. Dudley, "Whose textiles and whose meanings?" in E. Dell and S. Dudley (eds.), *Textiles from Burma*, London: Philip Wilson Publishers, 2003.

Chin Textiles

BARBARA G. FRASER AND DAVID W. FRASER

THE CHIN

The Chin (Zo, Lai, Kuki) peoples of western Burma, northeastern India, and eastern Bangladesh number between 2 million and 2.5 million speakers of the forty or more languages of the Kuki/Naga branch of the Tibeto-Burman language group. Approximately half of the Chin peoples live in Burma, half in India, and a small number in Bangladesh.

The Chin can usefully be divided into four major groups on the basis of geography, language, and culture. The Northern Chin are located in the northernmost five townships of Burma's Chin State (Haka, Falam, Tiddim, Thlantlang, and Tonzang), but extend into the Kale Valley, India's states of Mizoram and Manipur, and Bangladesh's Chittagong Hill Tracts. The Southern Chin concentrate in Chin State's townships of Mindat, Kanpetlet, and Matupi. The Ashö, who are known as the Plains Chin, reside still further south, in the lowlands of Burma's Rakhine State, Sagaing Division and Magwe Division, and in the hills of Bago Division. The Khumi, Khami, and Mro mostly live in Paletwa township of Chin State, but extend into the plains of western Rakhine State and the hills of Bangladesh's Chittagong Hill Tracts. Chin textiles in the Denison collection represent primarily two of these groups: the Northern Chin and the Ashö.

Each group has cultural and linguistic similarities with other Chin groups, but often has developed a distinctive culture. While the practice of swidden agriculture, patrilineality, the payment of bride price, animism, and division into clans apply across all groups traditionally, the specifics of these and other cultural and social considerations often differ from group to group, even from village to village. Northern Chin and Mro are characterized by their hierarchical traditional society, with systems of village and regional chiefs and gradations of status within villages. Traditionally, they hosted an elaborate array of graduated Feasts of Merit,[1] by which donors gained status in both the current life and the afterlife. Traditional Southern Chin, Ashö and, in India, Old Kuki societies are generally non-hierarchical, with small independent villages, a headman and village councils elected by the villagers, small lineage groups, and ungraduated Feasts of Merit. Wealth and status both within the family and within the village play an important role for all Chin groups.

In traditional Chin culture, textiles were worn both to manifest the status of the wearer, as well as for utilitarian purposes. Textiles were often, though not always, specific for one sex or the other and for people at different stages in life. In many cases, patterns varied from one language group to another, although particular patterns were shared across cultural divisions. Certain textiles were reserved for the various festivals associated with hunting, war, marriage, and the Feasts of Merit. In some instances, only people who had hosted a specific feast or killed a particular animal could wear a textile associated with high status. The importance of the role of these textiles, however, has been greatly attenuated over the last century with the influence of British colonization, Burman Buddhist society, and the widespread conversion of Chins from animism to Christianity.

TEXTILE CONSTRUCTION

Chin textiles are traditionally woven by women on a back-tension (backstrap) loom, using cotton, flax, hemp, or silk. The dominant colors are commonly blue (or black) and red, reflecting the importance of the locally produced dyes, indigo and lac. Over the last 150 years Chin weaving practices have changed as the use of flax and hemp has diminished. Locally grown cotton has increasingly been replaced by imported cotton, and commercial dyes have replaced most vegetable dyes, although indigo continues to be widely used. Silk has long been imported.

As is typical of back-tension looms, Chin textiles are mostly warp-faced. The higher warp density (commonly twenty to fifty warps per centimeter versus eight to fifteen wefts per centimeter) makes the structural wefts all but invisible in the finished textile. The Chin are distinctive, however, in making textiles that combine warp-faced and weft-faced portions—as well, sometimes, as twill or balanced plain weave—in a prescribed array. Because the back-tension loom permits the weaver to make a textile no wider than the span of her two arms, most Chin textiles are made of two loom-widths sewn together. Because a Chin weaver uses a circular warp, the textile is a continuous cylinder when it comes off the loom, with a short segment of unwoven warps linking the top of the textile to the bottom.

Chin weavers most often pattern their textiles with warp stripes and supplementary wefts. Weft patterning may be done with a supplementary weft, which when not floating on the obverse to create the pattern, either rides in the shed with the structural weft (one-faced supplementary weft patterning) or floats on the reverse (two-faced supplementary weft patterning). In the former case, no pattern appears on the reverse, while in the latter a (typically crude) complement of the pattern on the obverse is seen on the reverse. In Chin textiles the floats are typically short, particularly on the reverse. Supplementary wefts may travel from selvage to selvage (continuous) or may turn back at the edges of design areas (discontinuous). In one-faced supplementary weft patterning, two or more colors of supplementary wefts may be found in a single weft row, the two floating separately or in tandem. In the process of weaving a Chin weaver typically manipulates the supplementary weft with a porcupine quill.

NORTHERN CHIN TEXTILES

The Northern Chin comprise more than forty widely dispersed groups ranging from the various Kuki groups in northeastern India, south through the Chin Hills to the Zotung of southern Haka township and environs, and further south along the Kaladan River to the Mara in Paletwa township.[2] From east to west, they range from Kalemyo, the gateway town just east of Chin State, to the Chittagong Hills of Bangladesh, and to Mizoram in the west. Denison University's collection includes textiles from six of these groups: the Haka and the culturally-related Thlantlang, the Lautu, the Tiddim, the Thado, the Zotung, and an unidentified group living in the Falam area—most likely the Tashon. It also includes a blanket attributed to the Matu, a group living in the southern Chin Hills that has adopted many of the textiles of the Northern Chin living near them.

Without a doubt, the most important textile for the Northern Chin is the ceremonial blanket, which is their most highly valued inanimate possession. Writing in 1869, Lewin reported that the best blankets "are dyed blue and interwoven with crimson and yellow stripes."[3] The Denison collection has three ceremonial blankets, the oldest being represented by DU 1967.2, said to be a Matu man's blanket (Figure 3.1), and which fits Lewin's description in color and patterning.[4] This early form has many of the characteristics of more recent Northern Chin ceremonial blankets including the cross-knit looping join and the yellow and red diamond twill band with the diamond motif centered in the red weft band. Twill weave, which is difficult to execute

second, and third structural wefts. The three supplementary wefts in a band synchronously float over four warps and under four warps from selvage to selvage. This pattern is then repeated, offset by four warps, creating a lively checkerboard-like surface on the blanket. The blanket is made of two joined loom widths. It is warp-faced (thirty-six warps and ten and a half wefts per centimeter). Warps and wefts are both homespun white cotton. One end is a fringe that has been plied and knotted. The other end is rolled and oversewn. Blankets of a related construction are used elsewhere in Burma by people who are not Chin.

3.5 Skirt (*nik sing*)
Chin, Tiddim. Estimated 1940–1965. Commercial cotton. L 120 cm, W 55 cm. Gift of Reverend and Mrs. Franklin O. Nelson. DU 1967.9.
Women in the Tiddim area of the Chin Hills wear short wrap skirts that are decorated with narrow black and red warp stripes. Frequently, the fourth stripe on each side of the center and the outer stripes are more ornate than the others. On some skirts, they are multi-colored while all the other stripes are monochromatic. On Denison's skirt, these more ornate stripes are white, decorated with discontinuous, one-faced supplementary weft motifs like the stripes found on Tiddim ceremonial blankets. A detail of the mid-portion of one end of the Denison skirt is shown here, with warps horizontal in this view. Approximately one-tenth of the skirt is shown. On some rare exemplary skirts, all the stripes are white and are decorated with discontinuous, one-faced supplementary weft designs. These

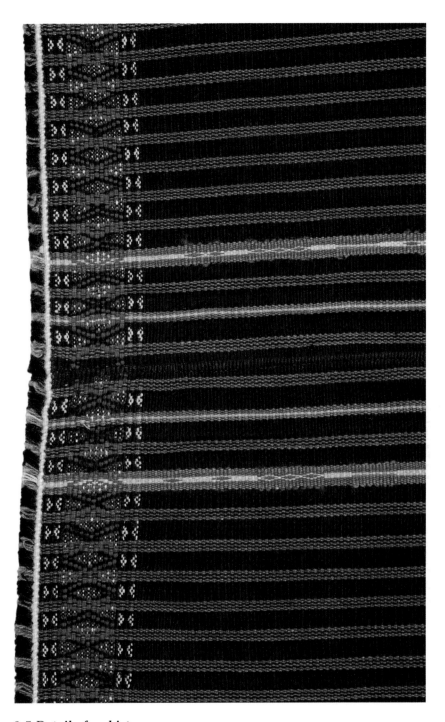

3.5 Detail of a skirt

skirts must have been worn by a high status woman. The Denison skirt is in two loom widths, overlapped at the center seam and joined simply. It is warp-faced (forty-eight warps and ten wefts per centimeter). The warps are black, red, white, green, and yellow. The structural wefts are black, and the supplementary wefts are red, yellow, black, and green. As is the case with the Denison skirt, the ends generally are decorated with a narrow band of continuous, one-faced supplementary weft diamonds and

crosses. The ends are finished with running overhand knots.

3.6 Head wrapper
Chin, Matu. 1950 or earlier.
Cotton. L 99 cm, W 48 cm.
Gift of Reverend and Mrs. Robert Johnson. P67.308.

Matu women wear a head covering in blue, red, and white warp stripes, fringed at one end. The Denison head covering is two loom widths and warp-faced (twenty-six warps and eight wefts per centimeter). The warps are red, light brown, white, and dark blue. The wefts are dark blue. One end is finished with two rows of running overhand knots and plied and twisted fringes. The other end is sewn under. This piece was the gift of Reverend and Mrs. Robert Johnson, who gave a substantially

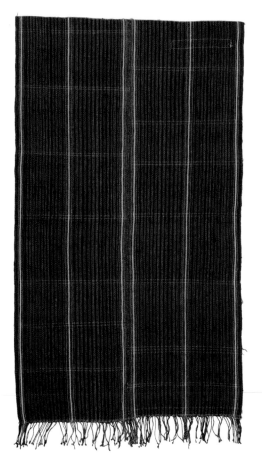

3.6 Head wrapper

similar example to the Chin Baptist Mission Women Fellowship in Maryland. Reverend Johnson noted on the label of the Chin Baptist Mission Women Fellowship example that it was "old style" when he collected it in 1966.[21]

3.7 Bag (*maimaw*)
Chin, Haka. 1966 or earlier.
Silk. Bag: L 23 cm (front) and 38 cm (back, including flap), W 15 cm;
Strap: L (shoulder to edge) 92 cm;
L (total) 184 cm.
Gift of Reverend and Mrs. Robert Johnson. P67.311.

As Chin clothes have no pockets, bags are an important part of the attire of every Northern Chin group. They are generally worn with the strap hung over one shoulder and the bag hanging down one side of the body. This bag, a gift of Reverend and Mrs. Johnson, is traditional in its construction. The body is two loom widths joined at the bottom of the bag. The strap is one loom width. The strap on this bag is sewn into a tube, although on other bags it is left flat. The cross-knit looping join of the two loom widths that constitute the body of the bag and the fact that it is woven completely in silk indicate that this probably is a bag that was used for ceremonies and other important occasions. It is warp-faced (forty-eight warps and thirteen wefts per centimeter) and decorated with motifs woven in discontinuous, two-faced supplementary weft patterning in green, white, and gold silk. The warps and structural wefts are red silk. It is decorated with countered weft twining along the top of the bag and above the fringe at the end of the straps. The flap corners are folded under and oversewn.

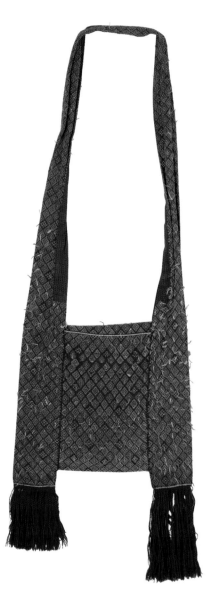

3.7 Bag

3.8a Bag
Chin, Thado. 1966 or earlier.
Commercial cotton. Bag: L (mouth to bottom) 21 cm, W 21 cm; L (total) 42 cm; Strap: L (shoulder to edge) 88 cm, W 14 cm; L (total) 176 cm.
Gift of Reverend and Mrs. Robert Johnson. P67.312.

3.8b Diagram of alternating float weave patterning on warp-faced plain weave

This bag, a gift of Reverend and Mrs. Robert Johnson, is in two loom widths (the bag is one loom width and the strap is one loom width), joined with cross-knit

Barbara G. Fraser and David W. Fraser

looping. The strap is sewn into a tube and joined simply. It is warp-faced (forty-eight warps and twenty wefts per centimeter). The warps are black, yellow, red, white, and green. The structural wefts are black, yellow, and pink. The contrast between the black field and the brilliantly colored warp stripes, including those in the snake pattern, along the center creates a visually lively bag. The snake pattern is woven in alternating float weave (see diagram 3.8b) in which the warps alternate in color (cross-hatched versus unshaded, in this diagram), creating a broad laddered warp stripe as the basic weave. The patterning is created on this background by floating warps of one color (unshaded) over three wefts (stippled) on the obverse.

A weft floats under three warps wherever a warp floats over three wefts. This structure has been mistakenly called "extra warp" or "supplementary warp" patterning, but in fact all the warps are structural; if the unshaded warps were removed the remaining "textile" would have no structural integrity. Among the Chin, this structure is only used by the Thado and related "New Kuki" groups, although it is widely used by other traditional groups in Burma and elsewhere in mainland Southeast Asia. The bag is also decorated along the top and at the ends of the straps with laid-in wefts and countered weft twining, and discontinuous, two-faced

supplementary weft patterning in yellow, green, and pink.

3.9 Bag
Chin, Tiddim. 1951 or earlier. Commercial cotton. Bag: L (mouth to bottom) 21.5 cm, W 15 cm; L (total) 43 cm; Strap: L (shoulder to edge) 65 cm, W 15 cm; L (total) 130 cm. Gift of Reverend Franklin O. Nelson. DU 1967.10.

This bag is a gift from Reverend Franklin O. Nelson. It is in two loom widths (the bag is one loom width and the strap is one loom width), joined with cross-knit looping, front and back. It is densely warp-faced (fifty-two warps and eight and a half wefts per centimeter). The warps are purple, white, and yellow. The structural wefts are red. It is decorated with continuous, one-faced supplementary weft patterning in yellow, green, and white.

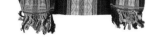

3.8a Bag

3.8b Diagram of alternating float weave patterning on warp-faced plain weave

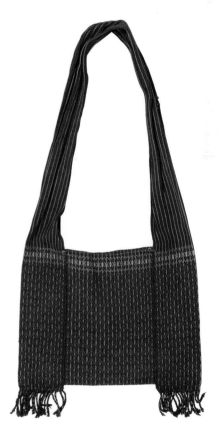

3.9 Bag

3.10 Man's tunic (*phyang*)
Chin, Kounsho. Estimated 1900–1940.
Homespun cotton. L (shoulder to edge)
99 cm, W (as tailored) 74 cm;
L (total) 198 cm; "Belt": L 198 cm,
W 13 cm.
Gift of E. Carroll Condict. P67.145.
This tunic was the gift of E. Carroll Condict, who was in Thayetmyo from 1912 to 1954. The material is warp-faced plain weave (eighteen blue and forty red warps and seven and a half wefts per centimeter) with blue, red, and white warps, and blue wefts. The countered weft twining (on front lower border only, as can be seen at the end of the "belt") is in white and red cotton. The twining rows may have been made by passing two closed loops of wefts of contrasting color (red and white, in this case) through each other.[22] Both the body of the tunic and the belt consist of two partial loom widths, with the center seam of the tunic joined with running twisted half hitches.

The belt formerly was the lateral red warp stripes of the body of the tunic; now the belt is sewn at the middle of the back. The minimalist decoration, limited to narrow warp stripes and a countered pair of rows of weft twining on one face only, suggests that this was woven to be a man's tunic for daily wear. It resembles in that regard the tunics of two Ashö teachers in the archives of the American Baptist Historical Society, which date between 1960 and 1966.[23] Most likely, the Denison piece was woven by a Kounsho woman, although in some cases, particularly with utilitarian textiles, it is difficult to distinguish the weaving of the Kounsho and the Utbu, an Ashö group that borders the Kounsho to the north, or the Lauktu, who border them to the west. The decision to cut panels out of the sides of the tunic to fashion a belt is decidedly untraditional. Tailored clothing made with a back-tension loom is distinctly unusual among the Chin and generally can be traced to the adoption of textile forms from other cultures, as with Mizo jackets.

3.11 Tunic (*phyang*)
Chin, probably Utbu or Kounsho.
Estimated 1880–1910.
Homespun cotton and silk. L (shoulder to edge) 103 cm, W 62 cm; L (total) 206 cm.
Gift of E. Carroll Condict. P67.146.
This gift of Dr. E. Carroll Condict is reportedly an "Ashoo woman's garment" from Thayetmyo. It consists of a single loom width (with the neck hole apparently cut and oversewn), with sides simply joined. The warp-faced fabric (twenty-four warps and eight wefts per centimeter)

consists of warps of black and white cotton and red silk and wefts of black cotton. The twining wefts are red silk and white cotton. The finish is rolled under and sewn with red commercial cotton. The homespun cotton and natural dyes in this tunic suggest a traditional origin for this textile that does not square with the construction of the neck hole, which was made, untraditionally, by cutting the finished cloth. That dissonance suggests that the current piece is one-half of what once was a much wider, two loom-width tunic. If the original tunic were, indeed, 124 centimeters wide, it was an imposing piece, probably dating to the nineteenth century. That dating would be consistent with the yarns, the use of silk, and the subtle narrow warp stripes

3.11 Tunic

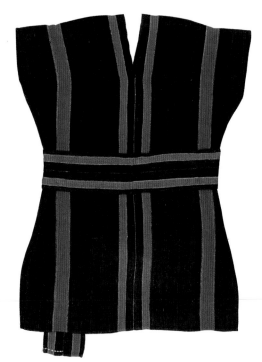

3.10 Man's tunic

Barbara G. Fraser and David W. Fraser

flanking the major red warp stripe. Nineteenth century Utbu and Kounsho women's tunics typically were marginally wider than they were tall, as this would have been. A still more impressive style of the old warp-striped eastern Ashö tunics had two major warp stripes in each loom width, as illustrated in Figure 3.8.

3.12 Woman's tunic (*kengkrang*)
Chin, Sunghtu. Estimated 1915–1924. Cotton and silk. L (shoulder to edge) 75 cm, W 62 cm; L (total) 150 cm. Gift of Agnes Bissell. P67.12.

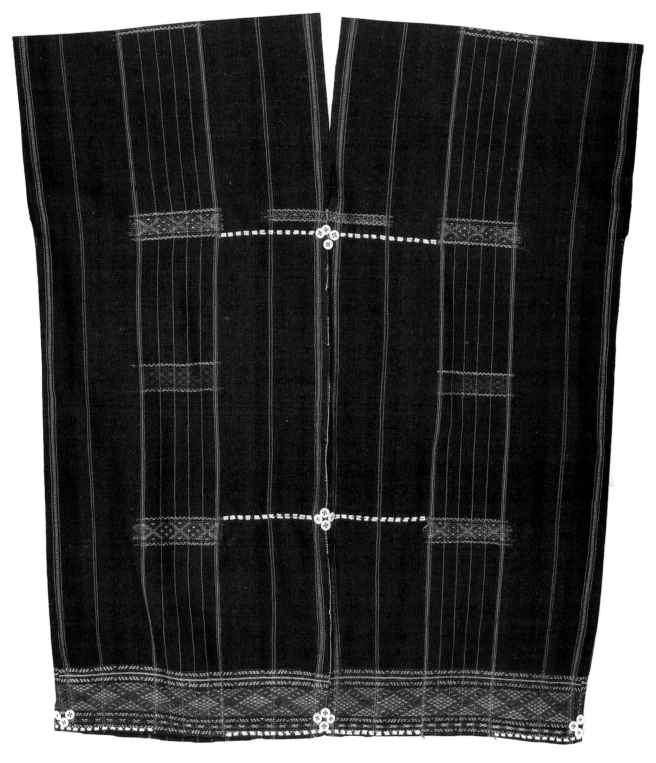

3.12 Woman's tunic

Given by Agnes Bissell, who was in Sandoway from 1901 to 1924, this *kengkrang* illustrates the typical layout of a Sunghtu woman's dress tunic, including the major band of one-faced complementary weft patterning along the lower border, seven rectangles of one-faced supplementary weft patterning along the midline of each loom width, and a narrow rectangle at the throat (and symmetrically at the nape of the neck). The supplementary wefts are red, gold, white, and green silk, while the underlying fabric is made of homespun cotton (twenty-two warps and seven and a half wefts per centimeter). The narrowness of the major decorative band suggests that it comes from the northern end of the Sunghtu range, perhaps from the area around Ann. More southerly Sunghtu tunics can have major bands that cover as much as the lower forty percent of the ground cloth. Tunics for every day use have much less decoration, and may lack the major band altogether. However, even utilitarian tunics generally have a line of embroidery, like that visible just below the supplementary weft patterning at the throat. Some Sunghtu women still wear traditional tunics both for daily wear and for festivals.

3.13 Woman's tunic (*phyang*)
Chin, Khamau. Estimated 1920s.[24]
Cotton and silk. L (shoulder to edge) 102.5 cm, W 84.5 cm; L (total) 205 cm. Gift of Reverend L.W. Spring and his children. P67.34.

Reportedly from Sandoway, this tunic was the gift of Reverend L.W. Spring (who was in Sandoway from 1915 to 1921 and from 1922 to 1929) and his children. Its two loom widths of warp-faced fabric (twenty-two warps and twelve wefts per centimeter) are joined with *abrung* embroidery on the center seam and fairly simply on side seams. The warps are black, green, yellow, and red cotton, and the structural wefts are black cotton. The discontinuous, one-faced supplementary weft patterning is done with red and white cotton and yellow silk. The finish is turned and over-sewn. This style of Khamau tunic dates back at least to 1855, when the first Chin textiles were acquired by a Western museum. The relatively high weft density suggests this example is not as old as the earliest pieces (whose weft densities are approximately nine per centimeter), and the presence of a green warp yarn suggests a twentieth century date. In terms of structure and design, however, it is perfectly traditional. The major design across the breast (and symmetrically across the back) is created by two supplementary wefts, one of red cotton and one of yellow silk, that float on the obverse when they do not ride in the shed with the black structural weft. On the reverse (inside), therefore, the pattern is

3.13 Woman's tunic

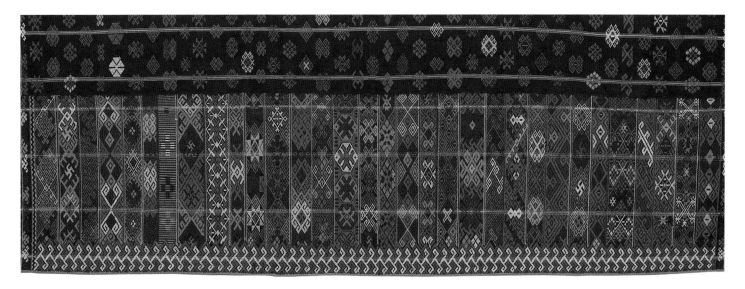

FIGURE 4.4 Detail of vertical bands on the lower panel of a skirt cloth of
a style historically produced by the Jinghpaw and the Hkauri sub-group.
First half of the twentieth century. See Catalogue no. 4.5.

acted as a recruitment precursor for the colonial
military and security establishment, were from the
hills around Bhamo and close to the China border.
Early photographs of these first recruits suggest that
their bags were individualized, personal items and
displayed some variety. Later, however, the bags of
soldiers became more standardized and seem
typical of the type exemplified by Catalogue
no. 4.8, with thick long red tassels and intermittent
rows of white beads adorning the front.

In the 1930s, there were efforts by the colonial
administration to re-settle demobilized Kachin
soldiers along the railway corridor south of
Myitkyina, and many former soldiers did eventually
reside in this increasingly volatile environment
where there was much rivalry (sometimes erupting
into violence) with Shan and other communities.
The groups that tended to migrate to this place
continued to be those either from the army in search
of land or communities close to the China border.
These soldiers, sometimes of Jinghpaw, Zaiwa, or
Lachik origin, engaged with the "Htingnai" identity,
but some of their clans might also have migrated
into and out of this region historically. Thus, a
conflation of identities became connected with these
bags as the communities from which they may have
originated interacted in a new context in the
pre- and post-Second World War setting.

The technical production of bags of this type was
greatly admired, and there are accounts of how,

after the Second World War, they were increasingly
difficult and expensive to purchase as a result of the
mass dislocation of peoples and loss of knowledge
of their production. Their status and popularity
may explain why there are numerous examples of
these bags in the Denison collection, and also why
the geographical and political access by the Baptist
Mission to the communities that produced them
facilitated this. Furthermore, it may also explain
why there are no recent examples in the collection,
as the art of producing these bags seems to have
largely disappeared. This contention is supported by
the findings of a recent textile project conducted by
the Green Centre for World Art at Brighton Museum
and Art Gallery in Brighton, UK, in which the
production of a Htingnai-region fringed bag became
a major project, involving a reinvigoration of the art
by a weaver from Htingnai who had not woven such
a bag for thirty years.[15]

The items described thus far represent but a
small percentage of the Denison Kachin collection
as a whole, but they are technical highpoints. The
rest of the collection raises questions about the
relative decline of material wealth and knowledge
of material culture in the inter-war period when
many of the items seem to have been made. Figure 4.6
(Catalogue no. 4.9) and Catalogue no. 4.10, both a
Bhamo Jinghpaw woman's style jacket, and
Catalogue no. 4.11, possibly a Htingnai region
woman's jacket, are notable for their use of silver.

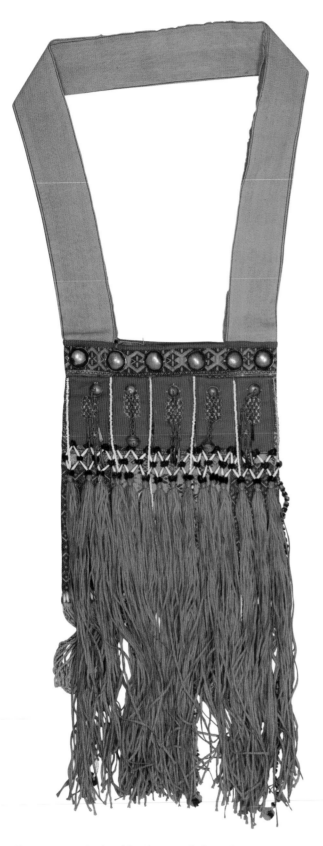

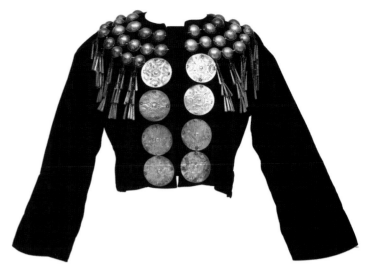

FIGURE 4.6 Jacket typically worn by Jinghpaw Kachin women from southern Kachin State or the northern Shan States.
Mid twentieth century. See Catalogue no. 4.9.

However, compared to some uses of silver ornamentation seen on the jackets of Kachin women, these are relatively modest. Easily quantifiable historically is the fact that the quality of many of the silver *soi* (discs) on these jackets seems relatively low and that the silver seems to have many impurities. There were significant transformations in material wealth in the region in the inter-war period, which continued through the devastation of the war and beyond into the demonetization policies of the early 1960s, which caused many households to lose their savings overnight and created renewed economic challenges to the adornment of jackets as personal wealth items. Ho Ts'ui-p'ing has made a detailed study of changing notions of personal wealth ownership and display among "Kachin" people residing close to and beyond the Chinese border at this time, with silver adornments on dress being related to changing ideas of personal wealth.[16] Ethnic dress as a whole, not merely the museologically privileged domain of hand-woven textiles, can be seen to occupy a complex place in the evolving relationship of the nation state to local categories of identity.

In the early twentieth century, there were many new challenges that served to reconfigure the context of textile production in the Kachin region. Forced migration and internal displacement seem often to have a devastating impact on traditions of hand weaving.[17] One may hypothesize, for example,

FIGURE 4.5 A shoulder bag made by a Lawngwaw (Lhaovo or Maru) weaver.
First quarter of the twentieth century. See Catalogue no. 4.6.

Mandy Sadan

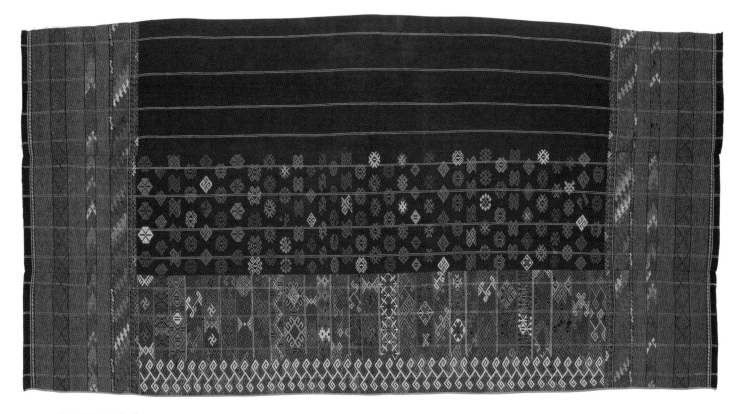

4.4 Skirt cloth

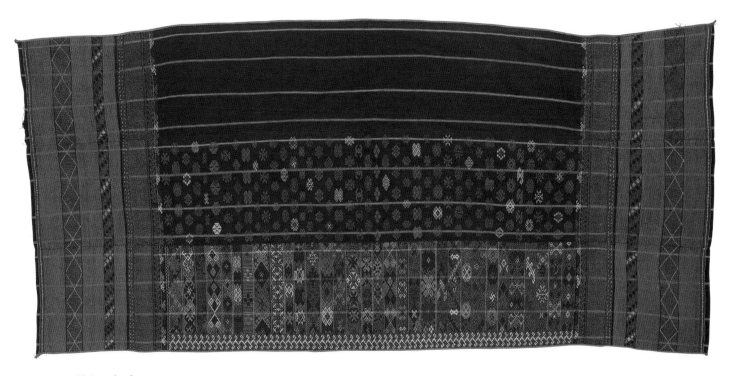

4.5 Skirt cloth

because of the geographical location of the groups, may in this case also be extended to include the Jinghpaw sub-group of the Hkauri. Today, the use of narrow vertical "stripes" of highly varied designs across the bottom band of the skirt cloth is most commonly associated with the Lachik peoples, who also reside in this region. However, historically it seems that this style was more prevalent amongst Hkauri and Jinghpaw peoples than the Lachik. The transfer of the design from one group to another probably reflects historical changes in conceptions of identity in this complex ethnographic region, and thus any specific attribution of this piece is likely to be somewhat flawed.

4.6 Shoulder bag
Burma, Southern Kachin State and northern Shan State. Kachin - Lawngwaw/Maru and Zaiwa. First quarter of the twentieth century. Cotton, wool flannel, silver, seeds, and beads. Pouch: L 30.5 cm, W 26.7 cm. Gift of Grace L. Pennington and Irene P. Miller. DU 1968.259.

The shoulder bag was probably made by a Lawngwaw weaver (the name Lawngwaw is sometimes written as Lhaovo, and the Lawngwaw sub-group of the Kachin is often referred to as Maru). Lawngwaw shoulder bags were typically intensely decorated, utilizing multiple small designs that cover the bag and many bright colors. Frequently, the straps were heavily decorated with both woven designs, shells, seeds, and other adornments. Stitched onto the front of the Denison bag are a series of plackets, the center of which has been cut out to expose black and white weaving and edged with herringbone stitches. The long, red fringes attached to the seed patterns incorporate strands of glass beads and woolen pompoms, again suggesting that this bag was made by a Lawngwaw weaver. However, other groups in this region, such as the Zaiwa peoples, also utilized such fringes. The body of the bag is decorated with supplementary weft designs. The silver adornments on the bag are of poor quality and are used

relatively sparsely, indicating that this was not a particularly valuable personal item.

4.7 Shoulder bag
Burma, Southern Kachin State and northern Shan States. Kachin - Bhamo Jinghpaw, Hkauri, and Htingnai. Early to mid twentieth century. Cotton, wool flannel, silver, beads, and seeds. Pouch: L 34.3 cm, W 30.5 cm. Gift of Mrs. David Tin Hla (Daw Hla Thwin). DU 1969.160.

This is a shoulder bag possibly made by a Htingnai weaver.

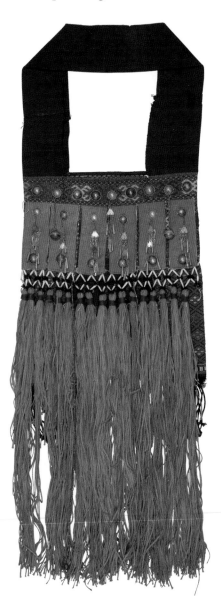

4.7 Shoulder bag

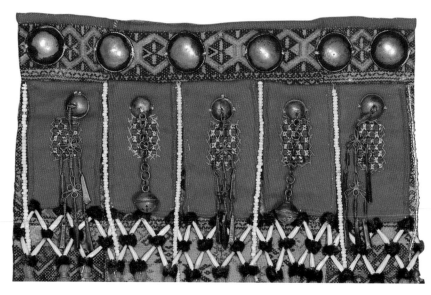

4.6 Detail of a shoulder bag

Mandy Sadan

4.18 Shoulder bag

Burma, Southern Kachin State and northern Shan State. Kachin - Bhamo Jinghpaw and Lawngwaw.
Circa 1915–1930.
Cotton warp, wool weft, and Job's tears.
Pouch: L 27.9 cm, W 25.4 cm.
Gift of John F. Marshall. DU 1970.26.

This shoulder bag is of market quality and was probably made by a Lawngwaw weaver or a Jinghpaw weaver residing close to Lawngwaw and Zaiwa communities, with whom the use of seeds as decoration on bags was common. The use of large, supplementary weft patterns on a red background is typical of Jinghpaw designs in this region. However, the size of the swastika designs and the bold use of colors along the top edge of the bag suggest that its production has been influenced by machine-loom weaving techniques. It may, therefore, have been fashioned in response to missionary efforts to commodify the production of Kachin textiles, which were particularly significant in this region.

4.19 Shoulder bag

Burma, Southern Kachin State and northern Shan State. Kachin - Bhamo Jinghpaw. Early to mid twentieth century.
Cotton warp, wool weft, and silver.
Pouch: L 28.6 cm, W 26.7 cm.
Gift of Mrs. David Tin Hla.
DU 1969.162.

The shoulder bag was probably made by a Jinghpaw Kachin weaver from the south or southeast of Kachin State, today commonly referred to as Bhamo Jinghpaw. This style of bag has become a generic type of "Kachin" bag that is today readily available in markets in lower Burma and the urban areas of Kachin State. The supplementary weft designs employed are relatively simple, particularly in their primary use of red on a black or indigo ground, with rows of silver discs around the top of the bag at the front. These discs, or *soi*, would traditionally have been made by Sino-Shan silversmiths. The designs varied over time, especially in response to the increasing appeal of such bags in a broader Burmese market. This bag seems to have been made by a relatively inexperienced weaver, suggesting again that it has its origins in the commodification of such bags for market sale.

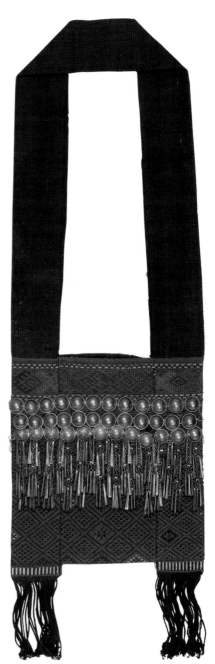
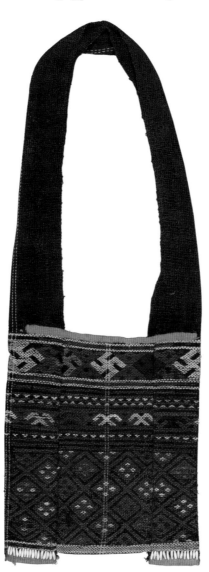

4.18 *left* **and 4.19** *right* **Shoulder bags**

Notes

1. Young students sometimes tie knots in the straps of their shoulder bags and their contemporaries decode from the position of the knot over the shoulder whether or not the wearer has made a romantic commitment to another, or is "still looking."

2. The complex interaction of these last two as contemporary social models is perhaps best reflected in the Kachin case through the selection by non-Kachin men of a generic "Kachin" (actually *Hkahku*) male skirt cloth of green and purple plaid design as a symbol of support for the National League for Democracy. This party, most notably lead by Daw Aung San Suu Kyi, won the 1990 elections but was subsequently denied power by the ruling military.

3. "Classic" in this case implies the privileging of this kind of textile in foreign museums and collections, where they are very frequently to be found, as well as by local people from the north of Kachin State who consider this kind of bag in particular to be an example of high artistic and technical skill.

4. U Thant Myint, *The Making of Modern Burma.* Cambridge: Cambridge University Press, 2001.

5. Terms in parentheses refer to the most commonly found alternative spellings or referents of these groups.

6. M. Smith, *Burma: Insurgency and the politics of ethnicity.* London: Zed Books Ltd, 1999, p. 158.

7. B. Lintner, *Land of Jade: A journey through insurgent Burma.* Edinburgh: Kiscadale Press, 1990; Global Witness, *A Conflict of Interests: The uncertain future of Burma's forests.* London: Global Witness, 2003.

8. This comment derives from personal communications made over an extended period with Kachin people from Kachin State who seem to have little knowledge of the contemporary Singpho situation in Arunachal Pradesh. In 2003 large numbers of young Kachin people tried to cross the border to seek political asylum, but this led to a severe restriction being imposed upon cross-border traffic.

9. IOR [India Office Records]: L/PS/7/18 – 11th April 1878, 2nd May 1878, 15th July 1878 "Entry of Missionaries to the Kahkyen Hills."

10. *Nat* is a Burmese term, and its historical incorporation into local expression is uncertain. In Jinghpaw, the multiple categories of spirits all have their own generic name, and usage of the term *nat* seems mostly likely to have originated as a form of hybridized auto-ethnography in cross-cultural encounters.

11. *Htingnai* is commonly used as a geographical referent rather than an "ethnic" one, because of the extremely complex interaction of both Kachin and non-Kachin groups in this area, and the difficulties in defining what terms such as "Kachin" or "non-Kachin" might mean in this setting.

12. For some background to this work, see *Burma Frontier Photographs: 1918–1935*, E. Dell (ed.), London: Merrell Publications, 2000.

13. J. Schneider, "The Anthropology of Cloth", *Annual Review of Anthropology*, vol. 16, 1987, p. 414.

14. This large diamond-shaped pattern would be one of the first designs that a young weaver would learn and would typically be found near the outer edge of a side panel.

15. L. Maddigan, "Making Textiles in Myitkyina, 2001–2." *Textiles from Burma*, E. Dell and S. Dudley (eds.), London: Philip Wilson Publishers, 2003, pp. 161–67.

16. Ho Ts'ui-p'ing, "Rethinking Kachin Wealth Ownership", paper presented at 4th EUROSEAS Conference, Paris, 2004.

17. S. Dudley, "Textiles in exile: Karenni refugees in Thailand." *Textiles from Burma*, E. Dell and S. Dudley (eds.), London: Philip Wilson Publishers, 2003, pp. 133–41.

18. M. Sadan, "Textile Contexts in Kachin State." *Textiles from Burma*, E. Dell and S. Dudley (eds.), London: Philip Wilson Publishers, 2003, pp. 169–77.

19. I am grateful to Hkanhpa Tu Sadan for his comment on this bag.

5

An Introduction to Lahu Textiles

LISA MORRISETTE

The Denison University collection contains fine examples of the bags and the distinctive blue-black, indigo-dyed clothing decorated in lively appliqué of the Lahu. This material includes six coats, three pairs of trousers, four skirts, a woman's headdress or turban, a child's cap, six shoulder bags and two smaller coin bags, and a woven sash, along with other fragmentary pieces. These textiles were largely donated to the museum by Baptist missionaries who worked in Burma and Thailand. The missionaries acquired the pieces either as gifts from their converts or as specially purchased souvenirs (Figure 5.1).[1] This introduction to Lahu textiles explores how this clothing was worn and its significance within Lahu society by focusing on dress as a vehicle for aesthetic and social display and as an attribute of group and personal identity.

The Lahu are one of the smaller hill groups living in the mountainous regions of northern Burma along the Yunnan-Burma border, an area which extends south to Kengtung in Shan State and eastward into northwestern Laos and northern Thailand. The Lahu language belongs to the Tibeto-Burman language family known as Lolo, and is related to that of the Akha and Lisu. These latter peoples live in close proximity to the Lahu but constitute distinct cultural groups.[2] Within the larger population of the Lahu there are separate sub-groups, including the Lahu Nyi (Red), Lahu Sheh Leh, Lahu Na (Black), and Lahu Shi (Yellow). They are both united and separated by language, as several Lahu dialects are spoken by the different groups.[3]

The similarities and differences between the Lahu can also be seen in their dress and techniques of adornment.[4] Along with language, this has been a popular way of distinguishing between the groups. Missionaries, ethnographers, and travelers to the areas populated by the Lahu groups have regularly reported on the cut and color of their dress.[5] Generally, each of the Lahu sub-groups employs a distinctive color in their clothing or its decoration, and that color has become a characteristic feature associated with the group's identification and naming. Variations in embroidery and decorative techniques, and in the style and cut of coat or jacket worn with either trousers or skirts, are also discernable. These differences serve both to connect the group and visibly to separate it from the other sub-groups. Nevertheless, a common Lahuness can be seen in the related decorative techniques, such

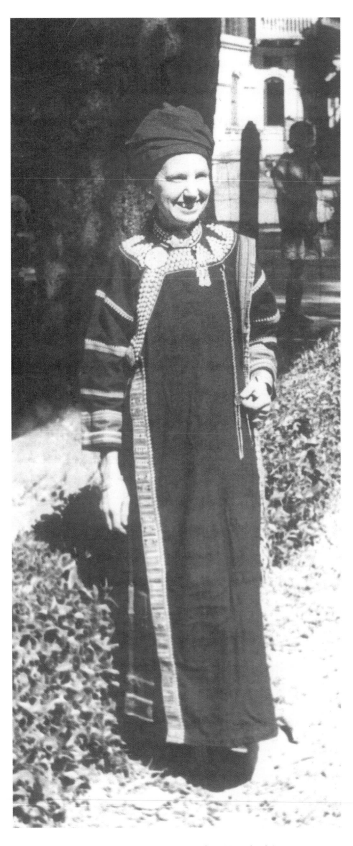

FIGURE 5.1 Missionary in Lahu Na clothing.
Courtesy of the American Baptist Historical Society, American Baptist Archives Center, Valley Forge, PA.

as appliqué, scalloping, and embroidery, which are shared by all the groups. Paul and Elaine Lewis, missionaries who spent many years among the Lahu of Burma and Thailand, have said, "If at New Year time one could visit in sequence Lahu Nyi, Lahu Sheh Leh (also Cheleh), Lahu Na, and Lahu Shi villages one would experience the full impact of the diversity of these groups, and yet recognize a common Lahuness."[6]

Despite the apparently simple process of demarcating groups through dress and textiles, it is critical to recognize that such labeling or identification by this technique is only one aspect of a whole set of cultural practices which outsiders, as well as insiders, have used to define ethnic and cultural identity, and that this is a complex and problematic practice.[7] Given that dress categories are often not discrete and that traditions change over time, it is not possible to state definitively that particular dress items have always belonged to specific groups as they exist currently.[8] Clothing is subject to the vagaries of fashion and the availability of materials. While textiles constitute a visible means of creating identity from inside, and a convenient means of naming and labeling from the outside, they are not a singular means of locating ethnicity. Bearing this in mind, by comparing the Denison collection to contemporaneous material from the early twentieth century through the 1960s, it is possible to identify the majority of objects at Denison, including the coats, trousers, and shoulder bags, as most likely produced by the Lahu Na or Black Lahu. While the black turban cloth is of a type worn by several groups, it is recorded as having come from a Black Lahu village. Skirts like the Denison ones were utilized by the Red Lahu, but may also have been worn by other groups, including the Black Lahu. The cap, small bags, and the sash are less easily attributable without further provenance information.

From photographs and descriptions of dress of twentieth century Lahu Na people, it is evident that the traditional male outfit consists of a blue-black jacket with a Chinese-style side closing, loose trousers reaching just below the knees, and leggings. The men's trousers are trimmed with narrow bands of stitching. The Denison collection holds three pairs of such trousers, two of which are trimmed with embroidery. On the trousers shown in Figure 5.2, the uppermost decoration is the widest and consists of a red section, in the center of which is

Lisa Morrisette

a line of yellow stitching flanked by two dark pink ones. At the bottom edge is an embroidered pattern with solid lines of brown, fuchsia, and ochre yarns, sequences of three stitches of brown yarn, two stitches of pale green yarns, and a single stitch of the fuchsia yarn. The latter three are piled on top of each other creating a pyramidal shape that is similar to the triangular patterns of silver bosses on the women's coats.[9]

Highly decorated shoulder bags are a major flourish of Lahu Na male dress for festivals, and such bags were also important accoutréments for everyday use.[10] They have many practical uses for both sexes and all sub-groups, and are used for "holding everything from food and tobacco to bullets and felled small game."[11] Catalogue numbers 6.7–6.8 and 6.12–6.14 are examples of such bags. One type is composed of blue-black cloth and traditional patchwork and scalloping. The back-strap woven shoulder straps are tufted with pompoms, giving a festive touch to the everyday, and additional tufted pompoms were added for celebrations.

The Denison collection has several examples of Lahu Na women's coats, probably dating to the first half of the twentieth century. These outfits consist of a blue-black, indigo-dyed, ankle- or calf-length coat that opens down the center front or across the shoulder and down the side.[12] In either case, the coat is slit up the sides to the waist and is decorated with bands of colorful appliqué in brilliant hues of red, white, yellow, and green and edged with scalloping. Some coats have blue yokes, which contrast with the dark base fabric, embellished with silver domes or buttons and large floral medallions that function as fasteners (see Lahu Catalogue nos. 6.1–6.6).[13]

Michael Howard, in describing Lahu dress, notes that,

> The skirt consists of three panels. The top panel is a piece of handwoven Shan or Laotian striped cloth, the middle panel is black with splice strips in red and other colors, and the bottom panel is black with a red hem line.... The skirt also may have a top panel of striped handwoven cloth, but contains less decoration in the two other panels.[14]

This bears some resemblance to a description of Lahu skirts made in the early twentieth century. In *Notes from the Bankfield Museum*, Mr. H.S. Hallet is

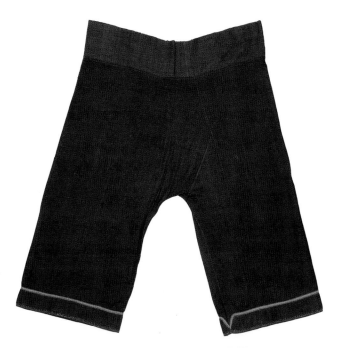

FIGURE 5.2 Trousers *top*; detail *above*.
Burma, Lahu, Lahu Na. First half of the twentieth century. Cotton. L 96.5 cm.
Gift of Walt and Henry Sutton. DU 2001.10.

recorded as describing a skirt that may have originated with the Lahu. He also states that the pattern on a woman's skirt reflects the clan to which she belongs.[15] The same publication illustrates another skirt made of three sections, one of which is a Chinese fabric.[16] Denison's collection has four skirts that are similar to these. The tube skirt illustrated in Figure 5.3 is composed of several distinct sections.[17] The top part, which comprises about half the length of the skirt, is a predominantly red-orange, coarsely hand-woven piece of fabric. Below this are two narrow fold lines of pink and red cloth, a wider strip of bright blue cloth, and two narrow fold lines of red

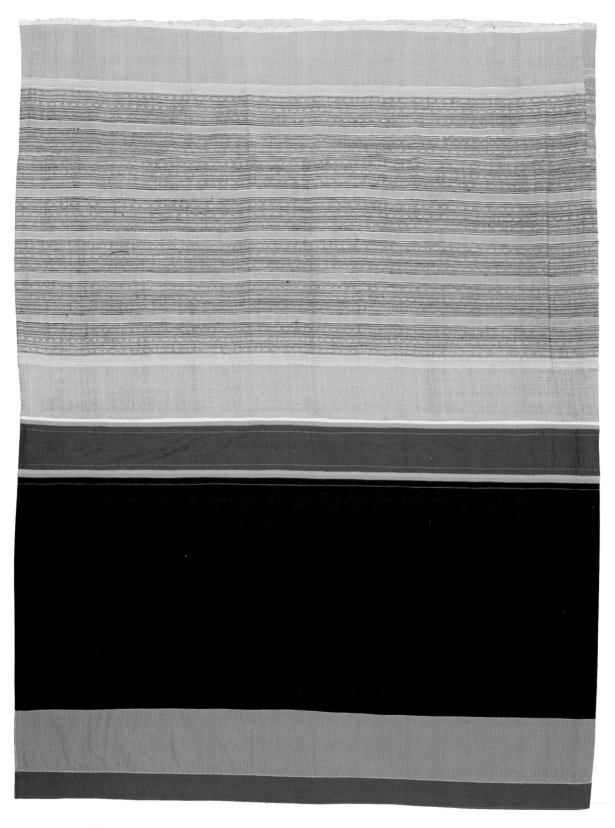

FIGURE 5.3 Skirt.
Burma, Kengtung. Lahu. Mid twentieth century.
Cotton. L 106.7 cm.
P67.143.

LAHU TEXTILES CATALOGUE

6.1 Coat

Burma, Lahu, Lahu Na. Early twentieth century.
Coat body: bast fiber; decorative appliqué: cotton. L 113 cm, W 47 cm; Cloth: W 23.5 cm.
Gift of Reverend and Mrs. M.V. Young. DU 1968.11.

This coat with a closing at the center front is the oldest, most worn one in the collection. It is composed of two pieces of cloth stitched together along the selvage edges down the back of the coat. The side seams are carefully enclosed with red fabric and a narrow fold line of yellow fabric, so that it is impossible to state definitively that they are selvage edges. This trimming is joined for 2.5 centimeters in the underarm area, but beneath this, the side seams are left open. The sleeve fabric is warp-faced, as is the coat's base fabric, with the warp running in the direction of the sleeve width. The sleeves are 38.7 centimeters long and are made of a single piece of fabric. This differs from the other coats in the collection which have sleeves made of two pieces of fabric each joined in the center of the sleeve. Scalloped edging, narrow fold lines, and decorative stitching are still applied midway across the sleeve, though in this instance they serve as an embellishment only. The decorative elements were added before the sleeve seam was sewn. The narrow stand-up collar is attached to the body of the coat, and a circular yoke that is 8.9 centimeters wide encloses the collar and the coat seam line. The yoke is a lighter blue color than the rest of the piece, a common feature in all of the coats. Atypically, however, the yoke is attached to the inside of the coat. The edge stitching of the yoke, securing the outer border to the coat, is done using a very close hem stitch that becomes a decorative line on the right side.

The coarseness and irregularity of the cloth, including most of the appliqué fabrics, indicates that it was probably hand woven. The black appliqué fabric used in the smaller piecework and also in the narrow fold lines has a satin structure, which indicates that it is a commercial product. The colors of the fabrics suggest that they were dyed with natural dyes. The left sleeve is a darker blue than the coat and the other sleeve, indicating that it was dyed at a different time.

The narrow, exposed fold lines have been finely accomplished. Combined with the multiple rows of hand-stitching required to secure them, these fold lines develop into firm edges, particularly at the center front opening. The scalloped edging, which is quintessentially Lahu, is found at the junction of the appliquéd fabrics and the base fabric. This coat shows both types of patchwork, with small geometric shapes at the center front and the larger patchwork at the side

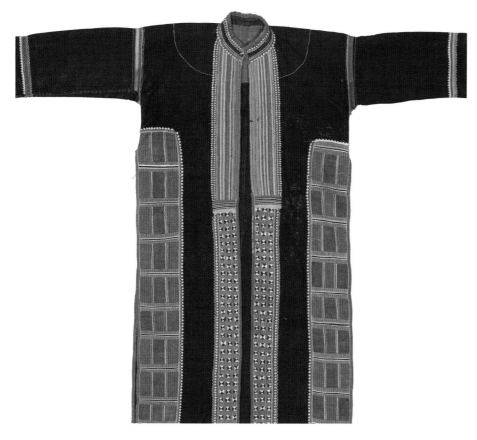

6.1 Detail of a coat

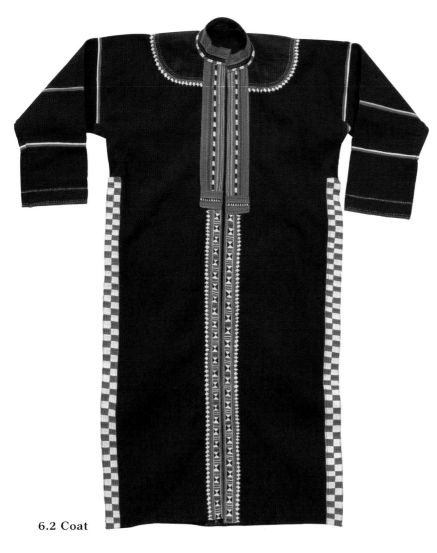

6.2 Coat

woven cloth, with no shoulder seam. The cloth is a warp-faced plain weave with fourteen warp ends and ten weft picks per centimeter. The sleeves are made of the same fabric as the body of the coat. One selvage is joined around the armhole of the coat. To make the sleeve long enough, an additional length of fabric has been added which is joined decoratively with narrow, exposed fold lines and hand-stitching. Two additional sections of appliqué and embroidery encircle the sleeve for decorative purposes only. An interesting feature of this coat is the use of an underarm gusset or insertion, which gives the wearer added fabric for better mobility. The underarm seam is very short, only 6.4 centimeters, and beneath it the sides are left open. Embellishing the side slits is large patchwork of red and white squares alternating in two rows and made of commercially available fabric. Commercial fabric is more compactly woven, enabling better manipulation and thus more precise cutting and stitching, as is evident in the crisp shapes here. Geometric appliqué composed of a single row of black and white diagonally cut shapes surrounded by many exposed narrow fold lines and a scalloped edge borders the center front closing. The yoke, which has been applied to the outside of the coat, is made of cotton and is dyed a lighter indigo color than the coat. Stitch work that is functionally required for maintaining the integrity of the coat has been executed in such a way that it adds a decorative element. For example, running stitches, stacked in blocks of three, are used to flatten the yoke seam and the

seams. In both cases, the patchwork has been embellished and supported by the exposed narrow fold lines.

The back hem is reinforced on the wrong side with a 9.2 centimeter wide band of light indigo-dyed fabric. On the right side of this supported area is an embroidery panel. Microscopic examination indicates that the embroidery yarn is not cotton. It varies in structure, being either "S" or "Z" twist, in both single ply and two-ply. The irregularity along the yarn length suggests that it may be hand-spun. The panel is covered with large stars, zigzags, and bird's feet in an airy and largely random design

that is executed with large stitches. The round shapes have been created with four rows of large blanket stitches. The result is a delightful and playful, yet amorphous, image on an otherwise very structured, organized, and rigorously executed coat.

6.2 Coat
Burma, Lahu, Lahu Na. Acquired in the Taunggyi area from an old lady in 1922. Coat body: bast fiber; Decorative appliqué: cotton. L 104.2 cm, W 53.3 cm; Cloth: W 26.7 cm.
Gift of Irene P. Miller and Grace L. Pennington. DU 1967.145.
This coat, which shares many characteristics with Catalogue no. 6.1, is made of a narrow-width

appliqué, and scalloped appliqué with couched embroidery. All of the decorative work is applied directly onto the base fabric. The bag is composed of a single piece of fabric with no bottom seam, but despite this, the front and back of the bag have not been decorated with the same design. Both machine and hand-stitching are used.

The bag has a narrow band-woven strap composed of a variety of colors—black, red, yellow, white, and green. Black and white alternates in the warp, with a selective pick-up of all white or all black to create a saw-tooth effect. The weft is a black yarn, but because the band is warp-faced, it is not visible. Just below the last row of decorative appliqué on both sides of the bag, weft insertions of red, yellow, and white create fifteen centimeter tails, which hang alongside the strap. Four additional groups of weft insertions enter the warp from both sides of the strap and exit one quarter of the way across the strap, creating pompom-like structures. The warp ends create a fringe along the bottom.

6.8 Bag
Burma, Lahu, Lahu Na. Pre 1923.
Body of bag: bast fiber; Decorative appliqué: cotton; Strap: cotton. Bag: L 26 cm, W 19 cm; Strap: L 102.9 cm, W 4.1 cm.
Gift of Irene P. Miller and Grace L. Pennington. DU 1967.149.
This bag is very similar to Catalogue no. 6.7. Although a much different color sequence is used in the warp yarns of this bag's strap, the alternating pick-up of white and black is still an important part of the design. There are five weft insertions of tails and pompoms.

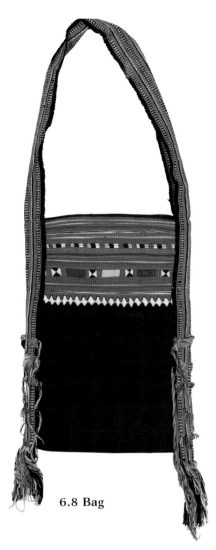

6.8 Bag

6.9 Turban
Burma, Lahu, probably Lahu Na. Pre 1923. Bast fiber. L (excluding fringe) 261.6 cm, W 24.1 cm.
Gift of Irene P. Miller and Grace L. Pennington. DU 1967.144.
The turban, supposedly part of a set with Catalogue no. 6.2, is constructed of the usual type of narrow woven base cloth. The central portion of the turban is woven smoothly. The warp yarns have been made into a 30.5 centimeter fringe by twisting groups of about eight yarns together and tying a knot at the end. The last fringe grouping on one of the ends has been inserted through a bead. Approximately

6.9 Detail of a turban

4.5 centimeters from the end of the turban there are three clusters of ridges, each composed of three weft strands of heavier yarn 0.3 centimeters apart. Each cluster is 4.5 centimeters distant from the next. About thirty-eight centimeters of the thicker weft yarn is left hanging beyond the edge of the fabric, creating a fringe along the selvage edge. Some of these weft fringes have been damaged and broken away.

6.10 Strip of pieced work
Burma, Lahu, Lahu Na. Mid twentieth century.
Cotton. L 116.8 cm, W 3.8 cm.
Gift of Reverend and Mrs. M.V. Young. DU 1968.15
The strip of pieced work is composed of different, commercially available cotton fabrics which have been cut into triangles and stitched together to form squares of alternating colors. The

squares are grouped into blocks of two or four and machine-stitched together. It is a curious piece, as it seems unfinished, and in this condition it is not strong enough to withstand wear. It might have been intended as a supply of small geometric shapes for subsequent appliqué work.

6.11 Sash
Burma, Lahu. Mid twentieth century.
Cotton. L (excluding fringe) 167.6 cm, W 6.4 cm.
Gift of Mrs. Erville Sowards. DU 1975.3.
The sash is a warp-faced textile. Produced in bright pink, yellow, green, black, and white, the warp striping is concentrated along the edges and down the middle of the sash, while two broad bands of white and green warps that are alternately picked up to the face of the fabric create a saw-tooth effect. The yarn used for the warp is very fine and therefore three strands are used for each warp end. A heavier black yarn is used for the weft, but it does not contribute to the design because the warp threads are so numerous and dense. The warp threads are twisted together into four groups at the ends of the sash and tied, leaving enough length to create a pompom.

6.12 Bag
Burma, Lahu, Lahu Na. First half of the twentieth century.
Cotton. L (excluding fringe) 30.5 cm, W 29.5 cm; Strip: W 10.1 cm; Strap: L 84 cm, W 9.5 cm.
Gift of Reverend and Mrs. M.V. Young. DU 1968.9.
This bag is composed of two strips of cloth, produced in a warp-faced pick-up weave. A separately produced strip forms the sides of the bag, as well as the

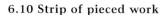

6.10 Strip of pieced work

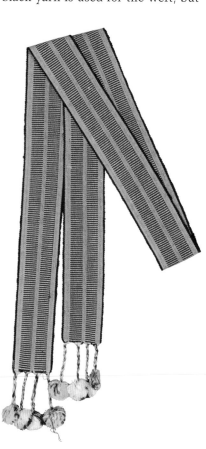

6.11 Sash

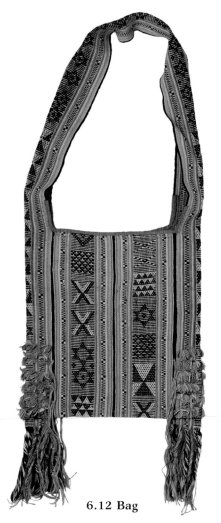

6.12 Bag

were raised to form an opening called the shed during weaving. In producing the cloth, the weaver passed the weft through the shed with the aid of a wooden shuttle. Shuttles, carved in narrow curved shapes and planed to a smooth surface that passed easily through the shed, varied in length from twenty-five to fifty-five centimeters, depending on the complexity of the weaving pattern and the thickness of the yarn. After each weft was inserted, the weaver used the beater to press the newly inserted weft yarn tightly against the already woven cloth.

Fitting the warp yarns onto the loom was a time-consuming process, as each warp had to be passed through the reed or beater to ensure equal spacing between the yarns and a consistent width to the finished cloth. The yarns were further threaded through heddles which were connected to different harnesses, the support structure that raised the warps to create the shed. Tai weavers often stored heddle shafts and beaters together in sets. Each set contained the end threads, and therefore pattern, of a previous warp. When beginning a new piece, the weaver selected the set she wanted and tied the new warp to the end-threads left from the previous warp. This ingenious shortcut saved completely re-threading the heddles and reed every time a new warp was prepared.

The decoration of Tai textiles was not limited to weaving patterns, but also incorporated a number of items purchased from traders. This was possible because the landlocked Shan States were part of an extended network of trade routes. Caravans of ponies, bullocks, and oxen transported goods along established paths, although inter-regional trade was affected by the fact that many routes often became impassable in the monsoon season. The markets were generally situated in valleys, and people traveled down from the hills to sell their produce, returning home with a range of goods, including fabrics, yarns, and trimmings to decorate their textiles. The American Presbyterian missionary William Clifton Dodd wrote a description of the textile trade that, although it specifically names Kengtung, could be applied to many of the Shan States.

Kengtung is the crossroads of the nations. The long caravans come and go constantly in the dry season, down from Talifu [Dali] and Yünnan fu [Yunnan], and nearer points in China; and up from Rangoon, Maulmein, and Bangkok; they meet and pass each other at Kengtung ... The Indiaman sits in his permanent shop and displays his silks and velvets; while the Chinaman ... sits on his mat on the ground, with beads, buttons, needles and combs spread out before him.[11]

Various ethnic groups were involved with trade in the Shan States, and these included the Chinese (Haw), Burmans, Indians, and Shan people. The merchants dealt in silk yarn and silk fabrics from China and Burma, brocades and mill cotton from India, and European fabrics and lace. They also carried a variety of buttons, embroidery silks, skeins of wool, ribbons, and other trimmings. Most of these imports and trimmings are represented in the Denison textile collection.

THE TAI

The Tai groups represented in the Denison textile collections call themselves Tai Yai (or Tai Ngio), Tai Neua, Tai Lue, and Tai Khoen. These names represent various groups living in Shan State in present-day Burma, as well as peoples inhabiting other areas of Southeast Asia and Yunnan Province in China. The Tai produced a large array of textiles. Traditionally, the men wore wide cotton trousers and loose-fitting shirts with turbans, and jackets and blankets during the colder months, while women donned wrap-around or tube skirts, blouses, jackets, and occasionally, turbans. Those who could afford it dressed in textiles of silk and imported fabrics. Connected by trade and tributary relationships to the courts of the surrounding larger principalities, such as Siam and Burma, Tai royalty wore ceremonial court dress when paying homage to foreign kings.[12]

TAI LUE

The Tai Lue live in the valleys of Sipsong Pan Na (Xishuang Banna Province, southwest China), in the eastern Shan area, particularly Kengtung, Mong Yong, and Chieng Rung, and in villages and towns in Lan Na (north Thailand), where they settled in the nineteenth century. They were renowned for their weaving skills and high-quality textiles produced for the household and the Buddhist monastic community.

The small group of Tai Lue textiles in the Denison collection was woven with undyed cotton in the ground weave and with supplementary weft designs that involved either hand picking the pattern row

by row with the aid of a wooden sword, or inserting shed sticks into the warp in a predetermined pattern. A temple hanging in the Denison collection, originally listed as a curtain or coverlet in the museum archive, has an undyed, hand-spun, cotton ground weave with a wide supplementary weft border in red and black cotton (Figure 7.1).[13] It was woven in two lengths and joined at the selvage so that the border patterns were matched. The top edge is hemmed, while a section of leno gauze weave forms the bottom edge. The fringe is plaited and knotted. The supplementary weft pattern on the sheet reflects the breadth of Tai design with rows of stylized images, including that of horses, flowers, repeat hooks, diamond patterns, and what appear to be wooden roof structures. Similar images and patterns used in the border can also be found on pillows and ceremonial sashes.

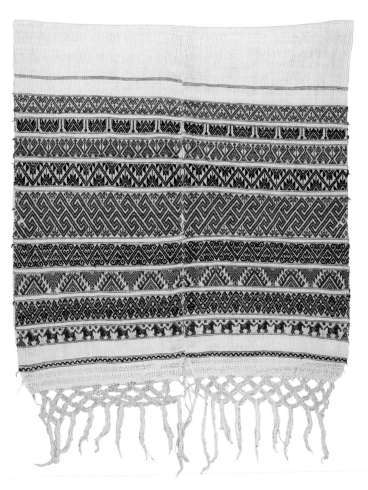

FIGURE 7.1 Temple hanging.
Burma, Shan States, Kengtung. Tai Lue. First half of the twentieth century.
Cotton. L 248.9 cm, W 101.6 cm (two 50.8 cm strips).
Gift of F. Faith Hatch. DU 1969.248.

TAI KHOEN

The Tai Khoen inhabit the central and eastern Shan valleys, and in the nineteenth century were the majority population on the plain of Kengtung, where a Tai Khoen dynasty ruled. On festive occasions and at court ceremonies, the women wore a silk turban, a long-sleeved silk blouse or jacket that flared at the waist, and an ankle-length tubular skirt (*sin mai kam*). The skirt worn on such occasions was spectacular with many bands of gold and silver sequins and metal thread, as well as silk embroidery, which together would have sparkled and shimmered.

The Denison collection contains an example of such a skirt (Figure 7.2). At the top of the textile is a red cotton waistband, used to ensure that the skirt would stay in place, because silk was prone to slipping unless a belt was worn. Below the waistband is an area of undyed cotton weft threads over the ruddy purple warp. The remainder of the skirt has a black weft. The patterning of horizontal stripes is produced in the weft using a variety of colors, including magenta, pink, purple, two tones of green, blue, yellow, peach, and black. The gold metal threads are woven in a twill motif of long floats. In the middle of the striped area is a section where the pattern interlocks in a tapestry-like effect.[14] This pattern was established through a discontinuous weft of dove-tailing colors, with the areas of intersection outlined with gold thread which was also composed of discontinuous weft threads. At the bottom of the striped section, a black band is visible, beneath which are further stripes. A piece of pink silk, in satin weave and supported by cotton at the back, is attached to the base of the skirt. Embroidery using chain and satin stitch embellishes the pink silk, as do the couched mother-of-pearl sequins and gold thread embroidery. The latter surrounds the floral and leaf patterns enclosed in tendril-like circles. A band of green commercial velveteen forms the bottom of the skirt.

The components that together compose the central panel and hem of the Denison skirt are not of the finest quality. The best skirts had more silver and gold metal thread woven in the weft, and silk velvet was used for the hems, in contrast to the cotton velvet of this sample. In Figure 7.3, Princess Tip Htila of Kengtung is wearing a more expensive version of this type of skirt.[15] Some foreigners commented on the huge cost of producing

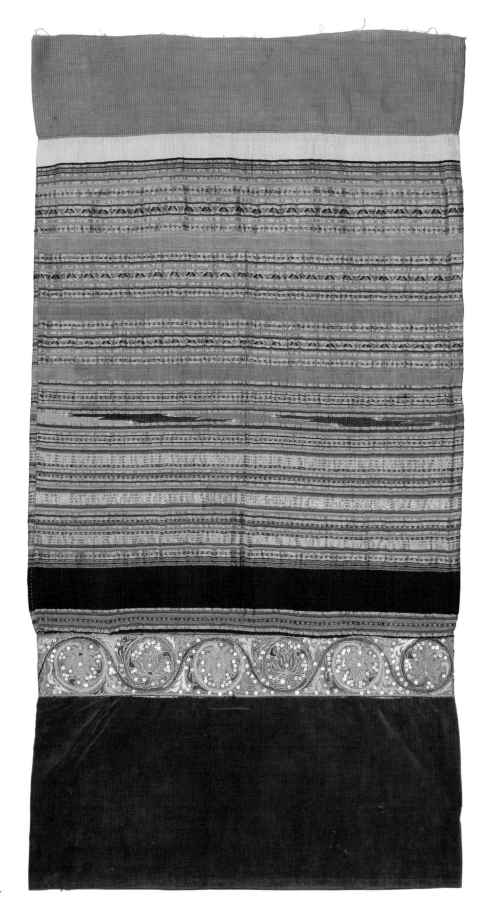

FIGURE 7.2 Skirt.
Burma, Shan States, Kengtung. Tai Khoen. 1930.
Silk and cotton. L 123.2 cm.
Gift of Vellora W. Bray. DU 1973.75.

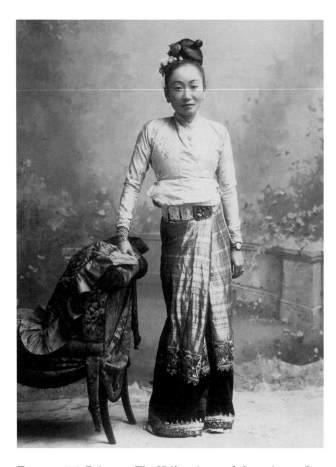

FIGURE 7.3 Princess Tip Htila, sister of the prince of Kengtung, photographed in 1902 dressed in Tai Khoen style.
By permission of the British Library (photo 430/78 [75]).

such textiles. W.C. Dodd writing in the 1920s, for example, noted that each gold flower and leaf in the band of embroidery sewn in the hem cost one rupee, more than a day's wages for most laborers.[16]

The skirt in the Denison collection was presented to the missionary Vellora W. Bray in 1930 upon her departure from the Shan States Baptist Mission. Mrs. Max D. Miles, a friend of Bray's, wrote to another friend in October 1973, describing the occasion when the skirt was presented,

> Saturday night the school gave a concert in her honor ... After all the entertainment they called Vellora up on the stage, and in front of all the people, Sao Nang Wo Tip Noi, the Sawbwa's [prince's] favorite wife, dressed her in a complete and luxurious Khun [Tai Khoen] costume. ... The Khun costume is almost the same as the Shan except that the jacket part is skin-tight in the sleeves and over the bust and

around the waist and then flares out below the waist. ... The teachers, children and parents contributed all the money. The skirt has real gold woven into it ...[17]

The tube skirt was made specifically for Bray, and the fact that the villagers had paid for it would explain the secondary quality of the piece. Nevertheless, the skirt would have required considerable effort and expense to produce, and thus indicated the importance of the missionaries to particular communities in Burma.

TAI YAI AND TAI NEUA

The Tai Yai live in villages to the east of the Salween River. The Baptist missionaries worked among them, particularly in the towns of Hsipaw, Bhamo, Namkham, and Mongnai. The Tai Neua inhabit the Northern Shan area and Sipsong Pan Na (Xishuang Banna Province, south-west China). The Tai Yai and Tai Neua women wore similar forms of turban, ankle-length skirt, and blouse.

The Denison collection of Tai Yai and Tai Neua textiles is primarily composed of women's dress items. An example of a traditional, weft-faced Tai textile can be seen in Figure 7.4. This ankle-length tubular skirt is composed of a dark, cotton cloth woven in diamond twill weave. The central panel is tan-colored silk decorated with single vertical strands of beaten silver and copper metal wire and vertical bands of diamond-patterned supplementary weft in turquoise, cerise, orange, and red silk yarn, as well as silver metal thread. Extremely narrow strips of metal-covered leather frame the supplementary-weft diamond bands, while larger strips of leather, also covered with a film of beaten silver or copper foil, were sewn on after every four rows of patterning. Below this vertical design is a horizontal band of brownish-red velvet appliquéd with leather that was covered in beaten silver foil, now largely worn away. The velvet is decorated with flat silver sequins arranged in triangles, repoussé metal sequins, and raised, dome-shaped sequins hung with metal attachments. The entire tan silk panel is appliquéd onto the base cloth, and two horizontal bands of black cotton velvet are also stitched on the base cloth at the bottom of the skirt. This skirt is typical of Tai designs produced in the northern Shan States in the late nineteenth century. It would have been worn with a turban (see Figures 7.5 and 7.6).

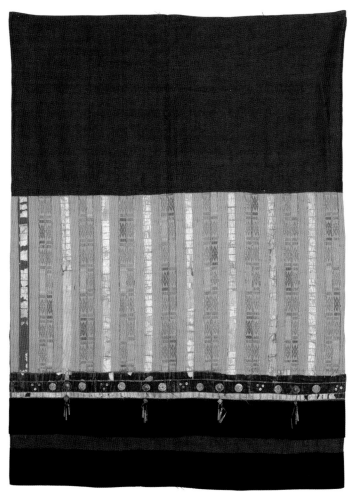

FIGURE 7.4 Skirt.
Burma, Shan States. Tai Yai or Tai Neua. First half of the twentieth century.
Cotton. L 96.4 cm.
Gift of Mrs. R.P. Currier. DU 1974.4.

The Tai groups were influenced by other peoples who also made their homes in the Shan States, such as the Karen and the Kachin. Weaving techniques and patterns produced in the area were used by a variety of groups, suggesting considerable interaction among them. A turban cloth in the Denison collection, for example, has a black, raw silk warp and weft woven in plain weave (Figure 7.5). The warps are widely spaced, packing the wefts down and creating a weft-faced textile. The turban has matching end borders of wide weft stripes in peach and green separated by thinner bands of metallic threads and pink silk. A section of naturally colored silk is interspersed with five shots of metallic thread and bordered by strips of leather covered with beaten metal. There are also decorative twill borders

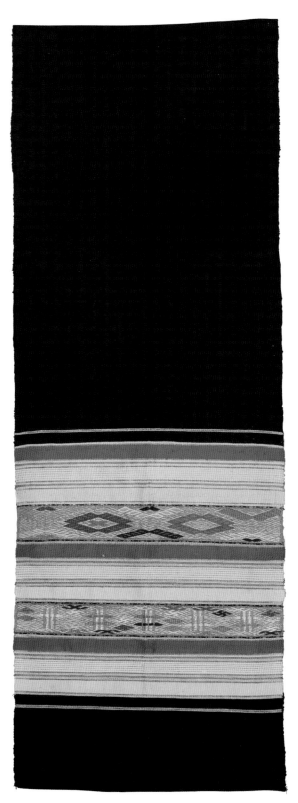

FIGURE 7.5 Turban cloth.
Burma, Shan States. Tai Yai or Tai Neua.
First half of the twentieth century.
Cotton with silk and silver. L 213.3 cm, W 13 cm.
Gift of Reverend L.W. Spring and his children. P67.52.

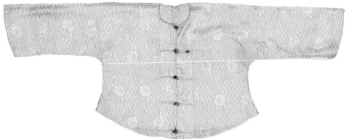

FIGURE 7.7 Blouse.
Burma, Shan States. Tai. Twentieth century.
Silk and glass. L 36.8 cm.
Gift of Mr. and Mrs. Dana Albaugh. DU 1971.464.2.

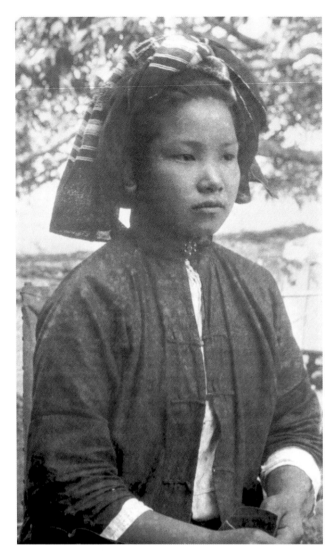

FIGURE 7.6 Shan woman wearing a turban.
Photograph by James Henry Green, WA0700. Courtesy of the Green Centre of World Art, Brighton Museum and Art Gallery.

of brown, green, pink, yellow, purple, magenta, and peach silk and gold-wrapped thread. Because of the wide spacing of the warp, this twill pattern is elongated in the weft direction, and the stripes are lustrous due to the weft-faced nature of the textile. Stripes and diamond patterns as seen on this turban can also be found on some Karen and Kachin textiles.

Through imports, the Chinese also had an impact on textiles in the Shan States. Several blouses and jackets in the Denison collection provide evidence of this trade. For example, a long-sleeved blouse with a shaped bodice that fastens in the front with loops and pink faceted glass buttons is made of a Chinese, commercially available, damask-weave silk fabric with a repeat pattern of cream flowers

and diamonds (Figure 7.7). The fabric was probably bought in the local market and made up by a resident Indian or Chinese tailor. In the nineteenth century, imported Chinese silk, silk brocades, and European and Indian silks and cottons were available in many Shan markets, and were fashionable with urban women in the Shan States, Lan Na, Burma, and western Laos. Many of these fabrics were opaque, but some imports, including silk chiffon, fine cotton lawn, and cotton *broderie anglais* were semi, or totally, transparent. Worn with a camisole underneath, they were popular during the hot season (see Catalogue no. 7.1).

Trade records from the Shan States include lists of ready-made blouses and jackets imported by Chinese merchants. The fabric for a long-sleeved, black satin jacket in the Denison collection may have been purchased in the market and made to measure, or, equally plausibly, the jacket was acquired ready-made. The piece has a shaped bodice that flares below the waist and curves at the hemline (Figure 7.8). Interestingly, the cloth is a cotton-backed silk, where the cotton weft and silk warp are woven in a satin structure, resulting in silk floats on the outer face of the jacket and cotton ones on the inner one. Externally, the jacket thus has the appearance of silk. It is also embellished with ten-centimeter side slits bound with a wide strip of yellow velvet on the inside. Yellow velvet further lines the inside of the center front, and inside the bottom edge of the jacket is a band of pink, satin-weave, glazed cotton. The shirt collar is lined with purple velvet. Five silver buttons, stamped with the head of the British monarch Queen Victoria (r. 1837–1901), are fastened with black satin loops.

Shoulder bags were also a significant part of Shan dress and paraphernalia. Villagers used practical bags

FIGURE 7.8 Jacket.
Burma, Shan States. Tai. Twentieth century.
Cotton and silk. L 64 cm.
Gift of Mrs. R.P. Currier. DU 1974.3.

to carry food, preparations of betel and lime for chewing, and small tools, such as knives and shears, for work in the fields or forest. These sturdy bags were woven of durable cotton and waterproofed inside with vegetable gum. Bags were also a common gift item. The missionaries reported that woven shoulder bags were the presents most frequently offered to them by their converts. Making gifts of bags was a means to mark birthdays, anniversaries, and Christian holidays (see Catalogue no. 2.4).[18] Tai Buddhist princes and members of the elite also presented bags to missionaries in recognition of the educational and health work they provided. The bags offered as gifts were heavily decorated, and often made of silk. Some bags incorporated writing into the patterns. One shoulder bag at Denison has an attached label, written in Shan and English, stating that it was given to "Mamma Pennington" on the 22nd of March, 1923 by Prince (*saohpa* or *sawbwa*) Hla Maung (Figure 7.9).[19] The body of the bag is woven in a small, pointed twill pattern with alternating shots of hand-dyed, black cotton and blue silk in the weft. The blue silk forms the diamonds in the center of the pointed twill, and fine stripes of three shots each of white cotton and yellow silk border the upper edge of the bag and the adjoining sides. Woven in half basket weave, the shoulder strap is made of a light madder cotton warp and weft with stripes of sixteen ends of a golden-yellow cotton warp. A herringbone-like stitch joins the sides and front together in a decorative fashion. The short fringe is composed of twisted and knotted warp threads.

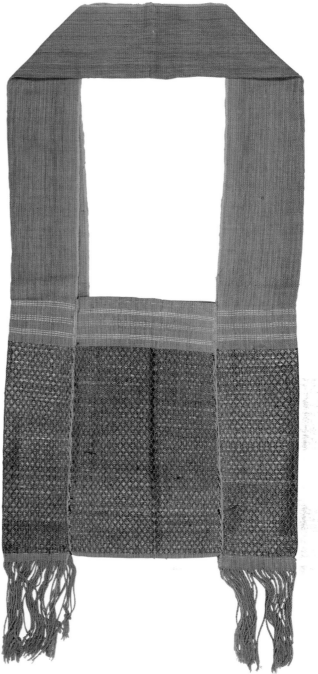

FIGURE 7.9 Shoulder bag.
Burma, Shan States. Circa 1923.
Cotton. L 25.4 cm, W 30.5 cm; Fringe: L 11.4 cm.
Gift of Grace L. Pennington and Irene P. Miller. DU 1967.154.

Tai textiles in the Denison collection are limited in number, yet they reveal the variety of weaving techniques utilized, as well as the range of clothing styles produced, in the Shan States. The plethora of imported goods available from India, China, and Europe further enabled the Tai to enhance their textiles.

THE WA

Foreigners have generally ignored Wa textile production, choosing to concentrate on other aspects of the culture, such as their headhunting rituals. The Chinese who traded with the Wa described them as "wild Wa" if they took heads from strangers and anyone vulnerable, and as "Wa" if they took heads for ritual purposes only.[20] Other foreign accounts also concentrated on head-hunting practices, and they were classified as "wild Wa," "intermediate Wa," or "tame Wa," depending on how regularly they took heads. This terminology also accorded with the amount of clothing they wore, with the tame Wa wearing the most extensive dress—a difference that may have arisen based on levels of contact with the Shan and other more settled communities.[21] A further distinction was made between wild and tame, depending on whether the Wa continued to practice head-hunting or had established permanent communities in the Shan States and abandoned the tradition.[22]

At the time when the missionaries were working among them, some of the Wa lived in settled communities and cultivated fields of cotton, sugar cane, and opium poppies outside their villages. They were metal smiths, extracting iron from the hills to make swords, muskets, and smaller items, such as knives and cowbells.[23] For weaving, the Wa used backstrap looms, rather than the frame looms employed by the Tai. With a backstrap loom, there is no rigid frame, and the warp beam is attached to two upright posts anywhere in the house with the weaver sitting on the floor. The loom has a warp beam, a breast beam attached to a backstrap, a harness with string heddles, a reed, a shed stick, a beater, and several lease sticks. The warp threads are wrapped continuously round the warp and breast beams, and lease sticks help keep the warp straight and free from tangles. The shed, through which the weft is passed, is created with the shed stick and harness.

Wa textiles have not been the subject of extensive studies, and there is little information about their weaving, dress practices, or textile trading available.[24] Although small in size, the Denison collection of Wa textiles, which includes a skirt cloth, tunic,

FIGURE 7.10 Skirt.
Burma, Shan States. Wa culture. First half of the twentieth century.
Cotton. L 121.9 cm, W 58.4 cm.
Gift of Reverend and Mrs. M.V. Young. DU 1968.6.

Susan Conway

7.5 Detail of a turban cloth

The long, cotton warp threads were twisted and joined at the shoulder to form the strap.

7.7 Shoulder bag
Burma, Shan States. Early twentieth century.
Cotton, silk, and Job's tears. L 28.2 cm, W 28.6 cm.
Gift of Mrs. R.D. Buttermore.[30]
DU 1969.9.

Composed of both cotton and silk, the bag was produced in two pieces in plain weave. One length was folded to create the central panel of the bag's body, and the second forms the shoulder strap and the side panels. The body and sides are composed of a black

pattern. Shan turban cloths were made from a range of home-spun, hand-woven cottons. The cloth could be tightly wrapped around the head with the hair coiled on the side, or the hair could be concealed in the pleats. Some men preferred a rakish angle with the pleats off-center, while others folded the fabric into a cone shape that made them look impressively tall. On festive occasions Shan men wore elaborate turban cloths. The wealthy wore pastel-colored Chinese silks and silk brocades, as well as Indian silk brocades.[29]

7.6 Shoulder bag
Burma, Shan States. 1923 or earlier.
Cotton. L 27.3 cm, W 20.3 cm.
Gift of Grace L. Pennington and Irene P. Miller. DU 1967.158.2.

Produced on a backstrap loom, this shoulder bag has a hand-spun, undyed cotton warp and weft with red cotton woven in a repeat diamond pattern of pointed twill. The top border is composed of undyed cotton with rows of colored threads—green, yellow, and red—in alternating sheds. The decorative, pronounced twill pattern in green and red was probably produced with a pick-up (hand-picking) technique. The bag was woven in one piece, folded in half, and sewn along the selvage.

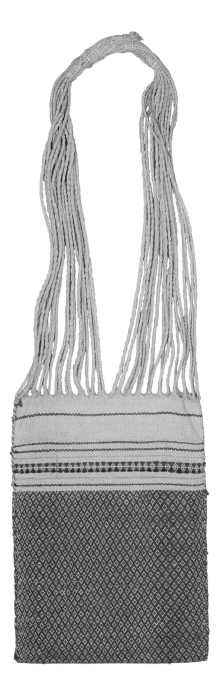 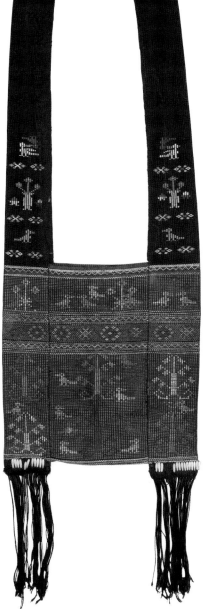

7.6 *left* and 7.7 *right* Shoulder bags

cotton warp and weft and covered with a green silk continuous supplementary weft, while the shoulder strap is made of a black cotton warp and weft. Supplementary discontinuous weft threads in hues of pink, red, white, cream, and blue were used in the creation

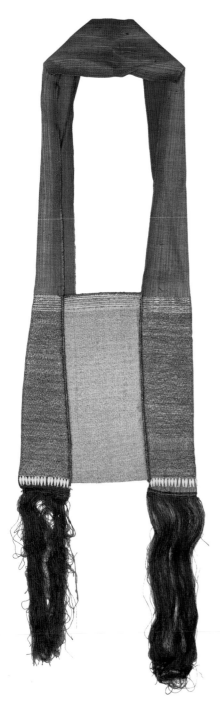

7.8 Shoulder bag

of the designs on the two portions of the bag. The body and sides of the bag were divided into three sections bounded by stripes and a zigzag line. Separated by a horizontal band of repeat floral patterns, the narrow top section and the large-sized bottom portion of the bag display patterns of trees and birds. The fact that the sides have the same pattern as the bag indicates considerable planning on the part of the weaver, because the pattern had to be woven upside down on one side in order for it to appear right side up on both sides of the bag. On the strap there are similar bird and floral motifs to those seen on the body and the sides, but the effect is different because they are not surrounded by green threads but by black cotton. The addition of continuous and discontinuous supplementary wefts to the shoulder strap adds to the width of the final product, making the strap narrower at the top of the shoulder, despite being the same piece of cloth. At the bottom of the bag, the strap and sides revert to plain, black warp and weft yarns which are decorated by Job's tears stitched above the fringe. The fringe is composed of twisted warp yarns which have been knotted at the ends.

7.8 Shoulder bag
Burma, Shan States. Twentieth century. Silk, cotton, gold metal threads, and Job's tears. Bag: L 25.4 cm; total L approximately 86 cm.
Gift of Robert E. Leake. DU 1979.10.
Like Catalogue no. 7.7, this shoulder bag was woven in two pieces (one for the central body and one for the strap and sides), probably on a backstrap loom. It was produced in a diamond, return-point twill pattern with an

unbalanced structure of thick weft yarns and fine warp ones, giving the weft maximum exposure. The body is composed of white cotton warps, while the sides of the bag have a blue silk warp, indicating that the strap/sides and the body of the bag were woven on separate warps. Both have a weft of gold metal thread wrapped around a silk core. The shoulder strap has an undyed weft. The bag's parts were joined together with a herringbone stitch, creating decorative ridges. Blue silk stitching also travels across the top edge of the front and back of the center panel. At the top of the bag is a weft stripe pattern in pink, green, and yellow threads. Job's tears were attached to the base of the piece of cloth that forms the strap and sides. This bag was expensive to produce because of the use of gold metal thread and was probably intended as a gift for an important person.

7.9 Length of silk
Burma, Shan States, Inle Lake area. Mid twentieth century.
Silk. L 332.2 cm, W 94 cm.
Gift of Ann Rohrer. DU 1968.98.
This length of plain-weave silk has a blue warp and weft, interspersed with warp *ikat* (tie-dyed) stripes of white, yellow, blue, and dark pink silk in stylized floral and leaf patterns. The main pattern rows alternate with four rows of white and blue tie-dyed silk. The warp *ikat* technique involves tying and dyeing the warp threads prior to weaving. Standard lengths of woven silk like this sample were sewn into ankle-length tubular skirts to which plain cotton waistbands were usually added. Silk *ikat* from Inle Lake was exported to Lan Na and other

inland states, carried by Shan and Burmese traders. Some elite hill tribe women also wore this type of silk *ikat* on festive occasions.

7.10 Piece of fabric
Burma, Shan States or Lan Na.
First half of the twentieth century.
Cotton. L 96.5 cm, W 67.3 cm.
Gift of Reverend and Mrs. M.V. Young.
DU 1968.20.
This length of cotton, woven in balanced plain weave, has a light madder warp. The weft contains wide, black horizontal stripes, and narrow stripes of indigo, light green, dark green, and black, frequently alternating with very narrow (two shots) pinkish-purple stripes and the light madder of the warp. This type of cotton length was intended for use as an ankle-length tubular skirt. Similar cotton skirt lengths were produced in the villages of the Shan States and Lan Na. Made of mill cotton of varying qualities, they were worn by village women to work in the fields and at home. Wa and Karen women, living at lower altitudes than they usually occupied, also wore this type of design in place of more durable short skirts worn with leggings in the hills.

7.11 Shoulder sash
Burma, Shan States, Kengtung. Tai Lue.
First half of the twentieth century.
Cotton. L 83.2 cm, W 20.3 cm.
Gift of F. Faith Hatch. DU 1969.247.
This shoulder sash has a plain cotton ground weave. The bands of floral and geometric patterns in burnt orange, red, purple, and black were produced with hand-spun, cotton supplementary weft yarns. These supplementary weft bands of varying widths are flanked by two picks of black, yellow, and red stripes. The middle portion of the cloth

7.9 Detail of length of silk

7.10 Piece of fabric

7.11 Shoulder sash

7.12 Blanket

ceiling of temple buildings where the laity worshipped. This shoulder sash is described in the Denison records as a "runner" suggesting that it was used to cover the center of a table. The donor, Faith Hatch, may have been unaware of its ritual significance.

7.12 Blanket
Burma, Shan States, Namkham. Tai Lue.
First half of the twentieth century.
Cotton. L 124.5 cm, W 39.4 cm.
Gift of Helen K. Hunt. P67.51.
This hand-spun cotton blanket, used as a bed cover, has an undyed cotton warp and weft with alternating bands of red and black continuous supplementary weft in repeat patterns of diamonds, stripes, and stylized star motifs and shapes. The supplementary weft pattern was either hand-picked in the warp, using a wooden sword, or a predetermined pattern was inserted in the warp using shed sticks. These techniques were employed by all Tai weavers in the Shan States. The blanket was originally described in the Denison records as a curtain or coverlet.

7.13 Petticoat
Burma, Shan States, Kengtung.
Tai Khoen. 1930.
Cotton and silk ribbon. L 116.2 cm.
Gift of Vellora W. Bray. DU 1973.76.
The petticoat is made of two pieces of white, glazed cotton, probably imported from China. At the bottom is an appliquéd silk band composed of purple, green, yellow, and white yarns. Folded next to the silk band, pleated, and top stitched with two rows of threads is an extra piece of glazed cotton. It was cut on the bias and sewn on top of the petticoat fabric. There are four further horizontal pleats, each alternating

displays alternating picks of heavy and thin wefts so that the heavy weft shot is consistently placed in the same shed during weaving, creating a pronounced length-wise wale. The yarns at the wale's start and end are red and burnt orange. The piece is edged with a warp fringe.

Tai Lue men wore this type of shoulder sash when they attended Buddhist temple ceremonies. Longer versions of this textile, with more complex patterns, were presented to Buddhist monasteries at the time of religious festivals. They were suspended from the

with two rows of stitching. At the bottom there is a gap of nearly two centimeters and then another pleat and a single row of stitching. At the base of the petticoat, the main piece of fabric was folded up and the raw edge tucked under and top stitched.

This petticoat was presented to Vellora W. Bray in 1930 with the Tai Khoen skirt in Figure 7.2. Women's petticoats were viewed as potential polluters of men and great care was taken to ensure that men did not come in contact with them. This superstition is based on the story of Princess Camadevi of Lamphun, who, according to legend, wore a white petticoat until it was soiled. She washed the petticoat and cut it up to make a turban and sent it to an enemy. He wore the turban and lost his abilities and powers. The Kengtung Chronicle claims that this is the reason why Tai Khoen women wear white petticoats under their ankle-length skirts.[31]

7.14. Panel of cut work
Burma, Shan States. Late nineteenth century.
Cotton. H 88.9 cm, W 201.9 cm.
Gift of Colonel and Mrs. L.B. Bixby.
DU 1968.312.
This piece is a rectangle of plain mill cotton cut like a stencil. The cut-work is in repeat trellis, diamond, leaf, and floral patterns that resemble the border and ceiling designs of seventeenth and eighteenth century Buddhist wall paintings in Burma. Some pencil markings on the cloth suggest the incomplete outline of a Buddha image. This cotton textile may have been intended as a temple hanging, or as decoration for a tiered canopy constructed over a funeral bier. It was donated by Reverend Bixby's

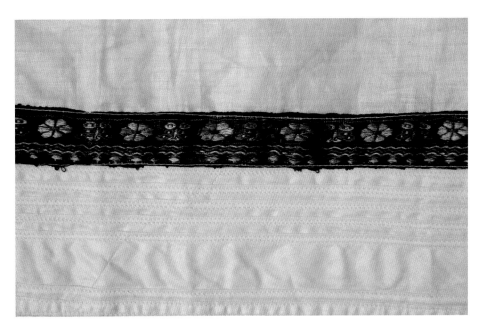

7.13 Detail of petticoat

grandson who listed it as a temple hanging of white cotton cloth made into the appearance of lace by cutting it with a pen knife.[32]

WA MATERIAL
7.15 Tunic
Burma, Shan States. Wa culture. First half of the twentieth century.
Cotton. L 41 cm.
Gift of Reverend and Mrs. M.V. Young.
DU 1968.5.
Sleeveless cotton tunics were worn extensively by many of the hill groups found in Burma,

including the Karen, Chin, and Wa. This hand-spun, cotton tunic dyed with indigo was woven in half basket weave on a backstrap loom. It is constructed from two rectangles folded at the shoulder and sewn together along the selvage at the center front and back and under the arm holes with openings left for the head and the arms. The center front and back seams were over-stitched with interspersed rows of red and white cotton yarn in cross

7.14. Panel of cut work

7.15 Tunic

7.16 Detail of a blanket

of the fabric and the intricacy of design, rather than by the style and cut of a garment. Brightly dyed, boldly patterned cloth tended to be the prerogative of the young, while muted colors and smaller, more subtle designs were preferred by senior members of society. Foreigners have remarked that with respect to clothing at casual events, there was little to distinguish Burmese royalty from other participants.[3]

For everyday wear, weavers throughout Burma have traditionally produced lower garments in an imaginative array of stripes and plaids from local and imported yarns. Examples in the Denison collection range from a man's *longyi* in a simple plain weave patterned by two intersecting lines of color on a monotone ground to textiles incorporating numerous different colored yarns in the warp and weft (Catalogue no. 8.3). Plaids have also been created with, and enhanced by, the insertion of extra thread elements such as supplementary weft, a prevalent patterning technique in the Arakan and Gangaw areas (Catalogue no. 8.4).

To reinforce the various gradations of Konbaung society, particularly, but not exclusively, at the court level, numerous sumptuary edicts were carefully laid down dictating what could be worn or used by whom and under what circumstances. Punishment was meted out to those who had the temerity to dress above their station. Fabrics with metallic threads, sequins, and embroidery were limited to royalty, high officials, and tributary princes who pledged their allegiance to the Burmese king. On formal occasions, they were weighted down with heavily embroidered outer garments and elaborate headdresses.[4]

With the demise of the monarchy in 1885, and the consequent lapsing of the sumptuary laws, many of the *nouveau riche* attempted to emulate former royalty in the splendor of their dress. Gold and silver embroidered shawls, lavish imported brocades, figured silks, and other intricately patterned fabrics, as well as velvet sandals, once the prerogative of royalty, became popular with the new elites. Despite the desire of some to emulate their former masters in textile splendor, changing life styles during the colonial period led to the demise of the *htamein* and to an eclipse of the *pahso* in favor of the universal adoption of the approximately 100 centimeter long by 150 centimeter wide ankle-length tubular sarong or *longyi* worn by both sexes. It is secured at the waist by a side pleat in the case of the female and by a front knot or a central tuck for the male (Catalogue no. 8.5). The woman's tubular silk skirt shown here has a soft black cotton waistband (Figure 8.2). The lower skirt selvage has been edged with a binding of black velvet. Woven in a plain weave, the warp stripes of this weft-faced fabric are less prominent due to the greater number of weft picks in relation to the number of warp threads. At the turn of the century, such plaids were popular for everyday wear by both sexes. Today, plaids are largely the preserve of the male population.

The tailored *eingyi* jacket also underwent a transformation in the late nineteenth and early twentieth centuries. With changing life styles, the traditional neat-fitting, long-sleeved *eingyi* for women with its front ties, nipped waist, and flaring hemline fell from favor and was relegated to the theatrical closet. Instead, around the beginning of the twentieth century, women turned to the looser, more comfortable, Chinese-inspired jacket designs, with their variant yokes and wider sleeve styles, which

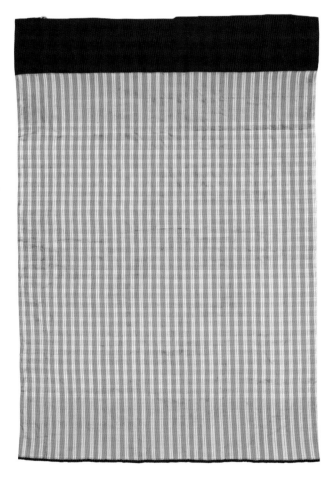

FIGURE 8.2 Woman's tubular skirt (*longyi*).
Burma. Early twentieth century.
Silk and cotton. L 111.4 cm.
Gift of Mrs. T.F. Holbert (née Florence Conrad). P67.296.

were fastened in the front or at the side with either cloth buttons or matching jewelry studs, sometimes encrusted with precious stones, such as diamonds, sapphires, and rubies. Shorter and looser than the traditional woman's *eingyi,* the new form was more practical and compatible with the changing life styles brought about by the colonial presence. The women also delighted in the wide range of quilted fabrics, shiny satins, and semi-diaphanous organdies, nylon, and laces that became available through colonial importation policies, as is evident in a number of examples in the Denison collection. The jacket in Figure 8.3 is made from imported muslin with scattered western floral motifs and is fastened with ceramic, bead-like buttons which are detachable.

Burman men, influenced by the more conservative norms of western male dress, abandoned their more flamboyant traditional *eingyi* in favor of a short, sensible, sober, colored, collarless cotton jacket with pockets. It is buttoned in front by small Chinese cloth fasteners and worn over a western shirt. The men also gave up wearing their colorful individually tied headscarves in favor of an innocuous, "ready-made," light, plain, colored silk turban known as the *gaung-baung.*

The most highly prized fabric for clothing in Burma was, and is, *lun-taya acheik,* which is woven on a traditional Thai-Burmese loom in an interlocking tapestry weave with fifty to 200 small, metal, boat-shaped shuttles (*lun-taya*). Its origins are controversial. Local and nineteenth-century foreign sources state that the weaving technique was introduced into Burma by captive Manipuri weavers in the late eighteenth century, but textile researchers have yet to find any Manipuri textiles resembling

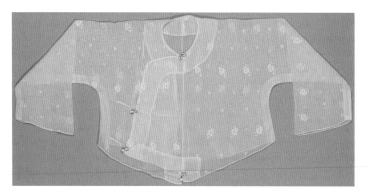

FIGURE 8.3 Woman's jacket (*eingyi*).
Burma. Twentieth century.
Figured muslin. L 41.9 cm.
Gift of Mr. and Mrs. Dana Albaugh. DU 1971.336.

lun-taya acheik. They tend to point to China with its famous dragon robes as a possible source of inspiration for the tapestry weave technique.[5]

The characteristic serpentine cable patterns known as *acheik* may also have been inspired by South China and Southeast Asia's Neolithic past and by natural phenomena, such as waves and clouds, and local flora and fauna. *Acheik*-style designs occur on fifth to ninth century Pyu pottery and beads and in temple wall paintings of eleventh to thirteenth century Pagan.[6] Cultural elements, such as crenellated walls and Burmese numbers, have also been incorporated into the *acheik* repertoire. Traditionally, designs primarily for men featured zigzag, cable, and interlocking lappet motifs, while those for women combined undulating and interlocking cable patterns with floral and creeper elements. *Acheik* patterns were also enhanced by the imaginative choice of color. A bold palette of chemically dyed reds, purples, pinks, greens, and yellows was generally preferred over pale, watery pastel hues. The Burmans have a predilection for combining lighter and darker shades within a similar color range to create some original *trompe l'oeil* effects in shimmering silk. Silver-wrapped yarns were also widely employed in *acheik* weaving.

Unlike the ubiquitous checked and striped textiles seen throughout Burma, *lun-taya acheik* has always been woven by professional weavers on traditional floor looms in small workshops in the Amarapura area using silk yarns imported overland from China. Chemical dyes have been employed since the 1880s. *Lun-taya acheik* has always been expensive, because it is labor intensive; two girls manipulating 100 to 200 shuttles back and forth through a warp of over 1,500 threads can only weave a few centimeters a day. Traditionally, girls began learning to weave around age twelve. By age fifteen they had committed the basic repertoire of designs to memory and were proficient weavers. Because of the close work involved, *lun-taya acheik* weavers are rarely over thirty years old (Figure 8.4).

Although there are vague references to certain patterns and colors being the prerogative of royalty, it would appear that the price of *lun-taya acheik* was the major restriction rather than carefully spelled out sumptuary laws.[7] In 1880, a sarong length of *lun-taya acheik* was worth anything between 150 and 400 Indian rupees, with 300 rupees being the equivalent of twenty to thirty pounds, a year's salary

Sylvia Fraser-Lu

FIGURE 8.4 A young woman weaving *lun-taya acheik*. *Amarapura, 2001. Photograph by Sylvia Fraser-Lu.*

of the "great line golden building" design (*maha-kyo shwe-taik*), a popular *acheik* motif inspired by the crenellated walls surrounding the former Konbaung palace complex. This motif was also very popular for men's *pahso*. The *htamein* shown here terminates in a pink-striped train woven with a cream weft over a warp of red and interspersed with narrow pin-stripes in black, red, and green. It is lined with a light, off-white cotton fabric and is in a fragile condition. Another example (Catalogue no. 8.6) with its finely woven and possibly naturally dyed yarns in subdued yellow, white, and green wavy and zigzag designs on a light blue ground, may be of similar age.

Typical of *lun-taya acheik* worn by young women around the turn of the twentieth century is one example donated by Miss Helen K. Hunt which dates to circa 1900 (Catalogue no. 8.7). A vibrant fuchsia pink is the ground color enlivened by a range of designs in red and pale pink. Silver thread, which was made by plying four to five cotton strands together and twisting a thin thread of silver foil around it, is also part of the decoration.[8] Denison has another example of *lun-taya acheik* in green, red, and fuchsia, which was at one time worn by the grand-mother of the donor, Mrs. David Tin Hla who was married to the first Burmese Denison graduate (class of 1926) (Figure 8.6). This brightly patterned cloth is typical of *lun-taya acheik* when it was at its height from the 1870s until the 1930s. The predominant red and green colors are enlivened by touches of silver and a number of design components in lighter and darker shades. Dominating the cloth between the red and green areas is a large, twisted, five-striped cable motif known as the dragon flower silver creeper pattern (*naya-pan ngwe-kyo*) from which spring sprigs of flowering creeper. A row of a white and fuchsia-pink two-stripe twist (*nit-sin lein-kyo*) separates the bands of the cable design at regular intervals. This *htamein* has been finished with the usual pink pin-striped train, but the pink nylon waistband was not part of the original ensemble. Denison records indicate that the donor's grandmother acquired the *lun-taya acheik htamein* around 1840. Due to the fact that the cloth has been colored with chemical dyes which were used in Burma from the late nineteenth century, the date of acquisition cited by the donor is too early. In a comparison with similar cloths, it is probably more accurate to assign a date of 1880 to 1900 to this piece.[9] The Denison Museum also has in

for a farm laborer or soldier in nineteenth-century England. Despite the exorbitant price of the fabric, late nineteenth to early twentieth century photo-graphs indicate that many Burmans of outwardly "modest means" did have at least one piece of *lun-taya acheik*, which would have been worn on important formal occasions, such as weddings, where donning extremely expensive fabrics gave honor to the host.

The Denison collection has at least two early, interesting examples of *lun-taya acheik*. One, a woman's *htamein*, was collected by Reverend Thomas Allen who served in Tavoy between 1853 and 1859, which makes it one of the earliest *lun-taya acheik* in any museum collection (Figure 8.5). It consists of a waistband of red velvet attached to a central panel of silk with warp stripes of white, pale yellow, olive green, and light pink that terminate at the sides in a plaid. The stripes, which appear horizontal when worn, have been patterned by an interlocking tapestry weave (*lun-taya*) in a variant

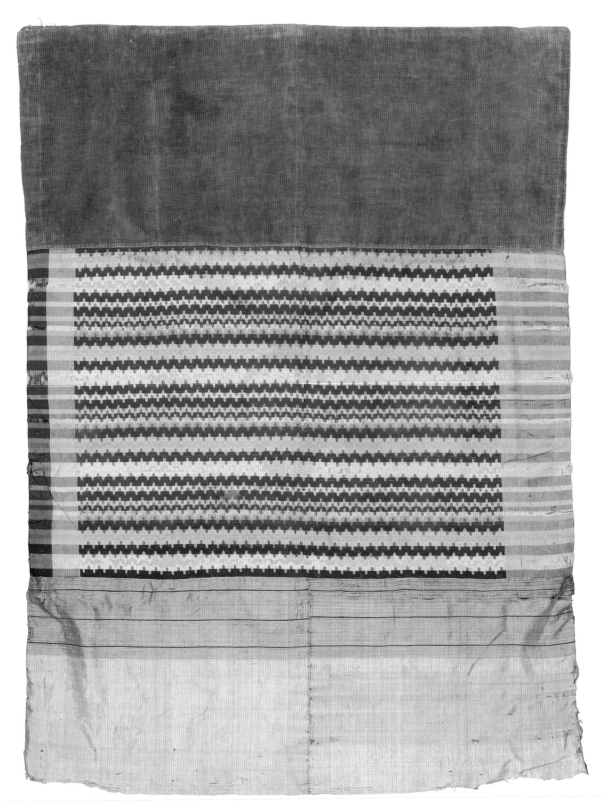

FIGURE 8.5 Woman's wrap-around skirt (*htamein*).
Burma, Amarapura. 1850–1859.
Silk and velvet. L 124.5 cm.
Collected by Reverend Thomas Allen between 1853 and 1859 and donated by his
granddaughter, Jessica Price. P67.61.

Sylvia Fraser-Lu

8.14 Detail of a woman's embroidered *longyi*

machine sewn. The attached band of white silk was embellished with a trio of zigzag silver lines. The embroidery on the central panel was executed with imported silver yarns in a running stitch and a long and short satin stitch. It features a band of peony-like blooms alternating with sprigs of cosmos-like flowers that owe their inspiration to European textiles.

8.15 Woman's *longyi*
Burma. Twentieth century.
Satin and cotton. L 116.2 cm.
Gift of Lillian Salsman. DU 1971.398.
The *longyi* was painted at the bottom with four birds seated on blackberry branches bearing leaves and flowers. Such designs were influenced by Chinese painting motifs. The *longyi* is made of peach-colored satin with a black binding along the lower hem. It also has a waistband of pale blue cotton for ease of use.

8.15 Woman's *longyi*

Notes

1. Shway Yoe (J. George Scott), *The Burman: His Life and Notions*, reprinted New York: Norton, 1963, p. 272.

2. Reverend Father Vincentius Sangermano, *A Description of the Burmese Empire, Compiled Chiefly from Native Documents*, translated by William Tandy, reprinted New York: Kelley, 1969, p. 24.

3. Shway Yoe, p. 467.

4. For a description of these embroidered royal costumes, see Frances Franklin and Deborah Swallow, "Identifying with the Gods: Burmese Court Costume," *The 1994 Hali Annual*, 1994, pp. 48–61.

5. G.E. Harvey, *History of Burma from the Earliest Times to 10 March 1824, the Beginning of the British Conquest.* London: Longmans, Green & Co., 1925, p. 239. Robyn Maxwell, *Textiles of Southeast Asia: Tradition, Trade, and Transformation.* Melbourne: Oxford University Press, 1990, p. 292.

6. Images of these were published in a pamphlet in Burmese by Tampawadi U Win Maung which was produced to coincide with an exhibition of traditional *acheik* by the Mandalay Division of Co-operatives in 1985.

7. Shway Yoe, p. 273.

8. Jane Terry Bailey (*Burmese Art Newsletter*, vol. 1, no. 4, June 1969, p.7) states that the silver grey hue came from cotton wrapped reed yarns. The present writer, to date, has not seen any examples where reeds were used as a base for metallic yarns in the manufacture of *lun-taya acheik*.

9. According to Dr. Isabel Wingate (*Fairchild's Dictionary of Textiles*, New York: Fairchild Publications, 1959, p. 21), aniline dyes were invented in England around 1826, but they were not commercialized until after 1856, and were not widely exported until a later date.

10. Frances Franklin, Noel F. Singer, and Deborah Swallow, "Burmese Kalagas," *Arts of Asia,* vol. 33, no. 2, 2003, pp. 56–69.

11. U Tha Myat, "Burmese Embroidery." *Burma: A Handbook on Burma with Special Reference to Burmese Customs, History, Economic Resources, Education, Famous Pagoda and Cities, published on the occasion of the centenary of the founding of the royal city of Mandalay 1221–1321 BE (1859–1959).* Directorate of Information, Union of Burma, Rangoon, 1959, p. 145.

12. These include workshops founded by artist U Tin Win and U Sein Myint.

13. *Burmese Art Newsletter*, vol. II, no. 1, May 1970, p. 1. This *kalaga* narrative was incorrectly identified as the *Vessantara (Wethandaye) Jataka*.

9

Lacquer

Sylvia Fraser-Lu

While lacquer is regarded as a minor art in most countries, this has not been the case in Burma. For the past three centuries it has been a major craft, and its importance has been equivalent to the combined modern use of ceramics, glass, and plastic. In the fine arts, lacquer has literally been the "glue" that has held much of the surface decoration together. A majority of religious and royal buildings and Buddhist images, be they of wood, stone, or plaster, have been lacquered not only for preservation, but as a base for glass inlay and as an adhesive for gold leaf embellishment.

Lacquer at one time was employed to furnish Burmese royalty with imposing thrones, couches, large glittering food trays with domed lids (*pwe-daw-ok*), various plates and bowls for sumptuous banquets, as well as accoutréments of rank for officials and courtiers. The highly revered monkhood continues to be provided with lacquered alms bowls, water goblets, fans, gilded shrines, preaching chairs, and sacred *Vinaya* texts transcribed on lacquer pages (*kammawa-sa*) and stored in lacquer-embellished manuscript chests (*sadaik*). Food offerings to monks are still conveyed to the monastery in large pagoda-shaped receptacles (*hsun-ok*). Objects given to monasteries and pagodas are presented and displayed on pedestal trays (*kalat*), which vie for attention amongst vases and other lacquer-decorated donations offered by the faithful as an act of merit.

At a more mundane level, lacquer has been used to produce distinctive, sturdy, well-crafted objects for everyday use. The most famous lacquer receptacle in traditional Burma is a cylindrical shaped betel box (*kun-it*) of woven bamboo, which is an item of hospitality in a Burmese home. The interior is fitted with two trays, the uppermost of which holds the small cups for chopped areca nut (*Areca catechu*), various spices, lime paste, and metal cutters, while the lower tray contains dried tobacco leaves. The bottom compartment is filled with heart-shaped betel vine leaves. A deep cover fits snugly over the sides to preserve freshness. Visitors, when offered betel, take a leaf, smear it with lime paste, and wrap it into a quid around a slice of areca nut and selected spices according to taste, before chewing the contents.[1] Cheroots, pickled tea and associated snacks, traditional medicines, clothing, letters, and horoscopes all have their distinctive lacquer boxes. Food is ladled from community vessels onto individual plates and bowls set on

FIGURE 9.1 Two young women incising a tabletop. *Royal Tortoise Lacquer, New Pagan, 1996. Photograph by Sylvia Fraser-Lu.*

a small, low lacquered table (*daung-lan*). Weaving, carpentry, and other crafts also have their particular implements preserved and beautified with a coat of lacquer, as are the musical instruments of a Burmese orchestra.

Using the resin from the *Melanorrhoea usitata*, a tree native to the hill regions of mainland Southeast Asia, lacquer producers have decorated Burmese wares in a number of distinctive techniques which differ from many of those seen on Far Eastern lacquer. The techniques utilized by the major regional lacquer centers in Burma are represented in the Denison collection in the form of both household and votive objects. Although most of the objects in the collection were made in the late nineteenth and twentieth centuries, there are a few which could date as early as the late eighteenth century.

YUN LACQUER

A large number of Denison's household objects, including bowls, cups, plates, betel boxes, vases, and trays, are from Pagan, a former capital of Burma which is currently the leading lacquer center. The area is famous for its incised decorated wares known as *yun*, which is also the generic Burmese term for lacquer. Producing *yun* ware is a time-consuming process. After a substrate of wood or woven bamboo has been well primed with a few layers of ash or finely sifted clay mixed with lacquer, it is finished with one or two coats of high-grade pure lacquer. The lines for each color in *yun* ware are then carefully etched into the surface with a stylus and filled with the desired pigment before

being dried in an underground cellar (Figure 9.1). Women usually work on a design's details because of their small hands, while the men incise the large motifs. After drying, the excess color is removed on a lathe, a new set of incisions made, and a different shade applied. Up to five colors may be used — black which is the natural color of lacquer, red from cinnabar, yellow from orpiment, orange from orpiment and cinnabar, and green from orpiment and indigo. It can take up to six months to produce an example of fine quality *yun* work.

Yun wares, consisting of bowls, plates, betel boxes, vases, and covered receptacles mainly for household use, are noted for their distinctive designs which range from simple repetitive motifs to densely patterned interlocking grids and narrative scenes from Hindu-Buddhist legends, Burmese history, and folklore. On the finest wares, the decorative elements have been skillfully manipulated to accommodate the unique shape and size of the object so as to create a balanced harmonious composition. Designs are usually framed by bands of vegetal motifs, geometric decoration, and compass-drawn concentric lines.

A number of objects made after 1900 may have small cartouches with writing in Burmese identifying the name of the maker or workshop and place of manufacture. In the case of a narrative, the title of the scene and the names of characters being depicted may be included.[2] Some well-known master craftsmen have their names or that of their workshop inscribed on lacquer items in the Denison collection. From Pagan, they include Hsaya Htwe of Zei-dan quarter, Hsaya Yone, Hsaya Shei, son of Hsaya Kyi, and Hsaya Htwa of Taik-kon quarter, Hsaya Htay of the Son-gon quarter, and Hsaya Nyo, Maung Aung Myaing, and Hsaya Kant of Pyi-zu quarter. Some of the more enterprising workshops, in the interests of making a sale, were not averse to proclaiming the superiority of their wares in their captions. On one piece of lacquer Hsaya Htwa billed himself as "number one," while Hsaya Nyo proclaimed a particular work to be "the best." Hsaya Yone and Hsaya Shei stated that their objects were original and genuine examples from their workshops, suggesting that on occasion these master craftsmen might have had to contend with imitators. Other lacquer craftsmen were content to wish the eventual recipient of their wares "good health and prosperity."

Classic *yun* designs are well represented in the Denison collection. For example, it has two betel boxes embellished with the Yunnan semi-circle motif (*ku-nan kan-byat*), a trefoil or quatrefoil link design. On the older, early nineteenth-century example, the repetitive trefoil motif was rendered in yellow against an overall, green, net-like filler pattern on a black ground (Catalogue no. 9.1a). On the slightly later example, dating from the mid-nineteenth century, the connecting quatrefoil elements were executed in wide bands of red against a similar green and black ground (Catalogue no. 9.1b). The museum has a number of examples of late nineteenth and twentieth century renditions of this design on an orange-red ground consisting of rows of fine, black, interlocking lines resembling a honeycomb unobtrusively overlain with miniscule yellow dots and framed by bands of parallel striations (Catalogue no. 9.2). Figural or floral ornaments may also occupy the center band of space cells in the design around the sides and within a central medallion on the lid.

Another design in a similar vein is the Mount Meru (*myin-myo*) pattern, which was named in honor of the cosmic mountain at the center of the Buddhist universe. It consists of one or more bands of interlocking rectangles joined by small squares and with redented corners on the outer links. A footed bowl at Denison was embellished with the Mount Meru (*myin-mo*) design in yellow (Figure 9.2). Signs of the Burmese zodiac (*yathi*) fill the central panels created by the design, and small mask-like figures pervade the intervening upper and lower spaces between the central motifs. The base is decorated with a small, lively page boy figure (*thu-nge-daw*). Two palm leaf shaped cartouches give the name and location of Hsaya Htwa's workshop, a well-known lacquer center during the colonial period.

The space cells created by designs, such as the Mount Meru pattern, may be occupied by figural elements and astrological motifs like the Eight Planets (*gyo-hsit-lon*) or the signs of the zodiac (*yathi*) on a plain ground or one of closely patterned worm-like curves (Catalogue no. 9.3). Such curves and hatch-stroke lines serve as background fillers for a number of repetitive floral-vegetal designs collectively known as *pan-bwa*. Of such designs, the best represented at Denison are some plates, bowls, and a box embellished in the *zin-me* (Chiangmai) pattern, a rhythmical design of plum-like flowers amidst leaf

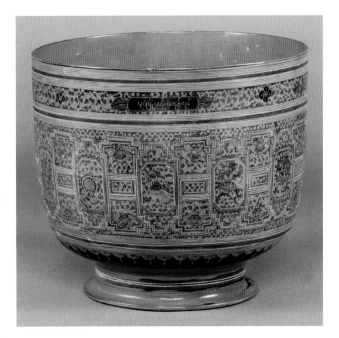

FIGURE 9.2 Footed bowl (*khwet*).
Burma, Pagan, Taik-kon Quarter. Workshop of Hsaya Htwa. Twentieth century.
Bamboo and lacquer. H 20.9 cm.
Gift of Mr. and Mrs. Abbot Low Moffat. DU 1985.1.

and branch meanders (Figure 9.3 and Catalogue no. 9.4). Inspired by the floral motifs on northern Thai painted lacquer, this design became especially popular with foreigners during the colonial period (1885–1948). Textile designs known as *za-yun* also made their appearance around this time. Executed on a checkered ground, they owe their inspiration to European lace, knitting, and weaving patterns. Denison has two very different examples; the larger, a circular covered box, is decorated with green and yellow geometric patterns on a black ground (Catalogue no. 9.5), while the other, a small betel box, features a floral design in green on a red ground (Figure 9.4). Set within a graph-like grid, the design bears some resemblance to a lace or a fair isle knitting pattern. The design is not repeated on the two interior trays; it only embellishes the outer cover of the box.

Sometimes small lively animal, human, and composite fantasy creatures, generically known as *yok-thei*, appear against a background of abstract vegetal designs (Catalogue no. 9.6). On more modern work, such figural elements are clearly visible, but on earlier examples, they may be difficult to discern because they have been cleverly integrated into the

FIGURE 9.3 Box.
Burma. Twentieth century.
Bamboo and lacquer. H 16.5 cm, D 27.6 cm.
DU 1968.114.

FIGURE 9.4 Betel box (*kun-it*).
Burma, Pagan. Early twentieth century.
Bamboo and lacquer. H 9.5 cm, D 12.5 cm.
Gift of Grace L. Pennington and Irene P. Miller. DU 1967.126.

swirling background elements. The *yun*-decorated betel box in Figure 9.5 features a lively *yok-thei* design composed of deer, hunters, and dancers against a green hatch-stroke ground. It was rendered in a bold, almost careless manner, a style which became popular during the colonial period. Captions below the rim of the lid state that the box was made at a Maung Aung Myaing's workshop and that it was an example of "Pagan Pyi-zu art," meaning that the workshop was located in the Pyi-zu Quarter of Pagan.

In traditional Burmese art, it was the custom for craftsmen to give equal emphasis to the decorative as well as the figural elements in a design. Known as *yok-let pan-kya*, such densely patterned designs were whimsically referred to as the "nightmare" pattern by foreign clientele. During the colonial period, it became popular to feature Burmese birds and animals as separate motifs within space-cells (*balu-gwin*) on a plain ground rather than depicting them fully integrated with the surrounding scrolling (Catalogue no. 9.7).

Figural and architectural elements are skillfully combined in the *let-taik-lei-kya* design, as seen on a pair of small bowls where the fantasy figural

chu-pan and orchid *dha-zin-gwei* scrolling designs synonymous with gold leaf lacquer. Some bowls are light and delicate, being made with a weft of horsehair rather than bamboo. While on a majority of objects the gold leaf was placed over a black ground, there are a few examples that were executed on an orange-red surface which imparts a warm burnished glow to the gold leaf. There is even a small cigarette box embellished with gold leaf on a blue ground, an innovation from the colonial period (DU 1968.110, not illustrated here).

One of the finest objects in the collection is a large, spherical, covered bowl embellished with wide circular bands of rhythmic *chu-pan* scrolling, a staple design for Burmese gold leaf lacquer, bounded by a series of concentric lines (Figure 9.8). For ease of handling, the lid, comprising one half of the object, has a protruding knob at the center embellished with a rosette. Concentric bands of scrolling, parallel lines, and lotus petal decoration spread outwards from the center to be repeated around the sides. Due to the high price of gold leaf, it is rare to see a bowl of such large size embellished in the *shwe-zawa* technique. Bowls of this shape were generally used for serving food, such as cooked rice and fruit, but in this case, being more ornamental than practical it was most likely used as a receptacle for votive and ceremonial objects. Such a bowl was usually placed on a stand when not in use and great care was taken when handling it, so as not to rub away the delicate gold leaf.

FIGURE 9.7 This man is painting a design in orpiment on a black lacquer ground in readiness for the application of squares of gold leaf.
Golden Pagan Lacquer Shop, Pagan, 1983. Photograph by Sylvia Fraser-Lu.

Another group of objects of particular interest are a pair of baluster vases (DU 1980.47, not illustrated here), a large betel box (P67.210, not illustrated here), and a *hsun-ok*, a footed receptacle with a pagoda-shaped lid used to convey food to a monastery as an act of merit (Figure 9.9). All are in excellent condition and are embellished with *chu-pan* scrolling interrupted by lobed cells (*balu-gwin*) enclosing a crouching *chinthe* lion motif against a black ground. Denison also has further examples of

FIGURE 9.8 Covered bowl (*bu*).
Burma, Pagan. Twentieth century.
Bamboo, lacquer, and gold leaf.
D 27.6 cm.
Gift of Mrs. Burwell B. Smith.
DU 1989.81.

FIGURE 9.9 Offering vessel (*hsun-ok*).
Burma, Pagan. Twentieth century.
Wood, bamboo, lacquer, and gold leaf. H 43.2 cm.
Gift of Zelma Graham. DU 1976.83.

rectangular and circular boxes featuring the same *chinthe* motif.

An illustrated panel from the Shan States, originally from the side of a small scripture chest (*sadaik*), depicts the Great Renunciation, where the Buddha-to-be is shown in the act of cutting his hair and thereby severing all attachment to his former life as a prince (Catalogue no. 9.11). In a similar vein is a wall plaque, featuring the Hindu goddess Padmani flanked by a pair of worshippers, which was rendered in the style of Indian deities depicted on the walls of the eleventh century Abeyadana temple at Pagan (DU 1976.42, not illustrated here). *Jataka* scenes may also appear in gold leaf, as can be seen on a plate bearing an illustration from the *Mahajanaka Jataka* (no. 538) (Catalogue no. 9.12).

Given the overwhelming preference for gold-decorated wares over other metallic-type finishes, silver leaf or silver pigments traditionally have not been widely used for embellishing Burmese lacquer, except in Mon *kammawa-sa* manuscripts. Nineteenth century Shan wares from Laikkha, however, were known to use a silver colorant on incised work, which was finished with a coat of varnish to impart a gold hue to the design. The Denison collection has three examples where a silver pigment was used to highlight the design incisions, such as on two small bowls featuring *zin-me* patterns (DU 1967.116 and DU 1968.61, not illustrated here) and a larger straight-sided bowl, possibly depicting a *nat* legend (Catalogue no. 9.13).

THAYO

Another popular decorating technique which makes widespread use of gold leaf is that of relief-molded lacquer. In this process, lacquer resin is mixed with the ashes of sawdust or bone to create a fine plastic compound known as *thayo*, which may be easily shaped with stone molds into a variety of figural, architectural, and botanic elements. On hardening, these components are lacquered on the back and applied to a base. The piece is usually finished with slivers of colored or mirror glass inlay and gold leaf. Known as *hman-zi shwe-cha*, the finished effect bears some external resemblance to European ormolu work. Production of *hman-zi shwe-cha* is currently located in the area east of the Mahamuni pagoda in Mandalay, the former nineteenth-century Konbaung capital of Burma. Here, artisans specialize in embellishing votive objects, such as images, shrines of various sizes, preaching chairs, manuscript boxes, ceremonial fans, stands, and alms food receptacles destined for presentation to a monastery or pagoda, or for use in private devotions.

The *hman-zi shwe-cha* technique probably reaches its highest development on manuscript chests (*sadaik*) commissioned by the faithful to be given to monasteries as a repository for hand-copied sacred texts of the Buddhist scriptures used to acquaint students with religious tenets. The sides of many such chests were embellished in low relief with narratives from the Life of the Buddha and that of his former existences, the *Jatakas*. Most popular are episodes pertaining to events leading up to the Buddha's Enlightenment. These include Prince Siddhartha seeing the four omens, leaving the

palace (the Great Departure), severing his hair (the Renunciation), practicing various austerities, and the assault of Mara.

Denison has two chests featuring the Great Departure. Although the subject matter is identical, the narratives were handled differently on each chest. The front panel of one of the boxes (DU 1972.24, not illustrated here) focuses on Prince Siddhartha leaving the palace. The right side panel depicts the prince in his carriage looking at the four omens (an old man, a sick man, a corpse, and a monk), while the left panel illustrates the Renunciation. The front of the second chest depicts the Great Departure, where the Buddha as Prince Siddhartha at the lower left sees the four omens in a panoramic fashion (Figure 9.10). To the right, he can be seen taking a last look at his sleeping wife, and at the top left, he is shown leaving the palace on his horse and being accosted by Mara, the tempter, who attempts to dissuade him from his course of action. The left side panel of the chest depicts a trio of seated images, while the right panel shows a horse and seated figure. Although the latter two are not shown here in typical poses, given the subject matter of the chest, it is possible to surmise that they represent Chana, the faithful groom, and Kanthaka, the Buddha's horse.

Denison also houses three monumental covered votive alms bowls (*tha-beik*). All come with matching stands. Although their size suggests receptacles for communal use, most likely they were donated for permanent display on or around the main altar at a monastery or pagoda. The most colorful is the single bowl resting on an hour-glass shaped stand (Figure 9.11). The lid and sides of this votive bowl are covered with a deep turquoise mosaic of glass

FIGURE 9.10 Manuscript chest (*sadaik*).
Burma, possibly Mandalay. Nineteenth century.
Teak, lacquer, and gold leaf. H 47.8 cm, L 68.5 cm, W 36.1 cm.
Gift of Konrad and Sarah Bekker. DU 1974.23.

FIGURE 9.11 Covered bowl on stand (*tha-beik*).
Burma, possibly Mandalay. Early twentieth century.
Wood, bamboo, glass, and gold leaf. H 60.3 cm.
Gift of Ann Rohrer. DU 1968.78.

Sylvia Fraser-Lu

overlain with raised, gilded vegetal arabesques. The latter spring from nine-petaled rosettes (*nawarat*) inlaid with cut glass and surmounted by effigies of alighting birds. Rows of different colored glass cabochons surround the rim on which rests a gilded cover. The latter is embellished around the sides with an interlocking cable design and overlapping *balu-gwin* cells filled with circles of sequin-sized slivers of blue and white cut glass. The decoration on the top of the lid radiates in concentric bands from a large, turquoise, glass mosaic rosette at the center. The outermost circle is composed of a wide band of green glass mosaic overlain by rhythmic arabesques of *chu-pan* foliage. The intermediate bands are formed by interlocking cable and lotus petal shapes. The hour-glass shaped stand (*kalat*) is also embellished with bands of inlaid saw-tooth, wave, and lotus petal components. The other two bowls are also heavily ornamented, like the *tha-beik* in Figure 9.11, with bands of cut-glass rosettes (Catalogue no. 9.14). The stand of the *tha-beik* on the right is augmented around the base by a quartet of reptilian forms.

Hman-zi shwe-cha decoration is particularly popular on pagoda-shaped *hsun-ok* offering vessels. Denison has an excellent example from Shan State, which is more squat and robust in form than examples from Pagan and Mandalay (Catalogue no. 9.15). It is embellished on a gilt and orange ground with a raised floral motif around the sides of the bowl in a design unique to Shan lacquer. The decoration on the foot of the bowl is also characteristic of Shan work.

There is a particularly elegant cylindrical storage box (*bi-it*) embellished with bands of undulating lines and floral scrolling rendered in low relief (Catalogue no. 9.16). Such a box might have originally been used for storing cosmetics and items of clothing. There is a similar, more closely embellished example in the Victoria and Albert Museum in London, which was said to have belonged to Thibaw, the last king of Burma.

A beautifully crafted gold betel-nut container encrusted with precious stones and set on a stand was an important item of royal regalia during Konbaung times (1752–1885). With the demise of the monarchy in 1885 and the consequent lapsing of sumptuary laws, effigies of these former royal objects came to be used by all and sundry during *Shin-byu* processions in which young novitiates of the monkhood re-enact the Buddha's decision to

renounce his royal inheritance in favor of a mendicant existence. For the procession, such boxes are usually carried on wooden stands by the prettiest young women in the guise of Mara's daughters who attempted to distract the Buddha. They remind participants of the sacrifices made by the Buddha during his quest for enlightenment. The most striking receptacles are the highly gilded, avian-shaped *hintha* betel boxes (*hintha kun-it*), of which the Denison collection contains a number (Figure 9.12). The body of the bird consists of a base and bowl of wood and outspread wings and tail of sheet metal openwork. Once the appendages have been attached, usually with nails, the whole is decorated with molded lacquer, glass inlay, and gold leaf. They are usually placed on gilded stands (*kalat*) edged with a frill of metal and inlaid with sequins of colored glass. The Denison collection also holds effigies of a *pyin-sa-yu-pa*, a composite animal with the wings of a bird, the body of a snake, the hoofs and antlers of a deer, and the trunk and tusks of an elephant, which is often seen surmounting the frame supporting the largest drum (*patma*) of a Burmese orchestra (DU 1976.27, not illustrated here). Other

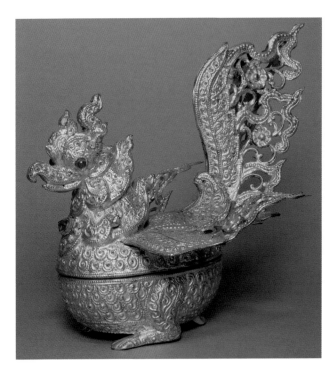

FIGURE 9.12 Bird-shaped betel-nut box (*hintha hsun-ok*).
Burma, possibly Mandalay. Twentieth century.
Wood, metal, gold leaf, and glass. H 26 cm.
Gift of Zelma Graham. DU 1976.81.

structures for holding gong and drum circles of a Burmese orchestra may carry *hman-zi shwe-cha* decorated openwork. The resonance case of the Burmese harp also sometimes has similar relief-molded or gold leaf *shwe-zawa* decoration.

Raised gilded lacquer decoration also adorns the unique rice baskets (*ko-kaw-te*) of Kengtung, the easternmost principality of the former southern Shan States located close to the borders of Thailand, Laos, and China. Boasting of a small lacquer industry that harks back to the eighteenth century, Shan artisans, by the early twentieth century, had come to specialize in producing a sturdy, footed lacquer rice basket embellished with embossed medallions, rectangles, and triangular forms filled with zoomorphic and anthropomorphic elements, and edged with vegetal and geometric border patterns. Originally the baskets were of plain black lacquer, but when the art of decoration became finer due to the production of a particularly pliant *thayo* composed of lacquer mixed with the ash of discarded *thet-ke* grass (*Imperata arundinacea*) thatch, they were upgraded from being primarily agricultural in function and came to be used for holding rice flour at religious festivals. They eventually came to be presented by the local ruler (*saw-bwa*) to individuals for meritorious service.

The earliest examples of the decorated baskets seem to have appeared around the time of the Kengtung ruler, Maha Byaggahajoti Kawng Khamfu (r. 1886–1895). They combined painting and raised gilded decoration around the rim, shoulder, and feet of the basket. Early motifs included tiger masks, a wish fulfilling tree (*karabuk*) around the sides, and effigies of crows on the feet.[4] Early in the twentieth century, to make the baskets more appealing to a wider clientele, the British authorities encouraged artisans to extend the design repertoire by injecting more "local color" into their motifs. Boldly modeled effigies of local ethnic groups, such as Khun, Kaw (Akha), Lahu, and Khamu minority couples, began to make their appearance in panels around the sides of the basket. Some artisans also began signing their work in a gilded cartouche on the base with the name of the maker, locality, and date of manufacture.

The Denison collection has some excellent examples of lacquer baskets dating to the late 1920s and 1930s, which are unique to Kengtung. One is almost completely covered with fine scrolling and a stylized version of the wish-fulfilling *karabuk* tree fills the corners (Catalogue no. 9.17). A cotton shoulder strap

is attached to metal holders on the rim. The other baskets feature effigies of minority people, some in single file separated by triangular divisions, around the sides. On one well-crafted black lacquered and gilded basket, the figures were arranged as four sets of couples separated at the corners by star-shaped roundels, with peacock motifs at the center (Figure 9.13). Depicted in high relief, the lively figures of couples represent different ethnic groups who inhabit the area around Kengtung. They may be identified by their clothing, headdresses, and musical instruments. Images of alighting crows decorate the foot supports of the basket.

During the eighteenth and nineteenth centuries, some inhabitants of villages in the vicinity of Ye-U in the Shwebo area north of Mandalay used a *thayo* made from teak sawdust and lacquer to fashion Buddha images during the dry season when there was a lull in agricultural activities. In "dry lacquer," a technique originally from China, a rough form of the image was shaped in clay over a wooden armature. A thin casing of lacquer-soaked cloth was wound around the clay core and a one centimeter-thick plaster of *thayo* applied. Facial features, folds of clothing and other important iconographical details were fashioned with a small knife. Upon hardening, the inner clay core was flushed away and the image finished with a fine coat of best quality lacquer and then polished. Relief-molded glass inlay and gold leaf might be added as further embellishment.

A beautiful example of a seated dry lacquer Buddha image (see Figure 10.8), which is outstanding for its fine proportions and serene facial expression, is also a part of the Denison collection. The remains of gold in the crevices highlight anatomical features and turns of cloth. This image probably dates to the late eighteenth or early nineteenth century.

KYAUK-KA

To the west of Mandalay in the Monywa area is the village of Kyauk-ka, which is second to Pagan in lacquer production. This village traditionally specialized in sturdy, everyday, plain black and red wares, such as sleek, curvaceous *hsun-ok*, towering *ok-khwet* food containers, and pumpkin boxes that are a staple of a majority of households and monasteries throughout Burma. Made from a substrate of coiled rather than woven bamboo, Kyauk-ka wares are noted for their strength and durability. Due to the area's relative isolation during the latter part of the twentieth century, such wares are not well represented at

Sylvia Fraser-Lu

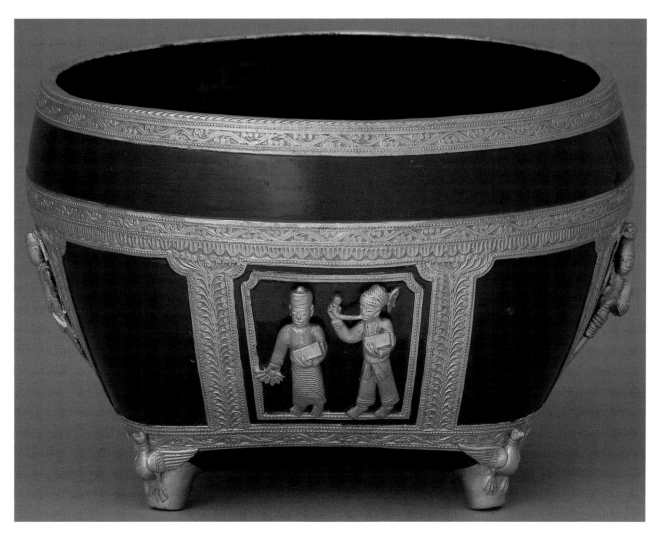

FIGURE 9.13 Ceremonial rice basket (*ko-kaw-te*).
Burma, Shan States, Kengtung. March 1933.
Bamboo, lacquer, and gold leaf. H 14.6 cm, D 20.3 cm.
P67.212.

Denison, but there is an excellent example of an *ok-khwet*, a traditional receptacle used to convey food to a monastery (Figure 9.14). This piece, made from coiled bamboo, was assembled from seven parts, all of which have been lacquered red on the interior and black on the exterior. The base consists of a deep fluted bowl supported by four small feet. A series of three trays of diminishing size fit snuggly one above the other and are able to hold a number of different dishes of food, which may at one time have included rice, curries, vegetables, and fruit. The uppermost tray probably functioned as a dish for pickles and other condiments. A small inverted bowl at the apex may have been used for drinking soup or serving the rice. There is an inscription on the base of the cup indicating the name of the lacquer worker who produced the

vessel and the town (Kyauk-ka). Other Kyauk-ka wares at Denison include a pedestal stand used to support a monk's alms bowl (Catalogue no. 9.18). The bowl shown here was purchased in Rangoon.

During the colonial period, in addition to traditional fare, artisans at Kyauk-ka were prevailed upon to expand the repertoire of objects to include items that would appeal to a foreign clientele. Consequently, tiered tiffin baskets, inspired by the wedding baskets of southern China, became popular, as did European-style flower baskets, trays, platters, and a number of covered bowls modeled on soup tureens and sugar bowls and replete with effigies of birds for ease of lid removal. Denison University has a large fluted rice bowl which is very similar in form to the base of an *ok-khwet* (DU 1970.46, not illustrated here), two small

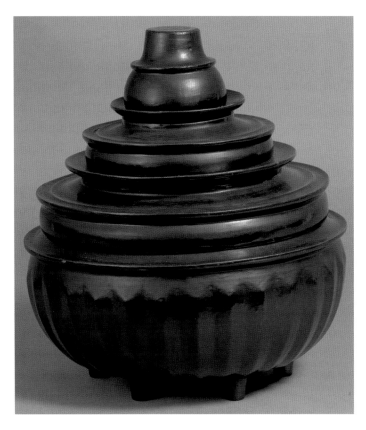

FIGURE 9.14 Offering vessel (*ok-khwet*).
Burma, Kyauk-ka. Mid twentieth century.
Bamboo and lacquer. H 35.6 cm.
Gift of Mary Spring Anderson. DU 1988.39.

covered bowls, which are no longer in good condition (DU 1967.41 and DU 1977.6, not illustrated here), and a black pitcher (Catalogue no. 9.19). All are black with red interiors and are typical of objects produced during the first half of the twentieth century for a western clientele.

SHAN STATE

Due to its relative isolation from the major administrative centers during colonial times, lacquerware from Shan State remained more traditional. Betel boxes, *hsun-ok* food containers, and *kalat* and *daung-lan* pedestal stands and stem bowls continue to be the most prevalent objects produced in Shan State. Shan lacquer forms are generally a little more squat and robust compared with their Burmese equivalents. The finest Shan wares may be distinguished by the clear brilliancy of the red pigment.

Painted wares in red and black are made in small workshops around Inle Lake by the Intha people, who delight in embellishing their wares with geometric designs which bear a resemblance to Northern Thai work of the Chiangmai-Lampang area. Much of the Shan incised work was made at Laikkha. This lacquer displays incisions that are thicker and less refined than on Burmese work, due to the fact that a stylus with a thicker point is used. Floral and geometric motifs are prevalent, usually in red and yellow on a black ground or in black on a red ground. Figures, when present, are lively and integrate well with the other decorative elements.

The Denison collection has three betel boxes and two sturdy pedestal cups from the Laikkha area. The boxes were embellished with incised floral decoration in yellow and black on a red ground (Catalogue no. 9.20). Lines of raised decoration toward the base, seen on these pieces, are typical of Shan work. The pedestal bowls also have a band of incised decoration around the sides. Their size suggests that they might have been commissioned as votive food receptacles for individual offerings made at one of the numerous Buddhist festivals held in the area. For example, the annual Phaung Daw U festival, which takes place each September, includes events like the transportation of sacred gold-covered images on a bird-shaped (*karaweik*) barge from the Phaung Daw U pagoda to towns bordering Inle Lake for veneration. At this time of the year, devout Buddhists make a point of presenting offerings, such as rice crispies, packaged cakes, candies, and flowers, in pedestal receptacles (Catalogue no. 9.21).

CONCLUSION

The Denison collection reflects nearly two hundred years in the history of lacquer production. With examples ranging from the latter reigns of the Konbaung kings, through the colonial period and into the post Second World War years, a number of objects clearly illustrate the various transformations which some of the well-known classic motifs have undergone over that period. Lacquer shapes for the most part have remained conservative and strongly utilitarian, and this is reflected in the Denison collection, with the cylindrical betel box being by far the most prevalent object. Because of widespread use at all levels of society, Burmese lacquer has much to reveal about Burmese material culture. The opening of Burma to tourism in the 1990s has promoted an upsurge of interest in lacquer, which has led to some notable exhibitions in Europe.[5] Denison University with this excellent resource is well placed to educate people about this unique and special craft.

LACQUER CATALOGUE

9.1a *left* Betel box (*kun-it*)
Burma, Pagan. Late eighteenth to early nineteenth century.
Bamboo and lacquer. H 7.5 cm, D 9 cm.
Gift of Col. and Mrs. L.B. Bixby.
DU 1968.338.

This small, personal betel box of woven bamboo has two shallow interior trays to hold the contents of a betel chew, including chopped areca nut, various spices, slaked lime, and tobacco. The interior of the lid and trays was finished in monochrome red lacquer. The exterior of the overlapping lid was embellished with one of the earliest known examples of the very popular Yunnan semi-circle design (*ku-nan kan-byat*), a trefoil linking frieze rendered in yellow over a mesh of green on a black ground. An abstract S-like curve was placed at the center of the space cell created by the frieze. The design was set between bands of parallel green lines which are also present on the exterior of the internal trays.

9.1b *right* Betel box (*kun-it*)
Burma, Pagan. Nineteenth century.
Bamboo and lacquer. H 8.9 cm, D 10.5 cm.
DU 1968.107.

This small betel box, replete with an inside tray, was embellished with a variant of the Yunnan semi-circle design (*ku-nan kan-byat*) where the red outlines were dramatically widened to emphasize the trefoil and interlinking cruciform elements set against a green chain pattern on a black ground.

9.2 Betel box (*kun-it*)
Burma, Pagan. Twentieth century.
Bamboo and lacquer. H 22.2 cm, D 24.1 cm.
Gift of Ann Rohrer. DU 1968.59.

This popular, twentieth-century example of the Yunnan semi-circle design on a betel box was expressed in a honeycomb of finely etched, black outlines set against an orange-red ground and enlivened with pin-sized dots in yellow. Small rosettes occupy the space

9.2 Detail of a betel box

cells created by the design. The focal point of the lid is a central medallion surrounded by a frieze of the Yunnan semi-circle design.

9.3 Betel box (*kun-it*)
Burma, Pagan. Mid twentieth century.
Bamboo and lacquer. H 18.4 cm, D 26.7 cm.
Gift of Zelma Graham. DU 1976.43.

On one of the two interior trays of this betel box is the inscription "number one production of Ma Hla Hsin and U Nyo Lwin." The box was incised in yellow with zoomorphs of the various animals, identified by Burmese captions, representing the Eight Planets design (*gyo-hsit-lon*). Shown here are the lion or *chinthe* (associated with Tuesday, the southeast, and Mars) and the elephant (associated with Wednesday, the south, and Mercury). This design, which is derived from Hindu-Burmese astrological beliefs, has special meaning for the Burmese. The day of the week on which one is born is regarded as vital information. Important decisions, such as selecting a name, a spouse, or a business partner, going on a journey, or even getting a regular haircut, take into account

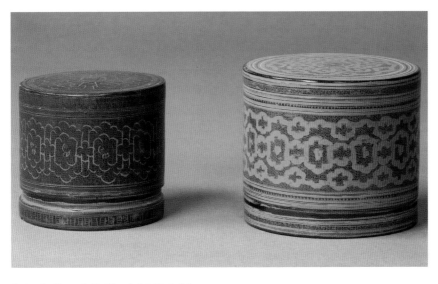

9.1a *left* **and 9.1b** *right* **Betel boxes**

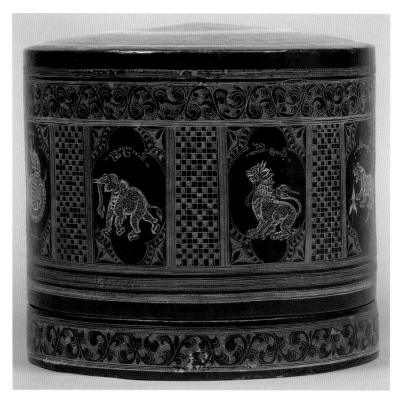

9.3 Betel box

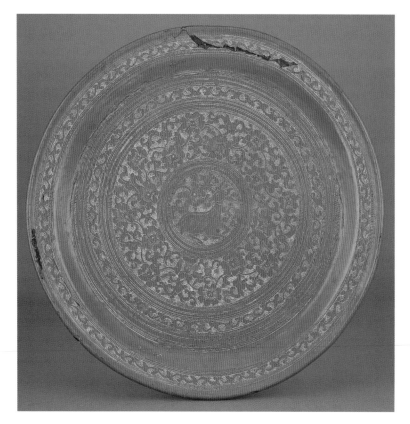

9.4 Plate

the astrological influences in the ascendant on that particular day of the week. The portrayal of this motif in Burma may also be interpreted as an expression of benevolence to all mankind. A devout Burmese Buddhist might conclude his prayers with "may those born on the seven days be well and happy."

9.4 Plate (*byat*)
Burma, possibly Shan States.
Early twentieth century.
Bamboo and lacquer. D 41.3 cm.
DU 1968.113.
Inspired by European platters, this large plate was made from coiled bamboo and embellished with a variant of the Chiangmai pattern (*zin-me*) in red against a yellow hatched ground. A deer occupies a medallion at the center. This plate is possibly of Shan workmanship.

9.5 Covered box (*cho-chin-hte*)
Burma, Pagan. Late nineteenth to early twentieth century.
Bamboo and lacquer. H 10.1 cm,
D 17.8 cm.
DU 1967.39.
This circular covered box was embellished with diamond and zigzag patterns set within a grid of green lines and bounded by parallel incisions of the same color. Yellow cross motifs occupy the spaces between the diagonal lines. The base was finished with bands of concentric lines in yellow. The interior, including a shallow tray, was roughly re-touched with red lacquer. The workmanship on this box lacks the precision of other examples.

9.6 Circular box (*cho-chin-hte*)
Burma, Pagan. Nineteenth century.
Bamboo and lacquer. H 18.4 cm,
D 17.8 cm.
Gift of Ann Rohrer. DU 1968.55.

Sylvia Fraser-Lu

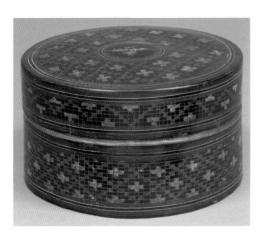

9.5 Covered box

This box is decorated with a classic *yok-thei* design of mounted riders, birds, and crouching animals in black, which were artfully integrated with the underlying pattern of worm-like curves on a green and black hatch ground. In later work the design and figurative elements were less well integrated. The base of the box was embellished with a *hintha* bird figure, the Burmese equivalent of

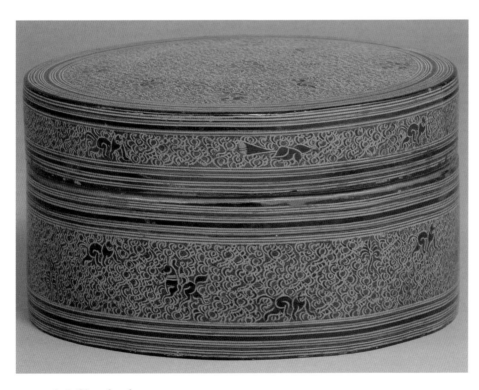

9.6 Circular box

the Indian *hamsa* or Brahmani goose, a semi-divine bird that is resident in various paradises.

9.7 Possibly a letter holder (*sa-chun bu*)
Burma, Pagan. Mid twentieth century.
Wood, bamboo, and lacquer. H 34.3 cm, D 5.7 cm.
Gift of Mrs. Phillip Greene.
DU 1967.105.

In the days of the Burmese kings, such a cylindrical-shaped container was used to store palm-leaves inscribed with various proclamations and other correspondence. When the use of paper became widespread around the mid-nineteenth century, this practice fell in abeyance. A lid helped seal the cylinder from humidity and insects known to attack palm-leaf. This object was embellished with Burmese lions (*chinthe*), which stand guard at pagoda entrances throughout Burma, and peacocks (*u-daung*), the emblem of the former Konbaung

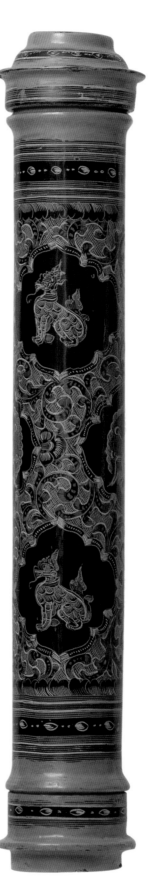

9.7 Possibly a letter holder

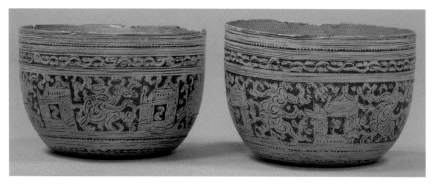

9.8 Pair of bowls

dynasty. These zoomorphs were set against a background of swirling *chu-pan* scrolling.

9.8 Pair of bowls (*khwet*)
Burma, Pagan. Twentieth century.
Bamboo and lacquer. H 7 cm, D 10 cm.
Gift of the Marshall family.
DU 1977.9a and DU 1977.9b.
These small bowls were embellished with the *lei-taik lei-kya* motif consisting of four buildings that alternate with flowing

fantasy figures, the outlines of which are rather difficult to discern from the random swirls of background decoration.

9.9 Water pot (*yei-o*)
Burma, Pagan. Workshop of the son of Hsaya Kyi. Mid twentieth century.
Bamboo and lacquer. H 18.4 cm.
Gift of Mr. and Mrs. John Holterman.
DU 1980.25.
This water storage pot is made from bamboo woven in two parts

and luted together. It is identical in shape to the ceramic paddle and anvil earthenware pots made by village women throughout Burma. It has a rounded base to prevent it from being inadvertently knocked over, but it comes with a circular stand on which to rest the pot. The sides were decorated with a generic example of the king at court motif (*nan-dwin*). This example shows the king in an audience hall surmounted by a multi-tiered *pyatthat* spire on one side and with a small figure inset above on the opposite side. The queens are shown to the left, and princes and officials kneel on the right. The base has a peacock with outspread tail, the emblem of the Konbaung dynasty. During the colonial era, the peacock and the *nan-dwin* motifs were a constant reminder to the Burmese of their independent past. On the shoulder of the pot, an inscription stating that the piece was made by the son of Hsaya Kyi suggests that the son was not averse to "cashing in" on a father's illustrious reputation as a craftsman.

9.10 Tray (*byat*)
Burma, Pagan. Twentieth century.
Wood and lacquer.
L 59.7 cm, W 42.2 cm.
DU 1968.57.
This tray depicts the demise of King Anawrahta (r. 1044–1077), founder of the Burmese kingdom of Pagan. The king may be seen on Thanmyinzwa, his splendidly caparisoned elephant, getting ready to attack Cakkhupala, a marauding buffalo that had been ravaging the outlying environs of the city. The demon buffalo, guided by the Lein tree spirit (an enemy of Anawrahta's from a previous existence), gores the king to death.

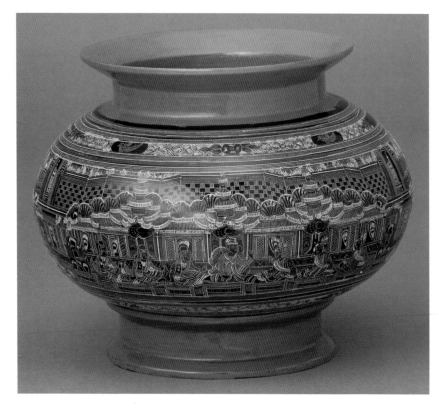

9.9 Water pot

Sylvia Fraser-Lu

9.10 Tray

9.11 Panel from a manuscript chest (*sadaik*)
Burma, Shan States, Inle area. Late eighteenth to early nineteenth century. Wood, lacquer, and gold leaf. H 35.8 cm, W 40.4 cm.
Gift of Konrad and Sarah M. Bekker. DU 1974.21.

This panel from the side of a small scripture chest in gold leaf (*shwe-zawa*) features the Great Renunciation, where the Buddha by the act of cutting his hair symbolically renounces his former life as a prince in favor of becoming a mendicant. To the right is the god Sakka with a covered bowl open to catch the severed hair of the Buddha-to-be for enshrinement in Tavatimsa Heaven. On the left is the Brahma Gatikara offering a set of robes

9.11 Panel from a manuscript chest

9.12 Plate

and the other requisites of a monk. Note the fine vegetal scrolling framing the panel and the leaf or bud (*daung*) ornaments which fill the corners of the panel.

9.12 Plate (*byat*)
Burma. Early twentieth century.
Bamboo, lacquer, and gold leaf.
D 45.7 cm.
Gift of Helen K. Hunt. DU 1968.269.

This well-crafted plate in black lacquer is beautifully illustrated in gold leaf with a key episode of the well-known *Mahajanaka Jataka* (no. 539) in which two brothers, Aritthajanaka and Polajanaka, fight a duel for the throne. The layout of this scene has become a generic portrayal for a disputed royal succession in Burmese art.

9.13 Bowl (*khwet*)
Burma. Twentieth century.
Bamboo, lacquer, and silver pigment.
H 14.9 cm, 15.6 cm.
DU 1967.367.
This incised decorated footed bowl is unusual in the subject matter of the illustration, which depicts a tiger and an ogre-like figure separated by a sprig of flowers. The imagery could

9.13 Bowl

represent a local folktale or a *nat* legend. The incisions are filled with a silver pigment, including the background, which is scored by a series of parallel lines.

9.14 Two covered bowls on stands (*tha-beik*)
Burma, Mandalay. Twentieth century. Wood, lacquer, glass, and gold leaf.

Right H 59.7 cm; Left H 51.4 cm. Gift of William A. Hensley. DU 1989.55 and DU 1989.56.
These bowls are embellished with bands of cut-glass rosettes from which spring lively flourishes of lacquer. They are set on tall, flaring stands replete with bands of horizontal, concentric molding. Further "support" for DU 1989.56

is tendered by a quartet of separately carved, rearing reptilian forms (*to-naya*), which extend from below the upper rim of the stand to rest their front paws on the base. In this placement, the *to-naya* is associated with the Hindu snake or *naga*, a symbol of abundance and fertility and guardian of the waters of the

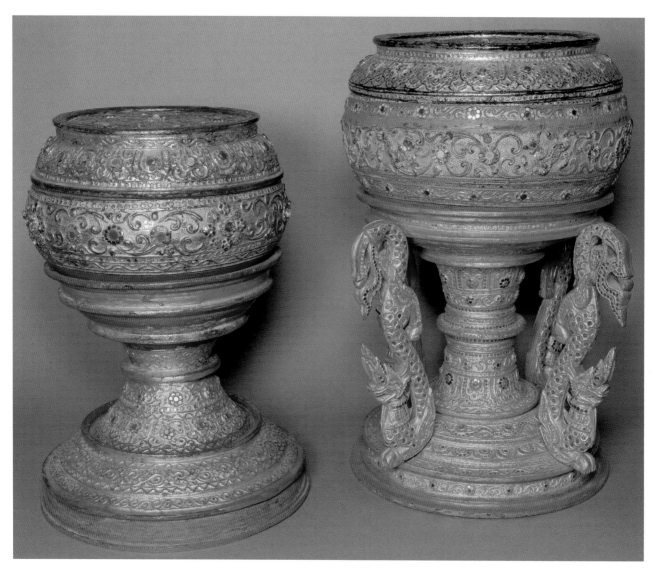

9.14 Two covered bowls on stands

earth and its subterranean riches. The presence of such imagery is considered auspicious when placed around the base of stands and the foundation pillars of monasteries.

9.15 Offering vessel (*hsun-ok*)
Burma, Shan States.
Mid nineteenth century.
Bamboo, wood, lacquer, and gold leaf.
H 34.9 cm, D 20.3 cm.
Gift of Mrs. T.F. Holbert (née Florence Conrad). P67.275.
Used to take meals to a monastery, this capacious vessel consists of a pedestal bowl replete with flaring foot ring and pagoda-shaped cover.

There is a tray inside to hold the various condiments and curries that went with the rice placed at the base of the bowl. This particular example, in gilt on an orange ground, was embellished with molded lacquer of four petaled rosettes alternating between rhythmic sprigs of vegetal decoration set between bands of beaded and undulating lines. The foot of the bowl was decorated with small vertical "rungs" of lacquer, simple wavy lines, and geometric patterns characteristic of Shan work. Originally an orange-red in color, the undecorated spaces between the molded decorations were touched up more recently with black lacquer.

9.16 Storage box (*bi-it*)
Burma, possibly Shan States.
Late nineteenth century.
Bamboo, lacquer, and gold leaf.
H 31.1 cm, D 42.5 cm.
Gift of Robert E. Leake. DU 1979.8.
This elegant gilded cylindrical box with a red interior was probably used for storing cosmetics or items of clothing. The low-relief molded lacquer bands of vegetal

Sylvia Fraser-Lu

contrapostal stance originally derived from Indian images, but it was popular during the Pagan period, particularly in painting, though less so in sculpture. As is typical of standing images, the Buddha's robes cover both shoulders and cling to the body down to the ankles. A line below the navel, raised and slightly uneven edges at the ankles and wrists, and an incised line at the neck are the only indicators of the presence of the robes on the body. The left hand and arm fold back towards the Buddha's body, grasping the robes that protrude between the thumb and forefinger, a *mudra* originally extant in India. The back of the robe is completely undecorated, indicating that the image was meant to be viewed from the front. The right hand was cast separately and is now lost. It may have been in *varada mudra*, the gesture of giving commonly portrayed on standing images. However, some Indian and Burmese images in a similar stance were depicted with the palm facing down to illustrate the Buddha taming the Nalagiri elephant, one of the eight great events of the Buddha's life. In Burma, the Buddha's hand was sometimes shown hanging down when walking.[12]

Other features of this Buddha include prominent nipples, rounded thighs, and a stomach swelling with the breath of life, all typical of the period. The facial features of the image also corroborate the proposed eleventh century date. Unlike the sharper features that were prominent at the end of the eleventh and the early twelfth centuries, the Buddha's face is round and soft, except for the pointed, narrow chin. The eyebrows are full arches over the downcast, inlaid eyes, and meet at the bridge of the nose. Two additional lines, one above and the other below the eye, emphasize the eye sockets. The well-modeled and carefully detailed nose is shaped into a slim, beak-like form, and the small, pursed mouth with a hint of a smile is characteristic of the late eleventh century. The earlobes are long and curve out before touching the shoulders, making the neck, incised with three lines, seem shorter than it is. The large, finely detailed hair curls turn to the right, and unusual for the time, do not follow the line of the eyebrows, but dip down above the nose.[13] The image also has a high *ushnisha* capped with a tapering finial that was once set with a jewel or semi-precious stone.

At Denison, the Buddha stood on a crudely carved, modern, wooden double lotus base. While

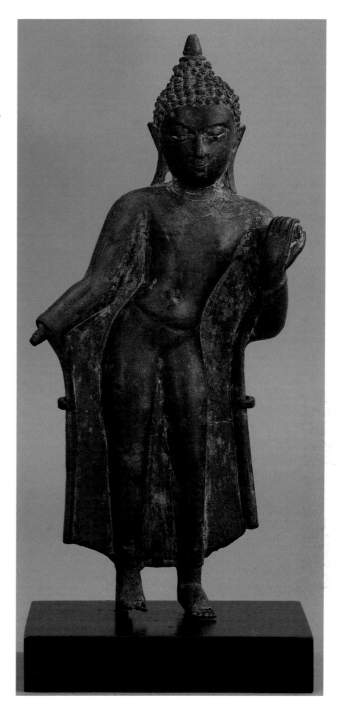

FIGURE 10.2 Walking Buddha.
Burma. Pagan period, circa 1070–1080.[14]
Bronze with inlays. H 27.9 cm.
Purchased with funds partially donated by Mrs. J. Hislop.
P67.242.

the image appeared to have uneven feet, its eccentricity was not evident until the base was removed. The Buddha's left foot is lower than the right one, which has an integral metal strut protruding from the sole. This suggests that the uneven position of

the feet was deliberately produced, and most likely indicates that the Buddha was meant to be walking. Although the walking Buddha may have emerged in Burma during the twelfth and thirteenth centuries, this type of representation was not popular. In an attempt to avoid showing the Buddha as anything less than a god, who maintained an appropriate separation from the earth associated with form and desire, the Burmese developed methods of indicating that the Buddha was walking without actually showing the image taking a step.[15] The Buddha's robe was shown swinging to the side, and occasionally the image was portrayed with one leg shorter than the other.[16] In another format which originated in India,[17] the Buddha was depicted standing in three-quarters profile with the back leg placed slightly ahead of the front one to indicate depth, both feet flat on the ground, and the legs placed at an angle to the torso, giving the image a distinct swaying appearance. The robe is level on both sides of the body in these images, despite the fact that such a stance sometimes represents a walking scene.[18] Although the robes of the Denison image fall evenly on both sides of the body, the fact that the right foot was deliberately cast higher than the left may be taken to indicate that the Buddha is walking. Such Buddhas cast in the round are rare in early Burmese art, with only a few extant examples known, making the Denison image a significant one.

FIGURE 10.3

Purchased in London in 1972, the elegant Buddha image of Figure 10.3 is seated on a plain plinth in *padmasana* (the lotus position) with the right hand calling the Earth Goddess to witness (*bhumisparsha mudra*), the most frequently sculpted gesture during the post-Pagan period and one that indicates the supreme significance of the Enlightenment. The robes are barely delineated with incised lines, while those robes that spill over onto the ground in front of the Buddha's ankles are indicated by a raised area on the plinth. As is typical of Burmese seated images, the robes cover the left shoulder only. The Buddha's broad shoulders enhance the delicate curves of his torso, which has a strong chest but slim waist. Unlike some later images, the Buddha's hands and feet are only slightly enlarged and do not dominate the sculpture. The face is similarly graceful, with downcast eyes, a small nose, a tiny, pursed mouth, and naturalistically arching eyebrows. The head of

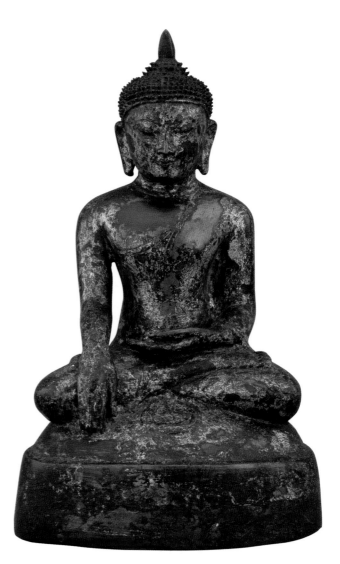

FIGURE 10.3 Seated Buddha.
*Burma. Ava period, sixteenth or seventeenth century. Gilded bronze. H 22.9 cm.
DU 1972.277.*

the Buddha is widest at the hairline, with the face tapering down to a rounded chin. The neck is short, but not so short that the head sits upon the shoulders, as in late Pagan period images, and the fact that the earlobes do not touch the shoulders relieves the potentially squat appearance created by a short neck. Set on the head like a cap, the Buddha's hair curls are sharp and spiky with a thin band separating them from the forehead. The *ushnisha* is low and has a small finial in the shape of a lotus pod, a common feature on early Buddha images in Burma.

Jane Terry Bailey described this Buddha as of the seventeenth century,[19] but the dating is problematic because the characteristics of late Pagan and Ava image types are combined in this piece. Pagan

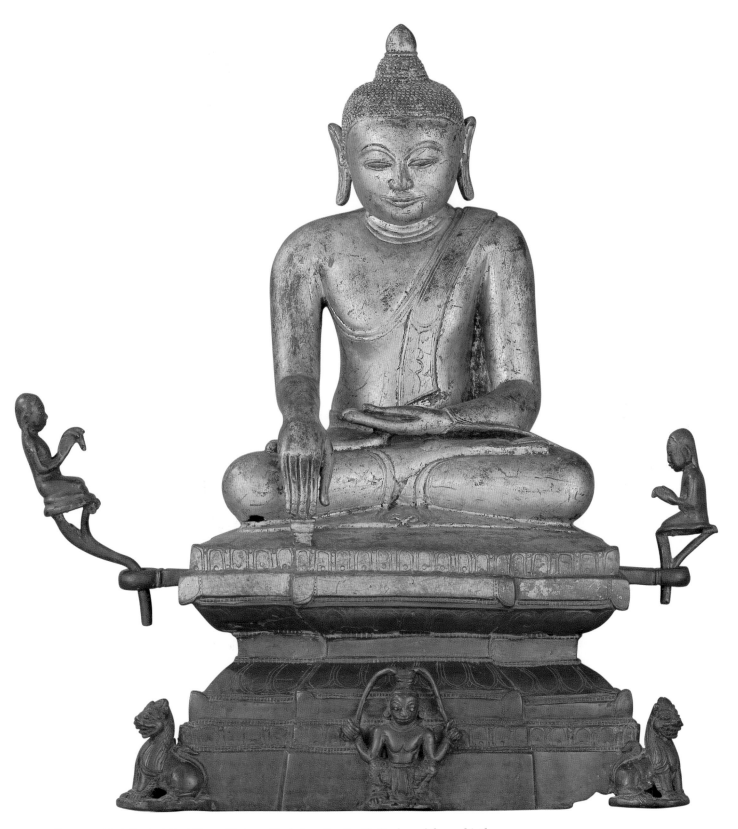

FIGURE 10.4 Seated Buddha with two disciples, the Earth God, and four *chinthes*.
Burma. AD 1628.
Gilded bronze. H 44.5 cm.
Gift of William A. Hensley. DU 1989.25.

period features include an *ushnisha* set slightly back on head, ears that have been displaced toward the back of the head, creating broad cheeks, earlobes that do not touch the shoulders, and a neck that is wide at the base. Additionally, the Buddha is fairly well-proportioned, lacking the large hands and feet of seventeenth and eighteenth century images. The broad head of the Denison Buddha which tapers down toward the chin is typical of sixteenth to eighteenth century images, and the band (here very narrow) separating the hairline from the forehead is also a later development.[20] Given the combination of stylistic elements, the image probably dates from the sixteenth or early seventeenth centuries.

FIGURE 10.4

Purchased in Mandalay in 1937 by Muriel Upfill's husband and eventually acquired by William Hensley, the Buddha of Figure 10.4 is one of Denison's best known and most published images.[21] The sculpture shows the Buddha seated in *padmasana* and *bhumisparsha mudra* on a stepped, waisted throne which is decorated with lotus leaves and beading. He is flanked by two disciples. At the four corners of the throne base are four mythical lions or *chinthes*, and in the front squats the Earth God. An inscription at the back reads, "Made in the month of *Nayon* (May–June) in the Burmese era 990 (AD 1628)." A metal slot on the back of the throne probably would have held a detachable halo or mandorla.

The Buddha wears simple robes, edged with a double line, that cover the left shoulder and rest on the throne in front of the image. The shoulders are broad, the chest prominent, and the short neck is marked with three lines. Diamond shapes embellish the soles of the Buddha's feet, and the fingers of the right hand rest upon a support. The head is wide with a rounded face that tapers slightly toward the chin. The small hair curls are raised above the forehead, giving them the appearance of a cap. The high *ushnisha* is surmounted by a small, rounded finial, which enhances the squat appearance of the image. The big ears have curving lobes but do not reach the shoulders. The facial features of the Buddha are somewhat pinched, with narrow-set, almond-shaped eyes under bulging eyebrows. The slim nose points toward the thin lips that curve in a small smile. The slightly puffy upper lip is a feature commonly found on seventeenth and eighteenth century images. Unusually, the mouth is surrounded by an extra line.

The disciples, *chinthes*, and the Earth God are significant elements of this image. Functioning in a protective capacity, *chinthes* can be found at the corners of Burmese stupas from as early as the eleventh century, and often flank doorways and entrances to sacred spaces. The use of *chinthes* at the corners of the throne indicates their guardian status. Extending from the throne opposite the knees of the Buddha are two rings used to hold images of the Buddha's disciples. The figures have been cast separately from the Buddha image, and the stalks on which they kneel are inserted into the rings. The two disciples are dissimilar, and they are probably not original to the image. The differing heights of the stalks on which they sit suggest an identification as Sariputta and Moggallana, the Buddha's chief disciples. Sariputta was the foremost disciple and therefore was usually represented sitting on the highest support on the Buddha's right side.[22]

Most unusual is the figure squatting, with its legs projecting to the sides, in front of the Buddha at the base of the throne. It holds two strands of hair, one on each side of its head, and its arms are bent into v-shapes with the elbows touching the raised knees. The head is surmounted by a high top-knot, and the figure wears ear plugs. It has coarse features with bulging eyes. A decorated *longyi* (sarong) tucked-up in a man's style covers the image from the waist to the knees. The unlady-like appearance of the figure suggested to F.K. Lehman that the image represents a Burmese nature spirit (*youkkhazou*) that guarded the Bodhi tree under which the Buddha sat to reach Enlightenment.[23] Upon further analysis of such representations, it seems possible to confirm this image as the Earth God, usually depicted as the Earth Goddess, wringing out his hair in witness of the Buddha's past good deeds.

Its masculinity, squatting position, and the two strands of hair are the unusual aspects of the image in front of the Buddha. There are representations of the Earth Goddess squeezing two strands of hair, the best known being one located in the museum at Pagan.[24] Catherine Raymond has written on images of the Earth Goddess in Arakan, where it can be represented as either male or female.[25] The Earth God in a male form is usually shown squatting, primarily with one knee lower than the other. In female form, it is usually depicted kneeling, but occasionally is shown seated cross-legged.[26] The squatting position portrayed here is mostly found in

incised lines indicating many folds and layers, and the edges of the robes around the chest, ankles, and on the plinth are indicated by further decorative lines. Between the two sections of robes that lie on the base in front of the Buddha is a lappet of cloth with a pointed end. Three rings are marked on a somewhat elongated neck and narrow earlobes rest on the shoulders.[44] The face is a softly rounded oval, rather than the more triangular shape found in the seventeenth and eighteenth centuries, which further confirms a later date for this piece. The eyebrows are gently arched and merge with the slender nose. The mouth retains the puffy upper lip, common on eighteenth century images, and curves up in a very slight smile. Narrow, meditative eyes give the image a serene expression. The hair, shown as a smooth, gilded cap, is raised off the Buddha's forehead. The high, round *ushnisha*, foreshadowing the fleshy cranial bumps of the Mandalay style Buddha image, was once surmounted by a finial, now lost.

FIGURE 10.9

The classic Mandalay style of Buddha image is reflected in this example from the Denison collection (Figure 10.9).[45] Standing on a single lotus base, the Buddha is clothed in elaborately draped robes edged with glass and mirror inlays, as well as *thayo* designs. The robe covers the torso completely, as is traditional for standing Buddha images in Burma. The left hand holds the robes out to the side, while the other grasps a myrobalan fruit between the thumb and middle two fingers. The robe also flares out on this side, presumably a result of the gesture of offering being made.[46] Most standing Buddhas from the Mandalay period hold the myrobalan fruit. Other features are also typical of Mandalay Buddhas: the large, rounded *ushnisha*, the broad band decorated with glass mosaics forming a floral pattern separating the hair from the forehead, and the curving, elongated earlobes that reach the shoulders. The face is a serene oval with a serious expression. Under barely arched eyebrows are narrow, downcast eyes. The nose is slender, and, although the mouth has a puffy upper lip reminiscent of earlier images, it too is thin.

The myrobalan fruit seen here is an almond-shaped object, and was originally a part of Mahayana imagery of the healing Buddha, Bhaishajyaguru. In the Burmese context, it appears to reflect the Buddha Shakyamuni as the supreme healer offering

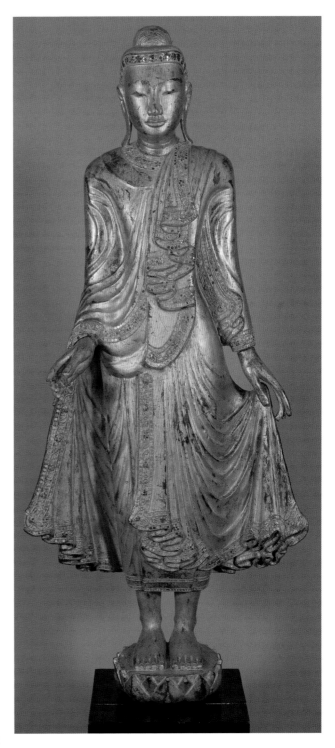

FIGURE 10.9 Standing Buddha.
Burma. Konbaung dynasty, mid to late nineteenth century. Lacquered and gilded wood with glass inlays. H 121.9 cm. Gift of William A. Hensley. DU 1989.79.

spiritual medicine (see also, Catalogue no. 10.3).[47] Jennifer White analyzed the development of both the seated and the standing Buddha image holding

a myrobalan fruit during the early nineteenth century in Burma. She attributed the iconography to remnants of Mahayana imagery that function well in a Theravada context. The Buddha as a healer can be a significant image, suggesting a resolution for both physical and spiritual woes.[48] These beliefs can be linked loosely with historical events in Burma. The eighteenth and early nineteenth centuries saw a significant rift in the monkhood over whether one shoulder or two should be covered while begging. The crises of the three Anglo-Burmese wars of the nineteenth century and the concomitant threats to Burma's culture would have further suggested that all was not well spiritually in the country. These stresses upon late eighteenth and nineteenth century Burmese society may in part have contributed to the popularity of the healing Buddha imagery.

FIGURE 10.10

Purchased in Paris in 1967, the Buddha image of Figure 10.10 is a typical example from the south of Burma, particularly the Moulmein area. It is one of three such examples in the Denison collection. Dating to the seventeenth or eighteenth century, an identification which is corroborated by the existence of a similar, dated piece discussed by Jean Perrin, this Mon Buddha is traditionally seated in *bhumisparsha mudra* with his feet crossed, one above the other, in *virasana* posture.[49] Mon images tend to have a somewhat abstract quality about them, and the Denison example is no exception. It has a disproportionately large head, hands, and feet, a stunted torso, and thin arms. The torso and arms are covered with carved bracelets, armbands, a beaded collar, and the chest is decorated. On the shoulders are raised triangular epaulets springing from arm-bands, a type of embellishment that became popular on later crowned images in eastern Burma. Two lotus flowers have been carved on the knees of the Buddha, another common feature on Mon images. Large, circular ear plugs are set above the earlobes, which taper to a point and rest on the Buddha's shoulders.

The most obvious indication of the Buddha's superior status is the crown, which on Mon images are usually composed of three layers; this image is unusual in having a five-tiered crown. The wide base of the crown sits low on the Buddha's head, reaching to the ears. It is surmounted by two concentrically arranged crowns with numerous points. The three upper tiers are less distinctly

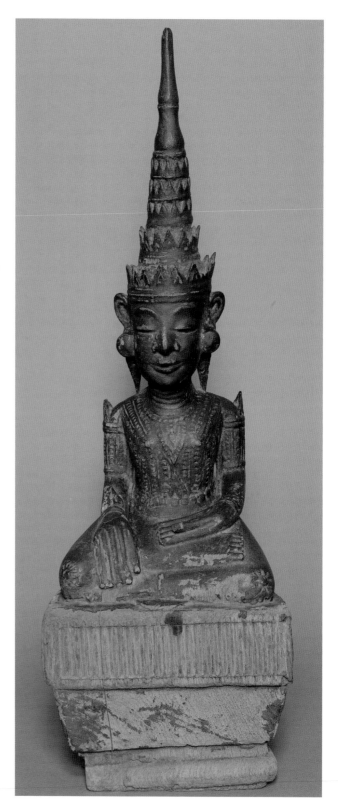

FIGURE 10.10 Crowned Buddha.
Burma, Mon State, Moulmein area. Seventeenth or eighteenth century.
Wood. H 70 cm.
DU 1967.112.

Alexandra Green

articulated and are almost the same size. This part of the crown functions as a single unit, and merges with the two-part finial.[50] Like the head, hands, and feet, the crown is disproportionately large for the image as a whole, focusing the viewer's attention upon it. Other features characteristic of Mon images include fingers of the same length, a popular style in Burma in the seventeenth and eighteenth century in general, and three lines on the neck. Facially, the Buddha follows Mon conventions with slit-like eyes, a broad nose, a slightly smiling mouth (also found elsewhere in Burma in many periods), and a long, straight face with moderately chubby cheeks.

The image is seated on a tapering throne composed of several layered sections that has as its primary decoration relief-carved, vertical striations. The fact that the Buddha is seated in the commonly used *bhumisparsha mudra* and is depicted crowned indicates that specific, standardized elements were employed across the country, while the variant features of the Buddha reveal the different aesthetic approaches ethnic groups in Burma took toward sculptural traditions.

DISCUSSION

Burmese art in general has been insufficiently researched, and no distinct chronology for Burmese Buddha images has been established.[51] The lack of scholarship on the latter topic has in part been caused by the widely disparate styles of these images, and also by the difficulty of finding material with adequate provenance. Burma is an ethnically diverse country with variant traditions of Buddhist religious practice, which may account for the many stylistic types. As more images are published, it will be possible to discern stylistic groupings that may contribute to a better understanding of art and context in pre-modern Burma. This selection of Burmese Buddha images from the Denison collection has been made with this aim in mind.

Amidst the stylistic dissimilarities, however, two iconographic features stand out for discussion because of their prevalence in Burmese Buddha images—the crowned Buddha and the use of *bhumisparsha mudra*. In disparate areas of the country, including Arakan, Mon and Shan States, and the central Burman zone, this *mudra* and the crowned image were the dominant forms, suggesting that standardization was enabled by religious and trade links across the region. The improvement of

technology, communications, and political administration also resulted in the expansion of textual, ritual, monastic, and doctrinal norms across central and peripheral areas.[52]

Bhumisparsha mudra became the gesture of choice during the Pagan period in Burma, but it was primarily after the thirteenth century that it dominated artistic norms to the near total exclusion of any other hand gesture. Most seated representations of the Buddha display the image with its right hand in the earth-touching posture. Exceptions became more common in the late eighteenth or early nineteenth centuries, though *bhumisparsha mudra* continued to predominate. Two theories have been forwarded to explain this phenomenon. Robert Brown has linked it to the significance of Bodhgaya in Theravada Buddhism. As the site of Gotama Buddha's Enlightenment, Bodhgaya is a direct connection with that event and with the purity of the Buddha. This link encouraged Burmese rulers to send missions to Bodhgaya to repair the temple site, and also promoted the production of votive tablets and plaques with scenes of the Buddha's life (see Catalogue nos. 10.12–10.16).[53] The use of *bhumisparsha mudra* in sculpture would have emphasized the Buddha's remarkable achievement at Bodhgaya.

John Ferguson connects the emphasis upon the earth-touching gesture to a direct focus on the Enlightenment itself. No other gesture was as commonly represented in Buddhist art because the Enlightenment was the most significant moment of the Buddha's life, a result, in part, of his perfection of the ten virtues. The stories of his previous lives, the Jatakas, and the narrative of his current life demonstrate these virtues. These narratives reflect the law of cause and effect (*karma*) in action. *Bhumisparsha mudra* thus connects the *Jataka* stories, the life of the Buddha, and the law of *karma* to the Buddha's defeat of Mara, and therefore the Enlightenment.[54] In other words, *bhumisparsha mudra* reflects the focus of Theravada Buddhist teaching, *nirvana*, and suggests the path to attain this goal.[55]

The second type of iconography that is common in Burma is the crowned Buddha. These images have been discussed in a variety of publications, ranging from articles to exhibition catalogues. Traditionally, crowned Buddha images have been considered representations of the Buddha as he defeated the haughty King Jambupati. This has now been generally discredited and is viewed as an explanation

developed after the fact to explain the iconography. While crowned images were made (primarily in wood) in Burma during the Pagan period, they did not become prevalent until the fifteenth century. The similarity of these Buddhas to ones produced in China and Tibet suggests that this style traveled along trade routes connecting the countries.

The predominance of crowned Buddha images in Burma is usually accepted as a representation of the Buddha as a supramundane *cakravartin* (world conqueror).[56] That there are clear connections between kingship and the religion is illustrated by the use of political terms to describe the virtues of the Buddha.[57] For example, in the *Milindapanha*, questions asked by King Milinda reveal the relationship between a Buddha and a king, particularly in the similarities of their roles as ruler and guide, in being held worthy of homage, and in the punishment of transgressors.[58] The mutual dependency between king and religion is embodied in the crowned image because it indicates, in part, that the Buddha could either have followed the path he did or have become a world emperor.[59] Illustrations of the link between the king and the Buddhist religion are also found in a variety forms of Burmese art besides sculpture, including wall paintings of the seventeenth to nineteenth centuries and the layout of the Mandalay royal palace (a replica of Tavatimsa Heaven), indicating the significance of the concept.

The combination of *bhumisparsha mudra* and the crown in sculpture can be considered to achieve a particular significance in Burma. The Buddha is represented crowned in *bhumisparsha mudra*, reflecting his "king of kings" status, because of his ability to reach Enlightenment. The visual association of a kingly Buddha in *bhumisparsha mudra* may furthermore have emphasized the Burmese king's own *bodhisattva* nature, further reinforcing the relationship between the Buddha and the king. Socially, the extensive employment of *bhumisparsha mudra* represents a facet of religious standardization and iconographic conservatism in Burma. Religious orthodoxy would have encouraged an interest in images that could safely be considered traditional, rather than illustrating the actual variety of religious beliefs. The growing predominance of crowned Buddha images between the fifteenth and the early nineteenth centuries additionally reflects the increasing level of centralization, as well as improved trade and communication networks, within the country. The use of these two dominant iconographic elements in representing the Buddha sculpturally thus probably reflected and satisfied contemporary political, social, and religious trends and requirements.[60]

The Denison collection of Buddha images and votive tablets is an eclectic one, being formed through purchase, trades, and gifts. Nevertheless, it demonstrates many elements found among other collections of Burmese Buddhist material, particularly the widespread iconographical features of the *bhumisparsha mudra* and the crowned image. The collection enlarges visual knowledge of Burmese Buddhist material, although the lack of provenance information makes it impossible to explicate the specifics of localized production.

BUDDHA IMAGES CATALOGUE

10.1 Seated Buddha

Burma, probably Shan or Mon States.
Nineteenth century.
Lacquered and gilded metal. H 22.9 cm.
DU 1969.7.

Lacquered and gilded, the Buddha is seated in *bhumisparsha mudra* on a waisted, stylized double lotus throne, on the back of which is a flat section, possibly for an inscription. The oversized hands, head, and feet contribute to the squat appearance of the image, as do the large ears with earlobes resting on the shoulders. The facial features are large. Elegantly arched eyebrows over downcast eyes are emphasized by a double line on the eyelid. The bridge of the nose is formed by the converging eyebrows, and just below the eyes, the nose widens sharply. The thick-lipped mouth emphasizes the heaviness of the face, and the feeling of compactness is enhanced by three lines squeezed onto the short neck. Rows of hair, rather than the usual hair curls (or the absence of curls), can be seen running towards the low *ushnisha* and elongated finial. A band separates the hair from the broad forehead. The hands and feet of the image are large and slab-like, with fingers and toes all the same length. The rounded object between the thumb and palm of the left hand probably functions as a support. The Buddha's robes, decorated only with a double line incised at the edges, cover one shoulder and lie on the throne in front of the legs.

The Buddha displays characteristics of Mon and some of the more unusual Shan area images. The squatness of the figure and the short torso, broad nose, and slightly smiling, wide mouth with large lips are similar to Mon Buddhas. The attenuated and boneless quality of the image's arms and fingers, however, can be Shan characteristics, as are the broad, squared-off shoulders. Most probably, the image was produced in the eastern zone of Burma or for that market.

10.2 Seated Buddha

Burma. Eighteenth or early/mid nineteenth century.
Bronze with traces of lacquer. H 23 cm.
Gift of Mr. and Mrs. Hillis Howie.
DU 1974.9.

The Buddha image is seated on a waisted double lotus throne in *bhumisparsha mudra* with one foot on top of the other (*virasana*). The Buddha's plain robes cover one shoulder, fall across his chest into his lap, and spill out onto the throne in front of his legs. The robes are raised and edged with double lines. Traces of coloring in the grooves of the robes and the throne suggest that the image may once have had a coat of lacquer and gold leaf.

The physical features of the image are dominated by the enlarged finial, which emerges

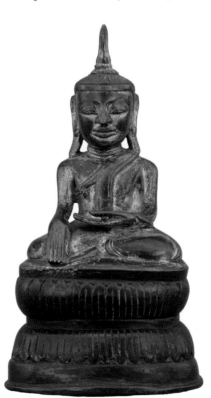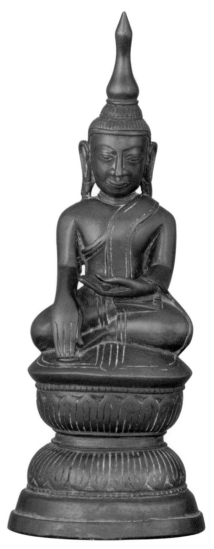

10.1 *left* and 10.2 *right* Seated Buddhas

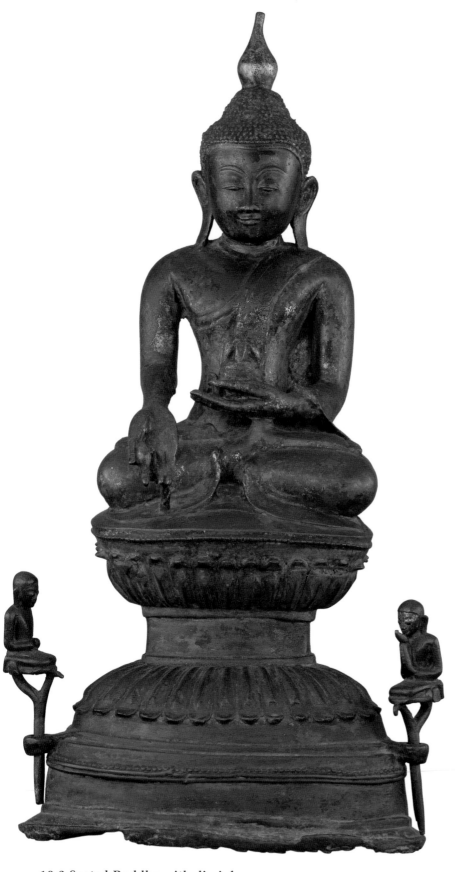

from the low, rounded *ushnisha*. The finial is bulbous at the base but rises to a lotus bud shape. The hair curls are not individually delineated, but are more generally indicated, and are separated from the Buddha's forehead by a thin band. The hefty ears are composed of two sections, the ear itself and the smaller lobe, the latter easily reaching the shoulder because of the short neck. The face appears as a wide oval, tapering very little from the broad, square forehead. The Buddha's almond-shaped eyes, delineated by double lines, are surmounted by gently curved eyebrows that reach to the bridge of the long, wide nose. As is typical of many seventeenth to nineteenth century Burmese Buddhas, this image has an enlarged upper lip and a mouth with a slight smile. Long fingers of the same length which curve outwards at the tips is another standard attribute of such Buddha images. The hand in the lap holds a rounded object, which probably functions as a strut supporting the thumb. In the Denison records, this Buddha is described as dating to the late seventeenth to early eighteenth centuries, but given its style, it is more likely to have been made during the eighteenth or early to mid nineteenth century.

10.3 Seated Buddha with disciples
Burma. Late eighteenth or early nineteenth century.
Bronze with gilding. H 62.2 cm.
P67.147.
Cast in bronze and then gilded, this Buddha dates to the late eighteenth or early nineteenth century. The image is seated on a high, waisted double lotus throne with a flat section on the back, possibly for an inscription or so

10.3 Seated Buddha with disciples

that the Buddha can be placed against a wall. Other characteristics typical of this period include the lotus-bud-shaped finial rising from a low, broad *ushnisha*, the narrow band separating the hair curls from the forehead, a rounded face, curving earlobes that touch the shoulders, and simple robes covering the Buddha's left shoulder. The broad shoulders are typical of Shan style images. Unlike many Buddha images from the period, this one is not in *bhumisparsha mudra*, but is seated holding a bowl in the left hand and a rounded object in the right. Two kneeling devotees flank the Buddha.

A Buddha image holding a covered alms bowl in the left hand and a myrobalan (a medicinal fruit) between the thumb and forefinger of the right, and which expresses the *varada mudra*, is a type that developed during the late eighteenth century, marking a trend toward new styles and iconographic forms. Although the Buddha as healer is an old and widespread concept, in Mahayana Buddhism the bowl and the fruit together indicate the healing Buddha, Bhaishajyaguru. During the period in which this Buddha image was created, Burma largely followed the Theravada tradition, but had adapted some aspects of Mahayana imagery into its artistic practices.[61] This image may reflect the incident in one version of the Buddha's life story when he received the medicinal myrobalan fruit from the god Indra (Sakka).[62] The bowl, when it contains medicinal waters, can also symbolize healing, and thus the two together suggest that such images represent Buddha Shakyamuni as the supreme healer.[63]

The giving gesture of the right hand suggests that the Buddha is offering healing, whether physical or spiritual, to the viewer.[64]

Buddha images flanked by two smaller figures in positions of obeisance have been in existence in Burma since at least the Pagan period.[65] In bronze, this has been a particularly popular motif since the sixteenth or seventeenth century. The figures of the devotees are cast separately, and their supports inserted into rings on the base of the throne or plinth. They hold lotuses, pennants, or are in the gesture of veneration (*anjali mudra*). While the two kneeling figures may be generalized devotees or disciples of the Buddha, they may also represent the Buddha's two chief disciples, Sariputta and Moggallana.[66] Sariputta attained the greatest wisdom (*panna*) of all the disciples, while Moggallana had the greatest power (*iddhi*). The images are therefore usually depicted with Sariputta on a higher support and seated on the Buddha's right side.[67] On the Denison piece, the supports are the same height, but one figure sits lower in the ring than the other. Most likely, they are devotees of the Buddha.

10.4 Seated Buddha on a seven elephant throne
Burma. Late eighteenth or nineteenth century.
Wood, lacquer, and gilding. H 57.8 cm.
DU 1973.23.
Representations of the Buddha seated on an elephant throne appeared around the sixteenth century and continued being produced into the nineteenth century.[68] The Denison collection contains three such images, one on a three, one on a five, and one on a seven elephant throne

(see Figure 1.3). All three are made of lacquered and gilded wood. The image shown here is seated on a seven elephant throne in *padmasana* and *bhumisparsha mudra*. The top of the throne has been decorated with swag-like elements, while the base has been scalloped. Supporting the upper part of the throne are seven elephants in high relief. Each animal wears a decorated head-dress and stands on its own base.

Stylistically, the Buddha image corresponds with other late eighteenth and nineteenth century images. It has a wide, relatively flat *ushnisha*, with a substantial finial rising in a cone shape. The head tapers down to a narrow

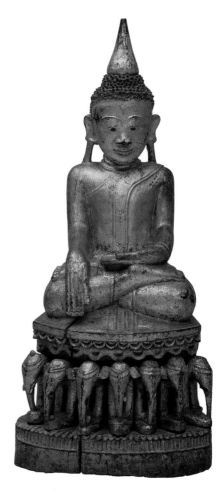

10.4 Seated Buddha on a seven elephant throne

chin, giving the face a triangular look. The eyebrows are arched over near-set eyes, which appear somewhat cross-eyed. Other facial characteristics include a broad nose and a slightly smiling mouth, as well as highly stylized and strut-like earlobes (see Catalogue no. 10.9). As is typical, the Buddha's neck has three lines, and his long fingers are all of the same length. The body of the Buddha is clothed in monk's robes, which cover the left shoulder. The robes themselves, delineated by a raised edge marked with carved double lines, cross the Buddha's chest, fall down the center of his body, drape over the ankles, and spill onto the throne in front of him.

Elephants are symbols of kingly power,[69] and many, though not all, Buddha images seated upon such thrones were crowned. This suggests that the Buddha was considered a universal monarch, a figure who was expected to own many elephants.[70] In one view, the Buddha seated upon an elephant represents him preaching to his mother and a divine assembly for several months in Tavatimsa Heaven. When he returned to earth, the Buddha descended a triple ladder accompanied by the gods Brahma and Indra (Sakka, defender of Buddhism), an action that is one of the eight great events of the Buddha's life. The rationale behind the idea that the Buddha seated on the elephants represents these events derives from the fact that the elephants may represent Sakka's three-headed elephant, Erawan.[71] Since Erawan is a single animal with three heads, it seems unlikely that this image, which has seven discrete elephants, depicts the

preaching event in Tavatimsa. The varying number of elephants—three, five, or seven—as part of such images suggests more generalized expressions of the Buddha's great spiritual power shown metaphorically through crowns, jewels, and elephants.

10.5 Seated Buddha
Burma. Late eighteenth or early nineteenth century.
Wood, glass inlays, lacquer, and gilding.
H 73.7 cm.
P67.284.

The Buddha image is seated in *bhumisparsha mudra* with his feet in the lotus position. Typical of images from the eighteenth and nineteenth centuries, the Buddha's feet are slab-like and his hands are large with a boneless quality. The excessive proportions of the hands and feet contrast with the short torso and gently rounded shoulders. The image is dressed simply

in monk's robes that are indicated by single line delineating the edge of the robe. The robes cover one shoulder and spill onto the throne in front of the Buddha's shins, where they are indicated by a double wavy line. The stylized double lotus throne is adorned with wavy lines of *thayo* (lacquer putty) decoration and glass inlays representing alternate lotus petals. The features of the Buddha's face and head are also typical of the period. The head bears a low *ushnisha* surmounted by a tapering finial. The spiky hair curls are separated from the Buddha's forehead by a thin, raised band. The line of the ears follows the contours of the oval face and short neck before curving out to rest lightly on the shoulders. Gently arching over downcast eyes, the eyebrows form the central line of the nose, which is not visually

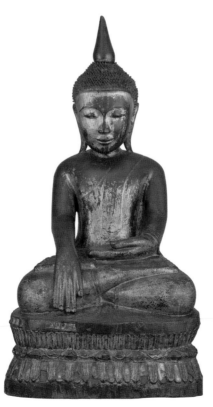

10.5 Seated Buddha

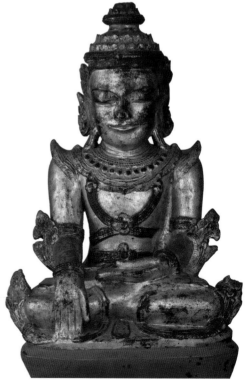

10.6 Crowned Buddha

Alexandra Green

dominant. There is a puffy area below the nose, which makes the upper lip prominent, but the lips, curving slightly upwards, are of similar size and shape.

10.6 Crowned Buddha
Burma. Nineteenth century.
Gilded lacquer. H 53 cm.
P67.153.

The Denison collection holds two Buddha images made in this style—the one shown here and P67.152, which is not illustrated. As is typical of Burmese Buddhas of the seventeenth to nineteenth century period, this crowned image is seated in *bhumisparsha mudra* with curving fingers of the same length. The plinth supporting the image is a crude waisted throne painted with red lacquer, but the Buddha has been carefully produced with extensive *thayo* (lacquer putty) embellishments that indicate royal status. The top of the head tapers above the crown, but swells out to form the *ushnisha*, the decoration of which is virtually identical with that of the crown. A narrow finial once emerged from the *ushnisha*, but is now lost. The Buddha's *ushnisha* and crown, particularly the band around the head and the two diminishing tiers of small, leaf-like elements, are similar to northern Thai pieces from the late eighteenth to nineteenth centuries.[72] Ornamentation adorning the body of the Buddha includes a thick collar with beading suggestive of jewels, a crossed band over the chest (the *salwe*, the Burmese royal insignia),[73] bracelets and armlets, a belt, and up-turned epaulettes and flanges at the shoulders, elbows, and knees, features also seen on Thai Buddha images. Underneath the adornments, monk's robes cover the

image's left shoulder and fall onto the throne in front of the legs.[74] The Buddha image appears somewhat squat, due to a disproportionately large head, short neck, and squared shoulders. The face is broad, tapering very slightly to the chin. The sharp eyebrows curve in a low arch over the downcast eyes and meet above the nose, which is thin except for the flaring nostrils. The mouth, with its elegantly delineated upper lip and softly rounded lower one, hints at a smile. The Buddha's pendulous earlobes curve before touching his shoulders.

10.7 Crowned Buddha
Burma. Late eighteenth or early nineteenth century.
Lacquered wood. H 89 cm.
DU 1967.114.

Once gilded over the exposed lacquer, the Buddha is seated in *bhumisparsha mudra* in the *padmasana* position upon a single lotus throne. The image has a high lotus-bud shaped finial surrounded by a pointed crown, similar to the Pala-Sena style, and extensive carved ribbons that fall to the shoulders. The ears are comparatively small and do not reach to the shoulders, even though they are adorned with large plug earrings. Other jewelry includes a collar of stylized lotus petals and a necklace with a central flower as a pendant in the middle of the chest. While this style is somewhat unusual, the general effect of the jewelry is similar to that from the Arakan, which became prevalent in central Burma as well. The Buddha's robes fall over the left shoulder, and the edges are visible around the wrists and ankles. The facial features are similar to those of images from

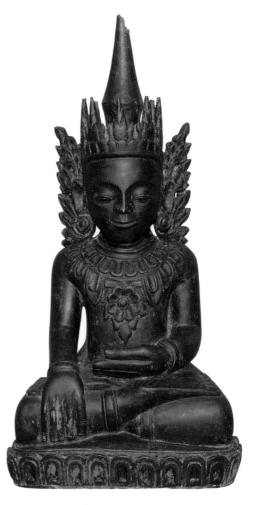

10.7 Crowned Buddha

the Shan States with a high forehead, arched eyebrows forming the central line of the nose, almond-shaped eyes with a double line indicating the eyelids, and a thin mouth with lips the same size and shape curving in a small smile. The area between the upper lip and the nose is puffy, as is commonly found on later images from Burma.

10.8 Crowned Buddha
Burma, probably Shan States. Late eighteenth or nineteenth century.
Wood, alabaster, lacquer, glass inlay, and gilding. H 73.7 cm.
Gift of Konrad and Sarah Bekker.
DU 1974.19.

Constructed of wood and alabaster, this Buddha is probably from the

Shan States, where the combination of differing materials was sometimes used to produce religious images.[75] The body, legs, arms, ribbons, and crown are all carved from wood, while the head, ears, hands, and feet are of white stone. The crowned Buddha is seated in *bhumisparsha mudra* with his feet in the lotus position. Details on the stone have been painted with red and black lacquer to accentuate the carving. The body, arms, and legs are slim and attenuated. The visually heavy crown and head have been decorated with *thayo* (lacquer putty), gilding, and inlaid glass mosaic. The three-stepped crown composed of vertical sections and surmounted by a finial is similar to those found on other Shan and Mon images (see Figure 10.10 and Catalogue no. 10.9), as well as Buddha images from Lan Na in Thailand.[76] As is common for wood images, the ribbons to the side of the Buddha's head and crown are solid, without the open-work elaboration possible on cast metal images. Typically, for seventeenth to nineteenth century Burmese Buddhas, the image's fingers are of the same length and the face displays a small smile. Distinctive Shan characteristics include narrow eyes and high highbrows, as well as a broad nose and thin lips.[77] These features are less exaggerated here than on other pieces from the Shan States, and it is possible that the sculptor was influenced by Chinese or Thai styles.[78] The Denison Museum also holds a second image, DU 1974.20, which is similar to the one illustrated here.

10.9 Crowned Buddha
Burma, Shan States. Eighteenth or nineteenth century.
Lacquered and gilded wood with glass inlays and thayo decoration. H 60 cm. DU 1967.50.
Crowned Buddha images were popular not only in the central dry zone of Burma, but could also be found in Arakan, the Mon area, and the Shan States. The image is an example from the latter area, according to the Denison Museum records, but stylistically it is somewhat unusual, particularly the crown. Seated on a plinth lightly decorated with a stylized lotus pattern and a section of cross-hatching, the Buddha displays the *bhumisparsha mudra*. The broadness and angularity of the shoulders contrasts with the slimness of the torso. The right hand has a distorted appearance, but the left one is typical of the period with elongated and curved fingers. The Buddha's robes fall over his left shoulder and also cascade from his lap down onto the plinth. Scrollwork and tassels indicating the ends of the fabric are carved in high relief. An elaborate *thayo* (lacquer putty) and glass-inlay collar, necklace, and bracelets lie over the robes. The Buddha also wears rings on the thumbs. The necklace and collar have been inlaid with glass mosaic in stylized floral patterns. On the knees are carved lotus flowers, common in the Mon area of southern Burma, which suggests the transfer of stylistic ideas between the two areas (see Figure 10.10). The crown is one of the most dramatic and eye-catching aspects of the Buddha. It is high, with a series of squared-off, ridged prongs beneath which there is elaborate decoration. These horizontal, patterned bands can be seen on other Buddha images from the same period. There was once a finial, now lost. The narrow, downcast eyes, broad nose, and slightly smiling, thin lips are typical of Shan images.[79] The face barely tapers down to a rounded chin, a feature found in more extreme forms during the seventeenth and eighteenth centuries, but which, by the early nineteenth century, was moderated, as seen here. The upper part of the face is exaggerated with an extremely high forehead, bridge of the nose, and eyebrows, giving the image a distorted appearance. The ears are composed of two discrete parts with bore holes for ear plugs, which are now lost. The stylized lobes have been transformed into struts, appearing

10.8 Crowned Buddha

to support the ears. The internal sections of the ears themselves are pointed, which is uncommon.

10.10 Reclining Buddha
Burma. Nineteenth century.
Bronze with glass or ruby inlays.
L 70.5 cm.
DU 1973.52.

Reclining Buddha images in Burma generally represent the *Parinirvana* of Gotama, the final extinction of the historical Buddha. Such images became increasingly popular in Burma during the mid to late nineteenth century. The Denison example is representative of the Mandalay style of Buddha image. It has a long, sinuous, and graceful form, which is emphasized by the left arm following the contours of the body. The right hand supports the head. The pooling of the robes in front of the torso and just above the knee is a standard feature of Mandalay reclining images, as is the embellishment of the robes. Here they have been decorated with red glass or ruby inlays. The image has a high, rounded *ushnisha*, but no finial. A wide band studded with red stones separates the small, tight hair curls from the forehead, which displays a prominent *urna*, symbol of wisdom, above the bridge of the nose. The flattened eyebrows curve to meet the central line of the nose, and the ears touch the shoulders.

The Denison Buddha also has some features that suggest that it may have been produced early in the development of the Mandalay style or was made in a periph-eral area and therefore subject to other influences. For example, the calmly meditative face is more oval and elongated than is traditional for such images,

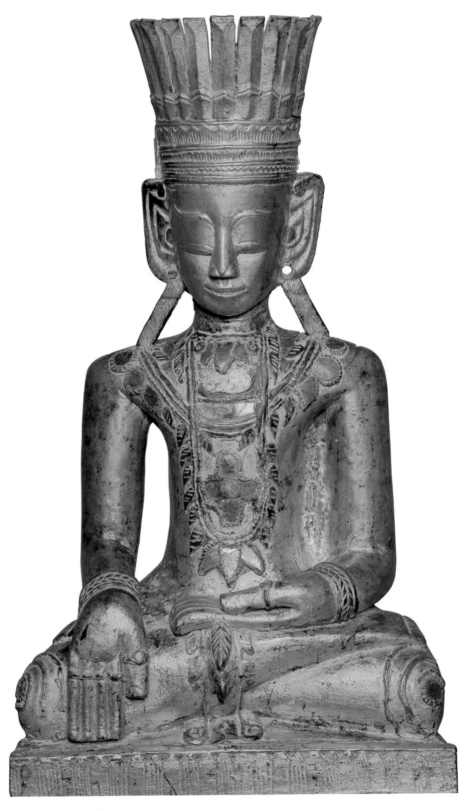

10.9 Crowned Buddha

Buddha Images Catalogue

211

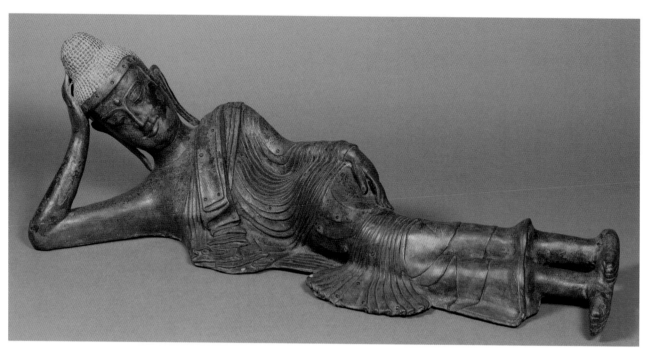

10.10 Reclining Buddha

and the heels protrude, which may reflect a link with northern Thai images.[80] The elongated and curving fingers also suggest a continuity with earlier styles.

Some painted reclining images portray the *Parinirvanas* of the previous Buddhas, or represent the Buddha reclining in a natural landscape surrounded by the five ascetics, who will become his first disciples, and listening to the god Indra (Sakka) playing the lute. The latter scene represents the god Indra (Sakka, protector of Buddhism) intervening in the Buddha-to-be's practice of extreme austerities by indicating the beneficial nature of the Middle Way. He first plucks a string on his lute that has been over-tightened and thus produces a shrill sound, and then strums an under-tightened one, which produces very little sound. When Indra plays a string that has been tuned correctly, neither too tight, nor too loose, the sound is perfect. Through this

demonstration the Buddha-to-be understands that starving himself will not lead to Enlightenment, and he resumes eating solid food. Thus, not all reclining Buddha images depict the final extinction, but may also represent other events. In sculpture, however, without the image of Indra or another indication that the Buddha is not the historical one, a reclining Buddha can generally be assumed to be a representation of Gotama Buddha's *Parinirvana*.

10.11 *(Left to right)*
Seated Buddha image.
Burma. Possibly eighteenth or nineteenth century. Bronze. H 8 cm.
Gift of Jane Terry Bailey. DU 1970.49.

Walking Buddha image.
Burma. Possibly eighteenth or nineteenth century. Bronze. H 12 cm.
Gift of Zelma Graham. DU 1976.46.

Seated Buddha image.
Burma. Possibly eighteenth or nineteenth century. Bronze. H 12 cm.
Gift of Zelma Graham. DU 1976.45.

Denison University holds examples of bronzes representing the twenty-eight previous Buddhas and scenes from the life of Gotama Buddha. Usually roughly produced with limited details, such images would have been buried in relic chambers.[81]

The three pieces illustrated here include two produced in the style of narrative bronzes that traditionally portray both pre- and post-Enlightenment events. Such narrative images are set upon open-work bases, a design which possibly originated in India. Given the small size of the sculptures, these examples could have been transported between regions by pilgrims or merchants.

The central standing figure with pendent arms represents one of the Seven Stations that the Buddha occupied during the seven weeks after his Enlightenment. Of the seven, there are two possibilities—the second week during which time Gotama stood

the neck, and position of the hands differ, and their facial structures also vary, with the monk on the left having a slimmer face and more highly arched eyebrows and eyes than the other. On both images, the eyebrows travel down to meet the bridge of the nose and the thick lips curve up slightly at the edges. The monks' ears protrude from their shaven, squarish heads, but do not touch the shoulders.

10.19 Dekkhina-thaka Buddha
Burma. Twentieth century.
Wood and lacquer. H 46.3 cm.
Gift of Captain Ralph McCoy.
DU 1969.227.

The Denison collection has one example of a Dekkhina-thaka image, a peculiar type of Buddha found in Burma. Such images retain characteristics of a traditional Buddha statue, but have additional features that establish their separate identity, as well as marking them out for a different function in Burmese Buddhist practice. The stylistic similarities with canonical Buddha images include a double lotus throne, the hands in *bhumisparsha mudra*, and the feet in the lotus position (*padmasana*).[97] The Buddha's robes here are decorated with beading and running floral motifs along the edges. This particular image is crudely carved, with chisel marks clearly in evidence.

Dekkhina-thaka images are immediately identifiable by the inverted lotus leaves draped over their heads, under which the *ushnisha* remains prominent. According to a Burmese legend of the Buddha's sojourn near Muchalinda Naga's lake, he was shielded from the sun by lotus leaves placed on his head, at which time he drew his head down between his shoulders. That there are no necks on Dekhina-thaka images reflects this action.[98] Usually there are nine lotus leaves on the image's head, but the Denison figure has fourteen.

Further connecting these images with water is the design of a lotus pond on the underside of the throne, a feature that is thought to date to the eighteenth century.[99] Not all images display the lotus pool design, and the patterns vary considerably. On the base of the Denison example the pond is represented by lotus plants, a fish, and a conch, all of which were found in the lake by which the Buddha meditated. Canonically, they symbolize mental purity, escape from suffering, and the universal nature of Buddha's teachings, but the fish also represents the 5,000 years of this Buddhist cycle; the lotus, serenity; and the conch shell belongs to the god Indra (Sakka), and hence is protective.[100] Due to the association of the Dekkhina-thaka with water and the fact that a *naga* is occasionally part of the pond scene, it has been suggested that these Buddhas are reminiscent of the event in the historical Buddha's life when he was sheltered by Muchalinda Naga during a rainstorm.[101]

Further identification of a Dekkhina-thaka image derives from nine dots on the body—one on the forehead and one on each shoulder, wrist, knee, and hip— where gold or silver nails have been inserted. The gold or silver forming the nails was once material engraved with sacred Buddhist verses or with magic squares (called *in:*), which augment the protective function of the image.[102] Occasionally, these points are omitted, as is the case with the Denison example.[103]

Dekkina-thaka images are not found in temples, but are placed on altars in people's homes, where they are believed to bring wealth and to provide protection from fire.[104] They are considered to function protectively by virtue of their association with the historical Buddha and Buddhist or supernatural concepts. Traditionally, they are made from the wood of the Bodhi tree under which Gotama Buddha reached enlightenment, but since such material is difficult to obtain, other types of symbolic woods have been substituted and slivers of the sacred tree are inserted into the image. Further associating the image with protection and Burmese astrological beliefs, the substitute tree is selected based on the day of the week on which the person commissioning the piece was born.[105] Unfortunately, information about the production of the Denison image is not available.

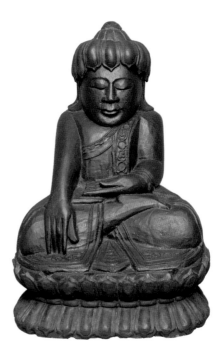

10.19 Dekkhina-thaka Buddha

NOTES

1. See Chapter 1 for a more extensive discussion of the formation of the Denison collection of Burmese art.

2. Political changes during the fourteenth to early seventeenth centuries and the periodic relocation of the capital during this time may have adversely affected the production of art in general.

3. Intermuseum Conservation Association records, 36/74.

4. Mid-West Conservation studio, conservation report, 2003. Held at the Denison Museum.

5. Letter from Jane Terry Bailey to Robert Brown, August 1, 1981, Denison University archives.

6. Pratapaditya Pal, ed., *Light of Asia: Buddha Sakyamuni in Asian Art*. Los Angeles: Los Angeles County Museum of Art, 1984, pp. 214–15.

7. *Archaeological Survey of India, Annual Report*, 1927–1928, pl. 54b. G.H. Luce, *Phases of Pre-Pagan Burma*. Oxford: Oxford University Press, 1985, vol. 2, pls. 30c, 30d, 31a (metal objects), 43d, and 44c (stone objects).

8. Pratapaditya Pal, *Asian Art at the Norton Simon Museum*, vol. 3. New Haven, CT: Yale University Press, 2004, pl. 33. Robert Brown in *Light of Asia*, pl. 100. Piriya Krairiksh, *Art in Peninsular Thailand Prior to the Fourteenth Century A.D.* Bangkok: Fine Arts Department, 1980, pls. 17, 19, and 54. Martin Lerner, *The Flame and the Lotus: Indian and Southeast Asian Art from the Kronos Collections*. New York: The Metropolitan Museum of Art, 1984, pls. 33 and 34. David L. Snellgrove, ed., *The Image of the Buddha*. Tokyo: Kodansha International, 1978, pl. 117.

9. Brown in *Light of Asia*, pls. 80, 89, and 101.

10. Ibid., pl. 99 and p. 215.

11. For further details of the Pala-Sena style, see Janice Leoshko, *The Iconography of Buddhist Sculptures of the Pala and Sena Periods from Bodhgaya*. Ph.D. dissertation, The Ohio State University, Columbus, Ohio, 1987.

12. Jackie Menzies, ed., *Buddha: Radiant Awakening*. Sydney: Art Gallery of New South Wales, 2001, pl. 43. G.H. Luce, *Old Burma Early Pagan*. Locust Valley, New York: J.J. Augustin Publisher, 1969, vol. 3, pl. 202b (Nagayon temple). This image has its robes swinging to the side indicating that it is walking.

13. Charlotte Galloway, "An Introduction to the Buddha Images of Burma." *Taasa Review*, vol. 10, no. 2, June 2001, p. 9.

14. Personal communication, Charlotte Galloway, May 2006.

15. Brown in *Light of Asia*, pl. 106.

16. See, for example, Luce, 1969, pls. 290d, 295a, 295b, 296a, and 314b.

17. Robert Brown, "God on Earth: the Walking Buddha in the Art of South and Southeast Asia." *Artibus Asiae*, vol. 50, 1990, fig. 13.

18. Luce, 1969, pl. 294d.

19. Denison Museum card catalogue.

20. Sylvia Fraser-Lu, "Buddha Images from Burma: Bronze and Related Metals, part 2." *Arts of Asia*, vol. 11, no. 2, 1981, p. 66.

21. See Jane Terry Bailey, "Addendum: Some Seventeenth Century Images from Burma with an Appendix by F.K.

Lehman: the Inscription." *Artibus Asiae*, vol. 48, 1/2, 1987, pp. 79–88. *Bulletin of the Burma Studies Group*, no. 56, December 1995, pp. 4–8.

22. T. Richard Blurton, "Burmese bronze sculpture in the British Museum." *Burma: Art and Archaeology*. Alexandra Green and T. Richard Blurton, eds. London: British Museum Press, 2002, p. 61.

23. Bailey, 1987, p. 88.

24. Luce, 1985, pl. 73c. Catherine Raymond, "Wathundayé divinité de la Terre en Birmanie et en Arakan." *Études birmanes en hommage à Denise Bernot*. Pierre Pichard and François Robinne, eds. Paris: École française d'Extrême-Orient, 1998, pl. F.

25. Raymond, 1998, pl. B.

26. Ibid., pl. H.

27. Pamela Gutman, *Burma's Lost Kingdoms*. Bangkok: White Orchid Press, 2001, pl. 173. Otto Karow, *Burmese Buddhist Sculpture: The Johan Moger Collection*. Bangkok: White Lotus, 1991, pls. 106 and 112.

28. *Burmese Art Newsletter*, vol. 9, no. 1, September 1977. *Burmese Art Newsletter*, vol. 10, no. 1, November 1978.

29. Aye Myint, *Burmese Design through Drawings*. Bangkok: Silpakorn University, 1993, p. 145.

30. In murals there are many examples of the Buddha being shielded by the *naga* king. Such images are a part of illustrations of the Seven Stations.

31. For example, the *bodhisattva* is a *naga* in the Bhuridatta Jataka (no. 543), and *nagas* listen to the preaching of the *bodhisattva*, Vidhura, in the Vidhurapandita Jataka (no. 545). Sarah Bekker, *The Naga: Many Faces, Many Forms*, unpublished manuscript, 1979, p. 3.

32. Ibid., p. 7.

33. Melford E. Spiro, *Buddhism and Society: A Great Tradition and its Burmese Vicissitudes*. Berkeley: University of California Press, 1982, pp. 260–61.

34. Charlotte Galloway, "Relationships between Buddhist texts and images of the Enlightenment during the early Pagan period." *Burma: Art and Archaeology*. Alexandra Green and T. Richard Blurton, eds. London: The British Museum Press, 2002, p. 51.

35. Blurton, 2002, p. 58.

36. See Karow (1991) and Blurton (2002) for examples of similar images. Janice Leoshko, Peter Brooke, and Barbara Creed, "The Jambupati Image—Some Examples from the Denison Collection." *Burmese Art Newsletter*, vol. 14, no. 3, May 1983.

37. Sylvia Fraser-Lu, "Ancient Arakan." *Arts of Asia*, vol. 17, March/April 1987, top right image on page 99. See also, San Tha Aung, *The Buddhist Art of Ancient Arakan*. Rangoon: Ministry of Education, n.d., pls. 33 and 34.

38. Blurton, 2002, p. 57.

39. Dorothy H. Fickle, "Crowned Buddha Images in Southeast Asia." *Art and Archaeology in Thailand*. Bangkok: Fine Arts Department, 1974, p. 100.

40. Ibid., p. 88 and 115.

41. Ibid., p. 93. U Mya, "The Origin of the Jambupati Statue." Summary by Dr. Gyi held in the Denison University archives, p. 7.

42. Than Tun, "Lacquer images of the Buddha." *Shiroku*, no. 13, November 1980, p. 28.

Management

Management

Principles and Practices

Second Edition

DAVID H. HOLT
James Madison University

Prentice Hall, Englewood Cliffs, New Jersey 07632

Library of Congress Cataloging-in-Publication Data

Holt, David H.
 Management, principles and practices / David H. Holt.—2nd ed.
 p. cm.
 Includes bibliographical references.
 ISBN 0-13-555822-0
 1. Management. 2. Industrial management. I. Title.
HD31.H6225 1990
658.4—dc20 89-25556
 CIP

Editorial/production supervision: Eleanor Perz
Cover design and interior design: Christine Gehring-Wolf
Cover art: Christine Gehring-Wolf
Photo research: Christine Pullo and Teri Stratford
Manufacturing buyer: Peter Havens

© 1990, 1987 by Prentice-Hall, Inc.
A Division of Simon & Schuster
Englewood Cliffs, New Jersey 07632

Printed in the United States of America
10 9 8 7 6 5 4 3 2 1

ISBN 0-13-555822-0

Prentice-Hall International (UK) Limited, *London*
Prentice-Hall of Australia Pty. Limited, *Sydney*
Prentice-Hall Canada Inc., *Toronto*
Prentice-Hall Hispanoamericana, S.A., *Mexico*
Prentice-Hall of India Private Limited, *New Delhi*
Prentice-Hall of Japan, Inc., *Tokyo*
Prentice-Hall of Southeast Asia Pte. Ltd., *Singapore*
Editora Prentice-Hall do Brasil, Ltda., *Rio de Janeiro*

Brief Contents

Contents

Part Three Organizing

Part Four Leadership: Managing Human Resources

Part Five Controlling: Managing for Results

Part Six On the Threshold of Management

Preface

As a result of global changes, managers are rapidly adjusting to a *global mentality,* recognizing that changes in Europe will realign our major trading partners in 1992, changes in China will create new opportunities and competitors in the Pacific Rim, and changes in the Soviet Union may lead to an era of economic cooperation with Eastern bloc countries. We are beyond the age of insular nations vying for a few select export markets, and a major objective of this text is to alert students to global affairs. Western industries must improve productivity to remain competitive, and managers must be prepared to do business globally.

Having spent several years in Europe and Japan, I am sensitive to America's tremendous national resource of innovative managers. We have an extraordinary technological basis and the educated professionals capable of meeting any challenge. I am also sensitive, however, to our impertinence as a nation caught resting on our past success as other nations outpace us.

I was recently "escorted" out of the People's Republic of China, only a few days after student demonstrators had been shot in Tiananmen Square. Arriving in Hong Kong, I took a quiet evening cruise on Victoria Harbor, sailing past tall buildings with glaring neon signs that sent brilliant multicolored reflections across the harbor water. I was chatting with a Chinese colleague from Hong Kong about international competition, and both of us were speculating on economic changes in China, Hong Kong, and the United States. He pointed to the commercial district of Hong Kong and asked me to pick out an American sign. I scanned the harbor lights, finding Panasonic, Honda, Nissan, Fuji Film, Cannon, and several dozen more signs for Japanese companies, but not one name of a United States business appeared in lights. Then he asked rhetorically why in Hong Kong he had to make a special request for an American beer or search catalogs for United States products. Why, too, he wondered, were the leading Japanese department stores in Hong Kong, yet American merchandisers were conspicuously absent?

The only logical answer seemed to be that Americans were not in Hong Kong because we chose not to be there. Certainly we have the capability to expand into any market almost anywhere in the world, but we have a rather low profile in comparison to the Japanese and other nations aggressive in business. I also visited a half dozen other Pacific Rim countries in 1989, and my senses were aroused to watch for American products. When I saw two Cadillac limousines outside a large building in Bangkok, I beamed with pride: Hey! We're here! But then I realized that the Cadillacs belonged to the United States embassy, and they were the last American cars I saw.

When I returned to the United States to continue work on this edition, I wanted to stress even more the important trends in global business management. In addition to the international management chapter (Chapter 20), examples drawn from international business enrich discussion throughout the text. Each chapter features a *Global Trends* box, which takes a closer look at world-wide businesses. The text highlights companies in Japan, Korea, Finland, the United Kingdom, France, West Germany, Canada, Mexico, Hong Kong, the People's Republic of China, Malaysia, Singapore, Sweden, India, Ireland, and the Middle East. Commentary on United States firms operating overseas has been integrated into discussion throughout the text.

I have not lost sight of America's strengths. In the first edition, I suggested that with Theory X, Theory Y, and Theory Z, we need a *Theory A* to capture the spirit and creativity of American enterprise. Theory A would encompass our pervasive spirit of individualism, our ability to adapt and to take entrepreneurial

risks, and our resolution to foster democratic institutions. I am now more convinced than before that there is a basis for Theory A. When Theory A is written, it will have as a foundation the American resurgence of productivity management and the renaissance of free enterprise. We have the innovative technology, inventive minds, the exceptional scientific foundations, and the aggressive entrepreneurial spirit to continue to lead the industrial world into the twenty-first century. Readers will find that this edition addresses the issues of innovation throughout the text and its ancillary material. We focus on entrepreneurship in a special chapter (Chapter 21).

With our ability to adapt to change, the United States should enter the coming age of information technology as a global competitor. Although we hear much about our shift from an industrial-based to a service-oriented economy, it may be more accurate to say that our manufacturing sector is adapting to information sciences, away from consumer goods and commodity products that are more efficiently produced elsewhere. The text addresses these changes in chapters on planning, organizing, decision making, and leading. We also look at how future managers will be challenged in a high-tech information age, including in this edition *a new chapter (Chapter 18) on Information Systems Management*.

Along with global competition, productivity is an important theme for managers as they look to the future of the United States. During the closing years of the 1980s, managers have not only embraced productivity but have predicated future strategies on productivity enhancements. This second edition is guided by the importance of productivity today and what its increasing importance will be as the 1990s unfold. This edition emphasizes the role that productivity plays today and the role that it will play in the 1990s.

CHANGES IN THE SECOND EDITION

As mentioned above, I have included in this edition a new chapter on Information Systems Management. Another new chapter on *Social Responsibility and Ethics in Management (Chapter 3)* provides an important foundation for studying management. Many of the changes in the second edition arose from my effort to create a truly student-oriented text. The many new features will promote students' interest and keep their attention. Examples, cases, and skill practice exercises reinforce learning by showing students how the material they are studying is put into actual practice in the real world of management.

Cases. The second edition has over 45 more cases than the previous edition. Each chapter begins with a case drawn from the world of management to introduce the chapter's central theme. At the end of the chapter, a return to the case reinforces the chapter's relevance. The cases, listed below, look at management as practiced in well-known organizations or by well-known individuals.

- Shearson Lehman Hutton
- General Motors Corporation
- The Sherman Antitrust Act
- Walt Disney/GE Storyboarding
- Hyundai Excel
- Brunswick Corporation
- PepsiCo
- AT&T
- Liz Claiborne
- Scott Paper Company
- Young American's Bank of Denver

- Pinehurst Hotel and Country Club
- Delta Airlines
- George Steinbrenner
- Ted Koppel
- Metalloy Corporation
- Control Data Corporation
- Staples—The Office Superstore
- General Motors' Bay City Program
- ATT's Joint Ventures
- Worlds of Wonder

At the end of each chapter are two *Skill Analysis cases* with which students can analyze management skills in practice. As the following list shows, the range of cases in the chapter-ending selection is quite broad. The cases, based on both large and small organizations, are drawn from private service, the manufacturing sector, and the public sector. These cases are all real.

- Characteristics of Top Managers in U.S. Firms
- What It Takes to Be Number One: Lessons from Wal-Mart's Sam Walton
- Adapting Theory Z: Can It Be Done?
- Nissan Sets Up Shop in Tennessee
- Environmental Concerns at Rencor Engineering
- Social Responsibility of Business: The Exxon Valdez Fiasco
- The NASA Space Shuttle Disaster
- Changing the Shuttle Launch Decision Process
- Dynascan's Hot Phones
- James J. Hill and the Great Northern Railway
- Exxon's $2 Billion Strategic Fiasco
- Lincoln Memorial Hospital
- Computers in Education Gather Dust
- Cow-Milking Technology Attracts Genetic Engineers
- Organizational Response to High-Tech Changes: Monsanto Corporation
- Crisis at Wrangler Corral Western Wear
- Matrix Assignmennts Prompt Career Changes for Aerospace Engineers
- From Taller to Flatter Structures
- Signetics Revamps Culture to Enhance Quality
- L. L. Bean, Inc.
- Job Redesign Goes Haywire at Flextone
- Teamwork at General Motors: Progress and Problems
- Staffing—Selecting Employees the Japanese Way
- Nine-to-Five
- Individual Motives—Corporate Women on Their Way to the Top
- The Turnaround at Remington Products
- "Who's on First" at Ranstar Corporation?
- Dogfight at Texas Air: Leadership the Lorenzo Way
- Confusion at Heritage Furniture
- The Need to Listen
- Broadcast News

- Andrew Carnegie—"Watch the Costs and the Profits Will Take Care of Themselves"
- Controls in Computer Manufacturing Plague Managers
- First Chicago Corp. Explores MBO For Bank Quality Control
- U.S. Treasury's Newly Minted Executive Information System
- Blake Realty—Leveraging Information
- Managing Stress and Conflict—A Study in Role Conflict and Crisis
- Kirk-Stieff Company—Changing with the Times
- Multinational Enterprises Find New Markets in China
- Going International Is as Close as Mexico
- ACE Students Go for Broke
- Hold That Tiger! Hold That Tucker!

Also new to this edition are the ***Integrative Part Cases***, which ask students to pull information from several chapters in analyzing a case. Longer than the skill analysis cases, the following cases broaden the instructor's options for classroom discussion and outside assignments. As with the chapter opening/closing cases, these are based on companies the students will easily recognize:

- Bhopal: The Worst Industrial Accident in History
- Xerox Redefines Its Purpose: New Plans for the 1990s
- Tucker: The Car of the Future Today
- Post-mortem on Leadership at Redgate Communications
- Becoming a Just-in-Time Vendor
- Multinational Start-ups

Global trends. These boxed features enrich each chapter's commentary by offering students a closer look at the nature of international management. They focus on both U.S. companies abroad and foreign companies engaged in global business operations. These boxes are identified with a ***globe icon*** as a way of visually reinforcing the significance of this coverage. Here's a complete list of the ***Global Trends*** boxes:

- Texas Instruments—A Global Team
- Hong Kong 1997—New Management Challenges
- Supporting a Global Policy for Industrial Strength
- Decision Making at Denmark's PRIVATbanken
- Offshore Manufacturing—Planned Globalization
- Watch Out Europe (America), the Americans (Europeans) Are Coming!
- Equal Partners: GE's Factory Automation Joint Venture with FANUC of Japan
- Mitchell Cotts Chemicals
- Management of Korean Chaebols
- A Japanese View of Global Acculturation
- Current State of Japanese Management Overseas
- Quality Training at Caterpillar Corporation
- Employees Are Cautious about Incentive Plans at Du Pont
- Local Leadership Is the Key to Global Success at Analog Devices, Inc.
- Going Beyond Berlitz
- Exxon: How to Prevent Another Valdez Disaster

- IMPACT (Integrated Materials-handling Production And Control Technology)
- IBM: Positioned for Global Competition in the 1990s
- Du Pont Transforms an International Division
- Managers in the Year 2000 Will Need Global Experience
- Mexican Entrepreneur Seeks to Solve Food Problem

Management applications. Each chapter presents a *Management Application* box, which supplements chapter discussions and enhances student understanding of how management concepts are practiced in modern organizations.

- Innovation: Taking Chances at Johnson & Johnson
- United Parcel Service
- Success Is Color-Blind—Barry Rand of Xerox
- Women in Business Make Decisions Differently than Men
- Stew Leonard—The Great American Milkman
- Marriott: Delegate and Hold Accountable for Results
- Spokes Bicycles: College Grad Applies Textbook for Success
- Forever Young: Ben & Jerry's
- An Office Is Where You Access Information
- Herman Miller's Secrets of Corporate Creativity
- Home Offices Transcend Space and Time
- An Innovative Approach to Medical Benefits—Allied Signal
- Brett Kingstone—Reaching Out to Motivate Others
- Leadership Commitment at Westinghouse
- Making Informal Communication a Positive Force
- Management Control at Garvey Industries
- Quality Performance Means Productivity at R. R. Donnelley
- Electronic Shopping Changes Perspectives on Packaging
- Group Lotus Car Companies
- Mitsubishi Diversifies
- I Can't Believe It's Yogurt!

Photograph and art programs. Approximately 130 full-color photographs appear in this edition. Each photo has been carefully selected to emphasize an example and to attract student attention to important concepts. Captions not only tie the photos to the text but are rich in content themselves. The text also presents more than 170 drawings, diagrams, and exhibits. Colorful and entertaining, each piece clarifies and reinforces crucial management issues.

Margin glossary. Each key term and its definition are positioned in the margin next to where the text introduces the term. The margin placement of key terms allows students to review the vocabulary of management quickly. Also, students have immediate access to the fuller discussion of the term that the text presents when they need more information.

Checkpoint. At the end of each major division within a chapter, a *Checkpoint* section poses review questions. Between twenty and thirty Checkpoint questions are positioned throughout the chapter to prompt instant review and to reinforce learning immediately. The Checkpoint questions are identified by a *checkmark icon*.

In-text real-world examples. In addition to the Management Application features and the Global Trends features, the text narrative itself offers a wealth of examples from the business world to illustrate and reinforce concepts. Examples are drawn from well-known companies and their management; from industrial, service, and manufacturing firms; and from entrepreneurial ventures and not-for-profit enterprises. In most instances, these examples are contemporary illustrations that use the most recent information available—the information available just prior to printing. Up-to-date examples of important incidents in organizations alert students to management problems. The text discusses the Exxon Valdez oil spill, the crisis at Eastern Airlines, and the buyout of RJR Nabisco. Successful managers provide students with useful insights. This edition looks at corporate leaders Lee Iacocca, Sam Walton, and Ross Perot and entrepreneurs Steven Jobs, Liz Claiborne, and Victor Kiam. Students benefit from the study of such well-managed organizations as Merck & Co., IBM, Hewlett-Packard, 3M, Wal-Mart, Xerox, General Electric, and Marriott Corporation. These are a few of the hundreds of companies and personalities woven into the text.

Synopsis for learning. Learning objectives open each chapter, outlining for students what they should learn from the chapter. The *Synopsis for Learning* chapter summary is organized around the learning objectives, focusing student attention on the chapter's central issues and working as a valuable student review tool.

Skill practice. Because learning how to put knowledge into practice has become so important, one of the following experiential exercises now concludes each chapter. These exercises, identified by a hand icon for "hands-on learning," give students the opportunity to practice and apply management principles covered in the text. (The *Instructor's Guide* provides thorough Teaching Notes for the *Skill Practice* exercises.)

- Exercise in Self Perception
- Creating a Psychological Contract
- Work Values
- Reaching Beyond Today for Tomorrow's Solutions
- Career Planning: Strengths and Weaknesses
- Leadership Styles in a Changing Environment
- Developing a Time Plan
- Building a Better Castle
- The Restless Engineer
- Merck & Co. Negotiates a Joint Venture
- Recall of Work "Ups" and "Downs"
- OSHA Training Guidelines: Developing Learning Activities
- Women as Managers: The Women As Managers Scale (WAMS)
- Pizza Division Problem
- Effective Communication
- Control: Correcting Performance
- The Quality Circle Meeting
- Too Many Pages
- Stress: Down or Up?
- A Role Exercise in a LDC Enterprise
- Mindscaping: An Exercise in Innovative Thought

THE DEVELOPMENT PROCESS

This text is the result of three years of intense development. To help me with this edition, Prentice Hall assembled a team made up of market researchers, marketing managers, an acquisitions editor, photo researchers, designers, production editors, and development editors.

We actually took the first step of this second edition when we were developing the first edition and gathering feedback from potential users in the spring of 1987. Their input entered a market research questionnaire that Prentice Hall annually revises and mails to more than 1,600 management professors. Through the results of this survey, the publisher and I garnered information on content, pedagogy, and supplements in the principles of management market. To expand on this data base, in the spring of 1988 Prentice Hall had fifteen users of the first edition provide feedback and revision suggestions. Using this wealth of information, the publisher and I formed a plan for the second edition's content, design, and package.

Each chapter of the first draft of the second edition received between four and seven reviews from principles of management professors. As I created the second draft, development editors worked with me word by word to ensure that I was presenting the principles of management to the student in the clearest possible way. Prentice Hall then had each second draft reviewed by a combination of expert reviewers in each functional area of management and principles of management instructors. Their fine-tuning led to a third and final draft that was technically accurate and pedagogically sound.

Development editors continued to work with me as I researched photos and wrote captions for them. This effort has resulted in a photo program that is fully coordinated with the text and that serves as an important part of the entire learning package.

I believe that the long process of development and the many resources that the publisher made available to me have led to an edition that is the most student-oriented principles of management text available.

THE SUPPLEMENTS PACKAGE

The supplements package is designed to enhance teaching and learning. Because teaching methodologies vary widely, Prentice Hall has provided a broad range of supplements, planned and coordinated so that each instructor may easily decide which ones are appropriate for his or her use. Considerable attention has been paid to the quality of all the supplements in their design, content, and text compatibility.

A description of each of the student supplements in the package follows. A list of instructor supplements is also provided. For complete information on instructor supplements, please consult the preface to the *Annotated Instructor's Edition* and the *Supplements Guide*.

STUDENT SUPPLEMENTS

Student Guide for Note-taking, Review, and Skills Practice. This innovative study guide provides (1) space for students to take notes in class, (2) review/study material, and (3) skills practice exercises. This organization gives students a single resource for reviewing class lecture material, studying text concepts, and putting knowledge to use in skills practice.

Management, Second Edition—ACUMEN Special Edition. Students can get *ACUMEN: Educational Version,* a managerial assessment and development tool, shrinkwrapped to the text at a special price. Designed for use on the IBM-

PC, ACUMEN has students respond to 120 statements and then provides a personalized profile comparing individuals to a composite group of managers. A 15- to 20-page report, which can be printed or read on screen, describes student managerial strengths and weaknesses and provides suggestions for improving skills.

Computerized Cases. Ten of the cases in the text have accompanying Lotus-based spreadsheet exercises for those problems and activities for which spreadsheets are most commonly used. A site license to copy the disk of exercises and an instructor's manual is available free upon adoption of *Management*, Second Edition.

Micromanaging. One copy of this book by George T. Geis and Robert L. Kuhn and a site license to copy the accompanying Lotus-based software are available free upon adoption of *Management*, Second Edition. The exercises cover general topics like time management rather than cases in the text.

Hypercard Simulations for Management. For those schools using Macintosh computers, we provide a site license to copy this multimedia simulation called Desktop Order. The simulation takes full advantage of Hypercard software, which comes automatically installed on Macintosh computers.

Modern Business Decisions. This microcomputer simulation by Richard V. Cotter and David J. Fritzsche has students form teams representing companies competing with each other. The player's manual is a for-sale item; the instructor's manual, instructor's disk, and site license to copy the student disk are available free.

Managing an Organization: A Workbook Simulation. Gary Oddou has developed this noncomputerized simulation that reinforces the practice of the functions of management. The player's manual is a for-sale item, and the instructor's manual is free.

Management Applications: Exercises, Cases, and Readings. This for-sale supplement provides an exercise, a case, and a reading for each chapter in a typical management text. Application activities allow students to learn more about a concept, analyze its use in a case, and practice it through an exercise.

Readings in Management. By Philip DuBose, this for-sale reader presents alternate viewpoints on topics discussed in the text, thereby increasing student critical-thinking abilities.

Special Topic Supplements. Available free in quantity upon adoption of the text, this supplement covers topics touched on in the text that some professors may want to cover in more depth. The topics are:

- A Closer Look at Systems Concepts
- Japanese Management: What We Can Learn
- Management by Objectives
- Forecasting in Management
- Legal Forms of Organization
- Divergent Views of Work Design
- Perspective on Labor Relations
- Getting Things Done: How to Make a Team Work
- Cost-Volume-Profit Analysis (Break-Even Analysis)

that have far-reaching implications for managing human resources. Innovation is the key to this transformation, for it is innovation that enhances quality and productivity.

To begin our study, we need to develop management concepts. We begin this chapter, therefore, with definitions of management and organizations, and then go on to discuss several aspects of managerial careers for those who will lead the nation into the twenty-first century.

DEFINING MANAGEMENT

Management can be defined as getting things done through others. This is a simple definition, but attempts by theorists to improve on it have been unsuccessful. Management, therefore, is a *process* with various *styles* of getting things done through other people. *Style* refers to how individuals choose to work within the management process. Unlike many other disciplines, a degree in management does not lead to a particular profession. A graduate in mechanical engineering, for example, can expect to pursue an engineering career, but a graduate in management will not seek employment as a "manager." A degree in management means you have learned the fundamentals and concepts of getting things done within organizations. We begin the study of management, then, with the concept of *organizations* and how organizations influence our lives.

management
The process of planning, organizing, leading, and controlling that encompasses human, material, and financial resources in an organizational environment.

CHECKPOINT

■ Define management and what it means to manage others in an organization.

■ Discuss the process of management and what it means to "be a manager."

ORGANIZATIONS

Organizations exist when two or more people mutually cooperate to pursue common objectives. An organization, therefore, is more than a gathering of individuals; shoppers in a busy supermarket do not constitute an organization, nor do crowds of people at a ball game. An organization consists of people working together to achieve common objectives, and while we often pursue interests independently as shoppers or sporting fans, we are also members of a great many organizations. We work jointly with others in our families, we are part of a collective student body in school, and we are members of teams, clubs, and religious groups. Some of us are involved in many organizations. Others have fewer formal organization ties, but even informal associations with friends are types of organizations. In both formal and informal organizations, membership is characterized by *mutual cooperation* in the pursuit of *common objectives*. When a group of friends get together for a party, common objectives surface. These may be simple, such as having fun or relieving stress, but the party does not "simply happen." Its organizers assign tasks, such as buying food and arranging for entertainment, and the party is successful when these tasks are well organized and effectively accomplished.

Organizations allow us to overcome individual limitations. Through combinations of human effort and resources, we achieve far more than we could acting independently. For example, one bricklayer working alone to build a wall has to mix mortar, carry bricks to the wall, and then lay the bricks. He does his work task by task, often with a lot of wasted motion between tasks—climbing up and down ladders and so on. Three persons, each separately assigned to mix mortar,

organization
The structure of relationships that exists when two or more people mutually cooperate to pursue common objectives.

carry bricks, and build the wall, can outperform three individual bricklayers doing all three tasks themselves. Similarly, ten students preparing for a party can coordinate their activities to accomplish more with less total effort than the same students could acting independently. This is called *synergism*. Synergy means that the results of combined efforts will be greater than the sum of individual efforts. Industrial nations have prospered through the synergism of well-managed organizations that have developed specialized and well-coordinated systems of work.

Organizational Purpose

Organizations have many purposes. For example, manufacturers create products, banks provide financial services, schools provide educational opportunities, and fire departments furnish protection. In business schools, we have typically approached the study of organizations from an industrial perspective, focusing on manufacturing enterprises. Manufacturing remains the preeminent economic sector. It still employs more people than the service sector, but there are now more white-collar, or service, jobs than blue-collar jobs, and there is a growing number of service organizations in Western economies. Service organizations include hospitals, recreation enterprises, airlines, and postal delivery services. Table 1-1 summarizes the leading Fortune 500 industrial corporations that provide a wide range of products, Table 1-2 lists the leading Fortune 500 diversified service firms, and Table 1-3 shows ten of the leading U.S. retailers.

Although every organization has its own objectives, all organizations have one common purpose: to provide value for stakeholders. Stakeholders are those individuals or groups that have an interest in, or are affected by, an organization's performance. Thus investors (stockholders in a corporation) depend on a firm for dividends; employees depend on it for their livelihoods; taxpayers rely on it to be a viable enterprise contributing to the public welfare; consumers depend on its products and services; and community businesses depend on it for their own continued growth and economic activity. Just as governments exist to

The trend toward an information society signals great changes, new forms of organizations, and a different work emphasis. Examples of information organizations are schools, museums, the electronic media, computer software, and telecommunication firms.

TABLE 1-1 Ten of the Largest U.S. Industrial Corporations (Ranked on Sales, Assets, and Return to Investors)

Company	Sales (million)	Assets (million)	Profit Return (rank in 500)
1. General Motors	$101,781.9	$87,421.9 (1)	276
2. Exxon	76,416.0	74,042.0 (2)	163
3. Ford Motor	71,643.4	44,955.7 (4)	67
4. International Business Machines	54,217.0	63,688.0 (3)	277
5. Mobil	51,223.0	41,140.0 (5)	256
6. General Electric	39,315.0	38,920.0 (6)	233
7. Texaco	34,372.0	33,962.0 (9)	229
8. American Telephone and Telegraph	33,598.0	38,426.0 (7)	168
9. E. I. du Pont de Nemours	30,468.0	28,209.0 (10)	217
10. Chrysler	26,251.7	19,944.6 (15)	315

provide valuable social benefits to citizens, so do manufacturers exist to provide valuable products to consumers and service organizations to provide valuable services to clients. When an organization fails to provide value, its reason for existence evaporates. Thus we arrive at a more useful definition of organizations: They are formal associations that combine human activities, resources, capital, and information with the intention of providing something of social value.[5]

Formal and Informal Organizations

Management education focuses on formal organizations because "formality" presumes human effort is deliberately focused on common objectives. Informal organizations are as pervasive in our lives, but they arise spontaneously and are often temporary. We will explore them more thoroughly in Part Three. It is important to note here that management is concerned with formal organizations—those with deliberate common objectives, clarity of purpose, and two or more individuals working together. Our party example is not one of formal organization if it represents a group of friends getting together on a Saturday night. If, how-

TABLE 1-2 Ten of the Largest Diversified Service Companies (Ranked on Sales, Assets, and Return to Investors)

Company	Sales (millions)	Assets (millions)	Profit Return (rank in 100)
1. Super Valu Stores	$9,371.7	$2,016.2 (33)	70
2. Fleming Companies	8,608.1	1,342.1 (41)	66
3. McKesson	6,671.6	2,207.6 (28)	59
4. Hospital Corporation of America	4,675.9	6,182.6 (1)	33
5. Ryder System	4,609.1	5,770.6 (2)	69
6. National Intergroup	4,541.3	2,098.6 (30)	58
7. Capital Cities Comm./ABC	4,440.3	5,378.4 (4)	10
8. Electronic Data Systems	4,323.8	2,957.9 (23)	N.A.
9. ARA Holding	4,019.0	1,656.4 (36)	N.A.
10. Fluor	3,924.5	2,061.2 (32)	18

TABLE 1-3 Ten of the Largest U.S. Retailing Companies (Ranked by Sales, Assets, and Return to Investors)

Company	Sales (millions)	Assets (millions)	Profit Return (rank in 50)
1. Sears Roebuck	$48,439.6	$74,991.3 (1)	22
2. K Mart	25,626.6	11,106.0 (2)	12
3. Safeway Stores	18,301.3	4,917.5 (11)	N.A.
4. Kroger	17,659.7	4,397.5 (13)	23
5. Wal-Mart Stores	15,959.3	5,131.8 (10)	8
6. J. C. Penney	15,332.0	10,842.0 (3)	5
7. American Stores	14,272.4	3,650.2 (17)	20
8. Federated Department Stores	11,117.8	6,008.7 (7)	26
9. Dayton Hudson	10,677.3	6,075.5 (6)	31
10. May Department Stores	10,314.0	6,181.0 (5)	25

Source: "The Service 500," *Fortune*, June 6, 1988, supplement D, p. 29. Copyright © 1988, Time Inc. All rights reserved.

ever, the party is a scheduled fraternity affair or a catered gala, then someone is likely to have responsibility for management. The "manager" will have to plan the event, gather resources, direct allocations, and control behavior.

Organizational Influence

Our lives are influenced by organizations that we often take for granted. Certainly we recognize that government organizations—ranging from the local police to the Internal Revenue Service—shape our society and our individual behavior. Other organizations provide our electricity, keep our phones working, package our toothpaste, manufacture our clothes, and so on. The better these organizations are at performing their tasks, the higher our quality of life. When organizations are more productive, the general public gets more for its money.

The concept of social value is important because many organizations create value without producing actual goods and services. For example, individuals create organizations for the singular purpose of human fellowship. These include retirement groups, social and travel clubs, and intramural sport teams.

The Essence of Organizations

formal organization
Two or more people involved in a mutual effort with formal authority for creating tangible benefits.

Formal organizations are generally concerned with a transformation process in which managers are responsible for creating tangible benefits. Managers achieve results by transforming resources into added value for stakeholders through a synergistic process. The concept of resources has been refined slightly from the general economic list of "labor, capital, land, and entrepreneurship" to "people, capital, materials, technology, and information."[6] We include under the category of "people" the entrepreneurial efforts of innovative persons and the leadership capabilities of managers.

Peter F. Drucker, one of this century's most prolific management writers, epitomized organizational and managerial activity when he noted that we have become a society of organizations, designed to be immortal, that are run by professional managers. In Drucker's view, the wealth-producing [forces] of our economy today are intangible and nonmaterial resources. These include the intellectual and organizational skills of creative leaders with entrepreneurial verve who not only transform resources but also make work interesting and meaningful to those involved.[7] Perhaps this is the essence of a free enterprise society, and

Drucker emphasizes that it is the combination of personal skills and innovation that drives our economy forward, with the important catalyst of management fashioning the transformation. Let us look more closely at the *process of management* and how it enhances innovation.

CHECKPOINT

- Why is membership in an organization characterized by mutual cooperation in the pursuit of common objectives?
- Explain what is meant by "synergism," and how specialization can produce group results that are greater than the sum of individual efforts.
- What purposes do organizations have, and how do these differ for formal and informal organizations?
- How do organizations influence our lives, and what responsibilities do managers have for enriching and protecting stakeholder interests?

THE PROCESS OF MANAGEMENT

The activities that make up the managerial process are commonly called the *four functions of management*. Although these are interrelated activities that separately have little meaning, we can better understand management by studying each activity in isolation. Figure 1-1 shows the model of this process.

Planning

Managers develop organizational objectives by planning. This activity is said to precede all other managerial functions, but of course it cannot take place in a vacuum. Plans evolve within organizations, usually while people are working and resources are being used and controlled. **Planning** is the process of defining an organization's objectives and determining how to achieve them. Objectives are benchmarks for measuring future performance. As managers, we plan today based on our assumptions about what will happen in the future. We seek direction for current and future actions, opportunities for improving our current organization for the future, and solutions to current problems in order to prevent future problems. In other words, managers plan so that organizations can move forward with the best probability of success.

George Steiner, a leading scholar in strategic planning, defines planning as deciding "what is to be done, when it is to be done, how it is to be done, and who is to do it."[8] Larger, more complex organizations face more daunting plan-

planning
One of the four major functions of management. It is the process of defining organizational objectives and then articulating strategies, tactics, and operations necessary to achieve those objectives.

FIGURE 1-1 The Functional View of Management

ning tasks than their smaller counterparts. Managers in large firms frequently tackle heady issues. Major power companies, for example, are currently preparing for the decade of the 2020s because it takes that long to plan, fund, and build a new power plant. Imagine trying to determine the electricity needs of a large city decades from now. What power sources will be used in the year 2020? What sort of computer technology will be employed to control electric generation? What will such a plant cost to build?

Smaller entrepreneurial firms seldom face issues as intangible and far-reaching, but their need for planning is equally critical. Clothing store managers who fail to plan for new fashion changes might easily find themselves with outdated inventory. A supermarket manager who makes a 1 percent error in costs may earn no profits because 1 percent is often the total net profit in retail groceries.

So many factors affect organizational performance that it is rarely adequate for managers to make decisions solely on inspiration. The planning function implies a formal, structured approach to help them *do the right things* while keeping clear objectives in mind. Intuition plays an important role, particularly for experienced managers, but effective planning is not a spontaneous exercise. It is the active process of establishing where one wants to be at a specific point in the future. Chapters 4, 5, 6, and 7 cover the important elements of planning and decision making.

Organizing

Once they are armed with good plans, managers must organize human and material resources to carry them out. Resources must be gathered and allocated, and the work of an enterprise must be coordinated. Gathering resources includes *staffing,* or the organization of human resources. It also includes purchasing materials, securing financing, and providing facilities. Once a firm understands its needs and sets about gathering resources, an allocation process evolves. Human resources are grouped in logical divisions of labor, schedules of operations are defined, and lines of communication are forged to ensure coordination of tasks.

These organizing activities occur within the context of a specifically de-

The success of some leaders has been attributed to charisma or other personal traits. Some people seem to have been "born to lead".

signed structure. The crux of organizing includes a deliberate *configuration* for the firm that defines how authority is structured, how communication flows, and how tasks are accomplished. This configuration differs from organization to organization and depends largely on the nature of each firm's work. For example, a manufacturing company will choose a structure based on production methods and technology, a university will choose a form of departmentalization that allows groups of professionals to work somewhat independently, and a hospital may require careful delineation of services within a structure that enhances working relationships among its activities.

We expand these concepts in Part Three, which is devoted to organizing, but there is an added dimension of organizing that is addressed in Part Four, which is concerned with leadership. This dimension is the *philosophy* of organization, which influences how we combine human resources with rapid changes in modern technology. In Part Four, we discuss, for example, how American firms are moving toward participative systems. Participation means involving subordinates in decisions that traditionally have been handled by individual managers.

Getting "organized" obviously means much more than defining structures, assigning jobs, and bringing together essential resources. A firm cannot function in anarchy. "Getting organized" implies the creation of a harmonious work environment, and harmony is largely the result of effective leadership.

Leading

Leadership implies a system of inequalities in which superiors influence subordinates—in other words, managers in authority direct human behavior to achieve organizational objectives. Several descriptive terms have been used interchangeably to describe the **leadership** function. These include "motivating," "actuating," and "directing." They all have in common the assumption that managers *influence* behavior. Exactly *how* they do this is subject to interpretation. Historians and philosophers have tried for centuries to understand how great men and women achieve extraordinary success. This success has sometimes been attributed to charisma. Alexander the Great is often cited as a charismatic leader. Sometimes it has been attributed to having a dominant personality. General George Patton comes to mind. Still other people seem to have been "born to lead," to have inherited the traits necessary to achieve monumental results under extraordinary conditions. Consider Martin Luther King, Jr., John F. Kennedy, and Sir Thomas Moore. Charisma, a dominant personality, and inherited traits are all capable of producing a great leader, yet most theorists still disagree on exactly how leaders are made.

> **leadership**
> The management function of influencing others to strive toward performance that achieves organizational objects; also called *directing*.

What we do know is that leadership can be studied, and as we become more aware of how successful men and women lead others, we can model the process ourselves. We can explore the nature of influence and acquire some understanding of what influences people working in organizations to perform well. We can see how behavior is correlated with certain styles of leadership. The chapters in Part Four are devoted to leadership topics, but the implications for effective leadership are discussed in every chapter from planning to controlling human resources.

Controlling

Managers have the daily responsibility to "keep things on track." This function of steering performance toward desired results is called **controlling.** The task is far more complex than the definition implies. Managers must evaluate performance, recognize problems, anticipate crises before they occur, avert catastrophies, and simultaneously make hundreds of little decisions that can be the difference between ultimate success or failure.

> **controlling**
> The management function of monitoring performance and adapting work variables to improve results.

Control is the complementary activity of planning. Managers *plan* to determine what to do and *control* to get it done. One aspect of the control process involves setting standards for performance, especially determining the quality of products and services. Another aspect of the control process involves monitoring results to ensure quality performance. Yet another aspect consists of making adjustments to improve performance. The net effect of these activities is improved productivity, which is a central theme of this text.

Three mainstream topics of managerial control are *coordinating, monitoring,* and *adjusting performance.* Quality control is also an important consideration, together with productivity measures, budgeting, and quantitative techniques used in managerial decision making. Finally, information sciences and computer applications are changing the way managers approach decision making. Most information techniques and applications are tools for improved decision making, but information systems have influenced other aspects of management such as communications and human relations.

Control issues form a major part of this text and are presented in Chapters 16, 17, and 18. However, the concepts of effective control, such as quality and productivity, run like threads through most chapters. New technologies in control systems are among the foremost innovations in the emerging information age, and students will find that many of their courses focus on these issues.

Emerging Concepts in Management

The final chapters of this text challenge students to think beyond the functions of management and to consider changes in global competition and new venture creation. Chapter 20 addresses international business, management of multinational enterprises, and how U.S. managers are preparing themselves for future competition, including the economic awakening of the People's Republic of China and the reorganization of the Common Market into a federation of European trading nations. Chapter 21 introduces the concept of entrepreneurship and explores how new ventures are developed in a free market economy. Entrepreneurship is described as the process of establishing new enterprises, and the chapter discusses small-business management for ventures such as local stores as well as management of high-growth ventures such as computer systems manufacturing.

CHECKPOINT

- Define each function of management: planning, organizing, leading, and controlling.
- Explain how the functions of management are interrelated to constitute the "process of management."
- Describe an example of this process and the activities related to each function of management.

THE ROLE OF THE MANAGER

A widely quoted study by management researcher Henry Mintzberg shows that managers have three general "sets of behavior." Each set has several associated roles, as Figure 1-2 illustrates. Mintzberg's conclusions followed an intensive study of selected organizations in which he identified patterns of behavior stemming from two conditions: first, managers have *formal authority* over others; and second, managers enjoy *differentiated status* according to rank. These two factors are instrumental in determining interpersonal relations with superiors, peers, and subordinates. Also, the roles that evolved from these interpersonal relations were found to be similar in all organizations studied.[9]

FIGURE 1-2 Managerial Roles

Source: Adapted from Henry Mintzberg, "The Manager's Job: Folklore and Fact," *Harvard Business Review,* July/August 1975.

Interpersonal Roles

The first set of behavior concerns interpersonal roles, and Mintzberg identifies three managerial roles within this set:

1. *Organizational Figurehead.* Executive managers perform a number of ceremonial duties such as representing the firm at public affairs and overseeing official company functions. Lower-level managers also have ceremonial duties, but usually of lesser importance, such as attending employees' weddings, greeting visitors, and acting as hosts for customers.

2. *Leader.* This role encompasses a range of duties suggested earlier, including motivating subordinates, guiding work-related behavior, and encouraging activities that help achieve organizational objectives. Managers at all organizational levels have leadership duties, although they vary in intensity according to the specific tasks and activities.

3. *Liaison.* All managers find themselves acting as liaisons between groups and individuals that are part of, or come into contact with, an organization. The liaison role is important for establishing relationships with suppliers, coordinating activities among work groups, and encouraging the harmony needed to ensure effective performance. Top-level executives are more concerned with external liaisons than lower-level managers, and these include relationships with government agencies, competitors, consumers, and public special interest groups. Lower-level managers are primarily concerned with internal liaisons to coordinate activities among interrelated work groups.

Informational Roles

Informational roles, as the term implies, involve communication among individuals and groups, but managers must also be adept at gathering and using information to help make effective decisions. Moreover, they should be able communicators who can transmit information and articulate decisions. Mintzberg sees managers as performing three informational roles:

1. *Monitor.* Managers monitor activity, solicit information, gather data, and observe behavior. Well-informed managers are prepared for decision making and can redirect behavior to improve organizational performance.

2. *Disseminator.* Here communications are reversed. Rather than receive information, managers transmit it to others in the organization. This includes articulating plans and objectives laid out by their superiors to their subordinates and making performance reports on their subordinates to their superiors. It also includes downward dissemination of information, such as feedback on performance by managers to their subordinates and lateral transmission of information needed by peers for decision making.

3. *Spokesperson.* Top executives are more important spokespersons than lower-level managers. A firm's policy on competition, its philosophy of investment, and its commitment to safety are common topics in executive speeches. Managers at all levels, however, are spokespersons. For example, when department heads meet to discuss operating budgets, they must be prepared to present information in support of their budget requests.

Decisional Roles

Mintzberg identifies four decisional roles that reflect managers' choice-making responsibilities:

1. *Entrepreneur.* In recent years, entrepreneurs have been identified with commitment to innovation, specifically to starting new companies based on innovative products or services. Managers do not start their own firms, but those in complex organizations act as entrepreneurs by seeking new ways to use resources and technologies.

2. *Disturbance Handler.* This may be the best understood role of managers because they have always had the primary responsibility for resolving problems. It may also be their most stressful role, for managers seem to be constantly faced with disturbances that threaten the harmony and effectiveness of their organizations.

3. *Resource Allocator.* This third managerial role links the planning and organizing functions. Managers must plan to meet their objectives and distribute resources accordingly. There will never be sufficient time, money, material, or manpower to accomplish all that is expected, so resource allocation often means carefully proportioning *scarce* resources.

4. *Negotiator.* The allocation process affects the manager's role as a negotiator. When scarce resources must be shared among many operating units, managers with superior negotiating skills will have an advantage over their less-skilled counterparts. Negotiating extends to many managerial activities both inside and outside the firm. For example, purchasing managers negotiate material prices and terms, personnel managers negotiate wages and conditions of employment, marketing managers negotiate sales, and labor relations managers negotiate union contracts. Negotiation, of course, does not connote "conflict," but it does imply personal bargaining between managers and employees to resolve differences in performance expectations.

CHECKPOINT

- Describe responsibilities a manager might have in relation to each of the three interpersonal roles of figurehead, leader, and liaison.
- Informational roles imply communication. Discuss the roles of monitor, disseminator, and spokesperson.
- What do managers do in their decisional roles of disturbance handler, resource allocator, and negotiator?

HOW MANAGERS SPEND THEIR TIME

Managers are often required to alternate among roles. In fact, the pace of change can sometimes be hectic. Mintzberg's research reveals how much time managers at different organizational levels spend in each of their roles. For example, chief executive officers (CEOs) spend about 59 percent of their time in scheduled meetings, 10 percent in unscheduled meetings, 22 percent at their desks, and about 6

percent on the telephone. The remaining 3 percent is spent on all other activities. By adding these percentages, you can see that CEOs devote nearly 75 percent of their time to communicating.

Middle-level managers also spend a great deal of time in scheduled and unscheduled meetings, on the telephone, and on desk work. In contrast, first-line supervisors (the lowest level of management) are more involved with short, unscheduled meetings; they attend fewer scheduled meetings than managers above them. Also, first-line supervisors spend more time than other managers in direct communication with nonmanagement workers about daily tasks.

Mintzberg's work represents a milestone in our understanding of how managers perceive their roles; current research is even more revealing. In 1988, Fred Luthans reported on his intensive four-year study of managers, which, unlike Mintzberg's, included individuals at all organizational levels.[10] Mintzberg's general role models were supported, but Luthans found greater emphasis among managers on *human interaction* and on *communicating*. Luthans also observes that formal planning, decision making, and controlling are crucial management activities, but that they are seldom the result of intuition. In addition, he identifies "real managers" as those who, embracing the challenge of organizational initiative, are innovative and productive. These characteristics distinguish *real managers* from *successful managers*. Successful managers survive, and may even be promoted, because of uncontroversial behavior, administrative efficiency, or a combination of good socializing and politicking. In contrast, real managers forge ahead, driving their organizations to higher productivity, creating quality products and services, and setting the pace for innovative endeavor. Figure 1-3 illustrates these differences in role behavior. In the next section, we explore managerial roles at various levels in the organizational hierarchy.

CHECKPOINT

■ Explain how managers at different levels in an organization spend their time planning, organizing, leading, and controlling.

■ Contrast the characteristics attributed to "real" managers with those attributed to "successful" managers. Why is there a distinction?

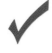

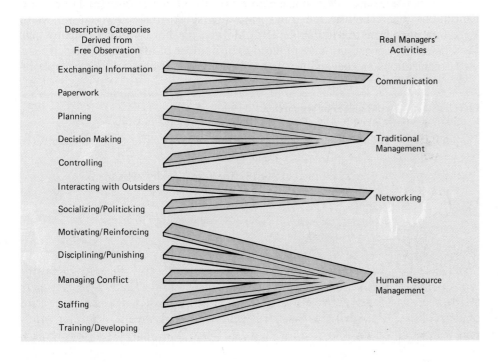

FIGURE 1-3 The Activities of Real Managers

Source: Fred Luthans, "Successful vs. Effective Real Managers," *The Academy of Management Executive*, vol. II, No. 2 (1988), pp. 127–132. Reprinted with permission.

THE MANAGEMENT HIERARCHY

As organizations grow, a *hierarchy of management* evolves so that there are fewer managers at higher levels and many more at lower levels. This management pyramid is shown in Figure 1-4. As you can see, executives are at the pinnacle, whereas first-line managers, such as shop supervisors, are near the bottom, close to operational workers. Between these two extremes are middle managers, who occupy a variety of specialized positions such as running departments, managing divisions, and overseeing plants. Principles of management apply equally to managers at every stratum, but the relative emphasis of activities changes at each level.

Many considerations influence the structure of a management hierarchy. Larger organizations simply cannot be managed by a few people, and as companies grow, increasing authority is delegated to an expanding cadre of lower-level managers. The complexity of operations, the type of technology employed, the geographic diversification of the firm, and the range of products or services managed also influence management hierarchy. Other factors include the number of individuals one person can manage and how work groups are structured. These points are discussed in the chapters on organization (Chapters 8–11), motivation (Chapter 13), human resource management (Chapter 12), and production (Chapter 17).

Division of Responsibility

While some organizations have few layers of management, others have many layers. Hierarchies evolve as a form of vertical division of labor. Executives concern themselves with far-reaching issues and grand, long-term plans for their organizations. They cannot become involved in everyday operations and also concentrate on decisions with major consequences. Operational responsibilities are therefore delegated to lower-level managers. The extent of this vertical layering depends on the nature of the organization. Universities typically have between four and six levels. Manufacturers often have between seven and ten layers. Service organizations, such as hospitals, may have as few as three or as many as twelve levels.

During the era of rapid industrial growth that followed World War II, U.S. firms added levels of management and created more complex, "taller" organizations, but currently the trend is toward substantial "downsizing." Many large industrial firms, including General Motors, the Ford Motor Company, and the Chrysler Corporation, have reduced their number of management levels. Service organizations are becoming "flatter," with fewer strata and more people re-

FIGURE 1-4 The Managerial Hierarchy

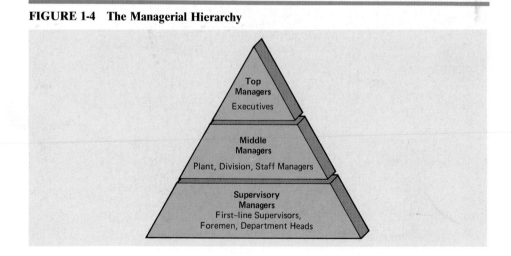

Some organizations, such as British royalty, are made up of many levels. In contrast, the Roman Catholic Church has only four levels, with the pope at the top and parish priests at the bottom.

porting to each manager. In effect, firms are becoming "leaner and meaner," which means more responsibility for fewer managers.[11] These changes reflect changing expectations for participative leadership and changes in information technology, which together, have reduced the need for middle managers in coordination roles.

Management Classifications

There are three clear categories of management in the hierarchy: *top management, middle management,* and *supervisory management.* Even in the federal government's eighteen management levels, individual positions can be classified in one of these three categories. Let's look more closely at each.[12]

Top management. The chief executive officer is by definition one person heading an organization. In rare instances two people share the leadership of a firm. For example, both Hewlett-Packard and Intel Corporation, two of America's leading high-tech Silicon Valley firms, have co-chairmen with joint executive authority. Most firms, however, vest CEO authority in one person. Top management also includes a few highly selected executives who share the huge work load of the CEO—the corporate treasurer, the chief financial officer (CFO), and a few of other specialists. In large diversified firms, top management includes executive vice presidents and division presidents who are responsible for strategic decisions.

Top managers are distinguished from other managers by the scope and nature of their responsibilities. They make decisions that can ruin an organization or lead it to take prodigious strides in profitability and growth. They determine long-range objectives, dictate the cadence of change, and establish a philosophy of leadership. These characteristics can be seen by studying prominent corporate leaders. For example, John Scully, CEO of Apple Computer Corporation, brought to that company new growth objectives, new strategies for marketing, and a new style of leadership that differed significantly from that of Apple's founder Steven Jobs. Lee Iacocca, CEO of Chrysler, became one of America's most notable industrial leaders by reversing the auto company's downslide. Both Iacocca and Scully are well known because they assumed top management roles under highly publicized adverse circumstances and succeeded, but other, lesser-known CEOs have equally difficult responsibilities in top management roles. For example, John Akers, chairman of IBM, is involved in a massive restructuring of the corporation while under heavy competitive pressure by other major computer manufacturers.[13]

Middle management. Multiple levels of individuals are sandwiched between executive managers and first-line supervisors. Unlike top managers, whose positions can be fairly well described, middle managers occupy a wide variety of positions in many strata that are hard to define. Plant managers, accounting managers, public relations officers, department heads, regional sales managers, and managers in charge of specialty areas, such as data processing or market research, are all middle managers.

Most middle managers supervise subunits of an organization; they direct the activities of other managers. Middle managers typically do not manage nonmanagement employees except for workers in specialty units such as data processing or accounting. In primary work environments—for example, manufacturing or sales—middle managers almost always have several lower-level managers reporting to them. In manufacturing, lower-level managers may be shop supervisors. In sales, they may be sales managers. Middle managers' responsibilities are largely dictated by the philosophy of organization prevailing in their firms.[14] For example, middle managers in a company with a flattened structure (few levels) will participate in many top-level decisions, but will also be close to actual oper-

ations. To use Mintzberg's model, they will have significant responsibility in "interactive roles," but these will embrace the "real managers'" activities of communicating and human resource management described in Luthan's model.

Taller organizations—those with more layers of management—tend to insulate each layer through more rigid reporting systems and job titles. In these companies, upper-echelon middle managers have decision-making responsibilities closely associated with top management. In contrast, lower-echelon middle managers focus more on operations (actual tasks and processes) and coordinate work with first-line supervisors.

Supervisory management. Supervisors are generally called "first-line managers'" because they constitute the first level above operational, nonmanagement personnel. They include floor supervisors, head tellers in banks, military sergeants, and charge nurses in hospitals. The majority of managers in nearly all organizations are supervisors who spend most of their time with employees. Their duties consist of technical control of operations, direct communication with employees, and resolution of immediate problems associated with specific tasks.

Unlike many higher-placed managers, supervisors tend to rise from employee ranks. Supervisory roles differ from those of other managers in three substantial ways. First, supervisors are expected to possess greater technical skills for hands-on work. Second, they are charged with the greatest responsibility for managing employee problems, resolving schedules, and controlling behavior. Third, they initiate most operational reports and performance information. This means supervisors shoulder the burden of transmitting most of the information generated in an organization and are often overwhelmed by their informational roles.[15]

Supervisors are highly visible. Their many superiors expect them to support higher-level objectives, report on employees' performance, and implement decisions made at higher levels. Employees expect them to provide direction and training, represent the work group, and make equitable decisions on schedules, raises, and grievances. Their peers in other first-line positions expect them to coordinate interrelated activities and to harmonize interdepartmental relationships.[16]

It is no wonder that supervisors feel they are constantly on the firing line. They are forced to make tough decisions, and many don't believe they have been given enough training in management to be held accountable for those decisions.

One of the ironies of management education is that supervisors—those who do most of the hands-on "managing"—are the least trained in management techniques. Most supervisors have never read a textbook on management, and only those in our largest corporations have access to formal in-house training programs designed to help them develop their leadership skills. Some authors argue strongly that one of the advantages of Japanese companies is that most of their supervisors are college-educated and well trained to manage human resources.[17] Management skills at the supervisory level may become even more important if, as Peter Drucker notes, changes in information technology shift more responsibility for information reporting and coordinating activities away from middle managers toward first-line supervisors. Drucker points out that many firms are eliminating entire levels of middle management, particularly where information systems can provide effective linkage between top-level executives and first-line supervisors. John Akers eliminated nearly 6,000 middle-management positions at IBM in 1988, and he anticipates a staff reduction of more than 20,000—and the elimination of an entire level of middle management—by 1990. Lee Iacocca cut two complete levels of middle management from Chrysler during the 1980s. In each instance, supervisors were given expanded leadership roles and were held more accountable for decisions previously made by a cadre of middle managers. So the nature of supervisory management is changing rapidly, and today's supervisors are expected to be better trained in leadership roles and more knowledgeable about management principles than supervisors in the past.[18] (The Checkpoint for this section appears on the next page.)

CHECKPOINT

- How are responsibilities divided among management strata?
- Explain the classifications of management and give an example of each.

FUNCTIONAL AND GENERAL MANAGERS

functional management
A definition of management authority based on expertise and specialization.

The hierarchy of management described by top, middle, and supervisory management is a *vertical* division of labor. Management is also divided *horizontally* along functional lines of authority. **Functional management** reflects a kind of specialization in which authority is vested in managers according to their fields of expertise. Department heads are delegated narrow slices of authority over particular areas. For example, accountants may be grouped in a single department and given broad-based authority for accounting but be severely restricted from involvement in production or sales. Accounting may be further subdivided into departmental sections such as payroll, payables, cost accounting, and auditing. Subunits within a large personnel department may include labor relations, recruitment, benefits administration, compensation management, and affirmative action.

line manager
A person who has direct control over primary operations of an organization such as production.

Functional managers are not all experts in professions such as accounting or personnel. Actually, most of them are in line positions. **Line managers** are concerned with primary organizational activities such as marketing and production. Departments are in turn defined according to functional line duties such as production control, receiving, sales, shipping, and customer service. Functional management positions developed out of the rapid expansion of individual firms during the 1940s and 1950s. For example, the growth of our factory system required specialized production managers. A commensurate increase in competition led to sales and marketing positions. The complexity of commerce also nourished financial management positions. Horizontal specialization spread rapidly to include managers adept at materials management, purchasing, logistics, market research, advertising, and many other areas.

Generalists, or general managers, usually oversee collective operations that include several functional managers. Plant managers are generalists, responsible for the totality of their plant operations. Division managers have similar roles in corporations. Top managers, by definition, are also generalists. These executives and upper-middle-level managers may have moved up to their positions from lower-level functional positions in "line" areas such as production or marketing. A number of higher-level generalists in manufacturing are engineers by training, and it is not unusual to find executive positions filled by financial specialists. Historically, a few top general managers "came up from the ranks" or carved out careers from nonmanagement jobs, but this is extremely rare today. Only experienced and educated managers have the skills needed to plan, organize, lead, and control in our global economy.

CHECKPOINT

- Functional management reflects specialization. Explain what this means for the horizontal division of authority in organizations.
- How do general managers differ from functional managers? Give an example of each and state how their roles are distinguished.

MANAGERIAL SKILLS

Managers in different occupations obviously need different skills. Those who specialize in functional areas tend to focus their energy on the technical aspects of their jobs, but they also lead others. In contrast, those in general management

positions have to manage a variety of people in many different situations, and this calls for integrative leadership skills. Research by Robert L. Katz, a specialist in organizational theory, has shown that all managers have similar skills in three important areas: *technical, human,* and *conceptual.*[19] He also notes that managers at different levels in an organization tend to emphasize one type of skill more than others, a finding that is reinforced by Fred Luthans.[20] Figure 1-5 shows the relative intensity of different skills at the three management levels.

Conceptual Skills

Managers ultimately spend much of their time communicating with others, making decisions, and solving problems. People with the ability to look at organizational problems from a broad conceptual base usually make decisions more consistent with organizational objectives. Top managers must go one step further to envision the long-term needs of the firm and make decisions that serve the entire organization. Conceptual skills are far more crucial for executives than for lower-level managers. For example, American executives who can envision an expanding global economy in which we will one day be actively trading with China will make decisions today that will prepare their organizations for those future opportunities. Supervisors in the same companies do not have to deal with such broad conceptual issues and are more concerned with meeting weekly production quotas.

Human Skills

All managers must acquire human skills, for all managers must lead, motivate, and influence others to achieve organizational objectives. Today a disproportionate number of middle managers find themselves in coordinating roles where hu-

FIGURE 1-5 Managerial Skills

Source: Adapted from Robert L. Katz "'Skills of an Effective Administrator," *Harvard Business Review,* September/October 1974.

man skills are emphasized: fine-tuning interpersonal relations, developing harmonious relationships among work groups, and motivating others. Supervisors also play a significant role in motivating others, and if the trend toward reducing the number of middle managers continues, supervisors will become more accountable for activities that require human skills.

Technical Skills

First-line supervisors, as well as many middle managers, are intensively involved in technical operations. They are expected to apply their education, job experience, and expertise to make things happen. Although lower-level managers cannot ignore conceptual and human skills, they focus on daily decisions involving technical operations and specific tasks assigned to their work groups. Supervisors are also typically evaluated on how well they accomplish those tasks, so technical expertise is important to their career success.

A Perspective on Skills

All three types of skills vary tremendously among individual managers and organizational positions. There are no hard-and-fast rules for establishing which skill is more important at any given time, yet clearly managers cannot advance up the hierarchy without conceptual abilities and strong human relations skills. Similarly, top managers need not be technically expert if they can lead others well and solve problems in complex situations. In the next section, we discuss entrepreneurs who typically own, manage, and operate their own ventures. A broad range of skills is often essential for successful entrepreneurship.

CHECKPOINT

- Discuss how conceptual skills are important for executive decisions.
- Leadership is related to human skills. Explain why, and discuss how human skills are important for achieving organizational objectives.
- Describe technical skills and how they differ in importance for executives and first-line supervisors.

ENTREPRENEURS

Our discussion so far has focused on corporate management, but new ventures and small businesses also offer substantial opportunities for managers. During the last decade, small businesses created more than 6 million new jobs for Americans, while the largest corporations—those in the Fortune 500—cut employment by more than a million jobs. There are about 16 million small firms in the United States, accounting for roughly 97 percent of all nonfarm businesses; these companies typically have fewer than 1,000 employees and do less than $10 million in sales.[21]

Firms that are small but growing, innovative, or high-risk ventures are generally called *entrepreneurial*. **Entrepreneur** is a French word used during the sixteenth and seventeenth centuries to describe persons who contracted their services. It originally applied to actors, building contractors, mercenaries, and others who bore the risk of their own enterprise rather than work within established

entrepreneur
An individual who assumes the risk of starting a new business, creating a new commercial product or service, and consequently seeking profitable rewards within a free enterprise system.

organizations.[22] While the literal meaning of "a go-between" or "one who undertakes service for a fee" has been lost, the connotation of free enterprise has prevailed. There are numerous modern examples of entrepreneurs who launched highly successful firms from independent and often humble beginnings. In fact, many of our largest companies began in ramshackle garages, not least among them Hewlett-Packard, McDonald's, Macy's, and the Ford Motor Company. Andrew Carnegie and J. P. Morgan laid the foundations of our steel industry, Edwin H. Land founded and managed Polaroid Corporation, and John D. Rockefeller fashioned an oil empire that nurtured hundreds of other companies.

Many entrepreneurs have been forgotten even though their companies have become part of the American heritage. Rowland H. Macy, for example, failed four times at the dry-goods business during the mid-1850s, an example of the high risk—and persistence—associated with entrepreneurship. It was his fifth attempt in 1858 in New York City that ultimately led to Macy's department store. More recently, four entrepreneurs, who are unlikely to become household names, forged a $1.3 billion computer technology company. Andreas Bechtolsheim, Vinod Khosla, Bill Joy, and Scott McNealy started Sun Microsystems in a rented apartment only a few years ago. They took their company public (issued public stock) in 1986, reached $1 billion in annual sales in 1987, and by mid-1988, were closing in on $2 billion in annual sales.[23]

Managers of entrepreneurial organizations must become generalists, able to assume a broad range of duties as well as to make executive decisions. Entrepreneurs also typically risk their personal wealth and reputations to pursue a new venture. But not every entrepreneur is to be found in a "small" business. Entrepreneurs also exist in established corporations. Research and development efforts in many firms confirm this observation. One extraordinary example occurred in Boca Raton, Florida, where a small team of corporate adventurers created the IBM Personal Computer. We explore the nature of entrepreneurship in Chapter 21.

CHECKPOINT

■ Describe an entrepreneur who started and manages a new venture.

■ Can corporate managers be "entrepreneurial"? Explain.

INTERNATIONAL DIMENSIONS OF MANAGEMENT

Nearly 25 percent of all U.S. corporate profits are derived from overseas investments, and American firms account for about 10 percent of gross world output in noncommunist countries. Many of our largest companies earn more than 50 percent of their gross revenues from foreign operations.[24] Today American managers, in turn, must cope with the increasing influence of foreign firms operating in the United States; this competition is stiff in electronics, automobiles, computers, petroleum, and food products, among others.

Managing in a global environment requires a comprehensive perspective. International business includes trade, finance, and the political economics of selling to and buying from foreign companies. International managers must operate overseas facilities, coordinate foreign subsidiaries of domestic corporations, and compete with a multitude of companies in diversified cultures. We treat these issues in Chapter 20, International Management, where we emphasize the changing nature of global business.

GLOBAL TRENDS 1-1
Texas Instruments—A Global Team

As the first U.S. semiconductor company to go international, Texas Instruments now operates in more than 30 countries on five continents with plants in 18 countries. Headquartered in Dallas, Texas, the company has encouraged its managers to mold a global team whereby innovations and technical expertise transcend national barriers.

TI created the first commercial silicon transistor in 1954 and, when the company manufactured transistors for the first commercial transistor radio later that year, it demonstrated to the world the practicality of these components in commercial products. In 1958, TI invented the integrated circuit, which revolutionized the electronics industry by reducing the size, weight, and cost of electronic equipment, making possible a wide range of new commercial, industrial, and military products. The company introduced the first integrated circuit computer in 1961, and in 1967, it unveiled the world's first hand-held calculator. In 1978, TI developed the first single-chip speech synthesizer; in 1984, the first multiport video RAM; and in 1987, the first single-chip artificial intelligence microprocessor.

These milestones in innovation meant tremendous challenges in management and organization, stimulating the company to create an information network within the firm that now links more than 50,000 computer terminals through a worldwide communications system. Simultaneous communication among thousands of managers and engineers in numerous locations redefined organizational relationships toward teamwork and away from bureaucratic strata. Messages and directives still "go through channels," but an idea for a new product design conceived in France can be discussed with TI managers in Korea, debated in Japan, tested in Brazil, and introduced in Chicago as if managers were clustered in one Dallas office building.

Managing at TI thus requires a global perspective encompassing diverse cultural interests through a team effort that accommodates people of various cultures speaking several dozen languages. It also means a commitment to quality, a spirit epitomized by TI when, in 1985, its bipolar semiconductor operation in Hiji, Japan, won Japan's most prestigious quality award, the Deming Prize. Named for an American statistician, the prize goes to one Japanese company each year for total quality control covering all aspects of business, including marketing, engineering, manufacturing, and support. TI's Hiji operation was the first wholly owned subsidiary of a U.S. company ever to receive the distinguished prize.

Source: "Milestones in Innovation," a report by Texas Instruments, Dallas, Texas, 1988. Reprinted courtesy of Texas Instruments.

CHECKPOINT

■ Based on an overview of the chapter, what challenges do you envision for managing in a global economy?

■ What attributes might a manager need to be effective in a firm that operates internationally?

PRODUCTIVITY—A CHALLENGE FOR INNOVATIVE MANAGERS

The concepts of management we have introduced thus far suggest diverse career directions for young managers entering the world of commerce. The familiar corporate world of domestic competition is, of course, the fundamental model explored in this and most other management texts, but it is not the only model. The world of entrepreneurs, for example, has been receiving much scholarly attention lately. Within the scope of entrepreneurial activity are new-venture creations, high-risk business operations, and small-business management. We have also noted the increase in global competition, which is compelling managers to view international relations more comprehensively. Every arena of business poses its own managerial challenges. Yet the ultimate challenge is for managers to create a nation of highly productive organizations, large and small, profit and nonprofit, that will assure Americans of a competitive economy, jobs, growth, and a high quality of life.

Productivity is the measurement of *net quantity output* related to the *total resources used.* Any product, service, or performance result can be evaluated in tangible terms using such techniques as market prices, units of parts produced, and number of people served. These results are then compared to the effort and resources needed to create them. For example, to grow a bushel of corn requires land, tools, seed, water, fertilizer, and hours of labor to plant, weed, and harvest. If a farmer can produce more corn using fewer resources per bushel of corn harvested, his productivity increases. Productivity measurements have historically focused on "labor-hours" as the primary input. Using this measurement as an illustration, a manufacturer who produced 100 units in a previous period using 10 labor hours and produces 110 units in the current period with the same 10 labor hours experiences a 10 percent increase in productivity. Labor-hours continues to be the standard for statistical comparisons, but it is a poor indicator of performance. Other resources must be included in the equation—capital, materials, energy, and information.

Figure 1-6 illustrates two dimensions of organized activity. First, most organizations exist to "transform" collective forms of resources into new products or services, as shown in the top part of the figure. Second, productivity is a relationship between resource inputs and the results of the transformation process, as shown in the lower part. Increases in productivity are achieved in at least three general ways. Resources can be reduced (while results are held constant); processes can be improved (increasing quality and quantity); and results can be improved by raising quality (using similar resources and processes).

Our definition of productivity emphasizes the output part of the equation—"net good quality output." The crucial word here is **quality.** If we measured

productivity
The relationship of combined inputs such as labor, materials, capital, and managerial verve to outputs such as products or services. It is the summation of quality performance that results in more efficient utilization of organizational resources.

quality
The concept of doing things better, not just more efficiently.

FIGURE 1-6 Organizational Model and Productivity

pure output without considering how many units were rejects, productivity would be based entirely on how rapidly we are able to manufacture the greatest number of products. That would be like judging the performance of a hospital on how fast patients can be treated without considering whether they are made well in the process. Similarly, in producing material goods, the number of good products must be evaluated, with defective work subtracted from results. A defective product obviously, often uses the same resources as a good product, but it does so without adding value to the process. Productivity, therefore, depends on how quality can be improved; in effect, it means using fewer resources to create a greater output. Most important, greater value is created in quality products and services at lower costs. This result is achieved largely through innovative combinations of resources, new technologies, creative leadership, and effective control systems that encourage employees to do quality work.

Recent U.S. Productivity

Between 1948 and 1967, private business productivity in the United States grew at an average annual rate of 3.1 percent. That was the best record among industrialized nations during the postwar period. Our productivity rate dropped to 2.3 percent between 1967 and 1973, however, and then it fell even more, to about 0.8 percent between 1973 and 1980. During the 1980s, it improved to an annual 3.5 percent rate, but, as noted earlier in the chapter, our performance still lags behind that of our foreign competitors. Japan, for example, posted annual average productivity gains during the same period of nearly 7 percent.[25]

Initial reactions to U.S. productivity "losses" centered on labor. Critics claimed that American workers were lazy, that they had lost the "work ethic," and that labor unions had strangled our industries. Actually, labor became a lower percentage cost of manufacturing during this time. Energy costs nearly doubled, however, and material costs increased rapidly during this time. Costs of capital also rose as investment markets tightened and interest rates climbed. More sophisticated technology added to the cost of production, and legislatively imposed burdens absorbed more of white-collar workers' time and effort. The resource relationship has changed, but because productivity continues to be measured with labor-hours as the primary input, management has been lulled into a false sense of direction, one that focuses on squeezing more out of employees instead of on using a firm's total resources more effectively. This misconception of productivity is beginning to change as we enter the 1990s.

Managing Productivity and Innovation

effectiveness
The result of making decisions that lead to doing the right things which help fulfill the mission of an enterprise.

efficiency
The result of making decisions that lead to doing things right which helps to achieve objectives with fewer resources and at lower costs.

innovative
Finding new ways to use or combine resources to create new products, services, processes, or technologies.

Managerial effectiveness is related to the total productivity of a firm's resources, not just labor or materials or energy or any other partial factor of performance. And while **effectiveness** (doing the right things) is critical, prosperity also requires **efficiency** (doing things right). Managers must efficiently use resources for the greatest results. Consequently, quality workmanship, quality materials, quality systems, and quality decision making add to the total productivity of a firm. When national productivity increases, it means that collectively we have generated better results while using our resources more effectively.

Every manager must therefore focus on improving his or her environment so that productivity increases. Higher productivity often means being **innovative** so that new technology is created, new systems are developed, and resources are combined *creatively* to enhance total performance. The backbone of every organization is the collective performance of its managers and their work groups. The ultimate challenge of management is to achieve organizational objectives through

the most effective use of resources. The only way to achieve these objectives is by a commitment to quality in every organized activity. The essence of this responsibility is captured by productivity consultants J. M. Juran and Frank M. Gryna, Jr:

> To meet the quality needs of society requires an active role by all major activities of an organization. Market research must discover the quality needs of the users; product development must create designs responsive to these needs; manufacturing planning must devise processes capable of executing the product designs; production must regulate these processes to achieve the desired qualities; purchasing must obtain adequate materials; inspection and test must prove the adequacy of the product through simulated use; marketing must sell the product for the proper application; customer service must observe the usage, remedy failures, and report on opportunities for improvement.[26]

These principles are not specific to manufacturing; service organizations have similar responsibilities to customers and similar resources—human and material—to manage. The role of entrepreneurial activity to create new processes and provide new technologies also cannot be underestimated. Innovation is at the heart of entrepreneurship, and it is needed equally by established firms and new ventures. In a global economy, where competition is increasingly across geographic boundaries, the role of innovation is accentuated. Throughout the text, we discuss innovation and productivity as important issues for future managers.

Changes Affecting Management

In summary, these are the factors that are beginning to affect managers now and are most likely to affect them in the year 2000 and beyond:[27]

1. *Frequent Changes.* A global economy signals pervasive involvement in world affairs, world trade, and the tensions associated with international competition. Cultural adaptations are being rapidly articulated; social restlessness and affluence induce new perceptions about work behavior.

2. *Technology Innovation.* Rapid and conspicuous changes will occur in technology, including robotics, telecommunications, biogenetics, and similar fields. Overseeing these changes will require greater sophistication by leaders better educated in technical disciplines than the present generation of managers.

3. *Shifts in Resource Allocations.* Sharply defined changes are occurring in energy development, natural resources, capital markets, and labor relations. Developing nations are wealthy in natural resources; industrialized nations are relatively shallow in those resources. Labor has become less important as a factor of production than the combination of resources and capital for transforming goods and services.

4. *Growth in Services.* Industrial management, and most management theory, evolved during the growth period that followed World War II. This focus on management is being replaced by one on services, such as recreation, health care, and telecommunications. Intellectual resources, such as expertise in information technology and robotic engineering, are becoming more important than physical resources, such as minerals and steel production capacity.

5. *Changing Expectations.* Employees are becoming more accustomed to participative decision making; they expect different relations than they have now with managers. Similarly, younger managers expect different relationships with older managers.

6. *Social Influences.* Special interest groups, and society in general, expect managers to behave ethically. Environmental concerns, equality legislation, and constitutional issues are redefining how we view corporate social responsibility.

This list is hardly exhaustive, but it makes it clear that managers of the future—those currently being trained in colleges and universities—will face extraordinary challenges. Management is barely beyond the embryonic stage of development; there has been less than a century of theory building compared to several hundred centuries for many sciences. It follows that greater changes in management are likely to occur as research in the field expands.

> ### CHECKPOINT
> - Define productivity and formulate an example of how resources can be used effectively to improve productivity.
> - Quality performance enhances productivity. Explain this statement and show how poor quality wastes resources.
> - Poor productivity has been blamed on a "lost work ethic" in America. Analyze this statement and explore how innovation affects productivity.
> - What are some of the changes affecting management today? Describe changes in technology or society that you believe might have important effects on management in ten years.

shirts would receive, say, 10 cents a pocket. The more pockets they sewed, the more they would get paid. This system is still used today in many firms.[6]

Among Taylor's contributions were instituting job analysis, time-and-motion studies, standardization of processes, efficiency techniques, and productivity measurements to systematically track labor costs. He also championed worker rest periods and introduced the idea of training for both managers and employees. His methods of "engineering jobs" have been strongly criticized, but perhaps history has been too harsh. True, he did stand over workers with a stopwatch to determine the most efficient ways to work, but he also developed safer work methods. His pioneering studies abolished traditional haphazard job assignments and unrelenting hours of work. These were sensational changes when Taylor implemented them more than eighty years ago.

Frank Gilbreth (1868–1924) and *Lillian Gilbreth* (1878–1972) formed an unusual husband-and-wife team who made significant contributions to scientific management. Frank's motion studies led to more productive ways to accomplish tasks; Lillian was a psychologist who became known for her research on fatigue and the effects of work on employees. An extraordinary woman, she complemented her life as a mother of twelve children with professional accomplishments in industrial psychology.[7]

Frank Gilbreth used motion pictures to study the structure of tasks. His most famous research was a motion study of bricklayers. He identified eighteen individual motions a worker used, motions that presumably had been part of bricklaying since ancient times. By changing the task structure, he was able to reduce the eighteen motions to five, which resulted in a more than 200 percent increase in productivity. This led him to a career of motion studies on tasks throughout industry. Today **motion study,** the study of the physical actions required to complete a task in the most efficient manner possible, has become part of our management language. Industrial engineers have combined Frank Gilbreth's methods with Taylor's to redesign jobs.

While her husband was doing his motion studies, Lillian Gilbreth was concerned with individuals and their performance at work under stressful conditions. She published her first paper in 1912 a doctoral thesis with her name disguised—and thereafter devoted herself to improving employee working conditions. Building on Taylor's ideas of rest periods, she advocated standard work days, scheduled breaks, and normal lunch periods. Her work also influenced Congress

motion study
The study of physical actions required to perform a task in the most efficient way possible.

Job redesign is important in industries where changes in technology have altered work methods and the physical requirements of tasks. For example, robotic television cameras were introduced in 1988 at NBC, and the job of physically positioning a camera by hand became obsolete. Employees who previously handled the camera work had to learn new skills associated with electronic systems to control several cameras simultaneously.

Gantt chart
A graphic illustration (usually a bar graph or diagram) that indicates time allocations for sequential operations and traces progress, routing, scheduling, and tasks in time intervals.

gainsharing
A method of bonus compensation based on a formula that shares profits or productivity gains among investors and employees.

bureaucracy
A model of organization based on defined positions, formal authority, and a regulated environment that includes well-documented rules, policies, and procedures.

to establish child labor laws and develop regulations for protecting workers from harsh and unsafe conditions.

Henry Gantt (1861–1919), a consulting industrial engineer, focused on "control" systems for shop-floor production scheduling. His Gantt Charts are common today and have been adapted for computerized scheduling applications. The **Gantt Chart** illustrated in Figure 2–2 is a graphic means of coordinating the flow of work. It is a progress report in visual form that identifies stages of work and operational deadlines. Gantt also established quota systems and bonus systems for workers and managers who met or exceeded their quota standards.

Gantt's control system, and bonuses supplementing basic wage rates are similar to the **gainsharing** concept currently acclaimed as the newest method of motivating employee performance. Gainsharing uses control techniques to monitor performance, compare results with established work standards, and pay employees bonuses in addition to base wages when results exceed standards.

Bureaucratic Management

The term *bureaucracy* evokes images of the federal government, a large, inefficient organization, and lots of red tape. Indeed, the word **bureaucracy** has become synonymous with bloated organizations. Most bureaucracies also have rather inflexible rules and a preponderance of regulations. Still, a large part of the industrialized world is modeled on bureaucracy, and basic principles of bureaucratic management dominate the way we think.

Max Weber (1864–1920) developed the bureaucratic model as a rational method of structuring complex organizations. He sought to define an ideal system where positions were well defined, the division of labor was clear, objectives were explicit, and a clear chain of authority existed.[8] Figure 2–3 shows Weber's rational bureaucracy.

Managing organizations that consist of thousands of individuals in hundreds of locations would be impossible without a rational system, and although we tend to avoid the label, bureaucracy has provided the organizational mechanisms needed to build large companies like GM, Exxon, and IBM. The connotations of inflexibility, coldness, and dehumanization were not intended by Weber when he introduced his bureaucratic model.

If we view rational organization in Weber's terms, there is nothing wrong with the concept of bureaucracy. Most of us prefer to have clear objectives, well-

FIGURE 2-2 Gantt Chart for Book Bindery

FIGURE 2-3 Weber's Rational Bureaucracy

structured authority, and formal guidelines. Weber also believed that employment decisions should be based on merit so that more productive and skillful people would rise to the top. The superiority of bureaucratic organization rests on defining positions and then filling them with qualified individuals. Weber was perhaps the first to address the problems of establishing a productive organization, and his ideas have inspired research in contemporary organizational theory.

The bureaucratic system has been criticized as inhumane because it first specifies jobs and then slots human beings into them. Bureaucracies have also been attacked for their propensity to "formalize" everything through endless rules and regulations. Also, it is easy for bureaucracies to become inflated beyond reason. Recently, they have been charged with throttling creativity, and our current emphasis on innovation fosters a cultural bias against bureaucractic systems.[9]

Still, large organizations rely on formal systems of management in rational structures, and even very small firms, such as neighborhood stores, tend to define authority within a chain of command and to establish rules that all employees are expected to follow. Large, complex organizations—whether government agencies or private enterprises—simply could not function without bureaucractic guidelines. Even companies aspiring to participative management require employees to accept authority and adhere to some standard of behavior.

Administrative Management

Perhaps the most influential classical theory is administrative management. Administrative management emphasizes management principles from a **functional perspective.** The significant contribution of administrative management has been the definition of the general duties, or functions, of managers within a framework of clearly articulated guidelines, or principles.

Henri Fayol (1841–1925), a French engineer who became managing director of one of France's largest coal mining businesses, was the first to propose a comprehensive list of administrative management principles. His fourteen principles are summarized in Exhibit 2-2. Today, we generally recognize four functions of management distilled from Fayol's original list: planning, organizing, leading, and controlling. Fayol believed that his principles had universal application and published them in a book, *General and Industrial Management,* in 1916. Although he was a contemporary of Frederick Taylor, Fayol's book was not widely distributed until 1949. The functional view of management is, therefore, a relatively recent addition to American literature.[10]

For years, Fayol's ideas were overshadowed by Taylor's scientific management concepts because industrialists were preoccupied with production issues

functional perspective
An approach that explains managers' responsibilities and activities according to general principles of management for planning, organizing, leading, and controlling.

EXHIBIT 2-2 Fayol's 14 Principles of Management

1. *Division of Work.* Specialization belongs to the natural order of things. The object of division of work is to produce more and better output with the same effort. This is accomplished by reducing the number of objects to which attention and effort must be directed.

2. *Authority and Responsibility.* Authority is the right to give orders and responsibility is its essential counterpart. Wherever authority is exerted, responsibility arises.

3. *Discipline.* Discipline implies obedience and respect for the agreements between the firm and its employees. Establishing agreements binding a firm and its employees should be one of the chief preoccupations of industrial heads. Disciplinary formalities emanate from these agreements, and may involve sanctions judiciously applied.

4. *Unity of Command.* An employee should receive orders from one superior only.

5. *Unity of Direction.* Each group of activities having one objective should be unified under one plan and one head.

6. *Subordination of Individual Interest to General Interest.* The interest of one employee or group of employees should not prevail over that of the company or broader organization.

7. *Remuneration of Personnel.* To maintain their loyalty and support, workers must be given a fair wage for services rendered.

8. *Centralization.* Like division of work, centralization belongs to the natural order of things. However, the appropriate degree of centralization varies from one organization to another. The problem is to find the measure that will give the best overall yield.

9. *Scalar Chain.* The scalar chain is the chain of superiors ranging from the ultimate authority to the lowest ranks. It is an error to depart needlessly from the line of authority, but it is an even greater one to adhere to it to the detriment of the business.

10. *Order.* A place for everything and everything in its place.

11. *Equity.* Equity is a combination of kindliness and justice.

12. *Stability of Tenure of Personnel.* High turnover breeds inefficiency. A mediocre manager who stays is infinitely preferable to an outstanding manager who comes and goes.

13. *Initiative.* Initiative involves thinking out a plan and ensuring its success. This gives zeal and energy to an organization.

14. *Esprit de Corps.* Union is strength, and it comes from harmony among the personnel.

Source: Abridged from Henri Fayol, *General and Industrial Management* (London: Sir Isaac Pitman & Sons, 1949), pp. 20–41.

in a rapidly expanding economy. The leadership function surfaced in management research during the late 1950s. Fayol's concern with organizing emerged as an important consideration in the 1960s. Not until the 1980s did his planning function became a conscious management theme, and the controlling function became popular only recently as managers began to realize the importance of meeting global competition through high-quality products and services. If most of Fayol's principles seem self-evident today, that is because his functional approach now dominates the study of management. In retrospect, his contributions represent an important transformation in management thought.

CHECKPOINT

■ Identify and discuss Frederick Taylor's contributions to management theory, and state how his contemporaries provided the foundation for scientific management.

■ Describe bureaucratic management, and contrast the advantages and disadvantages of a bureaucratic organization.

■ Besides Fayol's four primary principles of management, what other principles influence management? Choose several, and describe them in terms of current management practices.

THE BEHAVIORAL APPROACH TO MANAGEMENT

Although Henri Fayol's principles embrace human behavior and leadership, he was not among the mainstream theorists who formulated the **behavioral approach** to management. The behavioral approach—sometimes called the *behavioral science approach*—emerged from research by behavioral scientists, including sociologists, psychologists, and anthropologists, who sought ways of improving organization effectiveness by modifying individual and group behavior.

Three distinct eras are associated with behavioral concepts. The first was the 1920s, when research inspired what we now call the *human relations movement*. The second was the post–World War II period, when theorists focused on *human needs and motivation*. The third era is occurring now, as we search for *integrative concepts* that satisfy the dual necessities of meeting employee needs and improving productivity.

Human Relations Movement

The human relations movement focused on individuals working in group environments. Managers and employees were studied in terms of group dynamics. Early contributors to the movement concluded that by improving workers' satisfaction with their jobs, companies could improve their performance. Thus, managers were encouraged to be more cooperative with workers, to upgrade the social environment at work, and to reinforce individual employees' self-images. One of the early contributors to this movement was *Kurt Lewin* (1890–1947), who examined the effects of different types of leadership and wrote extensively about group behavior. Another was *Chester I. Barnard* (1886–1961), who advocated conciliatory management relations that enhanced cooperation between employees and supervisors.[11] The concepts of Lewin and Barnard are amplified in Part IV, where we discuss motivation, leadership, and organizational change.

Mary Parker Follett (1868–1933) was also one of the founders of the human relations movement. She felt that managers were responsible for motivating employees to pursue organizational goals enthusiastically, not simply to obey orders. She rejected the notion that managers should be groomed to give orders, believing instead that they should be trained to work with employees toward the attainment of common objectives. Follett laid the groundwork for studies in group dynamics, conflict management, and political processes in organizations. Later theorists would build on her work to contribute to advancements in industrial psychology and sociology.[12]

George Elton Mayo (1880–1949) pioneered experimental research on human behavior in work settings. Mayo and a Harvard University research team conducted a series of experiments at the Western Electric Company's Hawthorne plant in Illinois. Begun in 1924 to determine the effects of illumination on employee productivity, the experiments spanned several years.[13] In his fieldwork, Mayo was initially concerned with scientific management, but his results showed that human relations and behavior were far more crucial considerations for management. The **Hawthorne Studies** have became famous as enduring contributions to management thought. Exhibit 2-3 summarizes Mayo's findings and his associates.

The implications of Mayo's work are far-reaching. After the Hawthorne Studies, organizations were viewed as social systems with both formal and informal patterns of authority and communications. Mayo was among the first to suggest that managers needed interpersonal skills for counseling employees, diagnosing personal and group needs, and balancing technical needs for productivity with human needs for job satisfaction.[14]

These conclusions may seem perfectly reasonable today, but in the context of the industrial society of Mayo's time, they were exceptional. Mayo did his research before the era of collective bargaining and safety regulations, when the

EXHIBIT 2-3 Elton Mayo and the Hawthorne Studies

The Relay Assembly Test Room. The first significant experiment by Elton Mayo and his team at the Western Electric Hawthorne plant concerned employees, all women, in the Relay Assembly Test Room. One group was subjected to changes in lighting and different methods of altering the intensity of illumination. The other group experienced no change in work conditions. Researchers monitored other environmental factors and then followed work results closely. Mayo hypothesized that changes in illumination would yield one lighting condition that created the best productivity. His experiments clearly reflected the scientific management idea of finding the "one best method" of controlling the work environment.

However, no matter what the researchers did, productivity increased among the test groups. Even more startling, it increased in the control group. Even when all conditions were set back to normal, productivity increased. Mayo considered his research a failure until he interviewed workers. His findings centered on effects of research intervention and on human relations.

Test Room employees found working there more enjoyable during the experiments because they felt they were involved in something important. Management had changed during the tests, allowing more freedom, and employees found they had a much better relationship with their supervisors and could work without fear. They also became closer as a work group because of the enhanced social contact.

The researchers concluded that human factors influenced productivity, and over several years, they conducted more research in other areas of the Hawthorne plant.

The Bank Wiring Room. A piece-rate work system was observed in the Bank Wiring Observation Room. Once again, control and study groups were formed and observations were made about human relations. Researchers found that faster workers were pressured by their peers to slow down instead of working as hard as they could. In effect, the work group set the pace and enforced standards rather than management or individuals, who had the legal right to work as hard as they wanted to. Social pressure dominated behavior.

The researchers drew several conclusions from the Hawthorne Studies. First, *recognition and attention* to individual workers motivated them to work harder. Second, *group dynamics* influenced work substantially. Third, and perhaps most important, *intervention by researchers created a perception by workers, real or not, that they were doing something of value.* The act of intervention and its impact is now called *the Hawthorne Effect.*

Source: Summarized from F. J. Roethlisberger and W. J. Dickson, *Management and the Worker* (Cambridge, Mass.: Harvard University Press, 1939).

standard workday exceeded ten hours and children worked alongside adults. Factories were dim and cavernous; managers were expected to be "straw bosses"; and employees were considered little more than productive units much like machines. (In fact, machines, being more expensive, were usually better treated.) When Mayo and his colleagues published their research findings, many thought their conclusions were irrational.

Human Needs and Motivation

motivation
The concept of behavioral change or result of influence that alters an individual's performance.

The second era of behavioral research emphasized **motivation.** This research focused on employees' personal needs and how they influenced performance. Contributions to motivation theory by several important scholars immediately after World War II inspired greater efforts to understand individual behavior in work environments. This focus led to a field of study called *organizational behavior.*

Abraham Maslow (1980–1970) based his theory of human behavior on the idea that individuals work to satisfy unfulfilled needs, including simple physiological needs, such as food, and complex psychological needs, such as self-esteem. He suggested the hierarchy of needs illustrated in Figure 2-4. Maslow observed that a fulfilled need did little to motivate an employee. For example, a person who had sufficient food to eat could not be easily enticed to do something for a reward of food. In contrast, a person with an unfulfilled need could be persuaded

FIGURE 2-4 Maslow's Hierarchy of Needs

to work to satisfy that need. Thus a hungry person might work quite hard for food. Maslow called this the **deficit principle** and suggested that managers be alert for unmet needs and then create rewards to satisfy them. One of the higher-level needs—esteem, for example—might be met by formal recognition of an employee's performance.

Maslow also formulated a **progression principle,** whereby successively higher-level needs are activated once lower-level needs are met. In Maslow's view, lower-level needs that go unfulfilled tend to take precedence in an employee's mind over higher-level needs. For example, for someone who is hungry, the need for food will outweigh the need for self-respect. This particular aspect of Maslow's work is controversial because many people ignore lower-order needs, such as safety, to satisfy higher-order needs, such as the social need for love.[15] Maslow's theory is discussed in relation to motivation more thoroughly in Chapter 13.

Douglas McGregor (1906–1964), a contemporary of Maslow's, brought a fresh perspective to management and challenged leaders to think of subordinates as responsible, capable, and creative. McGregor felt that throughout most of history leaders had treated subordinates as irresponsible and lazy. He called this approach to management **Theory X.** Theory X managers tend to be autocratic, control-oriented, and distrustful. Theory X assumptions lead managers to view human nature pessimistically. In contrast, McGregor identified a second perspective, **Theory Y,** that reverses these assumptions about human nature. Theory Y managers view subordinates optimistically as individuals who want the challenge of work, prefer self-control, and are capable of responsible, independent judgment.[16]

Exhibit 2-4 outlines McGregor's assumptions about Theory X and Theory Y management. Although these insights may seem obvious today, the world of management has not accepted Theory Y in practice. Those enlightened managers who have made the transition to Theory Y, however, have found that subordinates accept responsibility and are quite capable of individual initiative.

Integrative Concepts of Organizational Behavior

Scholars have been unable to fully reconcile Maslow's and McGregor's perspectives on human nature, and despite the importance of these two men's contributions, their theories often do not coincide with reality. Early human relations

deficit principle
A crucial aspect of Maslow's theory of motivation based on human needs that suggests an unsatisfied need becomes a focal motivator while a satisfied need no longer influences an individual's behavior.

progression principle
Abraham Maslow's concept that successively higher order needs in his hierarchy of human needs are not active motivators until lower order needs are fulfilled.

Theory X
A set of assumptions that employees are lazy, unambitious, and must be coerced to work; hence, a managerial approach based on fear tactics.

Theory Y
A set of assumptions that employees are generally responsible, want to have meaningful work, and are capable of self-direction; hence a managerial approach based on conciliatory behavior.

GLOBAL TRENDS 2-1
Hong Kong 1997—New Management Challenges

In 1997, Hong Kong reverts to the sovereignty of the People's Republic of China (PRC) and may become known as Xiang Gang. The Crown Colony of the British Empire, however, is more than an isolated island on a Chinese peninsula; it is the gateway to China and economically the busiest city in the Pacific. To 5.3 million Chinese, it is home, and for several hundred thousand foreigners, it is headquarters for trade and multinational operations. Hong Hong currently has 1,153 registered multinationals, nearly half of them U.S. corporations; this is second in number only to New York City. The city is famous for its teeming humanity, thumb-sized cockroaches, and organized crime. Today 82 percent of the population is squeezed onto less than 10 percent of Hong Kong's 320 square miles. Hong Kong is a compression of ten distinct ethnic groups, speaking twice as many dialects and representing three times as many religions and cultures.

From a commercial standpoint, Hong Kong is the busiest container freight depot in the world, erects a new forty-story skyscraper nearly every twelve months, has the world's sixth largest commercial building—and the tallest outside the United States—has the greatest number of Rolls-Royces per capita, and conducts more banking business than any other city in the world outside of New York. It is a powerhouse financial center with perhaps the most volatile and exciting stock market in the world.

The global pursuit of business will intensify in 1997 when Hong Kong provides the PRC with a commercial window to the world and a market for Western companies of 1.6 billion Chinese. Nevertheless, Western managers face unusual challenges: they must position their businesses in a socialist system, introduce technology to a nation that is at least a century behind our state of industrialization, and market in a country that lacks the commercial and financial infrastructure and the distribution system to support more than localized trade. Hong Kong will be the pivot point for global enterprise in the Pacific Rim. American companies are expected to have a strong presence there—the International Trade Association estimates that nearly 40 percent of the largest 1,000 U.S. firms will have operations in Hong Kong or the PRC by 1997.

Source: Adapted from Jan Morris, *Hong Kong* (New York: Random House, 1989), Chapters 1 and 2; and "NICs and the Pacific Rim," *International Trade Association Newsletter,* January 1989.

research was value-laden and more philosophical than practical. Classical theories, though practical, went to the opposite extreme and ignored the human side of enterprise.

integrationist
A theorist who integrates concepts of several schools of management thought to suggest improved management practices.

Behavioral scientists who followed McGregor and Maslow expanded their ideas and attempted to integrate human behavior concepts with the practical necessities of managing organization. These **integrationists,** among them *Victor Vroom, Lyman Porter,* and *Edward Lawler,* have taken McGregor's ideas, applied Maslow's need concepts, and studied how organizations can use scientific

EXHIBIT 2-4 McGregor's Assumptions on Theory X and Theory Y

Theory X Most human beings dislike work and avoid it whenever possible; they must be forced, threatened, and directly controlled in order to achieve organizational goals. Most people are lazy, prefer to be directed, shun responsibility, have little ambition, and want security. The average human being avoids leading and wants to be led.

Theory Y Work is natural, and most people prefer the physical and mental effort of working. Commitment to objectives is also a natural state for most individuals, particularly when rewards are associated with achievement. Human beings can exercise self-control, prefer self-direction, and have the capacity for innovation and creativity. Under most reasonable circumstances, the majority of people will accept responsibility, many individuals seek leadership rather than the security of being led.

Source: Adapted from Douglas McGregor. *The Human Side of Enterprise* (New York: McGraw-Hill, 1960), pp. 33–34 and 47–48.

techniques to achieve results. They have proposed methods of instituting systematic change in organizations, resolving conflict, achieving objectives through motivated individuals, and improving group dynamics for greater productivity. The central theme of integration is that understanding human behavior is the key to effective management, but that plausible management practices must still be based on scientifically sound concepts.[17]

Most recently, integrative approaches have focused on national trends in productivity and how organizations can improve their performance. McGregor's use of "X" and "Y" identifiers for management styles has been expanded to include *Theory Z,* which has become a convenient label for Japanese management philosophy. More precisely, Theory Z captures the essence of Japanese management techniques as practiced by excellent firms in the United States.

William Ouchi introduced **Theory Z** in 1981 to describe American adaptations of Japanese organizational behavior.[18] His theory is based on a comparison of management in Japanese organizations—called *J-type* firms—with management in American firms—called *A-type* enterprises. Exhibit 2-5 compares A- and J-type organizations. Ouchi recognized that cultural differences between the two nations prevent American managers from adopting Japanese techniques without modification. For example, Americans are highly mobile; we often seek opportunities, jobs, and career advancement by changing employers. Japanese workers, in contrast, tend to make a lifetime commitment to their organization. Still, Ouchi discovered similarities between practices in America's leading firms and Japanese organizational behavior. For example, in Hewlett-Packard and IBM, long-term employment has been the norm, even though it falls short of a lifetime commitment. Typical A-type firms rely on individual management decision making and J-type firms rely on collective decision making, but a number of excellent U.S. companies endorse a "collaborative" decision-making process closely approximating J-type behavior.

Perhaps the most important element in Theory Z is its combination of human relations concepts with scientific management techniques. The Z-type company endorses collective responsibility, a pervasive concern for employees, and a commitment to participative decision making. These organizations recognize individual and group needs, but simultaneously develop exceptional quality control techniques and scientific work methods. This style of management incorporates classical principles, behavioral tenets, and human relations concepts to emphasize quality and productivity. Figure 2-5 on page 49 illustrates the characteristics of a Z-type company.

Theory Z
A reference to Japanese management practices of consensus decision making, quality circles, and employee participation to enhance productivity.

**American—
Type A**

Mobile Employees. Employees seek opportunities, advancement, and career changes by moving between employers and organizations.

Personal Decision Making. Americans tend to rely on individual judgment and prefer to make decisions unilaterally, either as managers or as individuals controlling their own destiny.

Individual Responsibility. Americans prefer taking personal initiatives and shouldering responsibilities as individuals rather than in groups.

Rapid Advancement. Employees gain economically and socially from rapid advancement, with a premium on success as measured by promotions.

Specialization in Careers. American organizations are founded on specialization of skills and labor; employees create intensity in career choices and follow specialized career paths.

Explicit Control Mechanisms. Western nations emphasize explicit standards and controls for work and evaluation; employees expect explicit control mechanism and guidelines.

Focused Concern for Employees. American firms tend to view employees in their roles at work, paying less attention to the "complete" profile of the individual: family, social issues, personal health, and general well-being.

**Japanese—
Type J**

Lifetime Employment. Japanese workers tend to make a lifetime commitment to their organizations and, in turn, organizations assume responsibility for lifetime employees.

Collective Decision Making. Employees and managers seek consensus on decisions and endorse collective decision-making processes.

Group Responsibilities. Japanese prefer group processes and accept group responsibilities through conciliatory communications; group rewards are not uncommon.

Slow and Systematic Advancement. Employees rise slowly through established ranks; when opportunities arise for promotion, loyalty and harmonious behavior are considered.

General Career Perspective. Japanese organizations do not emphasize specialization but prefer flexibility and internal training so they can reassign personnel and develop skills among those who are members of the organization. Careers are linked to organizations, not professions.

Implicit Control System. Japanese organizations emphasize quality control and process control methods, often with trained engineers in operational positions, but standards and work criteria are replaced by major objectives; control is left implicitly to shop-floor decisions.

Holistic Concern for Employees. Japanese organizations take account of employees beyond the work environment and often aid in providing housing, day-care services, and mental and physical health counseling, among other things; employees are considered integral members of the total organization.

Source: William Ouchi, *Theory Z,* © 1981, Addison-Wesley Publishing Co., Inc., Reading, Massachusetts. Adapted from page 58. Reprinted by permission of the publisher.

Theory Z has inspired an exuberant effort by scholars to study J-type (Japanese-type) and A-type (American-type) organizations and how Z-type organizations might evolve in the future. Western managers are currently fascinated by the idea of achieving "productivity through people" by adopting plausible aspects of Japanese management techniques. Recent best-selling books on management have underscored these themes, and many scholars have concluded that Theory Z has evolved beyond the "fad" stage and signals a prodigious change in our corporate culture.[19]

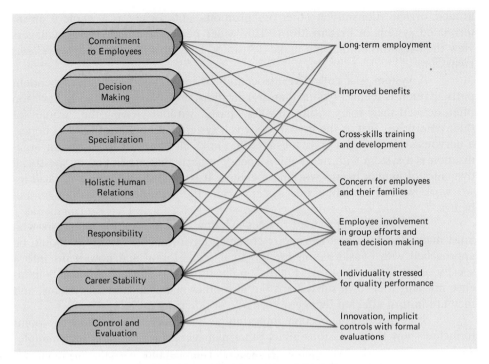

FIGURE 2-5 Z-Type Organizations: The American Adaptation

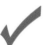

CHECKPOINT

■ What were the conclusions drawn by researchers during the Hawthorne Studies? Be prepared to critique these findings.

■ Define Maslow's *deficit principle* and his *progression principle*.

■ Contrast McGregor's assumptions about workers in *Theory X* and *Theory Y*.

■ After comparing American and Japanese management practices, discuss whether they are interchangeable. Could an American firm adopt Japanese techniques? Could a Japanese firm adopt American techniques?

CHANGING PERSPECTIVES AND CONTINGENCY VIEWS

Most astute managers recognize that the era of industrialization is being replaced by one based on information technology. Managers are studying new ways to use information technologies to improve the competitive profile of their organizations. For example, our smokestack industries, such as auto and steel manufacturing, are rapidly adopting robotics and computerized control systems in order to survive. These dynamic changes are, in turn, influencing how we view management concepts. Universal management principles, scientific management techniques, and narrowly defined human relations concepts are being reevaluated. A broader view of management has evolved, encompassing *systems theory* and *contingency management*.

Systems Theory

Managers have discovered that our rapidly changing society requires a broader perspective about organizational behavior than one limited to work groups or individual organizations. Decisions made in a single work group affect other

groups, organizations affect other organizations, and society as a whole is an interrelated system of organizations. This wider perspective alters how managers view their responsibilities and make decisions. They now need to adopt a *systems viewpoint*.

A **system** is a collective association of interrelated and interdependent parts. Even if it seems obvious that organizations are systems, managers have too often defined their roles within singular "parts" without viewing the "whole" of their enterprise. Just as the human body is a system with organs, muscles, bones, a nervous system, and a consciousness that links all the parts together, an organization is a system with many interdependent parts that are linked by the social dynamics of human beings working together. It is not the machines and facilities we work with that define our systems, but the relationships among human beings.[20]

The systems approach provides a frame of reference for managers who must make decisions in a constantly changing environment. Decisions should be approached with consideration for the total organization and how it fits into a society of other organizations. Figure 2-6 illustrates this concept. Managers influence not only their own subsystems but also other managers and subsystems, and they are in turn affected by decisions made in other organizations.

Systems concepts become important as managers broaden their viewpoint to include how their decisions affect other managers. In a hospital, for example, decisions in support areas such as X-ray departments and laboratory services affect the scheduling of patient care by ward nurses. Similarly, policies on hospital admissions often dictate laboratory test schedules, surgery schedules affect staffing patterns, and decisions about outpatient care alter physicians' responsibilities. External organizations also affect internal decisions. For example, government policies on Medicare reimbursement influence patient care and billing procedures.

Manufacturing organizations may have dozens, perhaps hundreds, of subsystems as well as many external influences. Automobile manufacturers, for example, deal with several thousand material and parts suppliers. A simple misunderstanding about delivery schedules for tires can halt an auto assembly line. Think what a power failure does to a computer service firm, or how a truck driver's strike affects local grocery supplies.

General systems theory has had a number of important implications for management. Research shows that effective communication is crucial for managing large enterprises. The emergence of systems concepts during the late 1940s created new fields such as *management information systems* (MIS). Systems theory also led to scholarly research about the general principles of management. Con-

FIGURE 2-6 A General Systems View

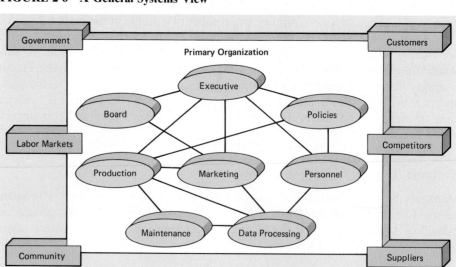

system

A collective association of interrelated and interdependent parts; organizations are systems of divisions, departments, and specialized activities.

trary to Taylor's belief, there is no "one best way" of doing anything because human behavior changes with circumstances. Therefore, instead of searching for theories with absolute conclusions, scholars have begun to focus on *contingency management* as a method of reconciling systems dynamics.

Contingency Management

The problem with the universal principles of management promulgated by early theorists is that few principles really are universal. **Contingency management** has emerged to address this dilemma. Advocates of contingency management argue that managers should adapt their leadership behavior to accommodate different situations or, alternately, should be assigned to situations that suit their leadership styles. Rather than suggest "one best way" to manage, contingency management implies that there are many effective ways to behave as managers, each depending on the circumstances of the work environment.

contingency management An approach to management that suggests leadership behavior should be adapted to accommodate different situations, or, alternatively, leaders should be assigned to situations that best fit their leadership styles.

Substantial support for contingency management comes from research showing that management methods used in one circumstance seldom work the same way in other circumstances. Parents find this out quickly when they realize that spanking one child may get good results, but spanking another can result in emotional disturbance. Some employees are best motivated by economic rewards, whereas others have a greater need for challenging work. Still others care mostly about protecting their egos. Moreover, the same individual may be motivated by different things in different situations.

If individuals are motivated by different things at different times, the implication is that managers must constantly adapt to circumstances. If performance is contingent on circumstances, effective management requires that supervisors be capable of rapidly analyzing changes and adapting their own behavior accordingly. Carried to the extreme, of course, such behavior could cause chaos, but advocates of contingency theory believe that managers can identify dominant patterns of behavior and circumstances and thereby develop compatible leadership responses.

The initial research that led to a contingency view of management focused on situational analysis. Attempts were made to find common principles of management that applied generally to similar situations. Fred E. Fiedler was among the early proponents of contingency management. He stated that managers must identify specific responses to specific problems in specific circumstances, and that a given problem and its response would be unique in each situation. Unfortunately, Fiedler did not describe situations or patterns of management behavior that could be correlated, and his research was strongly criticized. Opponents of contingency theory found nothing revolutionary about saying that what works in one situation at one time may not work in others. They argued that Fielder was advocating an unconstructive smorgasbord theory of management that offers little help to managers trying to make better decisions. Nevertheless, Fiedler voiced a common concern: that environmental factors alter both how managers behave in leadership roles and how subordinates respond to them.[21]

Scholars who have pursued Fiedler's theme have not found much evidence to support a contingency theory. Clearly circumstances affect all that we do, but no one has proposed a systematic way of classifying circumstances and appropriate management responses to them that would work for a majority of organizations. Nonetheless, there is still significant interest in the contingency approach. Fred Luthans, a researcher in organizational theory, has extended Fielder's work to identify four contingencies that must be addressed by managers:[22]

1. An organization's structure of management authority must match the demands of its environment.

2. An organization's structure of management authority must coincide with its system of technology.

3. Individual subsystems, such as departments and work groups, must match their particular environments, and management authority must coincide with the technological requirements of those subsystems.

4. The leadership behavior of managers in the organization, and in its subsystems, must be appropriate to situational demands.

The contingency viewpoint is important in the study of management because it alerts us to approach concepts and practices with some latitude. Although contingency theory has not been supported by rigorous research, this perspective does exemplify current management thought.

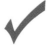

> **CHECKPOINT**
>
> ■ Describe a system of organizations and how a manager's decision in one organization might affect other organizations.
>
> ■ What are the fundamental considerations of contingency management?

QUANTITATIVE MANAGEMENT

quantitative management
An approach to management based on decision theory, use of statistical techniques for problem solving, and application of mathematical models to organizational processes.

management science
An approach to management also called the *quantitative school* that relies on models and mathematical analysis to improve decision making; alternatively called *operations research.*

The move toward an information society has fostered extraordinary changes in **quantitative management** techniques. These are the techniques used in numerical analysis of organizational problems, statistical studies, and mathematical model building to improve management decisions. One area of quantitative management is called **management science,** not to be confused with Taylor's "scientific management." Management science uses mathematical models for quantified decision making. Its methods involve rather sophisticated techniques, extensive use of statistics, and complex decision-making models. For example, a company will use consumer survey information to model probabilities of demand for its products or services, and on that basis will determine how much to produce. This will, in turn, trigger decisions about hiring employees, opening sales offices, contracting with suppliers for materials, and so on.

The historic origins of management science are found in World War II, when the Allies developed hunt-and-kill tactics for enemy submarines. Using statistical models, military experts were able to locate German submarines with high probability. They were also able to improve logistics between the United States and Europe, plan strategic troop movements, and deploy new weapon systems effectively. Today, NASA administrators rely on these techniques for bringing together an awesome array of organizations and resources to accomplish space expeditions. Large firms embarking on major projects, such as the design of a new weapon system, use management science methods to plan for and coordinate the myriad details of such immense undertakings.

Most applications of management science are reserved for complex situations requiring highly specialized knowledge. Practicing managers benefit more from mathematical techniques developed in an area we call *operations management.* Computer technology has also led to the unparalleled growth of *management information systems.*

Operations Management

operations management
The application of quantitative techniques in production and operations control using analytical models to improve organization activities.

Operations management is concerned essentially with using quantitative methods for production and operations control.[23] These methods are not necessarily mathematically complex; most of them use simple statistics and are easily understood. In this area of applied management, some of the more useful techniques are inventory control models, material-handling procedures, purchasing systems, pro-

MANAGEMENT APPLICATION 2-1
United Parcel Service

Founded in 1907, United Parcel Service (UPS) was the first commercial messenger service in Seattle, Washington. The firm grew rapidly because of its low-price, efficient organization. UPS founder James E. Casey put a premium on customer service and pioneered new work methods.

During the 1920s, Casey hired Frank B. Gilbreth and a team of scientific management consultants to improve UPS work methods. Using time-and-motion studies, the team helped create loading, package-handling, and delivery procedures for a UPS network that extended along the West Coast. Casey also stressed the concept of company "culture" seventy years before it became a common phrase in management. He wrote a monograph at the end of World War I called "Determined Men" and distributed it among his employees as a guide to UPS performance. His philosophy for efficiency and service is still circulated today.

UPS today uses many of the careful methods it developed in its early years. Drivers are timed for deliveries, strict quotas are maintained for processing parcels, and schedules are rigorously monitored. A package sorter is expected to handle 1,124 items per hour and make no more than one mistake in every 2,500 parcels. Supervisors, through tight quality control, correct those few errors. *Quality* is the key word at UPS. Operating with more than 104,000 ground vehicles and 364 aircraft, UPS delivers nearly 11 million parcels and documents *every day* to 122 countries and territories in Western Europe, the Pacific Rim, and North America. With net earnings of about $900 million on $11 billion revenue, UPS is the most profitable U.S. transportation business.

The success of UPS is based on its exquisite system of human resources. The company has 220,000 employees who are committed to high-quality customer service. Internal promotions provide employees with excellent career opportunities, and they enjoy wages and benefits well above those of UPS's competitors. Managers have a liberal stock bonus plan based on profit sharing that gives them partial ownership in the company. Looking forward to the 1990s, UPS has a cadre of 2,000 engineers who are expanding a system of five mainframe computers and nearly 20,000 personal computers to electronically control parcels in transit. The company is also training employees for multinational operations in 41 countries. One of the most innovative projects will link UPS directly into a U.S. Customs computer system to ensure that what is shipped actually passes through customs. Although labor costs are high and the company has spent heavily on automation, productivity gains by UPS keep customer prices the lowest in the industry.

Source: Behind the Shield (Greenwich, Conn.: United Parcel Service of America, 1988), pp. 1–16; "UPS Initiates Expedited Document Delivery Service to 163 Countries and Territories," *News from United Parcel Service*, April 24, 1989; and Kenneth Labich, "Big Changes at Big Brown," *Fortune*, January 18, 1988, pp. 56–58.

duction scheduling systems, and cost-control processes. The obvious applications of operations management are in production environments, but less obvious applications have substantially improved service operations. For example, banks have used the new techniques for customer service systems.

Honeywell-Bull Corporation surveyed more than 300 of its managers about MIS and found that although all managers wanted far more information support, only a small percentage were computer or "systems" literate. Those surveyed unanimously held that in the 1990s managers would have to be computer literate and understand information concepts in order to be effective.

Source: James C. Wetherbe, *Executive's Guide to Computer-Based Information Systems* (Englewood Cliffs, N.J.: Prentice Hall, 1983), pp. 7–8.

There are literally hundreds of applications for operations management techniques. Productivity has improved as a result of these applications because managers are better informed about operational effectiveness—they can simulate operations, monitor results, and reduce errors more effectively. In short, operations management methods enable managers to make better decisions.

Management Information Systems

management information systems (MIS)
Management information systems are integrated networks of information that support management decision making, often through computer applications and data base systems.

The field of **management information systems (MIS)** evolved alongside computer technology. Using computers however, is not the same as having a management information system. MIS are integrated networks of information that support management decision making. Usually the information is computerized, but an MIS also includes the human aspect of integrating information and data throughout a firm. MIS is a natural extension of systems theory, in which interrelated components of organizations must be orchestrated. It includes the vertical integration of management functions from top-level executives to first-line supervisors, as well as the horizontal integration of activities among functional areas such as production, marketing, personnel, and finance.

One of the main roles of MIS is to recognize *information as a resource* and then use that resource effectively to better achieve organizational objectives. Using information resources effectively requires MIS managers to consider how best to collect, store, process, and transmit data. Information is like other resources, such as labor, capital, and materials, except that it is usually internally generated rather then acquired. An MIS system includes people, hardware, software, data, and processes. The ultimate aim of generating management information systems is not to overwhelm managers with information, but to create systems that provide sufficient and accurate information in a timely fashion.[24]

CHECKPOINT

- Explain how management science influences decision making and helps managers to be more effective.
- Describe operation management, and give an example of an application.
- Why is information considered a resource?

At the beginning of the chapter, we gave an overview of recent changes at General Motors Corporation. Rather than "telling" employees what to do, GM managers are being encouraged to jointly determine responsibilities with their subordinates. Executives have also begun to meet informally, to listen to one another, and to emphasize teamwork. Union officials and most hourly workers, however, are skeptical about GM's sincerity. Unfortunately, the company has a half century of bureaucratic rationality to overcome, and managers have been nurtured on what is ironically called, "John Wayne individualism"—compete, win, and win, and win.

GM has yet to regain its position as the world's No. 1 automaker, and two decades of shaky performance have resulted in plant closings, layoffs, and dozens of fadlike changes that have been labeled "15-cent solutions to million-dollar problems." For example, in 1984, Smith announced he was going to reorganize management to rid GM of its inflexible bureaucracy, but the reorganization never occurred. Today reorganization is again being attempted through leadership training for more than 2,500 senior GM managers, but critics say it is a feeble effort. Nevertheless, GM is pleased with its progress toward team building and worker participation. Buick shop-floor teams cut defects by more than 90 percent during 1988, and in 1989, engineers and plant workers were making team decisions on designs for 1991 models. New bonus systems rewarding innovative ideas were set up for implementation in 1990, and all employees began to receive profit-sharing payments in 1989. The new GM plan, initiated in 1988, to change from a static bureaucracy to a flexible and innovative organization, is expected to take two decades to implement. ■

A SYNOPSIS FOR LEARNING

1. Describe the historical foundations of management practice, and understand the three major approaches to management theory.

Though management owes much to ancient cultures, management came of age with the industrial revolution. Scientific management evolved during the unprecedented economic growth of the nineteenth century. The accepted view today is to recognize three approaches to management: classical, human relations, and quantitative. Systems theory and contingency management are also important approaches to management theory.

2. Discuss the concepts of scientific management and administrative management.

Scientific management holds that there is "one best way" to accomplish any task, which can be determined through scientific research. This "optimal" method can be used to define jobs, refine processes, and organize systems of work. Administrative management does not hold that "one best way" exists. Perhaps the most influential approach to modern management, administrative management proposed fourteen important management functions that pertain to every manager in an organization.

3. Describe the rational model of bureaucracy.

Max Weber used the term *rational bureaucracy* to describe an ideal system in which positions are well defined, the division of labor is clear, objectives are explicit, and a clear chain of authority exists. Standardized systems would provide a consistent approach to decision making.

4. Explain the focus of the behavioral approach and the human relations movement.

Behavioral studies have focused on leadership roles for managers who must motivate employees to accomplish work in the most productive ways. Theorists within the human relations movement have studied situational variables—the complex interactions of individuals within work environments—and the nature of work itself.

5. Contrast American and Japanese management philosophies.

Americans are very mobile; they change jobs often, seek rapid advancement, and will make several career changes during their working lives. Japanese employees, on the other hand, are committed to one organization, seldom change jobs, and do not seek rapid advancement. Americans are more individualistic; they like to make individual decisions and rely on their personal judgment as managers. In Japanese firms, group decision making is the norm and consensus processes are encouraged.

6. Explore systems theory and contingency management concepts.

Systems theory requires managers to define their role within the entire system, which is made up of individual but interrelated parts that must be coordinated. *Contingency management* stresses that managers should adjust their leadership behavior to meet different situations.

7. Describe quantitative approaches to management and MIS.

Management science has emerged as a theoretical field on the cutting edge of high-powered mathematical modeling that provides managers with information-based systems for making decisions. These decisions encompass operational activities such as inventory control, scheduling, forecasting, production control, services, budgeting, cost control, materials management, and purchasing. Most of the models used are grounded in statistics and make extensive use of computer technology; together they constitute a branch of management called *management information systems*. Another approach to quantitative management, *operations management,* is an applied discipline of systems controls and decision making.

SKILL ANALYSIS

CASE 1 Adapting Theory Z: Can it be Done?

The following discussion illuminates attitudes toward Theory Z in some American firms. The conversation was among five executive managers and a consultant following a Theory Z seminar in Washington. Discussants included: Don, executive vice president for a telecommunications firm; Ross, president of a commercial printing firm; Cal, vice president of manufacturing for a company that makes mufflers and auto exhaust pipes; Dave, executive operations officer for a bank holding company; Paul, president of a plastics fabricating firm; and Bob, the lead consultant at the seminar.

"What I don't understand about the Japanese," Ross said, "is how they get employees to cooperate in groups. I mean, we have quality circle groups

BUSINESS ETHICS

Business ethics concerns moral right and wrong as applied to business enterprises, executive policies, and behavior. Because our major business institutions largely determine who will carry out the work of production, how work will be organized, what resources that work will consume, and how profits will be distributed, we have become extremely sensitive to the *ethics* of accomplishing those tasks.[4] This sensitivity has led to pressure on government to regulate corporate behavior, and to a corresponding pressure against intervention. These points are discussed later in the chapter, but it should be clear that business ethics has become one of the most challenging issues facing managers today.

business ethics
The concept of moral right and wrong as applied to business enterprises, executive policies, and behavior.

Management Perspective

The current emphasis on business ethics does not mean that managers have only recently discovered morality, nor that their organizations have only recently become socially responsive. To the contrary, most of our leading companies have been concerned with ethical behavior for many years. Xerox Corporation had equal employment practices for hiring minorities a decade before affirmative action legislation was passed in 1972. Westinghouse Corporation instituted policies of equality in compensation and employee promotion to eliminate sex biases during the 1950s, nearly twenty years before the Fair Labor Standards Amendment of 1974. Du Pont introduced rigorous standards for hazardous waste disposal during the 1940s, long before the Environmental Quality Protection Act of 1970. Other companies, such as the Hewlett-Packard Corporation, established programs to enhance the work environment during the 1930s. Management Application 3-1 profiles Hewlett-Packard's initiatives. Consortia of companies and professional associations, including the American Institute of Certified Public Accountants, the Public Relations Society of America, the National Association of Manufacturers, and the Business Roundtable, have developed comprehensive "codes of ethics" to guide members' behavior.[5]

Most professional associations deal with standards of ethical behavior as an extension of other issues. For example, the American Institute of Certified Public Accountants has established a code of conduct for members but focuses primarily on accounting rules and practices for CPAs. This is not the case with the Business Roundtable, which was founded in 1972 specifically to study business ethics and to refine corporate expectations for business conduct.[6] The Roundtable is made up of more than a hundred top executives from the nation's most respected companies, including American Express, Boeing, Champion International, Chemical Bank, John Deere, General Mills, General Motors, GTE, Hewlett-Packard, Johnson & Johnson, IBM, McDonnell Douglas, Norton, and Xerox. The spirit guiding the Roundtable can be traced to the early postwar period, when major firms began asking how they were to conduct business in the new complex global environment.

In 1945, Boeing Company's CEO William Allen articulated a code of ethics that ranged from employee relations to contracting with foreign governments. Allen's approach was one of encouragement rather than regulation, and Boeing managers and employees not only accepted a code of ethics, but actually nurtured it. Under Allen, Boeing established a reputation for "squeaky-clean" behavior that endured for nearly three decades. Allen is reported to have had one standard for his own conduct: He wanted to do the right thing, not merely comply with the law or respond to pressure.[7]

Chemical Bank of New York, a financial institution with 270 branches in the United States and 55 foreign offices, provides an example of ethics in a service enterprise. In 1988, it was ranked fourth among the Fortune 100 in commercial banking, with $78 billion in assets and more than 28,000 employees.[8] Long before equal opportunity in employment was mandated by law, Chemical Bank created

MANAGEMENT APPLICATION 3-1
Hewlett-Packard's Commitment to Employees

 Hewlett-Packard emerged from a modest garage during the 1930s to become one of the most admired corporations in America. Among the earliest high-tech entrepreneurs, William R. Hewlett and David Packard were in Silicon Valley forty years before it was known by that name. Commitment is the singular value on which HP was built, and while the firm has had a few minor layoffs and setbacks, it has always maintained a strong commitment to its "internal stakeholders," HP employees, as the following description shows:

> As products of the great depression, Bill and Dave decided that HP would not be a hire-and-fire organization. They felt job security was of the uppermost importance and built a company based on a loyal and dedicated work force. . . . An emphasis was placed on preserving the work force and finding the right niche for each person. The first employee was hired in 1939 . . . To protect employees, Bill and Dave established catastrophic medical insurance (in the late 1940s), which was virtually unknown at that time by other employers. An employee Stock Purchase Plan was established (in 1959) to allow a broad base of employee ownership . . . HP established flex-time working hours during the 1960s, protected employees by cross-training them, retarded expansion when it appeared to put undue burdens on employees, and in 1986, celebrated 40 years of employee participation in management decisions."

Source: "Hewlett-Packard Company: Managing Ethics and Values," *Corporate Ethics: A Prime Business Asset* (New York: Business Roundtable, 1988), pp. 66–76.

its own equal employment program. By the 1960s, it already had minority employment objectives. By the end of the decade, the bank had established lending programs for socially and economically disadvantaged customers, and in 1971, it was the first bank to hire ex-offenders in a program aimed at the social rehabilitation of "hard-to-employ" persons. Chemical Bank also holds seminars for managers in its overseas offices, and is steadfast in enforcing its own code of ethics, one that exceeds legal mandates. For example, it refuses to finance military arms exports—a legal activity—and it avoids doing business directly with South African companies.[9]

Boeing and Chemical Bank are only two among thousands of firms with ethical and socially responsible self-initiated programs. Most similar corporate efforts are hidden from view, such as minority loans programs, scholarships, charitable donations, community support service, and employee assistance programs. We usually hear about corporate ethics (good or bad) only when some incident makes headline news.

Responding to Society's Expectations

The concept of social responsibility theoretically involves the fulfillment of a firm's social obligations, but scholars have yet to define clearly what those social obligations are. From management's view, it makes good sense to avoid criticism and to "respond" to society's expectations. *Good response* will stave off controversy and keep a firm's image and sales intact. But how a company should respond in

a given situation is questionable. Should it give to the United Way? Should it actively boycott South Africa because of that country's apartheid policies? One person's values will dictate a particular set of actions, whereas another person's values will dictate another, perhaps contradictory, set of actions. Trying to gauge society's collective values on most issues is a monumental task.

To escape this philosophical conundrum, the meaning of *corporate ethics* has been revised. Instead of viewing corporate responsibility in absolute terms, many executives now view it in relative terms as **corporate responsiveness.** The rationale is that ethical behavior is judged by how well a firm is *perceived* to respond to an issue rather than by what it does in absolute terms. From a management perspective, being responsive is good business; the "absolute facts" of a situation may mean little to the public. For example, in the public's perception, the absolute fact that the Ford Pinto had a flaw that caused its gas tanks to explode was not the issue; the reluctance of Ford to recall the flawed models was. Asbestos illness at John Manville chemical plants was a serious problem, but it was not the critical issue in lawsuits. Instead, litigation focused on whether managers knew about the asbestos situation and tried to rectify it. Some knew, none responded, and the firm went bankrupt.[10]

Whistleblowers

News of asbestos illnesses among employees at John Manville chemical plants was "leaked" to the press, design flaws in the Ford Pinto came to the attention of consumer safety advocates through "anonymous" tips from inside Ford Motor Company, and dangerous hazard waste disposal practices at the Love Canal near Buffalo, allegedly by Hooker Chemical Company, were "revealed" to the press by a company engineer. In each instance, individuals who "blew the whistle" did so cautiously and in fear of losing their jobs. **Whistleblowers** are employees who go against their employers to publicly reveal unethical behavior. They do so as an act of conscience, frustrated by their company's lack of response (or outright cover-up) that allows an unethical practice to continue.[11]

Whistleblowers have little protection, and they risk a great deal by their actions. Even if they do not lose their jobs, they can be passed over for promotion, personally harassed, assigned to unpleasant tasks, ridiculed by co-workers, and blackballed in their profession. Many are dismissed, although in recent court cases, fired whistleblowers have been awarded damages and reinstated in their jobs. This is hardly a satisfactory solution, however; whistleblowers find little comfort in winning a lawsuit when their employers, peers, and, in some instances, families condemn their acts. Whistleblowers are often publicly applauded for having the extraordinary fortitude to reveal socially irresponsible activities within their companies, but privately denounced for their disloyalty.[12]

Once again, the critical issue is not the "absolute facts" of an incident but the *perceived* response, or lack of one, by a company. This often leads to the implicit assumption that if things are so bad in one area that an employee feels compelled by conscience to risk his or her career to blow the whistle, the company is probably covering up many other unethical practices. That assumption may be substantiated by investigation, or it may turn out that the problem that prompted the whistleblowing was an isolated incident. Either way, the company will have to endure the repercussions of a public denunciation. Corporate responsiveness, therefore, is good business, and managers find that a *planned response* is the best and most profitable course of action.

Planned Responsiveness

Responsiveness implies two types of actions. On the one hand, responsive managers may recognize *potential* social problems and *proactively* do something about them before they become crises. On the other hand, managers may be so jarred

by events that they are *pushed* into reacting to those events. In the latter instance, they are responding to problems that already exist.

A **proactive response** is illustrated by self-initiated actions by a company to withdraw a defective product from the market. A **reactive response** is illustrated by the same firm being forced to withdraw the defective product from the market. A forced response might be caused by something as simple as a local news story alleging that a product is defective. It can result in huge class-action lawsuits if the company does not respond in a way that is perceived to be appropriate by the public. For example, the Gerber Products Company immediately recalled half a million jars of baby food following a news story in 1984 that reported glass fragments in their baby food. A full investigation was conducted by the Food and Drug Administration and by Gerber research teams, and the consumer complaints were found to be unwarranted. No glass fragments were found in Gerber's baby food. A second news story two years later in 1986, again claimed that customers had found glass slivers in Gerber's baby food. This time, Gerber's refused to recall their products without evidence and stated publicly that the allegations were false rumors. Once again, the FDA investigated thoroughly and exonerated the Gerber Products Company. Glass was found in the complainant's baby food, but the FDA concluded that it was the result of her dropping a grocery bag and cracking the baby food jar. The decision by Gerber executives not to recall their baby food jars, even though appropriate, was questioned by the public; Gerber's products were boycotted in some stores, and its baby food sales dropped off sharply for more than a year.[13] Society will evaluate the firm that "reacts," passing favorable judgment on managers who seem to respond expeditiously and honestly, while condemning those who do not.

The Continuum of Response

Managers have few hard-and-fast rules to guide them toward an appropriate response, but there is a *continuum of social responsibility* with four types of responses serving as benchmarks. When a problem occurs, such as the rumors about Gerber's baby food, managers may deny any wrongdoing and resist taking any corrective action. They may also resort to a legal defense, using factual information to support behavior that has met the "letter of the law." Or they may respond in earnest to resolve the problem, as Gerber executives did during the first recall of baby food in 1984. Finally, they may try to prevent the problem from occurring in the first place. For example, the FDA found that the Gerber Products Company had exceptional production technology and quality controls that would prevent glass fragments from getting into baby food. These four responses are points on a continuum illustrated in Figure 3-2.[14]

- *Obstruction* is a categorical rejection of wrongdoing. Managers resist investigation and obstruct change, even to the point of fighting compliance laws in court.
- *Defense* is rationalization through meeting legal requirements—complying with the letter of the law to minimize cost and interference while using the law as a shield.
- *Accommodation* is the acceptance of social responsibility to take positive and ethical actions to rectify questionable activities with candid and open communications.
- *Proaction* is the planned effort to identify potential problems and to take positive and ethical steps to prevent questionable activities from ever occurring.

Clearly, it is less risky for a firm to take a *proactive* approach and create programs that will help avoid problems than to adopt a *reactive* approach, which

FIGURE 3-2 A Continuum of Managerial Response

invites public scrutiny. Reactive behavior implies "crisis management" and correlates to *obstructive* or *defensive* behavior on the continuum. Managers who choose *accommodation* are "reacting" to a problem after the fact, but theirs is a plausible and responsible response because they are candidly trying to resolve issues ethically. Since managers cannot anticipate every problem, accommodation may be the most they can do in a given situation. *Proaction* implies a conscious effort to avoid crises. Effective relationships between organizations and their stakeholders are established by managers who consciously adopt proactive behavior. Managerial relationships are studied next to illustrate the point.

CHECKPOINT

- ■ Define business ethics and explain why there has been increasing pressure on government to regulate corporate behavior.
- ■ Review the presentation on the business roundtable and explain why business leaders emphasize the need for professional "codes of conduct."
- ■ What is meant by "social responsiveness"?
- ■ Identify the primary types of responses on the "continuum of social responsibility."
- ■ Assume that you are in a managerial position and are asked to pass on unsafe products to consumers because the firm cannot afford to correct product errors. How would you respond? Would you "blow the whistle"?

MANAGERIAL RELATIONSHIPS

A systems viewpoint helps us understand relationships that exist between managers and their organization's stakeholders. Managerial behavior must recognize systems, such as a network of companies in an industry or an organization as part of the local community. Each part of a system, however, has a boundary separating it from other parts. An organization, for example, has a purpose, a membership, and perhaps physical facilities that separate it from other organizations. College students and local citizens not part of campus life separate themselves with perceptual boundaries so that a "town and gown" system of two diverse groups evolves. In organizational terms, there are hundreds of internal and external systems of groups that must develop working relationships. These relationships are influenced by managers through *boundary-spanning roles*.

boundary-spanning role
A managerial responsibility created by proximity to external constituents to link their interests to those of the company through effective communications.

One who has a **boundary-spanning role** is responsible for linking the organization with its external constituencies.[15] This can be a formal responsibility prescribed for, say, a public affairs officer, who is expected to keep up with any changes that may influence a company's operations and to communicate information about the company to external constituencies. Purchasing managers are "boundary spanners" as they conduct business with suppliers; so are senior executives of corporations when they provide vital communications linkage with stockholders, lenders, competitors, government agencies, and customers. Lee Iacocca of Chrysler has said that his singular job was to bridge a credibility gap between Chrylser and its customers.[16] Victor Kiam, CEO of Remington Products, Inc., explains that when he bought the company, the crucial issue was to sell the Remington Electric Shaver by selling the quality of the company—to bankers, investors, dealers, suppliers, and customers.[17]

Boundary-spanning roles can also be informal. They are implied by the nature of a manager's job. Marketing managers are expected to span the boundaries between the company and its customers and also to improve the company's image in the community. This can be accomplished, for example, by joining a Rotary club or by doing volunteer work with the United Way. Labor relations managers are expected to span the boundaries between a company and its employees' union and also to support programs that make the company a good place to work for everyone. For example, a company may institute internal safety training programs or make external efforts to improve neighborhood housing, thus helping to make the community a pleasant living environment.

Boundary-spanning activities define how relationships evolve within various systems and between an organization and its stakeholders. Figure 3-3 illustrates this link with social responsibility. Social responsibility, and the more pragmatic concept of social responsiveness, depend on stakeholder perceptions, not hard-and-fast rules. Nevertheless, the patterns of relationships within stakeholder groups help managers guide their behavior.

Customers

All organizations have customers. Private-sector, for-profit firms sell products or services. The federal government serves American citizens collectively. Schools have a customer base in students, parents, and the wider network of social organizations, such as future employers, who rely on well-educated youth for the next generation of employees. Not-for-profit organizations such as the United Way serve constituents that include the Red Cross, the Boy Scouts, and various charities. Figure 3-4 shows several of these relationships.

The term *customers* may sound inappropriate in some instances—one does not usually think of the Red Cross as serving customers—yet managers in all organizations must provide value to their clientele. Politicians who fail to serve the needs of their constituents will be voted out of office. Universities that fail to provide quality education will cause their students to switch to other schools. Even deserving organizations such as the Boy Scouts will lose public support and funding if their programs become shoddy or their leadership weak.

Social responsibility in customer relations means creating an exchange of value between buyers and sellers. That exchange may come through prices paid for products and services, votes, donations, or community support for programs. Social responsibility to customers has several broader meanings as well. It means providing safe and reliable products, being honest in advertising (or political campaigning), and embracing lawful and ethical behavior within the community. As we shall see later, social responsibility also includes the obligation of organizations to resolve social issues such as equal employment. Although these meanings go beyond a narrow interpretation of customer relations, the image a firm projects to its corporate citizenry influences customers and their decisions to do business with the firm.

FIGURE 3-3 Boundary-Spanning Relationships

FIGURE 3-4 Customer, Client, and Constituent Relations

Employees

Perhaps one of the most rapidly changing areas of management is attitudes toward employees. Until recently, employees were viewed as elements in the economic development of the firm; more specifically, labor was treated as a factor of production. This viewpoint resulted in generations of adversarial relations between managers and their employees. Employees, for their part, saw managers as exclusively representing owners' interests. Today enlightened managers avoid this archaic relationship and encourage organizational members to take an active interest in their firm's fate. Figure 3-5 contrasts these two views.

Indeed, opinion leaders voice a growing belief that employees have property rights in their organizations stemming from their investments of time and labor. Peter Drucker believes these rights to be as valid as those of financial investors.[18] In Japan, the concept of an organization is not based on property rights or financial investments but on the collective membership of human resources. Therefore, the Japanese tend to view employees and managers as partners in a social entity. Extending this view to a systems perspective, Japanese organizations are often jointly committed to successful endeavors so that community citizens, government agencies, and religious groups all feel they have a vested interest in how well companies do.[19]

This philosophical change in organizational relations has instigated a number of efforts to involve employees in decision making. As we shall see later—specifically in Chapter 10 when we discuss authority and in Chapter 14 when we discuss leadership—various forms of participation and team management processes have evolved. Most derive from the idea that all individuals in an organization are responsible for their organization's conduct and are accountable for results. Social responsibility is everyone's concern; managers and nonmanagement employees must foster ethical behavior to support social values and lawful activities.

A human resource viewpoint. A prevalent view of social responsibility concerns how organizations respond to society's expectations for human resource management in relation to employees. From this perspective, managers are held accountable for equal employment opportunities, equity in pay and promotion, elimination of unjust situations such as racial discrimination, and the lawful administration of corporate affairs. Government legislation mandates certain types of practices, such as compliance with affirmative action guidelines, but the public's image of a firm is seldom governed solely by its compliance with laws.

FIGURE 3-5 Traditional vs. Enlightened View of Employees

Resource considerations. Relatively little regulation exists at the second level of competition: resources. The struggle for resources can be cutthroat; at the minimum, it is an arena of intense free enterprise. Significant research in this field has been conducted at the Harvard Business School and published by Michael Porter in his exceptional work *Competitive Strategy*.[26] Porter explains that organizations must not only have access to sufficient raw materials, but must also generate cost-effective relationships with resource vendors. He extends the concept of strong vendor relationships to financial sources (bankers, money market brokers, and stockholders), subcontractors of equipment, tooling, and parts, and labor markets (employment bureaus, universities, and unions).

Organizations compete for raw materials on a daily basis. Purchasing managers vie for price advantages, quality materials, advantageous shipping schedules, and preferential treatment by suppliers. When purchasing is effective, a firm's cash flow is improved while its costs are minimized. If, for example, a company spending 40 percent of its money on material is able to acquire the same materials for 10 percent less, that represents "up-front" cash. This gain can be directly passed on to consumers through lower prices, resulting in a significant marketing advantage for the company. In many highly competitive industries, profits are rather small, so a slight savings in materials can have a huge impact on profit margins.

Competition for materials can sometimes result in unpleasant or illegal behavior. Bribery is not unusual, particularly if raw materials are located overseas, where "buying" supply contracts is a way of life. Special favors and gifts to suppliers are not uncommon, and other unethical tactics range from kickbacks to providing "escort services" for buyers. The importance of securing ample materials at favorable prices cannot be overemphasized, but clearly the potential for managerial misconduct is substantial. To reduce corruption, the federal government enacted the 1977 Foreign Corrupt Practices Act. Although it is specifically aimed at multinational operations, the act has substantially influenced all supplier-purchaser relations.[27]

Technology considerations. Competition for materials and supplies is mirrored by fierce competition for new technology and advantageous use of innovations. Patents, copyrights, and trademarks help protect organizations to some extent, but there is still a tremendous amount of corporate piracy. This activity is particularly evident in high-tech, high-growth industries such as computers and microcomputer software. Few guidelines exist for these growth industries. Even in those instances where the law is clear, piracy of innovations such as valuable software programs cannot be adequately policed.[28] Patents and other means of legal protection provide a form of legal retribution, but they cannot prevent the theft of technology. They are of little help to a firm that has spent years perfecting a new product only to have it compromised, copied, or stolen by competitors.

Personnel considerations. Pirating of personnel is also a common business problem. Competition becomes conflict when organizations surreptitiously entice key managers, inventors, engineers, or other important personnel away from one another. The loss of a key molecular geneticist, software developer, or computer systems designer can destroy an emerging firm. Key individuals who change jobs take with them knowledge of their previous organizations. Gaining an insider's view of a competitor's operations and knowledge of a competitor's proprietary technology gives the acquiring firm a tremendous advantage. It is not surprising that well-placed managers in high-tech firms enjoy huge under-the-table bonuses along with extraordinary salaries and benefits. In an age when knowledge is a premium resource, corporate espionage has given new meaning to the task of personnel recruitment.[29]

CHECKPOINT

■ What is a "boundary-spanning role" for managers?

■ Identify and discuss the various constituents that influence managers and their decisions.

■ How have employee relations changed in recent years? Argue from the viewpoint of property rights and employee expectations.

■ Describe various aspects of competition and how managers must concern themselves with ethical relationships between competitors.

■ Review selected legislation related to consumer protection and explain how each benefits consumers.

GOVERNMENT REGULATION

Competition is ultimately regulated by federal and local governments, and although laws sharply distinguish between legal and illegal conduct, few managerial decisions are so clear-cut. Courts are therefore called upon to rule on cases, and when these decisions become a matter of record, they add to the body of regulation. In most instances, court decisions simply clarify legislation, but clarification often means more restrictive interpretations of regulations that further limit managerial freedom to make decisions.

It is natural to think of business regulation as a federal province because nearly fifty major statutes have been enacted since the mid-1960s. (Exhibit 3-2

EXHIBIT 3-2 Selected Major Legislation Related to Business

Pure Food and Drug Act, 1906

Federal Trade Commission Act, 1914

Water Power Act, 1920

Food, Drug, and Cosmetics Act, 1938

Federal Water Pollution Control Act, Amendments of 1961

Oil Pollution Act Amendments, 1961

Air Pollution Control Act, 1962

Drug Amendments of 1962

Clean Air Act of 1963

Equal Pay Act, 1963

Civil Rights Act of 1963

Automotive Products Trade Act of 1965

Water Quality Act of 1965

Fair Packaging and Labeling Act, 1966

National Traffic and Motor Safety Act, 1966

Child Protection Act, 1966

Age Discrimination in Employment Act, 1967

Air Quality Act, 1967

Consumer Credit Protection Act, 1968

Radiation Control for Health and Safety Act, 1968

Child Protection and Toy Safety Act, 1969

Natural Environmental Policy Act of 1969

Environmental Quality Improvement Act of 1970

Occupational Safety and Health Act of 1972

Equal Employment Act, 1972

Consumer Product Safety Act, 1972

Noise Control Act, 1972

Rehabilitation Act of 1973

Fair Labor Standards Amendments of 1974

Employee Retirement Income Security Act, 1974

Magnuson-Moss Warranty Act, 1975

Resource Conservation and Recovery Act, 1976

Foreign Corrupt Practices Act of 1977

Pregnancy Discrimination Act of 1978

Fair Debt Collection Practices Act, 1978

Trade Agreements Act of 1979

Comprehensive Environmental Response, Compensation, and Liability Act, 1980

Economic Recovery Tax Act (ERTA), 1980

Tax Equity and Fiscal Responsibility Act (TEFRA), 1982

Deficit Reduction Tax Act, 1984

Tax Reform Act of 1986

lists some of this federal legislation.) State and local governments, however, also exert tremendous influence over businesses. Local authorities, for example, administer license laws, constrain operating hours, regulate advertising, impose taxes, and police environmental protection laws. State governments regulate legal forms of business, hazardous waste disposal, insurance, and employment practices. Agencies at all levels of government influence business by exercising power. For example, the Internal Revenue Service exerts control through its interpretation of tax laws. At the executive level, presidential orders—called Executive Orders—carry the weight of law even though not enacted through Congress.

The number of laws affecting business has increased prodigiously in recent years, so it is not surprising that Americans have mixed emotions about legislative intervention. Those managers who spend time and money filling out forms and wrestling with regulations may feel harnessed to a system of lawful oppression. Yet managers who benefit from government intervention praise it for forcing improvements on society. Let us examine both viewpoints.[30]

The Case for Governmental Regulation

The federal government has a constitutional mandate to protect individuals through effective legal systems, provide protection of property rights, create services that benefit a majority of citizens, and ensure national security. It follows that services such as fire and police protection, court systems for adjudicating disputes, and military agencies are undisputed responsibilities of public institutions mandated to promote the general welfare. When government becomes involved in regulating how employees are hired, disciplined, fired, or retired, the mandate is far less clear. Supporters of government regulation point to an impressive body of evidence that business managers have exploited workers, mismanaged human resources, and made poor decisions about equal opportunities, thereby compelling our society to rely on government intervention. The underpinning of this argument is that when business fails to manage itself effectively, the only recourse is government coercion.[31]

Many business organizations benefit directly from regulations such as protective trade tariffs, antitrust legislation, fair pricing statutes, securities and investments regulations, truth-in-advertising laws, and a host of guidelines relating to safety, radiation control, credit reporting, bank reporting, and hazardous materials controls. Businesses are also aided by regulating agencies such as the Food and Drug Administration, the Federal Communications Commission, the Interstate Commerce Commission, and the Securities and Exchange Commission. Not all managers agree that regulation by these agencies is beneficial, but supporters of it frequently cite advantages gained by firms and industries through regulatory controls.[32]

The arguments for and against government intervention often stereotype managers as categorically against regulation. The same polarization process labels business managers as cold, unfeeling capitalist bureaucrats who pollute rivers, dump radioactive materials in school yards, and exploit employees to make a profit. Such stereotyping is unfortunate because the vast majority of managers are humane, responsible, and concerned citizens. Many also support government intervention, believing that regulation will not affect well-managed firms.[33]

The Case Against Government Regulation

Most arguments against regulation center on cost and profit issues. Social obligations, particularly those imposed by law, are costly. When reasonable, these costs are not at issue. But the burden of meeting government-imposed reporting standards, documenting behavior, and otherwise informing government agencies of

The Goodyear Tire & Rubber Company reportedly used 3,200 poinds of paper to write a 345,000-page report *in one week* to comply with Occupational Safety and Health Administration (OSHA) guidelines. Goodyear estimated that it spent $35.5 million and consumed thirty-four employee-years simply to meet reporting mandates to federal agencies in one year. That figure would have been more than doubled if state and local reporting had been included. In the same study, a survey of forty-eight major U.S. companies showed that more than $2.6 billion is spent on compliance reporting annually.

Source: Ralph E. Winter, "Paper Weight: Many Businesses Blame Government Policies for Productivity Lag," Wall Street Journal,October 28, 1980, p. 1.

business operations can be tremendous. Complying with regulations, however, arguably detracts from profits and provides little value to a company in return.

Economists have estimated that the direct costs of federal reporting exceed $100 billion annually, and even that estimate has been refuted as too low. A prestigious study by the Brookings Institute estimated that program costs associated with just one agency, the Environmental Protection Agency (EPA), are more than $50 billion per year, with increases approaching $10 billion annually projected for the early 1990s.[34] The study also found no measurable improvement in environmental factors in any of the major EPA program areas.

Critics of regulation cite these extraordinary costs coupled with massive diversions of resources to unproductive ends.[35] The effect on business is that stockholders, consumers, and employees come off second best. Stockholders lose in terms of reduced profits; hence, firms with stiff regulatory obligations tend to be less attractive to investors. Consumers lose by having to pay higher prices for goods and services to cover the increasing costs of the compliance burden. Employees, particularly managers, have to redirect efforts away from operations toward compliance activities.

The Brookings Institute suggested several other, more subtle problems with regulations. New enterprises, for example, must comply with many more regulations and meet more rigorous guidelines than established firms. The reason is that older firms simply could not continue doing business at the levels of compliance required by most government agencies, so the legislation specifically exempted them from making sudden and comprehensive changes. An interesting but perplexing result of this policy is that in regions of the country with older industrial concentrations, such as the Midwest and Northeast, compliance costs are lower than in growing regions with more new businesses, such as the South. In effect, new high-growth enterprises are hobbled by mountains of regulations.

Opponents of government intervention maintain that in a free enterprise system, government involvement must be minimized. Nobel Prize laureate Milton

4

Decision Making

Walt Disney introduced *storyboarding* as an organizational form of decision making hundreds of years after Leonardo da Vinci devised it to construct large murals. In creating the first storyboard, Leonardo made hundreds of small drawings—each representing part of a proposed mural—then affixed them to a wall so that he could study them. Disney appropriated Leonardo's visual technique, constructing a huge cork-covered wall and inviting teams of artists to pin their drawings to it, study a story plot, and develop a sequence of animation. He found that the storyboard encouraged a wealth of new ideas for stories, movies, and graphic innovations.

General Electric has built replicas of Disney's cork-lined wall to encourage creative thinking among managers. Teams with a specific problem to solve gather at a meeting and each person jots down ideas on small cards that are pinned to the wall. The cards are arranged under various headings, such as "New Designs" or "New Manufacturing Methods." Team members then debate these ideas, discarding most, rearranging some, formulating new ones. GE first implemented the storyboard technique at its thirty-year-old dishwasher facility in Louisville, Kentucky, during the 1970s. In terms of ideas, it was great success. Managers and engineers came up with a futuristic automated manufacturing plant with major product innovations. Not all team members enjoyed this type of decision making, however; some became disgruntled and others engaged in heated arguments with their colleagues.

Consider the advantages and disadvantages of group decision making. Would you advise GE to continue storyboarding? If so, what advice would you offer about how to improve the process?

Few human activities are more universal than decision making. We make hundreds of decisions each day and an extraordinary number in our lifetimes. Many decisions are simple: choosing clothes to wear or selecting food from a menu. Others are complex: choosing a career major in college or purchasing a house. Managers face the same range of decisions, but unlike personal decisions, those made in organizations often affect thousands of other people. For example, Lee Iacocca's decision to restructure Chrysler Corporation preserved 100,000 jobs while eliminating nearly 40,000 others. Managers regularly make less dramatic decisions, but they still affect many people.

Our public leaders also make decisions with far-reaching implications. Decisions about tax laws, environmental standards, health services, and education alter our behavior and quality of life. For example, one of the provisions of the 1988 Congressional Trade Act requires the Commerce Department to make public thousands of scientific innovations from 700 federal laboratories. Congressional hearings have indicated that this decision means more than 3,000 new products could become commercially available.[1] Consumers will benefit from new medicines, household products, and computer enhancements, but executives of companies that will be affected by this decision have mixed emotions. Those in larger firms, such as General Electric, Merck, and IBM, with the financial and marketing strength to commercialize scientific innovations, favor the provision; hundreds of executives in smaller firms without financial or marketing strength are afraid they will be driven out of business.

Obviously there is a tremendous difference between deciding what to eat for lunch and whether to pass a major trade bill, yet all decisions are similar in that they involve a conscious selection of actions based on some logical evaluation of circumstances. In deciding to restructure the Chrysler Corporation, Iacocca had to consider 162,000 employees, numerous lenders who held more than $5 billion in loans against the company, and more than 5,000 companies that sold materials and parts to Chrysler. Simultaneously, hundreds of supervisors on Chrysler's assembly lines were making decisions about work schedules that affected only a few employees. Both Iacocca and his supervisors had to consider the risks, costs, and effects of their decisions in specific circumstances.

Another factor affecting decisions is that circumstances change, and because human beings are not only fallible but emotional, they are likely to make different decisions under a variety of conditions. It is important, therefore, to understand the nature of decision making and how managers adapt to organizational situations to make effective decisions.

THE NATURE OF DECISION MAKING

Decision making is the process of defining problems, generating alternative solutions, choosing one alternative, and implementing it. The terms *decision making* and *problem solving* are used interchangeably in the context of management because managers constantly make decisions to resolve problems. For example, if a bank teller's cash drawer is short at the end of the day, the bank has a problem to resolve. The teller may be stealing money or making mistakes, or something may be wrong with the bank's cash control methods. If the bank manager investigates and discovers that the teller has been making mistakes, a decision has to be made on how to correct the problem. The teller may be fired, given more training, or reassigned to work not requiring the same skills. Among those three alternatives, the bank manager may choose to train the employee further in cash control methods. If so, after the decision is implemented, the manager would closely monitor the employee's work to determine whether training had resolved the problem. If it had not, the manager would have to consider another alternative.

The definition of decision making should be expanded to include identifying opportunities, developing alternative action plans to take advantage of those opportunities, choosing one action plan, and implementing it. In discussing strategic planning in Chapter 6, we will stress opportunities for strategic decisions. Nevertheless, the *process* for solving problems or taking advantage of opportunities is the same. In making any decision, managers have the moral burden to help accomplish organizational goals without endangering others or misusing resources.[2] In the bank teller example, for instance, cash shortages may have occurred because of an inefficient method of handling customer transactions. If so, the manager has the opportunity not only to improve internal cash control but also to give customers improved service. He or she may select between computerizing teller transactions or adding more highly trained tellers. The choice, however, must take into account the bank's goals in the customer service area, the costs of implementing a new system, and how tellers' job responsibilities will change. Effective managers try to make logical decisions that take into consideration all relevant circumstances, people, and resources.

The nature of the decision, or the problem, will often dictate how we approach its resolution. The more complex or uncertain the issue, the more likely we will employ a *rational decision-making* technique, described in detail later in the chapter. Less complex problems or those with which we have had a great deal of experience may be resolved intuitively. In management, we also distinguish between decisions that are *programmed* and those that are *nonprogrammed*.[3] Figure 4-1 illustrates these two categories of decisions.

Programmed and Nonprogrammed Decisions

Programmed decisions are those that are made in predictable circumstances and have predictable results. Results are predictable because similar decisions have often been made before under similar, and recurring, circumstances. The high-tech age has enriched our language with new terms for old problems. *Programmed* is a term borrowed from computer jargon meaning "structured" and "having definite parameters." In making programmed decisions, therefore, managers have clear parameters and criteria, based on previous experience with similar problems. Problems are often structured and alternatives are well defined.

Many managerial decisions are structured through policy directives, rules, and procedures. For example, if it is company policy to discipline an employee who is repeatedly absent, then a manager will simply follow procedures for documenting absenteeism and decide what disciplinary measure to take. Thus company policy may require a supervisor to write an official reprimand to warn an employee that he or she may be suspended from work without pay or fired if further unauthorized absences occur. The written reprimand goes into the employee's personal folder, and if absenteeism continues, the supervisor initiates the decision to suspend or fire the person.

programmed decisions
Decisions that have been made so often under similar circumstances that past experience provides clear guidelines for managers.

FIGURE 4-1 Programmed and Unprogrammed Decisions

Students must make programmed decisions throughout college. The decision to succeed at their studies entails attaining a certain grade average to pass, a certain cumulative grade point average to graduate, and credits from certain courses to satisfy particular degree requirements. Administrators make decisions about retaining students and awarding degrees according to programmed criteria.

Most programmed decisions tend to be *routine* because managers understand the circumstances and the probable results of their decisions. Experienced managers will have made the same decisions many times before; consequently, inexperienced managers will be able to find clear guidelines to help them make those decisions. Organizations adopt analogous processes to guide managers through complex decisions about production, marketing, financing, and a host of other situations. For example, a complex purchasing decision becomes routine after a manager buys materials several dozen times; decisions about pricing, how much to order, and choosing the best suppliers follow routine purchasing procedures. Programmed decisions reduce anxiety while improving quality in decision making. Organizations achieve greater stability in their operations and a more predictable pattern of behavior through them. Yet when managers have less discretion about their decisions, individual initiative suffers.

nonprogrammed decisions
Decisions derived from unstructured analysis or generated from individual evaluation of nonroutine situations; decisions that lack clear analytical parameters or substantial precedent.

Nonprogrammed decisions are those that are made in unique circumstances and often have unpredictable results. Managers may either find themselves facing problems that are ill-defined or in a situation that has never occurred before.[4] For example, Steven Jobs and Stephen Wozniak introduced the first Apple microcomputer in 1978 without knowing who would buy it or how it would be used. Tom Monaghan's Domino's Pizza franchises numbered more than 3,000 in 1988, yet when founded ten years earlier, a "non-restaurant" with total home deliveries had never been tried before.[5] Lee Iacocca's decisions to reduce the size of Chrysler Corporation and to seek government-guaranteed loans were unprecedented in the automotive industry, but then, none of the big three automakers had ever before faced bankruptcy.

Executives almost always face nonprogrammed problems. Their task is to deal with changing circumstances that can seldom be foreseen. Henry Mintzberg researched how executives make decisions and concluded they have four decision-making roles that require significant individual judgment.[6] You may recall that in Chapter 1 we examined these key management roles: disturbance handler, entrepreneur, negotiator, and resource allocator. Because each of these roles lacks structure, people in these roles are responsible for many unusual decisions. For example, resource allocators must find new, more efficient ways to use the firm's resources. Thus Henry Kaiser substituted aluminum for steel in car bodies during the early 1950s when the steel industry was in turmoil; the result was a new industry based on aluminum products, and success for Kaiser Aluminum. Disturbance handlers must resolve problems that are unaccounted for in programmed circumstances. First-line supervisors must make decisions, for example, about how to handle employees incapacitated by drugs. Negotiators by definition must assimilate opposing viewpoints or collaborate with other individuals or groups concerning uncertain issues. This is most apparent in collective bargaining agreements with labor unions. And perhaps most important, entrepreneurs are continually engaged in finding innovative solutions to critical problems. Mitch Kapor created Lotus 1-2-3 spreadsheets for microcomputers when he recognized that accountants and bank loan officers wanted an accurate, easy-to-use, and easy-to-learn software program for performing complex calculations.[7]

Adaptability and Creativity in Decision Making

In many cases, decisions are neither programmed nor nonprogrammed but fall into a gray area between the two extremes. Thus managers may have some information about a problem and some feeling for how a similar problem was handled before, yet still lack clear guidelines for making decisions. They are expected,

eotyped as exploitative because top management chooses to endorse autocratic managerial policies or views labor as a combative force. In another firm, enlightened management may create a cohesive work environment through labor-management cooperation. Decisions throughout each firm will differ significantly. There is also a tremendous difference among individuals in their abilities to handle risk. Some managers are **risk averse:** they avoid situations with perceived risk or uncertainty. Others are **risk takers:** they are eager to take on high-risk problems in uncertain circumstances. Decisions at the higher levels reflect individual managers' attitudes toward risk, and subsequent decisions by lower-level managers reflect the attitudes toward risk of influential superiors.

Step 7: Implement the Decision

Few managers have the luxury of making decisions and having others carry them out. Most managers have the responsibility for their decisions and for subordinates who must act on their recommendations. For example, James R. Houghton, chairman of Corning Glass Works, announced a strong commitment to improve quality at Corning in 1986, and then set up an internal training institute to educate the company's 20,000 employees in quality improvement techniques. The "problem" was how to improve quality at Corning, and the "decision" was to create a company-wide commitment to quality through education and training. The "alternatives" considered were more forceful work rules, bonus incentives, and hiring quality consultants to help reorganize the company. The action plan that Houghton chose to implement was a five-year in-house training program with the objective of improving quality by 90 percent by 1991. Houghton felt responsible for setting a tone, so he was among the first students in Corning's institute, and he set aside five hours every week to talk informally with employees about the quality program. Houghton also listens to his employees, and when one has a recommendation that can improve Corning's performance, that individual is given the responsibility and backing to see that it is implemented.[21]

As we progress through the text, it will become apparent that all four major functions of management are intertwined in the implementation process. Planning is primarily a decision-making activity. By *planning,* managers define an organization's objectives and formulate action-based alternatives. Then resources and personnel are *organized* to support those alternatives. Managers carry out their actions through effective *leadership. Controlling* those activities concludes the cycle and is important enough to constitute a separate step in the decision-making process.

Step 8: Evaluate and Adapt Decision Results

The final step is concerned with controlling activities that reinforce decisions. Once decisions are implemented, controls are needed to guide action toward desired results. This is, of course, essential for implementation, but effective managers use control and feedback mechanisms not only to ensure results but also to provide information for future decisions. To continue the example of Corning Glass, during the first three years of the quality training program, periodic questions were developed to solicit opinions and recommendations on the program from every Corning employee. Houghton noted that 99 points emerged from the employee surveys, each one leading to constructive modifications in the company's operations. New quality control measures were also put in place, and Corning has a consumer feedback system to evaluate how buyers perceive the quality of the company's new products.

Illustrating a Decision. Figure 4-5 illustrates a complete rational decision-making process for purchasing a computer. This is the type of decision made

risk averse
An aversion to taking perceived risks, preferring instead to make decisions with a high degree of clarity.

risk takers
A propensity to pursue risks by those eager to resolve problems with uncertain outcomes.

FIGURE 4-5 Buying a Business Computer: An 8-Step Decision Process

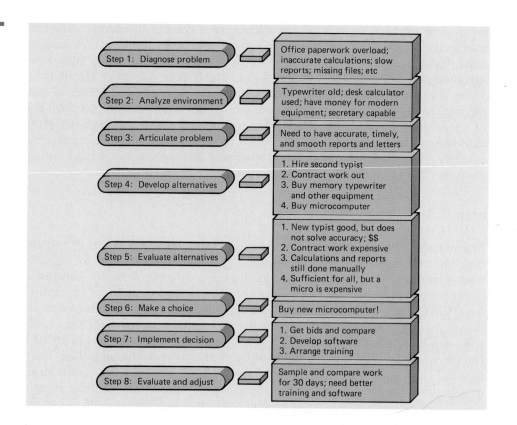

Step 1: Diagnose problem → Office paperwork overload; inaccurate calculations; slow reports; missing files; etc

Step 2: Analyze environment → Typewriter old; desk calculator used; have money for modern equipment; secretary capable

Step 3: Articulate problem → Need to have accurate, timely, and smooth reports and letters

Step 4: Develop alternatives →
1. Hire second typist
2. Contract work out
3. Buy memory typewriter and other equipment
4. Buy microcomputer

Step 5: Evaluate alternatives →
1. New typist good, but does not solve accuracy; $$
2. Contract work expensive
3. Calculations and reports still done manually
4. Sufficient for all, but a micro is expensive

Step 6: Make a choice → Buy new microcomputer!

Step 7: Implement decision →
1. Get bids and compare
2. Develop software
3. Arrange training

Step 8: Evaluate and adjust → Sample and compare work for 30 days; need better training and software

hundreds of times a day in thousands of organizations. When buying a personal computer, for example, we want to consider price, software availability, service support by the vendor, and perhaps the attractiveness of the model. We are also concerned with the type of computing tasks to be done; thus the speed and performance of the computer will be critical. We might also be concerned about compatibility with other computers at work or school. Other things that influence our decision might be the reputation of the vendor, favorable financing, and our emotional bias toward one brand or another.

CHECKPOINT

■ What are the steps in a rational decision process? Create a flowchart of the decision-making process and explain what a manager does in each step.

■ Why is it important to analyze both the internal and external environments when trying to identify the right problem to solve?

■ Discuss the three elements of a "viable" alternative. They are sufficiency, feasibility, and realism.

THE DECISION-MAKING ENVIRONMENT

The rational decision-making process may seem cumbersome to those who have made few complex decisions. Actually, it is not always necessary to follow a complicated routine. The nature of a decision and the conditions surrounding managers will influence how decisions are made.

Certain environmental factors influence decisions more than others. Under conditions of risk or uncertainty, decision makers must deal with complex issues. When conditions are certain, decisions reflect "choice making" with less complex issues. Figure 4-6 illustrates these conditions. We will now look at each one closely.

FIGURE 4-6 Conditions for Decision Making

Certainty

Conditions are **certain** when managers know outcomes under each set of alternatives. Therefore, choosing one alternative will have a defined result. Another choice will have a different and equally well-defined result. Decision making under these certain conditions seldom requires a lengthy process of investigation; a manager just selects an alternative and takes action. In another example, a manager faced with choosing among several different pieces of machinery will be given certain prices, and if the choice is strictly based on the purchase price, the decision is certain: buy the least expensive item.

Risk

When outcomes are not clear, but managers have enough information to assess results, a condition of risk exists. **Risk** assumes that a manager can calculate statistically the probabilities of outcomes associated with each alternative. Most managerial decisions involve risk; this accounts for the strong emphasis on teaching statistics in business schools. Risk also accounts for the premium placed on experienced managers who have faced risky decisions in the past and are better prepared than less experienced managers to judge probabilities of success or failure. Information and decision sciences play vital roles in decision making under risk conditions. The greater the amount of accurate and timely information managers have on a subject, the greater the likelihood that they can establish probabilities with reasonable reliability.

In organizational environments, the ability to estimate probabilities is important for making decisions about a wide array of investments, planning new products, entering new markets, estimating consumer behavior, and so on. In forecasting sales, for example, managers try to estimate how many customers are likely to buy products at a given price over a given period of time. Clearly, the best sales forecast can have errors because customers may say they will buy and then change their minds. This can happen for a variety of reasons, such as unexpected changes in competitors' prices, higher interest rates that frighten customers from buying on credit, and natural phenomena. During the summer drought of 1988, for example, fruit and vegetable prices went up as farmers lost crops and beef prices soared because there was not enough water to support cattle. This disrupted food supplies and altered consumer buying patterns at groceries; for instance, while turkey sales increased, beef sales declined.[22] By making use of statistical studies, however, food managers were able to adjust grocery inventories, thereby reducing the risk of having unsalable products in stock.

certainty
Certainty exists when managers know the outcomes under each set of alternatives.

risk
The situation of not being certain about the outcome of a decision while also having some information to sense probabilities, not a condition of total uncertainty.

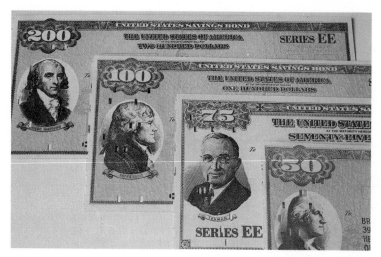

(left) A savings account, a certificate of deposit, and a U.S. government bond usually give you a fixed rate of return. These investments offer known and certain interest rates, which means conditions are certain. (center) The mathematical odds of winning at roulette can be accurately determined because a roulette wheel provides a specific number of possible outcomes for each spin. Although the outcome of a spin is never certain, the probabilities are known for a fair wheel. Roulette players face conditions of risk. (below) When Genentech, Inc., introduced t-PA, a heart drug, it could only guess at sales—no previous comparable product had been made or sold. In making decisions on how to finance, manufacture, and market t-PA, Genentech had no market information on the drug, no direct competitors for it, and no history of its use. Nor did Genentech have any experience manufacturing or selling the drug. Genentech faced conditions of uncertainty in deciding how to proceed with t-PA. Luckily for the company, at the end of its first year of sales, the drug grossed half a billion dollars, more than double the original sales estimate.

Source: Marilyn Chase, "Lost Euphoria: Genentech, Battered by Great Expectations, Is Tightening Its Belt," *Wall Street Journal,* October 11, 1988, p. A1.

Experienced managers will add an intuitive dimension to decision making by modifying estimates according to personal or subjective probabilities. An experienced marketing manager may have a feeling about how competitors will react to price reductions and therefore modify the sales forecast. Managers use their past experience, even if it is subjective, to infer outcomes about future events. This is particularly important when decisions depend on human behavior.

Uncertainty

Managers often must make decisions under conditions of **uncertainty,** when the probabilities are unknown and impossible to estimate. The first nuclear explosion was carried out under conditions of utmost uncertainty. No such bomb had ever been exploded before; no controlled nuclear explosion had been attempted; and scientists had no knowledge of side effects such as radiation. Speculation on the outcome ranged from having a "dud" to creating a catastrophic chain reaction. Many new high-tech inventions are as uncertain. Experiments in biotechnology, social research, and space exploration are so complicated, and we have such scanty information about their possible effects, that statistical probabilities are little more than guesses.

Managers do not have to rely entirely on guesswork under conditions of uncertainty. By using rational decision making coupled with several techniques of information science, they can make *inferential* decisions that are loosely called "informed judgments." Behavioral methods of accumulating information replace guesswork and help tap the greatest single human information resource—the brain.

uncertainty
The condition of not knowing, of having insufficient information to assign probabilities in a decision situation.

CHECKPOINT

■ Discuss how a decision is made under conditions of certainty, risk, and uncertainty. What differentiates each set of conditions?

■ How would you describe "high-risk" and "low-risk" decisions?

■ As a first-line supervisor, what type of decision would you most often have to make? Explain your answer. What if you were a top executive?

TECHNIQUES IN GROUP DECISION MAKING

Conditions of uncertainty or high risk often call for creative or novel decisions. In these situations, managers are just as challenged by the need to identify the right problem as by the need to develop viable solutions. During the Vietnam War, for example, strategists were more perplexed about why the war was taking place than about how the United States could resolve its involvement. Some viewed it as a civil war, others as a religious revolution, others as a war of independence between two countries, and still others as an ideological battle between democratic and communist forces. Various suggestions about how the United States should proceed changed as definitions of the problem changed. Similar questions about our social security system perplex politicians. Law enforcement officers wrestle with drug abuse problems. And business executives wonder what energy sources will be available for manufacturing in the future.[23]

Several extremely powerful techniques have been developed for gaining insight into these types of problems. They are called *behavioral problem-solving techniques* because they rely on the collective effect of interaction among individuals in groups to draw inferential solutions to complex problems. Several of the most useful techniques are discussed here.

Brainstorming

brainstorming
Associated with group decision making and creativity, it is a technique for generating many diverse ideas in an atmosphere free from criticism and explicit boundaries.

Getting people involved in the decision-making *process* is the key to all group approaches to problem solving, and brainstorming is perhaps the most interactive of all approaches. **Brainstorming** is a process of encouraging individuals in a group to be completely open, candid, creative, and spontaneous in their responses to a given problem. Human beings have been brainstorming throughout history, but the concept of *organized brainstorming* implies the concentration of group brainpower on a specific issue. This modern refinement brings together selected individuals with unique credentials to solve particularly complex problems. "Think tanks" such as the Rand Corporation frequently use this technique.

Brainstorming requires freedom of expression by individuals within groups with as little structure as possible to allow the greatest degree of human interaction. Figure 4-7 illustrates the process, and several guidelines have been developed for effective brainstorming.[24]

- *Criticism* must be minimized. It is extremely difficult to be critical and creative simultaneously. The most effective brainstorming occurs when ideas are encouraged without constraint or intimidation. Even outlandish and apparently foolish ideas are often valuable because they can spark creative ideas by others. Criticism can occur later, when ideas with little merit can be discarded.

- *Limitations* should not exist on the number and variety of ideas developed during brainstorming sessions. A long list of worthless ideas frequently evolves into one creative, perhaps extraordinary, alternative. Getting to that point is seldom achieved in a flash of brilliance but rather through an evolutionary process.

- *Synergism* should be encouraged through collaborative contributions and a healthy competition to build on participants' ideas. An initial idea coupled with another, and another, and another leads to a collective result that is the principal advantage of brainstorming.

Research has shown that brainstorming is most effective in groups of five to seven individuals; larger groups tend to bog down because of personal difficulties among group members. Longer periods of intensive group brainstorming are more productive than many short meetings. A collaborative solution takes time to form because it is an evolutionary process of wading through many, often worthless, ideas. When sufficient time is allowed for brainstorming, results can be impressive, but when time is short, participants can become combative rather than cooperative.[25]

Nominal Groups

nominal group
A panel established to develop ideas independently for resolving a particular problem, then through an exchange of ideas, refining those ideas until a group consensus emerges.

A refinement of brainstorming is the **nominal group.** This technique follows many of the fundamental guidelines for brainstorming but allows individuals to develop their ideas independently. Panel members initially establish their common pur-

FIGURE 4-7 Brainstorming Relationships

Boeing developed the swept-wing design for its B52 bomber during a weekend brainstorming session in a YMCA room rented by a group of five aeronautical engineers. Starting with pieces of toy models, childrens' clay, balsa wood, and paper and pencils, the group revolutionized aircraft design in two days. The engineers worked without a group leader, existing designs or blueprints, and rules other than to consider every comment no matter how laughable it initially seemed. Several hundred designs later, the team had modeled the B52.

Source: "Breaking the Mold Through Innovation," *Boeing News,* The Boeing Company, Seattle, Wash., reprint November 1972.

pose, then set about developing ideas in isolation from one another. The group reconvenes from time to time to exchange ideas and share contributions. Members then return to independent investigation.[26]

Nominal groups (often called NGs) have been found more effective than unstructured brainstorming groups, producing more original ideas with more usable recommendations. Nominal groups avoid much of the potential for criticism and interpersonal conflict that is present in brainstorming groups. Also, more well-developed ideas come from nominal groups because members can work toward fully articulated solutions on their own. Collaboration is achieved when panel members collectively consider individual alternatives.[27]

The recognized benefits of nominal groups have led to a formal method of decision making in organizations called the **nominal group technique (NGT).** The technique retains the advantages of group decision making while minimizing tne potential conflict arising from individual biases. The NGT process shown in Figure 4-8 has the following four steps:[28]

nominal group technique (NGT)
A group decision-making process in which members independently identify solutions to a problem or alternative opportunities. Then after options are fully articulated and discussed, members vote confidentially for preferences.

- *Step 1:* Panel members working independently develop and list ideas on a specific issue. Their ideas are privately conceived and written down without conversation or interaction with other group members.

- *Step 2:* Each panel member is individually queried on one idea in a "round robin" process. One person not involved in panel deliberations transcribes respondents' answers on a blackboard, or flip charts can be used to post answers conspicuously.

- *Step 3:* When all responses have been transcribed, panel members discuss, clarify, and elaborate points. Evaluation that highlights the advantages and disadvantages of each idea is encouraged.

- *Step 4:* Individual panel members silently and privately vote on ideas either by assigning a rank order or by using a predetermined rating scale for each idea. Votes are collected and tallied beside each posted idea, and decisions are based on pooled results.

A modification of the NGT procedure repeats steps 1 through 3, allowing panel members to flesh out new ideas or amplify recommendations prior to a vote. If a large number of alternatives result in no clear consensus for one

FIGURE 4-8 Nominal Group Technique

idea, the process may be repeated, each time resulting in fewer ideas and more refinements.

Delphi Technique

Delphi technique
Used in forecasting, problem solving, and creative processes, the Delphi technique surveys experts through several rounds of investigation to develop a profile of information, ideas, or solutions.

The **Delphi technique** is a survey method of polling panel members on a well-defined problem. Unlike brainstorming and nominal group techniques, Delphi does not bring individuals together in face-to-face meetings. Anonymity is maintained to encourage candid responses without the sociopsychological pressures of group interaction. Members are not only anonymous to one another but to coordinators as well. Polled responses are collected from individuals with guarantees against personal criticism or identification of respondents. Anonymity is particularly important when Delphi is used within an organization to poll colleagues or co-workers on sensitive issues.

The Rand Corporation established the Delphi Project for military strategists during the 1950s.[29] It was initially used for developing futuristic scenarios of social, political, and military conditions. For example, one round of Delphi asked respondents, "What are the ten most important problems facing our society in the year 2020?" In organizational environments, questions are less dramatic but often as far-reaching. These may include asking what style of leadership will be most effective for the next generation or how organizations much change to accommodate working mothers.

The Delphi process shown in Figure 4-9 begins with a well-defined topic, a specific point for response. Then selected panel members are asked for confidential written responses in a "first round" poll. All responses are transcribed into one document, which is then given to each panel member for evaluation and refinement. After seeing all responses, each member completes a "second round" of confidential response. This provides members with valuable insights and allows each person to refine his or her response to the original topic. During subsequent rounds of inquiry, members can substantiate their positions. The process is repeated until they achieve a reasonable consensus.

The Delphi technique is a compelling method of exploring complex issues without unwieldly analysis. It has the advantage of accumulating subjective information from experts without sacrificing personal beliefs and values. Delphi is plausible in situations of uncertainty or very high risk because a consensus decision galvanizes action in a democratic process.

FIGURE 4-9 **Delphi Method for Decision Making**

MANAGEMENT APPLICATION 4-1
Women in Business Make Decisions Differently Than Men

Not only are more women going into business for themselves, but more of them are rising to executive ranks than ever before. Most, however, are uncomfortable with traditional hierarchies and structured decision-making systems, and they are starting to change the way decisions are shaped by managers. For example, recent studies suggest that women executives are embracing participative methods faster than men. The following excerpt from *Inc.* magazine illustrates the point:

> Obviously, not all businesswomen are deaf to the old siren song of growth and expansion, wealth and power. But there is powerful evidence that women go into business for different reasons than men. And different motivations lead to a different set of measurements by which they judge success.
>
> Women watch their profits (who doesn't?), but they also evaluate their performances in terms of opportunities well met, creative urges satisfied, employees that are challenged and fulfilled. By and large, they place a higher value on respect from peers, satisfaction from customers, and good marriages that produce kids whose heads are screwed on straight.
>
> Oh sure, men may claim to embrace some of the same ideals. But let's face it: these are not the hallmarks of male business culture. There aren't many men who stay up nights worrying about how to adapt their businesses to more human values.
>
> From different motives and different goals come different ways of managing a business. Study after study show that women do a better job of encouraging and rewarding employees, of soliciting information and input, of seeking consensus. Men fight things out; women work things out.

Source: Ellen Wojahn, "Why There Aren't More Women in This Magazine," *Inc.*, July 1986, pp. 45–48. Reprinted with permission. Copyright © 1986 by Goldhirsh Group, Inc., 38 Commercial Wharf, Boston, MA 02110.

A major disadvantage of the Delphi technique is that group members can achieve consensus by compromising. The optimal solution may languish when the weight of panel opinion swings toward a compromise. The possibility of mediocre compromises can be a critical problem if the panel of experts is not carefully selected, or if members lack appropriate expertise or have strong personal biases. For example, posing a question about the future of nuclear weapons to military experts is likely to produce different results than posing the same question to scientists. Asking how organizations must change to accommodate working mothers will probably generate different answers from unmarried men and married women.

The Delphi technique has an advantage over nominal groups and brainstorming in that it permits large numbers of individuals to be queried without regard for location or sociopsychological characteristics. As noted earlier, the ideal in NGT and group brainstorming methods is between five and seven members. Delphi can solicit responses from many individuals on a global scale. Computers are used to transcribe, sort, and distribute information, thus reducing the complexity of dealing with vast numbers of responses. Recent innovations in teleconferencing and electronic networking have also exponentially increased the feasibility of large surveys.

CHECKPOINT

- When brainstorming, what guidelines are helpful for making effective group decisions?
- Diagram the process of the nominal group technique (NGT) and explain how decisions evolve from that process.
- Explain the Delphi technique and contrast it with brainstorming and NGT approaches. In what situations would the Delphi technique be most useful?

ROLE OF MANAGEMENT SCIENCE

Behavioral decision making is complemented by sound quantitative methods. Brainstorming, NGT, and the Delphi technique presume "nonquantitative" value judgments and intuition, but managers often use information gathered through analytical research to generate responses in these group decision-making situations. _Quantitative analysis_ is also used extensively to evaluate ideas generated through group processes, and in many organizational settings, problems are so complex that computational methods are essential to unravel problems and their solutions. These issues constitute the mainstream of management science.

management science
In decision-making terms, a process of model building, using quantitative techniques to resolve a problem.

The role of **management science** has been accelerating as new methods of information processing and computer applications rapidly become available, and management curricula typically contain several courses devoted to these topics. We will discuss these techniques and their importance for planning in the rest of Part II and for controlling in Part V; but here we can note that in decision-making terms, management science is the process of model building. Just as Boeing engineers built a model of the first B52, managers build models of problems. Then they test the models using scientific methods of inquiry and analysis.

Scientific inquiry begins by developing a model to simulate the problem. Unfortunately, managers can seldom create physical models, as engineers do for airplanes, but must structure a problem using mathematics. For example, a model of consumer behavior (researching a marketing problem) may use mathematical relationships (variables) for demand, product price, consumer income, and competitors' prices. These variables will be analyzed to determine how they affect one another and how they are likely to affect sales. Thus managers model the problem to answer a question, such as how much consumers might be willing to

Case Questions

1. Some critics of the new system have argued that the process is far too cumbersome and involves too many people to be of any use. Is this a significant flaw in the system?
2. How is current knowledge about effective decision making reflected in or overlooked by NASA's new procedures?

Sources: "NASA's Challenge: Ending Isolation at the Top," *Fortune,* May 12, 1986, pp. 26–28; and "NASA Overhauls Shuttle Launch Decision Process," *Aviation Week and Space Technology,* May 23, 1988, pp. 20–21.

SKILL PRACTICE

THE ROLE OF INFERENCE AND OBSERVATION IN DECISION MAKING

Procedure

A. Read instructions and evaluate statements for the Sample Story (Time allotted: 8–10 minutes)
After you have read and understand the instructions proceed with the four statements about the Sample Story. Circle the appropriate response: T, F, or ?. Then, check your accuracy by looking at the appropriate answers printed beneath the statements. If you do not agree with the given answer, go back to the story to check.

B. Evaluate the statements about The Story (Time allotted: 15–20 minutes)
Using the same basic instructions as for the Sample Story, proceed to read The Story and evaluate the 15 statements that follow it. The instructor will provide appropriate answers for these 15 statements and the rationale behind these answers.

C. Discussion of Nature of Inferences (Time allotted: 15–20 minutes)
Consider some of the errors that you made in evaluating the statements (in B above). Why did these errors happen? Were the answers supplied by the instructor equal to or superior to your own? What is the concept of the "uncalculated risk"?

Test your skill in the area of inferences and observation by reading the Sample Story first. Then when the instructor indicates, read the next story and mark the most appropriate choice for the 15 statements that follow it.

Instructions

Read the following story. Assume that all the information presented in it is definitely accurate and true. Read it carefully because it has ambiguous parts designed to lead you astray. No need to memorize it though. You can refer back to it whenever you wish.

Next read the statements about the story and check each to indicate whether you consider it true, false, or "?". "T" means that the statement is definitely true on the basis of the information presented in the story. "F" means that it is definitely false. "?" means that it may be either true or false and that you cannot be certain which on the basis of the information presented in the story. If

any part of a statement is doubtful make it "?". Answer each statement in turn, do not go back to change any answer later, and don't re-read any statements after you have answered them. This will distort your score.

To start with, here is a sample story with the correct answers:

SAMPLE STORY

You arrive home late one evening and see that the lights are on in your living room. There is only one car parked in front of your house, and the words "Harold R. Jones, M.D." are spelled in small gold letters across one of the car's doors.

Statements about Sample Story

1. The car parked in front of your house has lettering on one of its doors. (This is a "definitely true" statement because it is directly corroborated by the story.) T F ?

2. Someone in your family is sick. (This could be true and then again it might not be. Perhaps Dr. Jones is paying a social call at your home or perhaps he has gone to the house next door or across the street.) T F ?

3. No car is parked in front of your house. (A "definitely false" statement because the story directly contradicts it.) T F ?

4. The car parked in front of your house belongs to a man named Johnson. (May seem very likely false, but can you be sure? Perhaps the car has just been sold.) T F ?

Now begin the actual test (The Story). Remember mark each statement by circling the right response in order—don't skip around or change answers later.

THE STORY

A businessman had just turned off the lights in the store when a man appeared and demanded money. The owner opened a cash register. The contents of the cash register were scooped up and the man sped away. A member of the police force was notified promptly.

Statements about The Story

1. A man appeared after the owner had turned off his store lights. T F ?
2. The robber was a man. T F ?
3. The man who appeared did not demand money. T F ?
4. The man who opened the cash register was the owner. T F ?
5. The store owner scooped up the contents of the cash register and ran away. T F ?
6. Someone opened a cash register T F ?
7. After the man who demanded the money scooped up the contents of the cash register, he ran away. T F ?

Source: Reprinted by permission of Richard E. Dutton.

8. While the cash register contained money, the story does not state how much. T F ?

9. The robber demanded money of the owner. T F ?

10. A businessman had just turned off the lights when a man appeared in the store. T F ?

11. It was broad daylight when the man appeared. T F ?

12. The man who appeared opened the cash register. T F ?

13. No one demanded money. T F ?

14. The story concerns a series of events in which only three persons are referred to: the owner of the store, a man who demanded money, and a member of the police force. T F ?

15. The following events were included in the story: Someone demanded money, a cash register was opened, its contents were scooped up, and a man dashed out of the store. T F ?

5

Planning Concepts and Practices

In 1989, less than five years after its introduction to the American market, Hyundai's Excel became the No. 2 sub-compact car in the United States and the No. 1 subcompact import. The Excel's best asset has been its price—between $5,200 and $5,500—but it has succeeded because it was more than twelve years in planning. In today's world, few single-product companies survive for long without continuous planning to meet challenges by competitors.

Hyundai intends to grow and has plans to become a full-line manufacturer in the 1990s. A new upscale mid-size model, the Sonata, is the first step in the company's long-term plan to strategically reposition itself to compete directly with Honda's Accord, Toyota's Camry, and Ford's Tempo. The firm has established first-year sales objectives of 100,000 Sonatas, with a 20 percent increase in each of the second and third years. Management has set itself two technical objectives: to create the highest-quality mid- and low-priced imported automobiles in the United States, and to lead the field in innovative engineering.[1]

Think about Hyundai's objectives and whether other automotive companies have similar objectives. Consider also how the automotive industry has changed and how managers are being challenged to formulate plans in very complex circumstances.

Planning, organizing, leading, and controlling are the primary functions of management, and *planning* is the most important. Planning provides a framework

- Define the planning function and explain how formal and informal planning differ.

- Explain management planning responsibilities and how they relate to different types of objectives.

- Describe the various ways plans are communicated and how managers document planning activities.

- Explain why contingency planning is so important.

- Identify the steps in a formal planning process.

- Contrast the three main approaches to planning.

for organizing resources, structuring a firm, and controlling activities. Through the planning process, managers develop goals and objectives. These are the criteria by which we judge organizational effectiveness. Plans do not evolve in a vacuum, even though we say "planning precedes all other activities." We need managers to do the planning and an organization for them to function in. Think of planning as part of a cycle of activities, the first step of which is to establish objectives. Planning also provides information to help managers determine how to reach those objectives.

Long-range planning is called *strategic planning.* Each year managers at Ford, Xerox, the NFL, the Red Cross, and thousands of other profit and not-for-profit organizations engage in strategic planning to ensure that their objectives are viable and that they understand how to direct organizational activities to achieve them. Managers also make short-term plans that are *tactical* in nature, having a life span of about a year. For example, several years ago IBM "strategically" planned to introduce a new line of high-speed business computers; "tactically," it planned to introduce a new PC in 1988, an improved operating system in 1989, and a new business computer in 1990 that incorporated features of the 1988 PC and 1989 operating system. In the short run, managers have to do *operational planning,* which includes scheduling work, projecting labor requirements, and acquiring materials, capital, and technology. Tactical and operational planning issues are introduced in Chapter 7.

PLANNING DEFINED

Planning is the process of defining an organization's objectives and how it will achieve them. George Steiner describes the planning function as one in which managers must decide "what is to be done, when it is to be done, how it is to be done, and who is to do it."[2] A plan, therefore, is a navigational tool that maps out a destination and charts a course to get there. An objective is the result desired at a future point in time.

Hyundai wants to sell 100,000 Sonatas in the model's first year, and most undergraduate students want to earn their degrees in exactly four years at college. Organizations such as the United Way set fund-raising objectives, and corporations like Procter & Gamble, Turner Broadcasting, and CitiCorp have profit and sales objectives. These objectives are reached only when they are accompanied by plans outlining activities that must occur to get things done. The United Way organizes volunteers, schedules promotions, and develops programs for fund-raising events, all within a specific time frame for the annual drive. Students structure degree programs and establish sequences of courses to take. Corporations such as P&G and CitiCorp have plans for new products, expansion into new markets, and hundreds of other activities necessary to compete profitably.

Managers plan in order to make decisions *today* based on premises of what might happen in the future. We seek *direction* for current actions; we seek unknown *opportunities;* and we try to *solve* today's problems without creating problems in the future. The larger and more complex an organization is, the more difficult it is to establish workable plans, but even small enterprises operate in complicated environments. Effective planning reduces the guesswork managers face when making decisions.

planning
One of the four major functions of management. It is the process of defining organizational objectives and then articulating strategies, tactics, and operations necessary to achieve those objectives.

informal planning
A process of intuitively deciding on objectives and activities needed to achieve them without rigorous and systematic investigation.

formal planning
The process of using systematic criteria and rigorous investigation to establish objectives, decide on activities, and formally document organizational expectations.

THE NATURE OF PLANNING

Planning has both formal and informal elements. Some managers, for example, seem to do little more than "react" to situations according to their intuition. Others follow a thorough process of investigation before they make decisions. **Informal planning** is planning based on an intuitive process. **Formal planning** is

able profit. Managers also spend a great deal of time planning for costs and cash flow, even though they recognize how circumstances beyond their control can influence profits. For example, suppliers of parts and materials may alter prices, thereby increasing a firm's expenses. If energy costs, transportation expenses, or tax liabilities rise, that will affect cash flow and profitability.[9]

Growth objectives define targets for increased sales volume, expanded markets, new products, or better services. For example, Apple Computer Company's growth objective is to increase its sales of microcomputers during the 1990s by expanding *market share,* or percentage of the market. Currently, Apple holds 12.5 percent of the personal computer market, and a half-percent increase (.5 percent) to a 13.0 percent share of the projected $300 billion market for the 1990s translates to a sales increase of $1.5 billion. Apple plans to attain this objective by introducing advanced products and innovative office software applications each year. It has also targeted new consumer groups as a way of growing. It plans to place the existing Macintosh SE line in more professional medical offices, to construct networking systems for retail stores, and to create data bases for engineering and aerospace research.[10]

Sometimes growth and profit objectives conflict. Profitability can suffer if a firm aggressively expands sales. It may lower prices to attract customers, but simultaneously have to increase expenses such as advertising sharply. Texas Instruments, for example, mounted price-cutting campaigns and took huge losses in an ultimately unsuccessful attempt to expand sales for its microcomputers. Profits plummeted, stockholders became restless, and TI withdrew from the personal computer industry.[11]

Another important objective for managers is to maintain a certain level of *quality,* or excellence, of merchandise and services. One firm may consciously try to offer the best product in the industry; another may try to market an inexpensive product of limited durability. Both positions are equally viable in many industries. For example, there are inexpensive microcomputers with limited capabilities, yet highly sophisticated machines are also being sold at premium prices. The concept of quality is not necessarily related to price, even though price is usually a good indicator of quality. Another indicator is intended use by customers. Thus, to one person a quality microcomputer means the best one available for less than $300; to another customer, that same item will seem like junk.[12]

Still other objectives are *philosophical,* reflecting a company's desire to support social programs, promote environmental protection, or improve the quality of life for employees, local citizens, or society in general. For example, General Mills has supported social programs for many years through a company foundation funded annually with 2–3 percent of pretax profits. The General Mills foundation matches contributions by employees to the United Way and other charitable agencies, underwrites grants to employees for education, makes direct grants to universities for scholarships and research, contributes to more than seventy community environmental campaigns, and supports health care for the elderly.[13] Philosophical objectives often reflect the personal interests of key executives or owners. Some have strong personal commitments to ideals that influenced their careers. Philosophical objectives must be coordinated with the other objectives mentioned earlier, and must take into account income, expenses, growth, investors' interests, social needs, and employee expectations.

Establishing Objectives

Organizations have multiple objectives that must be orchestrated to avoid conflicts. Just as profit objectives can directly conflict with growth objectives, social objectives requiring cash expenditures can be opposed by investors who want the highest possible financial returns. Setting company objectives is more complicated than making isolated choices in each category of objective. Managers cannot de-

Successful companies consistently formulate solid objectives that are specific, measurable, reasonable, and time-specific. Sun Microsystems, a fast-growing computer systems company, established in 1986 an annual sales objective of $500 million by 1988; it reached that figure by the end of 1987. Sun also targeted profit at 7 percent per year; it achieved $36 million new income in 1987, a 7.2 percent return. Levi Strauss set out in 1985 to shift from working clothes to fashion clothes with the objective of having 50 percent of sales in fashions by 1990; the company reached this objective by the end of 1988. And Frito-Lay has become famous for its service objective of delivering fresh potato chips 99.5 percent of the time, to every customer, anywhere in the world.

Sources: Annual Report to Stockholders, Sun Microsystems (1988), p. 3; *Annual Report*, Levi Strauss Company (1988), p. 2; Thomas J. Peters and Robert H. Waterman, Jr., *In Search of Excellence: Lessons from America's Best-Run Companies* (New York: Harper & Row, 1982), p. 45.

fine profit objectives separately from social objectives. They must determine balance that ensures an appropriate level of profits while upholding social endeavors sponsored by the firm.

Well-defined objectives have several important characteristics. They are *specific, measurable,* and *realistic,* and each has a definite *time period* for achievement.

- ■ *Specific.* Objectives are expressed without ambiguity so that subordinates will understand them. A statement that a company wants to "maximize profits," for example, is too vague. A more percise statement would be that the company wants to "make 7.5 percent net profit on sales."

- ■ *Measurable.* Objectives are used to evaluate performance quantitatively; employees want to be able to understand when they are making progress and when they are failing to meet expectations. Objectives should, therefore, be measurable and expressed in terms that relate to performance. A specific objective of "7.5 percent net profit on sales" is measurable and has a clear meaning to managers responsible for profits and losses. For shop-floor workers, an objective to "reduce product defects to 3.0 percent" is also measurable and meaningful.

- ■ *Realistic and Challenging.* Objectives are meant to motivate employees to achieve results, so they must be realistic, as well as challenging. Unrealistic expectations may only stymie progress. For example, if a company wants to produce "200 items per hour at standard labor cost" and the production department knows this goal is realistic, then workers may try to achieve it. If the target is unreasonable, workers may ignore it and continue to produce whatever number of units they had been turning out in the past. Good objectives must also account for resource limitations and circumstances. Asking employees to produce "200 items an hour" when they cannot get raw materials on time to do so is unreasonable.

- ■ *A Defined Time Period.* Every objective should designate a certain time period to provide a frame of reference for performance expectations. An objective to achieve "7.5 percent net profit on sales" is specific and measurable, but it fails to state when this profit objective is to be achieved. A complete statement might be "to achieve 7.5 percent net profit on sales for 1991."

CHECKPOINT

- ■ Define the hierarchy of objectives in a business organization.
- ■ Identify types of objectives a company might pursue.
- ■ What are the characteristics of well-defined objectives?

THE PLANNING HIERARCHY

Planning responsibilities are different for managers at each level in an organization, and they correspond to the three levels of objectives. The emphasis an organization places on objectives will depend on its strategy, and its strategy is derived from its purpose. This relationship was introduced earlier and is expanded on in Chapter 6, Strategic Management. Tactical objectives are coordinated at middle-management levels and depend on major strategic objectives. Operational objectives are defined in the short term and in direct relationship to tactical objectives. Tactical and operational objectives are treated thoroughly in Chapter 7, Tactical and Operational Planning.

Board-Level Strategic Responsibility

The planning hierarchy, as Figure 5-2 shows, describes the delicate relationship between planning and decision making. Although we have specified three levels of plans and objectives, there is a fourth division of responsibility, which is assumed by the board of directors and the CEO (represented on the board) acting as overseers of the firm's mission. This does not mean that an organization has four levels of management, but rather that there are four levels of responsibility. Board members are not "operating" managers; in fact, many of them are appointed from other organizations to serve as investors' representatives. They rarely intercede in operational decisions except to fulfill their responsibility to safeguard investors' interests. The *mission*—or the way in which an organization carries out its purpose—is *purposely* placed at the top of the pyramid in Figure 5-2, above the board and CEO, to emphasize that although an organization's board is responsible for defining the mission, once it is established, the board and CEO subordinate their planning decisions to fulfill that mission.

Strategic Planning

The CEO, in conjunction with top-level executives, formulates long-term strategic objectives to reinforce the firm's mission. Figure 5-3 summarizes planning time horizons and emphasizes the difference between a company's mission and its strategic objectives. The mission clarifies organizational purpose and is written as if it will last forever. In contrast, strategic plans with long-term objectives are specified for a period of years; a five-year period is common for most United States companies.

For example, H. J. Heinz, the giant diversified food company, has the stated purpose to become a leading manufacturer of processed foods. Heinz's mission has changed little in forty years: it is to establish name-brand quality processed food products in wholesale and retail markets. Recent changes to that mission reflect the global orientation of the company and its markets. In 1988, Heinz announced its intention to sell its products worldwide. The company's specific objectives over a five-year planning period include becoming the No. 3 pro-

FIGURE 5-2 A Hierarchy of Planning

plants. SOPs also simplify complex activities. Airline pilots need not memorize preflight checks because SOPs provide step-by-step guidelines; doctors follow detailed surgical procedures to help ensure success. Good procedures provide a sequence of actions that, once completed, fulfill specific objectives. These objectives reinforce policies and help employees achieve results efficiently and safely.

Rules

A **rule** is a standing-use plan that requires a specific action without variation. A procedure evolves into a rule when the sequence of activities becomes mandated. Airline preflight safety checks fall into this category: A preflight safety check is mandated by law; the procedure has become a requirement to ensure passenger safety. Rules usually have a single purpose and are written to guarantee a particular way of behaving in a particular situation.

rule
A statement that tends to restrict actions or prescribe specific activities with no discretion.

We think of rules as restrictions because in practice most of them prevent us from doing something dangerous. Examples are rules against smoking in restricted areas, speed limits, and safety regulations that require workers to wear hard hats in dangerous areas. These rules leave little room for discretion. You either stop at a red traffic light or you don't; you can't stop "a little bit."

Although it may be difficult to see how rules extend the planning process, all good rules reinforce objectives. For example, while driving, we recognize the value of stop signs at dangerous intersections. Safety is the objective, and a rule "to stop" is a specific part of a broader plan to reinforce that objective. A rule that prohibits smoking in an office may be part of a comprehensive policy to protect employees' health.

Programs

A **program** is a *single-use plan* comprising multiple activities orchestrated to achieve one important objective. Madison Square Garden, for example, has a $100 million renovation program under way that includes nearly fifty activities, all coordinated to be completed in 1995. When these activities are finished, the *program* will end. The program agenda includes new parking, electrical wiring, sound systems, renovation of rest rooms and common areas, safety improvements, and redesigned athletic equipment. One of the program's activities is to replace 1,300 low-priced seats at the top of the Garden with a two-tiered ring of 88 luxury boxes.[25]

program
A single-use plan with multiple activities that can be orchestrated to achieve one important objective.

Programs have several special features that set them apart in the planning process. They are like stories or stage plays in that they have clear beginnings and definite endings. Program managers are given scripts to follow that reflect a systematic completion of activities that culminate in fulfilled program objectives.

Although we have said that programs are *single-use plans,* some types of programs are designed to be repeated. For example, universities develop academic programs, such as an undergraduate business degree program, that are replicated by hundreds of students. Each student follows a format of courses that must be completed to satisfy degree objectives. There is a clear beginning when the student matriculates into the program, and a definite ending when the student receives a degree upon graduation. In the sense that every student completes a degree program only once, it is a "single-use" plan; in so far as it is replicated for many students, it is a "standing-use" plan.

Most programs fall into the single-use category. NASA's Apollo program to land on the moon, once achieved, ended forever. Future NASA programs may build on the Apollo program's success, but they will have their own set of unique objectives.

Projects

A **project** is a *single-use plan* with a specific and uncomplicated short-term objective. Projects are similar to programs but distinguished from them in three important ways. First, projects are unambiguously planned with single objectives. The single activity to build luxury box seats for Madison Square Garden is a *project* within the larger scope of a *program*. Second, projects are not repeated. Unlike business degree programs that are replicated by hundreds of individual students, projects stand alone as single, focused activities. Building a new employee parking lot is a project that will not be repeated. Third, projects tend to be accomplished in short periods of time. For example, building an employee parking lot may take only a few weeks, and if it is part of a program to improve working conditions, other short-term projects may follow, such as building a cafeteria or setting up a day care center for employees' children.

Budgets

A **budget** describes in numerical terms resources allocated to organizational activities. A budget also communicates organizational expectations for results. By budgeting, managers identify resources, such as money, materials, human resources, and overhead support, allocated to an activity. Budgets also are clear statements of expected results expressed in measurable terms, usually dollars. We instinctively think "accounting" when talking about them, yet many budgets are expressed in terms other than money. Production budgets, for example, can be expressed in number of units produced. There are budgets for man-hours, machine hours, inventory levels, computer time, customer credit, and many other activities. Marketing sales quotas, which are really budgets, are used to express sales activity in both dollar and unit volume figures. All budgets define resources and results in quantified terms, and are set, as indicated, within a fixed period of time. Marketing quotas may be budgeted monthly and quarterly, production budgets may be specified for weekly, monthly, and quarterly operations, and financial budgeting may reflect monthly, quarterly, and annual planning periods.[26]

Budgets help to coordinate activities by providing specific information to monitor performance. They are used to control activities, track results, and restrain managers from misallocating resources. By having consistent measurement criteria, such as dollars, they provide excellent documentation that all employees can understand. Unfortunately, budgets are too often viewed only as restrictive controls, and can, in fact, become repressive. Used effectively, they are valuable management tools. Minnesota Mining and Manufacturing has consistently been ranked among the top five most admired corporations in America by *Fortune*, and budgetary excellence has been cited as one of 3M's greatest assets. The company was singled out for "using its financial control system to encourage rather than curtail innovation and creativity. Numbers are used to set goals and measure performance rather than to deny expenditures or punish unmet expectations."[27]

Budget projections, called *pro forma* budgets, anticipate future results. These projections typically include a set of strategic budgets based on sales forecasts, and contain pro forma income statements, pro forma cash flow statements, and pro forma balance sheets. Strategic budgets are broken down into tactical budgets with specific annual projections for divisions or functional departments; tactical budgets are also called annual operating budgets. Lower-level budgets describe in detail weekly, monthly, and quarterly activities, and provide the numerical information for operating schedules. A **schedule** is a commitment of resources and labor to tasks with specific time frames. Therefore, budgets and schedules reinforce each other to clarify expectations in measurable terms.

The 3M company supports 6,000 scientists and engineers who add more than 200 products each year to the 60,000 it sells. Exceptional planning and careful budgeting ensure coordination for projects ranging from a new type of sandpaper to a Ganz Meter (shown) to test light reflection.

CHECKPOINT

- Explain the difference between "standing-use" and "single-use" plans.
- Describe the uses of policies, procedures, rules, programs, projects, and budgets.

FLEXIBILITY IN PLANNING

Planning is a process of looking into the future, and since the future is uncertain, so are plans. Plans must have a degree of flexibility so that managers can adapt to circumstances. Policies are only guidelines, and procedures are preferred sequences for activities. In both instances, managers have discretion to adapt behavior to situations. Rules are not flexible, although they can be changed. In fact, few plans are so certain that we can afford to take away management prerogatives.

Flexible planning allows for reasonable deviations in performance, recognizing that wherever human beings are involved, there will be some variation in behavior. This was known to Frederick Taylor, who measured work in steel mills and observed as much as 300 percent variation among workers doing the same task. Similarly, Elton Mayo discovered that circumstances affected performance tremendously during the Hawthorne experiments. These men did their research more than half a century ago, yet current research suggests that even today companies with sophisticated information processing have great difficulty predicting performance. For example, Intel Corporation, a major Silicon Valley manufacturer of integrated circuits, found that the combination of changes in technology, materials, staffing, and unforeseen circumstances (such as power outages or flu epidemics) influenced operating results by as much as 20 percent.[28]

Flexibility in planning suggests nothing more than using common sense. It means planning as well as possible, but not using plans as sledgehammers to

FIGURE 5-5 Demand and Managerial Flexibility
Demand is influenced by both internal and external forces. We often find that demand is "soft," meaning that our forecasts are less certain than we anticipated. Flexible plans allow feedback to management and changes in normal activities without a substantial realignment of objectives. Lack of flexibility often leads to costly adjustments, overruns, stockpiled inventory, and poor sales because of management's unwillingness to adjust operations.

force managers into a narrow range of behavior. For example, budgets carry a connotation of absolute precision, but few are iron-clad. Intel Corporation uses complex budget forecasting techniques, but gives its managers discretion within a range to adapt operations. 3M managers are held accountable for results, but budgets are reviewed often and adjusted when necessary to give managers the resources they require to accomplish their objectives.

Consider how circumstances beyond a company's control can affect consumer demand. These are shown in Figure 5-5. Customer demand is a function of so many variables that even the best forecasting methods often fail to predict it. To business executives, buzzwords like "cost overruns" and "stockpiled inventory" conjure up images of planning gone haywire. Flexible planning allows managers to adjust to circumstances in order to minimize huge variations in results. This does not imply that anything goes. It simply means that every manager must recognize how the best plans can change. Plans are dynamic, and planning itself is an ongoing process of approximation. In some instances, the changes are so vast that simply adapting existing plans is insufficient. Managers need a contingency plan to implement when the original plan is seriously disrupted.

CHECKPOINT

■ Why is flexibility in planning important? Develop an example of how a plan, expressed through a budget, can be made flexible.

CONTINGENCY PLANNING

contingency plan
A conscious effort to develop alternative plans to be prepared for future conditions.

A **contingency plan** is an alternative set of objectives and activities that can be implemented if circumstances change so drastically as to make the preferred plan infeasible. Effective planning provides a range of contingency actions based on reasonable assumptions about future circumstances. This statement makes two crucial points. First, we plan on reasonable assumptions. Second, we plan in part by looking into a crystal ball to estimate future circumstances. A more sweeping element of planning than flexibility is involved here. When we discussed flexibil-

10. Immediately begin to plan "to plan." Immediately after the laser project got under way, DEC strategists turned to making plans for new computer products, such as integration hardware to link multiple computers. As the laser project progressed, managers were already trying to envision how it would become obsolete and what product innovations they would need for the next generation of computer-integrated printing technology.

Establishing Objectives

Objectives must be established to define long-range operations. This is the task of strategic managers. Initially, objectives are communicated to tactical managers, who then specify objectives for their subordinates. When managers find they cannot provide realistic tactical objectives that satisfy strategic preferences, strategies may be reconsidered. Reconsideration can also occur at operational levels, as tactical objectives are broken down into short-term plans. The process of establishing objectives is a coordinated effort that leads to examination of both internal and external constraints.

Evaluation of Environmental Factors

Objectives are not determined in isolation. Managers must consider limitations on their decisions. These originate in both the internal environment of the firm and the external, political, social, cultural, and economic environment. Internal influences include limited resources, capital, and skilled personnel. Examples of external influences are legislative constraints, high interest rates, and technological advances by competitors.

Articulate Assumptions

Assumptions tend to evolve from the constraint evaluation process. When managers identify profit expectations by shareholders as a constraint, a statement is articulated about how those shareholders might react if profits fall short of expectations. In other words, constraints are turned into statements of assumed behavior either by ourselves or others. Managers want to predict probable operating conditions during the planning cycle, but they also want to identify trends that may affect the firm. These are developed by asking "what if" questions, the answers to which provide managers with lists of planning premises.

Involvement of Management and Staff

Executive managers are inextricably involved in planning, but it is less clear who else should be involved and to what extent. According to management theory, involving a greater number of managers will result in better plans and more widespread acceptance of objectives. In reality, though, most managers are pressed for time, so fewer of them participate in formal planning than theory suggests. Planning is more often accomplished through small groups such as planning committees or staff planning specialists. Different leadership styles also affect planning processes. Most United States managers are inclined to be less participative and more autonomous in decision making; consequently, executives are more likely to develop plans with the participation of only a few other persons.[35] Whereas staff specialists are engaged as full-time planners, lower-level managers usually become involved in formal plans as an adjunct activity.[36] How managers

participate and how planning is organized are important topics examined in greater detail later in this chapter under "Approaches to Planning."

Alternatives

A successful planning process will generate several options for managers to consider. These options are alternative courses of action that can achieve the same result. Management's task is to decide among them. For example, if a company's objective is to increase profits, one option might be to increase sales. This can lead to decisions on pricing, promotion, changes in the sales force, and changes in distribution systems. An alternative to increasing sales may be to lower costs by trimming the work force, reducing inventory levels, or using substitute materials in production.

Managers usually consider many alternatives for a given situation, but a *viable alternative* suggests a proposed course of action that is *feasible, realistic,* and *sufficient.* To be feasible, an action must not only be possible but must also have a reasonable chance of success. To be realistic, the alternative must square with reality, such as accommodating prerogatives of executives, complying with the law, and conforming to expectations by those who have to carry out the work. To be sufficient, activities, once accomplished, must fulfill the company's objectives.

Stratifying Plans

Once alternatives are decided upon, a stratifying effect takes place. Starting at the top, policy statements express preferred objectives. At the tactical level, procedural directives reinforce objectives; programs and projects may also be developed at this level. At the lowest levels, operational plans reflect schedules and performance budgets.

Let us suppose a firm is committed by top management to a growth strategy by penetrating its competitors' markets. The desired result is greater sales. At the tactical level, marketing managers gear up for an aggressive sales effort. The tactics of getting more products sold may take many forms, such as price competition, heavy advertisement, or special product sales in new markets. The tactical marketing plan is then communicated downward to operating and field managers, who establish sales quotas and monthly or quarterly sales activity plans. Examples of operational sales activities are scheduled sales, periodic rebates to customers, and special-event advertising.

Communication of Plans

A great deal of communication must take place to get this far in the formal planning process, but as noted earlier, most managers are only involved in a limited aspect of planning. Plans are therefore documented to establish responsibilities, and planning documents are carefully distributed to those who will be involved. This is where formal policy statements, procedures, rules, programs, projects, and budgets play significant roles.

Long-range plans are strategic summaries. They rarely include division and departmental planning data. At lower levels, progressively more detailed and specific documents define areas of responsibility and budgets. If documentation is effective, one should be able to start at the top with the stated mission, work down to policy statements, then find annual performance objectives, and finally come to directives, procedures, programs and projects that set forth operational activities.

Implementation

Many well-founded plans never get off the ground. It is important to consciously include *implementation* as a step in the planning process, so that plans are supported by management, resources are committed, and people will act on decided courses of action.

In Chapter 1, we said that the planning function was arguably the most important management function that preceded organizing, leading, and controlling. The latter three functions are concerned with implementing plans. Organizing brings together human, material, and financial resources in a workable structure for implementing plans. Through effective leadership, managers convert resources into products or services by motivating employees to work toward established objectives. Controlling is the function of evaluating performance, measuring progress against established objectives, and adjusting actions to ensure success.

Plan to Plan

Changes in the environment and in the organization subvert even the best plans. Long-range plans are most susceptible to change due to external influences. Annual plans are supposed to be less variable, but only a naive manager expects performance to match objectives perfectly. At the operations level, performance should be closer to expectations, but even here schedules are subject to many disruptions. Managers must therefore assume change and "plan to plan" soon after one round of planning decisions.

> ## CHECKPOINT
>
> ■ What is meant by evaluation of environmental factors?
>
> ■ Identify three categories of assumptions that managers need to articulate when planning.
>
> ■ What are "alternatives" and how are they used in a comprehensive plan?
>
> ■ Explain why it is important to "plan to plan."

APPROACHES TO PLANNING

While the planning process describes how managers in most companies develop plans, there are three distinct *approaches* that describe who has responsibility for formulating plans. Each approach involves different managers, and each reflects a different philosophy of planning.

Centralized Top-down Planning

Top-down planning is the prevalent approach in small and highly centralized organizations. It is the traditional approach, embracing a philosophy of hierarchal authority in which strategic planning is first done by executives, tactical planning follows to reinforce strategic objectives, and operational planning is accomplished after tactical plans are in place. Previous discussions on planning roles for managers and the planning process reflect the centralized top-down approach because that is the most common practice in American companies.

The term *centralized* is used because planning responsibilities are assigned to a few executives at the organization's highest echelons. The term *top-down* is used because these executives assume the burden of establishing a firm's major

top-down planning
The prevalent approach to planning in which a centralized group of executives or staff assume the primary planning responsibilities.

objectives, writing policies, and communicating to lower-level managers expectations for formulating progressively more detailed plans. In larger, more complex organizations, executives charged with planning responsibilities have a planning department with staff experts who do most of the actual planning work. Major organizations that make use of formal planning departments include NBC, Edison Power & Electric, Ford Motor Company, Allied Chemical, and CitiCorp. In each firm, staff planners are responsible for essentially every aspect of planning *except* making actual decisions; managers in operating positions, from the CEO down to a first-line supervisor, must decide what objectives to pursue and what activities to implement to fulfill those objectives.[37] This distinction is important. Although staff planners are specialists in advisory roles and in most instances the planning department reports to the CEO, the planners themselves have no authority to make decisions.

Decentralized Bottom-up Planning

bottom-up planning
An approach to planning in which authority to establish objectives and planning responsibilities is delegated to lower-level managers who are expected to initiate planning activities.

Bottom-up planning is an approach that delegates planning authority to division and department managers, who are expected to formulate plans under the general strategic umbrella of corporate objectives. Companies using this approach have a headquarters planning staff, much like the planning department in a centralized top-down system, but the headquarters staff coordinates, rather than develops, plans. The term *decentralized* is used to emphasize that authority is pushed downward and throughout a company for independent planning initiatives. The term *bottom-up* is used to emphasize that planning decisions made at lower levels are aggregated at higher echelons to form a comprehensive company plan. Lower-level decisions can be vetoed by executives, but it is more likely they will be reviewed by company executives and revised with the help of headquarters planning staff.

This approach involves more managers in planning, and it appeals to those who advocate participation in decision making; however, it is an effective approach only when company leaders truly believe in a philosophy of shared responsibility and have the organizational structure necessary to allow divisions and departments to function somewhat independently. General Motors, Procter & Gamble, IBM, and Teledyne Ryan have decentralized planning systems, but all these companies are also organized with multiple divisions. At GM, the Pontiac Division operates independently of the Chevrolet, the GMAC, and the GM Truck Divisions, and acquired GM companies, such as Electronic Data Systems (EDS), are semiautonomous divisions within the GM family. Planning is carried out in each division, coordinated at GM's headquarters, and documented as a composite General Motors strategic plan.[38]

Team Planning

team planning
A participative approach to planning whereby planning teams comprised of managers and staff specialists initiate plans and formulate organizational objectives.

Team planning is a participative approach that relies on *task force* teams comprising managers and planning specialists temporarily assigned responsibilities for formulating plans. Westinghouse, Hewlett-Packard, Delta Airlines, Mariott Corporation, and Lockheed are a few of the major companies that endorse team planning, but many companies are moving toward it to encourage participation by more employees.[39]

Each of these companies has designed a unique team system, but their planning activities are generally similar. Top management sets the process in motion with articulated strategies supported through executive planning committees. These executive committees comprise staff planners and managers who generate information for planning premises needed by lower-level teams. Guidelines are then drawn up by top management for division-level teams with the responsibility

GLOBAL TRENDS 5-1
Offshore Manufacturing—Planned Globalization

National Semiconductor Corporation, one of the largest United States manufacturers in microelectronics and semiconductor circuitry, has moved a significant part of its production to Malaysia. This Pacific Rim nation, known more for rubber and palm oil exports than for manufacturing, is rapidly becoming one of the centers of "offshore manufacturing." National Semiconductor located a major plant there several years ago to take advantage of low-cost production, and then expanded to keep pace with the competition. Motorola, RCA, General Electric, Hewlett-Packard, and Texas Instruments are among the growing number of competitors located in Malaysia, and their customers—manufacturers in telecommunications, microelectronics, and information systems—also have major interests in Malaysia and nearby Indonesia.

Offshore manufacturing became important to the semiconductor industry in 1985 when Silicon Valley companies were hit hard by low-cost imports from Japan and Korea and firms such as National Semiconductor began "downsizing." Downsizing translated into making painful layoffs, reducing production levels, and curtailing overhead costs through permanent changes in facilities. The downsizing at National Semiconductor and several other major firms in 1986 unnerved industry leaders, who recognized that if American manufacturers continued to retrench, they would collectively be overwhelmed by foreign manufacturers who were expanding. National Semiconductor decided it had to stop "trimming" and start "growing," but cost effectively and on a global basis.

National's managers wanted to locate as much as possible of the firm's semiconductor production offshore as soon as possible. Malaysia was selected because many of the company's customers had already been attracted there. However, National Semiconductor had conflicting objectives. On the one hand, it had always prided itself on being socially responsive to employee and community needs, and if it relocated its manufacturing abroad, several thousand American jobs would disappear, several thousand families would suffer, and the community would lose millions of dollars annually in economic activity. On the other hand, management realized that continued downsizing would have the same effects—and perhaps worse if the company could not survive.

National Semiconductor made a strong strategic commitment in 1987 to grow, and in growing, to ensure its employees of opportunities at home and abroad. An in-house planning system was established, headed by two program managers reassigned from the corporate-level human resources staff. A corporate team became responsible for coordinating a second tier of planning teams drawn from each major area of the company's business. They were charged with identifying business objectives, analyzing competition and industry trends, and developing integrated action plans for a twelve-year period through the 1990s. Today planning teams exist throughout the company, and participation is open to all employees.

Participative planning teams made the decision to go offshore, and established cost-control objectives, new-product research objectives, and market growth objectives. After several years in Malaysia, National's planners have also decided to reposition the company as a global competitor, seeking markets in Europe and Asia in addition to those in the United States, while pursuing expanded joint ventures in manufacturing in Malaysia.

Source: Adapted from "Highlights of Policies on Foreign Investment," *Malaysia: Your Profit Centre in Asia* (Kuala Lumpur: Malaysian Industrial Development Authority, 1988); and George Bailey and Julia Szerdy, "Is There Life After Downsizing?" *Journal of Business Strategy,* January–February 1988, pp. 8–11.

for formulating tactical plans. Division managers are often given a menu of strategic performance expectations, such as objectives for product development, market expansion, and financial results. Division teams coordinate their plans with strategic planning teams, and managers at both levels jointly determine the tactical plans to reinforce strategic objectives. Division managers in turn articulate these objectives and tactical plans to lower-level operating managers. Operating teams repeat the planning process, and the accumulated decisions are aggregated into a comprehensive company plan.

Team planning is not a compromise between the top-down and bottom-up approaches; it is the integration of the best features of both. The major top-down element is that as much information as possible is passed downward, together with as many guidelines as possible for supporting the company's major strategic objectives. The major bottom-up element is a commitment to participation by subordinates, who are given tremendous lattitude for making planning decisions even though these decisions must be carefully coordinated with higher-level teams. Team planning benefits companies by bringing together staff and operating managers, by integrating plans between organizational strata, and by improving communication through participation.

> ## CHECKPOINT
>
> - Describe planning responsibilities for a planning department in each of the three approaches to planning.
> - How does team planning integrate the best of top-down and bottom-up planning features?

At the beginning of the chapter, we identified Hyundai's long-term strategy for becoming a full-line car manufacturer with two major objectives: to produce the highest-quality mid-size and subcompact cars imported into the United States, and to become the industry leader in product innovation. These were supported by tactical objectives to sell 100,000 Sonatas in the first year, with 20 percent sales increases in subsequent years.

Hyundai's objectives are realistic, but the company faces competition from other manufacturers with similar objectives. For example, Honda has built its reputation on quality mid-size cars, and Ford has led U.S. manufacturers with innovative designs such as the Taurus line. Hyundai is therefore entering a segment of the auto market where the nature of the competition differs significantly from that in the subcompact market. The automotive industry has, in fact, changed dramatically in recent years. Today more than 200 models are offered to consumers by nearly two dozen strong competitors.[40]

Industry *planning premises* have also changed. Competition is no longer a major confrontation among three dominant manufacturers, but a fast-paced series of skirmishes among dozens of competing models. There-

fore, planning has shifted away from centralized corporate endeavors to decentralized divisions where decisions on each model account for circumstances within unique market segments. Consequently, tactical activities have become more pronounced and short-term planning responsibilities more important. These shifts are apparent in the nature of automotive competition. New models are compared with others, emphasizing wider bodies, more leg room, less noise, greater head room, better gas mileage, and so on. Intense advertising, low-interest loans, "sale-a-thons," cash rebates, and other incentives are "industry standard" tactics. Thus, a new strategic entry, such as the Hyundai Sonata, is unlikely to gain attention without comprehensive plans coordinated with dealers, distributors, division heads, and top Hyundai executives.

A SYNOPSIS FOR LEARNING

1. Define the planning function and explain how formal and informal planning differ.

Planning is the foremost function of management, the first in a cycle of responsibilities that determines what is to be done, when it is to be done, how it is to be done, and who is to do it. Planning is accomplished within the framework of the firm's *mission,* which defines its purpose through its products, services, and major objectives.

Informal planning is an intuitive process. Formal planning requires rigorous investigation, careful definition of an organization's objectives, and well-defined activities to fulfill those objectives.

2. Explain management planning responsibilities and how they relate to different types of objectives.

Responsibilities are related to a management hierarchy with strategic, tactical, and operational dimensions. These three strata represent the active managers below the board of directors. The board has the responsibility to support top management in instigating and fulfilling major objectives. Executives constitute top management, and they are concerned with *strategic* plans which include long-term objectives and the strategies necessary to fulfill them. At the tactical level, middle managers break strategies into shorter time periods, translating major objectives into tactical plans and objectives. These typically are expressed in annual planning budgets with specific objectives. At the operational level, first-line managers and supervisors implement tactical objectives.

3. Describe the various ways plans are communicated and how managers document planning activities.

There are *standing-use* plans that can be repeated and *single-use* plans that are seldom repeated. Standing-use plans are documented and communicated through *policies, procedures,* and *rules.* Single-use plans are documented and communicated through *programs, projects,* and *budgets.*

4. Explain why contingency planning is so important.

A *contingency plan* is an alternative set of objectives and activities that can be implemented if and when circumstances change so drastically that the preferred plan is infeasible. Contingency planning is a vital responsibility for all managers.

5. Identify the steps in a formal planning process.

A general pattern of planning includes these steps: (1) establish major objectives, (2) evaluate the environmental factors and the competitive issues that can affect the firm, (3) articulate assumptions, (4) identify and involve the proper managers, (5) develop alternatives, (6) stratify plans, (7) communicate

and document plans, (8) determine programs, projects, schedules, and other activities necessary to accomplish documented objectives, (9) implement the action plan, and (10) immediately plan to plan.

6. Contrast the three main approaches to planning.

The *top-down* approach is a method of centralized planning and reflects the hierarchical authority of most organizations. The *bottom-up* approach is a method of decentralizing planning authority. The *team planning* approach is a participative method involving as many people as possible at each level.

SKILL ANALYSIS

CASE 1 Dynascan's Hot Phones

Dynascan Corporation of Chicago is a study in entrepreneurial success. The company was founded in the late 1970s by Carl Korn, who has created markets in CB radios, accessories, electronics, and a variety of consumer products that sell quickly at high profits. Total annual sales during the five-year period preceding 1983 averaged more than $100 million. But Korn's products tend to have "fad" appeal, like CB radios, and success at Dynascan depends on creating new markets with new products in rapid succession.

Korn entered the cordless telephone market in 1983, importing from Japan and Korea low-cost units called the "Cobra" phone. He quickly captured 20 percent of the U.S. cordless phone market. Dynascan's stock went up to $31 a share from a low of $2.60. Korn's efforts were publicized in a *Fortune* news article September 19, 1983, but the article noted how fragile Dynascan's phone market might be.

Cordless phones, for example, were a "hot item" in 1983. Because they were innovations, many buyers paid premium prices of between $100 and $250 a unit in response to emotional advertising. And while Korn was happy with sales, he noted that the CB boom in 1978–1979 had the same pattern of success, but fizzled quickly about two years after it began. Korn also marketed "fuzz-busters" (radar detectors), another boom-and-bust line. So although the Cobra had done well, he had reservations about its long-term appeal.

Dynascan was fortunate to be a market innovator in phones. Korn realized that cordless phones could go the way of CBs. Or they could catch on among suburbanites who want telephones for pools and patios, assuring long-term growth. For the suburbanite markets, Korn anticipates heavy competition from firms like General Electric and Panasonic.

There are also other factors to consider. Korn may well be up against a tidal wave of competitors and innovations. For example, in the same issue of *Fortune* magazine that applauded Dynascan's successes, ITT announced a "System 12" telephone. The ITT entrant was not cordless, but it linked data sources for electronic mail, financial service information, travel services, and an electronic telephone directory. During the early 1980s, deregulation of AT&T created hundreds of new companies offering both products and services as spinoffs from the Bell System. Bell System customers were offered their rented phones for sale at large discounts, and Motorola came out with a hand-held electronic mobile phone system.

Dynascan and Carl Korn epitomize American ingenuity; the company is dynamic and its leader is an entrepreneur who seeks opportunities. But Korn has obligations to stockholders and other investors to provide direction and profit-

8. Instructors (in the last few minutes of the class session) may want to ask for a show of hands on:

 a. How many found their greatest strengths (weaknesses) in the area of Things, People, Data, or Ideas?

 b. Does your perception of your strengths/weaknesses correspond with the perceptions of others? (Yes/No)

Other discussion of items still on the minds of the participants can be scheduled for a future class if the schedule permits.

6

Strategic Management

Brunswick Corporation is known for bowling balls, pins, and alleys, but today the $3 billion corporation also has global markets in recreation, marine, defense, and industrial products. The company began producing billiard tables in 1845 with a half-dozen employees; now it has more than 26,000 employees in five major divisions. During the early 1980s, Brunswick was not performing well and was the target of several takeover attempts. CEO Jack F. Reichert helped set a new strategic course, and now the company is positioned for growth in the 1990s.

Reichert explains Brunswick's success in terms of three S's: survival, strategy, and succession. The first task, to survive, followed hostile takeover bids in 1982, and Brunswick did so only through dramatic restructuring. It sold its Middle Eastern Health Care Services Division, a business Brunswick was uncomfortable with, trimmed nearly 25 percent of its employees, and rebuilt "winning divisions" by decentralizing management and giving shares of stock to every employee. Many mid-level and senior personnel lost their jobs when Brunswick eliminated five tiers of management, dropping from eleven to six levels between the CEO and line foremen. The remaining division managers and operating employees were given joint planning responsibilities; coupled with their new stock ownership, this motivated them to rebuild Brunswick into the *highest-quality producer* in every market it served. Thus, the second S, *strategy,* was long-term growth through quality. The third S, *succession,* was a commitment to Brunswick's people. In Reichert's words, "Of paramount importance is our people—their personal dignity, their pride in what they do, and the trust they have in their management."[1] Brunswick motivated its employees to provide quality products at a profit by making them investors and giving them responsibility for their own strategies.

OBJECTIVES

- Describe the strategic planning process.

- Explain how a strategic perspective influences management decisions.

- Describe the components of a situation analysis.

- Examine the SWOT analysis for making business-level decisions.

- Identify master strategies and their strategic alternatives.

strategic management
The senior management responsibility for defining the firm's mission, formulating strategies, and guiding long-term organizational activities consistent with internal and external conditions.

strategic planning
A disciplined effort to produce the fundamental decisions and actions that must be taken today to shape the long-term direction of an organization.

Recall from Chapter 5 that a company serves many *stakeholders*, and in Brunswick's case, investors, employees, and consumers were consciously considered in the initial retrenchment and the company's long-term growth strategy. Brunswick's survival, however, was not assured simply by trimming people and cutting losses to achieve a new strategic direction. As you read this chapter, consider how top management revived Brunswick.

A STRATEGIC PERSPECTIVE

Managers in executive positions have strategic roles that encompass long-range planning and complex decisions. Our introduction to planning in the previous chapter differentiated among strategic, tactical, and operational planning. At the strategic level of management, decisions are made that reach far into the future and encompass a firm's total activities. Tactical and operational plans and subsequent decisions are, as you will recall, more restricted and short-term in nature. In this chapter, we focus on strategic management activities, in particular, the planning and decision-making role of senior executives.

The term *strategy* implies long-range and broad-based considerations. It implies *change* and *uncertainty* because managers are often dealing with concepts and ideas that are novel or untried, but may in the near future be commonplace. Strategy also implies an organizational responsibility to contribute to society. In this era of increased international competition, many managers are preoccupied with revitalizing their firms to make them more productive and more profitable. Managers at multinationals have to deal with international competition and a variety of global associations with other firms and nations. Other managers are simply grappling with how to survive.

Strategic management is the process of planning a firm's long-term course of action, managing its comprehensive resources, and fulfilling its mission within its broad environment. Those involved in strategic management include members of the board of directors, senior operating officers, and, in larger firms, planning specialists and consultants. For example, General Foods Corporation has strategic planning groups at the executive level consisting of staff specialists such as economists and forecasters who work closely with line executives such as the chief financial officer, chief operating officer, and chief executive officer. At Procter & Gamble, planning teams are given strategic management responsibility at a lower division level. The P&G approach is to decentralize strategic decision making. Marriott Corporation is even more decentralized, with strategic planning and decision making pushed down three tiers to eight "business units."[2]

Strategic planning is a disciplined effort to produce the fundamental decisions and actions that must be taken today to shape the long-term nature and direction of an organization within its stated purpose and mission. As discussed in Chapter 5, those involved in strategic management define major objectives, develop strategies to accomplish them, and encourage lower-level planning that supports the firm's mission. Whether this is accomplished through a centralized core of line and staff executives or through a decentralized system of planning teams is less important than fostering an attitude in managers to *think and act strategically*. Strategic managers do not have thick strategic plans tucked into their back pockets; instead, they acclimate themselves to thinking strategically about where the organization is going, what major changes are likely to occur, and which major decisions will have to be made now to achieve their company's long-

term objectives. Such decisions cannot be made in an undisciplined manner. Managers need to prepare themselves by having well-developed strategic plans based on systematic research.

Among the most important questions strategic managers ask are: What products should we produce? What services should we offer? To whom do we offer these products or services? And what is our purpose for existing? For example, managers have introduced new products that have positioned their companies in new industries. In 1930, Du Pont was known for industrial explosives and construction materials, but then it introduced cellophane and moved into plastics. Other synthetic materials soon followed, including nylon and more than 200 different polyesters, and Du Pont was transformed into a plastics fabricating company. Soon after cellophane became popular, 3M Corporation, then a firm known for sanding abrasives, coated cellophane with an adhesive to create Scotch Tape, and the company repositioned itself as an innovator in films, adhesives, coatings, and sealers, including the recent Post-it note pads, and to whom do we offer these products? Scotch Tape was initially designed in one-foot-wide rolls to seal cardboard shipping boxes. Then a marketing manager at 3M envisioned Scotch Tape as a revolutionary product for home and office use, and 3M's fundamental marketing strategy shifted to the consumer goods market.[3]

The Nature of Strategic Planning

Organizations exist to make contributions to society. An organization is a collective enterprise, a group of individuals that provides society with more than individual enrichment. If it fails to maintain its contribution to society, it can disintegrate. When an American automobile manufacturer stops providing customers with quality cars, customers buy cars elsewhere, perhaps from a Japanese company; if too many customers buy foreign cars, the American manufacturer can become bankrupt. If a church fails to serve its members, it will lose its congregation. And if a university no longer offers sound academic programs, students will transfer to other schools.

Thus, when an organization no longer provides beneficial services or products to its stakeholders, society perceives little need for its existence. Strategy is concerned with the grand picture of how organizations serve society, and strategic planning is concerned with how organizations *intentionally and systematically* make decisions about products, services, customers, and human resources vital both to itself and to society.[4]

In their landmark book *In Search of Excellence,* Thomas J. Peters and Robert H. Waterman, Jr., note that managers of the best firms are adroit at planning and artfully apply the best information their firms can generate: "Show us a company without a good fact base—a good quantitative picture of its customers, markets, and competitors—and we'll show you one in which priorities are set with the most byzantine of political maneuvering."[5] Peters and Waterman are not advocating quantitative analysis; they are reporting a pattern of effective research coupled with innovative management among America's best firms. In fact, they observe that many disintegrating firms have relied too heavily on detached, analytical decisions at the expense of inquisitiveness and innovation.[6]

Several messages emerge from this and similar studies. First, intuition alone does not suffice for planning in a complex society. Second, analytical research is essential to enhance managers' ability to make good strategic decisions. Third, strategic planning is a blend of meticulous research and managerial verve to make better decisions. We should add that the process is also *future* oriented, compelling managers to seek plausible courses of action *today* to assure the organization's future.

The Changing Environment of Organizations

Strategic managers must also bear in mind that an organization is part of a social system that includes many dimensions of economic, cultural, political, social, and business influences, as well as internal subsystems of work groups and social networks.[7] America is quickly changing from an industrialized to a "postindustrialized" society in which *information technology* is replacing manufacturing in preeminence. The trend is not limited to the United States. Other industrialized powers such as Japan, Germany, and France are also moving rapidly into the information age. This transformation is well documented by John Naisbitt in his best-seller *Megatrends*. Exhibit 6-1 summarizes his findings.

Naisbitt notes that in 1950 only about 17 percent of United States workers were occupied in "information" jobs—creating, processing, and distributing information—but by the end of 1979, approximately 60 percent of U.S. workers were in information jobs. Extending these forecasts into the 1990s, Naisbitt and his co-author Patricia Aburdene in their best-seller *Re-inventing the Corporation* found that although information-related jobs would level off at about 63 percent of all jobs, corporations were already radically changing the composition of workers and management staff, reducing management levels, and redefining most middle-management roles. Recall that Brunswick went from eleven layers of management in 1982 to six in 1988, to streamline its operations. Ford Motor Company has cut two entire middle-management levels, and TRW, Hewlett-Packard, IBM, and United Technologies have made similar reductions.

EXHIBIT 6-1 Megatrends: Ten New Directions Transforming Our Lives

Industrial society is transformed to information society	"Although we continue to think we live in an industrial society, we have in fact changed to an economy based on the creation and distribution of information."
Forced technology becomes one of high tech/high touch	"We are moving in the dual directions of high tech/high touch, matching each new technology with a compensatory human response."
National economy rapidly is becoming a world economy	"No longer do we have the luxury of operating within an isolated, self-sufficient, national economic system; we now must acknowledge that we are part of a global economy."
Short-term goals are replaced by long-term rewards	"We are restructuring from a society run by short-term considerations and rewards in favor of dealing with things in much longer-term time frames."
Centralization is replaced by decentralization in government of society	"In cities and states, in small organizations and subdivisions, we have rediscovered the ability to act innovatively and to achieve results—from the bottom up."
Institutional help is replaced by individual self-help	"We are shifting from institutional help to more self-reliance in all aspects of our lives."
Representative democracy is giving way to participatory democracy	"We are discovering that the framework of representative democracy has become obsolete in an era of instantaneously shared information."
Hierarchies of authority are breaking into networks of behavior	"We are giving up our dependence on hierarchical structures in favor of informal networks. This will be especially important to the business community."
Growth in America is in the South not the North.	"More Americans are living in the South and West, leaving behind the old industrial cities of the North."
Multiple options for living replace simple either/or patterns	"From a narrow either/or society with a limited range of personal choices, we are exploding into a free-wheeling multiple-option society."

Source: Ten New Directions Transforming Our Lives, © 1982 by John Naisbitt. Published by Warner Books, Inc.

One reason for restructuring is that higher productivity is achieved with improved information systems and fewer but more highly skilled employees. In a survey by the American Management Association, companies with more than 2,500 employees reported, on average, a 10.2 percent work force reduction in 1988 and an estimated 1989 reduction of 17.3 percent. Most reductions were in support staff and operating positions, but an equivalent percentage of management positions were also dissolved. Although work force reductions may be smaller in the 1990s, it is also likely that companies will create fewer new positions.[8]

Technological advances change organizations. Whenever these advances occur, the roles of all organizational members—owners, managers, and workers—change. Organizational theorist Henry Mintzberg observes that for a given technology, there is a natural organizational structure that promotes harmony and productivity.[9] A large machine bureaucracy is excellent for mass production of say, automobiles, but a terrible model for a service organization such as a hospital. In high-tech firms like IBM and Intel Corporation that have mass-production requirements coupled with technical services, bureaucracies are giving way to consortia of small operating units, almost like companies within companies.[10] Marriott Corporation, described in Management Application 6-1, is an example of a service company with a similar organizational philosophy.

Strategic Shifts

Strategic managers also must evaluate their organization's situation relative to industry shifts and competitive changes. They make these evaluations in order to formulate plans consistent with an organization's capabilities. Later in this chapter, we will describe the strategic planning process in which one important step is the *situation analysis*. A situation analysis is an examination of industry structure, economics, competitive forces, and other external factors coupled with an internal diagnosis of the organization to identify **strengths, weaknesses, opportunities,** and **threats. (SWOT).** As we shall see, SWOT is extremely useful for discovering strategic "shifts" requiring managers to adopt new plans.

SWOT
A situation analysis that examines external factors and internal conditions of an organization to identify strengths, weaknesses, opportunities, and threats.

For example, the auto industry made a strategic shift into high-tech robotics during the early 1980s in response to pressing competition from foreign automakers. This shift in technology has had far-reaching implications. General Motors plans to close five major auto plants, reduce assembly workers by 20 percent, and restructure the corporation into more autonomous, smaller operating units by 1993. GM managers also expect total production to increase through the year 2000 and for the company to change from a five-to-one to a one-to-one ratio of skilled technicians to assembly-line workers.[11]

The shift toward robotics has made significant changes in other organizations. Cincinnati Milacron managers recognized the changes taking place in automation and transformed their company from one making conventional machine tools to one based on production of computer-integrated manufacturing equipment.[12] In response to such industry needs, a few universities, led by the Massachusetts Institute of Technology and Carnegie-Mellon University, have introduced robotics programs. Thus robotics engineering is now a discipline in American universities.

Social Responsibility and Strategic Issues

As noted earlier, an organization is perceived as useful only so long as it contributes to society. Thus, when our automakers failed to deliver quality cars at competitive prices, many American consumers switched to Japanese models. If U.S. automakers had not subsequently made strategic changes in their production technology, it is conceivable that most Americans would be buying imports today. If the U.S. automobile industry had failed to adapt, a ripple effect would have been

MANAGEMENT APPLICATION 6-1
Marriott: Delegate and Hold Accountable for Results

Marriott Corporation has enjoyed a fivefold increase in ten years and is growing at a 20 percent annual rate in sales and assets. Organized around the three major strategic business groups of lodging, contract food services, and restaurants, Marriott topped $6 billion in sales in 1988, and is positioned to crack the $10 billion threshold before 1992. The three strategic business groups control eight subordinate business units, which, combined, employ 200,000 people and have operations in 26 countries.

The company is the world's leading in-flight caterer, supplying 150 airlines with 100 million meals a year. It is one of the ten largest employers in the country, and the third largest hotel chain in the world, with 170 full-service hotels and resorts and nearly 100,000 rooms. Marriott operates or franchises more than 1,600 restaurants, including the Big Boy and Roy Rogers chains, and with the buyout of Howard Johnson's may top 2,000 units by 1990. This surge was bolstered by the acquisition of Saga Corporation, a food service company with close to $1 billion in sales to universities, hospitals, and public restaurants. Other divisions at Marriott are building new concepts in lodging with "Courtyard" hotels, sport resorts (such as the Camelback Inn in Scottsdale, Arizona), luxury centers (such as the Marquis Hotel near Times Square), and gateway four-star hotels in London, Paris, Vienna, Amsterdam, and Hong Kong. Add to that the Sun Lines cruise ships, Host International, and Marriott's original business, the Hot Shoppe chain.

Marriott is also a paradox in management. It is visibly run from the top by one man in a style that has changed little in sixty years. J. Willard (Bill) Marriott, Jr., logs 200,000 miles a year with notebook in hand to jot down less-than-perfect details in business operations. Bill's father, J. Willard Marriott, Sr., read every customer complaint card for fifty six years. The company has a mission and a fifteen-point philosophy statement that have transcended time, and although a hands-on management style is apparent, both father and son found out early that trusting in good people was the only way to achieve their goals. The eleventh point of Marriott's corporate philosophy is: "Delegate and hold accountable for results." Strategic planning was founded on that principle at Marriott nearly fifty three years ago.

Thus, strategy at Marriott is formulated by line managers in each business unit who are given the responsibility and held fully accountable. Division and line managers create three- to five-year plans, establish objectives and budgets, and coordinate these with senior corporate staff under a vice president for planning and business development. Acquisitions, entry into new markets, and international portfolio planning are the responsibilities of a board-level finance committee headed by Bill Marriott. Executives, however, do not interfere with business-level line managers; they set the tone and major objectives, then support business-level strategies to fulfill those objectives.

Marriott's corporate mission is "to have the best lodging and food service in the world." Each business unit is charged with becoming "(1) the preferred

felt among parts suppliers, businesses supported by automotive factories, and localities that rely on tax revenues from all these firms.

Companies that do not provide value to society are quickly weeded out. For example, in the biotech industry, approximately 500 firms emerged during the past decade with promises of exotic gene-splicing medical enhancements, potential cures for cancer, and chemical solutions for environmental problems such as

entific environments. The company's strategic objectives for its five-year plan are to achieve a 15 percent annual growth in sales with state-of-the-art scientific work stations and to achieve quality improvements for 99 percent reliability.[29] Hart, Schaffner & Marx manufactures quality clothing. Several of its men's labels are Hickey-Freeman, Jarmar, Christian Dior, Pierre Cardin, Cesarani, Jack Nicklaus, Playboy, and Johnny Carson. Its women's labels include Baskin, Hannys, Chas, and deJong's. HS&M's main objective is to become the market leader in high-quality clothes, and to maintain investors' returns at or above industry averages with consistent annual dividends. HS&M is organized with business-level strategies so that each clothing line has competitive objectives for sales, profitability, and quality image.[30]

Objectives rarely evolve without painstaking analysis and careful evaluation of environmental influences. This part of strategic planning is called *situation analysis,* and it will be described later in this chapter.

Formulating Strategies to Achieve Objectives

This third phase of the strategic planning process gives a blueprint for action. By **formulating strategies,** managers explain *how* objectives will be achieved. Formulating strategy, like setting objectives, takes into account all relevant information derived from the "situation analysis." Effective strategies address the following questions:[31]

formulating strategies
Managers formulate strategies through their planning efforts to explain how the company will achieve its objectives.

1. How will the company respond to changing conditions such as new technology, shifts in consumer needs, competitive pressures, and economic factors? Through a situation analysis, managers will also be able to discover opportunities to pursue and threats to defend against.

2. How will the company allocate resources among its business units to support business-level and functional-level objectives, while simultaneously preserving its financial integrity? In making such decisions management will also rely on information derived from a situation analysis and the portfolio of businesses defined at the corporate level.

3. How will the company compete in its industry and in its markets to fulfill strategic objectives? If it is organized around business and functional strategies, competitive strategies will be defined for each business unit.

4. Within each line of business, how will the company establish supporting strategies at the functional level? Answering this question will enable managers to coordinate functional activities to fulfill business-level and corporate objectives.

Strategies can include positioning the firm for growth through new products or new markets, global expansion, technological innovation, quality performance, cost-price leadership, and portfolio development. Brunswick Corporation, profiled earlier, has a strategy of diversifying its product line beyond bowling equipment to include recreation and industrial products, defense contracts, and leisure-time services. Coca-Cola has diversified into new products with diet and health drinks, juices, and twelve different soft drinks, and has entered the entertainment industry with the acquisition of Columbia Pictures. We expand our discussion of how strategies are formulated later in the chapter.

Implementing the Strategic Plan

Implementation is the process of making things happen. It involves allocating resources through budgets, developing programs and projects that "activate" the organization, and articulating policies, procedures, and rules managers can use in

GLOBAL TRENDS 6-1
Watch Out Europe (America), The Americans (Europeans) are Coming!

Strategic change has a special meaning for European Common Market nations today. In 1992, they will drop trade barriers and unite into a single competitive market. For American companies, the battle for markets in 1992 and beyond will be a decisive test of U.S. company strength. In the past, American companies have competed against a fragmented Europe, but the unification will create a $600 billion consumer goods market in Europe without barriers to trade among member nations. Companies from France will be able to do business in Germany, Great Britain, Italy, and a dozen other nations as easily as a U.S. company from Chicago does business in Detroit. But American firms in Europe will still be foreign companies facing the same, or stiffer, trade regulations.

How are American companies preparing for the challenge? The biggest and the best of U.S. multinationals began in 1988 with a modest investment of about $2.4 billion to shore up their European operations; this figure rose to a budgeted $19.7 billion for 1989, and a projected $40 billion for 1990. Some U.S. firms are so well established in Europe that competition with European firms is not threatening. Coke and Kellogg are classic Continental brand names, Ford and General Motors vie for the top spots in autos, and IBM and Digital Equipment dominate their European markets. Some, such as Colgate-Palmolive and AT&T, will remain strong even though challenged. Nevertheless, these and other U.S.

strategic implementation
The deliberate execution of strategies that achieve objectives through incremental activities defined in policies, programs, projects, budgets, procedures, and rules.

guiding activities on a daily basis. These components of planning were defined in Chapter 5 as means to *communicate* what must be done and to give managers *guidelines* for getting it done. **Strategic implementation** is the deliberate execution of strategies that achieve objectives through incremental activities defined in pol-

McDonald's replicated its winning fast-food concept nationally through franchising, then, using international joint ventures, expanded to Europe and Asia.

Source: Janice Castro, "Franchising Fever," *Time,* August 31, 1987, pp. 36–38.

master strategies and their alternatives. Strategic alternatives, which are described next, can occasionally apply to more than one master strategy.

Growth

Concentration. A **concentration strategy** is one of trading on a distinctive competency to prevail in one product area, one market area, or one technology. Many companies focus on doing one thing well. Holiday Inn, Inc., builds and operates commercial hotels and motels with services designed for family and commercial travelers. McDonald's provides a family environment for fast foods with predictable quality and service. Anheuser-Busch primarily brews and sells beer.

Both companies have developed a *distinctive competence,* one area of special ability that sets it apart from competitors, and uses this distinct competency to concentrate on one growth strategy. McDonald's is known for hamburgers, but its real product is good, clean, and reliable customer service in low-cost fast foods. Anheuser-Busch brews beer; even though the company has entertainment parks (Busch Gardens), real estate ventures, and professional sports interests (the St. Louis Cardinals), these activities are the results of historic accidents rather than mainstream strategies. All nonbeer assets and revenues do not add up to 10 percent of the Anheuser-Busch corporate picture.[42]

The fundamental logic behind a concentration strategy is to achieve a high degree of efficiency through a focal product or market. This strategy has dangers as well as obvious benefits. One of the dangers is that a company may become entrenched in a saturated market where growth is limited; even worse, the company may become committed to an obsolete product. For example, twenty years ago Texfi Industries was the undisputed world leader in synthetic yarn and the largest producer of polyester double-knit clothing. The double-knit fad ended quickly, but Texfi stayed with its product until the company nearly went bankrupt.[43]

> **concentration strategy**
> A strategy of trading on a distinctive competency to prevail in one product market, or technology.

Integration

Vertical integration. A **vertical integration** strategy is achieved by gaining ownership of resources, supplies, or distribution systems that relate to a company's business. In an effort to stabilize supply lines or reduce costs, a company will often integrate backward into suppliers or forward into distribution systems. By acquiring a supplier, it is able to eliminate an intermediary and gain access to materials it needs at a lower cost. A company may also want to solidify its supply lines to improve reliability and control the quality of materials. By integrating forward, a firm acquires part of its distribution system, perhaps even its own customers. This, too, is a move to improve reliability, such as by owning the trucking system that previously delivered a company's products or by purchasing retail outlets that were previously customers.

> **vertical integration**
> A strategy to gain control of resources, supplies, or distribution systems that relate to a company's business.

Horizontal integration. **Horizontal integration** is an effort to consolidate competition by acquiring similar products or services. For example, a company may acquire a close competitor to expand its own product line and reduce competition. Clothing manufacturers and athletic shoe companies have consolidated their industries through buyouts of close competitors, and the banking industry has been substantially restructured by complicated acquisitions and mergers. If these strategies do not violate antitrust legislation, amalgamations are legal, and horizontal integration is common among firms in major industries. Texaco, for example, bought Getty Oil, and Gulf Oil became part of Standard Oil of Indiana.[44]

> **horizontal integration**
> An effort to consolidate the industry, reducing substitutes or competitors or to improve the firm's product mix or market coverage.

Diversification

product diversification
A specific choice of growing by adding new products, either through internal development or acquisitions.

Product diversification. A **product diversification** strategy is achieved by expanding into new product lines, either through product development or acquisitions of products. Product development is probably the most common method of business diversification. Procter & Gamble has developed thousands of products, ranging from soaps to cake mixes, coffee to toilet tissues, and toothpastes to potato chips. The interesting characteristic of P&G's product diversification is that it maintains continuity in marketing for household goods sold primarily through supermarket channels. Sears diversified its retail stores by expanding from a hardware company to one that sells housewares, clothing, appliances, jewelry, and even precious furs. In recent years, the Sears expansion has assumed new dimensions with insurance, real estate, and securities brokerage services. Sears' method of diversifying was different from Procter & Gamble's. Whereas P&G developed new products through internal research, Sears purchased products and acquired companies.

market diversification
A method of growing by positioning existing products or services in new markets or for sale to new customers.

Market diversification. A **market diversification** strategy is accomplished by finding new markets and customer groups for existing products or services. Adding new markets is a straightforward growth strategy. Cincinnati Milacron, for example, developed generic robots that have only a few basic designs (defined by their size, handling capacity, and operating system), yet are marketed to a rapidly expanding range of different customers. The basic robot used for welding automobile frames can also be used for stacking boxes at Campbell Soup. Among Milacron's customers are automotive plants, warehouses, chemical manufacturers, farm implement companies, plastic fabricators, military installations, and schools.[45] The ability to sell a particular product to many different customers is the result of a marriage between engineering innovations and marketing skills. Growth is often achieved by taking a proven product into new markets. For example, Westinghouse sells light bulbs to a variety of customers. The same light bulb you may purchase in a retail store is also bought by electrical contractors, federal purchasing officers, and wholesale industrial suppliers.

concentric diversification
A growth strategy achieved by developing new products or services that complement the company's existing line of business.

Concentric diversification. **Concentric diversification** is achieved by developing products or services that complement one another to expand sales and a company's customer base. In this growth strategy, a firm remains close to its distinct competency.[46] Kodak followed this strategy since its early years by offering not only an expanding range of cameras but also film, camera accessories, processing paper, developing chemicals, and photo finishing services. Kodak also entered related fields with a proven product by adapting film for different customers. For example, a roll of Kodak film sold in a local drugstore is the same product packaged in wholesale quantities for professional photographers.

conglomerate diversification
A conscious effort to develop or acquire unrelated products, services, or technologies, thereby reducing the risk of being in one business subject to economic cycles or industry competition.

Conglomerate diversification. **Conglomerate diversification** is a conscious effort to develop *unrelated* products or services in unrelated markets. Conglomerates are more financially diversified than firms with product or market strategies. Organizations that have opted for a conglomerate profile usually have done so to avoid the risks associated with a single product or market. The motive for adding new companies or lines of products is financial. The most often quoted criterion for conglomerate expansion is that the new product (company or technology) will meet or exceed minimum standards for profitability.[47]

Conglomerates are created by buying entire companies or divisions. Since the early 1960s, the pattern has been for a stronger, cash-backed company to buy out another company that lacks the finances to operate efficiently. The acquired company usually has a distinct competency in products, markets, or technologies that is expected to become a high-powered asset once underwritten by the acquir-

ing firm. Conglomerate diversification does not always prove that "bigger is better"; recall our earlier examples of LTV and Beatrice Foods—one is bankrupt and the other has disintegrated. Still, the range of activities a conglomerate controls can be staggering. The Continental Group, for example, entered 1988 with approximately $8 billion in annual sales, 60,000 employees, 250 manufacturing facilities, and more than 1,000 sales offices in 130 countries.[48]

Retrenchment

Internal consolidation. **Internal consolidation** is a form of retrenchment in which a firm retreats to a more realistic position where it can compete profitably. Retrenchment, as we said earlier, means to fall back and regroup; it does not mean to capitulate. Consolidation can be accomplished by shutting down plants, trimming personnel, and reducing the range of marketing activities to achieve cost savings. Corporate *downsizing,* as noted earlier, is a process of internal consolidation to improve productivity and reduce costs. It can be accomplished by implementing new technologies that replace middle managers and labor-intensive operations. Chrysler is perhaps the best example of downsizing. At the end of 1979, it employed more than 162,000 people, was overextended with nearly $1 billion of excess debt, and could no longer compete profitably in the automotive industry. Then, with huge loans and government support, Chrysler shut down unproductive plants, built several new ones with automated technology, reduced the number of its employees to 99,000, and began competing profitably with fewer but better-built car models. Within four years, the company had cleared its loans and regained peak production, although with a third fewer employees and nearly 40 percent fewer managers.[49] More diversified companies face similar situations as a result of expanding beyond their ability to control operations. If the consolidation strategy works and the firm stabilizes, then management is free to choose a new long-term growth strategy.

internal consolidation
A form of retrenchment in which a company retreats to a more realistic operational position, reducing its costs and risks.

Divestiture. **Divestiture** is the process of selling off divisions or subsidiaries to restructure a company around a smaller but stronger portfolio of businesses. Either a company will dispose of unprofitable business units to regain profit performance for the total enterprise or it will sell off a good division to bail itself out of financial trouble. Selling poor performers is the more likely option. Divestiture is often an attempt to cut losses and allow managers to focus their strength on potential winners. Another reason for divestiture is that a business unit doesn't fit into the company's overall portfolio. This was precisely the situation when Sperry Rand Corporation sold its Remington Electric Shaver division to Victor Kiam. Sperry Rand's portfolio of businesses was focused on computer hardware, industrial electronics, and office system equipment. Remington was an orphan division, so when Kiam offered to buy it, Sperry Rand quickly agreed.[50]

divestiture
The process of selling off divisions or subsidiaries that are either poor performers or do not fit well with the company's long-term strategic objectives.

Liquidation. **Liquidation** is the final option and means simply "to terminate." For a concentrated firm, divestiture and liquidation mean practically the same thing, but for a diversified company, liquidation may mean years of systematic restructuring. For example, before LTV finally filed for bankruptcy in 1988, the company had spent nearly two decades making marginal profits and surviving mainly by periodically selling off divisions. One division, Braniff Airlines, was a healthy and profitable company when LTV sold it, and the sale generated sufficient cash to carry LTV through the mid-1980s.[51] Today liquidation is more likely to occur through a leveraged buyout or a friendly takeover when a struggling company is offered for sale. (The Checkpoint for this section appears on the next page.)

liquidation
The "final" option, liquidation is the decision to terminate business in a systematic way through bankruptcy or a complete sale of the company.

CHECKPOINT

- What is a concentration strategy and what is meant by a firm's distinct competency?
- Describe two ways to grow through diversification.
- How do vertical and horizontal integration strategies differ?
- Define *retrenchment* and explain two retrenchment alternatives and how they help a company reposition itself.

MAKING THE STRATEGIC DECISION

Strategic management is primarily concerned with decisions that ensure the organization will be *effective,* which means "doing the right things." Of secondary importance is *efficiency,* which means "doing things right."[52] Therefore, strategic decisions are concerned with choosing a master strategy and a planned strategic alternative to achieve the organization's major objectives; administering the strategy is important, but secondary to making the right choice of strategy to begin with.

Arriving at the right choice of strategy requires one more careful analytical step. The strategist must evaluate each option to ensure it is *realistic* in relation to environmental constraints, *feasible* in relation to organizational resources, and *sufficient* in relation to accomplishing the mission of the firm. Managers review all the external environmental considerations (see Figure 6-7) to identify weaknesses in, or threats to, individual alternatives. They also carefully review internal considerations (see Figure 6-8) to identify critical shortcomings of potential strategies.

The reevaluation process answers many of the same questions posed earlier in the chapter, questions such as "What service or product do we offer to maintain a viable customer base?" and "What is our technological competence?" The chosen strategy will also be acceptable to most managers and employees. It will satisfy the constraints of economics, regulations, finances, human resource skills, and material resource availability. And it will not be detrimental to society.

Earlier in the chapter, we introduced a general strategic planning process. Figure 6-9 expands that process with steps required in the situation analysis. This model identifies two strategic decision points. The first occurs when management selects a master strategy. The second occurs after the master strategy is reviewed to identify the specific strategic alternative to implement. Once both decisions are made, implementation can proceed, and the final stage in the process, control and evaluation, can take place.

FIGURE 6-7 External Factors That Influence Strategic Decisions

FIGURE 6-8 Internal Factors That Influence Strategic Decisions

FIGURE 6-9 Determinants for Analysis in the Strategic Planning Process

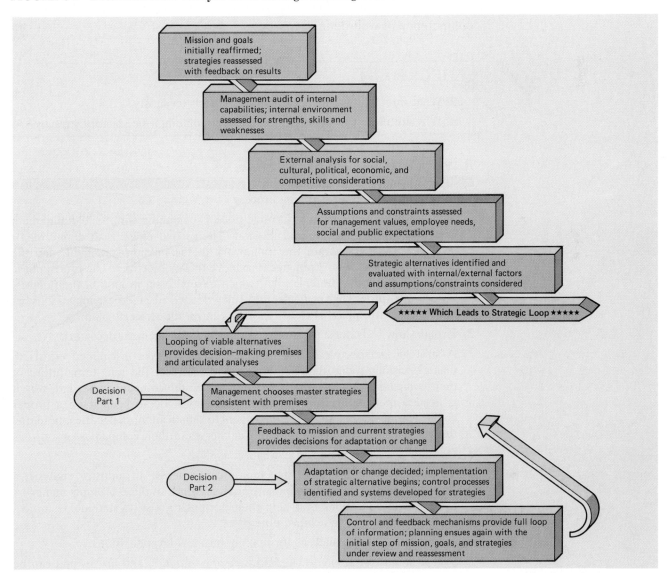

Strategic decisions are well illustrated by the Brunswick Corporation example introduced at the beginning of the chapter. Initially, Brunswick decided to *retrench,* to regroup around potentially strong divisions with a *downsized* organization. To implement its retrenchment strategy, Brunswick *divested* itself of a profitable division, Whittaker's Middle Eastern Health Care. Brunswick made enough money on the sale to underwrite organizational change and a comprehensive new human resource program. Selling the health care division was logical because, although it was profitable, Whittaker's did not fit into the Brunswick portfolio of manufacturing sporting goods and industrial equipment. By cutting out unnecessary levels of management and implementing a human resource program, the company positioned itself for growth. Ultimately, its strategy was to grow through *concentric diversification.* Brunswick made a commitment to manufacture quality products that complemented its existing product line, staying close to its distinct competency in well-defined markets.[53] ∎

CHECKPOINT

- What three conditions must a strategic decision satisfy?
- Why are there two decision points in formulating a satisfactory strategy?

A SYNOPSIS FOR LEARNING

1. Describe the strategic planning process.

 A strategic planning process has five phases, beginning with a clear statement of organizational purpose and mission. The second phase is to define major strategic objectives within the framework of the mission statement, and the third phase is to devise strategies to achieve those objectives. The fourth phase is to implement the strategic plan, which means to set in motion the policies, procedures, programs, projects, and rules needed to guide organizational behavior. The fifth phase is to consciously control the strategic plan.

2. Explain how a strategic perspective influences management decisions.

 A strategic perspective is one in which managers take disciplined efforts to make decisions today that are understood to affect the long-term future of their companies. Managers are aware of where the company is headed, why it is headed in that direction, and what they must do to keep it on a proper course. Strategic thinking alerts managers to significant opportunities, potential threats, and both the strengths and weaknesses of their companies.

3. Describe the components of a situation analysis.

 The situation analysis has three major components: an industry analysis, a competitive analysis, and a company analysis. Each of these prompts managers to investigate questions that help them formulate mission statements, objectives, and strategies to achieve objectives.

4. Examine the SWOT analysis for making business-level decisions.

 SWOT stands for *strengths, weaknesses, opportunities,* and *threats* and can be

used as a systematic analysis at every planning level. Employed at the business level, it is a method of looking into internal and external characteristics of competition. A company's strengths are internal factors that give it an advantage over other companies. Weaknesses are internal factors that put a firm at a competitive disadvantage. On the external side of SWOT analysis, opportunities arise from understanding changes in markets, products, or technologies and new opportunities can also emerge from government actions, changes in society, and global changes. Threats can come from external forces beyond the control of management.

5. Identify master strategies and their strategic alternatives.

Master strategies are devised by corporate-level planners to achieve long-term objectives and to provide an umbrella of guidelines for business- and functional-level strategies. Master strategies are expressed in broad terms and include growth, integration, diversification, and retrenchment. Strategic alternatives are the carefully articulated ways in which master strategies can be implemented.

SKILL ANALYSIS

CASE 1 Exxon's $2 Billion Strategic Fiasco

Few people will remember Exxon's "Office of the Future" or its much-publicized division Exxon Office Systems (EOS). They both disappeared in 1984, but not before they lost $2 billion and ended the careers of 8,000 people. EOS, heralded several years earlier as a contender capable of challenging IBM in business computers, became a record-setting strategic fiasco for Exxon.[54]

The initial strategy of EOS was to find the most innovative products in office equipment technology, acquire the best entrepreneurial firms in computer technology, and launch a frontal attack on the business systems industry. EOS was formed by a nucleus of QWIP, QYX, and Vydec acquisitions, and the mother company committed more money to the project than most competitors were grossing in sales each year. Unfortunately, Exxon's management had no clear plan and little understanding of the computer industry.

After acquiring the three entrepreneurial firms, EOS hired their three founders as consultants. These were young men on the rise who drove fast sports cars and preferred sports shirts and jeans to suits and ties. Nearly all their employees shared a similar social viewpoint, and they lasted only months in the suit-and-tie bureaucracy of EOS, whose top managers had been appointed from the ranks of near-retirement Exxon oil executives. EOS quickly became a mirror image of Exxon, steeped in process control with layers of management tucked away in field offices. Typical of large, established enterprises, EOS was expected to succeed through marketing, and management threw hundreds of millions of dollars into advertising. In fact, a technology-driven industry grows through innovation and product development, and Exxon unfortunately pursued neither. Exxon's first mistake, therefore, was to create an entrepreneurial firm run by risk-adverse corporate managers with objectives quite different from those embraced by high-risk innovators in competing firms.

EOS top management also turned over quickly. Exxon shareholders were led to expect profits and sales to leap past those of IBM, Xerox, and Burroughs, and when EOS lost money, heads had to roll. The last EOS division manager survived only a few months, the time he was allotted to "fix" the company just before the division was dismantled in 1984. His previous post had been manager of Esso Greece, about as far removed from office technology as one could get in the organization.

Exxon's view, when it still expected EOS to become the premier office systems company in the world, was that anything could be fixed with enough money. So more money was spent on more corporate managers, more salespeople, and more advertising. When stockholders asked about future plans, Exxon explained that it had no grand scheme or master plan for cementing the ventures, but was making all these investments to keep its options open. From the beginning, there was no well-thought-out strategic plan, and objectives for EOS changed according to the whims of revolving-door top managers. In the end, EOS was shut down quietly; a footnote in Exxon's annual report explained simply that some assets had been divested.

Some analysts blamed the demise of EOS on a cultural clash between entrepreneurs and professional managers with opposing objectives and expectations. Others said "oil men" couldn't run a "people business," one based on technology they knew nothing about. Still others believed that EOS implemented a de facto "global diversification" strategy before it had a distinct competency in a proven product line with which to diversify. And there were those analysts who believed that Exxon's managers foolishly superimposed oil industry planning premises on their competitive analyses for the computer industry. Ultimately, the question is: Did Exxon really expect to create a multi-billion-dollar company in a few years by throwing money into a venture only to keep options open?

Case Questions

1. Put yourself in the position of a strategic analyst. What do you think caused the demise of EOS?
2. What planning premises would you have proposed for EOS during the embryonic stage of the office systems industry?
3. Evaluate strategic alternatives for EOS at its inception. What might have been a winning approach to the office systems business?
4. From Exxon's corporate perspective, was office systems a logical business for diversification? Suggest alternative businesses that might have fit better with the firm's distinct competency.

CASE 2 Lincoln Memorial Hospital

Lincoln Memorial is a community hospital with about 250 beds serving a midwest city with a population of nearly 60,000. The hospital is part of a chain of corporate-owned health organizations since a decision in 1983 allowed LMH to be acquired. The board of directors was somewhat bitter over the decision to "sell out," feeling they had been forced into it by a federal mandate that drastically altered Medicare payment programs.

Medicare legislation during the early 1980s was aimed at reducing hospital costs by generating new government-defined rate systems and controls on services. These changes resulted in several hospitals being forced to deny operating privileges to doctors whose surgery cases—mainly heart patients—cost more than the new Medicare rate schedule allowed. This and similar cases have been researched and verified.[55] This was no apparent reflection on the physicians involved, but the Medicare mandate had created an absolute "flat-rate" system that forced hospital administrators to exclude higher-cost operations and services.

In another instance, a northern Virginia hospital reported it was drastically altering its strategy of offering specialized medical treatment that was too costly. Several teaching hospitals with high overhead costs associated with training programs decided to curtail nursing education programs.[56] In other instances, hos-

7

Tactical and Operational Planning

Pepsi Cola outsold rival Coca-Cola in the United States for the first time in 1988 through an aggressive marketing strategy. Success did not come overnight, nor is it assured in a mature industry where two giants battle for the title of "cola king" of America. PepsiCo has diversified its product line, but for its best-known division, Pepsi Cola, it established a *business-level strategy* of market growth to increase sales to a broader spectrum of customers. To implement this strategy, the division focused on marketing *tactics* to reach older teenagers and younger adults, two groups that had not been avid Pepsi drinkers. Marketing plans introduced during the 1970s were designed to create a "Pepsi Generation," and these were followed by "cola wars" and "taste tests" during the early 1980s. Then when both Pepsi and Coke introduced diet colas, marketing plans turned to "celebrity advertising" to neutralize the competition. Pepsi Cola's boldest stroke came during the 1988 Grammy music awards when the company featured Michael Jackson in explosive rock concert TV ads. Pepsi's sales leaped several percentage points, and the stage was set for industry-wide celebrity advertising blitzes.[1]

As you study this chapter, consider the nature of competition in the soft drink industry and how *functional-level planning* is formulated to reinforce corporate and business strategies. Also consider how managers at operational levels, such as those in charge of advertising at PepsiCo, must devise plans to implement higher-level strategies.

As we saw in the previous chapter, strategic planners define long-term objectives, and complex companies may have two or three levels of strategy. Corporate-level managers are concerned with a portfolio of products and services, business-level managers focus on division objectives, and functional-level managers develop plans to reinforce higher-level strat-

■ Describe the nature of tactical planning and related managerial roles.

■ Define the key elements of a marketing plan and a marketing program.

■ Explain production planning and the three approaches to production.

■ Describe human resource planning from a tactical perspective.

■ Discuss the responsibilities of financial managers in tactical planning.

■ Describe operational planning responsibilities and the critical task of scheduling.

tactical planning
The transformation of strategies into medium-term objectives and activities usually implemented by middle managers in functional roles.

egies. PepsiCo's portfolio of products ranges from snacks such as Frito-Lay to restaurant chains such as Pizza Hut. The division managers at Pepsi Cola, however, are concerned only with soft drink sales, and marketing managers have clear mandates for making their soft drinks successful.

This chapter focuses on tactical and operational planning that encompasses decisions in marketing, production, finance, and human resources. We follow the three-tiered model of planning—strategic, tactical, and operational—illustrated in Chapter 5. Figure 7-1 shows the foundation of that model. It excludes the three strategic levels described earlier and explored in Chapter 6 because, in reality, only very large companies have multitiered strategies. Most companies have an organization similar to that shown in Figure 7-1, where *tactical planning* is the responsibility of middle management and *operational planning* relates to activities and tasks at the lowest management level.

THE NATURE OF TACTICAL PLANNING

In **tactical planning,** middle management transforms strategies into more specific medium-term objectives. For example, G. D. Searle, a large pharmaceutical company, developed NutraSweet and obtained FDA approval to market the chemical sweetener in 1981. Searle's corporate-level strategy was to create new industrial and medical products that complement a product line of more than 600 medicines and pharmaceutical ingredients used by food and drug manufacturers. When marketing became feasible in 1981, the first year's objective was to position Nutra-Sweet as the only sugar-free sweetener in the diet soft drink industry. Searle failed to achieve that objective because the public—and major soft drink companies—were not ready to accept a chemical sweetener. Searle's managers had also relied on industrial sales tactics to introduce the product, such as making technical sales presentations to purchasing managers at soft drink companies. In 1983, Searle switched tactics and developed its own advertising program to generate consumer acceptance. Nationwide TV ads were aimed at convincing the public that a sugar-free sweetener was both good-tasting and safe. PepsiCo and Coca-Cola began using NutraSweet exclusively, and sales exploded to $600 million in 1984.[2]

Tactical Planning Periods

We noted in Chapter 6 that strategic plans are expressed in time periods of several years; a five-year planning horizon is popular. Tactical plans are much shorter, often expressed in annual increments of one calendar or one fiscal year. In the NutraSweet example, initial marketing objectives were specified for 1982, respecified for 1983, and substantially revised for 1984.[3]

Tactical plans do not have to be tied to a one-year time frame, but because they are associated with *annual budgets,* this is convenient. As we noted in Chapter 5, budgets provide quantified expectations and a clear allocation of resources. Because tactical objectives need to be specific, annual budgets at division and department levels are common. Actually, tactical plans are often longer than one year, even when they are budgeted in one-year increments. For example, Pillsbury outlined an eighteen-month market test phase before introducing Soft Breadsticks to the market. The plan had two intermediate tactical stages: a twelve-month trial period in a test market, and a six-month marketing research

FIGURE 7-1 Hierarchy of Plans

period to determine whether the product would sell nationwide. Independent budgets were established for each test phase, and seven different departments had specific tasks to complete in each budget period. Product development managers, for example, had to test several different combinations of ingredients, and consumer behavior analysts had to gather data on consumer perceptions of the new product. Other managers were concerned with advertising, packaging, competition, pricing, and manufacturing requirements.[4]

Shorter time periods are also possible in tactical planning. Fisher-Price toys are test-marketed in six-week increments to coincide with high-volume sales seasons. The company also coordinates manufacturing and sales campaigns for

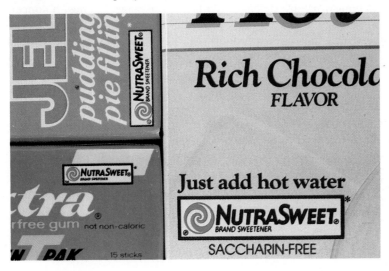

Although Searle started working on NutraSweet as a research project in 1966, fifteen years passed before it was marketed. During this period, NutraSweet evolved through more than twenty tactical planning stages, ranging from initial product lab testing to the arduous process of obtaining FDA approval.

six-month intervals on the assumption that most toys go through a short product life cycle. Reebok International altered the structure of the sporting shoes industry by establishing tactical planning periods based on seasonal needs. Before 1986, Reebok was a little-known manufacturer in an industry dominated by Nike, but Reebok introduced four different shoes that year, several more in 1987, and a line of ten models in 1988. During that time, Nike stuck to its plans for introducing a new line of shoes only once a year. Reebok's tactics of seasonal changes made it the market leader in U.S. sports shoes.[5]

Tactical Planning Considerations

Manufacturing firms have four major tactical planning functions: *marketing, production, human resources,* and *finance.* In addition, they may have specialized departments in supporting roles that develop tactical plans. For example, a manufacturer may have product engineering, distribution, credit, consumer service, and purchasing departments. In some instances, companies are large enough to also have separate departments for information systems, market research, plant and facilities, and others in supporting roles. Service organizations, such as banks, hospitals, and insurance companies, have similar planning functions, except that production is replaced by *service operations* and support activities such as engineering and distribution are unnecessary. In this chapter, we focus on tactical planning in each of the four major functions.

> **CHECKPOINT**
>
> ■ Describe how management responsibilities differ in strategic, tactical, and operational plans.
> ■ Identify and discuss several tactical planning considerations for managers in the functional roles of marketing, production, human resources, and finance.

MARKETING

Strategic marketing objectives provide a foundation for tactical marketing activities. Recall from our discussion in Chapter 6 that a master strategy is first defined (e.g., *growth*) and then clarified through a strategic alternative (e.g., *concentric diversification*). Once a strategy is formulated, responsibilities for making each component of the plan work are delegated to tactical managers. Thus, a concentric diversification strategy to develop new products requires a marketing plan for reaching consumers with these new products. Market plans that have a strategic foundation are based on answers to the following questions:

1. Why will customers buy our products or services? Price? Quality? Brand image? Convenience?
2. What is our product or service profile within the industry? Price comparability? Performance profile? Quality image?
3. What are our options for distribution? Wholesale? Retail? Field sales representatives? Licensed distributors? Mail order?
4. How will we promote products or services? Aggressive mass media advertising? Demonstrations? Point-of-sale displays?
5. Who is our primary customer? Do we have a unique market niche?
6. Who are our potential customers? How do we define them?

New products differentiated in some way from their competitors can often generate a price premium, but such premiums rarely last. Because Polaroid cameras were unique when first introduced in the 1950s, they commanded a high price. Now they sell for much less than most single-lens reflex cameras. Sophisticated hand-held calculators sold at high prices in the mid-1960s: A calculator costing $5.99 today sold for $89.99 in 1968. In less than two years, the prices of compact disk players plunged from $1,000 to under $200 as competitors proliferated. Once new competitors emerge, a firm can no longer claim to be unique nor charge premium prices.

Reasons for price changes are not as important as how market planners consciously choose pricing tactics. Again, a product with differentiated values for consumers can command a premium price, and a firm may choose to sell the product at that premium until forced by competition to lower prices. This is called *skimming,* a tactic that Coleco chose for its Cabbage Patch Kids dolls. In contrast, a firm may choose to set a nonpremium price to establish a strong market share to dissuade competitors or to *penetrate* a market through very high sales. Commodore used this pricing tactic with its Commodore 64 computer, and GM has announced that its Saturn models, due to be introduced in 1991, will have "the lowest possible price for maximum penetration."[15]

Quality plays an important role in setting prices. For example, Panasonic and General Electric maintain premium prices for their VCRs, relying more on quality improvements to distinguish their products. Other companies, such as Emerson, make VCRs to sell at discount or through mail-order catalogs at low prices. Prices can also be used to imply quality, such as prestige prices for Christian Dior men's clothes and Estée Lauder perfumes.[16]

Promotional tactics. Promotional activities significantly influence the image consumers have of a firm and its products. Apple has a low profile in office business systems, but its image is strong in home and educational markets. Early promotional efforts to sell Apple microcomputers to home enthusiasts and schools were successful. When, however, Apple attempted to enter the mainstream business market with the Lisa (and later the Macintosh), it used TV and magazine promotions aimed at the IBM PC. Unfortunately for Apple, this tactic only reminded consumers that IBM was the strongest in the business field. After this promotional failure became apparent, Apple quickly withdrew from its head-on campaign.[17]

Promotion is often equated with advertising, but actually advertising is only a small part of the promotional mix. Tactical promotions also include sales efforts like point-of-purchase displays, cash-back offers such as those made popular in automotive sales, special offers such as low-interest financing and giveaway campaigns, and many other efforts distinct from advertising. Promotional tactics include "personal selling"—emphasizing one-on-one interaction between salespersons and customers—coupled with discounting, contract purchasing, and customer service after sale. Often overlooked is public relations, a form of free advertising based on an effort to introduce newsworthy issues into the promotional mix.

Distribution. Although few courses in business schools treat distribution and logistics management in any detail, distribution is an important activity. Companies can often successfully market products that lack distinctive characteristics by distributing them in a unique manner. Distribution planning answers questions of *how* the firm will get products to market and *where* customers will make purchases. There are hundreds of ways to sell products besides the obvious channels of distribution such as retailing, wholesaling, and catalog sales.

Frito-Lay relies on a form of "rack jobbing" to market snack foods through a widespread network of route distributors. We noted in Chapter 5 that Frito-Lay has a customer-oriented strategy of service with a 99.5 percent on-time delivery objective. Effective distribution has made this relatively undifferentiated product line of snacks highly successful.[18]

Franchising is a major category of distribution that may be the fastest-growing segment of business in America. McDonald's was built on franchising and a marketing philosophy of clean stores in convenient locations. Other well-known franchises are Jiffy Lube, 7-Eleven, and Red Carpet Realty, but there are literally hundreds of products and services that owe their success to franchising with exquisite distribution systems. A few recent entrants include Merle Harmon's "Fan Fair," Julie Brice's "I Can't Believe It's Yogurt," and corporate-owned ARCO "am/pm markets."[19]

Distribution emphasizes physical placement of businesses. Holiday Inn Corporation locates hotel facilities at arterial traffic centers like airports, vacation spots, and business travel hubs. In the photocopying business, a California firm called Kinko's locates all its copy centers within walking distance of college campuses. Distribution can also be defined by how sales are controlled. IBM and Apple license dealers in carefully selected areas. Tandy Corporation mass-markets its microcomputers through Radio Shack, a company-owned and -controlled system of stores. Hewlett-Packard and Digital Corporation exercise tight control over district sales and distribution offices, and PC Limited is a factory-direct system bypassing intermediaries.

This introduction to distribution, product planning, pricing, and promotion has been brief. For our purposes, it is enough to recognize the elements of a marketing plan. Specifically, these are elements of a marketing program that are coordinated with production, finance, and human resource planning activities.

CHECKPOINT

■ Describe a marketing plan and a marketing program, and contrast the two.

■ What is a customer scenario and why would it be important to you if you were responsible for developing a marketing program?

■ How would you use a sales forecast to help plan product improvements and promotional activities?

PRODUCTION

production planning
Managers in product planning are concerned with manufacturing quality products in the right quantities for delivery to customers at the right time.

Production planning is concerned with manufacturing quality products in the right quantities for delivery to customers at the right time. Production and marketing objectives must be orchestrated because they are interdependent; production managers must understand how marketing programs will be implemented, and marketing managers must understand how products will be made and delivered to their customers. Figure 7-5 illustrates three distinct levels of production planning: strategic, tactical, and operational. Notice that marketing information is crucial at each level. Sales forecasts and marketing objectives affect production plans, yet the reverse is also true. Production is subject to constraints that not only affect how much can be manufactured but also how much can be sold.

Strategic Production Plans

Master strategies, such as for growth and diversification, partially depend on a company's production capabilities; plans to manufacture a great new product or to expand sales to new customers will be hollow if a firm does not have the necessary production capacity. At the same time, strategies drive production plans for long-term changes in technology, production processes, and product development. Recall from Chapter 6 that part of the strategic planning process is a *situ-*

FIGURE 7-5 Production Planning Process

ation analysis that specifically investigates the *strengths* and *weaknesses* of a company, and that several critical issues in this analysis concern technology and production capabilities.

From a strategic production planning viewpoint, managers evaluate a firm's *aggregate capacity*. The **aggregate capacity plan** establishes the maximum feasible output that can be manufactured and delivered during a strategic planning period. It takes into account major changes in technology, such as process changes away from labor-intensive assembly to automated assembly systems, raw material supplies, purchasing and inventory capabilities, manufacturing and storage facilities, and human resources required in production. Sales forecasts and strategic marketing plans are important for coordinating long-range production requirements with master strategies. The latter were treated in depth in the previous chapter, but in terms of tactical planning, the strategic *aggregate capacity plan* determines how medium-range planning will be formulated.

Tactical Production Planning

Strategic aggregate capacity plans are translated into annual production plans. These are sometimes called capacity plans or production budgets, but to avoid confusion, we will use the term *production plan*. A **production plan** specifies the planned volume of each product to be manufactured consistent with marketing plans for projected sales during a planning period.[20] The production plan also

aggregate capacity plan
This establishes the maximum feasible output that can be manufactured and delivered during a strategic planning period.

production plan
A formal production plan specifies that planned volume of each product to be manufactured consistent with marketing plans for projected sales during a planning period.

describes annual production quotas and budgeted resource allocations that are the basis for operational planning decisions. Notice that Figure 7-5 uses the term *master production schedule* for operational planning, and beneath it the term *materials requirements plan.* The master production schedule will be discussed later in the chapter as the focal point of operations planning; a materials requirements plan is a computer-based model for operations control, discussed in Chapter 17.

To get a simplified idea of the model, look at Figure 7-6. It shows that projected sales establish the requirements for *finished goods inventory,* the number of items that must be ready to be delivered when sales are expected. The finished goods inventory, in turn, establishes required production levels specified in the production plan, and the production plan then becomes the basis for operational decisions. In tactical terms, this implies an annual cycle of preplanned activities, but because customer demand is seldom the same month to month, annual plans must conform to *seasonal patterns of demand* that alter the requirements for finished goods inventory.

Retail stores, for example, have three or four heavy sales seasons, the busiest being Christmastime. The December sales volume at Sears and J. C. Penney's is nearly quadruple that of any other month, and for certain types of products, such as toys, the December volume is six times that of any other month. Firms depend on construction, such as those in lumber, structural steel, and insulating products, reach peak sales in early summer. Resort services (skiing, golfing, boating, camping) and agricultural suppliers (farm equipment, fertilizers, commodities) have two or three peak months each year when they make more than 80 percent of their annual sales. Companies that support these industries face similar fluctuations. For example, farm loans almost always precede farm revenue by many months. Consequently, banks face a heavy agriculture loan service demand early each year with payback periods later in the year.[21]

Production planning, therefore, requires more than an annual estimate of sales with production broken down into convenient increments; weekly or monthly production levels with similar quotas can result in serious inventory shortages as sales fluctuate, changing the demand for finished goods inventory. Service organizations face similar changes in demand, and their *operations plans*—the service equivalent to production plans—show similar variations. Johns Hopkins Medical Center in Baltimore, for example, has peak seasons for maternity care, virus treatment, cardiac care, and emergency orthopedics. Community hospitals located near universities are pushed to capacity toward the end of each semester and have fewer patients during summer vacation.[22]

FIGURE 7-6 The Production Plan

Production and operations planning can overcome these problems. Figure 7-7 illustrates three approaches to production planning. Each has different characteristics and is suited to different demand patterns, so that material resources, people, and inventory can be managed more efficiently and customers can be better served.[23]

Level production model. A level production model is implemented when sales are steady or show only minor fluctuations throughout the year. Companies in food commodities, such as salt, cereal, and milk, experience only minor variations

FIGURE 7-7 Approaches to Production

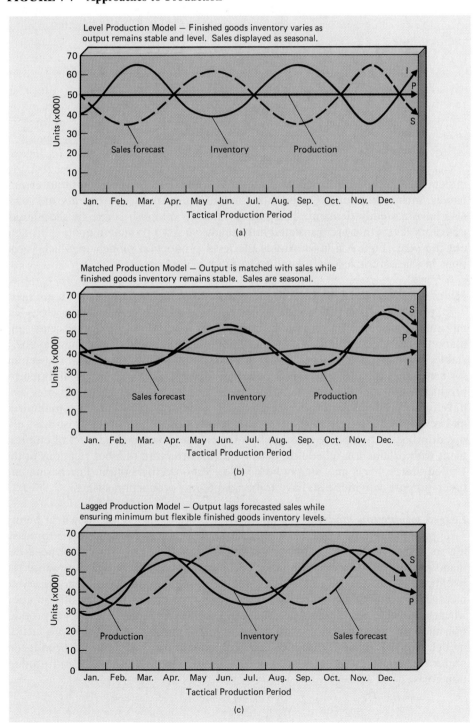

P&G, General Foods, and other producers of commodity staples establish a finished goods inventory level *above* the highest peak of forecasted sales. Thus, they always have some excess inventory; in other words, they do not ever "stock out." On one hand, level production seems efficient because plants can run at predictable levels throughout the year. On the other hand, when inventories pile up, warehousing and handling costs can become tremendous.

in demand, so they can schedule production with some degree of certainty. Companies, such as Procter & Gamble, that manufacture laundry detergents and soaps also have a steady demand. This allows them to establish stable finished goods inventory levels that are translated into steady weekly production quotas throughout the year. Figure 7-7a illustrates the level production model, in which variations in sales are inversely related to variations in inventory.

Matched production model. In the matched production model shown in Figure 7-7b, production is matched with projected sales. Although production varies significantly, inventory levels remain consistently low. Risks of obsolescence and market changes are minimized by matching output with sales and maintaining a stable, low amount of finished goods in stock. Keeping inventories low is essential for companies making spoilable products with short shelf lives. Meat and poultry producers are sensitive to inventory levels, and pharmaceutical companies also have many products with short shelf lives. Theoretically, costs are also minimized and revenues match expenses in concurrent periods, but this tactic also has serious drawbacks. It requires reassigning workers and changing the level of employment with production schedules; because of the structure of labor relations in the United States, firms may simply be unable to choose this option. Purchasing and other support activities also have to be adapted to production swings.

Lagged production model. In the lagged production model, shown in Figure 7-7c, production is scheduled ahead of sales. This model requires careful forecasting so that appropriate quantities are manufactured *just in advance* of peak demand periods. With proper planning, a company using this model can reduce the likelihood of stockouts, and at the peak sales period can produce inventory to meet demand with minimum surpluses. The firm creates a trade-off situation whereby inventories accumulate, but to a lesser extent than in the level production model; and production varies, but less so than in the matched production model. Toy manufacturers, agricultural equipment firms, and chemical producers prefer this approach because they need to minimize high inventory and production costs.

BRIDGING GAPS ACROSS FUNCTIONAL LINES

If managers could plan for their individual operating units independently of one another, there would be little need for "bridging gaps," but this is impossible. Each operation or functional unit is like a puzzle piece that must fit with others to make a complete picture. Each provides a subset of plans and objectives that must be synchronized to reinforce the common objectives of the organization.

Bridging gaps between divisions is a matter of reconciling differences to ensure harmony. Theoretically, it is the task of executive managers to pull organizations together, yet realistically it is the responsibility of all managers to consciously foster congruence and harmony. The planning process cannot be random or carried out in isolated divisions. All parts must fit nicely together. Marketing objectives must be reflected in production planning and scheduling, personnel with the right skills must be available at the times needed, and operations must be funded to ensure solvency.

One way of bridging gaps is to develop formal planning procedures that stabilize relationships between managers both vertically and at peer group levels. A formal planning process, as described in Chapter 5, provides consistency in daily operations and a forum for exchanging information among managers with diversified interests. Decisions are outlined and communicated through formal planning, and when a team approach to planning evolves, performance expectations are more clearly articulated to lower-management levels.

Before turning our attention to operational planning, we should recognize that tactical planning can involve more than marketing, production, human resources, and finance. These are the mainstream considerations, but in manufacturing, for example, other departments are involved in planning, such as research and development, process engineering, maintenance, information systems, public affairs, and various administrative functions. In service organizations such as hospitals, specialized planning is needed for radiology, nursing services, surgical and medical departments, research, laboratory services, and many other areas. In each instance, coordination is required among functional managers to offer tactical guidelines for operational planning.

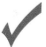

CHECKPOINT

- What responsibilities do middle managers have for coordinating their individual plans with others?
- Why must plans by synchronized, and what departmental managers might be involved in this process?

OPERATIONAL PLANNING

Planning at the lowest organizational echelons is called *operational planning*. **Operational planning** focuses attention on specific performance objectives expressed in monthly, weekly, or daily task requirements. It is planning for the shortest time periods by managers who must deal with first-line supervisors or directly with nonmanagement employees.

Production supervisors are apprehensive about sudden rush orders, flu bugs that keep workers home, machine breakdowns, poor weather that holds up supplies, and a host of other considerations that can wreak havoc in their schedules. Marketing managers tend to work in monthly time frames, but they have the same sense of immediacy about planning issues. Generally, operational planning is concerned with tactical planning issues, but expressed in shorter increments with more specific and immediate performance expectations. The following is a summary of operational planning issues:[30]

operational planning
Operational planning occurs at the lowest management levels and focuses attention on specific performance objectives for immediate results.

1. *Objectives* are stated in unambiguous and precisely measurable standards of performance. Production may have standard numbers of units of product per hour, day, or week. Marketing is usually concerned with sales quotas. Personnel may schedule and control for a certain number of employment interviews.

2. *Operating* plans must reflect division-level expectations for performance standards such as machine hours, man-hours, and product defectives.

3. *Budgets* are used in operational planning, less as cash controls than as translations of planned objectives into common denominators for performance. Operational budgets may be expressed in monetary terms, but more often they reflect physical measures of units produced or sold.

4. *Time* management is perhaps the core issue for supervisors. They must obtain performance results in restricted periods of time.

5. *Coordinating* operating unit objectives with others is a pervasive activity to ensure coordination of scheduled performance.

Importance of Operational Planning

Operating managers seldom recognize that they are consciously planning; they feel as if they are simply supervising operations. Thus, scheduling and budgeting may not seem like planning activities to them, and an elaborate formal process like that described for strategic planning will appear unnecessary. Most effective supervisors do, however, follow a formal, if simpler, planning process. They may set aside some time each week to meet with subordinates and discuss operational issues, and using the feedback they receive on recent activities, they plan ways to make improvements.

Such meetings occur in most well-run organizations. In participative environments, they form an integral part of supervisors' jobs. The *team approach* to planning introduced in Chapter 5, for example, can bring together supervisors and employees on a weekly basis to go over production or marketing reports, discuss machine scheduling or sales efforts, and preview expectations for the next planning period. Several different group approaches can be adopted, but the point is to create a constructive planning process that will yield the following benefits:

Problems defined. A conscious effort to think into the future and involve employees in the process will allow potential problems to surface. At first, a think tank approach yields insights into current problems only, but with experience, participants start asking "what if" questions that lead to identifying future problems. Once potential problems surface, the group can start working on creative solutions.

Alternatives developed. Managers will find that if they encourage participation and open communications, employees will offer innovative suggestions to solve potential problems. This process has been formalized into programs such as *Quality Control Circles (QCCs), People Involvement Programs (PIPs),* and *Total Approach to Productivity (TAP).*[31] QCCs, PIPs, and TAPs have one common characteristic: They are group efforts by employees to identify and solve problems. This is the essence of planning.

Productivity improvement. Operational problems usually concern efficiency issues, such as how to serve customers better or how to improve quality and performance, but quality and productivity issues are rapidly becoming focal considerations.

Improved teamwork. Making a group activity out of planning improves group cohesion. It also reduces tension between people and helps clarify individual roles. In well-devised operational planning activities, individuals from different work groups that have interrelated tasks are brought together to plan and coordinate their activities. For example, an assembly line may have several work centers, each one receiving products from work groups behind it in the assembly process and passing on products to groups ahead of it. Performance by a group ahead in the assembly process depends on performance by groups behind it. By bringing together representatives of these groups, the entire assembly process may be improved. Bridging occurs as individuals who must work together come together, and others who interface with the work group or otherwise influence operations are brought into planning discussions. For example, a production department may bring in materials procurement clerks, recruiters, and quality control inspectors to help the department plan production schedules.[32]

Operational Planning Activities

Most operational planning activities are concerned with *schedules.* A **schedule** is a time-phased series of activities to be performed to achieve a specific and measurable objective. Production managers are probably more familiar with schedules than managers in other functional areas because they use the terminology for most of their planning activities. For example, sales managers think in terms of results (such as monthly sales quotas) and accounting managers think in terms of deadlines (such as due dates for issuing payroll checks). Production managers have *master production schedules* that specify all orders to be filled during a production cycle. A production cycle typically is for one month. During this month, a company may have several hundred orders to schedule, and each order may require the performance of twenty or thirty operations in several departments.

A special *production control* department in each production area creates a master schedule; then supervisors in each work area schedule their workers and machinery to fulfill their responsibilities as outlined in the master schedule. Supervisory work schedules are usually set up for each week. An example of this is shown in Figure 7-9, where one week's work consists of several "jobs" assigned to work groups on three machines. To illustrate how careful planning can improve productivity, there are two schedules in Figure 7-9. Schedule A is inefficient compared to Schedule B because it sequences work poorly. Schedule B required more thought to set up, but it results in "uncommitted time" toward the end of the week when the following week's production can be started. A company with several work groups able to follow Schedule B for several months would save a lot of money and be able to manufacture more products in a shorter period of time.

Supervisors in production areas constantly schedule work for their employees, and the mark of a good manager is that work is accomplished on time. Yet, a company also expects its supervisors to achieve high productivity, good quality, and efficient use of resources. Figure 7-10 summarizes these tasks as well as the responsibilities for resource allocation and productivity planning. **Resource allocation** is the planned use of facilities, equipment, materials, energy, cash, and supplies. **Productivity planning** is paying conscious attention to quality, cost reduction, work simplification, and improved work processes that reduce total resources used while enhancing performance.[33]

Scheduling. Production managers schedule manufacturing work by setting output objectives, usually on a weekly basis, and assigning people to predetermined tasks. Sales managers schedule sales activities based on quotas, usually expressed monthly, and assign sales territories, customer accounts, and training tasks to sales personnel. Accounting managers have similar scheduling responsi-

schedule
A time-phased series of activities to be performed to achieve specific and measurable objectives.

resource allocation
The planned used of facilities, equipment, material, energy, cash, and supplies during a company's budgeting period.

productivity planning
The conscious attention to quality, costs, and work processes to improve resource allocation while achieving higher total company performace.

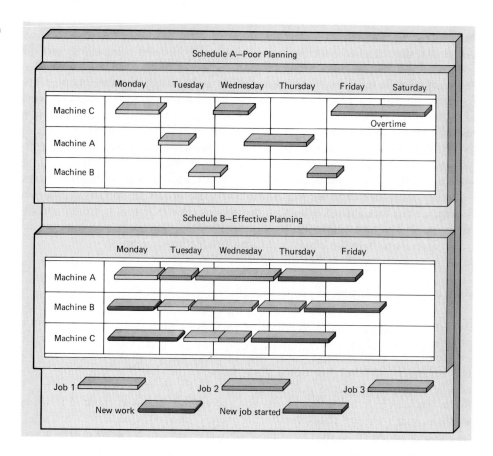

FIGURE 7-9 Improved Scheduling in a Machine Department

bilities for budgeting, preparing payroll, paying suppliers, documenting expenses, and so on. Scheduling extends to many other supervisory tasks, including maintenance, safety, training, recruiting, credit management, purchasing, transportation, inventory control, quality control inspections, packaging, and housekeeping. Large organizations have hundreds of similar scheduling responsibilities, each designed to achieve a small increment of planned work that must be accomplished to meet organizational objectives.

Resource allocation. Planning allocations of resources occur in parallel with scheduling activities, and the same vast number of supervisors will be involved for the same reasons: to achieve small increments of planned work that, taken together, help meet organizational objectives. Resource allocation includes providing an efficient layout of departmental work areas, allocating machines and equipment to tasks, conserving energy, using materials in cost-effective ways,

FIGURE 7-10 Primary Planning Tasks for Supervisors

avoiding waste in supplies, and helping employees use their time and energy more efficiently.

Productivity planning. Perhaps all good supervisory practices are meant to improve productivity. Effective scheduling and efficient resource utilization certainly improve performance. Productivity planning, however, has a more specific meaning. For example, whenever supervisors consciously attempt to improve quality, they also reduce scrap, reduce the time and materials needed to make a product, improve the capacity of machines and equipment, and lower overall costs. Productivity planning is also concerned with finding ways to improve work methods, thereby simplifying tasks and reducing costs. Similar productivity planning can occur throughout an organization. New computer applications in accounting, for example, are productivity enhancements.

CHECKPOINT

- Describe operational objectives for supervisors involved in production, marketing, human resources, and finance.
- Explain how operational planning might be accomplished by a manager in personnel administration and a supervisor in data processing.
- If you were a supervisor in a production role, what three responsibilities would be foremost in your mind?
- Explain how supervisors schedule activities and why scheduling and operational budgeting are important.
- From a human resource perspective, how do supervisors establish new planning processes to enhance productivity?

TACTICAL AND OPERATIONAL PLANNING IN REVIEW

We began this chapter by saying that strategies, tactics, and operational activities must be linked by systematic plans. We have ended with operational planning, which focuses on immediate, short-term objectives involving people in daily activities. When companies achieve these operational plans, their accumulated results satisfy tactical plans related to functional responsibilities at middle-management levels. When tactical plans are well defined and coordinated, they reinforce higher-level strategic objectives. This vertical linkage is crucial to an organization's effectiveness. Horizontal coordination is also essential to bring together marketing, production, human resource, and financial resources in a comprehensive plan.

As we conclude the chapter, recall the opening discussion about PepsiCo and the strategy the company adopted to position its soft drink line to compete with Coca-Cola.

The Pepsi Cola division achieved this objective through a series of tactical

plans, each one designed to make incremental progress toward the strategic objective of obtaining equal market share with Coca-Cola. The company also had to improve its research and development efforts to diversify its product line in diet drinks, change its packaging designs, and modernize its bottling technology. PepsiCo developed marketing tactics each year for a variety of ads and promotions that were so effective in improving sales that the company had to increase production by more than 40 percent in less than a decade. This growth had to be financed through a series of carefully planned capital expansion programs during the period 1978–1986, when it was difficult to attract investors and high interest rates made debt financing expensive. PepsiCo's success was the result of achieving a succession of plans articulated through strategies, translated into incremental tactical plans, and implemented through effective operations.[34]

A SYNOPSIS FOR LEARNING

Having studied planning in tactical and operational terms, you should be able to describe managerial responsibilities in both contexts and to discuss the crucial characteristics of tactical and operational planning. Returning to our initial learning objectives, the following is a synopsis of the chapter.

1. Describe the nature of tactical planning and related managerial roles.

Tactical plans usually cover one year. However, tactical plans may run longer or shorter to fit the needs of the particular business. In tactical plans, managers define activities to complement strategic objectives. Middle managers decide on annual objectives, express them through budgets, and break down major tasks into controllable activities to be accomplished.

2. Define the key elements of a marketing plan and a marketing program.

A marketing plan outlines short-term objectives and the activities needed to implement them in support of major strategies. The marketing plan in a diversified company will be called a "business-level strategic plan," but for a smaller firm, the marketing plan is a functional tactical plan that simply breaks down the strategic plan into short-term marketing activities. A marketing program details specific tasks in developing product characteristics, creating price scenarios, formulating advertising and promotional activities, and refining distribution channels.

3. Explain production planning and the three approaches to production.

Production planning starts with a solid sales forecast. Then an aggregate production plan is formulated for each tactical planning period. With a clear idea

of total sales expected, production planners can formulate a plan for meeting demand in the most cost-effective way. In the first approach to production, called "level production planning," manufacturing is kept approximately the same every week throughout the year. In the second approach, called a "matched model," production output is matched with fluctuating sales. In the third approach, called "lagged production," the finished goods inventory is stockpiled just prior to high-demand periods and sold down toward zero levels during low-demand periods.

4. Describe human resource planning from a tactical perspective.

Human resource planning is concerned with people joining and leaving organizations. Tactical human resource objectives are to meet organizational needs with skilled personnel, provide the training required for operational success, and coordinate with other managers the assignments of people to accomplish their tasks. These objectives are achieved through periodic "needs assessments" based on strategic plans and proposed activities in functional areas such as marketing and production.

5. Discuss the responsibilities of financial managers in tactical planning.

Most financial planning is viewed as strategic. Also, financial planners have to be closely involved with tactical and operational planning so they can match resources with organizational needs. During a tactical planning period, financial planners are concerned with profitability, cash flow, and budgeting expenditures so that annual marketing and production objectives will be met. They also interact with other managers to formulate plans consistent with financial limitations imposed by the company and by the economic environment.

6. Describe operational planning responsibilities and the critical task of scheduling.

Operational planning focuses on immediate activities and performance objectives. Planning activities include three categories of responsibility: scheduling, resource allocation, and productivity planning. Most supervisors participate in carefully designed operation budgets and schedules for labor, materials, and overhead. Scheduling concerns affect production managers, accounting managers, and training supervisors.

SKILL ANALYSIS

CASE 1 Computers in Education Gather Dust

As schools let out for 1988, a major issue still on the agenda four years after the initial enthusiasm was how to achieve computer education for students. Several studies reported dismal results for computer usage in both elementary and secondary schools. The Carnegie Commission, having suggested several years earlier that computers would have to be added to the three R's, found in 1988 that less than a third of elementary teachers were comfortable with the fundamentals of computer teaching aids, and perhaps no more than 5 percent of teachers could effectively use educational software in classes. The Educational Testing Service, which designs most of the tests taken by college-bound high school students, found that about 87 percent of eleventh-graders had used a computer, but 95 percent could barely respond to questions pertaining to floppy disks and keyboards; only 5 percent could field questions about spreadsheets, data bases, or information management.

The reports detailed two critical problems. First, prospective teachers are not taught how to use the technology in college, when they are being trained in teaching methods. Second, already employed teachers are given computers and software without commensurate training in how to use them. The response to these problems during recent years has been a sudden reversal in policies. Colleges have begun to require computer education for all education majors, and public school administrators have mandated that teachers learn how to use the new technology. Neither policy seems to have had much effect, however. Student teachers scramble through data processing courses, learn BASIC programming as a way of becoming familiar with microcomputers, and are pronounced "computer literate." At the school level, teacher workrooms get computers and more browbeating than encouragement or help.

Why are computers failing as teaching aids? Surveys of more than 24,000 students and a nationwide sampling of classroom teachers lay the blame on poor planning. School systems rushed to buy machines and to equip computer labs without planning the operational details for effective implementation. Budget allocations for technology are much more common than allocations for implementation. In Maine, for example, expenditures for computer equipment in 1987 were equivalent to about $2,700 per student, yet barely any money was spent on training or support services.

Other school systems bought bare-bones equipment that would only suffice if use was carefully scheduled, then provided no utilization plan. In Washington, D.C., for example, ten computer systems were put in every school—a ratio of one computer to every 200 registered students—but the computers were idle more than two-thirds of every school day. The National Science Foundation found that even in school systems with sufficient computers—perhaps one of every thirty-five to thirty-eight students—the allocation of computer time and support was lopsided. In most instances, a few classes in math or science (or one or two motivated faculty) would concentrate on computer usage, while all other classes (and teachers) avoided computer-aided instruction.

The way computers are used in schools is also a problem. Teachers assign drill and practice exercises more than 60 percent of the time. These exercises may introduce students to a keyboard and to the basics of handling a floppy disk, but they do little to enhance computer literacy. Programming is taught only at a rudimentary level and is allocated perhaps no more than 10 percent of computer-utilization time. Word processing consumes about 7 percent, and "other" uses, including everything from game playing to data base graphics, account for the rest of computer-utilization time. Everyone agrees that something must be done to improve computer education, but answers are not forthcoming. Some administrators say they need more computers. Others say they need teachers capable of using the technology. Still others say they need training budgets. Many outside observers say the schools need to focus on objectives, do a better job of allocating their resources, and motivate teachers to learn about information technology.[35]

Case Questions

1. Write tactical objectives for a high school that wants to implement a computer literacy program. In your answer, address technology needs, human resource expectations, and student learning objectives.
2. Describe a possible planning organization in a school system and the roles of administrators, teachers, and support personnel. What responsibilities would each have in terms of planning a computer literacy program and how should the school approach the planning process?
3. Assume a participative system and discuss how students might be involved in planning a computer literacy program. In your answer, discuss from a student's

Xerox Redefines Its Purpose: New Plans for the 1990s

Under founder Joseph C. Wilson, Xerox was the hot growth company of the 1960s and 1970s. Wilson acquired exclusive world rights to inventor Chester F. Carlson's xerographic process and introduced a technology that changed the way people work. By 1966, when Wilson handed the CEO's baton to C. Peter McColough, the company dominated the copier market. Because of its tremendous growth, Xerox needed financial controls and clear lines of authority. McColough, a Harvard MBA who had managed the recruitment and training of Xerox's remarkable sales force, implemented organizational reforms that produced good results but made Xerox too bureaucratic. He also recruited executives from big-name companies to fill key slots. The old managers found themselves working with strangers not committed to concentrating on high-quality reproduction products.

McColough tried to diversify Xerox by acquiring new technology companies, but few of these acquisitions were successful. His diversification strategy lacked direction, complicating decisions and eroding management's understanding of future plans. New products were introduced, ranging from personal computers to data communications networks, but few were commercialized. Major competitors—Eastman Kodak, IBM, NEC, Ricoh, and Cannon—submarined new Xerox products and grabbed a hefty part of the copier market.

When David T. Kearns became the company's third CEO in 1982, Xerox was in serious decline, no longer dominant in the copier market and uncompetitive or unprofitable in personal computers and network communications. Management was top-heavy, and bureaucratic inefficiencies had reduced planning to a series of disjointed decisions. By 1987, however, Kearns had begun to turn the firm around—Xerox's earned $465 million. This was below record-setting earlier years, but total revenues were up by 60 percent over 1982, to $12.9 billion. The company's return on equity was 9.5 percent, only about half of its best year, yet Kearns had positioned Xerox for the long run with a strategy of quality product development and a commitment to excellent planning.

A quality strategy had been essential. When Kearns took the reigns as CEO, the major Japanese competitors had a 40-to-50 percent cost advantage in copiers. In Kearn's view, Xerox had not recognized the severity of the poor quality problem because the bureaucracy had covered up flaws. He implemented a crash program toward quality planning, eliminating 15,000 jobs—many in higher management—and introducing shop-floor quality team planning systems.

Kearns also trimmed purchasing, reducing vendors from nearly 500 to fewer than 400. This significant change was heavily resisted by purchasing managers, who were convinced that thousands of vendors locked in competition kept prices down. Kearns proved otherwise. With a small staff and good planning, Xerox achieved a 99.2 percent quality record in 1987 (less than 1 percent defects) compared to a 92.0 percent record four years earlier (8 percent defects). By 1992, Xerox expects to have fewer than 250 vendors, who will be more like partners in a grand quality strategy than foes vying for contracts.

In hindsight, Xerox executives concede that the firm had lost direction. The new approach for the 1990s builds on the distinct competency of Xerox technology in document processing to focus on office systems, electronic printers, networks and software, and the reprographic quality Xerox can assure customers. Crucial change implemented by Kearns is a systematic delegation of management decision-making authority. The planning and decision-making system relies on management teams at each level of the organization. Major strategies are evolved at the top and reinforce the CEO's product focus and quality commitment. Division-level managers drive the tactical planning for well-defined product groups, and lower-level managers work down in the trenches with employees. Xerox's management is intent on reviving the entrepreneurial culture of its founder.

Case Questions

1. Describe and contrast the planning system that existed at Xerox during the 1970s with the one that exists now. Explore the potential advantages and disadvantages of both systems.
2. Identify and explain the three major strategies employed by Xerox's three chief executive officers.
3. Explore the quality issues discussed in the case. How would an 8 percent defective parts and components ratio affect profits, and why would fewer vendors lead to improved quality performance?
4. In making a competitive analysis, what issues would you want to have developed if you were CEO of Xerox? What competitive factors are most important to help reposition Xerox for the 1990s?

Sources: The Entrepreneurs: An American Adventure, Vol. 5 on VHS (Boston, Mass.: Enterprise Media, 1987); John A. Byrne, "Culture Shock at Xerox," *Business Week,* June 22, 1987, pp. 106–110; Joel Dreyfuss, "What Do You Do for an Encore?" *Fortune,* December 19, 1988, pp. 111–116; Gary Jacobson and John Hillkirk, *Xerox: American Samurai* (New York: Macmillan Publishing Company, 1986), pp. 1–4, 29; and Kenneth Labich, "The Innovators," *Fortune,* June 6, 1988, pp. 50–56, 60, 64.

Disney World does not hire people, it "casts people in roles." Employees are referred to not as employees but as "cast members." On their arrival at Disney World, cast members are thoroughly trained for their job. They learn how to be "on stage" every moment they're at work and to always show concern with helping others.

Warren Bennis, Frederick Herzberg, Rensis Likert, and Douglas McGregor.[7] These scholars have produced a significant body of literature about leadership, a topic that we discuss at length in Part IV, but we note here a fundamental conclusion from their research: Although formalization of work through specialization is essential, *behavioral* relationships must complement one another to ensure cooperation and enhance job satisfaction. The critical question is how to organize work without creating an organizational pathology of behavioral dysfunctions. We will discuss concepts of organizing with this question in mind.

Horizontal Job Specialization

Horizontal job specialization results from dividing complicated tasks into simpler jobs. Adam Smith's example of pin manufacturing is the classic illustration of how the *scope* of a task is reduced by narrowing the breadth of workers' activities. Pin making was broken down into logical divisions of work and individual performance was sharply defined and standardized. Figure 8-2 shows how one task with six operations is divided into six individual tasks, each one coordinated with the others. Horizontal job specialization applies equally to a group of tribal hunters in Borneo who assign different individuals the tasks of stalking, killing, skinning, and cooking meat and to a corporation such as ITT with worldwide operations to coordinate.

horizontal job specialization
The result of dividing complicated tasks into simpler jobs or operations, reducing the scope of tasks.

FIGURE 8-2 Horizontal Job Specialization

Vertical Job Specialization

vertical job specialization
The result of delegating responsibilities for tasks and decisions to subordinates, thereby narrowing the depth of tasks.

Vertical job specialization results from delegating responsibilities for tasks and decisions to subordinates. Thus, the *depth* of a job becomes narrower as subordinates assume decision-making burdens previously shouldered by the superior. As organizations evolve from small entrepreneurial firms into large complex enterprises, new tasks emerge that require further subdivision of work. A small shopowner such as a tailor who makes men's clothes may initially measure clients, purchase materials, make suits, and sell them, as well as run the entire business. As the business grows, he may hire apprentices and train them to specialize in making parts of each suit. The tailor will then do less tailoring and more overseeing of others' work. As the business further expands, the tailor will become so engrossed in management decisions that he will need an organization of salespersons, craftsmen, and support staff. This process is typical of any growing firm. As management jobs become too burdensome, there is a downward reassignment of tasks and authority, as Figure 8-3 illustrates.

In this figure, the organizational tasks of designing, making, and selling have been horizontally specialized, and the *depth* of each job has been narrowed to exclude decision making that vertically differentiates tasks. For example, when Victor Kiam bought Remington Products, Inc., the firm that makes Remington Electric Shavers, there were 480 employees in one Bridgeport, Connecticut, plant. Kiam as CEO ran the business with six senior executives in production, sales, engineering, and staff support positions. Less than ten years later, Remington has more than 2,000 employees and 80 senior managers with more sharply defined responsibilities.[8] For example, in engineering there are several divisions for product development, product design, and quality assurance, and within product development, there are subordinate engineers responsible for new products, such as the Lektro Blade Razor and the Remington Pool Alarm. Similarly, Ford has redefined its divisions, such as Ford Aerospace, Libby-Owens-Ford, and Ford Automotive, and, within each division, delegated functional responsibilities for marketing, product research, manufacturing, quality assurance, human resource management, and consumer research, among others. These areas have been subdivided, with decision-making authority pushed downward to more subordinates. As we shall see in Chapter 9, this is the prevalent method of decentralizing authority.

Job Enlargement

job enlargement
An organizational development technique for combining two or more tasks into one, usually at one level of skill, to improve variety, reduce boredom, or improve efficiency in work.

Job enlargement is the process of combining tasks to create a new job with broader activities. It is concerned with the breadth of work. Boredom and dissatisfaction are combated by adding more operations to a given task. Employees

FIGURE 8-3 Vertical Job Specialization

perform a wider range of tasks, but without vertical integration of decision making. Job enlargement is the antithesis of specialization.

In manufacturing, for example, two specialized job classifications have evolved called "machine operators" and "machine set-up technicians." For a production run of automobile bumpers, a metal-pressing machine will be set up by a technician who rigs the machine and makes adjustments to conform to design specifications. Then a machine operator who has no part in the set-up procedures runs the machine to make bumpers. In many companies, these two jobs are being combined so that machine operation and set-up tasks are components of one person's job.

Similar job combinations have been implemented at Firestone, General Motors, B. F. Goodrich, and Pacific Bell to improve employee morale and performance. At Firestone, machine operators skilled at running rubber-vulcanizing equipment also do their own quality control tests with computerized monitoring equipment. At GM, robotic technicians perform preventive maintenance on their machines and control their parts and supplies inventories. At Pacific Bell, sales representatives train new employees and conduct market research as consumer consultants. In each instance, jobs have been redesigned and enlarged to challenge employees and to expand the breadth of their activities. The result has been more satisfied employees who are more productive.[9]

Job Enrichment

As discussed earlier, specialization is necessary for a firm to grow, but it can create problems such as boredom, fatigue, and stress. If carried to extremes, vertical job specialization pigeonholes subordinates into decision-making roles that are isolated and emotionally deadening. To combat the problems of overspecialization, jobs are often *enriched*.

Job enrichment is the process of expanding a person's responsibilities so that the work becomes more challenging and satisfying. Specialized tasks are expanded in *job depth* to include greater decision-making responsibilities. Individual jobs are enriched by combining vertical relationships, so that machine operators monitor and correct their own mistakes, for example, instead of being monitored by inspectors and having their errors corrected by other operators. This gives employees greater autonomy for controlling their work and making decisions.[10] They become more than workers as they share in decisions about *how* to perform tasks and *what* tasks should be accomplished.

In most hospitals, doctors, nurses, and technical specialists differentiate their jobs carefully. A patient being treated in an emergency room may be diagnosed by one doctor, have lab work evaluated by another, be treated by yet another, and be shifted among several specialists in the process. The doctors, laboratory specialists, and nurses all perform their specialized tasks with little concern for what others are doing. In contrast, with integrated medical teams formed through job enrichment efforts, each team member is involved in team decisions and the total care of the patient. In cardiac rehabilitation, for example, heart attack patients have been diagnosed, clinically treated, rehabilitated, and provided with extended care by a team of physicians, nurses, and counselors who stay with them from the initial incident to satisfactory recovery.[11]

job enrichment
The vertical combination of tasks that increases one's duties and responsibilities; job depth is enhanced to improve job satisfaction.

Balancing Specialization for Productivity

Henry Mintzberg believes that "job enlargement pays to the extent that the gains from better-motivated workers in a particular job offset the losses from less than optimal technical specialization."[12] Jobs enlarged to extremes, however, can create problems. Employees can become overloaded, with the result that they per-

form poorly or quit. Individuals vary in their abilities and preferences to handle enlarged jobs. Some people prefer the clarity of simple tasks, whereas others like diversification. Striking the right balance becomes crucial with job enrichment because some employees will try to avoid decision making, preferring instead to work in less demanding positions, while others will enjoy the responsibility of making decisions and be eager to assume greater leadership roles.

Job organization has come a long way from the simple division of labor observed by Adam Smith, yet experts have very few solid suggestions about *how* to design jobs or *when* integration of tasks will be beneficial. We do know that enlargement and enrichment concepts coupled with careful analysis of job design are crucial for assuring productivity. We also know that before a job enlargement or job enrichment program can be developed, managers must account for individual differences among their employees and for circumstances peculiar to their company. For example, union collective bargaining agreements may prevent combining jobs. The ultimate rationale for improving jobs is to improve the quality of work and productivity in the work environment.

Organizing and designing jobs have come to be synonymous with *quality of work life*, known by its acronym *QWL,* and QWL programs have become synonymous with productivity improvement efforts. **Quality of work life** is the concept of making work meaningful for employees in an environment where they are motivated to perform and satisfied with the results of their work.[13] The behavioral implications of this discussion will be treated in Part IV, on leadership. At this point we want to use this information to study how modern organizations have evolved. Specialization has been the force behind organizational evolution, but there are other considerations.

quality of work life (QWL)
The concept of making work meaningful for employees in an environment where they are motivated to perform and satisfied with their work.

> ## CHECKPOINT
>
> ■ Define and explain specialization and standardization.
> ■ How is work design related to organizing people and resources?
> ■ Contrast horizontal and vertical job specialization.
> ■ Discuss how jobs are enlarged and enriched.

FORMAL ORGANIZATIONS AND STANDARDIZATION

Our preceding discussion centered on the redesign of work by enlarging and enriching jobs, but there are times when organizational evolution produces the opposite effect. As previously stated, new jobs are created and relationships become more complex as organizations grow. To reduce confusion, individual and group tasks are formalized during the growth process, with the result that jobs become more narrowly defined and tasks more standardized.

Work can also be standardized by redefining the flow of operations. Technology often dictates work flow. For example, assembly-line systems represent a sequential flow of operations. A tire cannot be installed on a new car before the wheel assembly is attached to an axle; similarly, brakes cannot be tested until the tires are in place. This sequential flow of operations dictates a standard pattern of work organization.

Standardization may also result from management policies and legal mandates ranging from safety procedures to equal opportunity laws. Laws and rules impose constraints and lead to internal policies and procedures to guide management decisions. Policies and procedures do not necessarily impose constraints, but they do define preferred behavior. Laws and rules, policies and procedures, tend to standardize human effort. The stereotype of a standardized organization is a

bureaucracy in which jobs are formalized and work flow is prescribed. Because bureaucracies are so prevalent, we will look at them next.

CHECKPOINT

■ How does organizational growth affect formalization and standardization?

BUREAUCRATIC AND ORGANIC STRUCTURES

Formalized organizations, particularly in the public sector, tend to be labeled *bureaucracies.* A **bureaucracy** is a form of organization in which activities are rationally defined, division of work is unambiguous, and managerial authority is explicitly vested in individuals according to skills and responsibilities prescribed for their organizations, and it implies a less rigorous division of labor in a less formal environment. The fundamental difference between bureaucratic and organic organizations is in the degree of *formalization.* "Organic" implies a flexible entity, one "full of life," and although it is fashionable to think of a bureaucracy at the polar extreme, both stereotypes may be unrealistic.

bureaucracy
A form of organization in which activities are rationally defined, work is divided unambiguously, and authority is formalized through prescribed skills and responsibilities.

Bureaucratic Structures

As we saw in Chapter 2, the German sociologist Max Weber coined the word *bureaucracy.*[14] He has been credited (or discredited) with creating an organization form that has dominated Western civilization during the twentieth century, one that is inflexible, formal, coldly rational, and dehumanizing. Weber, however, created nothing; he merely described and put a name to what he saw in European organizations at the turn of the century. We recognize five characteristics of modern bureaucracies:[15]

1. *Fixed and official jurisdictions of authority.* Activities are governed by rules and regulations that fix decision-making parameters, align specific duties, and strictly define command privileges.

2. *Firmly established rational chains of command.* Graded levels of authority are structured in an absolute hierarchy with a narrow span of control over subordinates. It is the positions that are defined, not the individual roles within them. Therefore vacancies are filled by individuals who meet defined criteria; positions are not redefined to suit individual characteristics.

3. *Quantified and thoroughly documented information.* Nearly everything is reduced to writing in bureaucracies. Decisions and conferences are recorded, files are maintained, and allocations are quantified, which creates complex administration systems.

4. *Supposition of expertise.* Because positions are filled by individuals who have met defined criteria, it is assumed that people at each skill level have expertise. Selection for employment, then, is based on job skills; promotions are made according to job criteria rather than personal attributes.

5. *Management is technically scientific.* Although the art of management is recognized as important, managers of bureaucratic organizations rely on rules and procedures. This reliance leads to the assumption that once managers learn administrative processes, they will have the technical knowledge necessary for managing organizations.

chain of command
A vertical line of authority between successively higher levels of management, unbroken and direct, linking each stratum in the hierarchy of management.

span of control
The effective number of subordinates that report to a superior in a given work environment.

Two specific attributes mentioned under characteristic 2 should be explained: *chain of command* and *span of control*. A **chain of command** is the unbroken line of authority between the lowest and highest positions in an organization. It is the description of rank-ordered authority, and in a bureaucracy, there is a presumption that a subordinate will seek direction, communicate decisions, and take orders directly from an immediate superior. A **span of control** is defined by the number of subordinates one manager supervises. In a bureaucracy, the assumption is that an optimal span of control can be unambiguously determined by rationally studying how work is performed and what decisions must be made by the manager. Bureaucracies typically have narrow spans of control whereby managers supervise few subordinates. This results in many levels of management in which little authority is delegated.[16]

Organic Structures

In the classic 1966 article "The Coming Death of Bureaucracy," theorist Warren Bennis heavily criticized bureaucracies and proposed that we create *organic* organizations.[17] According to Bennis, we have outgrown our need for a rational form of organization modeled on machine efficiency and explicit, inflexible lines of authority. In this view, Weber's ideal of a rational organization was a response to the "irrational" world of work of the Victorian age, when employees labored under capricious managers and subjective rules. Formalized organizations brought order and provided employees with protection.

In contrast, Bennis believes today's world of rapid change, complex technology, and diversified knowledge requires flexible patterns of organization. In his view, bureaucracies are ill-adapted to the evolving management philosophy of humanistic values with democratic ideals. In place of bureaucracy, Bennis has proposed flexible organizations, with executives as coordinators and employees organized according to their personal skills. His article heralded the arrival of organizations based on groups of projects rather than on stratified authority. As we shall see in Chapter 9, many of these changes are taking place, but bureaucracies have not disappeared. To the contrary, the sheer size and complexity of contemporary organizations often lead to greater rationalization.

Bureaucratic and Organic Structures Critiqued

Milestone research by Tom Burns and George Stalker illustrated that bureaucratic structures are preferred in stable environments and mature industries, but that when the environment is uncertain or an industry is experiencing rapid

change, bureaucracies are ineffective.[18] Burns and Stalker concluded that *mechanistic* forms of organization such as bureaucracies are too inflexible and too burdened with impersonal rules to be effective in dynamic environments.

In contrast, they found that *organic* organizations appear to be quite adaptable to change. Managers in such organizations are comfortable with individual decision making and informal patterns of communication. They also work with few rules and procedures, and thus have great latitude for making decisions. Yet too much latitude, particularly in large and complex companies, can result in chaos. Burns and Stalker concluded that where adaptability and speed of innovation are essential, the organic form of organization is superior, but that in stable environments and in organizations so complex as to need careful coordination, the bureaucratic approach is superior. However, as illustrates, conclusions about the comparative effectiveness of the approaches can be misleading.

If we view bureaucratic and organic structures as models at opposite ends of a continuum, then organizations in more or less stable environments are more likely to be bureaucratic, whereas those in more or less unstable environments are more likely to be organic. Few organizations are totally bureaucratic or totally organic. Most organizations have a natural tendency to formalize jobs and authority to improve predictability of managerial decisions and results of operations.[19] Therefore, primary operations tend to conform to bureaucratic processes, but in other areas of a firm, such as a research design department, the nature of work may be organic. Thus, an organic structure is likely to emerge in those areas, as well as in any organization where creativity and innovation are emphasized. In strategic management positions where executives interact with an uncertain outside world, behavior is likely to be more fluid; consequently, structured rules and procedures do not develop.

Hallmark Card Company is an interesting example of how a firm can use both bureaucratic and organic concepts to advantage.[20] Hallmark has endorsed a philosophy of "flexible relationships" since it was founded in 1910, and through eighty years of change, major wars, a depression, and several recessions, it has never had a layoff. The company has reduced jobs through technical improvements and factory automation, but while jobs have disappeared, the people who used to be in them have been retrained for work elsewhere in the company. According to Hallmark's CEO, Irvine O. Hockaday, many of the company's workers have a broad inventory of job skills, and they work in flexible teams that ebb and flow with the pace of work. One cutting-machine operator works as a custom card imprinter, painter, or modular office assembler as needed and reports to different supervisors. In Hockaday's view, this flexibility would be impossible in a company locked into bureaucratic job titles in a static chain of command. Still, Hallmark operates four production plants with 500 illustrators and 20,000 employees who print over 11 million cards a day, and without exceptionally well-defined procedures, schedules, and work processes, production printing would be chaotic. Hockaday explains that production processes and procedures are rationalized with technology for maximum efficiency with one exception: production teams make production decisions, and employees' jobs are not threatened by changes.

Figure 8-4 shows Mintzberg's conceptual view of a complex organization. He indicates there are five parts to organization, each one capable of evolving independent organizational behavior and structure. The strategic apex is likely to be organic and relations highly interactive; the technostructure and support staff may become organic if left to their own devices, but will often be drawn toward bureaucracy if the operating core and middle line are bureaucratic.

Ultimately, a successful organization will evolve a structure that provides the best framework for quality and productivity. There are too many variables in a complex society to suggest that any one form of organization is best. The driving force of specialization will shape job design and generally define group tasks. Standardization is the natural result of our tendency to strive for stability, but the

FIGURE 8-4 Major Components of Organizations

Source: Henry Mintzberg *Structure in Fives: Designing Effective Organizations* © 1983, p. 11, Adapted by permission of Prentice-Hall, Inc., Englewood Cliffs, N.J.

personal attitudes and social ideals Bennis alluded to pose countervailing forces to standardization.

CHECKPOINT

- Identify and discuss the five characteristics of a bureaucracy.
- How would you explain the concept of an organic structure?
- In what circumstances might bureaucracies be beneficial?
- Discuss advantages and disadvantages of bureaucracies and organic structures.

CONTINGENCY THEORY AND ORGANIZATIONAL STRUCTURES

Contingency theory implies that organizations must be capable of adapting to situations under various circumstances. The notion of "one best design" for most companies is discarded in favor of "design based on contingencies." Researchers have categorized contingency factors into four basic concerns: the organization's *age and size,* its *technology* and that of the industry, *environmental forces* that influence decisions, and the *power and personal attributes* of the organization's executives.[21]

Age and Size

The longer an organization has existed, the more formalized its behavior is likely to be. With age comes standardization of systems and procedures; it follows that older established organizations in both private and public sectors reflect bureaucratic decision making.

The age of the industry is just as important as the age of individual firms within it. A new electric utility company, for example, will structure itself to be similar to other electric utility companies. In retailing, construction, steel, and autos, company structure tends to follow industry norms. Newer high-tech industries, such as microcomputers, have few presumptions for forming organizations.

The size of an organization influences its structure in several ways. Small utility companies, for example, may not imitate the bureaucratic style of larger cousins even though they are often drawn toward the prevailing design. Instead, smaller firms with less complex management relationships may be quite informal. A small college, for instance, may be able to register students in classes without elaborate procedures, whereas a large university requires complex procedures.

Size and age of organizations usually define the need for more or less elaborate control systems. The larger the firm, the more elaborate the system needed for control; hence, the more complex its administration. Older firms, particularly in older industries, develop more elaborate relationships with more differentiated and specialized administrative tasks. Hierarchies grow with specialization, and since authority becomes more sharply focused with differentiation, these firms evolve toward bureaucracy.

An organization's size also influences whether work will be more or less departmentalized. American industry consists of many large firms with departmentalized structures dividing work along functionally specialized lines. As firms grow and diversify, these divisions proliferate. More, and larger, divisions are accompanied by greater rationalization of authority, and the organization evolves toward bureaucracy. For example, earlier in the chapter we noted that Victor Kiam, CEO of Remington Products Company, takes pride in having a "family" of employees with close social ties. Remington expanded fivefold in less than ten years, with a similar expansion of key executives. It has recently acquired several new businesses, including the New England Patriots and Franzus, the largest travel appliance company in the United States. The company has divisions in Europe and Asia, and its sales exceed $300 million annually. The Remington family still exists in theory, and Kiam remains loyal to his ideals of close, personal attention to his business and his employees. But several new layers of management, coupled with executive job descriptions and formal reporting channels, are bringing Remington into the sphere of large-company bureaucratic systems.[22]

Departmentalized organizations make systematic efforts to replicate standardized patterns of work. Management wants predictability across departments and stability within them. McDonald's worldwide chain of fast food restaurants was initially a small, rapidly changing organization, but today virtually every process and most operations are standardized. Rules, procedures, job descriptions, uniforms, restaurant design, prices, servings, and so on are formalized and replicated in nearly every McDonald's location.

Technology

Before we can discuss how technology influences structure, we need to understand the meaning of technology. **Technology** is the total accumulation of tools, systems, and work methods used collectively to transform inputs into outputs. One way to think of technology is to divorce knowledge and behavior from the work process. This leaves "instrumentation," the equipment and physical processes of work, as technology.[23] Accountants, for example, can use a pencil or a computer to work out budget calculations, and the results will be similar. However, computer technology requires fewer accountants with greater skills; therefore, the way work is organized will differ significantly.

In a classic study, Joan Woodward identified three distinct categories of technology in modern industry, each defining a different trend in structure. Her three categories of *unit, mass,* and *process* production also describe a general pattern of change as a company or industry grows.[24]

technology
The total accumulation of tools, systems, and work methods used collectively to transform inputs to outputs.

Unit production. Woodward observed that most new enterprises start with a customized service for a select clientele. Units or small batches of products or services are emphasized rather than mass production. In some instances, companies make it their business to customize products through a unit or small-batch process. Henry Ford began by producing a single customized race car; mass production came much later. Ray Kroc started with one San Bernardino hamburger stand that featured milkshakes, not hamburgers; his vision of a worldwide McDonald's chain evolved several decades later.

Unit production is nonstandard, often informal, and indicates a close system of individual control in management. Owner-managers usually have a hands-on style of decision making. They are involved in most aspects of the company, and employee specialization is not sharply defined. Frequently, employees work independently, and middle managers supervise many subordinates in diverse jobs. Woodward noted that small-batch operators had an average of twenty-three production workers for each manager in contrast to sixteen workers for each manager in mass-production systems.

Thus, in unit or small-batch systems, flatter organizations with fewer layers of management exist. Each manager supervises greater numbers of subordinates than in mass or process systems, and operators have greater autonomy over a wider range of work, resulting in less formalization.

Mass production. Mass-production technology is characterized by formalized work. Specialization is the rule, and there is rigid separation of formal authority for decision making. In stereotypical assembly-line mass production, labor is subdivided, work is interdependent, and there are a great number of management controls. Work is entrenched in formal methods and well documented through job descriptions. Technical equipment may be sophisticated, but job specialization reduces work to simple, easy replicated tasks.

Mass-production technology makes possible the kind of fine-tuned operation with emphasis on efficiency that is crucial when a company is producing thousands of like items for customers. Company success is often predicated on mass-production techniques that make it the low-cost competitor. For example, Ford began to turn around its manufacturing program after a disastrous 1982 sales year when the Honda Accord was positioned against the Thunderbird and captured half of Ford's domestic market. Management attributed disaster to inefficient mass-production techniques and a proliferation of Thunderbird "options" that added more than $1,000 to the sticker price of each Ford. The 1982 Thunderbird had 69,120 options compared with 32 for the 1982 Honda, and even though the Honda had a 25 percent import duty, its full retail price was lower than the manufacturing cost of the Thunderbird.[25]

Mass production is the basis for the "machine bureaucracy" Warren Bennis saw as a cold and dehumanizing work environment that alienated employees. Woodward also found that mass-production systems stifled individuality and were so stressful that workers often became hostile toward their work and one another. In a machine-paced environment, rules and procedures dictate activity and make workers feel exploited. A tighter span of control by more managers over fewer workers is necessary to moderate conflicts, and this results in taller organizations with many layers of management.

Process production. Companies that require continuous production use a process technology that converts materials into homogeneous and undifferentiated products. Examples are chemical production, petroleum refining, and beer brewing processes. The difference between these process systems and mass-production technology is automation. Mass production relies on interdependent assembly-line mechanisms, whereas process production relies on continuous conversion of materials through automatic systems. Mass production ties many less-skilled workers to repetitive machine-paced tasks. Process production uses fewer

tured around functional specialization in marketing and production for oil-based chemicals and plastic products, but the oil shortages threatened Monsanto with the loss of its primary raw material, and rising oil prices endangered the company's profits. Monsanto responded by turning to research and restructuring its entire organization to pursue new product innovations. The following is an excerpt from a *Fortune* article about the change:

> The company devised a clever way of altering its culture to facilitate the change. It began investing in Biogen, Genentech, Cetus, and Genex—all start-up biotechnology firms. Then it invited scientists from some of these outfits to company headquarters to train Monsanto employees. . . . The next step was to finance biotechnology projects inside the company. Monsanto tripled its basic research budget and is building its own research park near St. Louis. To further expand R&D, Monsanto formed joint ventures with the biotechnology firms.
>
> Not quite what you would have expected from an old-line chemical company. The point is that technological sophistication is spreading, and as it spreads, it becomes harder and harder for companies that don't join in to maintain a competitive edge. The merging of technologies—electronics and mechanics, for example, or biotechnology and food processing—has created the potential for much faster change in industry after industry.[50]

The thrust of the article was that organizations must change not only their strategic outlook on industry but also their organizations in order to be responsive and adaptable. Another excerpt from the same article focuses on this point:

> The most difficult challenge may be creativity and the people who embody it. Companies that have mastered high-speed management try to keep the mental light bulbs on by establishing small teams to design, manufacture, and market new products. Whatever they're called—entrepreneurial groups, independent business units, skunkworks—these teams remove the bureaucratic straitjacket from product development. . . . To be successful, independent business units must be small, hardworking, and preferably located somewhere away from the normal corporate premises.[51]

Change did not come easily for Monsanto. Before 1972, the firm had prided itself on being a stable company in the petrochemical industry. Oil and its resin-based raw materials were relatively secure for American manufacturers. The 1973 oil crisis forced Monsanto to recognize its vulnerability, and management made a commitment to change the company's direction and scope of business interests. Still, bureaucratic traditions were so firmly in place that the company seemed paralyzed for several years. It was not until 1983 that significant change began to take place.

In early 1984, the "skunkworks" for R&D appeared. This was an ad hoc group of research scientists who were allowed to pursue research projects with little management intervention or control. They spearheaded several dozen new project ideas and helped the company set up joint ventures with other companies, like Biogen and Genentech, to bring together petrochemical and biogenetic technologies. New products and market research laboratories were brought on line, and Monsanto expanded into the sports markets with equipment, plastics, and Astroturf. It also produces medical supplies, equipment, surgical accessories, and building materials. In addition to complicated biotech chemicals, Monsanto has made innovations in a wide range of consumer products.

During the process, the company's structure has flattened. There are fewer middle managers but more technical specialists, and the breadth of operations has expanded considerably, with division managers in charge of more than a hundred product lines. Even so, much of the innovation has come from joint ventures with smaller firms physically separated from Monsanto, and global marketing and distribution are accomplished through autonomous subsidiaries located on four continents.

Case Questions

1. Identify and discuss the environmental factors that influenced Monsanto to change structurally. In your answer, explain how the technological imperative has altered the firm.
2. Explore why it took Monsanto more than a decade to soften its bureaucratic lines sufficiently to launch new projects. Why must such a firm set up physically remote independent operations to assure creativity and innovation?
3. Discuss the case issues in terms of Bennis's once-futuristic forecast of an "end to bureaucracies." Could Monsanto have continued to succeed in its historic chemical market within a bureaucratic framework? What organizational factors are important today? Support your answers.

CASE 2 Crisis at Wrangler Corral Western Wear

Jim and Fay Kaman had one of the most successful western wear stores in Virginia in 1985, but in 1988, their business collapsed and so did their marriage of 25 years. The short history of the Kamans' business venture is a story of how an entrepreneurial firm failed to organize for growth.

In 1984, the couple decided to launch their own business. Jim had been in corporate life since graduating from college in 1975, and had been successful in all his posts; his last position was assistant to the vice president for finance of a tobacco company. He had a strong record of advancement and had been a highly rated manager supervising eighteen other employees. During his last few years with the corporation, however, Jim found himself loaded with paperwork and "burnt out" because of the bureaucracy. He wanted a change. He wanted to be his own boss, and he had the savings and security to try it.

He and Fay bought the Wrangler Corral in a fast-growing university city in the spring of 1985. Initially, they worked the store themselves with only a sales staff of two. Business boomed, and by Christmas, they had leased the adjoining store space to expand their facilities. Inventory nearly tripled, sales continued to grow, and the store's sales staff had increased to four. But Jim was working at least six days a week, often fourteen hours a day, and Fay was overloaded with bookkeeping and store accounts.

Jim found some relief by computerizing inventory and sales records, but he ran the computer himself and made all pricing, advertising, and inventory decisions. He also handled purchasing, cash, and store operations. Fay began to feel pressed by the demands of the store. She decided to limit her involvement and wanted Jim to schedule himself on a five-day week. This led to a number of arguments, and Jim felt that Fay was letting him down.

Things got progressively worse, and during 1987, the couple seemed to argue about everything. Fay said that the "Corral was Jim's mistress," and he accused her of wanting to enjoy the success but not work for it. Jim moved out of their house and threw himself into work even more intensively, opening a second store in a growing nearby community.

Then Jim began having one crisis after another. He could not keep sales staff for long in either store. It appeared that several employees were stealing him blind. Prices were getting mixed up on brand clothes items. He became overextended on payments, and it was not unusual for him to get into arguments with employees and customers. With Fay's help, he reasoned, none of this would have happened.

The couple's oldest daughter tried to reconcile Jim and Fay several times, and in early 1988, she managed to get the couple to call a truce and vacation together in Florida. Jim appointed his senior employee as temporary manager. Yet, for the first four days of the vacation, Jim called to check on things a half dozen times each day. He regretted going on the trip and was cynical about being forced to lie around uselessly in the sun. Finally, on the fifth day, Jim began to

unwind. He actually started enjoying his vacation and stopped phoning his stores. The couple resolved to get back together.

Jim returned to work to find that his manager had held things together nicely. He made the management job permanent, appointed a manager for the second store, and over the next month practically gave his employees full rein. In short, he reversed his management style and delegated most business decisions. Jim scheduled himself on a five-day week, as he used to in the corporate world. Fay was relieved to have Jim take this viewpoint.

After several months, problems returned. Sales were down, inventory was in disarray, and cash was short. Jim thought things would improve, but the situation worsened. He stepped back in with a strong hand to resolve the problems, fired both managers, and worked to save the business. Meanwhile new competitors had opened and Jim's business stalled. He collapsed under the pressure and was hospitalized with ulcers. Even worse, he reflected on his reconciliation with Fay and decided he should never have "eased up" on running the business. Although Jim blamed Fay for many of his problems, she refused to accept the blame. Fay left to live with her oldest daughter, and Jim watched his business and his marriage dissolve.

Case Questions

1. Identify the crisis of *early growth* in the Wrangler Corral expansion. What danger signs should Jim have foreseen, and how might he have expanded without overloading himself?

2. After returning from vacation, what crisis did Jim and Fay face in their business? How might they have overcome the *late growth* problems?

3. Draw organization charts to depict the store structure during the initial, early growth, and late growth periods. How could Jim have structured authority better in each period of growth?

SKILL PRACTICE

BUILDING A BETTER CASTLE

Introduction

Setting group goals helps bring together people and other resources needed to accomplish an organizational task. Once tasks are finished it is usually necessary to explain or "sell" the rationale and the result to another person or group. That other person or group often has approval power or recommendation (forwarding) control over the finished project. Therefore, the ability to communicate results effectively is really a "hidden" part of the original assignment.

In this exercise, small groups will be created and asked to take the materials provided and create a castle that will be used as a restaurant adjacent to theme parks (such as Disney World) throughout the United States. *Other* group members serve as the consumers for this event, and they will be expecting a "sales presentation" from a representative on your team.

Background and Instruction

Your group is one of three product-development teams working within the research and development division of the GTM (General Turret and Moat) Corporation. GTM has decided to enter new markets by expanding the product line to include fully designed and produced castles, rather than selling components to other companies, as it has in the past.

Source: Reprinted by permission from William C. Morris and Marshall Saskin, *Organization Behavior in Action.* Copyright © 1976 by West Publishing Company. All rights reserved.

Each of the three teams has been asked to design a castle for the company to produce and sell. Given limited resources, the company cannot put more than one design on the market. Therefore, the company will have to decide which of the three designs it will use, discarding the other two designs.

Your task is to develop and build a castle. You will have 45 minutes to produce a finished product. At the end of this period, several typical consumers, picked by scientific sampling techniques, will judge which is the best design. Before the consumers make their choice, each group will have two minutes to make a sales presentation.

To: Project Team #1

From: Edward Grimbsy Bullhouse III
 Chief Executive Officer
 General Turret and Moat Corporation

Subject: Development of New Castle Product

In order to perform effectively and to develop a useful product for our firm, I have decided that _____ will serve as manager of the product development team # 1. It is _____ responsibility to see that the team develops a useful and feasible product, and I hope that all of you will cooperate with _____ in this effort.

To: Project Team #2

From: Edward Grimbsy Bullhouse III
 Chief Executive Officer
 General Turret and Moat Corporation

Subject: Development of New Castle Product

In order to perform effectively and to develop a useful product for our firm, I am asking that you select one of your team to serve as manager of product development team #2. I trust that you will also determine and select any committees, task forces, subgroups, etc., that are needed in order to perform your job.

To: Project Team #3

From: Edward Grimbsy Bullhouse III
 Chief Executive Officer
 General Turret and Moat Corporation

Subject: Development of New Castle Product

In order to perform effectively and to develop a useful product for our firm, I am asking that each of you put forth your maximum effort. I trust that you will provide us with a worthwhile product that can contribute to the profits of the firm.

CASTLE BUILDING

Observer's Guide

During the course of the building period, observe what is happening within your particular group. Specifically, you should look for the following things:

1. What was the reaction of the group to the memorandum?
2. What was the basic structure of the group?
3. To what degree did people specialize and work on some particular part of the overall task? How did this specialization come about?

4. Who was (were) the leader(s) of the group? How was leadership determined? How effective was the leadership in helping the group to perform its task?

5. Were there any specific patterns of communication among members of the group, or did everyone talk with everyone else?

6. How were important decisions made? Did you see conflicts, or were decisions made cooperatively and with compromise?

7. Give some other general observations.

After the session be prepared to discuss your observation with the entire group.

9

Organizations in Transition: Structural Evolution

Liz Claiborne, the company, may lose Liz Claiborne, the creative genius who announced her retirement in 1989 after a stellar career in fashion as the most recognized designer of women's clothes in the world.[1] With husband and partner Arthur Ortenberg, Liz Claiborne started her company in 1976 on the premise of making fashionable clothes for women at affordable prices. At the time of her announced retirement in early 1989, Ms. Claiborne's company was selling more than 500 different clothing and accessory items for men and women through 3,500 merchandisers on four continents. Gross sales of $1.2 billion in 1988 topped the industry for brand-name designers, yet with the retirement announcement, stock prices tumbled and investors questioned whether the company could survive without its founder. Liz Claiborne, Inc., however, did not become a billion-dollar company on the strength of a single creative design genius.

As one of three women CEOs in the Fortune 1000, Liz Claiborne also had a genius for organization. She developed a core of thirty-one designers, each supported by a cadre of enthusiastic fashion specialists. The company also has semiautonomous operating divisions in each major line of merchandise, ranging from perfumes to retail stores. Liz Claiborne designed the company around a "culture" of individual expression and independent control, and the transition from CEO to retirement was as well planned as her best fashion creations. As you study this chapter, consider the ways companies organize, grow, and deal with transition periods.

departmentalized
Logically grouping work activities based on expertise, products, markets, customers, or projects to enhance planning, leading, and controlling.

decentralized
Dispersing of authority through delegation that gives successively lower-level managers greater decision-making responsibility.

span of control
Also called the span of management, it is the number of subordinates that can be effectively supervised given the type of task, technology, and environment of work.

unity of command
The concept that a subordinate should report to only one superior or receive only one set of directions from one superior at one time.

In this chapter, we will study several ways managers structure their companies to achieve growth. As a company expands, for example, authority has to be delegated to more managers who develop new products or new markets. As American companies set more involved in international business, their structure will become more critical. Although multinational firms are discussed in Chapter 19, we will describe how they become more or less decentralized to compete effectively in global markets. We will also discuss how companies encourage innovation through "new venture units," a method of empowering employees to break away from the restrictions of their corporate jobs to pursue new ventures. Later in the chapter, we will look at organizational models emerging in high-tech industries. These are called "matrix" organizations, and they present new challenges for management.

The previous chapter introduced concepts of organizing and emphasized that as companies grow, patterns of activities and decision making change. Activities are grouped into specialized departments, and decision-making authority is delegated to managers with expertise relating to activities within those departments. This is called *departmentalization,* and we begin our presentation with this topic.

DEPARTMENTALIZATION

The term *departmentalization* is often confused with decentralization, but the two are not synonymous. When an organization is **departmentalized,** a horizontal grouping of specialized activities is attained. When an organization is **decentralized,** decision making is vertically altered, with more authority delegated to lower levels of management. We will discuss decentralization separately later in the chapter.

Departmentalization is a pragmatic segmentation of a company's activities when growth requires more people doing more things. It is usually linked with functional authority, such as creating departments in marketing, production, and accounting. However, as we shall see momentarily, there are several ways to departmentalize a company. Departmentalization relies on specialization, which is the core determinant of organizational structure. As organizations grow or become complex, they need more specialists involved in a wider range of activities. As more people are hired, more managers are needed to control more narrowly defined activities. These points are emphasized by Pradip N. Khandwalla, an organizational researcher:

> The more specialized the tasks performed by individuals, the more likely they are to be grouped together by areas of specialization to permit effective supervision.

> The greater the similarity in the kind of work performed by individuals and in their norms and values related to work and to interpersonal relations, the greater the probability of their being grouped together for maintaining morale.

> The more diversified the demand for a service within an organization, the more likely it is that individuals providing that service will be grouped together to facilitate access to them.[2]

There are several other reasons for organizing employees into specialized groups. As mentioned in the previous chapter, an important consideration is **span of control** (number of people effectively supervised), also called *span of management.* If tasks are interdependent, management under one supervisor with compatible skills can widen the span of control and improve coordination. **Unity of command,** individuals reporting to only one superior rather than several, is also enhanced by departmentalization; confusion is avoided when orders come from

Data Systems (EDS), Hughes Aircraft, and Group Lotus, the British maker of high-performance cars. GM also recentralized management by combining Canadian activities, creating a small-car group, and moving toward a big-car group comprising Buick, Oldsmobile, and Cadillac. A number of factories were closed and several others were recombined under a major technological modernization program. Although more new car models were rolled out in 1987 and 1988 than in any two-year period in GM's history, there was also a major thrust to centralize parts manufacture through interchangeable systems and standardization.[12]

Perhaps the most significant centralization move was to revamp GM's entire approach to computer automation. In 1984, GM had more than 100 different computer networks and 7,000 employees involved in data systems, all seemingly working against one another. In seeking to acquire EDS, Smith envisioned a centralized information system under one roof that would redefine how GM employed information technology. Once EDS was purchased, Smith collapsed all of GM's computer networks, design and manufacturing technology, and the responsibility for automation into it. In effect, the "fourteenth floor" in Detroit (the legendary GM headquarters in its corporate building) became the epicenter for GM decisions. By 1989, GM had a core of under 500 executives running a giant of more than 800,000 employees in fewer factories than before, and with a single information system serving the combined auto divisions.[13]

GM is a manufacturing mega-corporation, yet many service industries are following the same trend toward recentralization. The banking industry is being reshaped by "mega-banks" created through mergers and acquisitions that result in a tremendous number of financial services under centralized team management. Citicorp, the world's largest privately owned banking institution, has constructed an executive empire characterized by close-knit corporate strategic planning. Citicorp is based on a coalition of management control with recentralized financial decisions, investments, and services, instituted mainly by CEO John Reed. During the deregulation era of the 1980s, mergers and acquisitions resulted in fewer but larger banks with centralized data processing and electronic coordination of far-reaching services.

Centralization is also occurring at middle-management levels largely because of new technology in information sciences that allows greater access to more operations. Even among salespersons, who prize autonomy, a move toward centralization is resulting in executive sales teams. These sales teams include marketing, technical, and staff specialists who work jointly with major customers. Large companies have used sales teams for years to provide the combined expertise they need. A new weapon system being developed for the Department of Defense may

Citicorp's focused power and influence came to light when CEO John Reed moved $3 billion of Citicorp's reserves against third-world loans in 1987, inciting similar moves by fifty other banks and altering U.S. relations with countries such as Argentina.

Source: "The Shape of Banking," *Business Week,* June 18, 1984, pp. 104–8, 110. See also John Reed, "The High-Tech Daredevil at Citicorp," *Fortune,* January 4, 1988, pp. 28–30.

require a team of engineers, contract administrators, lawyers, finance specialists, and technicians. Many heir-apparent CEOs of major corporations built their careers in functional specialties such as finance, but moved up the corporate ladder through executive teams. This trend is also appearing in small firms, where key executives are becoming intimately involved in marketing efforts.[14]

Information as an Environmental Imperative

Our age of rapid technological development requires managers to redefine organizational efforts and their roles in a high-tech society. Perhaps the most sensational characteristic of this era is the pervasive impact of information systems on decision making. Information is the basic element for making decisions, and delegation is rationalized when lower-level managers have better information to base decisions on. Therefore, as patterns of information change, they influence patterns of decision making.

Widespread implementation of information systems creates two conflicting forces in most organizations. On the one hand, lower-level managers armed with data bases, terminals, microcomputers, and so forth have rapid access to an exceptionally large pool of information. With these tools, they can monitor and control operations far better and with less analytical assistance than previously. On the other hand, information systems tend to be controlled through large-scale, centralized operations, as illustrated by GM's recentralization of information through its EDS purchase. Paradoxically, as access to, and dissemination of, information prompts greater decentralization of decision-making, concentration of information prompts management to centralize many decisions.

Figure 9-7 illustrates these apparently contradictory forces. Although both work simultaneously, they seldom affect the same areas of an organization similarly. For example, improved information systems allow manufacturing supervisors to monitor operations better on the plant floor (decentralization), whereas manufacturing schedules are generated through computer-based data systems (centralization). Either way, this technology alters decision structures and authority.

Information systems are generally reshaping firms toward centralized activities. Banks, for example, process more information more efficiently through centralized data systems than they can through branch operations. Similarly, team sales efforts are frequently more effective than those of individual representatives. Computer-aided design and computer-aided manufacturing systems (CAD/CAM)

FIGURE 9-7 Influence of Information Systems on Organization Structure

Changes in organization are also apparent in medicine. Doctors are reorganizing into group practices and cooperatives often similar to ESOPs and limited partnerships. Health maintenance organizations (HMOs), in which members pay a fixed fee for near-total medical coverage, are becoming increasingly popular. HMOs are incorporations of medical professionals with "member patients" or contracted clients, including state and federal employees. HMO doctors are both employees and shareholders who hire professional managers. These managers report to doctors as shareholders, and have doctors as employees report to them. Physicians not attracted to HMOs—preferring instead a fee-for-service and independent practice with group benefits—have formed partial associations for marketing and administration. These organizations are called independent practice associations (IPAs). Still other doctors have gone a step further and formed preferred provider organizations (PPO), groups that sell accounts to corporate clients and service them through long-term contracts so that all employees of a corporation are treated at a group discount rate.[29]

The Question of Centralization

Centralization is occurring rapidly in organizations in which information systems are being implemented. It is also being induced by competitive pressures resulting, as noted above, in new forms of legal services and medical practices. A number of firms, however, are becoming more decentralized for the same reasons. Sears' financial networks, brokerage services, and high-speed mail and postal services rely on finely tuned electronic systems of information dissemination to provide services to thousands of locations. One of management's more challenging questions, therefore, is how to coordinate centralized administration with decentralized decision-making processes. In the next few pages, we'll look at one pattern of organization that is being used to reconcile these contradictory trends.

CHECKPOINT

- What effect does participative decision making have on organizational structure?

- Explain the concept of a "skunkworks," and discuss how these new venture units are influencing organizational structures.

- Define and discuss ESOPs, and RDLPs, and new equity positions in terms of organizational decision-making authority.

- During this era of transformation, how are professional organizations changing?

MATRIX MANAGEMENT

In a **matrix organization**, teams are formed on a temporary basis to manage a project or complete an activity within a company's existing structure. At the center of matrix management is a combination of specialists gathered from a number of departments to form autonomous operating units under the leadership of a project manager. The project manager may be hired from outside or be reassigned from an internal position. Figure 9-9 depicts a matrix organization in which there are two chains of command. One is vertical, linking employees in production, engineering, materials, personnel, and accounting with their functional departments. The other is horizontal, linking the same employees with their project.

Matrix teams are drawn together to tackle specific problems or to work on well-defined projects. For example, American Cyanamid, a manufacturer of

matrix organizations
An approach to organizing work based on forming temporary teams from the ranks of existing employees who are responsible for completing well-defined projects.

FIGURE 9-9 Reassignment in a Matrix Organization

Copyright 1964 by the Foundation for the School of Business at Indiana University. Reprinted by permission.

industrial and agricultural chemicals, has formed matrix teams to develop new synthetic products, research new fertilizers, and market new herbicides. Xerox used matrix teams to create desk-top publishing software and a new integrated office system. Martin Marietta Corporation formed a network of matrix teams, each with several hundred team members, to work on various stages of the MX Missile Project. Hughes Aircraft, ITT, TRW, Texas Instruments, Caterpillar, Avco, Boeing, and Lockheed are other companies that use matrix techniques extensively.[30] In each instance, the matrix teams will exist until they complete their assigned projects. Then they will disband and team members will return to their functional departments or be reassigned to new projects.

Many companies have a hundred or more matrix teams operating simultaneously. Each new assignment pulls together a different group of personnel from a variety of departments. In many instances, the team includes individuals hired specifically for the project. Members of matrix teams usually face a series of recombinations and adjustments that can make life exciting or distressing. For example, an engineer at Hughes Aircraft may spend two years at White Sands

Case Questions

1. Do you believe that the current trend in restructuring is beneficial for U.S. industry in the long run? If yes, why? If no, why not?
2. What can organizations do to reduce the stress and anxiety being experienced by middle managers?

Source: "Caught in the Middle: Six Managers Speak Out on Corporate Life," *Business Week*, Sept. 12, 1988, pp. 80–88; and "Sizing Up Corporate Staffs," *Industry Week*, November 21, 1988, pp. 46–52.

SKILL PRACTICE

THE RESTLESS ENGINEER

Introduction

Do our occupations tend to "create" our professional personalities, *or*, do our professional personalities (work-related skills and abilities) predetermine our occupational choices?

Careers differ from jobs in that careers have a *pattern* of related jobs. There is sequence that reveals a plan by the career holder. A series of jobs can be held that shows no connecting pattern or relationship. There is an old saying: "If you don't know where you're going, any road will take you there."

As time passes and circumstances change, dynamic organizations change also. Employees, especially professional employees, should be ready to reevaluate whether they want to stay in their changing organization or move to another firm.

Instructions

Read (review) Case 1, Martin Marietta: Matrix at a Price, at the end of this chapter.

The instructor will form several groups of four or five people. Each group will have 30 minutes to discuss and decide the following:

1. What can you tell about Dean's views of his career in aerospace thus far?
2. Assume that the matrix structure is *not* a problem for Dean. Is there something he can do to find a better fit for his talents/goals in an organization?
3. Dean states he sees two options (mentioned at the close of the case). Are there other options for him? What are they? (List in order of long-run career value to Dean.)

Each group should elect a spokesperson to report that group's conclusions to the entire class.

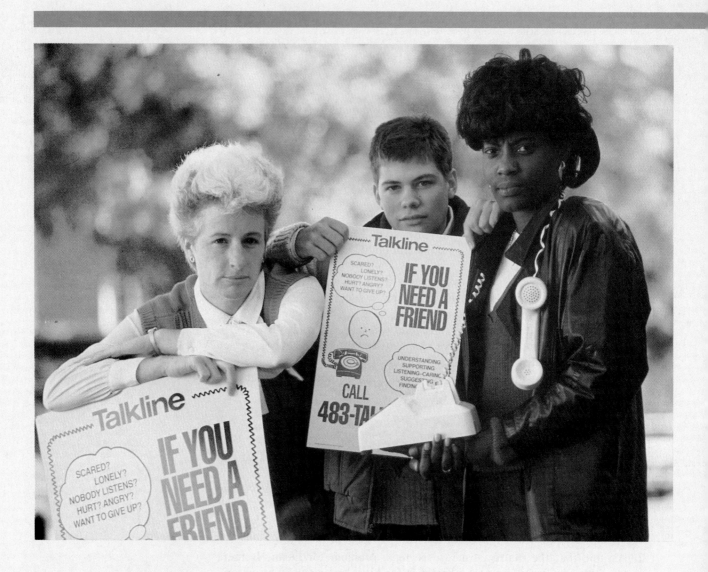

10

Social and Cultural Characteristics of Effective Organizations

From the turn of the century through the 1960s, Scott Paper Company was the world's leading producer of sanitary paper products. Scott Towels and Scott Tissue, the company's flagship products, enjoyed nearly 60 percent of total U.S. industry sales for five decades. Scott managers grew complacent, however, with the result that the company became paralyzed in red tape and bureaucratic rigor. Marketing managers were unresponsive to consumer needs, production managers were more concerned with meeting schedules than with product quality, and executives were coasting toward retirement. By 1970, Scott Paper Company was no longer competitive with Procter & Gamble, Georgia Pacific, or Kimberly-Clark; all three outsold Scott with new products.

By 1980, Scott's market share in sanitary paper products dropped by more than two-thirds to almost 20 percent. Profits were also low, and not many managers or employees stayed with the company for more than a few years. Then, in November 1980, forty-three-year-old Philip E. Lippincott was named CEO, and the company began to change. Lippincott developed a strategic plan with three criteria: concentrate on making quality products that Scott knows best; eliminate distractions, such as Scott's leisure furniture line and lighting business; and change the corporate culture so that all employees can be part of, and feel pride in, the company.

Lippincott met all three criteria, and by 1989, Scott rebounded with an 11 percent increase in market share and a threefold increase in corporate earnings. Lippincott has created an atmosphere of shared values among employees, a culture of making the best products, enjoying work, and being good citizens. Employees are rewarded for excellent performance, and are encouraged to make decisions with little management direction. These changes have created a sense of self-determination among Scott's employees.

- Explain what culture is with respect to organizations.

- Discuss the attributes of some of America's best-managed organizations.

- Contrast the concepts of power and authority.

- Explain the concept of acceptance.

- Explore line and staff issues in terms of delegation of authority.

- Describe the spectrum of delegation and authority in Western firms.

- Discuss changes in authority emanating from social and cultural influences.

In addition, the company has implemented public service programs that involve managers and employees in activities outside the company. For example, employees volunteer to staff Talkline, a hotline in Philadelphia that helps people deal with problems such as child abuse and drug addiction. The company founded SERVE—Scott Employee Retireee Volunteer Effort—to help retired employees take an active role in their communities. And Scott has sponsored Project ORBIS, a flying teaching hospital dedicated to combating blindness around the world. Lippincott believes that employees feel good about themselves and their company because of these programs, and that therefore they work harder to improve the company.[1]

Scott Paper Company has become an organization based on shared values and activities by all employees. As you study this chapter, consider how important it is to establish relationships at work that go beyond the formality of prescribed tasks.

Organizations are social systems. The formal structures studied in Chapters 8 and 9 are like the table of contents for a book in which complex human relations and activities are chapter and verse. It is these relations and activities that produce an organizational culture. Each organization evolves a unique profile reflecting the values and beliefs of the collective membership. This chapter will examine organizational culture, organizational authority and power, and social relationships in organizations.

We also want to expand the concepts of staff and line authority in relation to managerial roles. Because managers exert influence to get things done, this chapter examines how they gain and then use power to influence subordinates. As noted in Chapter 9, important changes are occurring in organizations. Therefore, we will also discuss authority within organizations and the changing relationships between managers and subordinates.

ORGANIZATIONAL CULTURE

culture
A shared set of values and beliefs that determine patterns of behavior common to groups of people; corporate culture refers to patterns of behavior based on shared values and beliefs within a particular firm.

In any organization, **culture** is the shared language, events, symbols, rituals, and value systems of its members, working together in a system affected by its environment. Organizational culture evolves from past members' behavior and is reconstituted by current members.[2] Defined more clearly, culture is: "A system of shared values (what is important) and beliefs (how things work) that interact with a company's people, organizational structures, and control systems to produce behavioral norms (the way we do things around here)."[3]

Existing firms have cultural underpinnings that reflect these shared values and beliefs; consequently, each organization has behavioral norms for getting things done. Newly formed organizations experience the challenge of creating cultural underpinnings, of developing a philosophy of management, a system of values, and a set of beliefs that together transform individual effort into organizational behavior.

Culture in America's Most Admired Firms

Merck & Company has earned the title of America's most admired corporation for the third year in a row. In fact, the 1989 annual *Fortune* survey gave Merck

the top rating after a stunning year in 1988 when the company achieved the highest rating ever given by a company since the survey began in 1978.[4] The company was cited for innovations, including major breakthroughs in cardiovascular drugs, antibiotics, and a new anticholesterol fighter called Mevacor. The survey polled more than 8,000 top executives, outside directors, and analysts, asking them to evaluate firms on the eight key attributes that constitute a company's *corporate culture*. These attributes are innovativeness; quality of management; value of long-term investment; ability to attract, develop, and keep talented people; quality of products or services; financial soundness; community and environmental responsibility; and use of corporate assets.

Table 10-1 summarizes the survey's findings. Rubbermaid and Philip Morris were rated extremely high overall because of their human resource attributes. Both were perceived as having a strong culture of quality management and exceptional systems for attracting, developing, and keeping talented people. They were also considered financially strong, with diversified interests beyond their traditional product lines. 3M and Wal-Mart scored extremely high on innovativeness, management, and human relations. Exxon and Shell Oil returned to the top ten after several years of absence. However, Exxon's votes were cast before the Alaskan oil spill incident. PepsiCo and Boeing have consistently been in or near the top ten with strong market performance and management. Herman Miller has captured public attention after two generations of creative designs and high-quality furniture.

TABLE 10-1 America's Most and Least Admired Corporations

THE MOST ADMIRED

Rank	Company	Industry Group	Score*
1	Merck	Pharmaceuticals	8.87
2	Rubbermaid	Rubber products	8.41
3	3M	Scientific/photographic equipment	8.18
4	Philip Morris	Tobacco	8.15
5	Wal-Mart Stores	Retailing	8.12
6	Exxon	Petroleum refining	8.05
7	PepsiCo	Beverages	8.04
8	Boeing	Aerospace	8.03
9	Herman Miller	Furniture	7.99
10	Shell Oil	Petroleum refining	7.96

THE LEAST ADMIRED

Rank	Company	Industry Group	Score
296	Kaiser Tech	Metals	4.21
297	Manufacturers Hanover	Commercial banking	4.18
298	Control Data	Computers (and office equip.)	4.17
299	Goldome	Savings institutions	4.08
300	LTV	Metals	3.88
301	BankAmerica	Commercial banking	3.82
302	Meritor Financial Group	Savings institutions	3.70
303	Texas Air	Transportation	3.67
304	Gibralter Financial Corp.	Savings institutions	3.34
305	Financial Corp. of America	Savings institutions	1.82

*Score is based on 10.0, and 306 firms were rated.

Source: Carol Davenport, "America's Most Admired Corporations," *Fortune,* January 30, 1989, p. 69. © 1989 Time, Inc. All rights reserved.

Companies on the least admired list were generally cited for shaky human relations, intractable managers resistant to change, and lack of direction other than to generate profits. Respondents openly criticized executive management in such companies as Texas Air and Bank America for less-than-admirable strategies, low-quality products or services, and disregard for human relations and social responsibilities.

Conspicuously missing from the top ten, but still highly regarded, were IBM and Hewlett-Packard, two firms that had in the past been nudging one another for the top position. IBM is no longer viewed as a technological leader; it is seen instead as a company that prefers to let its competitors assume the risk of innovations. Because of its less-than-sparkling financial performance, Hewlett-Packard also slipped from the top ranks, although it is still considered an exceptionally well managed firm with a strong commitment to employees and socially responsible endeavors.

Although the rankings change each year, a pattern has emerged that reinforces the importance of organizational culture. Firms with a consistently strong profile of commitment to quality management and to upholding good human relations are ranked high. Similarly, firms that are simultaneously committed to innovation and responsive to community and environmental needs are ranked high. The top few companies that achieve these goals reap the rewards; conversely, those that do not arouse substantial ill-will among their peers. Research on organizational culture and attributes of companies held in high esteem by the business community strongly support these findings.[5]

Culture Transforms Systems

America's most admired companies have undergone evolutionary changes that have resulted in tremendous differences in how they organize work and encourage quality performance. Internal cultural changes have transformed social systems, redefined authority, and altered basic philosophies of doing business. In contrast, beneficial cultural changes have failed to occur in most, if not all, of the least admired companies. Their authority relationships continue to be steeped in outdated traditions, and their management philosophies reflect narrow viewpoints.

You cannot gain a true appreciation of differences between well-managed and poorly managed firms from a textbook. Personal experience is required to understand them. Even if students could be magically transported into an operating environment, the differences would not be readily apparent. However, the following passage may provide some insight:

> Strange things happen at the best plants. Workers complain about machines being idle for too long and then fix them on their own to reduce downtime. A plant manager smiles approvingly when he encounters the head of the janitorial crew dictating a letter to the manager's own secretary.

> The fanciest conference rooms are sometimes found not in the administration building, but inside the plant, for workers to use when meeting with foremen. . . . The best-run factories don't look alike when you first walk into them. Stepping into GE's spanking new dishwasher plant, an awed supplier said recently, is like stepping "into the Hyatt Regency." By comparison, stepping into Lincoln Electric's 33-year-old, cavernous, dimly lit factory is like stumbling into a dingy big-city YMCA. . . . But it isn't too much to say that, in general, trust has replaced strife, and communication has been substituted for confrontation. In most well-managed plants, workers now get frequent reports on plant profits, product quality and cost, the competitive situation, and other subjects—information that wasn't normally released to them before.[6]

Both Lincoln Electric and General Electric are well thought of, and although their physical environments differ, their social systems and cultures are

MANAGEMENT APPLICATION 10-1
Herman Miller's Secrets of Corporate Creativity

Herman Miller, Inc., has been making creative furniture for several decades, and has been ranked as America's No. 1 furniture company by *Fortune* magazine for five consecutive years. A major reason for the company's success is its creative leadership. Chairman Max DePree is a strong advocate of a participative corporate culture, and he uses unusual terms to explain the art of leadership. He prefers the term "covenantal" to "contractual" when talking about human relationships, and refers to "tribal storytelling" to explain how a familylike culture evolved at Herman Miller.

To DePree, covenantal relationships are born of shared ideas and value systems. Instead of a contractual agreement with managers and employees, DePree encourages an environment of mutual responsibility and commitment to innovation. His primary goal is to establish relationships "in which it is OK for everybody to do their best." Therefore, Herman Miller, Inc., is a participative company based on employee stock ownership; that is, every full-time employee is a shareholder. In addition, the company has monthly bonuses and profit-sharing plans, but the heart of Herman Miller's creativity is an unusual organization.

Creative designers are given private studios at the Zeeland, Michigan, company headquarters, but they are neither expected to live near Zeeland nor work there. In fact, DePree encourages designers and craftsmen to find more stimulating haunts—even to practice other disciplines—to keep their creative juices flowing. For example, one designer is on a $100,000 a year retainer and has few creative restrictions. Most designers also share in royalties, and successful products can bring them fame. For example, a famous lounge chair, the Eames lounge chair, is named after its designer and exhibited in New York's Museum of Modern Art.

By urging designers to get out of the corporate enclave, DePree has forged links with the broader society. By encouraging project development teams and internal participation, he has solidified an internal social system for making great furniture. In his own words, DePree is seeking a form of enterprise that is "inclusive" rather than "exclusive." He wants common benefits from a collective effort, not individual benefits from a selective effort.

One result of Herman Miller's commitment to creativity and quality is the classic lounge chair and ottoman designed by Charles Eames.

quite similar. Each has created exceptionally high standards for quality products and services. Each has socialized its employees so that everyone is a quality inspector. In each company, workers can stop production lines until parts are free of defects. Workers control line speeds in conjunction with management systems. GE and Lincoln Electric have restructured authority so that group decision making involves managers and employees. Also, each company has invested in human resources through training, improved reward systems, and an enhanced quality of working life.

Lincoln Electric has been a leading manufacturer of arc welding equipment for nearly half a century, and the firm relies on its "Million Dollar Employees" for its continued success. Lincoln's employees earned this title through innovations that saved the company more than $1 million in operating costs. Lincoln's employees are also well rewarded. In a good year, machine operators can earn as much as $80,000 from bonuses based on their level of work. Employees like being part of the Lincoln Electric family and rarely see themselves as simply working for a company.[7]

Changes in Organizational Relationships

From a social-anthropological viewpoint, the best-managed organizations have broken away from the conventional wisdom that authority should emanate from a rigid hierarchical system to adopt more open and flexible systems. William Torbert, a researcher and theorist in organizational behavior, suggests six characteristics of companies that have made this transition:[8]

1. Organization members from top to bottom share assumptions about the larger purposes of the organization.
2. There are organizational norms of open disclosure of information, conciliatory support, and open communication.
3. Individuals evaluate the effects of their own behavior on others in the organization, as well as the effects of the organization on its environment.
4. Organizational members are encouraged to find unconventional solutions to conflicts.
5. A deliberately chosen structure, unique in the experience of the participants, supports changing values and a social system of beliefs with commitment over time.
6. Role differentiation and interpersonal relations have a horizontal instead of a vertical emphasis.

Clearly these six characteristics do not explain all the differences between the best- and worst-managed firms, but there is strong evidence of a pattern among the more successful firms. This pattern includes a propensity to reallocate power and redefine authority according to values of group participation, quality performance, and equitable relationships. In the following sections, we expand on the theme of *power,* why authority must be *accepted* to be effective, and why conciliatory relationships enrich an organization's performance.

CHECKPOINT
- Define the concept of corporate culture.
- Why are some companies esteemed while others are less well thought of?
- What are some of the most important differences between the best- and the worst-managed American companies?

EXHIBIT 10-1 *Power Sources in Organizations*

Legitimate	Stems from authority of ownership and delegated responsibilities.
Expert	Depends on perceived skills and appropriate expertise in tasks.
Coercive	Relies on force and fear of reprisals, both physical and economic.
Referent	Charismatic power derived from the ability to create devotion and allegiance.
Reward	Includes compensation, promotion, esteem, expectations, and recognition.

SOURCES OF POWER

Although at first glance, *power* and *authority* may seem to mean the same thing, the two differ significantly. **Authority** is the culmination of formal rights, duties, and responsibilities associated with a position of management. In contrast, power is the "force" or ability to physically move something. In an organizational sense, **power** is the ability to *influence* others to get things done. As we shall see, power can exist separate from authority, and authority (which may be a source of power) does not guarantee a person will have the power to get things done. Many powerful individuals are not in positions of authority, and many others in authority are powerless to influence behavior.

Power is defined according to its sources, and in management, five sources are preeminent. Exhibit 10-1 summarizes these five sources of power, and although we will discuss each one separately, managers exert influence and derive acceptance through constructive use of all five.[9]

authority
The formal or institutional right to command stemming from official delegation of position, one common source of power.

power
The ability to influence others by modifying behavior to accomplish preferred results.

Legitimate Power

Legitimate power is associated with the authority of a formal position in management. It stems from the concept of ownership or *property rights,* in which a business owner is presumed to have a legitimate right to command subordinates. This is the primary source of power in any organization.

These prerogatives are less clear in complex corporations where ownership is separate from management. Corporations often have diversified stock ownership far removed from management; public organizations, such as schools, are

legitimate power
Also called *formal authority,* it is the right to manage derived from delegation based on ownership or property rights.

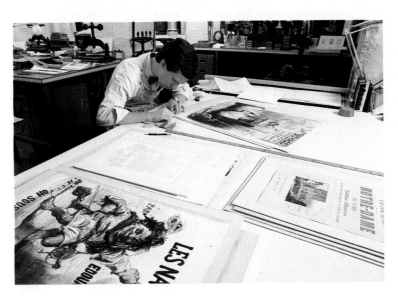

This artist runs his own business. The exercise of legitimate power is easily seen in a small business whose owner also manages the business. It is the fundamental right of a property owner to allocate resources, make decisions that affect profits, decide on products and services, and direct personnel.

ultimately owned by taxpayers. The managers of complex organizations, then, are limited to proxy positions as owners' representatives. In all organizations, owners' property rights give them the right to hire executives, who in turn act for owners to hire others. This notion is fundamental to American organizations, yet legitimate power is diluted through the process of growth and organizational expansion. As managers delegate authority, the prerogatives flowing from ownership become more and more muted. The power base for the federal government or the Exxon Corporation is quite vague.

In an interesting twist to the concept of property rights, it has been suggested that workers have as much right to be involved in decisions as managers. The argument is that because we recognize a manager's authority based on capital investment, we must also recognize an employee's property right derived through labor investment. This insight is based on the economic theory that separates factors of production into land, labor, capital, and entrepreneurship. Some theorists argue that employees have an equal, or even greater, right to be involved in decisions than stockholders because they have invested an irreplaceable commodity in the organization, whereas stockholders' investments often consist of no more than temporary stock transactions.[10] The argument is summarized by Peter Drucker in Exhibit 10-2.

Expert Power

expert power
The ability of managers to lead others and influence behavior through acceptance of their expertise or special knowledge.

Expert power is based on technical competency or skills respected by individuals willing to be influenced by the person who has the expertise. Therefore, it isn't necessary to have a position of authority to have power. Many people are powerful because they are experts in their fields. Often it is a matter of comparative expertise; we turn to others who seem to know more or who are better qualified than ourselves for advice or leadership. We turn to doctors for medical help, to lawyers for legal advice, and in organizations, to managers for advice and decisions. However, if our supervisors seem to lack the expertise we expect of them, we might turn instead to a co-worker for help.

The assumption of expertise can also cause problems. Because we respect a doctor's ability to treat us medically, we don't automatically assume he or she

EXHIBIT 10-2 The Job as Property Right

In every developed non-communist country, jobs are rapidly turning into a kind of property. . . . In the U.S. recent legislation has given the employee's pension claim a great deal of protection traditionally reserved for property. . . . The various fair-employment regulations in the U.S. whether on bahalf of racial minorities, women, the handicapped or the aged, treat promotion, training, job security, and access to jobs as a matter of rights. It's getting harder to dismiss any employee except 'for cause.' And there is growing pressure, including a bill before Congress, to make the employer responsible for finding the employee an equivalent job in the event of a layoff.

Jobs, in effect, are being treated as a species of property rather than as contractual claims. Historically there have been three kinds of property: 'real property' such as land; 'personal property' such as money, tools, furnishing and personal possessions; and 'intangible property' such as copyrights and patents. It is not too farfetched to speak of the emergence of a fourth—the 'property in the job'—closely analogous to the land in premodern times.

In modern societies . . . the overwhelming majority of the people in the labor force are employees of 'organizations'—in the U.S. the figure is 93%—and the means of production is therefore the job. The job is not 'wealth.' It is not 'personal property' in the legal sense. But it is a 'right' in the means of production, an 'ius in rem,' which is an old definition of real property. Today the job is the employee's means of access to social status, to personal opportunity, to achievement, and to power.

Source: Peter F. Drucker, "The Job as Property Right," *Wall Street Journal,* March 4, 1980, p. 18.

can manage other doctors or medical workers. Unfortunately, however, many managers have gained their positions through technical skills rather than through leadership abilities. For expert power to be effective, of course, the nature of an individual's expertise must be appropriate to the situation, but managers cannot rely solely on their technical expertise to influence employee behavior.

Coercive Power

Coercive power is the ability to force action by instilling *fear*. Fear of physical harm is of little concern to most American employees, for we have developed safeguards and penalties against this kind of coersive power. Managers can, however, punish or discipline subordinates, and they can instill fear in other ways.

> **coercive power**
> The capability to punish, rather than reward, or to withhold rewards to influence preferred behavior; power based on fear and force.

For example, we fear reprisals. If we do not perform as required, our next assignment may turn out to be an unpleasant one. We may find our promotion blocked by an offended supervisor, or we may put our next pay raise in jeopardy by not bending to the wishes of management. In fact, it is not uncommon for people to be fired because they failed to conform to management's expectations. Employees fearful of economic reprisals respond to managers' prerogatives in order to protect themselves from economic losses. Job security is a crucial consideration in periods of high unemployment, but even if their jobs are secure, most people want to position themselves for promotion and to avoid ridicule. We all live with coercive power whether or not we are willing to admit it. Fortunately, managers do not generally use fear as a way of getting things done, even though most realize they have power over employees as long as they can influence decisions about pay and job security.

Referent Power

Referent power is based on the personal respect of subordinates for their leaders, and consequently, their desire to be identified with those who are admired most. Everyone wants to feel part of something, to be accepted by a group or to have friends. We seek reference points in life, and we tend to conform to group norms at work as we try to fit in with our peers. We also find that we like working for people who have that elusive quality called charisma, a special attribute of leadership inspiring allegiance and devotion. We probably work better with people who accept us, and more enthusiastically for people with whom we would like to be identified.

> **referent power**
> One of the five power bases which stems from individual preferences to be identified with a leader; often associated with charisma.

Referent power in an organization emanates from a charismatic individual able to draw others into a cohesive work group. Charismatic managers gain influence by the admiration they inspire. History records many leaders who are revered, mourned, and immortalized. Their accomplishments are not what we recall most; we embrace their personal characteristics. Abraham Lincoln is remembered as the kind, intensely sensitive man burdened by a sorrowful war; John F. Kennedy as the youthful cavalier president; Martin Luther King, Jr., as the unselfish champion of civil rights. Incidentally, Adolf Hitler and Libyan leader Muammar Gaddafi qualify as charismatic leaders, and although we deplore the results of their leadership, we recognize their power. The ability to inspire allegiance does not imply a beneficial use of that power.

Although few managers can aspire to become great charismatic leaders, all can strive to create a cohesive atmosphere in their organizations. They can develop *empathy* for co-workers and work toward closer personal attachments between themselves and their subordinates. Referent power is the influence that managers derive from their subordinates' admiration.

Reward Power

reward power
One of the five power bases whereby managers can influence behavior by controlling rewards in a positive, motivating way.

Reward power is based on the straightforward notion that people work for gain, although gain does not necessarily mean money. Of course, money is one source of reward, but we also work for promotions, which are psychologically rewarding as well as economically advantageous. On a simpler level, rewards can include words of thanks, praise for jobs well done, awards for outstanding performance, and plaques for noteworthy accomplishments.

Influence is exerted through an organization's reward system. We may seek monetary or psychological rewards and therefore work harder at our jobs. Rewards can also backfire if not used equitably. As previously noted, we all live with a certain amount of fear; having a reward withheld can be as psychologically devastating as an outright threat. Because everyone seeks rewards and also has individual fears, it is no small feat for managers to simultaneously alleviate fears and employ rewards to influence behavior.

Some employees are primarily motivated by a desire for compensation and promotion, so they will be more willing to work for managers who can directly influence compensation and promotion. Other employees may value individual recognition and work harder for praise. We cannot generalize about the influence of rewards. They are inextricably entwined with individuals and the chemistry of the work environment. What we do know is that employees must recognize and accept rewards as important if those rewards are to influence their work behavior.

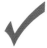

> ## CHECKPOINT
>
> - Differentiate between power and authority.
> - Identify and explain the five primary sources of managerial power.
> - Discuss why managers cannot rely on legitimate power alone to influence employees' behavior.

ACCEPTANCE

zone of indifference
A concept articulated by Chester Barnard that implies a range of acceptance by subordinates to orders with few objections. Beyond the zone, subordinates are no longer indifferent and object to orders.

Managers influence behavior when their authority is accepted. No source of power has meaning if employees refuse to accept it as meaningful. You can't induce someone to work for a large raise if money is not important to that person, nor can you coerce someone with a threat if he or she thinks you lack the ability or authority to carry it out.

Chester I. Barnard wrote about acceptance in 1938. He suggested that the extent to which orders are obeyed and workers perform rests on the degree of *acceptance* by workers of a manager's authority.[11] In this view, influence is not the result of the degree of authority passed downward but instead a function of acceptance from the bottom up. Influence, then, rests with subordinates.

Barnard used the term **zone of indifference,** shown graphically in Figure 10-1, to illustrate his concept. In his view, each subordinate perceives how far a manager can go when issuing orders. When managers ask subordinates to do something that falls routinely within this zone, they have no problem accepting the order. However, when subordinates perceive an order to be outside the zone, they are no longer indifferent and may refuse to carry it out. It is impossible to define an absolute perimeter to this zone of indifference. The range of acceptance depends greatly on a subordinate's perceptions, a manager's ability to gain acceptance, and the particular work environment.

FIGURE 10-1 Conceptual
Model of Barnard's Zone of
Indifference

Beyond the zone; behavior unacceptable

The fringe

Zone of acceptance; employees perceive
manager to have proper authority to make
decisions within this scope of behavior

The fringe

Beyond the zone; behavior unacceptable

Barnard's zone is flexible. In his view, managers can broaden the zone of acceptance in many ways. For example, employees may become more tolerant of directives as a manager becomes more technically skilled. Closer working relationships will also reduce employee resistance to supervision; in other words, the zone broadens as referent power increases. Perhaps employees will do more for greater rewards, and probably they will be less resistant to management prerogatives when the economy is more threatening and they have fewer job options.

Mismanagement shrinks the zone of acceptance. Consistently asking employees to do more than expected (to work outside the zone) will increase their resistance to authority. They will then become less tolerant of all management directives. Similarly, flaunting authority can annoy subordinates and shrink the zone. Also, creating credibility gaps by inequitably distributing rewards or punishments will certainly diminish a manager's influence. Anytime an employee feels harassed or imposed upon, the zone shrinks.

Although the concept of acceptance suggests that power can be gauged by observing relationships between superiors and subordinates, circumstances also play an important role in defining zone limitations. A young man who would never think of killing someone in peacetime will obey a command to do so in battle. Workers who do not normally tolerate managers "barking out orders" may react obediently and swiftly in times of emergency.

CHECKPOINT

■ How does acceptance theory reverse the influence process?

■ Describe Barnard's zone of indifference.

■ How do circumstances alter the acceptance range of Bernard's zone?

INFORMAL POWER AND INFLUENCE

Formal power structures are identified on organizational charts within hypothetical pyramids of authority. In contrast, informal power structures are observed by examining behavior. Figure 10-2 illustrates how relationships within an organiza-

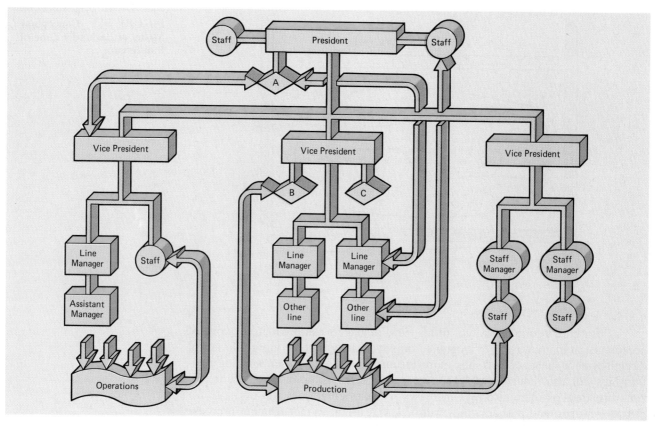

FIGURE 10-2 The Power Overlay

Note: The power overlay indicates consideration of communications "out of channels" at points A, B, C, and between several staff and line personnel. Those who control information tend to be influential in organizations. The outside channels of communicative behavior imply informal power structures.

tion may be distorted by informal influence. Whereas formal power relationships are defined, informal power reflects influential relationships between individuals.

Power relationships are revealed by how one person influences the way another person acts. If superiors were the only people who influenced behavior, formal and informal power structures would be identical, but they are not. Position power is only one dimension of influence; anyone anywhere in the organization can influence behavior.

Secretaries seem to have influential positions because they control information or have knowledge that others seek. Often an executive's secretary has nearly as much insight into and control over business affairs as does his or her boss. Lower-level managers frequently seek information from secretaries rather than from their supervisors. You might recognize this example: In most college departments the chairperson's secretary is often the best source of information on courses, class openings, and the like. The secretary is not necessarily better informed than the chairperson but is more accessible and so more influential.

FIGURE 10-3 Employees Get Answers

Note: Employees who perceive needs for information will find that information even if it means going to unofficial sources. Managers who fail to listen risk loss of influence.

Let's consider two crucial points. First, the person who has access to information becomes important. Second, if one person is more accessible than another, we take the path of least resistance for help. Either way, we reinforce that person's influence by seeking information and help. Individuals who control resources can influence others. People in need of those resources, including information, create informal power structures by going out of channels. As Figure 10-3 shows, these relationships have no particular pattern.

Proximity also affects the degree of influence people have. In banks, home office loan officers tend to have more influence than branch managers. Although the two have the same rank in the official management hierarchy, home office loan officers' close proximity to executives gives them higher visibility and greater contact with superiors than branch managers enjoy. Proximity implies greater status and, in turn, more influence. Home office managers are, therefore, systematically more influential than branch managers.

CHECKPOINT

■ Explain how informal power influences organizational relationships.

■ Why are individuals who control information resources influential?

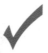

AUTHORITY

Our discussion of power and influence has taken us full circle. We began with definitions of power, emphasized the need for acceptance, and explained the fundamental differences between formal and informal power structures. We return now to position power, or authority, because this concept is the underpinning of organizations in Western societies.

A person's authority is based largely on his or her position within the hierarchy of management. In fact, we often think of "position" and "authority" as synonymous. Some authors have begun to refer to this type of authority as *institutionalized*, which implies that the higher a manager is in the organizational hierarchy, the greater that person's authority to control others.[12] Positions of authority are like rungs on a ladder, and we aptly view this as *scalar authority*. We also tend to think of authority in a chain relationship and refer to position power in terms of *unity of command*. Both terms were introduced in Chapter 8 and are important for a clear understanding of authority relationships.

Scalar Authority

scalar chain
The concept of a clear, unbroken line of authority derived from unambiguous delegation throughout the management hierarchy.

All of us accept the notion of hierarchical authority; we have come to expect it in organizations. Since we also prefer order and clarity in our lives, we expect managerial authority to be ordered and clear. We want formal reporting channels to be unambiguous. A scalar chain of authority provides this clarity. In the **scalar chain,** there is a direct linkage between each level of management from bottom to top in an organization. We have many metaphors in our culture to illustrate it. Thus, we speak of "climbing the ladder of success" and reporting up the "chain of command." Scalar authority means that we report to someone who in turn reports to someone else; there is no ambiguity about who reports to whom.

Unity of Command

unity of command
The concept that a subordinate should report to only one superior or receive only one set of directions from one superior at a time.

While scalar authority implies a direct reporting relationship, **unity of command** means that each person should report to only one superior. Subordinates should not have more than one superior telling them what to do. We expect only one person at a time to be in charge; therefore, when someone other than our immediate superior gives us an order, we tend to resent it. If authority is to be accepted, it must be clear who has it.

Realistically, an absolute chain of authority and unambiguous reporting channels are rare today. They may exist in some highly disciplined military units, but in practice most reporting channels are "soft" and employees answer to or work with several senior managers. For example, a personnel administrator at an auto parts manufacturer recently said that he reported directly to the executive vice president, but after a brief discussion, it was obvious he reported to about six executives. He was directly responsible to the controller for manpower budgets, yet reported to a different vice president for employee grievances, turnover, and illnesses. He also reported directly to the president on affirmative action problems. In addition, he worked with plant managers on manpower planning, with quality control managers on training, and with union officials on contract matters.

Balance of Authority and Responsibility

Authority is delegated in order to spread the burden of management. Complex organizations would accomplish little if one person had to do everything. However, delegating authority to someone does not necessarily mean that person can be held responsible. For example, a purchasing manager may be authorized to contract for and buy raw materials, but if the president of the firm retains the right to sign each purchase order before it is issued, then the purchasing manager acts more as a clerk, the president is really doing the purchasing. Can the purchasing manager then be held responsible for purchasing decisions?

Only when authority is backed up with the support and tools necessary to get the job done can responsibility be implied through delegation. Managers are responsible for results when they control circumstances that affect performance. If a purchasing manager is going to be held accountable for properly ordering raw materials, then he or she must be allowed to determine what to order, how to contract with vendors, and how to process transactions.

Managers in large organizations face a more perplexing problem of accountability. Staff managers do much of the specialized work that line managers would do in smaller firms. Personnel managers in large firms recruit, screen, hire, and often oversee the training of new employees for a wide array of departments. In smaller companies, line managers may do most of the personnel work short of actual recruiting. In any-size company, line managers are responsible for quality

workmanship and productivity, yet many of them have little or no voice in hiring the employees they will be supervising. If productivity is affected by poorly skilled employees, who, then, is accountable?

Line and Staff Authority

As discussed in Chapter 9, most organizations have two spheres of management: *line* and *staff*. Line managers are directly concerned with primary tasks of the firm. Staff managers are in support roles, advisory roles, and specialist fields. Authority in each sphere is different. Staff managers generally do not have authority to become directly involved in line operations. Line managers generally don't have the expertise or desire to become involved in staff support activities. Still, the lines of demarcation are not always clear.

Line managers rely heavily on staff for support and expertise. Staff managers generally are not supposed to make decisions for line operations, but in many instances they do. Quality control managers, for example, can and do halt production. Labor relation specialists critically influence terms of employment, and safety inspectors alter working conditions in line operations. Credit managers may veto sales. Affirmative action officers may override hiring or firing decisions. Some of the confusion about staff and line authority can be resolved by classifying different types of staff personnel. Figure 10-4 sketches three possible relationships, but many more adaptations exist.

FIGURE 10-4 Three Views of Staff Assistants

Note: Department personnel view managers and assistants as optional sources of authority. Personalities may dictate relative differences in influence with subordinates.

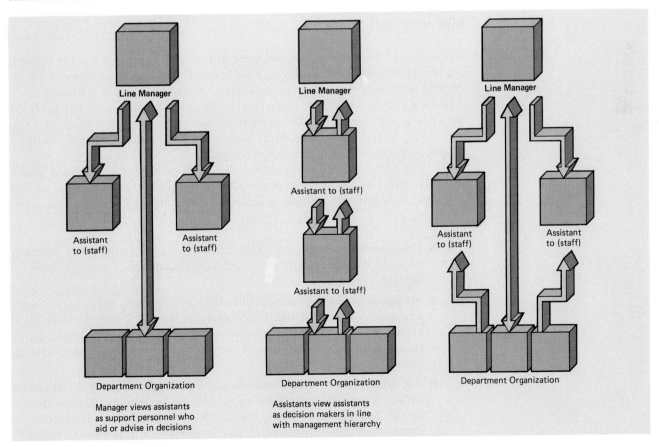

General assistants. There are cadres of staff specialists at the top echelons of organizations serving as advisers. Some are personal staff advisers appointed to aid specific line officers on important and sensitive decisions.[13] Many of them work in special surroundings that require them to have one foot in the organization and one foot in the outside world. Attorneys who contract with a corporation fill this role. Consultants find themselves in similar positions, particularly when they develop long-standing client relationships.

Staff assistants. People occupying these positions usually have hard-to-define areas of responsibility. Vague job titles are used, such as "assistant to the vice president," "special assistant to the president on consumer affairs," and "administrative assistant to . . .". The difficulty in identifying staff authority is compounded by the personalities of executives for whom staff assistants work. An autocratic manager may keep personal staff assistants as "go-fers" who fill demeaning roles and seldom influence decisions. Other managers may rubber-stamp their assistants' decisions. In the latter situation, it is often difficult to know who is making the decisions.

Line assistants. As line managers become overloaded with work, they often seek help. People brought in to relieve line managers of their workloads are not strictly staff because they usually do more than advise. Most assistants in these positions are viewed by employees as heir apparents to the line managers.[14] There are dangers associated with appointing line assistants. First, many appointees are actually given very limited authority and are *not* in line for their superior's job. This situation can be discomforting to assistants because other employees will perceive them as management's lackeys. Second, assistants who aspire to a manager's position may be viewed by co-workers as threats. In either situation, cooperation will be fragile.

Line and Staff Issues

Management faces a continuing dilemma of line-staff responsibility. On the one hand, organizations have a growing need for staff specialists and expertise. With so many government regulations concerning employment, safety, pensions, environmental protection, prices, wages, and so on, few companies can rely solely on line managers to handle all these perplexing issues. On the other hand, as more staff managers find positions in firms because their expertise is needed, decision-making authority is becoming more dispersed.

We cannot categorically define all the problems or even suggest how a particular structure of management is affected by this sensitive mixture of line and staff managers, but several situations increase the potential for misunderstandings:

- *Encroachment* is a common problem. Staff managers can easily encroach on a line manager's authority by directly influencing, or making, decisions beyond their staff authority.

- *Infringement* suggests a conscious effort to usurp line authority or otherwise overrule line managers' decisions. In fact, staff managers are often expected to infringe. An affirmative action officer, for example, has a mandate to review employment and promotion decisions and to change hiring decisions if necessary.

- *Ambiguity* in staff roles leads to many problems; some were discussed earlier. The single most bothersome difficulty is deciding who has authority for decision making and the extent of that authority. If authority is vague, then so is responsibility, and accountability may be impossible.

- *Perceptual* problems arise from substantial differences between staff and line managers due to education, age, and experience. Managers with different backgrounds are likely to come up with different solutions to the same problem. The advice of knowledgeable staff managers may be unacceptable to line managers and vice versa.

- *Concurrent authority* between line and staff managers is a persistent problem in most large companies. This can occur, for example, when research engineers have a voice in production methods and production line managers must implement the engineers' ideas. Staff MIS managers often work jointly with line managers to develop computer systems. In these instances, they share authority, which provides ample opportunity for conflict or misunderstanding.

The concept of concurrent authority is particularly important today as organizations are evolving toward more participative management. Concurrent authority is not abnormal, but often purposely devised. Engineers from research and production do work together jointly and share authority. MIS and line operating managers do team up to solve problems. Misunderstandings and friction occur not because these collaborations are unusual but because outdated views of traditional line and staff authority stymie change.[15]

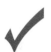

CHECKPOINT

- Explain the concepts of scalar authority and unity of command.
- Define and contrast three categories of staff authority.
- Discuss several situations that can lead to misunderstandings between line and staff managers.

DELEGATION OF AUTHORITY

Many line-staff conflicts can be minimized by proper delegation of authority. **Delegation** is the downward dispersal of formal authority to make decisions. Therefore, when we speak of "proper" delegation, we mean formal authority that is vested in line and staff managers for effective decisions and accountability.[16]

delegation
The process of partially distributing authority to subordinates for making decisions or performing tasks.

Patterns of delegation are based on the evolution of organizations centuries ago. As small family-owned industries expanded beyond the ability of their owners to run them efficiently, they hired a few key people to share the burden of management. These early managers were "straw bosses" possessing the general authority to oversee operations. Specialization was not widespread until the 1800s, when extraordinarily rapid growth forced Western firms to divide task responsibilities.

The most common practice was to put one person in charge of manufacturing and another in charge of sales. Further growth created needs for finance managers, accountants, and other specialists. Then World War I created a tremendous need for transportation, logistics, purchasing, accounting, and office management. As a result, organizations were forced by circumstance into a departmentalized mentality. Demarcation of authority between functional sectors of a company became common only after World War I, with mass assembly-line techniques.

Thus, delegation of authority within organizations evolved by necessity. To many smaller businesses, the process of delegation means the same thing now that it did 200 years ago—a method of getting help for overworked owners. In larger companies, delegation means transferring specific authority to managers for highly specialized tasks.

The Spectrum of Delegation

A spectrum of delegation defines the degree of management decision-making authority. Minimum delegation creates a situation in which management seeks only personal advice from "personal staff advisers." At the other extreme is thorough delegation of authority whereby subordinates have autonomy to make decisions. Figure 10-5 illustrates six strategic points of delegation along this spectrum, each with different degrees of authority:[17]

- *Personal Assistance.* At one end of the spectrum, minimum authority is delegated. Subordinates act solely as advisers. They may influence decisions, but they do not participate in decision making.

- *Participative Assistance.* Subordinates have a voice in actual decision making, but this is only a "degree of participation," not "equal participation." At this point on the spectrum, subordinates are involved in decisions where their expertise is needed, and they may advocate positions, but they do not actually participate in making decisions.

- *Joint Decision Making.* Shared responsibility for making decisions between superiors and subordinates is not uncommon. At this midpoint on the spectrum, subordinates have crossed the line that separates "advising" from "decision making." Decisions made in this context derive from group behavior. Committees are used extensively for joint-task decisions, and superiors may consider recommendations from subordinates or work together with them to reach consensus.

- *Subordinate Decision Making.* Greater delegation occurs as subordinates are given positions and commensurate responsibility for independent decision making. The formal positions that are created are either in staff or line management, and the people in those positions have appropriate authority for making decisions without the direct participation of superiors.

 There are two general models of management behavior for decision making as subordinates accrue authority. A superior may retain the right to review all decisions by subordinates prior to implementation, or may choose instead only to be informed periodically of decisions. The first model is delegation with a string attached. Subordinates make decisions, but because superiors review them, subordinates may be asked to reconsider their decisions. The second implies a more sweeping transfer

FIGURE 10-5 Degrees of Delegation Along the Spectrum of Authority

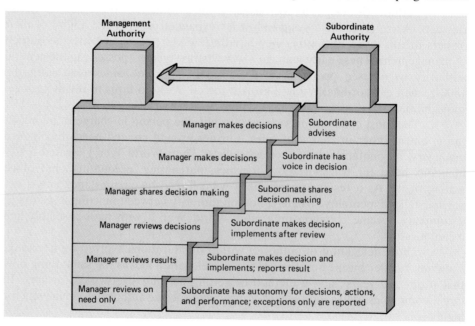

of authority. Checkpoints are eliminated, so that subordinates make decisions and routinely inform superiors only afterward. Superiors still intervene when necessary, but subordinates are generally left alone to make decisions.

- *Autonomy in Decision Making.* The greatest formal transfer of authority occurs when subordinates are autonomous within legal and ethical limits. This is the point on the spectrum where authority is generally transferred to subordinates. Superiors will be informed of results through periodic reporting procedures, but otherwise subordinates succeed or fail within a general framework of full accountability.

- *Near-Abdication.* Delegation does not occur beyond autonomy; instead, managers abdicate! Unfortunately, some managers think that once authority has been delegated, their subordinates must bear the full burden of success or failure, but, in fact, no manager can completely avoid responsibility. If we assume that every organization has a clear line of authority and a definite linkage of responsibility, then no manager is ever completely free of accountability for subordinates' behavior.

Reasons for Delegating Authority

We have touched on reasons managers delegate authority. Figure 10-6 summarizes these reasons, together with the barriers that retard effective delegation. The reasons for delegation are:[18]

- *Managerial Overload.* If managers simply have too much work, they need assistance. This is the classic model of delegation where a general but limited transfer of authority relieves operational pressures.

- *Need for Expertise.* This is the most common reason for delegating authority in complex organizations. Specialization is needed in so many situations that no one person can successfully handle decisions across the breadth of a firm.

- *Proximity of Tasks.* A fundamental reason for delegating authority is to situate managerial control as close as possible to activities. Supervisors' proximity to tasks suggests a logical transfer of authority to ensure timely decisions at operational points.

- *Behavioral Needs.* Managers often delegate authority to create a psychological climate of cooperation. We all want to feel important to our organizations, to believe we are making a contribution. We feel part of the process when we have contributed to decisions that affect us. Managers find they can develop subordinates more effectively by bringing them in on actual decision-making situations.[19] Quite often superiors do not need the help, but by identifying individuals with leadership potential and of-

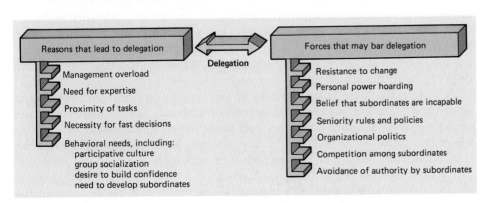

FIGURE 10-6 Factors That Influence Delegation

fering them the opportunity to expand their responsibilities, managers develop these people for future leadership roles.

This is only an introduction to the behavioral topics pertaining to delegation and decision-making authority. Chapters 13 and 14 expand on behavior and leadership concepts.

Barriers to Effective Delegation

We have discussed delegation as if all managers willingly relinquish some of their authority. Generally, this is *not* true. Managers, in fact, tend to hoard authority and strongly resist giving it up. Some business owners hold on to authority so tightly that they destroy their companies by making too many decisions that experts would have handled better. In large organizations, managers often control decisions so closely that they throttle motivated behavior. The halls of defunct organizations echo with such catch phrases as "It will get done faster if I do it myself," "Subordinates lack the experience to do the job right," and "I don't have time to train these people, I need performance."

Despite the element of truth in those phrases, they are shortsighted. As work piles up and problems go unattended, managers who "didn't have time" to train others eventually run out of time to do anything effectively. Then they *really* have no time to train subordinates and find little support when they desperately need help. Managers and owners who do not have the patience to encourage subordinates to share in decisions discover that the people under them are not only unused to making decisions but also shy away from authority when it is finally offered to them.

Another barrier to effective delegation is stereotyping. General managers often view functional experts as rather narrow specialists who lack the ability to handle broader issues of leadership. There is no logical reason for this view because decision-making and leadership qualities depend more on individual characteristics than on technical expertise.

There are other barriers to effective delegation. Organizational politics often block delegation of authority. Union seniority rules may prevent the promotion of capable employees. Co-workers can generate peer pressure to resist authority. Competition between managers leads to power hoarding. And many subordinates refuse to accept authority because they do not want the responsibility.

Toward More Effective Delegation

Two fundamental elements of effective delegation are *clarity* and *sufficiency*. First, managers must be clear in their own minds about why they are delegating authority and they must make it plain to subordinates what authority is being delegated. Second, managers must delegate sufficient authority to accomplish what is intended without abdicating responsibility.[20]

clarity
Managers must be explicit about how they expect subordinates to make decisions and the extent to which they have authority to make decisions.

Clarity means that managers must be explicit about how they expect their subordinates to make decisions. If subordinates are to have advisory authority, then both they and their superiors should clarify the boundaries of that authority and agree on how decisions are to be made. At the other extreme, if subordinates are supposed to act autonomously, then managers must articulate their expectations and resist the temptation to intervene.

Actually, these polar extremes do not present problems for management nearly as often as the intermediate degrees of authority. The demarcation noted earlier between advisory situations and participative management is real, but where the role of adviser ends and that of decision maker begins is elusive. Problems occur when subordinates overreach their authority.

If it is important to be clear about expectations, it is equally important to reinforce them with consistent behavior. Managers cannot set up participative

systems for making decisions and then overrule subordinates' decisions. Clarity of delegation is essential to provide subordinates with decision-making parameters, but it is also crucial to define boundaries of behavior for superiors. This ensures cooperation and helps to avoid conflict in managerial ranks.[21]

Sufficiency means balancing authority with performance expectations. Managers cannot be held accountable for decisions they are only superficially involved in. If managers hire advisers, they cannot expect them to be accountable for decisions.

For example, recently a plant manager complained that he was no more than a "glorified clerk," a whipping boy of the company's president. When asked why he felt this way, he said that although he apparently had profit-and-loss responsibilities for millions of dollars' worth of production, he couldn't hire a janitor without clearing it with the president. A review of some of his decisions revealed that he had tremendous authority to make production and marketing decisions. He was expected to quote prices to customers, schedule production, maintain the plant, and otherwise be accountable for his division's overall performance. When profits slipped, he was called to account, and when they were good, he received a bonus. However, his decisions were often overruled. The president had vetoed his decisions to buy a photocopier for his sales staff, to change supervisors' assignments, and to purchase substitute raw materials for plant operations. Because almost any of the plant manager's decisions could be vetoed, he could not reasonably be held responsible for profits and losses.

We cannot generalize about sufficiency: it has no objective measurement because situations and individuals vary. Yet, intentions must be clear between superiors and subordinates. Both must understand the extent of their authority and accountability.

sufficiency
Subordinates can only be held accountable if they have sufficient authority to make decisions relating to activities for which they are responsible.

CHECKPOINT

■ Describe why managers delegate authority.

■ Identify key points along the spectrum of delegation.

■ Identify several crucial barriers to delegation that manages must overcome.

■ Explain how clarity and sufficiency are important for effective delegation of authority.

AUTHORITY AND DELEGATION—A STATE OF CHANGE

So far, we have discussed authority and delegation from a normative viewpoint. We have defined terms and introduced concepts that reflect how things are supposed to be in organizations today, but we live in a dynamic world where authority structures and established ways of delegating authority are at the cutting edge of change. Consequently, we conclude this chapter with a brief introduction to a Japanese management philosophy for decision making that many theorists say will dramatically alter American authority structures.

Traditionally, U.S. companies structure management authority in layers, each successively higher layer having greater control, greater prestige, and greater responsibility. There are two interesting characteristics of this layering of authority. First, U.S. managers define roles in terms of individuals. The primacy of the individual in America permeates everything we do. Individualism and stratified authority combine to create expectations for strong, autonomous, self-assured, and independent decision makers. Second, we want a tightly structured hierarchy with clear and unambiguous reporting channels. We want to know where we stand in the organization.[22]

A well-defined power structure with strong, individualist behavior is central to the American ideology of management. We take great pride in being in-

GLOBAL TRENDS 10-1
A Japanese View of Global Acculturation

Although much is said about how Americans should adopt Japanese business practices, little is said about what the Japanese can learn from American business practices. Tamotsu Yamaguchi, chairman of the board of the Bank of Tokyo Trust Company in New York, believes the Japanese can learn much from Americans about "acculturation" of managers in international business. The Bank of Tokyo, under its trust arrangement in New York, has 200 Japanese employees and more than 5,000 American employees. It is one of Japan's largest international organizations, with 32 home branches, 250 overseas branches, and 25 foreign subsidiaries.

During its 100 years of American operations, the bank's managers have learned how to adapt to the American culture. For example, only a few of its New York managers are Japanese, and promotions are based on performance, not longevity, as they are in Japan. There is no guarantee of lifetime employment, no "school ties" for gaining employment, and no preference for male employees—all common characteristics of Japanese firms. The bank's decision-making systems lean toward group consensus, as in Japan, but are individualistic—relying on the autonomy of independent managers—as in America. Also, the majority of the bank's directors are Americans, which is not the case for most Japanese companies in the United States.

Yamaguchi said that although the bank's culture reflects Japanese values, it has adopted American values of independence. Thus, the bank engenders in employees a sense of loyalty to their organization, yet managers encourage independent initiative and understand Americans' mobility in quest of advancement.

One of the most important lessons learned by the bank's Japanese managers is that the American approach to international business is better than the Japanese or European approach. Yamaguchi identified three patterns of global business behavior to explain this.

The first he characterized as "Japanese/German." In this pattern, all overseas posts are filled by Japanese (or German) managers who were hired at home and sent overseas to control a foreign subsidiary. The Japanese (or German) managers carry with them the cultural values and expectations of the parent company and its superiors, which causes conflict with native employees and slows adjustment to foreign behavior and business customs.

The second pattern Yamaguchi identified as "English/French." In this "colonial" approach, executives behave much like foreign service officers sent overseas to establish subsidiaries. They hire and train domestic local managers, but maintain an elite control through parent company executives. The result is a cloning of host-country managers who are expected to fit into the colonial mold and adapt to the parent company's business practices.

The third pattern Yamaguchi calls the "American style." In his view, this is the most effective because it allows highly capable managers, whatever their nationality, to occupy executive positions. Lower-level positions are often filled locally, and there is no presumption of imposed values by a parent company or its executives. The result is an adaptive organization oriented to results, not management prerogatives. According to Yamaguchi, the best international Japanese firms are learning this lesson, but too many retain a paternalistic culture that retards overseas expansion. He concludes that Japanese managers must become acculturated to the American spirit of internationalization.

Source: Tamotsu Yamaguchi, "The Challenge of Internationalization: Japan's Kokusaika," *Academy of Management Executives,* Vol. II, No. 1 (1988), pp. 33–36.

11

Effective Organization of Jobs and Groups

Young American's Bank of Denver is not a typical bank; it neither serves a typical clientele nor expects its staff to do the things usually done by bank employees.[1]

Customers, for example, are likely to hug their banker after a transaction, and bank employees spend as much time in school classrooms as anywhere else. This behavior is not peculiar when you consider that the average age of checking account holders is fourteen, the average age of borrowers is sixteen, and the oldest client is twenty-two.

The bank, you see, is solely for kids. It was founded by Denver cable-TV operator Bill Daniels, and during its first four months, it attracted nearly 5,000 customers and $1.5 million in certificates of deposit. Most of the bank's savings and checking accounts are tiny—no more than several hundred dollars—and loans are generally on the same scale. Young American's Bank is not a joke, however. Kids are treated as serious customers by bank employees, who have unusual responsibilities. Work at this bank is more complex than at other banks serving adult clientele; employees are expected to provide personalized service, work together with parents and children, and simplify banking services. According to bank president Linda Sanders, employees have created a family atmosphere where business is enjoyable and jobs are satisfying.

Employees at Young American's Bank redefined their jobs to reflect the fundamental purpose of bank services—to help customers with their financial needs. Loan processing was simplified, accounting language and statements were clarified, and staff became adept at explaining the usefulness of financial services to youthful clients. Most employees give talks at schools, hold classes at the bank, and run seminars for families on topics such as how to obtain credit, handle a checking account, and write a business plan.

The organization of Young American's Bank seems typical of banks, with a management hierarchy and standard job titles for employees, but Sanders describes the bank as an organization of individuals who see themselves as associates; there are no "jobs" at the bank, only associated responsibilities of people interested in helping their clients. As you study this chapter, consider how the nature of a *job* at Young American's Bank has changed relationships among employees.

In preceding chapters, we saw that organizing is accomplished through structure and that management responsibilities are defined within that structure. We also noted that cultural changes and technological advances have created an era of transformation that is simultaneously pulling us toward centralized systems and mandating greater participation by organizational members. In this chapter, we focus on how individuals working in particular jobs and groups help create successful organizations. The synthesis of jobs within groups is the foundation of organizational performance.

The concepts discussed in this chapter are closely related to leadership and motivation, issues discussed in Part Four. Thus we move away from macro concepts of structure to micro concepts of human endeavor. We begin with an overview of how human interaction within organizations has changed in recent years. This is followed by a discussion of jobs and how they are designed. Finally, we concentrate on job content and the development of work situations.

SOCIAL CHANGE AND EFFECTS ON HUMAN INTERACTION

As we saw in Chapter 10, an organization's culture is a composite of individual and group values, beliefs, ethics, and behavior. What happens when these change? The organization changes, of course, but so do employees' social behavior and their opinions of their jobs.

Perhaps it is not overly dramatic to say that greater changes have taken place in our society during the past few decades than ever before. As Figure 11-1 shows, more than 80 percent of all scientific discoveries and nearly 90 percent of all applied technology breakthroughs in human history have occurred during the last several decades.[2] This conclusion is not surprising since more than 85 percent

FIGURE 11-1 Technology Explosion in the Late Twentieth Century

Source: D. Bruce Merrifield, Assistant Secretary, Productivity, Technology, and Innovation, "The Measurement of Productivity and the Use of R&D Limited Partnerships," U.S. Department of Commerce, 1984.

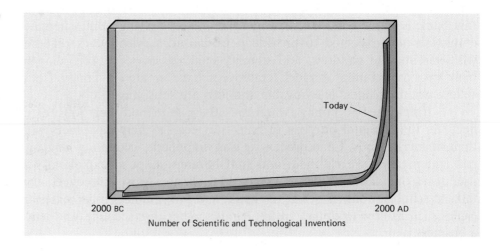

Today

2000 BC 2000 AD

Number of Scientific and Technological Inventions

of all scientists who ever lived were alive in 1970, and the volume of scientific literature has more than doubled since 1970. We can get some idea of the information explosion when we realize that nearly 1,000 new books in the English language are published each day; that is more than the annual number of books published a century ago. In addition, computer applications will probably quintuple the rate of information dissemination before the end of the century.[3]

There are costs associated with these rapid changes. In this century alone, we have consumed nearly half of all the energy used during the past 2,000 years. We have doubled our production of goods since 1970 and accelerated the rate of resource utilization to meet the needs of a population projected to double in about 35 years.[4] The sheer number of innovations requires incredible changes in organizations and our methods of managing people at work. Robots are altering the nature of jobs and how tasks are accomplished. Artificial intelligence is rapidly transforming manufacturing processes, services, and professions.[5]

Perhaps the most startling changes are those taking place among human beings. Family structures have altered to accommodate dual-career marriages. In Western societies, women have finally begun to occupy higher positions in economic, political, and social systems. There have been compelling changes in attitudes toward work, the status of minorities, government, education, parenthood, retirement, and even sex. People now expect work to be more interesting and meaningful. They want to participate in decisions, share group endeavors, and be rewarded with a higher standard of living.[6]

The social and technological changes that have already occurred only hint at what the twenty-first century may bring. The present pace of change is so rapid that our current ways of doing things are likely to provide little useful guidance even in the near term. In management, there have been enormous changes since Frederick Taylor proposed "scientific management" and Max Weber described "rational bureaucracy"—changes in authority structures, in how we make decisions, and in how managers direct new methods of work. Many organizations are challenging the frontiers implied by these changes. Yet, simultaneously, many organizations are still struggling with the fundamentals of designing jobs and creating effective work groups.

CHECKPOINT

- How are scientific and technological changes affecting our jobs and work behavior?
- What social changes have altered our expectations for meaningful work?

THE NATURE OF JOBS

A **job** is the content of work, a set of task responsibilities that a single employee is responsible for performing. The concept of a job has evolved along with organizational structures since owners and managers became differentiated from employees. Therefore, a job is a relatively modern concept, more sharply defined through industrialization. For thousands of years, people filled predetermined roles based on their social class. The upper class did not "work"; therefore, "jobs" were the domain of the lower classes. Somewhere between these two extremes were vast numbers of persons who worked only when they found it absolutely necessary or when they could get jobs. Some of these people became entrepreneurs and merchants because they were barred from assuming roles in the highest classes and viewed jobs as the lot of serfs. When machines began to supplement human work during the industrial revolution, only meager pay differentiated machine from man.[7]

job
A defined set of tasks that a person performs in relation to organizational objectives.

Concepts of work and jobs had changed little by the early twentieth century. Specialization had determined job positions for most of the nineteenth century, but this meant nothing more than the separation of labor tasks. Then Taylor introduced systematic ways to design jobs for greater efficiency. His colleagues and disciples elaborated the efficiency theme to include *human engineering,* which dealt with the interactions of jobs and equipment to standardize behavior. This development gave impetus to assembly-line technology, which was America's dominant production technique until recently. The foundation of the assembly line was work simplification: breaking tasks into their lowest common denominators for maximum efficiency during repetitive manufacturing.

Assembly-line techniques presuppose that workers will relinquish control of their jobs so that they can adapt their skills and pace their work to accommodate machines. Despite the modern antipathy toward treating individuals as cogs in a machine-paced environment, assembly lines have not disappeared. Ironically, modern technology has found ways to make them even more efficient. Many companies with repetitive assembly procedures are among the most productive in the world; examples are GE's washing machine plant and Apple's Macintosh manufacturing system, both of which use automated production systems. Others, like Dana Corporation, Honda America, IBM, Ford Aerospace, and GTE, continue the American industrial tradition of commitment to exceptionally well-managed assembly-line manufacturing systems.[8]

Clearly, workers in these rigid systems feel stifled by the monotony of their work. Productivity and quality performance suffer when employees are discontent, but more important, repetitive manufacturing systems stifle innovation. Since the middle of this century, absenteeism has become frequent, more employees are changing jobs, and many are losing interest in doing quality work. These problems are often attributed to the boredom of assembly-line jobs or the decline of the work ethic, but as we shall see in this chapter and in Part Four on leadership, there are many other reasons for behavioral problems in organizations. In

Like many other manufacturing plants, Honda's plants in Marysville, Ohio, resembles earlier industrial assembly lines only in process. High-speed assembly lines prevail, but tools and technology have changed.

Chapter 8, we introduced the concepts of *job enlargement* and *job enrichment* as methods to reduce boredom and discontent. These were discussed in terms of how to alter organizational structures. Now we look at them to see how they affect individual jobs and personal satisfaction.

Job Enlargement

Recall from Chapter 8 that job enlargement expands an employee's range of tasks by combining several operations into one broader job. For example, at Ford, one employee now assembles interior auto molding, headliners, and door attachments—operations that were previously done by three different workers. Machine operations and setup tasks at Tenneco's Monroe Shock Absorber Division are accomplished by one person rather than two. And at Mercedes-Benz, German production workers are often responsible for more than a dozen different assembly tasks previously accomplished by as many workers on an assembly line.[9]

These changes began to take place after World War II, when a new generation of enlightened managers recognized that workers exchanged more than performance for economic benefits, that psychological rewards were as important as wages. Significant changes occurred during the 1950s and early 1960s, when managers began to try to reduce boredom by expanding job content, but it was not until the 1980s that managers tried in earnest to improve the quality of work through new combinations of work methods. These new combinations increased workers' responsibilities for quality performance rather than just a greater number of tasks, thereby giving them more discretion over work methods and control of their jobs.[10]

Job enlargement by itself does not create more satisfying work. It will enhance satisfaction only when job content is enlarged to include participation by employees in decisions related to their performance and work methods. When that happens, behavior is affected through a psychological contract that recognizes employee needs beyond economic gratification.

Job Enrichment

Job enrichment, you will recall, increases job *depth,* thereby adding to an employee's authority for decisions about the nature of his or her work. While job enlargement alleviates the worst rigidities of assembly-line production, its conceptual framework is restrictive. Early behaviorists saw its shortcomings and the need to enhance the psychological contract by enriching jobs and, consequently, modifying the way individuals viewed their work roles. Thus employees were given a greater voice in goal setting as well as more responsibility for improving quality. In contrast to the horizontal "loading" of job enlargement, job enrichment created vertical depth in job content.[11]

In the next section, we examine the work of Frederick Herzberg, a research psychologist who used job enrichment to improve *job satisfaction.* His work has important implications for leadership, but its central concern was to change individual jobs to enhance organizational performance.

> ## CHECKPOINT
> - What was the concept of a "job" during feudal times and during the 1800s? What is the concept of a job today?
> - What does it mean to "enlarge" a job?
> - Explain "job enrichment" and how it is linked to job satisfaction.

HERZBERG'S TWO-FACTOR THEORY

In the late 1950s, Frederick Herzberg introduced his **two-factor theory** of motivation, which posited that employee satisfaction is achieved mainly through changes in job content. According to Herzberg, satisfaction depends on the work itself (intrinsic satisfaction with the job), recognition, achievement, promotion (advancement or growth), and other factors having to do with the inherent nature of work.

The two-factor theory evolved when Herzberg and his associates realized that job satisfaction and job dissatisfaction were influenced by different and distinct sets of variables. Through interviews with thousands of workers, technicians, and managers, Herzberg's team identified certain factors associated with satisfaction and separate factors associated with dissatisfaction.[12]

Company policies, for example, seldom added to satisfaction but were often sources of dissatisfaction. On the other hand, personal achievements seldom led to dissatisfaction but were often cited as sources of satisfaction. Herzberg categorized factors associated with dissatisfaction as *hygiene factors* and those associated with satisfaction as *satisfier factors*. Figure 11-2 illustrates how dimensions of work fall preponderantly into one or the other category.

FIGURE 11-2 Herzberg's Research Findings on Hygiene and Satisfier Factors

Hygiene Factors

Hygiene factors tend to be related to the work environment or the job context. These include company policies, pay, guidelines for administration, rules affecting job security, physical surroundings, and the nature of supervision.

In Herzberg's view, management must improve or control hygiene factors to reduce dissatisfaction. Hygienic management is much like brushing your teeth: It reduces the likelihood of problems and prevents trouble. Management must prevent poor salaries, restrictive work rules, autocratic supervision, job insecurity, unpleasant work surroundings, and other factors that can lead to dissatisfaction. However, by merely preventing trouble, managers do not necessarily enhance organizational performance; they may only lessen the risk of employee dissatisfaction. Providing equitable salaries, for example, may avoid dissatisfaction, but that does not mean that employees will be satisfied with their jobs or motivated to perform better. Satisfaction and motivation depend on other factors.

hygiene factors
In Herzberg's two-factor theory, those potential dissatisfiers that can be troublesome if not properly managed, yet are factors having little motivation potential.

Satisfier Factors

Herzberg believed that satisfaction was an entirely separate dimension from dissatisfaction. **Satisfier factors** lead toward higher worker morale, motivated performance, and greater psychological rewards from work. They are related to job content and to what individuals actually do.

Personal growth through work, a sense of achievement derived from effective performance, recognition for quality work, and promotion or advancement stemming from individual efforts are all satisfiers. Management can affect job content by changing job parameters or redesigning jobs. Herzberg argued strongly for a plan of job enrichment in which employees assume greater responsibility and discretion for decisions about the nature of the work itself.

Managers can also develop improved personnel systems, better work methods, and personal development programs that enhance employees' careers or otherwise give them greater opportunities for growth. By rewarding sustained high-quality performance, management will create an environment that encourages innovative behavior. These are only a few of the implications of satisfiers; more will emerge when we examine motivation in Chapter 13.

satisfier factors
Motivating factors associated with job content, achievement, recognition, and intrinsic rewards including promotion.

Balancing Herzberg's Factors

Managers must attend to both dimensions of the Herzberg model. On the one side, they must control hygiene factors, and on the other side, they must creatively implement satisfier factors to motivate employees. Hygiene factors might be minimized by revising policies, restructuring salaries and benefits, generating equitable systems for job security, and remodeling unpleasant work facilities. Managers should also address minor sources of irritation, such as congested employee parking. As mentioned, however, these preventive measures cannot substitute for improvements in factors that actually motivate quality performance.

Satisfiers include the broad range of job content issues. Although it is easy to say "Use motivation tools wisely," doing so is complicated. Job content issues are unique to each person in each situation, and although Herzberg's two-factor theory is a valuable framework for examining how jobs can be influenced, job enrichment requires a program of job change and redesign tailored to the needs of a particular organization and its employees.

Job Enrichment in Practice

Most job enrichment programs have focused on encouraging team efforts and recombining jobs to create a more cohesive task environment. Altering the nature

of individual jobs and employee relationships has systematically improved organizational productivity. Extensive case studies on job enrichment programs support the conclusion that they work.[13] Several examples are particularly noteworthy.

A General Foods plant in Topeka, Kansas, started from scratch in 1971 to build employee teams in an enriched atmosphere. Workers were assigned to teams with fewer than fourteen members. Each team had a leader, but decisions traditionally made by supervisors were now made by group consensus. Team members also cross-trained in one another's skills to allow periodic job rotation within teams. Moreover, rewards for improved quality and productivity went to teams rather than to individuals. Results at the plant were encouraging: Productivity increased, customer complaints decreased, employee turnover and absenteeism went down, and the plant became more profitable.[14]

Volvo, the Swedish automaker, furnishes perhaps the most vivid example of enrichment. Managers of the Volvo plant at Kalmar, Sweden, reorganized workers into autonomous work groups, each having between two and twenty-five members responsible for specific sets of tasks. One group, for example, handles electrical wiring, another concentrates on car body assembly, and a third creates the car's interior. About twenty-five teams are needed to complete a finished automobile. Volvo teams have the freedom to exchange jobs among members, speed up or slow down work, reject work on site, schedule jobs, and develop team objectives. Compensation is related to productivity and group efforts, and additional team awards reinforce positive results through recognition.[15]

Volvo's management built its team program around Herzberg's satisfiers, but did not overlook hygiene factors. For example, work stations are located near large, sunny windows whenever possible, and special machines turn cars up on one side so that work on undercarriages can be done cleanly and comfortably. (Traditional auto lines have "pits" for employees who work on cars passing overhead.) Workers at Kalmar are not glued to one place on an assembly line; in an intriguing innovation, teams move with their assemblies on mobile conveyors. This reduces the boredom associated with repeating one task over and over again at the same place all day long. Finally, company policies emphasize quality rather than simply quantity of output. The combined results of these job-related programs have made Volvo one of the top ten automobile exporters in the world, consistently rated as a cost and quality leader in the industry.[16]

Enrichment programs do not have to be the all-embracing efforts they are at Volvo and General Foods. There are many less ambitious enrichment programs for individuals and small groups in all types of organizations. For example, clerical duties have been redefined so that typists' work includes making decisions

FIGURE 11-3 Job Enrichment through Redesign for Group Technology

about correspondence, arranging travel, or coordinating data processing. Machine operators have been cross-trained in maintenance and technical setup procedures. Shop-floor workers have been trained in quality control inspection. Salespersons have been brought into market research and consumer affairs. Figure 11-3 shows how enrichment can work in a limited application.

MANAGEMENT APPLICATION 11-1
Home Offices Transcend Space and Time

Home offices used to be limited mostly to self-employed individuals, but business-people are finding them perfect for putting in extra hours or for escaping the problems of commuting to the office. In fact, productivity has increased dramatically among businesspeople working at home, and most find a home office far more satisfying than fighting traffic, paying for expensive parking, and elbowing through crowds much of the day. More than nine million of the people working at home in 1988 were professionals and managers.

Today's home office can have practically every convenience of a formal corporate suite, and being away from the company office is not a serious barrier for many people. A PC equipped with word-processing and spreadsheet software is ideal for doing financial or operational analyses as well as for writing reports. With a modem, a copier, and a facsimile machine, you can tap into data bases, communicate worldwide, and do most of the impersonal work required of most managers—usually better and faster than you could in corporate quarters.

Bill Donohoo handles sales and corporate planning for Gibson Group, Inc., from his home in Huntington Beach, California. This might not sound unusual until you know that his corporate offices are in Cincinnati, Ohio. Regardless of Donohoo's physical location, he would spend most of his workday on the phone to clients and the remainder on reports and paperwork. Charlene Weiss supervises eighty field managers, all working out of home offices for the National Opinion Research Center (NORC). NORC is based in Chicago; Charlene Weiss is in Fountain Hills, Arizona.

For well under $10,000, a home office can be set up that includes excellent equipment, furnishings, and a communications system. The same office in a commercial building would cost at least double that amount. In fact, it is their low costs that make home offices attractive to many smaller firms. For example, Tradenet, Inc., a Boston software company that services brokers in the oil industry, set up home offices for its officers in preference to locating them in expensive corporate offices, thereby saving capital, staffing, and operational costs.

Home offices have their drawbacks. Those who work at home have no opportunities for personal collaboration or socialization with co-workers, which is why they often schedule a day or two each week at the company office. Instead of begrudging the commute to work, they find these trips rejuvenating. Home offices can also be a problem if family activities intrude on work. Moreover, companies find it harder to evaluate performance, track working hours, and manage benefits for employees working at home. And employees working at home have difficulty separating personal and business expenses (for example, allocating utilities costs) to meet IRS reporting requirements. Since a standard forty-hour work-week is not scheduled at home, keeping track of time for those paid by the hour is also difficult. Nevertheless, the concept of organizing work is changing, and "office" no longer means proximity to company activities.

Source: Sarah Glazer, "Setting Up an Office at Home," *1988 Inc. Office Guide*, pp. 28–32. Reprinted with permission, *Inc.* magazine. Copyright © 1988 by Goldhirsh Group, Inc., 38 Commercial Wharf, Boston, MA 02110.

A caveat: Job enrichment will not cure all organizational ills. Every job does not need enrichment, nor is every company in a position to implement enrichment programs. Some tasks cannot be changed because of legal barriers such as collective bargaining agreements. The structure of a firm's technology may also dictate a pattern of work that allows little room for adjustment.[17] For example, some microchip manufacturing tasks are so specialized that those who do them are purposely exempted from other tasks. Quality control, instrument calibration, materials handling, and other tasks in microchip manufacturing are each allocated to highly specialized technicians. The responsibilities for each task are so sensitive that if several of these tasks were combined, the psychological stress would endanger overall performance. The scope for job enrichment varies according to the individual work environment; job enrichment cannot be generalized as a way to resolve all job-related problems.

CHECKPOINT

- How does Herzberg differentiate between job satisfaction and job dissatisfaction?
- Define hygiene factors and management's responsibility for controlling them.
- Define satisfier factors and how managers can use them to improve job performance.
- Explain job enrichment in Herzberg's framework of hygiene and satisfier factors. Describe the advantages and disadvantages of enrichment programs.

JOB DESIGN

Enlargement and enrichment aim at modifying selected attributes of jobs and their environments. The assumption behind these programs is that employees who are relatively more satisfied with their jobs will generally perform better. Nevertheless, there is an ongoing debate about the *causal* relationship of satisfaction and performance. One side suggests that employees satisfied with their jobs will do better-quality work, whereas the other side suggests that better performance will lead to employee satisfaction. Knowing which comes first is less important than knowing that job satisfaction and performance are generally related. Therefore, managers want to design jobs to generate better results.

job design
A process through which jobs are defined and tasks are allocated.

Job design is the conscious process of identifying the content of work that a single employee is responsible for performing. Later in the chapter, we will discuss *job redesign*, which is changing an existing job to improve performance. The critical question in designing or redesigning jobs is: What will an employee be responsible for doing? The definition of each job depends on the environment, the perception of the job by the people doing it, and the relation of the job to other jobs. These elements require investigation into what we call *task attributes*.

Task Attributes

requisite task attributes (RTA)
A model that describes categories of elements common to all jobs, which include tasks, interaction with others, and mental states of employees.

The first comprehensive evaluation of task attributes was published by Arthur Turner and Paul Lawrence of Harvard University in 1965.[18] They described three elements of behavior in jobs, each having several **requisite task attributes (RTA)** (see Figure 11-4). The three elements, which are common to all jobs, are activities of tasks, interaction with others, and mental states.

FIGURE 11-4 Requisite Task Attributes of Jobs

Activities. The first major behavioral element includes what people do, the tools and machines required for their jobs, and the expected results. Tax accountants, for example, may be expected to calculate company taxes, maintain records, file appropriate government reports, and suggest ways the firm can improve tax administration. In addition, they may be expected to work with certain types of computers. These activities are prescribed in job descriptions as part of the defined roles for which individuals are hired. There are also discretionary activities implied by each job. Tax accountants may be expected to make judgmental decisions about handling depreciation. Two attributes identified with the activities element are:

- *Variety:* the number of different tasks or actions prescribed with respect to defined roles and job expectations.

- *Autonomy:* the degree to which employees have discretion to make decisions about activities associated with their jobs.

Interactions. The second major behavioral element concerns how employees relate to co-workers. Interactions focus on interpersonal relations and human contact. For example, tax accountants may work with cost accountants, advise line managers, serve on strategic planning committees, and communicate with government tax representatives. Job descriptions will define some of these interactions, but will seldom spell out expected behavior or explain the dynamics among individuals. Two attributes identified with interactions are:

- *Required interaction:* necessary or prescribed interdependence between individuals who must cooperate in order for tasks to be accomplished.

- *Optional interaction:* voluntary cooperation, communication, or joint efforts that can be incorporated into tasks.

Mental states. The third major behavioral element relates to attitudes, perceptions, and feelings that individuals have toward their jobs and work environment. Included in these mental states are the knowledge and skills needed to complete tasks. Tax accountants may be required to have certain credentials, demonstrate competency in certain laws and procedures, and perhaps be able to deal with strategic planning issues. In addition, they may be expected to be competent communicators, work well with others, and accept advisory roles to line officers. Two attributes of mental states are:

- *Knowledge and skill:* the formal degree of preparation, skills, and demonstrated competency for a given job, and the informal mental capabilities expected of individuals in that job.

- *Responsibility:* the undefined but perceived degree of accountability, including appropriate attitudes, values, and beliefs implicit in jobs.

Turner and Lawrence also identified six **associated task attributes (ATA)** that influence job design and job-rated satisfaction. The first of these, *pay,* requires no elaboration. The second, *task identity,* suggests the degree to which workers can identify their efforts with end results. Auto welders usually don't identify their work with the end product because they are far removed from the totally finished automobile. By contrast, auto painters can step back from a car and see how their work relates to the quality and image of the final product. The third ATA is *cycle time,* or the time required to complete a task. Short cycle times for mundane tasks can be extremely boring, but long cycle times in complex tasks, although interesting, can be extremely stressful. The fourth ATA factor is *level of mechanization,* or the technological sophistication required for a job. *Working conditions,* the fifth ATA, refers to such factors as noise levels, cleanliness, fumes, and safety conditions. The sixth and last ATA, *capital,* is the level of investment (in training expenses, for example) associated with a job.

These categories of task attributes are broken down further into dozens of individual considerations. Research by J. Richard Hackman and Edward Lawler has added two attributes—*friendship opportunities* and *feedback*—to the list of Turner and Lawrence.[19] The first relates to social activities and human relations beyond a work group. For example, new managers at GE are oriented to responsibilities beyond their formal positions—including working with managers in other areas on committee assignments, helping staff trainers develop programs for employees, and encouraging interdepartmental social events, such as picnics and softball tournaments—that bring all GE employees closer together.[20] Feedback refers to communication with workers about their performance and contributions to work-related objectives. At IBM, managers are expected to become skilled communicators capable of giving employees feedback on their performance and explaining how they can improve their work. IBM considers this aspect of managerial work important enough to provide annual training courses to all managers on performance evaluation and employee guidance.[21]

Implications of Defining Task Attributes

Research clearly illustrates the close association between task attributes and job satisfaction. Managers design jobs by prescribing many of these attributes, and, as noted, other attributes evolve from attitudes, beliefs, and perceptions brought to the job by employees. Every job has many components, and if some are clear, many are vague and immeasurable.

When a manager decides to design or redesign a job, the undertaking may be as complex as the job itself. Job enlargement—expanding one part of a job—cannot be accomplished in isolation from other task attributes. For example, you cannot ask a tax accountant to assume strategic planning responsibilities without altering skill requirements, social interaction, and the tax accountant's perception of his or her job status. Job enrichment programs create task teams that are even more difficult to design than individual jobs. Tasks become group oriented, interaction and social patterns are altered, performance expectations change, and responsibilities for making decisions are redefined.

Even marginal adjustments in individual job attributes can significantly improve job satisfaction. Simply upgrading an employee's skills may provide opportunities for more challenging work and advancement. Consider how training a secretary in word processing might lead to creating company publications on en-

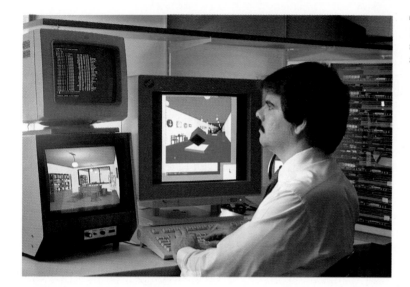

hanced computer systems. Naturally, a change may also be disruptive and lead to unexpected problems; tinkering with an employee's job is sometimes counter-productive. If the secretary trained in desk-top publishing is expected to create company publications when that person already has enough to do, the added work of designing brochures or writing news releases may be a stressful burden. The secretary may not be a creative writer or enjoy designing company publica-tions. It is the manager's responsibility to anticipate how job design efforts will be received by employees and how they will perceive their redefined tasks.

CHECKPOINT

- Define and contrast job design and job redesign.
- Identify requisite task attributes and associated task attributes.
- Explain several important implications for defining task attributes.

JOB CHARACTERISTICS MODEL

Building on job attribute research, J. Richard Hackman and Greg R. Oldham developed a model for redesigning jobs. Called the **job characteristics model,** it is a process of identifying and modifying *core job dimensions* to challenge em-ployees to perform a wider range of activities requiring greater skills.[22] Thus, job redesign is associated with job enrichment to achieve four results that improve quality of working life for emloyees and productivity for the organization: (1) *high work motivation,* (2) *high quality performance,* (3) *high job satifaction,* and (4) *low absenteeism and turnover.*

The relationship of core job dimensions to work results is shown in Figure 11–5. The degree to which a job includes these core dimensions determines *criti-cal psychological states* for employees, and the combined effect of the psycholog-ical states influences work results. Also shown in the figure is an *employee's need for growth,* derived from Maslow's need hierarchy described in Chapter 2. When employees seek personal growth and achievement—higher-order needs—they will welcome enrichment programs that influence their psychological states. Thus, pos-itive changes in core job dimensions are likely to improve work-related results. However, employees who are not motivated by higher-order needs—those who view their jobs as means to fulfill lower-order physical and safety needs —are un-likely to welcome enrichment programs. Changes in core dimensions may have little effect on work-related results.

job characteristics model
An approach to job redesign that identifies core job dimensions and critical pyschological states that affect job performance and, when coupled with an employee's need for personal growth, will influence job redesign decisions.

FIGURE 11–5 The Job Characteristics Model

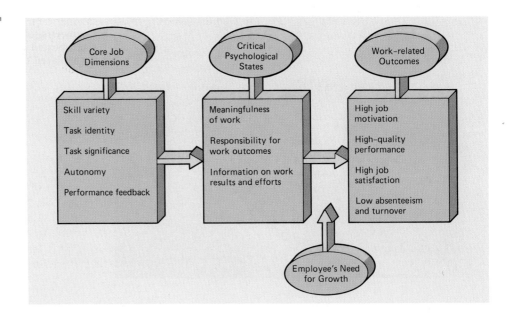

Core Job Dimensions

Although not all jobs can be enriched, research by Hackman and Oldham indicate that a well-devised job redesign program can achieve significant improvements by altering one or more of five core dimensions, which are:

1. *Skill variety*—the extent to which a job requires different skills. If a job requires little skill, it may not be challenging to an employee. In contrast, a job requiring an employee to use a wider range of skills in a variety of activities usually will be more challenging and satisfying. A TV newsperson who only reads stories written for broadcast uses few journalistic skills. However, by also covering news events, writing stories, and coordinating video film for broadcasts, this person will use several different skills in a variety of situations.

2. *Task identity*—the extent to which an individual can identify with the results of his or her work. Highly specialized jobs are often low in task identity because employees perform segmented tasks without seeing the finished product. When several operations are combined, or when a team works together to complete a set of tasks, employees recognize the results of their efforts and have greater task identity. In the Volvo manufacturing process discussed earlier, teams complete each major segment of auto assembly and so employees do more than one small task.

3. *Task significance*—the extent to which an employee perceives his or her job to be important to the company, co-workers, and customers. Employees will feel better about what they do when they feel their jobs are meaningful to others. Some employees have difficulty perceiving the importance of their jobs and are less motivated than others who readily understand the value of their work. A machine operator making automobile bumpers will find it difficult to envision how high-quality bumpers will influence customers to buy cars, yet an inspector who tests finished cars can easily understand how a shining, well-running automobile will attract customers in a showroom.

4. *Autonomy*—the extent to which an employee can make decisions about his or her job. When employees have few choices about work methods, tools, performance criteria, or schedules, they may feel harnessed to a job rather than in control of it. In other instances, employees have sub-

stantial latitude for scheduling their work, choosing materials, tools, and work methods and so feel more involved in their jobs. A high school teacher who is told what to teach, how to prepare classes, and what books to use has little autonomy. However, a teacher who is given a course and the responsibility to outline classes, select books, and schedule class activities has greater autonomy. A person with greater autonomy usually finds a job more challenging and satisfying.

5. *Performance feedback*—the extent to which an employee receives information about the results of his or her efforts. Some jobs, such as teaching and scientific research, are low in feedback. The results of these jobs are often difficult to identify, even after many years. Other jobs, such as nursing and product engineering, have high feedback. Employees will be more highly motivated by receiving positive feedback, and they will perform better when told of ways to improve. If the nature of the job does not provide adequate feedback, managers can find ways to inform employees through evaluation systems or follow-up reports that share with employees information on results of their efforts.

Implications of the Model

Hackman and Oldham suggest that managers study their subordinates' jobs to identify core dimensions determine how they can be changed. By also understanding their subordinates' personal needs for growth and achievement, managers can make realistic decisions about redesigning jobs to improve employee performance. By creating logical job redesign programs, managers will also avoid changes that could frustrate employees and be detrimental to performance. For example, an effort to increase the skill variety in a job could overload an employee who is already working with complicated tasks.

The job characteristics model is most useful when managers employ it to better understand core job dimensions that can be changed to enhance the quality of working life for employees. In Hackman and Oldham's view managers' efforts to effect positive change will promote employees' personal desires for growth and achievement and so improve their psychological states, resulting in improved work performance and organizational productivity. The model also emphasizes the responsibility managers have to plan carefully job redesign programs rather than to make job changes haphazardly.

CHECKPOINT

■ Explain the relationship between core job dimensions and work results.

■ Describe how personal needs influence the results of changes in core job dimensions.

■ Discuss why it is important to understand how jobs can be improved.

A STRATEGY FOR EFFECTIVE JOB REDESIGN

Job redesign is the conscious process of changing the content of a job to improve performance. Because changes in one job may affect others, job redesign is often a major organizational effort involving several departments; in many instances, it is a strategic consideration that alters the fundamental nature of an organization. Therefore, a plan is necessary to ensure thoughtful and purposeful redesign. Figure 11-6 illustrates the eight-step strategy for job redesign discussed below.[23]

job redesign
The conscious process of changing an existing job to improve performance and conditions of work for an employee.

FIGURE 11-6 Strategic Steps in Job Redesign

Source: Ramon J. Aldag and Arthur P. Brief, *Task Design and Employee Motivation,* p. 76. Copyright © 1979 by Scott, Foresman and Company. Reprinted with permission.

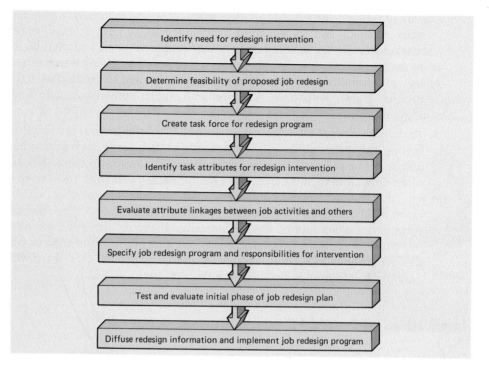

Identify need for redesign intervention

Determine feasibility of proposed job redesign

Create task force for redesign program

Identify task attributes for redesign intervention

Evaluate attribute linkages between job activities and others

Specify job redesign program and responsibilities for intervention

Test and evaluate initial phase of job redesign plan

Diffuse redesign information and implement job redesign program

Step 1: Identifying Need

Some reasons for job changes are fairly obvious, such as technological innovation. Symptoms of organizational problems, such as high turnover and absenteeism, are less obvious, yet signal a need for change. Social changes, competition, the evolution of individual careers, cultural values, and many other factors can induce changes in jobs. Managers have to monitor these environmental signals to identify when jobs need updating or job processes require modification.

Nearly 75 percent of the largest U.S. firms have formal programs monitoring employee jobs.[24] IBM, for example, conducts annual employee surveys using questionnaires, select interviews, feedback from seminars, and periodic psychological testing. Cummins Engine employs a continuous program of intervention testing and evaluation using internal staff specialists and outside consultants. These efforts are not unusual for well-managed American firms.

Some of the procedures used to evaluate jobs are extremely complex. The *Position Analysis Questionnaire (PAQ),* an evaluation instrument used to gather very detailed information on jobs by specialists who develop comprehensive job redesign programs, examines 189 job elements related to an employee, and a nearly equal number of issues related to tasks and the job environment.[25] Using an evaluation instrument such as the PAQ requires expert human resource consultants or well-trained staff, but in most instances, individual managers study their employees' jobs through a simpler method called *job analysis.*

A **job analysis** is conducted by using a brief checkoff sheet that identifies tasks, skills, physical requirements, and duties specific to an individual job. This results in a **job inventory** describing the tasks and attributes related to each job. A secretary, for instance, may be expected to type at a certain speed, take shorthand, file, greet visitors, and operate certain office equipment. Some secretaries may be required to handle classified government documents, speak a foreign language, use a word processor, and perhaps manage other office workers. Secretaries in research laboratories may need to be familiar with technical literature, and those working in legal offices may have to be educated in law and procedure. By periodically conducting a job analysis, managers can identify secretarial job requirements so that when work conditions change, they will know how the job must be redesigned.

job analysis
A formal method of identifying tasks, skills, physical requirements, and duties specific to an individual job.

job inventory
The result of a job analysis, the inventory describes tasks and attributes related to each job.

12

Staffing and Effectively Managing Human Resources

Located in the heart of North Carolina, Pinehurst Hotel and Country Club offers the ambiance of southern charm and the service of a world-class resort.[1] Founded in 1895 by Boston philanthropist James Tufts, Pinehurst was originally developed as a winter refuge for New Englanders. In 1896, Tufts hired Frederick Law Olmsted, designer of New York's Central Park, to plan a resort village on 5,800 barren acres. During the five years that followed, more than 220,000 tree seedlings were planted, a village was developed, and The Pinehurst Hotel, originally called The Carolina, was completed. In 1901, Scotsman Donald J. Ross was hired to build a series of championship golf courses, and he stayed until his death in 1948, becoming America's premier golf course designer with 400 courses, 7 of them at Pinehurst.

Today the hotel has 310 rooms with 160 separate condominiums and cottages. The surrounding resort boasts seven golf courses, a health spa, a gun club and several shooting ranges, stables, a riding club, indoor and outdoor swimming pools, twenty-eight tennis courts, and a 200-acre lake for water sports. During its colorful history, Pinehurst has hosted more than fifty major golf tournaments, attracting the game's legends from Bobby Jones to Jack Nicklaus. Annie Oakley, sharpshooter and star of the Buffalo Bill Wild West Show, came to Pinehurst in 1916, and for several years gave shooting exhibitions and trained men and women in marksmanship. Movie stars, astronauts, world statesmen, and seven American presidents have vacationed at Pinehurst.

In addition to being ranked as one of the world's best country clubs for nearly five decades, Pinehurst has a staff that has consistently won acclaim. Bellman Ralph Gacoma, for example, was named "Bellman of the Year" by the Hotel and Motel Association in 1982, and Pinehurst bellman Stan Faircloth took top honors in 1988. Also in 1988, the resort

grounds maintenance crew under John Clark won the national "Grand Award" from the Professional Grounds Management Society. Pinehurst was ranked in 1988–89 as one of the "Ten Best World Conference Resorts" for service, conference personnel, facilities, and business programs.

Pinehurst president Patrick A. Corso attributes the resort's success to its personnel. Although management has attracted some famous people to its organization, most employees are hired locally, then trained and encouraged to make a career with Pinehurst. Usually, they are recommended by existing employees, and most management positions are filled through internal promotions. In training staff, management uses industry programs, resort seminars, and "mentoring," in which more experienced employees give personal guidance to less experienced and newly hired employees. As you read this chapter, consider how Pinehurst has built a successful organization on solid concepts of human resource management.

P art Three dealt with organizing human resources through task specialization, job design, and group decision structures. We showed that organizing material and human resources was the second major function of management (planning being the first). The third function—leading—concerns actually getting things done. In this chapter we discuss *staffing*, the process of acquiring the skilled human resources needed to accomplish organizational objectives in a timely fashion. We also examine managers' responsibilities for training, compensation, and performance evaluation. This chapter serves as a transition from organizing to leading, and as a foundation for Chapters 13 through 15.

In all but the most capital-intensive organizations, people are the prime determinants of productivity. In this age of extraordinary emphasis on technological change, we sometimes forget to distinguish between tools and their users. Technological advances are crucial for success, but it is people who galvanize knowledge, skill, and technology into effective performance. As we expand the horizons of technology, we encounter new challenges in managing human resources.

MAJOR FACTORS IN HUMAN RESOURCE MANAGEMENT

We study *human resource management* from both the "personnel specialist" and "operating manager" perspectives in the following pages. The term *personnel*—along with *employee relations* and *manpower management*—is often used interchangeably with *human resource management*. Personnel and its substitute terms, however, are most precisely used to refer to the specialized duties of personnel administration. Human resource management is a broader term; it includes responsibilities for personnel, as well as the responsibilities of operating managers for effective use of human resources. **Human resource management** is the sum of activities required to attract, develop, and retain people with the knowledge and skills needed to achieve an organization's objectives.[2]

Thus, human resource management encompasses recruitment, selection, training, compensation management, labor relations, benefits management, performance evaluation, discipline, grievance handling, counseling, and career development. Many of these activities are relegated to personnel specialists, but everyone responsible for subordinates is involved in them.

human resource management
The sum of activities required to attract, develop, and retain people with the knowledge and skills needed to achieve an organization's objectives.

FIGURE 12-1 Human Resource Management Activities

The composition of an organization rarely stays the same for long. As companies grow, they add employees, and as older employees retire, younger replacements are hired. As companies adopt new technologies, they hire employees with the necessary technical skills or train existing employees. Also, in our society, most employees change companies rather frequently. These shifting situations require managers to pay constant attention to staffing. In larger companies, personnel specialists are primarily responsible for staffing, though operating managers are also involved. Figure 12-1 illustrates the major activities of human resource management, which are summarized below.[3]

Human resource planning. Managers plan for future human resource needs, including the types of skills and number of employees required to fulfill organizational objectives. **Human resource planning** is the process of forecasting employment requirements and determining available external resources within relevant labor markets in order to decide when, why, and in what numbers employees will be needed in the future. Strategically, managers establish long-term plans for fulfilling human resource needs. At operating levels, line managers plan short-term work schedules, replacement, and training. They also cope with the ebb and flow created by recruitment, terminations, retirements, transfers, and promotions.

Recruitment and selection. Staffing begins with **recruitment,** the process companies use to locate qualified job candidates, entice them to apply for openings, and maintain a labor pool of managers and nonmanagement employees. Recruitment requires effective public relations, advertising, visits to college campuses, and often sophisticated techniques such as sponsoring job fairs. **Selection** is the process of choosing new employees from the applicant pools through evaluation, testing, screening, and interviewing. Recruitment and selection are the responsibilities of personnel specialists, but operating managers are involved in the process in two critical ways: First, they decide job specifications and the type of employees to be recruited. Second, they often make the actual selection decisions.

Orientation. New employees must be inducted into organizations. **Orientation** is a process of indoctrination to familiarize employees with company policies, safety codes, objectives, and work expectations. Orientation may also include technical training to acquaint newcomers with specific work conditions, equipment, and processes. Effective indoctrination programs incorporate a human re-

human resource planning
Planning for future personnel needs, skills, labor changes, and related issues (such as compensation and retirement) based on strategic evaluation of internal factors and external conditions.

recruitment
The process of attracting qualified applicants to an organization through activities such as advertising and campus visitations.

selection
The process of choosing and hiring employees from among those candidates recruited for the organization.

orientation
A formal program of indoctrination to introduce new employees to their job responsibilities, co-workers, company policies, and work environment.

Part of the orientation process in many business and service organizations today consists in training new employees in how to obtain and use data from computers. These new employees of a travel agency are being instructed in how to use computers for airline reservations.

training
Instruction for specific job skills, usually associated with nonmanagement employees.

development
Programs for long-term improvements focused on leadership, productivity, and organizational issues, often associated with management.

compensation management
The management of wages and salaries, including raises, bonuses, and monetary incentives, by operating managers who deal directly with their subordinates and specialists who deal with compensation systems.

benefits management
An area of specialization that deals with pensions, insurance, workers' compensation, dental plans, educational benefits, vacations, health care, and other "fringes" important to employees.

performance evaluation
The process of appraising subordinates' behavior and providing feedback to help them improve their performance.

lations element, permitting newcomers to become familiar with their co-workers and supervisors.

Training and development. Most organizations differentiate between training and development. **Training** programs are usually associated with "vocational teaching" of specific job skills for nonmanagement employees. In contrast, **development** programs prepare employees for advancement or managers for expanded responsibilities.

Compensation and benefits management. **Compensation management** includes wage and salary determination, raises, and similar monetary issues. Operating managers deal with compensation at the individual level by recommending raises or tracking data for bonuses. **Benefits management** is a multifaceted area of personnel specialization that deals with pensions, insurance, workers' compensation, dental plans, educational benefits, vacations, and a variety of "fringes" such as sick pay, recreation, health care, maternity leave, day care, and use of company vehicles. Although they are called *fringes*, the term is misleading because today benefits account for nearly 35 percent of total compensation. During recent rounds of collective bargaining in the automotive, steel, and aerospace industries, workers have focused more on gaining or retaining benefits than on higher wages.[4]

Performance evaluation. Most decisions concerning employees are based on some method of judging their work. **Performance evaluation** is the process of appraising subordinates' behavior and providing feedback to help them improve their performance in the future. In smaller firms, this may be an informal process, but in larger companies with the resources to support evaluation systems, performance is usually analyzed through formal processes. Personnel specialists are seldom directly involved in employee performance appraisal, as this is the line supervisor's job, but they are responsible for providing line managers with effective appraisal systems.

employees with needed skills and abilities, thereby sensitizing them to opportunities within the company.

One method of assessing internal human resources is through a **skills inventory,** which is a data base detailing each employee's qualifications, education, interests, and career aspirations. Using a skills inventory file, managers can locate employees who fit vacancy needs or who have potential for development. This low-cost search-and-sort system for internal recruits benefits employees by giving them preferential access to jobs and advancement opportunities. One of the strengths of Quebec-Telephone Company's human resource system discussed earlier is its employee career development program. A primary feature of this program is the "career data base," the Canadian company's equivalent of a skills inventory, through which most positions are filled by existing employees.

skills inventory
A data base detailing each employee's qualifications, education, interests, and career aspirations.

Human resource planning focuses on staffing positions, but determining "where we are now" also requires an assessment of attitudes, behavior, and performance. As noted, human resource objectives can involve behavior, satisfaction, quality performance, and employment stability. Although many of these areas of concern cannot be objectively measured, managers can reasonably assess them with behavioral science techniques. For example, Frederick Herzberg's two-factory theory, discussed in Chapter 11, illustrates how employers can evaluate job satisfaction through well-designed questionnaires or interviews. Managers can then use these assessments to plan programs in job enrichment or human resource development.

Organizations can also trace patterns of behavior such as absenteeism, turnover (resignations and dismissals), grievances, poor workmanship, and accidents. Comparing these data over time (monthly or annually) and also with data from similar organizations will give managers important clues about the state of the organization's internal human resources.

Determining How to Accomplish Objectives

The next crucial task is to translate objectives into actions. Personnel scholars believe that the best way to do this is through human resource *programs*. Glueck, for instance, noted that since human endeavors are so complex, programming that results in viable strategies to achieve objectives is required. These objectives are based on theories and research generated from such diverse fields as sociology, economics, organizational behavior, and industrial psychology.[9]

Organizations large enough to afford professional staff can support formal programs, but many smaller firms lack the necessary resources. In companies with fewer than 500 employees, one personnel specialist may handle everything from orientation of new employees to strategic human resource planning. Implementing new programs will therefore be the responsibility of line managers, most of them inadequately trained in human resource management.

To return to our university example, assume that there are not enough trained faculty members to provide basic computer literacy courses for every student. There are three possible alternatives to remedy the situation. First, the school can hire additional faculty members. Second, it can replace some faculty members with individuals skilled in computing. Third, it can retrain existed faculty members in computer skills.

The first option, hiring new faculty members, will require additional funding. It will also probably generate controversy as computer personnel move into faculty posts previously allocated to other departments; for example, the math department may gain several new positions, whereas history or fine arts may lose some. This option is seldom popular, but it is easy to implement: The administration simply reallocates positions by fiat. The second option, replacing faculty members, will prove equally unpopular. Here responsibility is shifted from university administrators to first-line department heads, who make hiring and firing

decisions. The third option, retraining, involves shared responsibility between administrators—who allocate money—and department heads—who implement training programs. This option is often most popular because it gives faculty members a participative role. However, it may take longer to implement, and the time spent on retraining will detract from other duties of faculty members.

Which option is chosen will depend on the university's environment, its existing resources, and a host of considerations about current personnel, external markets, and competition. The decisions are similar for most positions in industrial and service organizations.

Monitoring Progress

Human resource planning is incomplete if management has not established programs for evaluation and control. Many of the same techniques used to assess "where we are now" can be used to monitor "how we are making progress." The advantage of employing the same techniques is that they yield comparative and consistent data over time. Many firms, however, lack either the data or the expertise for assessment, so they periodically hire consultants to make program assessments. A better solution is to hire consultants to teach managers how to assess and monitor programs themselves.

Returning to our example, the university will need a method of assessing progress in its computer literacy program. This may include testing of instructors to judge their competency to teach computer skills, testing of students to see how well instructors are meeting the teaching objectives, periodic interviews with faculty to learn their perceptions of the program, and a follow-up reporting system coupled with student and faculty evaluations. Whatever method is used, a sound monitoring system is needed to ensure that progress toward objectives is occurring in a timely fashion.

Forecasting and the Planning Function

human resource forecasting
The process of estimating future demand for employees based partially on estimated demand for products and services and partially on productivity, technological changes, and social changes.

Ensuring that the right number of people with appropriate skills will be employed at the right time to fulfill organizational objectives requires accurate forecasts of employment needs. **Human resource forecasting** is the process of estimating future demand for employees, based partially on anticipated demand for future products or services, and partially on future expectations for productivity improvements, technological changes, and socioeconomic changes.[10] Exhibit 12-1 indicates the importance of forecasting over the short term and the long term.

The forecasting process starts from an understanding of the company's objectives for sales, profits, and technological changes. Unless strategic managers provide human resource planners with accurate estimates of company activities, employment planning is impossible. Once they have an accurate estimate, planners can determine the number of employees needed. For example, past records of production and sales will show the relationship between these activities and employment levels. If the company's production and sales methods remain the same, a 10 percent increase in sales should require a similar increase in employees. If the company anticipates using new production techniques, then planners must redefine production jobs and their labor requirements because the new technology may result in a need for fewer production workers with different skills.

Planners must also have company information on finances and budgets to forecast compensation and related costs of maintaining a work force. If financial constraints limit the option to hire new employees, planners may consider retraining programs to fill higher-level positions—usually a less expensive alternative than hiring from outside. Another advantage of encouraging promotions is that it allows a company to fill less-skilled jobs with lower-paid, entry-level employees. Thus budget limitations can influence human resource planning decisions.

EXHIBIT 12-1 Forecasting Human Resources Over Time

	Short Term (Operational Planning Period)	Long Term (Strategic Planning Period)
Demand	Replacement for authorized employees, changes, layoffs, turnover, retirement, deaths, transfers, and promotions.	Replacement patterns plus growth from products and services, new technology, social factors, new skills requirements, competition, demographics of workers.
Supply	Promotions, transfers, census changes, job redesign, recalls, local labor available, market and competition, economic factors.	Short-term supply cycles and group redesign, population shifts, labor market demographics, competitive nature of labor markets, education, employee expectations, and economic trends.
Needs	Net new employees required and available, new skills, and time-lines for recruitment.	Periodic cycles and trends for net new census for long-term human resources which affect current decisions.

Another consideration influencing forecasts is labor union contracts that mandate how management can hire, terminate, or replace employees. Unions can also veto decisions to introduce new production techniques, or alternatively, encourage changes in work methods that improve productivity. Either action will alter forecasts of human resource needs. Planners must also consider the characteristics of existing employees. For example, a company with an aging work force may expect an increase in the number of retirees, and thus a need to recruit replacement employees.

Forecasting must also take account of the labor supply—the availability of candidates for employment in the labor market. Regardless of forecasted needs, if there are insufficient candidates for employment, management cannot implement a recruiting program. Labor shortages will force a company to adjust its

Anheuser-Busch was in the midst of modernizing its St. Louis brewery when top management abruptly halted the project. Had plant modernization been completed on schedule, in 1989, hundreds of workers would have been laid off or forced into early retirement. If the project could be completed in 1991, only a few employees would be affected. Because management felt a commitment to employees, the date for completion of the plant's overhaul was rescheduled for 1991. Management also directed company planners to start programs to ensure that no employees would lose their jobs because of technological change. Anheuser-Busch is an example of a company in which social objectives influence forecasts.

Source: Bill Saporito, "Cutting Costs Without Cutting People. *Fortune*, May 25, 1987, pp. 26–32.

objectives to worker availability, and forecasts will change to match these new objectives. For example, several years ago, GM decided to automate production with robotic welders at its Flint, Michigan, plant. Forecasts indicated that about 1,300 robotic technicians would be needed for the several hundred new robotic welding machines purchased. But planners had not researched the labor market well. Recruiters were able to hire only twenty-four qualified technicians, so GM had to delay its automation for two years to train employees in robotics.[11]

CHECKPOINT

- Describe human resource planning as both a strategic and an operational management responsibility.
- Discuss the planning process and the four main questions it must answer in relation to human resources.
- Identify and discuss three human resource objectives.
- Examine the relationship between organizational objectives and human resource forecasting.

RECRUITMENT

The personnel function is most closely associated with recruiting and selecting new employees. The purpose of recruitment is to provide sufficient qualified candidates for employment. Most jobs are filled through generalized recruitment, which is simple and standardized. For example, companies attract operating personnel through newspaper advertisements. In contrast, recruiting executives and skilled employees is a complex and expensive process. Although the two processes differ substantially, both depend on well-articulated job descriptions.[12]

Job Descriptions

job description
A written statement of expectations and duties related to a specific job. An expanded view would also include how responsibilities are tempered by the person assigned to the job.

Recruiting is based on **job descriptions,** written statements specifying what jobs involve in the way of duties and qualifications. Exhibit 12-2 provides condensed job descriptions for two positions, one a nonmanagement job in data processing, the other a management position in MIS. Fully developed job descriptions may be a page or more in length, but these are impractical for advertising vacancies. Condensed versions are like newspaper headlines—they attract attention without telling the whole story.

Detailed job descriptions specify wages or salaries, required skill levels, qualifications for operating equipment, responsibilities for supervision, and such additional requirements as security clearances and physical work limitations. Personal characteristics may also be specified if it is important to select people who will easily fit into a given environment.

Nonspecialized Internal Recruitment

Many firms prefer to *hire from within,* that is, to fill vacancies through promotions and reassignments. Job postings on bulletin boards are typically used to attract employees to bid for nonspecialized openings. Both the company and its employees benefit from providing advancement opportunities to motivated workers.

Internal hiring is inexpensive compared to external recruiting and is preferred by employees. Still, the system has drawbacks. Selection tends to favor employees with the greatest seniority rather than the best qualifications. In some

EXHIBIT 12-2 Abbreviated Job Descriptions for Two Information Positions

Director, Management Information Systems	Reporting to the Executive Vice President, the Director of Management Information Systems shall be responsible for providing corporate-wide information services, designing and implementing data systems and decision support services, and implementing projects in consultation with key managers. In addition, the Director shall serve as adviser to the Board of Directors for internal information systems. The Director is responsible for liaison with corporate division heads and shall demonstrate leadership for all systems personnel and data processing staff.
	The Director's position assumes an exceptional background in systems development; an MBA is preferred, as well as six-plus years of progressive experience in management positions. Current requirements emphasize knowledge of COBOL, RPGII, and Assembler languages with direct experience in both mainframes and microcomputer applications.
Programmer Analyst	The Programmer Analyst reports to an appropriate section manager for project support and information processing. Two-plus years experience is expected for a Level I position; four-plus years for a Level II position. Programmers must have demonstrated knowledge of Assembler and COBOL languages, data entry and retrieval, and hardware-handling equipment in support of mainframe and remote-entry micro networks. Data-base experience for real-time manufacturing, CAM, and MRP applications desired.

instances, labor agreements require giving priority consideration for new openings to senior employees. Internal recruitment also prevents fresh talent from entering the firm. On balance, though, internal hiring is beneficial because it helps stabilize employment and develops stronger commitments between employees and their organizations.

Specialized Internal Recruitment

Hiring managers and specialists is difficult, and selection is based more on ability than seniority. Companies preferring internal recruitment for these positions must be ready to support development programs and to encourage the career aspirations of their employees. A skills inventory, as discussed earlier, simplifies the recruitment process and gives managers insights into employee career expectations, as illustrated in Exhibit 12-3. Performance evaluation systems also help identify promotable employees.

Because candidates often lack the skills or experience necessary to fill more responsible positions, a company that prefers internal recruitment of managers and specialists must be prepared to help employees through formal development programs. This is feasible for larger organizations, but most companies do not have the resources to support such programs. Smaller firms also have a smaller pool of employees from which to draw talented personnel, so most resort to outside recruiting to fill important jobs.

Nonspecialized Outside Recruitment

Outside recruitment is normally done in local labor markets composed of people who are unemployed or in the process of changing jobs. Because most organizations experience ebbs and flows in their need for operating personnel, local labor markets are dynamic. Advertising attracts the bulk of job hunters, but most companies also have a continuous flow of walk-in applicants. Walk-ins seldom apply precisely when openings occur, but promising candidates may be hired in antici-

EXHIBIT 12-3 Skills Inventory Employee File

Employee Name: _____ **Department:** _____

ID # _____ **Soc. Sec. #** _____ **Date Hired:** _____

Job Classification	Date Rated	Experience to Date	Skills Data	Comments
Primary:				
MIS Manager and Programmer	1/89	2 yrs. DP ops. 3 yrs. Asst. Mgr. 4 yrs. Mgr.	B.S. degree COBOL, APL. RPG.	Rated as excellent
Secondary:				
Robotics Technician	Not rated	NC institute training	20 hrs. in job seminar	Rated on NC computer
Other:				
Freelance Writer	—	31 articles and 17 news stories	—	Has made name in travel news
Software Engineer	—	2 programs sold to Boston firm	MS DOS and Graphics	Royalty shared with firm

Interests:

Ed is an avid ski competitor and has shared design on computerized ski training program. He has also won travel editor award for writing on unique sporting events in unusual places.

Ed is taking courses in electrical engineering as postgrad student, hoping to become qualified in systems relating to robotics development.

Long-term goals expressed in research and design management for software and integrated production graphics programming.

pation of future openings. Once again, larger firms can afford this luxury, while smaller ones tend to fill only vacant positions.

Applicants also come from local state employment offices, veterans' referral services, and through the recommendation of existing employees. The last type of referral represents a form of personal networking, and although it results in few hirings, companies consider the employees who are hired this way to be very reliable. After all, people put their own reputations on the line when they suggest candidates.

Finally, operational jobs are occasionally filled through ads in trade journals and professional magazines or through job fairs. Nurses, for example, are actively recruited through job fairs and nursing magazines.

Specialized Outside Recruitment

Professionals and managers are often recruited through professional publications, college placement offices, and reputable agencies. There is no local labor market for specialized individuals; firms may have to recruit nationally to find key executives and highly specialized personnel.

Many employees in the hotel management industry have been trained at Cornell University's School of Hotel Management. The school's career day for graduating students attracts recruiters from many of the top hotel organizations throughout the country. Such events, sponsored either by recruiters or the schools themselves, are common recruiting devices.

Most organizations tailor recruitment programs for each category of applicant. College recruiting, for example, is aimed at attracting talent for entry-level technical and managerial positions. Each year recruiters visit selected schools to find a sufficient number of qualified candidates for available openings. Some companies recruit at schools with reputations in particular fields, such as accounting, banking, or engineering. Yet if a company needs unusual talent, such as genetic engineers, its recruitment effort may become international.

Recruiting executives is expensive and time-consuming. It is usually done through executive search firms, advertising in newspapers such as *The Wall Street Journal,* personal contacts, and professional associations. Candidates for executive positions are generally employed already and must be enticed to change organizations. Sometimes the competition for key individuals becomes so fierce that they are virtually pirated away from their companies by lucrative offers. This type of recruiting is far different from merely advertising a job vacancy.

CHECKPOINT

■ How are job descriptions used in recruiting?

■ Describe and contrast specialized and nonspecialized recruitment.

■ Who is responsible for recruitment in a large organization?

SELECTION

The purpose of selection is to fill positions with the best people available and to do so in a timely manner. Figure 12-4 illustrates a general model for selecting employees. It begins with an application, which assumes recruitment efforts have

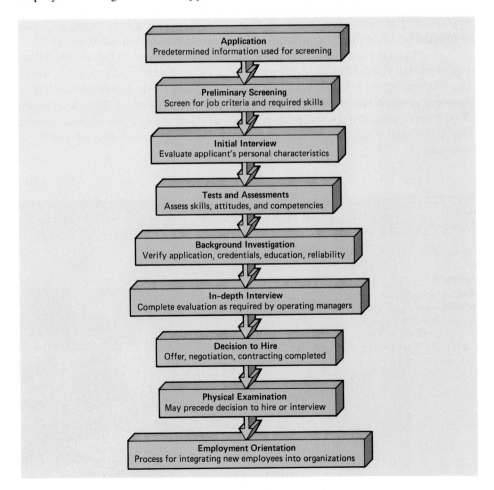

Application
Predetermined information used for screening

Preliminary Screening
Screen for job criteria and required skills

Initial Interview
Evaluate applicant's personal characteristics

Tests and Assessments
Assess skills, attitudes, and competencies

Background Investigation
Verify application, credentials, education, reliability

In-depth Interview
Complete evaluation as required by operating managers

Decision to Hire
Offer, negotiation, contracting completed

Physical Examination
May precede decision to hire or interview

Employment Orientation
Process for integrating new employees into organizations

FIGURE 12-4 General Model for Personnel Selection

been successful enough to create a slate of qualified candidates. Applications provide comparable information on candidates, serve as formal requests for employment, and become permanent records for those hired.

Initial screening interviews reduce the applicant field to a manageable number of individuals. Screening helps interviewers gain insights into traits and characteristics not apparent on a candidate's job application. Interviews also allow applicants to gain insights into the organization. Through this process, the applicant, the employer, or both may decide that the candidate is not right for the job.

Many organizations require formal testing. Tests for operating personnel focus on skills, such as typing ability or operational competency. Skill tests may be mandatory for a job rating, and are common in civil service systems. Psychological and personality tests may be necessary when the position requires a security clearance or is otherwise sensitive. Most tests are designed to evaluate whether candidates will fit into the organization and are not controversial. In the past few years, however, disputes have developed over some tests, such as pre-employment drug tests and AIDS screening tests.[13]

Companies also do background investigations to establish the truthfulness of a candidate's answers on the job application. What applicants say they can do and what they actually can do are often quite different. It is not unusual to find outright lies on application forms; more than half contain misleading information about candidates' qualifications.[14] That is why some organizations now require potential employees to take lie-detector tests. In addition, interviewers often need further information about employees to make reasonable hiring decisions. Assume, for example, a company is looking for a computer programmer with the ability to use COBOL. Two applicants may list COBOL among their skills, but after checking their references, it may turn out that one has had no more than a college course, whereas the other has had several years' experience. Background checks usually consist of telephoning references for elaboration and a rating of applicants. But sometimes they are rather complex and include security checks, credential verifications, and written evaluations solicited from references.

Personnel staff usually conduct the in-depth interviews for nonspecialized positions, but candidates for professional and management positions are generally interviewed by the line managers for whom they will work. Interviews with management committees are not uncommon. An important part of the selection process, interviewing can consume much time and effort. Only a few applicants reach this stage, and a so-called interview may stretch into several days of on-site assessment.

When a position involves certain physical tasks, successfully passing a physical exam or a stress test may be a condition of employment. For positions in food- or drug-manufacturing firms or in health-care agencies, rigorous physicals are necessary to verify that applicants are free from any contagious disease, which could be passed on to co-workers and customers.

Job offers are made at the end of in-depth interviews, a short time afterward, or following formal negotiations. If more than one applicant is interviewed, an offer is usually made to the top candidate first. A company seeks a definite answer before considering other candidates. If an offer is accepted, the terms of employment are drawn up and signed. For specialized positions, contracting can be complex and will often include stock options, bonus agreements, and job security clauses.

Most organizations require physical examinations to establish health records and provide data for insurance. Today many companies also require the people they have hired to take urinalysis tests to detect drug usage. As noted earlier, controversy surrounds the right of employers to require these exams, as well as those used to detect the presence of AIDS.

Selecting Managers

The general model for selecting employees is useful but not always adequate for finding good managers. When organizations recruit for entry-level managers, the selection model is excellent, but when they recruit for upper-level positions and experienced managers, a more elaborate process is required.

In-depth interviews of potential executive managers by executive managers are the rule. These are buttressed by pragmatic background searches and exuberant discussions aimed at drawing out candidates' qualities. Applicants' track records are examined thoroughly, though they are not always good predictors of future performance. Candidates may have had extraordinary success in the past through luck, exceptional "chemistry" between themselves and their subordinates, or other circumstances that have nothing to do with managerial verve. A successful manager in one organization may fail miserably in another. Thus, peer-level managers try to discover if a candidate has the interpersonal skills to motivate and work with others. They also try to determine the candidate's emotional stability, self-confidence, and leadership capabilities.[15]

Assessment Centers

Many large companies use assessment centers to evaluate management candidates. At an **assessment center,** structured exercises probe the decision-making behavior of candidates under conditions that mirror actual work conditions. Applicants may be given individual tasks or placed in simulated work groups charged with solving complicated problems. One frequently used method is called the *in-basket exercise.* Candidates are allotted a limited time period—an hour or so—to cope with a variety of memos, telephone calls, reports, and materials typically handled by employees in these positions. The in-basket is usually overloaded to put the candidate under tremendous stress. This process was introduced at AT&T during the late 1960s, and it has since become a preferred means of assessing managerial potential at Merrill Lynch, IBM, GE, and other prominent companies.[16]

Other assessment center techniques include role-playing incidents, management games, and group problem-solving exercises. In each instance, candidates are presented with a decision-making dilemma and asked to resolve it. For example, Merrill Lynch simulates a stock transaction office and has candidates respond to a series of rapidly placed inquiries from clients (roles played by company employees). They are then evaluated on how they handled inquiries, advised on securities, and resolved conflicts purposely created by the role players. In addition, candidates are put into leadership roles, asked to direct a subordinate's work, and then evaluated on how well they handled a problem employee. Candidates may also be asked to make a formal presentation explaining their deci-

assessment center
A method of evaluating employees—usually managers—by conducting exercises, simulated work situations, tests, interviews, and psychological testing to determine skills and managerial potential.

sions and conduct during the assessment period. A panel of evaluators rates all the candidates and makes selection recommendations.[17]

Assessment center programs are conducted by specialists and held at the employing organizations' facilities. Since these programs are expensive and difficult to maintain, only organizations with a continuous influx of management talent can afford them. Smaller firms have discovered the value of microcomputer programs that simulate decision-making situations. Since data bases that provide comparable results for large samples of applicants are now being developed, even the smallest firms may be able to use assessment center techniques in the future.

> ## CHECKPOINT
>
> ■ Describe the purpose of selection. Who makes selection decisions?
> ■ Explain the options for selecting new managers.
> ■ Discuss how assessment centers are used in selecting managers.

ORIENTATION

Orientation is a formal program of indoctrination to introduce new employees to their job responsibilities, co-workers, company policies, and work environment. Too few organizations actually have such programs; in most instances, employees simply sign employment agreements and are told when and where to report to work. Orientation is left to co-workers or supervisors, who may do little more than explain where restrooms are located and when to take a lunch break. Basic orientation procedures require most employers to at least fulfill the obligations summarized in Exhibit 12-4. At the other end of the spectrum, formal orientation programs involve weeks or months of "break-in" duties, classes, and training.

Orientation is composed of two elements. The first involves merely pointing out the location of amenities and telling new employees how to fill out benefit forms and what is expected in terms of reporting, leaving work, parking, and eating lunch. The second is a process of socializing new employees, easing them into work groups, fine-tuning their job-related expectations, and identifying reporting relationships. Socialization may also involve establishing a mentor relationship with another employee whereby the new person learns "how things usually get done" in the informal work environment.[18]

Purposes of Orientation

There are several benefits of conscientiously including new employees into the organization through a formal orientation program:[19]

■ *It develops realistic job expectations.* New employees often have inaccurate work expectations. Even people experienced in their professions must gain a fundamental understanding of their new organization and "how things really work" because every organization has unique cultural values, group dynamics, networks of co-workers, styles of leadership, and governing policies. In fact, the chief purpose of orientation programs is to provide information about job expectations. The informational process has evolved in many firms to include psychological development and sociological integration, on the theory that this is the best way to reduce anxiety in new employees and correct their expectations, as well as to integrate them into work groups.

■ *It improves productivity.* Properly oriented new employees will get "up to speed" quicker and perform at higher-quality levels than those not

ture of supervision. By handling these factors effectively, managers can minimize job dissatisfaction. Satisfier factors influence job satisfaction; they include recognition, promotion, achievement, the intrinsic nature of work, and opportunities for personal growth. By handling these factors effectively, managers can maximize job satisfaction.

As we have said, there is a strong connection between Herzberg's and Maslow's work on motivation. Herzberg's hygiene factors coincide with Maslow's lower-order needs, and his satisfier factors coincide with Maslow's higher-order needs. A synthesis of the two theories gives managers a good understanding of how unfulfilled needs motivate employees, and how those needs can be addressed through rewards, recognition, promotion opportunities, and job redesign.

McClelland's Acquired-Needs Theory

The **acquired-needs theory** proposes that people develop a profile of needs that influence their behavior. These needs are learned through life experiences and are affected by the individual's personality. The acquired-needs theory was formulated by David C. McClelland during the 1960s on the basis of earlier research on human potential and personality done by John W. Atkinson. Atkinson had hypothesized that everyone enjoys an "energy reserve" that can be tapped to fulfill personal goals, and that there are three basic human orientations derived from individual personality profiles.[13] McClelland found that people were not born with these orientations or needs, but instead learned them. So employees bring to organizations a lifetime of learned needs that influence their behavior, but organizational circumstances further influence these needs. McClelland's three acquired needs and examples of related behavior, illustrated in Figure 13–4, are:[14]

■ *Need for achievement*: a person's desire to be independent, to accomplish complex tasks, and to resolve problems.

■ *Need for power*: a person's desire to influence or control behavior in others, to compete, and to exercise authority.

■ *Need for affiliation*: a person's desire to associate with others, to form friendly relationships, and to avoid conflict.

McClelland's theory proposes that everyone has all three needs or orientations, but that one will dominate and affect the individual's decisions and behavior. Thus employees with high achievement needs enjoy challenges and thrive in complex and stimulating environments. They are best suited to situations where independent responsibility and autonomy prevail. McClelland also argued that achievers require clear and adequate feedback on their performance coupled with well-defined goals. One implication of this theory is that achievers do not always make the best managers because organizations are based on diffused authority and group activities, and achievers are often uncomfortable in situations of group

acquired-needs theory
A theory developed by David C. McClelland that proposes people develop a profile of needs through life experiences.

FIGURE 13–4 McClelland's Acquired Needs and Related Values

responsibility and control. Among the most creative persons in organizations, they often break away to form their own new enterprises. In other words, McClelland's theory associates achievement needs with entrepreneurs.[15]

Individuals high in power needs are more suited to management positions, but note that "power" as McClelland uses the word does not imply dictatorial behavior. Rather, it suggests a sense of responsibility for controlling others and for influencing subordinates' behavior. Power-oriented managers are comfortable with executive decision making, often relishing the intensity of highly competitive situations; power-oriented employees are likely to seek advancement and aggressively assume responsibility for controlling work activities.

Affiliation needs reflect a desire for social interaction. People with high affiliation needs prefer friendly, participative work environments where the quality of group interaction is more valued than creativity and the ability to influence others. They are also successful as integrators, bringing together departments and workers with diverse interests, coordinating interdependent tasks, and helping to resolve conflicts. Few affiliators are happy or successful in line management and executive positions, where emotionally difficult decisions must often be made, such as disciplining employees, enforcing policies, and retrenching outdated technologies. Their propensity to solidify friendships interferes with their willingness to make the kinds of decisions in which organizational effectiveness comes ahead of social compatibility.[16]

Working on the premise that these needs evolve through a learning process, McClelland conducted experiments to try to alter them by placing individuals in different circumstances. He specifically tried to enhance participants' achievement needs by moderating power relationships and encouraging creativity in situations requiring independent actions. McClelland was successful in altering people's orientation, but found that when his participants returned to their previous environments, they reverted to previous patterns of behavior. McClelland concluded that for individuals already strongly set in their ways, matching work and career environments is crucial, and that people established in organizations undergoing rapid change require counseling and education to help them adapt to new circumstances. Thus McClelland's success in modifying needs indicates that managers can improve organizational performance by influencing behavioral changes in employees, but that this requires conscious and permanent changes in organizational circumstances.[17]

In summary, content theories are concerned with motivating employees by addressing their needs. Each theory defines human needs differently, but all agree about managers' responsibilities for influencing behavior by fulfilling those needs. Collectively, content theories have provided a foundation for research to discover how employees react to different organizational stimuli, and this research has led to a branch of motivational theory called *process theory*.

CHECKPOINT

- In terms of content theory, what factors influence behavior?
- Describe Maslow's theory and the deficit and progression principles.
- How does Herzberg's work correlate with Maslow's need hierarchy?
- Discuss McClelland's approach to motivation and his categories of needs.

PROCESS THEORIES

Content theories emphasize people's perceived needs. In contrast, *process theories* emphasize that employees make decisions about how they will perform at work. They are viewed as making conscious and subconscious evaluations of con-

templated actions and the consequences of those actions. In other words, personal expectations of outcomes associated with performance are critical for determining how employees will be motivated to perform. If they expect and want rewards for doing work, they will do it. If they expect and value recognition for certain behavior, then they may consciously decide to behave accordingly. These are rudimentary examples of a complex hypothesis. The key point is that process theory views individuals as decision makers who weigh the advantages and disadvantages of their behavior.

Expectancy Theory

Introduced by Victor Vroom during the early 1960s, *expectancy theory* suggests people not only are driven by needs but also make choices about what they will or will not do. **Expectancy theory** proposes that individuals make work-related decisions on the basis of their perceived abilities to perform tasks and receive rewards.[18] Vroom established an equation with three variables to explain this decision process, as Figure 13–5 shows. The three variables will be given probability values, and are:

■ *Expectancy*: the degree of confidence a person has in his or her ability to perform a task successfully.

■ *Instrumentality*: the degree of confidence a person has that if the task is performed successfully, he or she will be rewarded appropriately.

■ *Valence*: the value a person places on expected rewards.

Because the model is multiplicative, all three variables must have high positive values to imply motivated performance choices. If any of the variables approaches zero, the probability of motivated performance also approaches zero. When all three values are high, motivation to perform is also high.

Thus, when you believe you are able to accomplish a task, your self-confidence will lead you to assign a high value to *expectancy*. When you also believe that once you have accomplished the task successfully, your reward will be commensurate with your achievement, you will assign a high value to *instrumentality*. Finally, if you consider the reward to be important, you will assign a high value to *valence*. A low value assigned to any variable will result in a low score, thus a low probability of motivation to perform the task. For example, assume that you feel certain you can perform (expectancy of 1.00) and that you will receive the associated reward (instrumentality of 1.00), but you are indifferent to the reward (valence of 0.50). When multiplied, the result is low ($1.00 \times 1.00 \times 0.50 = 0.50$), which could be interpreted as "indifference."

To see this more concretely, let's assume that two students are quite capable of doing A work (high expectancy values) and both are studying for their final exams in management. One student has a B average in the course, the other an A− average. Assume that a strong A on the final will give the B student an

expectancy theory
A theory concerned with motivation that suggests people make conscious decisions about behavior based on expectations of outcomes.

FIGURE 13–5 Expectancy Model of Motivation

Motivation = Expectancy × Instrumentality × Valence

$$\{ M = E \times I \times V \}$$

A for the course. Will this student study hard for the exam? The answer depends on the values the student assigns to the two remaining factors. Although expectancy is high, we do not know how much faith the student has that the professor will award him an A for the course. Even if he believes an A is a good possibility (high instrumentality), he may feel that passing the course with a "decent" grade is all that matters (low valence), and go out for pizza instead of studying. Now the A- student may feel confident that if she studies tonight, she can easily get an A for the course (high instrumentality). If that matters enough to her (high valence), she will pass up the opportunity to go out for pizza with the B-student.

Of course, the issue is rarely so simple as whether to study for an exam or go out for pizza because most actions have multiple outcomes. Good performance may enhance promotion opportunities, support merit pay raises, and generate recognition and higher self-esteem. But an individual may make a trade-off when the high performance that enhances opportunities and rewards also leads to alienation from co-workers. In McClelland's terms, an individual high in affiliation needs will not risk alienating co-workers solely for a chance at promotion. Someone with a high need for power or achievement, however, will be willing to risk friendships for the chance to be promoted.

The implications of expectancy theory for managers have been emphasized in research by David A. Nadler and Edward E. Lawler, III. Figure 13–6 shows their expanded model of expectancy. Their suggestions are summarized in the discussion below.[19]

Figure out what outcomes each employee values. The first step is to find out what stimulates each employee, what rewards and outcomes he or she values. Nadler and Lawler suggest that managers can discover this simply by asking employees what they want from their jobs and by observing their behavior. More complex methods include data analysis by consultants who correlate patterns of past behavior with reward structures. This step is a diagnosis; it is not meant to actually influence behavior.

Determine what kinds of behavior are desired. Skilled managers will not rush to motivate workers until they themselves have set performance goals. Once they have specified appropriate performance objectives in measurable and observable terms, they will be equipped to determine desirable behavior by workers.

FIGURE 13–6 Simplified Expectancy Theory Model of Behavior

Source: David A. Nadler and Edward E. Lawler, III, "Motivation: A Diagnostic Approach," in J. Richard Hackman, Edward E. Lawler, III, and Lyman W. Porter (eds.), *Perspectives on Behavior in Organizations* (New York; McGraw-Hill Book Company, 1983), p. 75.

Make sure desired levels of performance are attainable. One requirement of the expectancy model is that individuals be reasonably certain they can achieve the performance levels expected of them. If expectations are set too high, even the most enticing reward will not motivate behavior. Employees must be convinced that what is asked of them is feasible before they can become excited about payoffs associated with success.

Link desired outcomes to desired performances. Nadler and Lawler emphasize that managers must link rewards and other desired outcomes explicitly to preferred performance expectations. The linkage must be clear, well communicated, and reinforced with examples that build credibility. If rewards are extrinsic, such as bonuses for better performance, then managers must implement concrete and well-publicized payoffs. If rewards are intrinsic, such as self-esteem, then managers must create recognition factors that are obvious and equitable. It is also critical to evaluate all outcomes to ensure that they are achieving the desired results.

Analyze the total situation for conflicting expectancies. Considering the differences in perception among employees and the likelihood that people with different needs will be working together, it is nearly impossible to establish a reward structure that will satisfy everyone consistently. Monetary rewards that motivate one person may be a low priority for another. Esteem may motivate some individuals, but be little valued by others. More importantly, some rewards perceived as exciting by some employees will be merely irritating to others. Therefore, every reward system should seek to minimize negative factors and emphasize positive ones.

Make sure changes in outcomes are large enough. Unless the desired behavioral changes are trivial, rewards cannot be trivial. Since most efforts to change behavior and motivate performance are significant, managers who institute trivial rewards will only elicit employee ridicule.

Check the system for its equity. Rewards must be differentiated so that excellent performers receive more than good performers, and good performers more than poor performers. Here managers have to discard the notion of equality, unless they want all employees to do precisely the same task at precisely the same level of performance. As Nadler and Lawler suggest, equity is not equality but fairness. The equity issue has resulted in important changes in relations between managers and employees, and these changes have led to a separate theory on equity.

Equity Theory

Equity theory is concerned with individuals' perceptions about how fairly they are treated compared with their peers. One of the most sensitive issues in management is equity in rewarding workers' performance. Equity means fairness; motivationally, it means employees' perceived fairness of rewards or treatment at work. Perception of equitable rewards is an important link between performance and satisfaction. This is illustrated in Figure 13–7.

equity theory
A theory of motivation that suggests individuals modify their behavior based on perceptions of fair treatment and equitable rewards.

The primary research on equity theory was done in 1963 by J. Stacy Adams, who showed that perceived inequities lead to changes in behavior.[20] When individuals compare their rewards to those given to others doing similar tasks and feel inequities exist, they will react in one of the following ways to achieve satisfaction:

- *Increase* their performance and work to justify higher rewards when they perceive a positive inequity—when their pay, for instance, seems too high by comparison with others.

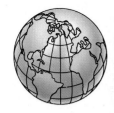

GLOBAL TRENDS 13–1
Employees Are Cautious About Incentive Plan at DuPont

A new incentive pay plan at DuPont Company has been warmly received by some employees and questioned by others. In 1989, DuPont established a profit-sharing bonus plan in its U.S. fiber division. The plan covers 20,000 workers in five major plants and twenty facilities headquartered in Wilmington, Delaware. Under it, employees will receive incrementally smaller pay raises over a five-year period until their base wages are 6 percent lower than employees in other DuPont divisions. Over the same period, the company will phase in profit sharing that could result in bonuses for fiber division workers that exceed the base rate of other DuPont employees by 12 percent. Thus, fiber division employees will have a lower fixed-wage base, but a bonus system that could result in substantial pay increases.

If annual division profits are equal to or exceed 80 percent of the fiber division's profit objective, employees will receive a bonus of 3 to 18 percent, depending on the size of the profits. If, however, annual profits fall below 80 percent of the division's profit objective, there will be no bonus and workers will receive only the base wages, at 6 percent below company averages.

Employees who expect the company to remain a strong international competitor welcome the plan as an incentive to work harder in order to earn more money. They believe they never before had the opportunity to control their own destiny, and think they could probably improve company performance by 150 percent under the program. Other employees are skeptical of workers' ability to influence company profits and, therefore, believe the plan will result in few bonuses and lower take-home pay. Although they agree that workers could improve performance if motivated to do so, they feel that too many other factors influence profits for them to make a great enough difference to earn bonuses.

The opponents of DuPont's plan suggest that although management might make decisions, such as writing off assets, to reduce profits arbitrarily, the more likely danger to bonuses are competitive factors beyond employees' control.

- *Decrease* their performance and work to compensate for lower rewards when they perceive a negative inequity—when their pay, for instance, seems too low by comparison with others.

- *Change* the compensation they receive (usually when they perceive that rewards are too low) through legal or other action, or by inappropriate behavior such as misappropriation or theft.

- *Modify* their comparisons—for example, by persuading low performers who are receiving equal pay to increase their efforts or by discouraging high performers from exerting so much effort.

- *Distort* reality and psychologically rationalize that the perceived inequities are justified.

- *Leave* the inequitable situation—by quitting the organization or by changing jobs or careers—because they think inequities will not be resolved.

Inequities arise out of many different situations, and they occur in promotions, benefits, work assignments, job ratings, employee recognition, transfers, and the nuances that can make a job pleasant or unbearable. Many of these are emotionally charged, ranging from racial problems to sex discrimination. On a daily basis, even minor managerial decisions can lead to perceived inequities.

In many commercial transactions, communicators and receivers must be knowledgeable in more than one language. In foreign currency exchanges, a precise understanding of different languages is absolutely necessary.

The Basic Communication Model

Figure 15–1 illustrates the basic communication model. The process of communication requires a full cycle of events from sender to receiver and back to sender. A common misconception is that communication is over once a sender has encoded a message and transmitted it. In fact, simply encoding and transmitting is merely "broadcasting"; no common understanding is assured. The complete cycle of communication consists of encoding a message by a sender, transmitting it through a medium, decoding the message by a receiver, and then authenticating receipt and understanding of the message by a receiver through feedback.[3]

Encoding. A sender is the source of information who **encodes** a message by using symbols, words, pictures, or gestures. Anyone who initiates communication does so from a perceived need to share information or feelings. This need may be little more than a desire to have social contact, or it may be an important need, such as teaching someone how to perform a certain task. The encoding process is crucial to ensure that an intended receiver understands what is being transmitted. Improper encoding can distort a message and confuse the receiver.

The method of encoding partially depends on the channel of communi-

encoding
A message is encoded by a sender who uses symbols, words, pictures, or gestures to formulate the message content.

FIGURE 15-1 The Basic Communication Process

Sender — Initiates message → Encoding — Symbolic message created → Channel — Medium of transmission → Decoding — Symbols interpreted into message → Receiver — Receives message

Feedback:
Receiver reverses process to respond to sender

cation one chooses. For example, if you decide to speak privately to another person—the channel is personal oral communication—you can then choose language, structure your statement, amplify its meaning with physical symbols, and further embellish your message with facial expressions. Your tone of voice will also add meaning to the message. Roger Smith, CEO of General Motors, emphasizes that "Managers must be able to convey their vision in an inspiring and forceful way—in other words, to lead—or else that vision will never be fully realized."[4] He prefers personal speeches and interviews to publicize GM activities because they allow him to use facial gestures, hand movements, and eye contact to reinforce his messages.

Consider the question "How do you like your job?" If asked by a manager of a new employee and accompanied by a warm smile, it could be taken as encouragement. But if asked with a raised eyebrow and a certain aloofness, it could be perceived as "You aren't cutting it here; shape up if you want to keep your job."

channel
A medium of communication between sender and receiver; the method of delivering a message.

Channel. The **channel,** or medium, determines how communication is transmitted. Personal conversation is the most obvious channel of communication, but oral communication can be between two individuals, one sender and a group, or between groups (such as between a chorus and an audience). The verbal media, such as letters, memoranda, reports, and electronic message boards, are another channel. Graphic channels range from sketches to videotapes. Nonverbal communications include gestures, facial expressions, and so-called body language. A channel can also refer to the type of communication method used, such as a telephone, a microcomputer, a textbook, or the mail.

The choice of channel is critical in the communication process. For example, it would be awkward to ask, "How do you like your job?" through a memo. How could the employee understand the manager's meaning, and how could the employee respond? Then again, if this question were rephrased so that the employee was also asked to suggest ways to improve the job, a letter or questionnaire might be more appropriate.

Channel selection may involve a combination of media. An employee questionnaire, for example, might be followed by short, personal conversations between supervisors and subordinates. A new safety rule might first be communicated in company newsletters, graphically illustrated with posters, and then reinforced through meetings. This method is often used by firms when dealing with critical issues such as a new policy requiring employees to wear safety glasses in hazardous areas.

To effect major changes companies frequently find it necessary to structure complicated networks of communication channels. For example, after the 1987 merger of the Burroughs and Sperry corporations into Unisys Corporation, now the world's second-largest computer company, managers had to devise ways to inform more than 90,000 employees about organizational changes and how they would affect their jobs. Before the merger, a managerial task force compiled a transition guide entitled *Leadership in the New Company—Managing the Transition.* This 32-page document, written in simple language, explained the proposed merger, the new management structure, and leadership practices that would be instituted. It also announced transition training programs and invited employees to become part of "focus groups" to resolve problems associated with forming the new company. More than a thousand employees participated in focus group discussions, and their suggestions were acted upon to create job training classes, career counseling services, and leadership seminars to make the transition a smooth one. In 1988, managers were encouraged to open dialogs with employees, institute group meetings, and reinforce information with follow-up letters, employee newsletters, and weekly public reports on changes. Outside consultants were retained to facilitate communication among employees of the two former companies and between managers and employees of Unisys.[5]

turn the firm around, but within a few months, yet another layer of management had been added. *List* and several other publications were being heavily advertised for mass markets, and new personnel policies had been initiated to counter the "lax attitude of workers not used to professional corporate business." For example, work breaks were rigorously enforced, dress codes were instituted, and all grievances and suggestions were required to be in writing and sent "through channels." The last remnants of a team environment were quashed.

Stage Three: The Buyback

In October 1985, Leonsis bought his company back for much less than Thomson had originally paid him for the firm. He then changed the name to Redgate Communications Corporation and reorganized his staff with key personnel who also became investors in the firm. He turned the company around by 1986 and generated $8 million in revenues. Sales nearly doubled in 1987, and by early 1988, Redgate was positioned to go public.

Leonsis explained the repurchase as more than merely buying back low for a good deal. "I couldn't believe what had happened to my firm, he said. "These guys took a great bunch of people and turned them into corporate robots." One of the original staff who had by then survived two buyouts and four successions of managers said that she felt human again with Leonsis, who believed in his people, gave them responsibility, and held them accountable for results. More importantly, he turned the organizational chart upside down and made business exciting. Customers were put on the top of the chart, she explained, so that everyone would realize for whom they worked. Leonsis saw himself at the bottom, helping his employees coordinate their efforts to put the customer on top.

The company retains its original business concept and publishes *The Macintosh Buyer's Guide, The Apple II Review, The Amiga Buyer's Guide*, and *COMPAQ* magazine. In addition, Redgate has cor-

porate clients for a variety of publishing and marketing communication contracts, including Apple, Commodore, Compaq, CCI, Coyne Kalojian, Kodak, Harris, Hewlett-Packard, Lotus Development Corporation, Motorola, Texas Instruments, Wang, Warner Communications, and Xerox Information Systems.

Leonsis summarizes his views of successful business succinctly. On motivation, he says, "If you are motivated only by money, you will be unhappy and will fail in the long run." On hiring and managing, he says, "Hire people smarter than yourself and delegate authority . . . you will want to be able to take vacations." On planning, he says, "Have a clear picture of what you are doing and what business you are in . . . then make sure you and your people are in it with commitment." Leonsis said that he does not take himself too seriously, but he takes his people very seriously and trusts them. In his opinion, the Thomson managers held the exact opposite viewpoint.

Case Questions

1. How did each executive approach motivation? Explain what you think were motivators for employees under Thomson's division manager and under Ted Leonsis.
2. Contrast the two styles of leadership under different Redgate owners in terms of the Blake and Mouton Grid and in terms of Likert's System 4 management theory.
3. Explain and evaluate Leonsis's style of leadership in terms of the leadership continuum. Discuss his approach to delegation and state whether you agree with it. Would you agree if Redgate were a larger firm with older and more experienced workers? Explain your answer.
4. What situation variables and environmental factors influenced management decisions at Redgate? How would leadership change if the firm doubled in size? Explain in contingency leadership terms.

Source: Brett Kingstone, *The Dynamos: Who Are They Anyway?* (New York: John Wiley, 1987), pp. 216–25. Copyright © 1987 by Brett M. Kingstone. Reprinted by permission of John Wiley & Sons, Inc.

they received was wrong nearly 20 percent of the time. As a result, the company recorded a substantial loss of customers and had a poor service reputation. After the buyout, American Express implemented new service standards to reduce by half the late payments to customers and reduce to less than 5 percent payment errors by 1988. This goal was accomplished through operational changes and transactions controls with periodic improvement objectives. By 1988, Sherson had eliminated 98 percent of customer errors and was able to send payments 55 percent faster. Monthly transaction reports instituted during the program to compare results to incremental improvement objectives continue to be used as the firm strives to eliminate all errors and provide 100 percent on-time performance.[7]

FIGURE 16-4 Control Charts and Boundary Control Limits

If a company's performance matches standards, we may reasonably assume there is no need for adjustment. Most standards, however, are targets with ranges of acceptable outcomes. Comparisons therefore take into account acceptable deviations within a predetermined tolerance range. Figure 16-4 is an example of a control chart with range data. Management predetermines the upper and lower limits of acceptable deviation in performance results. Control charts are reports that accumulate results and are periodically updated so patterns can be examined graphically for unusual changes. In open control systems, control chart deviations beyond range limits prompt management intervention. Closed systems will not use control charts, except as report documentation, because automatic sensors trigger adjustments.

Taking corrective action. The conclusive reason for having effective control systems is to take corrective action to raise performance results to acceptable standards. Corrective action is based on informed decisions, derived from first comparing actual and planned results and then evaluating reasons for deviations. In the Falconer Glass Company control chart, as Figure 16-4 shows, performance has fallen below acceptable standards, but there is no clear indication why this has happened. The responsible manager must investigate the cause before taking action. In fact, the outcome could be attributed to a number of reasons. A ma-

MANAGEMENT APPLICATION 16-1
Management Control at Garvey Industries

Asked for the secret of his success, Ray Garvey, founder and CEO of Garvey Industries, replied, "The fortunate thing about business—it requires the constant attention of management." Ray Hugh Garvey grew up in the farmland of Kansas, and after working his way through college, he began to mold one of the nation's most diversified closely held corporations. Garvey Industries is a multinational company doing business in grain, farming, storage, transport, oil exploration and drilling, real estate development, property construction and management, mortgage investment, cattle ranching, and insurance. The firm has housing projects and commercial real estate in Peru, Thailand, and Taiwan in addition to senior citizen homes in the United States and in Pan American nations.

Garvey Industries runs on what management calls the "no place to hide" system. Each project is assigned a project manager who is fully accountable for its success or failure. Control is clearly articulated in the five points that are part of every manager's job description:

1. To analyze and define the problem or opportunity.
2. To establish the goals and objectives to achieve success.
3. To plan, implement, and accomplish the desired results.
4. To administer and control the program.
5. To constantly evaluate performance and adapt to change.

Garvey Industries emphasizes decision making that balances the priorities of excellent planning and exquisite control by managers trained, motivated, and equipped with skills and tools necessary to attain excellence. In Ray Garvey's words, "Ordinary people can accomplish extraordinary things."

Source: Garvey Industries, Inc., "Information Profile on Garvey Industries," Wichita, Kansas, 1986.

chine may have failed, a substitute operator may have been doing poor work, lightning may have caused a power outage, or materials needed for the job may have been defective.

A manager who simply blames employees for poor productivity without careful analysis will destroy a control system. In the Falconer Glass Company control chart, for example, the huge deviation on 12/2 (the second day of the week) was traced to a faltering machine used for edging glass. The machine was repaired, and production was restored the next day. Before the machine problem was discovered, however, the supervisor in charge had blamed two operators for doing poor work, an accusation that led to a formal grievance against the supervisor.[8]

Taking appropriate corrective action is a crucial prerequisite for effective control. Controls by their very nature create tension that can lead to inappropriate decisions. They tend to have financial overtones, with standards set in accounting terms. Many managers view the entire process as unpleasant and restrictive, and thus may not always be motivated to push budget numbers, meet quotas, and satisfy profit and loss imperatives.[9] But there is nothing mysterious about managing for effective control. Organizations must find ways to motivate subordinates to take appropriate corrective actions backed up by workable systems and plausible standards of performance. (See Chapter 13, Motivation: Productivity Through People.)

CHECKPOINT

- Describe how the feedforward process influences decisions.
- Why do managers distinguish between controllable and uncontrollable variables?
- Define and contrast open and closed control systems.
- Describe all steps in the control process and managers' responsibilities in each instance.

TYPES OF CONTROLS

The process we have been discussing is a conceptual framework for control. Management theorists have identified three types of control that lead to different decisions. These are *steering controls, yes/no controls,* and *postaction controls.*[10]

Unlike controls in electric power stations, operating procedures do not automatically adjust operations. Computerized transaction machines used by bank tellers will not register transactions when tellers fail to follow predetermined series of actions.

Steering Controls

steering controls
Controls used to adjust behavior or operations, such as correcting speed and direction of a car.

Steering controls are used while operations are in progress to keep activities on course. The most common example of a steering control occurs when a person is driving a car. The driver makes hundreds of decisions based on mental evaluations to keep the car on course, at the proper speed, and out of danger. Craftsmen who build furniture make similar evaluations, steering their efforts and adjusting their activities to achieve a predetermined objective. In petroleum refining, automation replaces human endeavor, and mechanical sensors substitute for human judgment in keeping crude oil flowing through a refining process at the correct speed and temperature. Similarly, electric power generation is monitored through a system of measuring devices that gauge predetermined levels of electricity, automatically increasing or decreasing power for outgoing lines.

Operational procedures are steering controls employed by organizations to alert employees to preferred work methods. Service organizations such as banks use procedures to guide tellers in daily transactions. In manufacturing environments, steering controls often take the form of direct observation, much like driving an automobile.

Steering controls are primarily feedforward controls designed to prevent mistakes. Like experienced drivers, experienced managers have good insight into guiding operations, but, as noted earlier, they must at times take appropriate corrective actions. Even experienced drivers can stray into oncoming traffic and cause accidents.

Yes/No Controls

yes/no control
A screening technique that yields a "yes" or "no" (go or no-go) decision at selected checkpoints in an operation.

go, no-go controls
Another term for "yes/no controls," go, no-go controls have fail-safe standards dictating absolute corrective action or no action.

Practicing managers have another term for **yes/no controls: go and no-go controls.** Corrective action dictated by this type of control is rather obvious: either "go" or "stop." Corrective action can go only one way or the other, like turning on or off a light switch. These controls are used as fail-safe methods in critical operations, and can be incorporated into steering procedures at specific points to modify operations. Students who have sketched flow charts in computer programming exercises will recognize the use of go, no-go options as controls.

A common example of these controls is the commercial airline preflight checklist that incorporates critical go and no-go options. If an oil gauge indicates low pressure or a radio fails, the preflight check will stop, and so will the flight.

Yes/no controls are also used as delimiters for management decisions. For example, department managers may have discretionary use of funds to buy supplies charges up to $1,000. Beyond that amount they must obtain higher approval. Salespersons may be able to accept credit charges up to a certain amount and then need approval. Safety inspectors may be able to shut down operations under certain conditions. Yes/no controls usually leave little room for doubt about what action managers must take.

Postaction Controls

Statistical control procedures have strong postaction elements. The term *postaction* implies a comparison of actual results with standards "after the fact." Deviations from standards are evaluated and corrective action is taken to avoid similar mistakes in the future. When instead of simply measuring end results postaction controls are integrated with operations, they enhance steering decisions.

Most postaction controls stem from formal reporting systems that periodically accumulate information. Reports such as monthly accounting summaries provide information on budgets and performance. Obviously, nothing can be

done to change these results, but they can be used to make changes in future operations. Quality control inspections are good examples of postaction controls. Products that are found to be defective are rejected; in some instances, companies have scrapped hundreds of completed products. This is an expensive process, so whatever the problem was, management clearly does not want it repeated. Inspection reports are studied to find out what went wrong so that corrective action can be taken to prevent future disasters.[11]

Integrating Different Types of Controls

Steering, yes/no, and postaction controls are convenient labels for studying elements of control in the total process. Figure 16-5 presents an overview of these three types of control and how they are used. Rarely is one type of control employed in isolation. In fact, managers seldom formally differentiate between types of control but choose controls based on answers to the following questions:

1. What controls are needed to assure performance expectations?
2. What are the critical control points for monitoring operations?
3. Who is capable of measuring performance and making corrections?
4. Is an operation critical enough to justify the costs of controls?

Managers may not clearly articulate these questions when developing control systems, but they explicitly answer them. For example, a preflight check for a commercial airliner is a result of recognizing that this control is necessary to assure public safety. The actual preflight checklist defines critical control points and what is to be monitored. Flight crews have been assigned the responsibility for these control checklists because they are ultimately responsible for flying the aircraft. Other personnel, such as ground crews, will have control lists as well. Preflight checks coupled with a rather extensive array of other controls are expensive, but the costs are justified by the high risk of failure if controls are neglected.

The yes/no controls used in preflight checks are only one component of the controls employed for a commercial flight. Others are activated during and after the flight. Anyone who has glanced inside a cockpit knows that it contains many instruments. Few of these are needed to actually fly a plane; most are steering controls for monitoring flight operations. Postaction controls include pilot debriefing sessions, evaluation of information from in-flight recorders, and reports on schedules, costs, maintenance, and other elements of airline operations.

Even the best controls and a fully articulated system of checks will not guarantee success. Planes crash, and when they do, even more stringent controls are inaugurated. Tenacious attention to detail is essential, but it is also very ex-

FIGURE 16-5 Relationship of Types of Control to Activities

pensive. For operations that are less critical than an airline flight, managers trade off a certain level of error for cost savings. Harmonizing organizational priorities for cost effectiveness and for essential control requirements is one of the tougher responsibilities of managing.

> **CHECKPOINT**
>
> ■ Explain how steering controls are used in a product assembly plant.
>
> ■ Identify examples of yes/no controls in a service firm and in a government agency.
>
> ■ How are reports used in postaction controls for quality assurance?

CONTROLLING RESPONSIBILITIES

Managers must motivate employees while monitoring performance and often instituting unpopular control techniques, and, as just noted, they must also harmonize diverse interests. Both managers and employees may view the controls with some trepidation. Control is an exercise of authority, and many of the techniques employed can be tedious and stressful.

Deciding What to Control

control points
Designated places or times during operational activities to measure progress, sample results, or test products.

Since managers cannot possibly control everything, they must decide what operations are essential to control. Some activities require close supervision, others need only periodic examination, and still others can be ignored. For those that must be tightly controlled, managers have to determine critical control points. **Control points** are places or times selected during operational activities for testing, sampling, or measuring progress. For example, Lockheed Corporation uses *acceptance sampling*—a statistical control for accepting or rejecting products—at forty-three points during the assembly of a commercial aircraft passenger cabin. Windows, for instance, are tested to ensure that they will meet pressurization standards. If they fail the acceptance tests, assembly work stops until they pass. After they pass, interior cabin walls are put into place and fastened. These are tested for proper seams and rivets. After walls pass, overhead panels are assembled and tested, and so on until the cabin is finished.[12]

Manufacturing companies set up controls to monitor production output, resources (materials, labor, and capital), and marketing operations (sales, credit, and distribution systems). Examples of controls are man-hour efficiency reports, inventory control reports, monthly cost and expenditure reports, ratios used for measuring asset and labor productivity, profitability ratios, and market growth statistics. Controls are also developed for periodically measuring the physical results of production, sales, human behavior, and financial management.

Some firms control processes. For example, hospitals must control procedures for giving medications. Chemical manufacturers evolve process controls for combining and producing complex medications. Oil refineries monitor the conversion process that creates gasoline, usable refined oil, and other commercial products from crude oil. We have even developed controls to monitor human biological processes; a pacemaker attached to the human heart monitors heart rhythms and activates to prevent the heart from stopping or slowing down.

These examples illustrate how important it is to make conscientious decisions about what to control. Once these decisions are made, points of control must be established that ensure adequate monitoring without disrupting operations. Sampling procedures are instituted at control points in manufacturing to

evaluate quality without slowing performance. Figure 16-6 is a conceptual diagram of control points in a process conversion system.

A useful way to select control points is to locate them where change takes place. For instance, when a batch of soup is mixed, a sample is drawn and tested just before the mixture is put into cooking vats. Then temperature checks are made while the soup is being processed. When the soup is transferred from vats to distribution canning processes, another sample is tested. Once canned, sample cans are drawn for inspection. This process occurs at each point of change until shipments leave the factory. Most control points that monitor performance during production—or some other operation, such as surgical procedure—are designed to signal managers to continue or stop action. If everything is proceeding properly, action continues; if not, the system is halted until corrective action is taken.[13]

Another way to select control points is to locate them at the most important or most critical parts of operations. Classic **ABC inventory systems** follow this method. **A items** are imperative for operations and thus are closely monitored; **B items,** having less importance, are less closely controlled; and **C items,** which can be readily replaced or substituted, might not be controlled systematically. A items are typically expensive and justify expensive controls, but if an inexpensive item is crucial to operations, it too may be rigorously controlled. At the other extreme, C items are almost always inexpensive and can be replaced rapidly if shortages develop, so any expense for control is difficult to justify.[14]

Setting Standards

Managers must determine what standards of performance are satisfactory. As noted earlier standards must conform to organizational objectives. They are generally related to output, expense, or resource controls.[15] Standards reflecting production output or services are usually expressed in quantities. Frito-Lay, for in-

ABC inventory systems
A formal method of classifying materials according to their importance and cost.

A items
Materials and parts imperative to operations that seldom have substitutes and would be expensive to replace, thereby requiring extremely close control.

B items
Materials and parts that are important to operations and requiring close control, but they can be replaced or substituted even though costly.

C items
Materials and parts that have many substitutes and are usually inexpensive to purchase and store; C items are not closely controlled.

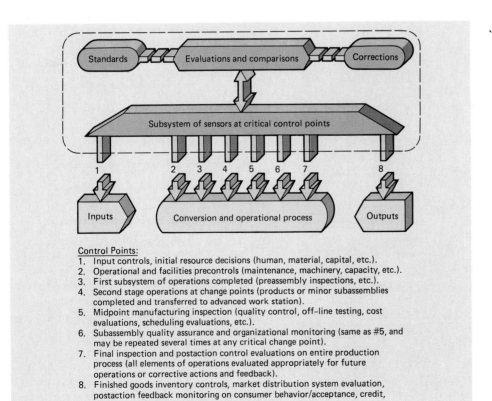

FIGURE 16-6 Control Points in a Process Conversion System

Control Points:
1. Input controls, initial resource decisions (human, material, capital, etc.).
2. Operational and facilities precontrols (maintenance, machinery, capacity, etc.).
3. First subsystem of operations completed (preassembly inspections, etc.).
4. Second stage operations at change points (products or minor subassemblies completed and transferred to advanced work station).
5. Midpoint manufacturing inspection (quality control, off-line testing, cost evaluations, scheduling evaluations, etc.).
6. Subassembly quality assurance and organizational monitoring (same as #5, and may be repeated several times at any critical change point).
7. Final inspection and postaction control evaluations on entire production process (all elements of operations evaluated appropriately for future operations or corrective actions and feedback).
8. Finished goods inventory controls, market distribution system evaluation, postaction feedback monitoring on consumer behavior/acceptance, credit, costs, profitability, and productivity analyses.

stance, seeks 99.5 percent on-time deliveries, and Greyhound Corporation focuses on safety measured by numbers of accident-free passenger miles. Production standards may simply count parts made per hour. Quality is an important standard and includes measurement criteria such as the number of defective parts created per hour or the pounds of scrap generated per ton of materials.

Expense control standards are perhaps most noticeable because modern organizations extensively use budgets and reports reflecting accounting data. In general, expense standards are applied to labor costs, machine utilization, material efficiency, and administrative budgets.

Resources are subject to monitoring techniques and standards developed prior to allocation. These types of controls, called **initial controls,** are preventive measures designed to guide managers toward effective decisions about activities such as purchasing materials or hiring employees.[16] The difference between expense and resource controls is standards for measurement. For example, expense controls for human resources measure actual use of labor hours. Resource controls in human resource management are concerned with evaluating skills and personnel needs to make recruitment decisions. Figure 16-7 shows a personnel selection process with initial or preventive controls. Similar controls are employed in materials management for purchasing, capital funding, and technological development.

initial controls
Preventive control measures to guide managers in resource allocations and other decisions such as hiring, purchasing, and capital funding.

Measuring Results

Actual measurement of results is often left to staff specialists who can deal with data more expertly than line managers, and without disrupting work. For example, cost accountants are responsible for accumulating expense data, comparing actual to standard results, and developing appropriate reports. With rapid implementation of computers, these analyses are becoming instantaneous, or "real time," allowing nearly constant reporting.

FIGURE 16-7 Initial Control Points in Personnel Selection

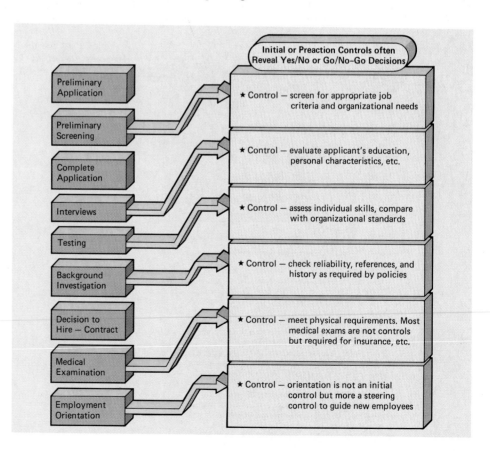

Staff managers in accounting, MIS, quality control, engineering, and other areas bring expertise to organizational controls, but in many instances, line managers must be responsible for direct measurement. For example, only supervisors can make performance evaluations, which are often subjective. Similarly, compensation management for equity in wages and salaries, skills development processes, personnel upgrading, and discipline require the judgment of supervisors.

Reporting

Reports must have value to those who receive them. Reports that are well designed provide managers with timely and relevant information without overloading them with extraneous data. Some organizations are parsimonious with information; others generate excessive reports. In either case, managers are likely to be poorly informed and make poor decisions.

Real-time reports represent a quantum leap in communication because activities are continuously monitored and status reports are instantly available. Inventory control is one area where real-time systems have wide application. Computers can store data on inventory stock, update files with new purchases or issues, describe locations of stock, assimilate price and cost information, and provide a rich assortment of reports, including ones about stock status, orders, and vendor analysis. When a part is issued—sold or transferred to production—on-line computer programs automatically update stock status.

To be useful in developing effective control systems, reports must communicate sufficient and accurate information to the people responsible for taking corrective actions. Good reports are joint productions of staff experts and oper-

Although they are less used, traditional paper-bound reports are still the standard. These include weekly, monthly, quarterly, and annual reports on sales, production, assets, and cash flow. Operational reports tend to be short-range and used by supervisors to control activities in the field or on the shop floor. Reports that reach division levels in middle management tend to be aggregated summaries. At corporate levels, reports are most often long-range and reflect strategic performance in financial, profit, and market terms.

ating managers. Those who request reports must define what information is needed; those who create reports must be expert at accumulating and analyzing the information requested.

Corrective Actions

The firing line is where corrective actions take place. Not all managers set standards or evaluate results, but they all are responsible for taking corrective actions because it is the manager's job to solve problems.[17] Corrective actions lead to revised information or revised standards that influence future plans, which brings us full cycle to the stage of preplanning.

Toward Effective Control

Effective systems incorporate every type of control in appropriate and complementary relationships. Though such systems are tailored for each organizational environment, they have common characteristics. Following is a list of several important points for developing effective control systems.[18]

- *Understandable*. Standards of performance must be clear and include measurable criteria. Management responsibility should be well defined, and performance expectations should be expressed in language or numbers that everyone can understand.
- *Justified*. Controls will be effective if they are acceptable to operating personnel. Standards must therefore be plausible, and expectations must be perceived as purposeful. Employees may well ignore or sabotage control methods or standards they view as superficial or capricious.
- *Coordinated*. Controls must be integrated with one another and with plans so that corrective actions make sense. Criteria must be valid measurements of desired activities, and prescribed adjustments must be realistic. Coordination is crucial to assure that actions taken in one area do not create even greater problems in another.
- *Accurate*. Reports on which corrective actions are taken must reflect diligent analyses. Inaccurate information is one of the most annoying problems managers face. Good decisions made on faulty data solve nothing.
- *Timely*. Information must be available to managers when they need it for making decisions. The attraction of real-time systems is rapid access to an extraordinary amount of information. With technological advances such as new production techniques and computer systems, the risk is that operating systems will outrun control capabilities; controls must keep pace with technology.
- *Realistic*. Control systems must achieve intended purposes without being excessive. Excessive controls can result in oppressive monitoring that suffocates employee behavior and costs more than expected savings.
- *Acceptable*. Controls must be acceptable to employees as appropriate means of improving organizational performance. Good controls establish boundaries of behavior without throttling initiative; the standards are attainable and the evaluation methods foster harmony, not cynicism.

Controls and Performance

Since controlling is a process of evaluating decisions that ultimately affect future operations, control decisions have an implicit risk factor. If we also consider that most controls involve sampling rather than comprehensive monitoring, it is safe

EXHIBIT 16-3 Financial Ratios for Solarflex Window Manufacturers

Liquidity Ratios	Current Ratio	$= \dfrac{\text{Current Assets}}{\text{Current Liabilities}}$	$= \dfrac{11{,}965}{3.611} = 3.31$
	Acid Test	$= \dfrac{\text{Current Assets} - \text{Inventories}}{\text{Current Liabilities}}$	$= \dfrac{4{,}285}{3{,}611} = 1.19$
Leverage Ratios	Debt-to-Net-Worth	$= \dfrac{\text{Total Debt}}{\text{Net Worth}}$	$= \dfrac{13{,}873}{26{,}461} = 0.52$
Coverage Ratios	Times-Interest-Earned	$= \dfrac{\text{Earnings b/Int. and Tax}}{\text{Interest Charges}}$	$= \dfrac{6{,}935}{1{,}664} = 4.2 \text{ times}$
Profitability Ratios	Gross Margin	$= \dfrac{\text{Gross Margin on Sales}}{\text{Sales}}$	$= \dfrac{10{,}965}{34{,}386} = 31.9\%$
	Net Profit Margin	$= \dfrac{\text{Net Profit after Taxes}}{\text{Sales}}$	$= \dfrac{3{,}554}{34{,}386} = 10.3\%$
	Return on Equity	$= \dfrac{\text{Net Profit after Taxes}}{\text{Net Worth}}$	$= \dfrac{3{,}554}{26{,}461} = 13.4\%$
	Return on Assets	$= \dfrac{\text{Net Profit after Taxes}}{\text{Total Assets}}$	$= \dfrac{3{,}554}{40{,}334} = 8.8\%$
Operating Ratios	Inventory Turnover	$= \dfrac{\text{Cost of Goods Sold}}{\text{Average Inventory}}$	$= \dfrac{23{,}421}{5{,}662} = 4.1 \text{ times}$

vestment (ROI). ROI approximates return on equity (ROE), identified in the exhibit, but is a more complex equation that accounts for capital turnover, profit realized on owners' equity, and asset utilization. Managers also employ ratios to assess cash flow, capital efficiency, consumer credit, working capital, labor costs, and productivity.

Interpreting Financial Ratios

Financial ratios have little value unless you know how to interpret the data. An ROE of 10 percent doesn't mean much until you compare it to some benchmark. A company could turn 10 percent ROE in the current year and be elated because in previous years ROE had been half that much. But if the firm is in an industry where ROE averages 15 percent, managers have to wonder why they are performing so poorly. As noted earlier, Campbell's pretax earnings ratio of 7.8 percent in early 1989 alarmed analysts because the industry average was 8.5 percent.

Ratios do not prove anything by themselves; their usefulness lies in the comparisons they permit. For example, the current ratio should be well above 1:1, and if a firm has a ratio of 2:1, it might seem secure. However, if the industry average is 2:1 and the firm has a current ratio of 4:1, its short-term assets may be poorly managed. The company may have unnecessary inventory, a great amount of cash sitting idle, or heavy accounts receivables that are difficult to collect.

Ratios provide consistent measurement among firms, across industries, and over time. By converting raw data into percentage ratios, managers factor out differences in company size, sales levels, and other hard-to-compare characteristics. For example, a computer manufacturer with a gross profit margin of $20 million on $400 million in sales has a gross margin of only 5 percent. A competing firm with $20 million gross profit margin on $100 million in sales is much stronger with a 20 percent gross margin. Had only gross sales dollars for the two companies been compared, the first one would have seemed stronger; and had net sales dollars been compared, the companies would have seemed equal. The lower 5 percent gross margin does not necessarily mean the large firm is doing poorly; it may be having problems, but it may also be growing by aggressively offering low prices. Again, ratio analyses are diagnostic tools that require interpretation.

Break-even Analysis

break-even analysis
Also called *cost-volume-profit analysis,* it is a mathematical relationship among revenues and fixed and variable costs that determines profits at various levels of sales.

Many different quantitative analyses are available to assess company performance. Most have characteristics of financial controls, often using cost and revenue data. One of the easiest analytical techniques managers can employ is the break-even analysis. **Break-even analysis** is applied most often to determine the level of sales required to generate revenues that equal total costs. When total revenues exactly equal total costs, the company breaks even.[32] Figure 16-9 illustrates the model.

This analysis requires a specification for *fixed costs,* which are assumed to remain unchanged even though production and sales vary. It also requires a specification of *variable costs,* which are assumed to be marginally the same for each unit of sales. In addition, a *unit price* is used that remains the same for each item sold. By multiplying unit price by sales volume, a revenue line is established. Sales volume also determines variable costs at each level. To obtain a total cost line, fixed costs are added to variable costs.

At sales levels below the break-even point, revenue is charted and losses are calculated. Profits are similarly estimated at sales levels above the break-even point. These are rough approximations, but enriched versions of the model allow for precise estimates. The model illustrated in Figure 16-9 is also a simple *linear analysis.* This is an important distinction, because in a linear model, fixed costs do not change regardless of production changes, sales activities, or variable cost factors. Variable costs also remain exactly the same for every unit of production, and prices remain absolutely the same regardless of sales volume. In the real world, costs and revenues do not behave in a linear fashion, so practical applications of break-even analysis use *nonlinear* models in which cost and price behavior change at different levels of sales. Break-even analysis is sometimes called **cost-volume-profit analysis** because managers do more than find a break-even point for revenue and costs; they also examine relationships of all variables. Thus a price line might be incremented by a few cents on each dollar to derive an array of revenue projections. If cost lines remains stable, the result is a series of revenue lines that intersect total costs at different points, showing managers a variety of break-even points. This is equivalent to posing "what if" questions about price changes or discounts. The same type of simulation can be devised for any of the variables.

cost-volume-profit analysis
A refinement of break-even analysis using the same variables to examine relationships between different cost components, revenue and costs, and profit changes due to changes in costs, prices, or sales volume.

Computer-generated models have made break-even analysis popular because the variables can be changed easily to simulate operational and financial changes. Break-even analysis is also a powerful control because operational data can provide a "snapshot" of cost-volume-profit relationships at any given point in time. The simplicity of this analytical technique makes it ideal for such diverse

FIGURE 16-9 Break-even Graph

4. Each trio of Summers, Nolan, and the observer will gather as instructed. Proceed with the role-play meeting. Be prepared to report (briefly) to the class on the *specific* outcome of the meeting. The observer will report on the *process* your meeting followed. (20-25 minutes)

5. With the time remaining, orally present the results of the meetings, or submit a brief written note to the instructor on the outcome of your meeting.

Exhibit 1 Observation Guide for Summers/Nolan Role Play—Types of Power Observed and Examples

Type of Power	Possible Example	Actual Example
Legitimate	Role as "the boss" Title and rank Goals part of MBO procedure Goal attainment achieved or blocked because of the way other departments in the bank performed	
Referent (positive)	Friendship Personal relationship How other "good managers" performed	
Referent (negative)	Guilt Withdraw friendship, relationship	
Expert	Information about how other managers or branches performed	
Reward	Positive comments Praise and encouragement Promises of raises, bonuses, promotions Nolan agrees to improve, do better	
Punishment	Negative comments Blame Threats of no raise, demotion, firing Nolan refuses to accept blame, refuses to improve or do better, refuses to accept responsibility	

Control Data workers assembling high-performance disk drives.

17

Production and Operations Management Control

Control Data Corporation assembles office computer systems in five states and eleven cities from Boston to Los Angeles, and each location requires the same production techniques and consumer service. Quality is maintained through a carefully controlled system of purchasing, inventory, and process manufacturing called *just-in-time (JIT)*.[1] JIT is an inventory control system based on buying just enough materials to fill orders, delivering materials directly to production just in time to be used, and manufacturing products just in time to meet orders. Ideally, it eliminates raw material and finished goods inventory, assuring a continuous flow of materials and products from suppliers to final customers. Control Data implements JIT by using electronic purchasing and high-speed transportation to achieve a 99 percent on-time delivery record of the most critical parts needed in production. These parts arrive at assembly points the same day and within hours of scheduled use.

Parts are shipped to the company from nearly a thousand suppliers—many located overseas—and most arrive with such timely precision that Control Data maintains few warehouses. The company must still maintain a traditional inventory system to deal with parts and materials supplied by vendors that cannot cost effectively meet rigorous delivery schedules. Its goal, however, is to create the highest-quality, lowest-cost production system in the computer industry using 100 percent JIT. As you study this chapter, remember CDC's goal and its commitment to *quality* and *cost effectiveness;* they are the crucial elements managers seek to control to achieve high productivity.

productivity
The relationship of combined inputs such as labor, materials, capital, and managerial verve to outputs such as products or services. It is the summation of quality performance that results in more efficient utilization of organizational resources.

quality
The concept of doing things better, not just more efficiently.

Controlling is part of every manager's responsibilities. In the previous chapter, we emphasized that controlling means effective decision making that concentrates on controllable activities while anticipating uncontrollable circumstances that influence performance. In this chapter, we explore how managers use control techniques in production and operations to achieve high quality and influence behavior by employees to maximize productivity.

We emphasize behavior because managerial control is effective only when it guides someone's behavior. Although we examine control techniques used in production systems—including JIT—it is not the "tools" of control that are important but the improvements in performance their use creates.[2] Consequently, we study production and operations management to understand how managers systematically apply techniques in daily decisions to influence employees toward the kind of quality performance that determines productivity.

THE QUALITY-PRODUCTIVITY CONNECTION

Productivity is on everyone's mind today as the media keep reminding us that foreign competitors are outproducing Americans. **Productivity** is not a matter of producing the greatest number of products, but of providing customers with the greatest number of *quality* products at the lowest possible costs. Figure 17-1 provides a conceptual view of the quality concept.

Satisfying customer needs is the ultimate mandate of organizations and therefore a primary concern for control. Profit is a result, not a goal, of quality performance, and those companies that best satisfy customer needs with reliable products and services are often the most profitable.[3] Our discussion focuses on managerial decisions that encourage total quality control.[4]

The Quality Concept

In absolute terms, **quality** implies error-free, totally reliable products or services. Quality in the real world, however, is relative; it exists in the eye of the beholder. Customers measure a product's quality by how well it fulfills their expectations at a given price.[5] Figure 17-2 illustrates this relationship.

From a producer's standpoint, quality reflects a conscious decision to manufacture inexpensive or expensive products, and also to make things that work. Profitability problems and low productivity do not stem from attaching lower or higher price tags, but from making poor-quality products that do not work. Poor quality results in lost sales, recalls, a tarnished brand image, costly repairs, warranty losses, scrapped materials, wasted time, and many other expenses for the company. Quality problems can come from substandard materials, erratic supplies, careless purchasing, poor workmanship, design faults, and management blunders.[6]

Quality problems also affect product safety and reliability, and can lead to legal costs and huge losses in customer sales. This is often a very sensitive issue

FIGURE 17-1 Organizational Performance and Quality

FIGURE 17-2 The Quality and Service Concept

for service organizations, such as hospitals, where substandard performance can have life-threatening consequences. Most service organizations can control quality through processes similar to those used by manufacturers to improve purchasing, materials, safety, human resource performance, and reliability.

Total Quality Control (TQC)

A comprehensive approach to quality is suggested by the phrase **total quality control.** TQC implies a total involvement by everyone in the organization to provide customers with reliable products and services that fulfill their needs. An ideal TQC perspective encourages all employees—from executives to line supervisors and workers—to make themselves responsible for improving quality on a continuous basis. TQC is a strategic concept that must be implemented by top management. This is not the predominant view in America or other Western cultures, where quality control has instead been a specialized staff function that is the responsibility of a few highly skilled quality assurance engineers and inspectors with limited opportunities for surveillance and inadequate measurement techniques.

The companies most admired for their quality and services have long endorsed a TQC philosophy, both in management and in operations. General Electric Corporation has consistently been rated by peer companies at or near the top in its industry. It has implemented TQC practices in most of its plants and earned a reputation for reliability. Also ranked among the top six firms in the United States for quality products are Boeing Aircraft Corporation and Eastman Kodak. Service-oriented firms among the quality winners include J. P. Morgan and Dow Jones. At Dow Jones, publisher of *The Wall Street Journal* and purveyor of busi-

total quality control
The total involvement by everyone in an organization to provide customers with reliable products and services that fulfill their needs.

Large chains like Sears are based on the marketing concept that customers measure quality relatively. For example, Sears' customers may be purchasing a stereo system at discount to save money. The system they select may be encased in plastic, have reasonable but inexpensive speakers, and sport an off-brand name. Although the audio quality of such a system may be acceptable to such buyers, it is not that of a top-rated system. But the price is right; that is, perceived quality matches price. Even if customers purchase a cheap system, however, they expect it to work. Nobody wants to pay for defective items.

ness and technical services, TQC from the lowest strata to the boardroom has been a goal for several decades.[7]

The Productivity Concept

If quality is a way of managing, then productivity is the result of effective quality management. Traditionally, productivity has been concerned with greater quantities of output; thus measurements of productivity have centered on units of output without attention to *good* units of output. The most common measurement accounts for labor efficiency measured as output in units per labor-hour.[8]

Enlightened managers search for productivity standards that identify salable, good-quality products and services in relationship to all relevant inputs, including labor, capital, material, and energy. Productivity also affects prices when costs are reduced.

We can better understand these points by examining the costs of poor productivity. These include:

■ *Scrap.* Scrap costs are measured in ruined inventory and discarded materials. Other costs associated with scrap include wasted labor and machine time spent making throwaways.

- *Rework.* Rejected products are not always scrapped; some are repaired or reworked. Costs associated with rework include labor, materials, and additional operations needed to correct defects. There can be significant hidden costs in rework, such as lost sales due to poor customer service, handling costs of defectives, and additional administrative costs.

- *Downtime.* Facilities are often idled by internal failures. When a machine is set up incorrectly, an entire assembly line can halt. Downtime results from machine failure, unsatisfactory machine setup procedures, ineffective maintenance, or poor scheduling. Specific added costs include unscheduled maintenance, repair, lost labor time, and overhead.

- *Yields.* Poor controls result in wasted materials. These are not scrap from defects but actual waste generated by poor use of resources. For example, when parts are stamped out of sheet metal, there are wasted "cutoffs." By using good layout patterns and accurately stamping out parts, raw materials can be better utilized with less waste. In addition, innovative uses of waste materials can lower disposal costs.

- *Disposition.* Discarded products and waste must be disposed of. Even reworked items require management analysis and decisions on whether to scrap any or all of them. Costs associated with physical disposition include materials, expensed labor, overhead, and physical handling. For many sensitive products such as chemicals, paints, and explosives, disposal costs can be nearly half the initial cost of making the product.[9]

Costs Associated with Quality

Quality costs are incurred before manufacturing begins as well as during production and after products are sold. Many are hidden costs not traced specifically in traditional accounting systems. Several of the most obvious quality costs are:

- *Incoming materials.* Product failures, scrap, and rework can result from poor materials. Controlling the quality of incoming materials can be costly because it requires inspection, sorting, returning unacceptable materials, and extra administration. There are also sizable costs associated with having insufficient supplies or overstocking to prevent shortages.

- *Purchasing.* Purchasing must analyze utilization rates, fluctuations in production, seasonal sales, and maintenance requirements. Quality purchasing done diligently minimizes errors in ordering and ensures cost-effective procurement. Unfortunately, purchasing managers seldom have adequate support systems to do a quality job.[10]

- *Inventory.* Costs associated with poor inventory control are notorious. They stem from excess or short inventories, disruptions in shipments, mishandling, and outright losses. In manufacturing parlance, inventory losses are *shrinkage* and are usually difficult to trace.

- *Warranty and service.* After products are sold, there are costs of servicing defectives and honoring warranties. These activities are directly related to quality and can be captured in accounting documents. However, accounting models tend to limit costs to direct wages and replacement parts. Other costs—such as indirect overhead, capital financing costs applicable to warranty and service, and losses in future sales—are ignored.

Social and Human Costs Associated with Poor Quality

If poor quality leads to poor resource allocation, waste, scrap, and misused human effort, then U.S. society suffers from a general accumulation of these problems. This is the implicit assumption in political debates about national productivity and comparisons between ourselves and foreign competitors. Excessive waste in material and human resources has serious implications for our environment as well because it results in entropy. Entropy is the process of using resources in such a way that their previous natural mass is nonrecoverable; when a tree is cut down, it cannot be replanted, nor can burnt wood be recovered for other uses. In recent years, society has become more aware of the amount of damage being done to the environment. Jeremy Rifkin, a writer and lecturer concerned with environmental issues, emphasizes the quality theme in his book *Entropy*. Rifkin writes, "Our lives are bound up in constant repair. We are forever mending and patching. Our leaders are forever lamenting and apologizing."[11] The message is that everyone would benefit from less mending and repairing. Doing it right the first time conserves resources and human effort. Exhibit 17-1 lists the costs of poor quality and poor productivity.

> ### CHECKPOINT
> ■ Discuss quality from a consumer's perspective.
> ■ Explain how quality and productivity are related.
> ■ Identify and discuss costs associated with poor quality.

CONTROLLING FOR QUALITY AND PRODUCTIVITY

The quality-productivity connection provides a framework for examining techniques of control in greater detail. Effective quality control systems monitor operations at many different stages. They provide vigilance in purchasing, influence product design, signal needed changes in manufacturing processes, reveal gaps in human resource skills, and alert managers to shortcomings in leadership. They can also stimulate managers to study new methods and new technologies that can lead to innovations in both products and services.

Design Controls

Research engineers responsible for new products are concerned with materials, perceived quality required by customers, safety characteristics, and reliability standards. Quality engineers complement designers by helping coordinate plans

EXHIBIT 17-1 Costs Associated with Poor Quality and Poor Productivity

Material scrap	Shipment disruptions
Wasted rework	Warranty and service expense
Machine downtime	Excess inventory holding costs
Poor yields	Capital waste
Expensive disposition	Social and environmental costs
Vendor rejects	Safety and reliability risks
Excess purchasing expense	

with design application and monitoring progress toward new-product development. For example, at Data General, project leaders for new computer hardware and software designs are responsible for all phases of engineering, from initiation of designs to market introduction.

The integration extends to marketing research specialists, who provide the connection between customer needs and production. Thus companies develop new-product designs by harmonizing marketing and engineering expertise. A total quality control concept evolves in which a wide range of personnel who are empowered with decision-making responsibilities in design, production, and marketing cooperate to influence product development.

Product and life cycle analysis. This kind of control requires market analysis, a competitive (or industry) analysis, forecasting, and customer evaluation. The product must be assessed for image, reliability, functionality, appearance, serviceability, and operational cost to consumers. R&D engineers will have one part of this responsibility; market researchers another; and perhaps specialists such as psychologists yet another. If a team approach to control is taken, small groups of these experts will be empowered to monitor products and services and recommend appropriate changes to extend their life cycles.

Materials control and purchasing. Characteristics of materials to be used in manufacturing must be studied, their availability must be assured, and the reliability of suppliers under consideration as primary sources for materials must be evaluated. Adequate materials of the right kind and price must be available for production. Quality material control also encompasses systems for handling materials before, during, and after production.

Production control. Well-designed, cost-effective products may never get off the ground because of production limitations. Designers come up with exceptional new ideas all the time that a firm simply is not equipped to produce. Therefore production control managers and shop-floor engineers must be brought into the design process to ensure that the firm is working on feasible projects.

Special needs. There are many special considerations that affect product design. For example, new products may require changes in market distribution systems. Some may need special handling because they contain sensitive materials. Materials used in production may be subject to legal constraints such as EPA regulations. Unusual equipment may have to be purchased. Labor union constraints may prevail, or additional capital may be required. A total commitment

The integration of engineering responsibilities has become popular at many companies, including GM, IBM, 3M, Hewlett-Packard, Apple, and Convergent Technologies. These companies have found that new projects are developed more rapidly and with greater success by including people from other disciplines in their design team.

Source: W. Alan Randolph and Barry Z. Posner. *Effective Project Planning and Management: Getting the Job Done* (Englewood Cliffs, N. J.: Prentice Hall, 1988), pp. 73–74, 101–03.

to quality requires these and other issues that affect products, design characteristics, and methods of manufacture be resolved early in the design stage.

Product Controls

Historically, the notion of quality control was identified with control and inspection of the physical product, but this is only a small part of the picture. Product control for quality requires in-plant controls from the point of purchase to end-use field controls related to customer service. Note that there is a difference between product control and production control. **Product control** is concerned with reducing costs associated with poor quality and unreliable products, whereas **production control** is concerned with controlling the manufacturing process. The following discussion focuses on product controls.

Inspection and testing. Companies evaluate products at strategic points during manufacture to determine whether work and materials conform to standards. Inspection and testing require specialized skills for spotting problems and directing corrective action. Most U.S. firms train a select cadre of inspectors to perform these tests and make inspections, which include:[12]

- *Acceptance sampling.* Inspections may occur on receipt of raw materials, at critical points when subassemblies are completed, during manufacture after important processes, and prior to shipment when products are finally completed. Sampling data are used to make cost-effective evaluations on larger numbers of items, to accept or reject entire batch runs called *lots*.

- *Detailed inspections and tests.* These are performed on every finished product to sort out substandard items or identify inadequate processes. In some instances, close surveillance and careful testing methods are used because there is no room for error. Medicine is a good example.

- *Control sampling.* Periodic tests are done to detect significant variations in production processes or workmanship. Control charts are often used to compare performance deviations, but added control samples may detect early problems with machines, worn tools, bad parts, poor work flow, or personnel problems.

- *Quality rating inspections.* These procedures are used to classify processes or products with differences in quality. For example, eggs can be graded into several classifications according to size and color; oranges are also sorted for several characteristics. In lumber production, one processed tree yields a small proportion of high-grade wood useful in furniture manufacturing, medium-grade wood used in construction, and by-products for plywood fill or pulp.

- *Qualification testing.* Products are tested for performance to determine reliability criteria and safety features. Testing is also done to rate product capabilities. This occasionally takes the form of destructive tests, such as crashing cars to study accident characteristics. Drugs are tested in laboratories and clothing samples are tested for flame resistance.

- *Accuracy inspections.* Comparative tests by inspectors or instruments are only as accurate as the testers of their equipment. Therefore inspectors and instruments must be periodically evaluated. For example, calibration equipment is used to evaluate and correct deviations in test instruments. Inspectors are evaluated in laboratory settings to sharpen their skills.

Sensory evaluations. Quality cannot always be determined by technical standards and test results. Intangible characteristics of products or services may influence perceptions about quality.[13] Consumers judge the quality of many products

product control
Product control is concerned with reducing costs associated with poor quality and unreliable products.

production control
Production control is concerned with controlling the manufacturing process.

according to color, image, smell, taste, and other sensory perceptions. Controlling quality in terms of sensory criteria is subjective and difficult. Sometimes this is done with a simple sensory tests during production, such as taste tests by panels of experts or visual judgment evaluations. Other times comparison reviews are needed. These use preferred samples—such as swatches of fabrics with high-quality designs as the standard against which samples from production are judged.

In one type of sensory evaluation, market researchers employed by coffee manufacturers designed tests, surveys, or experiments to document what consumers want or expect from their coffee. They learned that coffee drinkers value aroma, taste, color, caffeine content, ability to reheat, consistency, and labels like "Colombian" and "mountain grown." Consumers were also influenced by packaging, container shapes, and perceptual factors, such as the notion that "fresh ground" is better than instant coffee. Since many of these perceptions were created in consumer minds by market promotions, the researchers were actually monitoring the effects of their company's promotional strategies.

Sensitivity analysis. Beyond field investigations and experiments, analysts must monitor subtle changes in consumer preferences. For example, coffee tests continue long after the product is established to detect consumer shifts toward low-caffeine blends, relative changes in preferences for instant blends or certain types of grinds—anything that might signal a major change in product needs. The introduction of automatic coffee makers, for instance, created a buying surge in drip and automatic coffee-maker blends.

Competitors' quality. Market analysts, engineers, and a host of other managers monitor the quality standards within an industry to assess subtle differences in competitors' products and services. It is not uncommon for a company to buy competitive products and then perform rigorous inspections and tests to compare them with the company's own products. Technical products such as microcomputers, earth movers, and machine tools are often "backward engineered" to assess competing products—and to learn how to make them. Backward engineering consists of tearing down a product to its last bolt, then documenting its restructuring.

Service and Use Controls

Service to customers does not end with a sale. After-sale service is a crucial part of quality management. If product quality is poor, or if something goes wrong with delivery and installation, the added costs to cover repairs and warranties can be huge. Quality costs of repair and replacement across ten major U.S. manufacturing sectors averaged 5.8 percent of total sales revenues during the 1970–1980 period. Warranty costs in U.S. durable goods manufacturing averaged nearly 6 percent of sales annually in the early 1980s. This record has not improved significantly in recent years, and J. M. Juran, one of the gurus of industrial quality training, estimates that the costs of customer complaints, product liability lawsuits, redoing defective work, and scrapped products exceed 20 percent of sales.[14] This figure rivals or surpasses average profitability in many industries.

Controls on service and use extend from monitoring customer support to obtaining feedback on warranties for production and design changes. Few of these activities are the responsibility of shop-floor supervisors; marketing managers and customer service field representatives usually supervise quality control for after-sale service. In one recent study, 35 percent of all customer returns were attributed to marketing service errors, and another 10 percent to mistakes in shipping and installation. In 5 percent of the warranty cases, the customer misused a product because of poor instructions or shoddy service by the company.[15]

Interplak, a division of Bausch & Lomb that manufactures expensive dental instruments, improved sales from $5 million to $120 million between 1985 and

FIGURE 17-3 Service and
Use Controls.

1989. The company's success is attributed to a strong after-sale service and follow-up program that has every regional sales office interviewing 98 percent of dentists in its area—those who buy Interplak as well as those who do not—to evaluate product reliability and consumer use. Interplak also uses consumer focus groups to gather information about product design and perceptions of the company's marketing. As a result, Interplak has made several major changes each year in its products, packaging, and instructions on oral hygiene provided to buyers.[16]

Figure 17-3 illustrates the relationship of quality to service and use controls. Several important issues that managers must consider are:[17]

■ *Packaging and delivery controls.* These ensure customer satisfaction, safety, and service. Package design is important not only for product image but also to protect against such hazards as tampering, moisture, spoilage, and theft. Package designs must also serve customer needs—for example, by providing labels with important safety and use information. The average cost of packaging and handling durable goods in U.S. manufacturing is about 22 percent of total costs. In the chemical industry, these costs can be as high as 60 percent.[18]

■ *Transportation and storage costs.* To determine the best methods of shipment with the least damage to goods, packing and handling techniques are tested and alternative modes of transportation are evaluated. Storage facilities are evaluated for safety and capacity, and customer facilities are checked because most customers have limited handling equipment.

■ *Installation service controls.* Quality control of installation is critical in reducing customer misuse. Many customers associate product quality with quality installation and after-sale service, expecting companies not only to honor warranties but also to provide continuing service.

CHECKPOINT

■ Describe how design controls are used to improve product reliability.

■ Contrast different types of inspections used in product control.

■ Discuss service and use controls that help consumers use products safely and correctly.

work of participative behavior. Successful MBO programs are characterized by periodic reviews and joint meetings between superiors and subordinates to assure goal-directed behavior and coordination.

The motivational advantages of MBO can be great when a climate of participation evolves. Then subordinates can achieve the self-control that transforms them from spectators into stakeholders. Proponents of MBO are convinced it works in most organizations when managers are willing to change their philosophy of managing human resources. For firms that are too small to have an MBO program, or that have intractable management styles, the idea is probably of little value.

Behavioral Assessment Controls

Managers use performance evaluations extensively to assess individuals and provide feedback. These are typically one-on-one techniques and cannot properly be called systems for human resource control. Nearly all performance evaluations rely on subjective methods. When applied consistently, these methods provide continuity among organization members and enrich communications.[44]

Differentiation and integration. Paul Lawrence and Jay Lorsch have suggested that in order to assess individual needs and change, it is first necessary to differentiate roles and see how they are integrated into organizations.[45] Essentially, the concept is that persons working in one situation will require different work schedules, rewards, and skills than persons working in other situations. For example, sales representatives deal with an external world of volatile markets requiring unstructured decisions, whereas production managers often work in regulated environments requiring structured decisions.

Organizations can differentiate individual roles by using psychological testing, periodic assessment tests on performance, comparison reports on group activities, and individual ratings on behavior. Performance is improved through more effective selection, reassignment, and training for specific roles. Rewards can then be coordinated equitably with these roles.

Intervention. Intervention techniques constitute an entire discipline of control methodology aimed at modifying behavior of both individuals and groups. Intervention usually requires a professional from outside the organization to evaluate needed changes and help implement them. These professionals are change agents or catalysts who are expert at facilitating creative modifications to behavior. **Organization development (OD)** is the name for this discipline; it implies that change agents help organizations develop improved performance systems.

organizational development (OD)
The process of changing organizations through behavioral science techniques, such as consulting intervention to improve performance, leadership, or decision-making systems.

OD and behavioral modification programs focus on many elements of performance. For example, programs may be targeted to alter planning systems, to sharpen managers' attention to critical objectives, to retrain managers, or perhaps to alter leadership patterns.[46] OD programs also deal with structural changes in management hierarchies, conflict resolution, job design, and influencing changes in organizational culture. These topics and OD changes techniques are discussed in detail in Chapter 19.

Programs for Improvement

Intervention and behavioral control techniques foster a wide array of programs. Three of the most common are:

■ *Personal development programs.* These include training seminars to upgrade specific skills, tuition assistance benefits for employees, and per-

sonal development efforts, as well as health, physical fitness, counseling, and social programs that enrich the quality of working life for employees.

■ *Management development programs.* These are concerned with upgrading professional skills. Seminars typically address a broad range of topics, ranging from how to improve listening skills to how to deal with robotics maintenance problems. Many seminars are aimed at specific groups such as first-line supervisors and offer assistance on a variety of issues from budgeting to using new MRP systems.

■ *Special topics programs.* These programs aim to resolve specific problems. In recent years, firms have sponsored productivity improvement, job enrichment, sensitivity training, and cybernetics programs, as well as courses in stress management, quality control, safety, computer literacy, and Japanese management techniques.

CHECKPOINT

■ Explain how a management audit improves leadership and managerial decision making.

■ Describe and contrast the three levels of concern for a social audit.

■ Discuss how MBO is used to integrate planning and controlling.

■ Explain how behavioral assessment controls enhance a company's internal control systems for improved quality and productivity.

New methods of intervention are continually being developed by specialists and educators, all with the rationale of improving organizational performance. Control programs that appear to have purposes other than control, such as skills training, are sponsored by companies because management believes they enhance individual or group performance.

There are many considerations for controlling behavior beyond the scope of this chapter. Most behavioral techniques are not primarily for use in controlling people—at least not consciously, as one would control materials. However, managers are responsible for helping employees to become more productive members of their organizations through quality performance. The relative emphasis on controls, and the types of techniques employed, may differ among managers, but the quality-productivity connection is irrefutable. This was emphasized at the beginning of the chapter in the case of Control Data Corporation. After establishing clear objectives for manufacturing computer systems without defects, CDC achieved a 99 percent quality record. Its success is attributed to exquisite manufacturing and service controls—a system of JIT management that minimizes inventory and capital expense—and a commitment by all employees to error-free performance.[47] ■

1. Discuss how improved quality enhances productivity.

Productivity is measured by a ratio of output to the total resources a company uses to create that output. Higher quality translates to higher productivity, because companies use fewer resources to provide manufactured products or services to customers.

The costs of poor quality are defective products that must be re-worked, serviced, or replaced, wasted materials, inefficient use of human resources and facilities, and excess inventories that add to capital overhead. From a social viewpoint, low-quality products result in wasted natural resources, unnecessary costs of disposition, and safety problems. Higher quality and productivity significantly reduce costs for companies and for society.

2. Explain design, product, and service and use controls.

Design controls are used to improve product reliability and reduce costs. Product controls include acceptance sampling to ensure high-quality manufacturing, tests of finished products to ensure reliability, and accuracy tests of both inspectors and their equipment to improve quality and product control systems. Service and use controls (such as field warranty checks, installation evaluations, and consumer surveys) focus on after-sale results.

3. Describe material controls and inventory management.

Material controls are concerned with efficient purchasing to provide to production when needed materials with the correct specifications in the right quantities. Inventory controls are concerned with receiving, storing, handling, and transporting three types of inventory: raw materials and parts to be used in production, work-in-process inventory that represents partially made or assembled products, and finished goods that are ready to ship to customers.

4. Describe and contrast EOQ, MRP, JIT, and statistical process controls.

EOQ is a model used to reduce costs associated with ordering and holding incoming materials. MRP is a computer-based system of scheduling purchasing and production in an integrated model. JIT is a management approach that eliminates inventory and defects by providing materials and parts directly to manufacturing points without intermediate stocking or warehousing. JIT also requires that precise quantities of materials be delivered without faults. Thus any deviation in delivery or quality will disrupt production. However, JIT eliminates the capital costs of inventory and requires—ideally—perfect quality performance.

5. Discuss production control and uses of PERT and CPM.

Production control is the process of monitoring operations to ensure quality manufacturing and on-time performance that complies with schedules. Companies faced with complex projects and production processes that require complicated sequential operations often use PERT or CPM, two network control systems. PERT maps out the sequence of events necessary to complete a project. It identifies the sequence of events and activities required for each event to graphically show management how work is to proceed and the time required to complete each event. CPM is similar to PERT, but also identifies alternative routes for scheduled events if original estimates of activities turn out to be too optimistic or too pessimistic. The "critical path," is the longest time period and sequence of events required to complete a project.

6. Explain management and social audits and the use of MBO in controlling.

A management audit uses surveys, interviews, and observations to appraise leadership performance. Managers are evaluated on how they handle subordi-

nates, schedule work, control quality, cooperate with peers, and reach their objectives. A social audit assesses a company's responsiveness to issues like product safety, environmental protection, consumer rights, community service, and ethical behavior by managers.

MBO is used to integrate planning and controlling activities in a participative environment. The MBO process mirrors a general control model in which subordinates and superiors jointly determine objectives and establish action plans for subordinate performance. Action plans contain realistic criteria for monitoring progress. Periodical progress evaluations between subordinates and superiors compare objectives with short-term results. Corrective action is taken where needed, and the MBO cycle is repeated.

SKILL ANALYSIS

CASE 1 Controls in Computer Manufacturing Plague Managers

A market shakeout for home computers occurred during the late 1980s as many marginal firms failed and many more were bought out by larger firms as major manufacturers took a dominant lead in sales. One of the smaller companies caught in this shakeout faced bankruptcy in 1988 even though it had had several years of excellent sales and growth. At its peak in 1987, this firm had a nationwide network of outlets with $180 million in sales, and from a marketing standpoint, the future looked exciting. But business turned sour quickly when major players in the computer industry aggressively positioned themselves with new, high-quality products and lower prices.

The company's managers and stockholders could not believe that disaster came so quickly, and when bankruptcy was apparent, there were several heated discussions. Some managers blamed workers, others blamed the poor quality of materials, and still others said that subcontractors were passing rejects. Stockholders blamed management, and retailers were unhappy with design engineering. All that was certain was that in spite of very good early sales, the firm's microcomputers had not kept up with customer expectations or remained competitive with the industry. Too many rejects were being rushed out of the factory; upgrade and peripheral designs seemed to be stalled or inadequate.

Closer inspection revealed several specific quality problems. In-process defects the previous year were more than 227 per 1,000 units. Reasons for this included: (a) defective casings and chassis with misaligned parts requiring substantial rework, (b) defective chips and electronic components requiring replacement in about 8 percent of sold units, (c) poorly constructed cable assemblies that required rework or replacement in 12 percent of units sold, and (d) assorted rejects of assemblies due to workmanship errors and handling mistakes.

Reports presented to the stockholders showed that most of these defective parts and subassemblies were purchased from outside vendors. Costs for materials and vendor chargebacks were estimated at 9.2 percent of total costs of operations. Meanwhile, the firm made up replacement pins and cable connectors that were unaccounted for in production summaries. Although managers did not itemize workmanship errors, they estimated that in-plant costs of materials and scrap were 3 percent of total costs. They pointed out that this was not excessive, but vendor problems were huge. The firm apparently maintained large safety stocks to assure smooth production runs.

Stockholders were unimpressed with this explanation and accused company executives of trying to find scapegoats among vendors.

One influential stockholder who also owned several retail computer stores pointed out design faults. He said the firm's computers had small screens, a compressed keyboard, and limited operating characteristics that would not support mainstream software. The combination of these factors, he noted, led to substantial discounting by retailers, and this in turn had put pressure on the firm's representatives to further discount to retailers in order to move its products.

The vice president countered this criticism by arguing that the firm's product was supposed to be a low-end, low-priced home computer that could not be expected to compete head on with big office systems. He further implied that several vendors were exploiting the market with high prices and low-quality materials.

Another stockholder at the meeting was also a supplier of some of the electronic parts used by the firm. Enraged by management's position, he threatened a lawsuit that would hold them all personally liable for mismanagement. He blamed design faults, but also noted that warranty replacement costs and service modifications absorbed far more than the explicit costs showed by management. Where was their quality control, he asked. Where was their concern for customers' design needs? The meeting ended with charges and countercharges leading nowhere.

Case Questions

1. What questions would you ask management about quality costs and production losses if you were a stockholder? What costs are associated with these issues?
2. Identify and discuss the apparent vendor and purchasing controls the firm might have employed to reduce losses and improve quality.
3. Discuss the design and warranty problems. Are these quality issues real, or was the vice president's perception reasonable?
4. How would you proceed to evaluate customer needs in the home computer market?

CASE 2 First Chicago Corporation Explores MBO for Bank Quality Control

Looking forward to the decade of nineties, First Chicago Corporation president Richard L. Thomas challenged his bank managers to redefine how quality banking services are achieved.[48] FCC is among the top 20 U.S.-based commercial banks with global subsidiaries, and the first task was to restructure internal bank management controls. Thomas created a strategic bank quality services unit that, during a two-year period, implemented "client service teams" at more than a hundred locations where operating managers dealt directly with bank customers. These were coordinated through "relationship managers" who became in-house consultants on services and liaisons to top management. The thrust of Thomas's program was to position FCC for the 1990s, providing customers with fast and accurate transaction services through cost-efficient banking systems.

A strategic team at First Chicago identified more than 700 quality service indicators that could be tracked and measured. Drawing from customer expectations and industry standards, FCC planning teams established levels of minimum acceptance for each of the indicators, and then through weekly performance meetings with operating managers and client service teams, began to devise ways to improve performance. The relationship managers acted as conduits of information for client service teams and operating managers, such as loan officers and department heads. These managers were challenged to use information from corporate bank clients, identifying relevant measures of quality from among the 700

indicators, to establish operating objectives and plans for reaching their objectives.

For example, in the area of commercial cash transactions where corporate bank clients conduct large transfers of cash, managers had nearly 80 performance indicators to consider. Three of those indicators were crucial. They included remittance banking in which clients received payments from third-party banks, cash transactions in which bank clients executed payments of money transfers, and personal transaction services in which the bank typically handled client transactions initiated by telephone.

FCC tracked remittance transactions since 1982 and found that prior to computerized services, errors occurred at least once in every 4,000 transactions. This record of errors seemed quite low, yet it also meant that customer transaction errors occurred about every four hours. Client service teams determined that no more than one error in 10,000 was acceptable. In terms of cash transactions, a cost indicator showed that that bank spent $10 every time it made a transaction correctly the first time. When there was an error, it cost the bank more than $400 to correct. Errors alone cost FCC between $7 million and $10 million annually. Client service teams tracked processing time for customer-initiated telephone transaction services, and they found that over a five-year period, a telephone order took nearly 20 minutes to complete. Based on overhead costs, these transaction costs exceeded bank revenues generated by the service; the break-even point was about 13 minutes per transaction.

Using this information, operating managers responsible for commercial cash transactions decided to institute management by objectives (MBO). They felt that a program with planned objectives and periodic controls was essential to improve performance.

Case Questions

1. Explain how an MBO program would be organized within the hierarchy of operating managers, client service teams, and relationship managers.
2. Discuss how MBO objectives might be established concerning the three examples of performance indicators.
3. Describe how performance might be monitored and how a review process might be established for operating managers.
4. Discuss briefly how corrective action might be taken to help managers improve.

SKILL PRACTICE

THE QUALITY CIRCLE MEETING

Introduction

The idea of quality implies highly reliable and error-free services and/or products. However, the perception of quality is in the eye of the beholder, and customers do measure quality by how well products or services fulfill expectations at given prices.

Quality problems can result from substandard materials, erratic supplies, improper purchasing, poor workmanship, design faults, and management mistakes. Quality also relates to product safety and reliability which, if poor, can lead to legal costs and large losses in customer sales. These are very sensitive

SKILL PRACTICE

TOO MANY PAGES

Introduction

Our need for voluminous amounts of information, coupled with our ability to rapidly produce printed documentation, is drowning readers in a sea of paper. Some have called this problem "information indigestion."

The U.S. Navy is currently faced with this very problem. A Navy cruiser may carry up to 26 tons of technical manuals with operating and maintenance instructions for its complex weapons systems. Each ton of paper that a ship has to carry means one ton less is available for fuel, or ammunition, or other supplies.

Even if well-indexed, a large manual requires considerable technical knowledge on the part of the user to find the information required to perform a maintenance function. Often two or three manuals have to be accessed simultaneously during a maintenance task. Only a couple of pages may be needed from each manual, but the entire manual must be carried to the work location. Updating these manuals is another major problem. Either the entire manual must be reprinted and distributed, which can cost millions of dollars, or new pages must be printed and distributed. These changed pages must then be manually posted by sailors throughout the Navy. What the Navy needs is an economical alternative to paper technical manuals. This alternative must act like a book and cost like a book, take up less space, provide more aid to the user, allow the user to interact with it faster, and reduce the update burden. There are millions of pages of technical manual documentation currently in existence. Any computer system that would replace them must be capable of digitizing this documentation at a cost of only pennies per page. It must produce an image that looks like a technical manual page, including foldouts and pictures. And it must allow the user to access any page in a manual at least as quickly as it can be accessed in the paper documents.

Instructions

- Small teams will be formed by the instructor with four to six members in each one. Each team will be part of the Super Tech Consulting Corporation. Thus, the teams will be Super Tech One, Super Tech Two, and so on. (10 minutes maximum)

- Each team should consider the problem the Navy faces with modernizing its bulky manuals. Consider the five key characteristics: accuracy verifiability, completeness, relevance, and timeliness. Teams should also consider MIS, DSS, Expert Systems (ES), and Teleconferencing.

- Teams should brainstorm the problem for 20 minutes, then scan the ideas generated and select the three that are considered by team members to be the most promising. These three should be ranked. (10 minutes)

- The instructor will ask one person from each team to present their top three ranked recommendations to the class and will make comments on the optimum solution, given realistic constraints in the Navy's situation. (10 minutes)

Source: Based on an article by George Dougherty, "Books Don't Float", *The Data Bus*, August 1987.

Becoming a Just-in-Time Vendor

A company implementing just-in-time manufacturing must help its suppliers become just-in-time vendors. Some manufacturers believe that all they have to do is tell their suppliers "Starting tomorrow, deliver 100 percent defect-free materials only when needed and only in the quantities needed," but it's not that easy. Westinghouse Electric Corporation found this out as it changed in recent years from a "traditional" vendor to a JIT vendor. The firm's JIT vendor role began in its Asheville, North Carolina, plant in 1986 when a major buyer insisted that WEC provide inventory on a JIT basis.

Joy Technologies, Inc., was the catalyst buyer. For years Westinghouse had supplied it with electrical components that Joy used to assemble machine tools and equipment. The traditional process was for Joy to place an order for bulk shipment of components well ahead of the time they would be needed. Westinghouse combined Joy's order with those of perhaps dozens of other buyers. Then, after receiving a sufficient number of orders, WEC assembled the components and bulk shipped in economic order quantities. The process consisted of mass assembly, stockpiling, mass shipment from a large finished goods inventory, and mass billing of buyers. Like other buyers, Joy ordered in advance and in large quantities to create "safety stocks".

Joy's purchasing process took from twelve to sixteen weeks and resulted in management placing large orders a few times a year while carrying three to four months of beginning inventory in stock. Westinghouse, in turn, lumped orders and created huge production runs based on EOQs several times a year for a number of electrical assemblies. It therefore carried huge stockpiles of wire and raw materials and juggled production schedules. Customers seldom knew when they would receive materials, and both buyers and vendors were in a constant state of frustration over delays.

Things began to change rapidly when the Asheville plant found itself in danger of losing the Joy account. Other Westinghouse Corporation plants had already begun to implement a concept of "village" manufacturing based on JIT, and, with Joy's prodding, WEC of Asheville made a major commitment to change.

Village manufacturing groups "cells" of workers and techniques in self-contained work areas. Such cells resemble autonomous work groups within companies. Once a schedule is created by production control, the village takes full responsibility for assembling, wiring, testing, and packaging products for delivery. After Asheville implemented the village concept, Joy and other manufacturers were able to place orders on a weekly basis—or more frequently—for small quantities of components. The village crew created custom-sized deliveries of inventory rapidly and also placed smaller orders of primary parts and materials on a frequent basis to avoid stockpiling. To achieve this, five areas had to be addressed at Asheville:

1. Every assembly had to have improved engineering drawings with careful design work to eliminate errors, ambiguities, and the need for bulk purchasing. This policy was vigorously pursued at WEC, and it resulted in improved products with simplified manufacturing and purchasing from the village vendors.

2. Flowcharts were developed in concert with village crews to solidify the best assembly process. This simplified process aimed at rapid and efficient procedures for error-free work.

3. For each assembly, new fixtures and dedicated equipment were designed for manufacturing and inventory handling. The process became a flow process without stockpiling and with minimum setup time; since they had dedicated equipment and procedures, the crew could make any size order from one to hundreds of units precisely matching a buyer's order.

4. Quality control became a 100 percent process within the village, with rigorous test procedures on every item made. Using newly designed QC equipment and testing processes designed for the precise item being made in a village, a very high degree of reliability was achieved without interruptions or cumbersome sampling techniques.

5. The village crew created new methods of packaging and labeling that allowed either a small purchase or major orders to be filled with speed and accuracy. As products were finished, they were packed, sorted, and shipped almost immediately, minimizing finished goods inventory.

The village inventory of parts was controlled through a "visual bin" process that represented close to the exact number of items needed for a day's production. Each evening, orders scheduled for the next day were reviewed and parts stocked. As this simple hands-on process evolved, a fully integrated MRP sys-

organization. Its major drawbacks are its disruptiveness, particularly if lower ranks don't accept the change, and its tendency to disregard human needs.

Bottom-up Change

At the other extreme, change may be instituted at the lowest organizational level. Strategic issues, technological mandates, and similar matters remain focused at the highest echelons, but responsibility for initiating operational changes is shifted downward. Top management tries to steer clear of operational decisions and innovations while encouraging a constructive change process.

A well-managed system that encourages **bottom-up changes** will be human-relations oriented, supporting individuals and small groups in their efforts to innovate and test new ideas. Hewlett-Packard is one of the foremost firms practicing the bottom-up approach. HP executives strongly encourage individual initiative at every level. Johnson & Johnson, 3M, Xerox, Merck, Disney, American Express, Delta, and Lincoln Electric also welcome grass-root changes.

Effective managers create a climate in which employees do not fear to make suggestions, change their approach to work, or attempt to alter the way things get done. The bottom-up approach does not imply participatory decision making, but rather an open environment that encourages individual initiative. One benefit of the bottom-up approach is that individual creativity is fostered. Another is that once change is approved, those who suggested it will be committed to seeing it through.

bottom-up change
An open environment for change where employees are encouraged to take independent action, initiating or recommending organizational adaptations.

Participative Change

One of the foremost writers on participatory management, Edward E. Lawler, suggests that organizations vary dramatically in their leadership and human relations profile. Thus it is vital to choose a complementary involvement strategy to effect a **participative change**.[19] Lawler notes three general models of involvement:

participative change
A strategy of implementing change through cooperative efforts, team decision making, and group initiatives.

- ■ *Suggestion*. In this approach, traditional authority structures prevail but employees are encouraged to make suggestions. Involvement is generated through group meetings, perhaps formal quality circle programs, and review systems within the hierarchy of management. Employees who make valuable suggestions may be brought into the change process or simply be rewarded by bonuses or other recognition.

The 3M company introduces more than 200 new products annually. The company achieves this output because its R&D technicians and engineers spend 25 percent of their time "bootlegging," or tinkering. One employee who "bootlegged" developed Post-it note pads. 3M has also responded to shop-floor initiatives, changing employee work hours and benefit systems and creating new methods of janitorial service.

Source: Christopher Knowlton, "What America Makes Best," *Fortune,* March 28, 1988, pp. 40–45. See also Thomas J. Peters and Robert H. Waterman, Jr., *In Search of Excellence: Lessons from America's Best-Run Companies* (New York: Harper & Row, 1982), pp. 243–46.

- *Job involvement.* Lawler builds on Frederick Herzberg's concept of job enrichment for this approach. Although a traditional hierarchy of management may prevail, individuals control how work is accomplished. Even if a company has no formal parallel structures such as quality circles, team performance is emphasized, along with skill-based rewards and personnel policies that support individual growth and development.
- *High involvement.* This descriptive label by Lawler implies an egalitarian approach to involvement. Individuals make decisions about work methods, have input to strategic decisions, and often serve on formal task forces to resolve major business issues. The organization may be traditionally structured, or it may be designed around business units and work teams. It is more likely that work teams will parallel functional management structures, but in any case, team skills are emphasized.

Lawler believes that simply choosing to implement change strategies through "participation" is too vague to work. A definite approach must be fashioned, but if it does not mesh with existing practices, the change to participation can be extremely disruptive. Nevertheless, tremendous benefits can be reaped from widespread involvement. The process itself opens many topics to constructive debate, and sensational ideas can emerge from collaboration. Commitment follows consensus, and although complete consensus is seldom achieved, merely moving toward it increases support by employees.

The Japanese are famous for making shared responsibility work. Their results have stunned many Western managers, who have watched their markets erode as more productive Japanese firms won customers. However, the Japanese culture accentuating consensus and conformity to group standards evolved over thirteen centuries. Just as we are fiercely independent, the Japanese are emphatically collective in decision making. Japanese executives are expected to be social leaders who facilitate group strength and harmonious human relations. They are also expected to sacrifice their individual goals for the good of the organization. In contrast, U.S. executives are expected to show individual strength and to bring drive and determination to their firms. Unlike the Japanese, American executives view the personal sacrifice of individual goals with horror. We prefer to think our organizations should accommodate individualism.[20]

Reconciling Change Approaches

At present, no one approach to change prevails. Western firms are so diverse and operate under so many different environmental constraints that it is questionable whether any approach will ever prove superior in all organizations.

In Western cultures, certain changes are best initiated by top management, whereas others are better initiated through shared processes. Technological changes often require company-wide or industry-wide leadership. A bottom-up approach is preferred when organizations need to cultivate an entrepreneurial spirit in the lower echelons. Participative methods will work best when behavioral change at all levels is necessary. It should be remembered, however, that even the Japanese with their preference for consensus decision making are careful to protect power and status.

Managing Resistance to Change

As noted earlier, serious personal and emotional barriers may hinder change. Table 19-1 summarizes several suggestions for dealing with resistance to change.

TABLE 19-1 Methods for Dealing with Resistance to Change

Approach	Commonly used in situations	Advantages	Drawbacks
Education + communication	Where there is a lack of information or inaccurate information and analysis.	Once persuaded, people will often help with the implementation of the change.	Can be very time-consuming if lots of people are involved.
Participation + involvement	Where the initiators do not have all the information they need to design the change, and where others have considerable power to resist.	People who participate will be committed to implementing change, and any relevant information they have will be integrated into the change plan.	Can be very time-consuming if participators design an inappropriate change.
Facilitation + support	Where people are resisting because of adjustment problems.	No other approach works as well with adjustment problems.	Can be time-consuming, expensive, and still fail.
Negotiation + agreement	Where someone or some group will clearly lose out in a change, and where that group has considerable power to resist.	Sometimes it is a relatively easy way to avoid major resistance.	Can be too expensive in many cases if it alerts others to negotiate for compliance.
Manipulation + co-optation	Where other tactics will not work, or are too expensive.	It can be a relatively quick and inexpensive solution to resistance problems.	Can lead to future problems if people feel manipulated.
Explicit + implicit coercion	Where speed is essential, and the change initiators possess considerable power.	It is speedy, and can overcome any kind of resistance.	Can be risky if it makes people angry at the initiators.

Source: Reprinted by permission of *Harvard Business Review*. An exhibit from "Choosing Strategies for Change" by John P. Kotter and Leonard A. Schlesinger, issue March/April 1979. Copyright © 1979 by the President and Fellows of Harvard College; all rights reserved.

- *Education.* Communicating with employees through an educational approach is advantageous when people need additional information to accept and implement change. It can, however, be time-consuming.

- *Participation.* Building on the participative approach to change, managers can reduce tension and improve cooperation for implementing needed changes. People who are involved tend to be committed. However, this can also be a time-consuming process.

- *Facilitation.* Often managers cannot overcome resistance without outside assistance. Facilitation is the process of bringing in specialists to intervene in constructive ways to make change go more smoothly. (See the discussion of organizational development in the next section.)

- *Negotiation.* A common method of reducing resistance is negotiation between those seeking change and those resisting it. This policy is not uncommon in unionized environments and often ends in a compromise agreement. If negotiations are constructive rather than adversarial, mutual agreements and cooperative behavior should result in smooth change processes.

- *Manipulation.* This is not advocated as an explicit strategy; nevertheless, managers who manipulate employees often get results. The earlier discus-

sion on ethics in change behavior illustrated how dangerous this strategy is, yet it regularly occurs.

■ *Coercion.* A straightforward use of authority overcomes resistance simply by dictating change. Coercion is the least acceptable form of change management, though there are many situations where force is expedient. For example, changes mandated by new laws require enforcement tactics by management; coercion takes the form of disciplinary action when individuals resist such legal changes as equal rights and affirmative action.

Resistance is a pervasive problem because few people accept change without a rationale. Some situations require a forceful approach. For instance, integration of public schools during the late 1950s and early 1960s was a tremendous change in organizational relationships. Without dramatic and often unpleasant tactics, including using armed guards to enforce court orders, integration might never have been accomplished. In most situations, however, change is more subtle and less emotional, and managers "sell" rather than "force" it. Figure 19-4 illustrates the differences between these two approaches.

The selling approach underscores participation. When employees have insufficient information to see the need for change, management initiates a communication program that accurately informs them about why change is needed, how it will be implemented, and what results it will have. This creates a cooperative environment with long-term benefits. When operating managers are not skilled enough to communicate effectively with employees, lack credibility, or simply don't have the time to oversee a change program, an organization may have to turn to outside consultants.

CHECKPOINT

■ Define and contrast top-down and bottom-up change processes.

■ Explain different levels of involvement by employees in a participatory change process.

■ Describe three reasons why individuals resist change.

■ Discuss how managers can overcome resistance to change.

FIGURE 19-4 Coercion versus Participation

ORGANIZATIONAL DEVELOPMENT

Much of what we have explored so far in this chapter relates to the field of organizational development. Wendell L. French and Cecil H. Bell explain **organizational development (OD)** as an effort to renew organizational processes, emphasizing cultural change patterns, by working with individual managers and teams.[21]

OD has been debated as a formal field of study. In one view, it is the application of intensive educational programs aimed at modifying managerial behavior toward more participative decisions and leadership.[22] Others avoid the term *OD,* preferring to refer to intervention consultants involved in these changes as "culturalists."[23] However they are labeled, consultants who become involved with organizations almost always change processes, work methods, jobs, structures, or patterns of behavior. They are expected to intervene, and if not to resolve specific problems, at least to act as catalysts for constructive change.

organizational development (OD)
The process of changing organizations through behavioral science techniques such as consulting, intervention to improve performance, leadership, and decision-making systems.

Assumptions for Intervention

French and Bell provide a comprehensive view of OD intervention and why changes in managerial behavior tend to improve organizational effectiveness. At the heart of OD is the assumption that nearly everyone can contribute much more to the attainment of objectives than current practices permit. The authors suggest that individuals have untapped energies that are often throttled by outdated ideas of authority and leadership. They also conclude that employees will be more cooperative if involved in team decisions.[24]

According to French and Bell, several conditions are critical to the success of OD programs. First, key people need to understand the value of behavioral intervention and become involved in the OD effort. Second, top management must actively support OD programs by committing resources and encouraging lower-level involvement. Third, OD programs must be continuing, long-term efforts if they are to enable participants to grow and experience successful changes. Fourth, an action research model that systematically provides diagnostic activities, information gathering, and articulation of plans must be followed. Finally, participation by managers, team members, and staff specialists is critical.[25] These assumptions and conditions for success provide a framework for intervention. The underpinning objective of OD is to expand participation through team-building techniques, as Figure 19-5 illustrates.

FIGURE 19-5 General Process of OD Intervention and Team Building for Change

OD Intervention Activities

There is a rapidly expanding list of activities by OD consultants. Some of the most notable are:[26]

- *Diagnostic activities.* Data is collected and analyzed using methods such as questionnaires, interviews, structured observations, group meetings, and operational information. Evaluations of individual, group, and organizational effectiveness are then made.

- *Team-building activities.* Consultants use diagnostic methods to enhance team performance. These include activities helping members to improve work methods, refine tasks, modify decision-making processes, resolve conflicts, and improve communication. A compelling rationale for team building is to encourage members toward consensus decision making.

- *Survey feedback activities.* Information derived from diagnostic investigations provides a rich assortment of insights, which consultants structure for reports and seminars and further refine for use in workshops and team development interventions to facilitate constructive changes.

- *Intergroup activities.* Closely associated with feedback and team-building techniques are strategies for resolving differences between work groups. An extension of this is third-party peacemaking, whereby consultants act not only to resolve dysfunctional conflicts but also to improve the general climate of cooperation through behavioral modification techniques.

- *Education and training activities.* Perhaps the most common form of intervention is to provide education and training. Consultants package seminars aimed at resolving social problems, dealing with cultural changes, improving leadership skills, and enriching individuals within organizational settings. Topics may include managing stress and planning career advancements.

- *Technostructural activities.* Consultants help define tasks, improve skills, restructure management systems, and revise reporting relationships. Given the assumptions of OD, most intervention activities are concerned with decentralizing power and increasing participation.

- *Process consultation activities.* Consultants focus on group dynamics and organizational processes to recommend improvements. These activities may include efforts to improve communication, alter intergroup cooperation, or institute improved personnel systems. Consultants may introduce conflict resolution techniques and career development programs to modify group dynamics.

Linking Change, Conflict, and Stress

Change engenders conflict and stress. As noted earlier, it often occurs only when anxiety is heightened to a point where management feels compelled to take positive steps toward creative solutions. As we shall see in the following sections, although anxiety, stress, and conflict can be serious problems, they are also essential for normal, productive activities. Managers often deal with these issues through unstructured change techniques, as Figure 19-6 shows.

CHECKPOINT

- Discuss the concept of organizational development (OD).
- Explain how diagnostic activities occur in an OD intervention program.
- Describe OD intervention as a process consultation activity.

higher-level activities, while rapid organizational changes may rattle the Type B person. Managers must consider work schedules, career development, counseling, committee assignments, delegation of authority, promotions, and other elements of human resource management to assure healthy stress conditions.

Symptoms and Consequences

Many symptoms of stress are visible in work behavior. Increased absenteeism, tardiness, strikes, work stoppages, high turnover, low-quality work, accidents, grievances, and employee theft are all traceable outcomes of individual distress. If an organization has human resource evaluation systems sensitive to these problems, managers can detect changes in behavior early and make diagnostic investigations into the causes of stress. Armed with this information, they can seek cures and preventive measures.

To audit individual and group attitudes, management periodically uses behavioral evaluation techniques. These can detect growing cynicism, distorted communications, inept decision making, erratic performance, or unhealthy anxiety. Management also uses survey information coupled with operational reports on quality performance to uncover potential stress problems. These investigations can also show management where a healthy environment is reinforcing effective behavior and eliminating stress.

Several other methods of investigation help audit both healthy environments and individuals as well as provide early warning signs of trouble. For example, physical examinations and nutritional evaluations can also pick up signs of trouble.[40]

Costs Associated with Stress

The ultimate cost of stress-related problems for individuals is death. The organizational cost is counted in lost time, accidents, health care costs, insurance expenses, and reduced productivity. The American Heart Association estimates direct costs of stress-related cardiovascular diseases in the United States to be between $46 billion and $60 billion annually. When coupled with indirect costs of turnover, grievances, and other disruptions, this figure can easily exceed $100 billion.[41]

Researchers have shown that the benefits of effective stress management programs far outweigh their costs. Rehabilitation programs for drug and alcohol abuse save companies $2 for every $1 in program cost. Stress prevention seminars have an estimated return as high as 800 percent.[42] Major corporations such as Xerox commission preventive care books, offer stress programs, and sponsor organized wellness clinics for their employees.[43] These and many other organizational programs reflect the simple axiom that individual and organizational health are interdependent.

CHECKPOINT

- Define and contrast the concepts of distress and eustress.
- Identify the main symptoms of organizational stress in work groups and discuss how managers can improve stress assessment processes.

MANAGING ORGANIZATIONAL STRESS

Several guidelines can generally help improve stress management. First, individuals must be able to recognize stressors and understand their consequences. Second, organizations must develop prevention techniques as well as techniques for

resolving distress. Effective stress management often includes a blend of training programs, counseling, company-sponsored wellness facilities, and effective evaluation systems that follow these guidelines.

Organization-Level Stress Management

Managers are primarily concerned with improving their work environments to minimize distress. Although they may benefit from company-wide support systems, it is often the individual manager who must tackle stress problems. Management can use the following eight operational strategies to manage organizational stress:[44]

- *Task redesign.* Individual tasks can be redesigned to improve the balance between individual and organizational expectations. Job evaluations provide insights into how individuals perceive their task roles. When used properly, evaluations can ensure a better "job fit." They make it possible to assign tasks that use people's abilities without overloading them.
- *Environmental change.* Specific changes in the environment can be achieved through techniques such as flexible work schedules. Management efforts that ease hassles within work groups include improved decision making and employee involvement programs.
- *Physical change.* A number of physical characteristics of the work place can be improved to alleviate stress. These include noise levels, oppressive temperatures, poor lighting and ventilation systems, unsafe conditions, congestion, and awkward methods of work. Equipment and tools can also often be improved.
- *Career development.* Training and counseling can be implemented to enhance individual self-concepts as well as provide specific career guidance. This preventive approach to burnout helps individuals grow within their organizations. When employees near retirement, preretirement planning programs and counseling will help prevent rustout.
- *Support system.* Managers can encourage employees to become involved in physical fitness programs, diet plans, and wellness techniques. They can also encourage their organizations to institute such programs if they do not already exist.
- *Role analysis.* Role conflict and role stress can be reduced by clarifying individual role expectations. This requires a systematic evaluation process that defines roles while articulating expectations.
- *Social support.* Social networking is critical for job satisfaction. Managers can improve social support within work groups by improving group communications, combating alienation, and assuring emotional support for those who need it.
- *Team building.* Managers are particularly concerned with building team efforts toward productivity through congruent goals, integrated work norms, and harmonious behavior. Stress is reduced by removing threats in working relationships and by supporting team achievements.

Individual Stress Management

Although organizations can develop systems and programs that support stress management objectives, it is ultimately the individual who must take the initiative in managing stress. The following suggestions have been found helpful:

- *Set realistic deadlines.* Rather than trying to accomplish more in less time, establish priorities with realistic expectations. Achieving results with adequate challenges but without overload is important.

- *Say "no" constructively.* Some people cannot seem to say "no" to any task handed to them. Saying "no" constructively does not mean you have to be obstinate or neglect your responsibilities. It does mean you are able to refuse to take on too much work or to spread yourself too thin.

- *Avoid maladaptive reactions.* Running away from a problem can relieve stress, but the form of escape is important. Resorting to drugs and alcohol, for example, is more harmful than facing tough issues squarely. Mentally blocking out issues or avoiding decisions is inadequate.

- *Do not let problems fester.* Stressful situations that mobilize the body are normal, but permitting the system to remain unbalanced is unhealthy. You must relieve stress by resolving the situation that created it.

- *Exercise properly.* When distressful situations arise, a healthy person is better able to cope both physically and psychologically. Exercise should be controlled and fit the individual. Choose exercise that you like; do not add to your stress by making yourself do unpleasant things.

- *Maintain a proper diet.* Eating proper foods is essential to good health. Although individuals vary in their nutritional needs, healthy persons with proper food intake will avoid many of the gastrointestinal problems associated with stress.

- *Relax and decompress.* Since stress is a natural part of life, the mind and body are continuously adapting to it. Both must have periodic rest to adjust to normal. Work breaks and lunch periods provide opportunities to get away and decompress. A brisk walk in the fresh air couples exercise with psychological relaxation. Many managers do not know how to use their breaks effectively. Some never take regular breaks, and others take lunch breaks only to talk business.

CHECKPOINT

- Discuss three ways organizational stressors can be managed to prevent individual and group problems.
- Identify and discuss three ways individuals can reduce the risks associated with stress-related diseases.

During the ten-year change program at GM's Bay City plant introduced at the beginning of this chapter, most of the organizational and individual stress management tech-

niques discussed in this chapter had to be implemented to achieve the company's goals.[45] For example, GM management and UAW representatives had to redesign tasks, introduce flexible work schedules, and help employees through career development training. Management and union representatives also encouraged workers to build team relationships and to make self-directed decisions about improved work methods. These organizational changes alleviated the stress of working in a repetitive manufacturing environment, and were instrumental in improving the quality of work life for employees. Personal stress management techniques were in evidence when management encouraged teams to meet and resolve problems without letting them fester. Employee teams also set realistic deadlines for changes, and consultants were brought in to counsel individuals as they altered their roles, either as managers or workers. ▪

A SYNOPSIS FOR LEARNING

1. Discuss the concept and nature of organizational change.

Change implies disruption, but for an organization to progress, constructive disruptions are essential. Managers must encourage change to improve organizational performance. As change occurs, it is important to have in place a system that assures a smooth transition from old to new methods, technologies, or expectations.

2. Explain the process of change and the major approaches to effect change.

Change in Lewin's model is a three-stage process. The first, *unfreezing,* consists of making employees aware that change is necessary. The second, the *change* stage, consists of introducing new methods and motivating employees to adapt to them. The third stage, *refreezing,* is the process of stabilizing changes made in the second stage by reinforcing desired behavior.

There are three approaches to change. In the first, called "top down," higher-level managers dictate what they want changed and use their authority to implement it. In the second approach, called "bottom up," higher-level managers only encourage change through incentives or methods of reinforcement, actual change is initiated and carried out by lower-level employees. The third approach, which does not have a formal name, relies on participatory management and teamwork by employees and managers working together to suggest and implement changes.

3. Discuss organizational development and intervention techniques.

Organizational development (OD) is an effort to renew organizational processes, emphasizing cultural change patterns, by working with individual managers and work teams. OD is an intense educational approach to effecting change, usually by having consultants work with managers and workers to alter patterns of behavior. One method of intervention, "team building," encourages participation by creating decision-making teams such as quality circles.

4. Describe types of conflict within organizations.

First, role conflict occurs within an individual when one role (parent) interferes with another role (employee) so that the employee fails to perform well at work. Second, conflict can occur between individuals, such as through personality differences or debates that one person must win at another's expense. Third, conflict between individuals and groups occurs when one employee is isolated from the work group, purposely disrupts group work, or rejects group norms. Fourth, conflict can exist between groups, such as line and staff departments.

5. Discuss methods of resolving conflict while enhancing healthy competition.

A conflict over resources may be resolved by creating excess resources for the competing groups. A conflict between individuals or groups may be resolved by a buffer, which can be physical separation or an individual who acts as a counselor or a negotiator. Resolution may be achieved by integrating conflicting parties through cooperative work patterns or liaisons among groups that tend to have misunderstandings. Personal intervention techniques, such as career development programs, are often used to resolve role conflict.

6. Relate stress to organizational productivity and personal health.

Stress is essential in accomplishing anything, and a certain degree of stress exists in every job. When employees endanger themselves physically or psychologically with excess strain or anxiety, they are undergoing *distress.* A healthy level of stimulation is called *eustress,* which is the effective mobilization of an individual mentally and physically.

SKILL ANALYSIS

CASE 1 Managing Stress and Conflict: A Study in Role Conflict and Crisis

Michele Anders celebrated her thirty-fifth birthday by finishing her second year at medical school. It was a happy occasion and she looked forward to a new career as a physician, but she had got to this point only after fourteen years of stress and conflict.

Michele was a third-year honor student in mathematics at a southwestern university when she married a graduate geophysicist and quit school to move to California with him. He entered the fast-paced world of young executives in a large oil company. Michele found a clerical position with an insurance company, and reentered college. After four years, she got a master's degree in computer science and earned promotions in the insurance firm. She became a project analyst and director of her firm's in-house forecasting unit.

Michele and her husband appeared successful and happy. They had a nice house, money, and position. Beneath the successful exterior, however, they were actually leading two separate and conflicting lives. He was in a corporate scientific career with travel and executive co-workers who lived in the fast lane. Michele worked in a very structured environment with little outside involvement other than her schoolwork. The couple spent little time together and divorced after eleven years. There were no children and few good memories, even though there had been no bitterness or disputes.

Michele was the oldest of four children, and during this time had also faced several family crises. Her grandfather died, seriously upsetting Michele's mother, but Michele was too far from home to comfort her mother. Then her father died unexpectedly at a young age. Michele had been close to her father, so this was a traumatic experience. She was given three days off by her firm to attend the funeral, but as the oldest child, Michele needed more time to help with arrangements and family affairs. Her firm was not receptive to this. Michele stayed on a leave of absence for two weeks because her mother was close to a nervous breakdown. When she returned to work, she was admonished for not making better arrangements for someone to do her work while she was gone.

Family pressures mounted when her mother became severely depressed. Michele's younger sister became pregnant while yet in high school and ran away, and after this incident, her mother had to be institutionalized following an at-

tempt at suicide. Michele was frustrated at being so far from home and unable to help her family.

Michele seldom spoke of her problems to anyone, but she began having physical and emotional problems that affected her work. A series of backaches actually incapacitated her for several days. She could not sleep well and frequently came to work tired and sullen. She began eating irregularly, lost weight, and was no longer interested in sex. However, she was able to block out many problems by driving herself hard at work. Ironically, this led to promotion as MIS systems manager even though her immediate supervisor had told her several times that she must "get her personal life together and quit letting nonwork issues interfere with professional responsibilities."

Michele always did a superior technical job on any project, and she prided herself on being the hardest-working person in her group. Her promotion was based largely on her technical accomplishments. However, she was abrasive to many of her peers, cynical about company policies, critical of decisions, and cold toward her colleagues. After her promotion, her new division manger became aware of these problems and apprised her of "poor leadership traits." He told her to leave personal problems at home and square up to her job duties or she would not have much future in the firm. Michele found she could ease up a bit by having a martini or two at lunch. Her behavior in the afternoon generally improved. She also found that a nightcap helped her sleep. Unfortunately, this occasionally led to a few too many and she was absent or came in late hung over several times.

This led to a confrontation with the division manager. He pointed out that she was doing adequate work but was not adjusting well to a manager's role. Michele was defensive and accused him of being insensitive and treating people like "9-to-5 machines." The division manger snapped back that she did not seem to realize that she was becoming more of a liability than an asset to the firm. Michele resigned on the spot.

Ten days later, she was hospitalized with a nervous breakdown. Nine months of counseling followed, including a rigorous diet and exercise plan. She emerged from this experience ready to rebuild her life, and in the following year was accepted into medical school. Michele made it, but not without high costs.

Case Questions

1. Identify Michele's role set and discuss various role conflicts she faced at work. How did these role conflicts affect her lifestyle?
2. Discuss how Michele's managers handled her conflicts at work. What suggestions would you have for managing similar situations?
3. Michele was under tremendous stress, but many individuals face similar problems. Identify her stressors and how she might have better managed them.

CASE 2 The Kirk Stieff Company: Changing with the Times

The Kirk Stieff Company of Baltimore, the nation's oldest silversmith, has been desperately trying to adapt to modern times over the past decade. The company was formed in 1979 when two long-established silversmiths, the Stieff Company and Samuel Kirk and Son, merged. Wild fluctuations in the price of silver bullion, however, almost immediately upset the company's plans for the future. While Stieff and Kirk were closing their deal, the price of silver doubled to $10 and ounce. It continued to rise to nearly $50 an ounce, before sliding back to $10 an ounce—all this within a period of months. At the same time, changes in the Amer-

ican lifestyle eroded the company's customer base. No longer did every newly married couple aspire to silver flatware, which accounted for half of Kirk Stieff's sales and profits.

The whole of the silver industry went into a slump, and Kirk Stieff was no exception. The company's heavy debt load—a legacy of Steiff's purchase of Kirk—made the situation even more precarious. The company laid off 100 people, but that did not solve the underlying problems. By 1983, the company was in crisis. That year, the entire silver flatware market fell by 45 percent, and Kirk Stieff lost one-third of its net worth.

The company's history and the nature of the silver business did not predispose Kirk Stieff to change. The company prides itself on a long tradition of excellence and hand craftsmanship. Many of the techniques Kirk Stieff uses to manufacture its products—hand engraving and chasing, for example—remain the same today as they were when Samuel Kirk and Charles Stieff first founded their companies in 1815 and 1892, respectively. New apprentices can only hope to become a master engraver or master chaser after five to seven years of training. Even the products change remarkably slowly. One of the company's best-selling silver flatware patterns was introduced by Samuel Kirk in 1830.

Given the weight of tradition and the naturally slow rhythms of the industry, it was difficult for Kirk Stieff to respond to its changing environment. In 1984, Chairman Rodney Stieff went outside the company to appoint a new president, Pierce Dunn. Dunn in turn recruited other talented managers who were prepared to break with the traditions of the silver industry.

Patrick Diaz, the new chief financial officer, overhauled the accounting department to provide managers with timely, relevant information—a new departure for Kirk Stieff. As a result of his efforts, company managers found that profits on some large accounts were really much smaller than everyone had assumed. They also discovered that many retailers were making more money on Kirk Stieff's products than was the company.

Johanna O'Kelley, the new vice president for marketing, was not herself especially fond of silver or of Kirk Stieff's traditional products. She set out to develop modern, innovative product lines for the company. One of her ideas was a silver kaleidoscope filled with semi-precious stones. The kaleidoscope fits Dunn's ideas about the company's niche. He feels Kirk Stieff will thrive if it produces unusual goods of exceptional quality for a small group of discerning clients who are willing to pay a premium price.

Dunn admits that the company is experimenting to find these special products and customers. A computer engraving department for corporate gift giving, for example, has exceeded management's expectations. Kirk Stieff's trophy work has also grown. Some 40 percent of the company's output is not even silver any more, but pewter produced under contract for Colonial Williamsburg, the Smithsonian, and other historic foundations. Kirk Stieff has also invested $200,000 in a New York showroom to attract retailers and opened a factory store at its main plant in Baltimore.

Dunn has also streamlined the production process and cut the company's manufacturing costs. In the firm belief that workers understand production problems best, Dunn has reorganized the factory into production cells that cross-cut department lines. Before, a job lot of a thousand items would pass through each department (stamping, spinning, soldering, and finishing, for example) in turn. Now, the small group of people who make up a production cell are solely responsible for taking a particular product from start to finish, including inspection and packaging. The use of cells has reduced inventory, improved quality, and accelerated production—all with fewer people.

Cell members work together to solve production problems. Take the kaleidoscope project as an example. The company assembled a team of four workers, each chosen for a particular skill, to manufacture the kaleidoscopes. These

workers elected a cell captain, and then, under his leadership, they figured out the most cost-and-time-efficient way to make their assigned product, while adhering to Kirk Stieff's high standards of quality.

The changes are not yet over at Kirk Stieff. The company has survived the immediate crisis, but is still not achieving its sales goals and has had to resort once more to layoffs. Dunn is optimistic, however, that the combination of new products and reorganized factories will return to Kirk Stieff to health.

Case Questions

1. According to Michael Beer, managers delay making changes until there is a crisis. What caused this crisis at Kirk Stieff?
2. In many ways, Kirk Stieff's business is a relic of the past. How do you think the traditional nature of silversmithing affected the company's approach to change?
3. Which kind of change strategy did the managers at Kirk Stieff use: top-down or bottom-up? To what extent did they try to involve the workers? Do you think management's approach was appropriate to the situation and the organization?
4. What kinds of conflict, anxiety, and stress do you think the changes at Kirk Stieff caused? Consider both the managers and the factory workers in your answer.

Sources: Episode 15 of the "Growing a Business" series of videos; and Jesse Glasgow, "Kirk Stieff Weathers Cloudy Times by Making Its Own Silver Lining," *Baltimore Sun*, October 22, 1988, pp. B16–B17.

SKILL PRACTICE

STRESS: DOWN OR UP?

Introduction

Most of us talk about and feel stress in our lives. However, we should understand that we all *need some* stress simply to have enough adrenalin to function as active human beings. Hans Selye in his book *The Stress of Life* (1976) points out that stress falls into two categories: distress or eustress. The second is the pleasant form when we feel excited and energized in a joyful situation. *Both* produce adrenalin and the fight—or flight syndrome. *Ideally*, whether stress is negative or positive, the body maintains its equilibrium as the products of the defensive responses are expended. It is the *intensity* of stress and *high unrelenting* levels of stress over time that can be very destructive.

Instructions

■ Consider, in Chapter 19, Figures 19-11, 19-12, and 19-13. Consider also Exhibits 19-1 and 19-2 (8 minutes)
■ The instructor will form teams of four or five people each. The role for each team is that of a company counselor with training in psychology. Read (reread) Case 1 at the end of this chapter. The time of your coun-

Source: Copyright © 1989 by Richard E. Dutton.

seling interview with Michele is at the point of her resignation. Your goal is to try to prevent her from following through on her resignation. At the very least, the hope is to help Michele lead a more healthful life. (10 minutes)

- The teams will meet in such a way that they will not disturb other groups. Develop your approach and create questions/suggestions for Michele as quickly as possible. Be prepared to have a spokesperson present these questions/suggestions aloud to the instructor and class. (20 minutes)

- Presentation by spokespersons. At his or her option, the instructor *may* select a panel of female class members to play the role of Michele. This panel will concentrate on the presentations and may vote on the most professional and most effective. (12 minutes)

- Wrap-up by instructor on coping with daily stress. (Time permitting)

Although the biggest-selling imported cars in Japan come from West Germany, racy looking American cars, such as the Chevrolet Camaro shown here, are popular among young and affluent Japanese buyers.

the company must train its own managers for international responsibilities, including how to operate in a culture where consumers and employees have different values, languages, customs, and beliefs. Ludicrous ad slogans can result when exporters are ignorant of the idiom of a foreign language. When 3M introduced Scotch tape in Japan with the ad slogan "It sticks like crazy," the Japanese interpretation was "It sticks foolishly." In Taiwan, the ad "Come Alive With Pepsi" was translated into Chinese as "Pepsi brings back your ancestors."[21]

Licensing. A common type of international business in this high-tech age involves licensing. **Licensing** is the process of selling to foreign companies the rights to use technology or market products. Under these agreements, an existing overseas company is contracted to make or sell a particular item to which the home firm has a proprietary right. This may include patent, a copyright, or a unique trademark. Although licensing is common among international firms, it can be extremely complex. For example, FiberView Corporation, a Colorado company that manufactures a range of high-tech and low-tech products, including medical instruments and lighting displays for Disney Corporation, has manufacturing facilities operating under a licensing agreement in Shanghai. FiberView located there in 1988 with the idea of using low-cost Chinese labor to produce most of its products for the world market. The Chinese, however, insisted on full disclosure of all the firm's proprietary patents, including new high-resolution television and CRT display processes. Submitting to this request would have destroyed FiberView's patent protection because China does not subscribe to international patent laws. The company chose instead to license a limited number of low-tech products, such as display signs, to its Chinese affiliate and to restrict manufacturing of its high-tech products to the United States.

 Franchising is a special form of licensing in which a franchisor contracts to provide a complete business enterprise to a franchisee in return for a fee and royalty payments. International franchises are similar to American franchises in which a franchisor provides each franchisee with equipment, materials, services, trademark rights, management systems, and standardized operating procedures. Foreign franchise agreements, however, adapted are for each culture. Often the franchisee contracts for the rights to develop businesses throughout a country. Also, foreign franchises are frequently controlled by governments instead of independent businesspeople. For example, the McDonald's that opened in Moscow in 1988 is more like a government partnership than a franchise; the Soviet government controls both profits and employees. McDonald's franchises in other

licensing
In international business, the process of contracting with foreign companies and selling them the rights to employ technology, market products, or use patents, copyrights, and trademarks.

franchising
A special form of licensing based on a contract in which the franchisor provides a complete business concept, together with support products and services, in exchange for a royalty or percentage of profits from the franchisee.

countries have substantial operational flexibility, contracting locally for supplies; and customizing their menus. West German McDonald's have beer on the menu; in France, they serve wine; and in some Japanese locations, a customer can order saki; McSpaghetti is a speciality in the Philippines.[22]

A company franchising overseas has the advantage of being able to enter foreign markets rapidly with a complete business concept. Companies with licensing agreements have the advantage of rapid market penetration through contracts with foreign companies with established markets and successful reputations. In both instances, companies seeking to expand overseas can do so with less financial risk and lower costs than they would incur if they developed their own foreign subsidiaries. However, their control over foreign operations is limited to their ability to break the licensing contract or void the franchise.

joint venture
A contract between two or more companies to invest in and pursue a business enterprise.

Joint venturing. Foreign expansion can be accomplished through **joint ventures** that bring together companies from different nations to form a commercial alliance. Each company has a partial ownership position in the new enterprise. In contrast to agency or licensing agreements that do not provide for investment by the parties involved, joint ventures are newly constituted enterprises in which the affiliates all make an equity investment.

Joint ventures are created to coalesce the unique strengths of each investing company. For example, GM joint ventured with Toyota in 1983 to expand its small-car line in the United States. Toyota had the technology and expertise to produce a high-quality small car, and GM had the marketing and distribution strength to rapidly penetrate every sector of the American automotive market. GM also joint ventured with Japan's Isuzu and Suzuki in the areas of product development and marketing. Xerox joined with Rank (UK) to create Rank-Xerox, an informations systems company in Britain, and Honeywell joint ventured with France's Bull and Japan's NEC to make computer-integrated manufacturing systems.[23]

In each of these joint ventures, individual companies brought unique strengths to the affiliation, such as proprietary technology, expert marketing, experienced manufacturing, or access to capital investments. Sometimes, a joint venture opens markets that were closed to a company through trade barriers or import quotas. Fanuc (Japan) joined with General Electric to manufacture industrial robots in the United States, thus circumventing the import limitations imposed on Fanuc by the U.S. government.[24] Some companies enter into joint ventures to secure critical raw materials, others to take advantage of exceptionally low manufacturing wages. For example, in 1989, the labor rate for a factory worker in mainland China was equivalent to $30 a month, resulting in production costs about one-tenth those in comparable U.S. facilities. The companies that sell Mickey Mouse dolls, Big Hauler trains, and Tonka, Mattel, and Hasbro toy lines are customers of joint venture firms manufacturing in Taiwan, Singapore, South Korea, and Hong Kong.[25]

Joint ventures between American and foreign firms operating in the United States are becoming increasingly common. Some of these ventures have had notorious press coverage, such as General Motors' agreement with Toyota to jointly create a California manufacturing facility that was hotly contested by the UAW.[26] Nonetheless, other U.S. automobile companies have followed suit. Chrysler joint ventured to obtain Volkswagen engines for its own cars and to sell Mitsubishi and several European models in the United States; Ford Motor Company, Fiat, and Alfa Romeo are locked into joint ventures for foreign and domestic markets. In other examples, Procter & Gamble's liquid Tide was developed in Europe, IBM is doing joint research on superconductivity in Zurich, and American Express is joint ventured with a software firm in Bombay, India, for a major portion of its programming.[27] Hundreds of other companies with less publicized products have similar contracts for products ranging from microcomputer parts to shoes.

Technical contracting. One of the least known but most pervasive practices is international contractual arrangements for technical services. Emerging nations, in particular, offer lucrative contracts to attract managerial, technical, and educational expertise for local enterprises through **technical contracting**. Major accounting firms such as Ernst & Whinney have established offices in scores of countries from Scotland to Nigeria; engineering companies such as Bechtel Corporation provide teams for dam building, power plant construction, and other huge projects worldwide. Universities contract for overseas programs, student and faculty exchanges, and economic development consulting. At the "Euromedicine Park" in the Languedoc-Roussillon region of southern France, more than twenty countries maintain medical research facilities, offering medical consulting on a global scale through their programs.[28]

technical contracting
In effect, technical contracting is the export of expertise and knowledge through consulting and assignment of personnel to overseas projects.

Subsidiary investments. The most conspicuous international involvement comes from formal investments in foreign operations. The stereotypical image of multinational corporations is that they are major investors in plant and equipment through their foreign subsidiaries. A **subsidiary** is a wholly owned foreign affiliate that has been established through acquisition or direct investment by the controlling MCN. As discussed earlier, this type of organization can take on a variety of structures and endorse different management philosophies. The MCN is the most sensitive type of international business venture and the one most heavily influenced by cultural, political, and socioeconomic factors. Countries that have substantial investments in one another, such as Japan and the United States, often find themselves on a collision course as they compete head-to-head in domestic markets with similar products. Other MNC–host country problems arise for a variety of reasons explored in the next section.

subsidiary
In international business, a wholly-owned foreign affiliate that has been established through acquisition or direct investment.

CHECKPOINT

- Describe different approaches to exporting products made domestically.
- Define and contrast licensing and international franchising.
- Explain how joint ventures are created and why they benefit the companies involved.

INTERNATIONAL RELATIONS

International business involves two or more countries that often widely differ in cultural and social values. Home-country firms move into an international arena for many good reasons, and host countries enjoy numerous benefits from these relations. However, the relationship is not without tension.

Host-Country Relations

When a company enters a less developed country, the host often benefits from the new jobs created. This is particularly true if LDC citizens are unskilled and have few opportunities to obtain wage-earning positions. Host countries also benefit economically from local spending by multinationals. Whenever companies build facilities, bring in equipment, and develop distribution systems, a tremendous amount of secondary economic activity begins. Each new venture expands the local tax base, creating revenue that pays for public services such as roads, water supply systems, and utilities. Also, an MNC usually transfers some highly skilled employees to LDC locations who require housing, medical services, educational facilities, recreation, and shopping. Therefore, new ventures often create ripples of broad-based support activities.

Disadvantages to host countries, particularly LDCs, arise from the disruptive nature of new ventures.[29] The most emotional issue is the multinational corporation's influence in host-country politics, either directly through aggressive manipulation or indirectly through the sheer weight of its economic activity. Unethical activities such as bribery or direct meddling in host-country politics were discussed in Chapter 3 as a dimension of social responsibility.

Even aggressive manipulation, however, is often less important than disruptions caused by the importation of values and behavior from high-tech cultures. American, British, French, German, and Japanese firms operating in remote parts of the world bring with them elements of their advanced industrial societies. Host-country peoples often cannot assimilate the knowledge or customs of these advanced societies without disrupting their traditional way of life. For example, a major oil exploration firm setting up in an LDC village can literally overwhelm the local lifestyle. Social, religious, and ethnic differences also make relationships precarious.

Another problem is that some of the advanced techniques offered by MNCs are impossible to implement in many countries. It is difficult to train local employees to use a simple diesel engine when they have yet to understand a wrench. Introducing computers to a society that has yet to develop widespread consumer electricity presents almost insurmountable difficulties. The result is that often an MNC enters a host country with sophisticated technology and exploits the LDC by extracting precious raw materials; the benefits of employment, income, and higher quality of lifestyle are realized by only a small number of local citizens. From the host country's viewpoint, the scale in Figure 20-5 may never be in balance.

Many other issues supercharge host-country relations. MNCs may reap huge profits that are rapidly transferred out of the host country. Little local development will occur if the MNC fails to train host-country managers and employees. The host country may watch its raw materials be exported to industrial states, leaving a scarred and desolate countryside. Existing social inequities may be exacerbated as the leaders of host countries get rich on MNC payoffs while the masses starve. And since most MNCs operate in host countries with the support of existing regimes, revolutionary movements target MNCs along with those regimes. These, and many more situations, complicate host-country relations.

On the positive side, there is overwhelming evidence that most multinational enterprises strive to assure benefits for host countries. Today the sensitivity of most host countries to the potential for economic exploitation by developed nations forces managers of MNCs to be exceptionally alert to misconduct. Rank exploitation and unethical behavior are rare; they simply are not good business. Success of most of the world's largest corporations, which often earn in excess of 50 percent of their income from foreign operations, attests to the rewards of part-

FIGURE 20-5 Host-Country Perspective of Advantages and Disadvantages of MNC Involvement

nerships with host nations. On their side, less developed countries have improved their economies, expanded public services, benefited from new technology, and found willing trading partners in advanced societies.[30]

Parity: Head-to-Head Relations

Even more sensitive than MCN–host-country relations is the ferocious rivalry that occurs when two nations with industrial parity compete for each other's markets. Historically, most of the world's wars have been rooted in economic competition. Britain and France waged war for much of the eighteenth century over economic dominance of European and colonial markets. The world wars of the twentieth century also had an economic basis.[31] Industrial parity can moderate international tensions, however, if sensible leaders in government and business seek mutually beneficial alliances.

Unfortunately, industrial parity and increased global competition among strong trading powers have led more often to greater tension. A grasp of the concept of "parity," which is not necessarily measured by comparing the absolute size or economic power of nations, is essential. Parity can be industry-specific so that global markets are dominated by a few entities. One example of parity is the equal strength shown by Canada, West Germany, and the United States in industrial-medical pharmaceuticals. Similarly, OPEC countries in conjunction with industrial giants in the Netherlands, Great Britain, and the United States set the pace for global competition in petrochemicals. Parity can also relate to actual trade activity between two countries. Thus, exchanges between Canada and the United States in commodities, products, technology, and agricultural products result in near equilibrium in trade. "Tension" arises when equilibrium is severely disrupted or when several nations aggressively compete for dominance. If unresolved, this tension will probably lead to collision-course competition.

In the 1980s, trade imbalances generated tension between Canada and the United States. Canada had become more expansionary, nearly doubling its export activity since 1980, and the United States was actively courting affluent Canadian markets while increasing its investment base in Canada's industrial sectors. The consequent tension initially prompted retaliation and political maneuvering by both sides. News coverage in both countries headlined public outcries, and top-level trade diplomats dueled with one another. Then in 1988, cooler heads prevailed, and the two nations signed a cooperative trade agreement. The Canada–United States trade pact seeks to realign imports and exports, stabilize currency exchange, and reduce artificial trade barriers between the two countries.[32]

This agreement is only the tip of the iceberg, for three exceptionally powerful trade "systems" are emerging in the global economy. The first is Europe, as redefined by the 1992 alliance of the twelve common market nations. The second is the Pacific Rim, headed by Japan and buttressed by the newly industrialized economies of Hong Kong, Singapore, Taiwan, and South Korea. The third is North America, strengthened by the Canada–United States trade pact. Tensions among these triad powers are rising. As a result, in Europe alone, 287 negotiations were opened in 1988 to try to resolve trade issues, and more than a hundred nations will participate in the "Uruguay Round" of trade talks, which seem likely to stretch into the twenty-first century.[33]

The hazards of collision-course competition between industrial powers are most apparent today in U.S.–Japanese trade relations. Some experts suggest that tension between the two nations is increasing to the point where an economic showdown is inevitable. Others argue that despite strained relations, a cooperative level of competition is feasible. The size of the problem can be gauged by Japan's phenomenal success in world markets. By the mid-1980s, Japan was running a trade surplus with virtually every major industrial nation; its 1988 surplus

with the United States approached $70 billion. Japan dominates the Pacific Rim, as Exhibit 20-1 shows, and in 1982 it surpassed the Soviet Union in gross national product to become the world's number-two economy, exceeded only by the United States.[34] Japan is the single largest foreign investor in the United States; nearly one out of every twenty American workers is employed by a Japanese-owned firm.[35] With ownership of five of the ten largest world banks, dominance in electronics, and near-parity with the United States in automobiles and industrial machine tools, Japan is exceedingly well positioned for the 1990s.

The extraordinary economic success of the Japanese rests on their talent for marketing; they have efficiently adapted to the international business environment. The U.S. reaction to this success is illustrated by the dichotomous attitudes of American consumers. Many Americans who buy Japanese cars, own Japanese-made televisions, listen to Japanese-made radios, and enjoy the precision of Japanese-made tools tend to view Japan as a major benefactor. Many other Americans view Japanese imports as a threat to American economic stability, jobs, and financial security. They advocate either boycotting Japanese products or erecting trade barriers against them. U.S. corporate executives and political leaders oscillate between these two views, sometimes seeing Japan as a valuable industrial trading partner and other times seeing her as a threatening adversary. That is why American policy seesaws back and forth; one day political and business leaders are demanding stiff tariffs, and the next day they are courting Japanese investments in domestic enterprises. Japanese leaders also swing back and forth between acknowledging they have to do something to reduce their huge trade surpluses and complaining about being penalized for success.

Home-Country Relations

The extreme sensitivity of collision-course international competition illustrates the kind of difficulties multinationals face in their home countries. An obvious criticism of MNCs is that they export jobs along with their products and services.

EXHIBIT 20-1 Pacific Rim Countries: Rising Economies

Country	Population (in millions)	Gross National Product		
		Per Capita	Total (billions)	Avg. annual Growth Rate (%)
Japan	122	$19,371	$2,395	3.9
Australia	16	12,051	195	3.7
New Zealand	3	9,595	32	2.2
Hong Kong	6	7,673	44	7.3
Singapore	3	7,673	20	5.0
Taiwan	20	4,823	95	9.1
South Korea	42	2,849	120	10.1
Malaysia	16	1,833	30	3.3
Thailand	54	898	48	4.9
Philippines	62	577	33	−0.7
Indonesia	175	401	67	3.6
China (PRC)	1,062	349	377	10.3

Source: Louis Kraar, "The New Powers of Asia," *Fortune,* March 28, 1988, p. 128. Copyright © 1988 Time Inc. All rights reserved.

MANAGEMENT APPLICATION 20-1
Mitsubishi Diversifies

Japan's largest industrial corporation, Mitsubishi, opened for business as a tiny *shokai* (trading and shipping company) in 1870, two years after Japan entered the modern era by abolishing 265 years of feudal dictatorship. The company, founded by Yataro Iwasaki, did not remain small for long. Through the last decade of the nineteenth century, Mitsubishi expanded its core business, shipping and trading of copper and coal, to include mining, fabrication, and insurance. By 1917, it had grown so large that it was reorganized into separate divisions, each handling its own products and technology of shipbuilding, steelmaking, coal and metal mining, banking, insurance, and trade.

Under the forceful direction of Yataro's son, Koyata, Mitsubishi was transformed into an international enterprise during the three decades from 1916 to 1945. Because it was one of Japan's prime military contractors during World War II, Mitsubishi was dissolved by the Allies in 1945. In 1952, however, the company was reformed, and it rapidly restored its international network of offices. Mitsubishi repositioned itself strongly in its traditional businesses and embarked on new ventures in chemicals, electronics, communications, and advanced materials manufacturing.

Today Mitsubishi is no longer primarily a trading company. With leading firms in almost every sector of Japanese commerce and offices in nearly every industrialized and developing nation, it is now a global conglomerate. A source of the company's strength is its corporate philosophy, articulated by Koyata Iwasaki nearly seventy years ago: to exercise "corporate responsibility to society," to operate with "integrity and fairness," and to promote "international understanding through trade."

Source: Mitsubishi,: *Annual Report,* 1983.

When MNCs are attracted to foreign shores by lower labor costs, the result is reduced employment opportunities at home. The same logic applies to capital investments. When MNCs build overseas and divert investment capital to remote facilities, domestic development lags. If this argument is valid, then the activities of multinational corporations reduce tax receipts, domestic income, and home-country spending. From a home-country perspective, the scale in Figure 20-6 will

FIGURE 20-6 Home-Country Perspective of Advantages and Disadvantages of Multinational Business

be unfavorably weighted. Proponents of this view argue for protective legislation coupled with higher tariffs to strengthen the domestic economy.

There is another view of MNCs that directly contradicts this argument. Those who favor multinational corporations emphasize that the MNCs reimport lower-priced consumer goods that provide American consumers with an enriched quality of life. They also point to data showing high tax receipts from sales abroad and import duties. Finally, they suggest that the increased trade MNCs make possible helps eliminate trade imbalances.[36]

It is hard to reconcile the differences between these two extreme arguments. Proponents of both views argue in emotionally charged tones in politically sensitized arenas; nothing short of a national resolution will satisfy either party. MNCs, meanwhile, continue expanding overseas to take advantage of low labor rates, inexpensive manufacturing facilities, and ready access to raw materials. They sell many products made overseas to foreign markets, but simultaneously reimport a large percentage of them to sell in the domestic market at favorable prices.

CHECKPOINT

■ Describe the advantages and disadvantages of international business for a host country.

■ Discuss the concept of competitive parity and collision-course trade.

■ Explain the advantages and disadvantages of international competition for the home country.

MANAGING IN THE INTERNATIONAL ARENA

It is not a quantum leap from domestic to global management. Richard N. Farmer, a long-time scholar of international management, strongly believed that good managers are quite capable of managing anywhere in the world, using skills very similar to those they use domestically. He acknowledges the need to adjust to different cultures, but insists that the functional requirements of managing an effective organization are similar across nations.[37]

Farmer's view is not universally shared. In a landmark study of four major nations—France, Great Britain, the Soviet Union, and the United States—David Granick noted substantial differences in management techniques.[38] Other researchers suggest that management characteristics classified as "scientific" tend to be universal, whereas the "art" of managing human resources requires interpretation.[39] Let us look closely at several of the major issues.

Culture

culture
A shared set of values and beliefs that determine patterns of behavior common to groups of people: corporate culture refers to patterns of behavior based on shared values and beliefs within a particular firm.

Culture is the values, beliefs, and attitudes shared by members of a society that collectively influence their behavior. It includes the national religious profile, language(s), ethnic heritage, stage of industrial development, and economic system. Since every country evolved from different roots and emerged as an independent nation under its own social system, cultural differences between nations and peoples can be pronounced. For example, Granick has demonstrated that the management structure in French corporations resembles a three-tiered "caste" system with rigid downward communication and stratified authority based on class status, the schools from which managers graduated, and family ties. The result is autocratic corporate environment that does not favor participative leadership methods. British firms retain some of the "old school ties" that assure graduates from

SKILL ANALYSIS

CASE 1 Multinational Enterprises Find New Markets in China

After a half century of tightly guarded shores, China suddenly opened up to the world and invited international trade during the early 1980s.[51] By the end of the decade, blue jeans were nearly as common as Mao jackets and rock music had become more desirable than political anthems to younger Chinese. More than $5 billion of American investment in plant and equipment had found its way into China by 1985, and another $7 billion has been earmarked for 1990. A number of European firms also set up manufacturing facilities in China, including a $220 million operation by Volkswagen. Top Chinese ministers and many Chinese businessmen are driving the world's highest-quality cars, and executive offices, even the most humble ones, are being rented at $6,000 a month.

 The story of China is similar to that of many less developed countries that have been ignored by, or isolated from, fast-moving industrialized societies. The Chinese executive who drives a Rolls-Royce today only a few years ago owned a "Shanghai Car," a shaky reflection of a 1947 Dodge. Besides the occasional Rolls-Royce, Volkwagens are becoming commonplace. In fact, Volkwagen's new assembly facility is only yards away from the archaic Shanghai Car production plant. Problems of rapid industrial expansion are mirrored in the auto assembly methods employed on both auto lines. Both the VW and the Shanghai Car are assembled with precision tools, but when a car door fails to fit on a VW, German advisers guide technicians to make adjustments, whereas when a Shanghai Car door fails to fit, a worker beats on the hinges with a wooden mallet. Also, within the Volkswagen plant itself, there are interesting anomalies, such as employees working with the latest in microcomputers in cramped quarters heated by paraffin lamps.

 As a wide array of consumer products begin to appear in China, a dichotomy between "haves" and "have-nots" is becoming visible. Thus, the average annual income for a Chinese citizen is barely $300 a year, hardly sufficient to purchase a Volkswagen or one of the AMC Jeeps being manufactured under a joint venture with a China state-owned enterprise. Even denim jeans cost close to a month's income. A safety razor that Americans would consider no more expensive than a bag of popcorn represents two days' pay for a worker at the Peking Airport.

In today's China, Madonna records, tapes, and videos are available to consumers. For many Chinese, however, they are still too costly to buy.

Industrialization does, however, promise rapid advancement for workers in skills and in wages. The daily wage for Chinese autoworkers, which was $2 in 1985, will approach $5 in 1990. This sum, which for the foreign manufacturer is virtually "nothing," represents a massive increase in take-home pay. Besides higher wages, industrialization has brought changes in work habits. The wooden mallet treatment for stuck car doors is being replaced by quality control systems. Workers can no longer close factories for a two-hour midday nap because assembly lines must continue to hum, but the six-day week and the ten-hour workday may be trimmed slightly.

Perhaps the biggest turmoil has occurred in politics. Despite strong indoctrination in the radical Marxism of Mao, China is eagerly adopting capitalistic production methods. Investment banks are emerging, cash bonus systems are appearing, and managerial promotions are being tied to productivity increases. Even the Communist Party newspaper has publicly announced that Karl Marx is irrelevant to the China of the future.

These sudden ideological changes and their potential impact on China and its citizens have not been examined closely, but the older generation of Chinese, who marched with Mao in the 1940s, embraced the Cultural Revolution of the 1960s, and wrestled with ideological clashes during the 1970s, are understandably dismayed to see their grandchildren break dance and bargain for rock tapes. In 1989, college-aged youth and younger workers demonstrated in Tiananmon Square, bitterly objecting to their government leaders' social and economic policies. Government forces drove students away, killing many, and buttressed the ideology of their rulers. The problems of 1989 illustrate how difficult it is for a country like China to reconcile economic, political, and industrial changes.

Yet to be reconciled are the attitudes of many government leaders and the vast network of bureaucrats who regulate a nation several times the size of the United States. Fleecing American visitors has become as important to minor politicians as Sunday television is to American football fans. Bribery has been common in state-owned agencies for years; the arrival of foreigners only means larger pocketbooks to tap. Government red tape can be strangling, and it will be a long time before computerization alleviates traffic congestion or improves airline scheduling. Modern agricultural equipment is available, but most farmers still rely on ox carts. Although computers are being introduced at a rapid rate, word processing and document handling are still done almost entirely by hand. The Chinese language, with its thousands of unique ideographic characters, simply defies programming; imagine a typewriter keyboard with thousands of keys!

Case Questions

1. Summarize the social and cultural characteristics that make it difficult to introduce industrial techniques of production and marketing into China. Discuss these in relation to American working norms.
2. If you were a manager about to be transferred to China to help develop a distribution office for a firm like Coca-Cola, what preparation would you need to be effective?
3. Using text discussions, explore issues that could become major problems for managers of multinationals operating subsidiaries in China.
4. What ethical conflicts do you envision for conducting business in China as a U.S. citizen? What cultural conflicts?

CASE 2 Going International Is as Close as Mexico

Mexico and the United States have been trading partners for more than a hundred years. The United States is Mexico's number-one market for exports, and Mexico ranks third for United States exports behind Japan and Canada. Our

trade relationships with Mexico are likely to accelerate for two reasons. [52] First, Mexico joined the General Agreement on Trade and Tariffs (GATT) in 1986 and signed a trade understanding late in 1988. These signaled to the United States and the world an effort by Mexico to dramatically change its role in the global economy. Second, the Mexican *maquiladora* program has created an unusual economy base for Mexico that is rapidly attracting American firms.

The term *maquiladora* is derived from an old Spanish word *maquila* that referred to grain millers who would grind a farmer's grain into flour for a percentage of the milled flour. Today, maquiladora is used to identify a domestic Mexican firm that transforms materials from a company of another nation into finished goods, with those goods being exclusively sent back to the foreign firm for sale. Specifically, with very few exceptions, the finished products made in the Mexican maquiladora cannot be sold in Mexico.

Although at first it seems unreasonable to exclude maquiladora-made goods from being sold in Mexico, on reflection it is a brilliant strategy. For example, an American company that contracts for maquiladora manufacturing benefits from unusually low labor costs and factory overhead. Mexico benefits from having a new plant that employs workers and improves the economy. By excluding products from domestic sale, Mexico benefits from a huge inflow of capital, but having no domestic sales, has no reciprical outflow of money; the American firm spends money, improving Mexico's balance of trade payments, but generates no income to counter that outflow. Meanwhile, the American firm has acquired low-cost manufacturing without going halfway around the world to another low-cost location such as Taiwan. From a geographical perspective, manufacturing in Mexico poses few transportation problems and is often easier than having products made and shipped within the United States.

The first maquiladora was started in 1966 in Juarez, Mexico, to make wood moldings. By 1989, there were 1,450 maquiladora employing more than 400,000 people and supporting more than a million indirect jobs that supplied or serviced maquiladoras. The number of maquiladoras are growing by nearly 25 percent annually, and that growth rate may accelerate rapidly during the 1990s. A number of recent political and legal changes in Mexico have led to this phenomenon. Export duties, for example, are exempted as long as the finished products are sent back out of the country. In July 1989, it became lawful for a foreign company to have a 100-percent ownership in a Mexican firm (previously, there had to be a 51 percent Mexican interest that restricted foreign investment). In 1989, the Mexican government also relaxed property ownership laws allowing direct foreign investment in facilities.

Relative labor and overhead costs are the primary consideration. For example, a top-grade machine operator in a Mexican maquiladora earns on average $3.25 an hour. Although that is 50 percent higher than what the operator would earn in a typical Mexican plant, it is far below the comparable $25 an hour rate in the United States. Other costs benefits include a standard 48-hour workweek in Mexico rather than a 40-hour week in the United States, requiring less overtime pay. There are also only seven paid annual holidays there instead of twelve or more in the United States. Nations other than the United States have also found the Mexican maquiladora program attractive. Rising labor rates in Taiwan, South Korea, Singapore, and Canada have enticed relocation of manufacturing to Mexican industrial areas. For example, Mexican labor costs are 38 percent lower than those in Taiwan, a common offshore site for many foreign firms, so that nearly a third of the new maquiladoras in 1989 were subsidiaries of firms from Japan, Canada, and Korea. Japan is expected to invest $1.5 billion in maquiladoras by 1992.

Mexican workers in maquiladoras enjoy high wages, good benefits, improved public facilities, and enhanced technological tools and training. They are far better off than their counterparts working in domestic plants. Communities with maquiladoras also benefit from economic activity, foreign investment, im-

proved housing, and increased taxes. However, there has been some resistance to maquiladoras by domestic Mexican firms who see foreign companies outbidding them for the best-skilled workers and technicians. They also suggest that domestic investments are being attracted to maquiladoras and their related contractors, thereby taking away capital from domestic firms and often driving up costs to local firms. In the United States, labor unions are complaining that jobs are being exported, lost to Mexico while American workers remain unemployed—particularly in the Southwest region. United States firms have also relocated away from cities such as Buffalo and St. Louis to Southwest cities along Mexico's 2,000-mile border, thus weakening the economies of northeastern and midwestern cities.

Case Questions

1. Discuss advantages and disadvantages of the maquiladora program for the host country. Expand on the case using text criteria.
2. Describe advantages and disadvantages of relocating operations to a maquiladora for the home country. Expand the case using text criteria.
3. What cultural, political, and social problems might a U.S. firm encounter by creating a maquiladora?

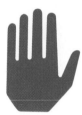

SKILL PRACTICE

A ROLE EXERCISE IN A LESS-DEVELOPED COUNTRY ENTERPRISE

Students may form into teams or work individually as instructed in class to research and present viewpoints concerning a new business school to be started in a small Middle East nation. The scenario of the nation follows:

Recently, this nation that borders oil-rich Saudi Arabia has suddenly become extremely wealthy due to massive oil strikes of its own. Coupled with its lack of importance as a military power, this has made the nation a prime area of multinational development efforts. So far it has remained apart from the wars and religious conflicts of the Middle East; its citizens are predominatley Sunni Muslim, and the nation has encouraged trade with Europe and the United States.

The nation's leaders have recognized how important it is to use revenues from oil exports to develop an industrial base for future growth and prosperity. They have sent many young students to Western universities for training. Others have worked for multinationals and learned the most common techniques for production and marketing. However, very few host-country natives have actually held management positions. Most are nomadic by heritage and protect a culture of rugged tribal individualism.

Two years ago, the nation endowed an expansion program for its major university. In addition to engineering studies, medicine, and agriculture, the university has announced a new business school. Currently, business courses are being taught by American and British professors on temporary contracts. As the curriculum expands, many more professors will be needed, new textbooks will have to be selected, and programs will have to be well defined. There have been controversies as students complain of topical coverage, such as management by objectives, and participative leadership techniques that they feel are unacceptable in their culture. National leaders are also disturbed that so few host-country professors are capable of handling business school concepts, and standard principles of management textbooks are under fire as being irrelevant.

Most important, local leaders and most of the nation's emerging managers are uncomfortable with principles and concepts taught in management courses that disrupt cultural norms. These include such matters as group decision making, assembly-line techniques that they feel enslave workers in unpleasant surroundings, and many of the motivational techniques that are viewed as manipulative.

Assignment

Choose one of two role profiles if working in teams. One team should take the position of host-country citizens. Individuals on the team should represent (a) a business student in the new program, (b) a business professor asked to teach management using this text, (c) a manager returning to school for mangement training, and (d) a political leader concerned with economic growth of the nation.

The host-country team should prepare arguments that present the advantages and disadvantages of the proposed business school, together with critiques of a principles of management course using this text and your course outline as an example. Discuss how business training will change the host nation, both pro and con, and how to improve the progeram (text, course, and training process) to best match cultural priorities.

A second team composed of consultants from the United States should prepare a similar brief and discuss issues to encourage a formal program based on American techniques, practices, and educational priorities.

Remaining students should write a critique of the role presentations and evaluate discussions for finer points concerning the institution of a formal business school curriculum. Examine the broader issues facing LDCs and the advantages and disadvantages of service contracts by Western technicians and professors brought to this nation to help form an industrial base.

FIGURE 21-5 Crucial Aspects of New-Venture Management

The term **entrepreneur** may be properly applied to people who incubate new ideas, start enterprises based on those ideas, and provide added value to society by introducing products and services based on their independent initiative. The term is inappropriate for those who simply choose to run their own businesses rather than work for others, including the average gas station owner, small retailer, and restauranteur. The gas station owner who plans for a chain of stations, the retailer who envisions nationwide discount outlets, and the restauranteur who intends to challenge McDonald's or Wendy's *are* entrepreneurs. The important distinctions are *vision* to grow, *determination* to provide constructive change, and *persistence* to turn an idea into a commercial success. As Figure 21-5 shows, these are the three most crucial characteristics of success in new-venture management.

The phrase *new-venture management* used in Figure 21-5 suggests that entrepreneurship is more than opening a new business. Vision by itself has little value; determination must be focused toward an objective, and persistence must be channeled in constructive ways. In opening a business, these three qualities are needed to bring new ideas to life. In working within an existing organization, they are just as important to help a firm become innovative and grow.

entrepreneur
An individual who assumes the risk of starting a new business, creating a new commercial product or service, and consequently seeking profitable rewards within a free enterprise system.

CHECKPOINT

■ Describe the elements of the definition of entrepreneurship, including wealth creation, risk taking, and personal commitment.

■ Discuss three different routes to entrepreneurship and what motivates people to take the entrepreneurial plunge.

■ Contrast the roles of entrepreneur and new-venture manager.

CORPORATE ENTREPRENEURSHIP

Suggesting that entrepreneurship can take place in established, large bureaucratic organizations is controversial. Our definition would not exclude managers from being entrepreneurs, however, if they combined resources in unusual ways to create innovative new products or services. The concept also implies that entrepreneurs take risks, which generally means committing personal resources to a project. If successful, they will reap major rewards; if not, they will lose much or all they put at risk. Corporate managers do commit their time and energy to projects, and sometimes they risk their careers, but they seldom risk their personal capital or place themselves in a position to win or lose great wealth.

The greatest point of controversy is ownership. From an economic or legal viewpoint, entrepreneurs are narrowly defined as having an ownership interest in a clearly defined venture. This interpretation would exclude salaried managers or wage-earning employees. Nevertheless, entrepreneurship does occur in established organizations. As we shall see, it can happen through product innovations, "spin-off" new ventures underwritten by the mother company, development of subsidiaries, and in several other ways. Managers and employees who instigate these new corporate ventures behave similarly to founders of independent businesses.[16]

Corporate managers of entrepreneurial ventures are therefore expected to have vision, determination, and persistence. They are also given greater profit-

FIGURE 21-6 Inventions and Innovations

and-loss responsibility, which can approach the autonomy enjoyed by independent business founders. The mother company provides the investment and is ultimately accountable for its success or failure; thus managers avoid the monetary risk of ownership. Still, more and more corporations are including managers in new-venture investments, and this further reduces the gap between "entrepreneurial managers" and "entrepreneurs." For example, Tektronix has encouraged new-venture management by creating special stock options for employees who become involved. General Electric has set up a new-venture fund to underwrite innovations, and gives employees who create operating units the opportunity to buy into their enterprises. One of GE's more successful spin-offs is GigaBite, a corporation engaged in research on superconductivity. Most often, the corporate approach is to reward an innovator through bonuses, put more resources at his or her disposal, and recognize the successful corporate entrepreneur through promotions. Art Fry, the 3M research engineer who developed the Post-it notepad, now enjoys easy access to resources, a higher position, greater latitude in his work, and substantial bonuses based on his innovations.[17]

Intrapreneurship

intrapreneurship
A term used in place of "corporate entrepreneurship," this label applies to managers who work within their existing organizations to create and commercialize new products or services for their organizations.

Corporate entrepreneurship has become known as **intrapreneurship,** a term meant to capture the notion of "intracorporate" venture activity. The implication is that formal entrepreneurship occurs within the established boundaries of existing organizations.[18] As we shall see, there are several models of intracorporate venture activity, but first it is important to understand that new products and services can be created through either *invention* or *innovation*.

Invention is the creation of something new. The resulting product of an inventor did not exist before. In contrast, innovation is a new way of using existing resources. Though both invention and innovation involve a tremendous amount of creativity, they are entirely different processes. Figure 21-6 illustrates this important distinction. For example, an innovation may be a new combination of natural elements that results in a useful and commercially viable product. Gasoline is an innovation, a derivative of a natural resource. Fertilizers are often combinations of nitrates and other chemicals made through an innovative process. In contrast, the first bicycle was an invention, and the microcomputer resulted from a half dozen inventions, including a system of mathematical calculations and microelectronics. Combining these inventions innovatively culminated in a commercially viable microcomputer.

Neither inventors nor innovators are necessarily entrepreneurs; many creative people with unusual ideas never get beyond the stage of creativity. Entrepreneurs breathe commercial life into their ideas, and by that criterion, independent entrepreneurs and corporate intrapreneurs are very much alike.

Classifications of Corporate Entrepreneurship

research and development (R&D)
The formal scientific and engineering function of designing new products, impoving existing ones, or developing new processes within an organization.

The traditional approach for creating new products or processes within the corporate environment is **research and development (R&D).** R&D is the formal activity charged with specific design or engineering responsibilities; however, new ideas, product improvements, innovative services, and new technologies can surface from many sources besides the R&D laboratory. Hans Schollhammer, an educator with years of engineering experience in entrepreneurship, has classified

the various ways entrepreneurship can occur in organizations. He also suggests that corporate strategies formulated to specifically support each approach influence how a firm will position itself for growth. His five classifications follow.[19]

Administrative entrepreneurship. Traditional R&D management is closely approximated in the administrative mode. The firm simply moves a step beyond formal R&D projects to encourage greater innovation or new inventions. The distinction that makes R&D entrepreneurial may be a state of mind, a corporate philosophy of enthusiastically supporting researchers toward greater achievement. R&D personnel are only partial contributors to bringing a new product to market or implementing a new technology. Other corporate personnel and resources help commercialize R&D innovations.

For example, Boeing became the world's foremost commercial aircraft manufacturer through the Boeing 727 project. The key to the Boeing 727 was the fan-jet engine created in 1961 for greater thrust and high-speed cruising. Seven years later, 400 Boeing 727 aircraft rolled off company assembly lines, and by 1984, when the last 727 was produced, Boeing had produced nearly 2,000 of them. This remarkably successful plane required teams of designers, marketers, scientists, and production engineers.[20]

Opportunistic entrepreneurship. Formal structural ties are loosened as product champions seek out and take advantage of unique opportunities. The traditional R&D perspective is avoided in favor of encouraging individuals to pursue ideas inside and outside the organization.

For example, First American Bank & Trust encourages individual managers to take profit-and-loss responsibilities for investing branch funds in unusual high-risk, high-yield opportunities. At First American, managers can also make capital acquisition decisions, such as buying computer network equipment or creating subsidiary businesses in real estate. A few of the bank's managers operate independently. Not part of the bank management hierarchy, they are compensated according to their investment performance.[21]

In sum, the opportunistic model suggests that managers accept some degree of isolation from corporate halls, after their career paths, and work semiautonomously to exploit opportunities within reasonable boundaries. They also may share generously in rewards.

Acquisitive entrepreneurship. Even further from traditional R&D models, the acquisitive approach encourages corporate managers to look externally for innovations that can lead to rapid growth and profits. Instead of developing ideas internally, corporations actively seek other firms that have invented new products or processes. In recent years, this strategy has led to almost frantic mergers and acquisitions in virtually every sector of the economy. In the microcomputer industry, corporations have added thousands of new products to their assets by acquiring firms that hold patents or that have incubated unusual ideas.

For example, Lotus Corporation rapidly expanded beyond its initial computer spreadsheet product, Lotus 1-2-3®, by acquiring in 1985, Software Arts and the copyrighted products VisiCalc®, TK!Solver®, and Spotlight®. Lotus also created formal alliances with Cullinet Software, Iris Associates, and Kanri Kogaku Kenyusho of Japan to establish international markets for more than two dozen new software programs.[22]

Imitative entrepreneurship. Sometimes likened to corporate espionage, imitative entrepreneurship takes advantage of other firms' ideas and inventions. The Japanese have suffered this label for years, particularly when they study an American product and find a way to improve upon it or bring it to market at a lower cost. Imitation abounds in all cultures; it is a way of "shaking out" less efficient producers. Since many inventors suffer from poor underwriting or lack of re-

sources, they are often forced to yield to more powerful and capable corporations. Other firms with talented people can often take a marginal product and create out of it something of high quality and value.

For example, the Korean electronics company Samsung assembled its first color television set in 1977. It was an amalgamation of parts and designs found in sets made by RCA, GE, and Hitachi. This was a prelude to Samsung's becoming the world's fifth largest color TV manufacturer within eight years. By 1983, the company's engineers had created their own version of a color TV that was more reliable and less expensive than any other set on the market. The company penetrated the U.S. retail market that year, Europe the next, and captured the largest share of low-price discount sales worldwide by 1985.[23]

Incubative entrepreneurship. After acquiring new products or patents, corporations must allocate resources to commercialize the acquisitions. This activity begins with an intense focus on development. The corporate pattern has been to create semiautonomous venture development units that nurture the new product or technology. These units are high-impact implementation teams working in high-risk endeavors. Few projects will be successful—in fact, most will be scrapped early in the development stage—so this type of activity requires corporate managers not easily discouraged by failure. They have to have the temperament to discard a poor idea, yet enthusiastically pursue the next idea with the same vigor. Managers in traditional career positions who must rely on patterns of success for promotions can seldom risk these activities. Corporations therefore create venture units that can develop a style separate from corporate politics and lockstep performance.

Corporate use of out-of-channel venture teams to develop innovative new products has been increasing. We introduced the concept in Chapter 9 as an unusual, and unofficial, way to create project teams called *skunkworks*—small teams of employees asked to develop and champion innovations outside R&D and other formal departments and reporting relationships.[24] Today they have official charters and are called *new venture units*.

New Venture Units

A **new venture unit (NVU)** is a separate team, division, or subsidiary created specifically to initiate new business ideas. By creating NVUs, companies debureaucratize the entrepreneurial process, giving a charter of autonomy for research and development to a volunteer team of employees. A small team can grow to division status, perhaps becoming incorporated as a subsidiary that pursues full commercialization of an innovation.[25]

The small-team model is followed by 3M, where venture units have accounted for nearly 25 percent of the company's increased operating profits since 1983. As noted earlier, a 3M team developed the Post-it pad and planned its introduction as a commercial product. After the innovative notepads were integrated into 3M's main product line for manufacturing and sales.[26] The original team regrouped on a voluntary basis for several other projects. At IBM, the new venture team that developed the personal computer was enlarged from a few individuals to fifty volunteers, who were given official status and encouraged to develop a full line of complementary computers. The PC team continued to expand until it was consolidated as IBM's Entry Systems Division.[27]

The corporate subsidiary model is less common than small-team or division NVU, but has had many notable successes. For example, General Mills expanded away from its food line into toys several years ago by creating Kenner Toys. Kenner was financed through General Mills and given autonomy to establish a product line of toys. Some of Kenner's best products have been Star Wars toys, Care Bears, and Strawberry Shortcake dolls, all developed in the NVU. Creation of the Master Card—and the entire bank card industry—was the result of

board in place, control shifted away from Tucker, and designs and production facilities were altered in response to unresolved production problems and increased costs.

Amidst these challenges, the Securities and Exchange Commissions (SEC) delayed the proposed stock offering because the corporation had failed to disclose all required information. In July 1947, when $20 million of the stock was offered, $15 million was purchased—but prices dropped and sales were hurt by rumors and negative publicity evoked by the SEC delay and by the Republican senator's report of unfavorable findings of an investigation into the Tucker corporation.

Just over a year after the offering, Tucker and a number of his associates were indicted on 31 charges including mail fraud, violation of disclosure requirements, and conspiracy. In early 1949, testimony of many witnesses substantiated the existence of a number of completed cars and Tucker's claim that he tried to produce the dream car for the public. Tucker and his associates were exonerated of all charges. Fifty-one cars had been produced (and most of these are still running and in good condition today), but the Tucker car company was dead.

Sources: Lucasfilm, *Tucker: The Man and His Dream*, Paramount Pictures, 1988; and Trudy Versor, *The Tucker Corporation: A Management Case Study* (Englewood Cliffs, N.J.: Prentice Hall, 1989).

Case Questions

1. Comment on the ways in which Preston Tucker did or did not emulate the characteristics of a successful entrepreneur.
2. Describe the growth and crisis stages of the Tucker Corporation.
3. What strengths, weaknesses, opportunities, and threats existed for Tucker and his corporation?

SKILL PRACTICE

MIND-SCAPING: AN EXERCISE IN INNOVATIVE THOUGHT

During a recent lecture to nursing students on entrepreneurship, the professor challenged students to think of careers, businesses, or new services that nurses could pursue besides working in hospitals. During a fifty-minute period, twenty-four nursing seniors mapped out seventy-one ideas for new opportunities. The process they used was simple brainstorming, but with a slight twist. The twist, to use the professor's terms, was "mind-scaping."

A mind scape is the process of starting with an obvious idea and branching out like a tree—each limb being a new idea stemming from the previous one. The following is a summary version of the nursing students' exercise.

The professor wrote one concept on the board to start the process: "health care." From that, students branched to these main topics: home health care, rehabilitation, meals on wheels, special nursing care, visitation, and counseling. Each branch created more ideas. For example, "rehabilitation" led to: cardiac rehabilitation, physical therapy, mental rehabilitation counseling, job retraining, accident recovery care, home dressing services, family aid, and kidney dialysis treatment. From home health care came: equipment sales, life-support systems calibration, pediatrics care, temporary nurse "on-call" services, and many others.

The same mind-scape process can be applied to almost any category of technology or major interest area. Following are several major categories of top-

FIGURE 21-A Mind-scaping for New Ideas

ics to stimulate interest. They can be assigned or personally selected for in-class or written exercises. Begin by listing one category and circling it, perhaps in the center of the blackboard or in the center of a piece of paper. Then develop root ideas that are closely related to the main topic. Circle these and draw lines back to the original topic. Choose one category that seems most promising, like "rehabilitation" in the previous example, and build new branches. See how far you can extend the tree in a reasonable period of time.

microcomputers	laser technology	robotics
genetic engineering	mass transit	communications
home entertainment	student services	furniture
travel	training	sports

Next, choose one of the branched ideas to develop more thoroughly and brainstorm the possibilities by answering the following questions.

Suggested Exercises

1. With a prepared mind scape, define a business concept around one of the selected branch ideas. Include a definition of the product or service, the target customer, and other relevant information such as potential location, facility needs, and likely demand.
2. Explain the obstacles you might encounter trying to start this business.
3. In general, what entrepreneurial skills would you need to assure that this venture is successful? What finances?
4. What competition might exist in this venture's market? What might be the opportunities for growth? Would you be excited about running this venture? Explain.

MULTINATIONAL START-UP

by Hal Plotkin

With the rapid internationalization of the U.S. economy, more companies are looking overseas early in their development. Indeed, some new firms are predicating their success almost entirely on penetrating foreign markets for their goods and services.

Of course, there have always been companies—such as import/export operations, shipping firms, and consultants—that have done virtually all their business abroad. But the globalization of financial markets, along with new communication technologies—facsimile machines, in particular—has greatly expanded the opportunities for fledgling companies to start their businesses overseas.

Crucial to the success of this new breed of multinational start-up is the strong demand in many parts of the world for products uniquely American. Whether for cosmetics, fresh fruits, or television shows, this demand can create lucrative openings for entrepreneurial ventures.

Flexible Marketing

Beauty Products International Inc. (BPI), a cosmetics-exporting firm founded in 1987 by three California businessmen, is a classic model of this new type of start-up. Rather than taking the usual route of building domestic sales and then hesitantly dipping a toe into foreign waters, company president James K. Yoder thought globally from the beginning. This focus paid off quickly.

Capitalized with only $25,000, by 1988, BPI had penetrated markets in Australia, Saipan, Malaysia, Indonesia, Singapore, South Korea, the Philippines, Malta, Kuwait, Nigeria, Greece, and Japan, with even larger deals pending in Mexico, France, and Taiwan. Since its creation, the company has shipped more than a million units of nail enamel and lipstick to wholesale customers around the world.

Central to BPI's success has been capitalizing on the mystique of American women, particularly California women. By leveraging this asset with a finely developed network of distributors and a willingness to adjust products to meet local tastes, in less than two years BPI has racked up sales of nearly $1 million.

BPI's success came in a niche ignored by larger, more established companies. Yoder's partner, Maurice Rasgon, has a childhood friend, Mark Friedman, whose factory supplies cosmetics to discount stores such as K Mart, which sell them at two for a dollar. Though Friedman had frequently received inquiries from potential customers overseas, they had never piqued his interest.

"He would just throw the letters in the wastepaper basket," Rasgon recalls, "because he thought it was too big a bother. Many of the letters were in foreign languages, or they were from places he had never heard of."

But Rasgon and Yoder saw a better use for those letters. They took them to their friend Kenton Post and used them to convince him to put up the $25,000 they needed to get started. Seeking to take advantage of the fascination with California around the world, they repackaged their discount cosmetics for their export-only "California Colors" line.

But if the California concept piqued the interest of overseas merchandisers, BPI's success rests largely on its flexible approach to each market. "Jim listens closely to his customers, and he never argues," notes BPI's Japanese marketer, Yasunori Satomi. "Americans are always asking, 'Why do the Japanese do that?' But that is a question for scholars. The question businessmen should ask is, 'How do the Japanese do this or that?' And that is the question Jim is always asking me."

In Japan, Yoder's ability to listen and learn is reflected in BPI's willingness to place the brand name on the lipstick's base instead of on the removable cover and to change the packaging color scheme upon request. As a result, BPI's slightly altered product line is now being test-marketed at Daiei, Japan's popular 3,000-store retail chain. Yoder is quick to point out the power of Japan's mass market: Sales of just twelve pieces per day per store will add $6 million to BPI's annual sales volume.

Yoder carries this flexibility into other markets. In South Korea, for example, his customer wanted a lipstick that slid more smoothly from its sheath. "So it costs us two cents more per piece," Yoder explains, "but now it is a very elegant product. Basically, we just try to find out what they want, and then we sell it to them."

This willingness to customize may soon pay off in big sales in South Korea, believes Jason Shin, managing director of the Seoul-based Poong Jin Company. Last summer Poong Jin test-marketed $20,000 worth of BPI's lipstick, and plans to quadruple its purchases this year.

Building Relationships

Effective and flexible marketing is only one aspect of building a successful multinational start-up. Equally important, particularly in Asia, is the patient constructing of relationships with key business contacts. For example, Western Orient Trading Company founder and president Jeff Thompson cites his close ties with his largest Japanese customer, produce wholesaler Tomio Arimoto, as perhaps the key element in his success. In only four years, Thompson's Mission Viejo, California, which markets high-quality American fruits and vegetables in Asia, has seen its sales jump from $1.2 million to $14 million.

"The second time I visited Mr. Arimoto," recalls Thompson, who still addresses his most important customer formally, "he prepared a Matsutake mushroom feast." The fleshy fungi, which sell for about $100 each in Japan, were the centerpiece of a meal that Thompson will try to top the next time Arimoto visits him in California.

Arimoto, who spent thirty years as an employee of Nishimoto Trading Company, a distributor for fruit marketing giant Sunkist, beams when Thompson's name is mentioned. "Most Americans who want to sell products here, they have mouths, but no ears," he says. "But Mr. Thompson is different. I tell him what we need, what size, what color, and he finds the very best products for us."

Grabbing the Opportunity

Yet, more than anything else, it is classic entrepreneurial opportunism that characterizes the new breed of multinational start-ups. Take Lyric Hughes, founder and president of T.L.I. International Corporation, a marketing services firm in Chicago.

When Hughes's favorite football team, the Chicago Bears, played in the 1986 Super Bowl, she made a bet with her friend NFL representative Jim Bukata. The deal was that if her team won, she would get the exclusive rights to rebroadcast the game in China. The Bears won.

Paying the NFL a paltry $200 for the first-ever rights to broadcast a Super Bowl to China's potential megamillion-viewer TV audience, Hughes opened up a new market for American sports programming in that country. Offering entry advertising rates for 30-second spots on China Central TV (CCTV) for less than the equivalent time in any major U.S. metropolitian media market, Hughes netted some $75,000 worth of advertising from the Super Bowl rebroadcast.

For their part, Chinese television officials believe their audience—more than 300 million viewers watched the game in 1987—is only beginning to get interested in such events. "Refrigerator Perry was very popular," says Cen Chuanli, CCTV deputy director of sports programming. "A lot of people liked the Refrigerator, a man who could eat a lot of food."

Whether cosmetics or cantaloupe, the Refrigerator or the California Girl, the international appetite for American products seems insatiable. For the entrepreneur willing and able to exploit it, the time has never been better.

Case Questions

1. Using MNC classifications, discuss each firm's approach to business. In your answer, explain how each used licensing, exporting, contracting, and other forms of business internationally.
2. Explore how each entrepreneur used a knowledge of the culture of the countries he or she was doing business with to generate cooperation with clients. How might cultural awareness be important for each firm during the 1990s?
3. From an entrepreneur's perspective, choose a product or service that you think might be valuable to a foreign customer. Using the start-up planning criteria for a new venture and information from Chapter 20, International Management, describe your customers, markets, and critical success factors. Why might your product or service be a success, and what factors could spell doom?

Source: Hal Plotkin, "Multinational Start-up," *Inc.'s Guide to International Business,* Fall 1988, pp. 15–17. Copyright 1988 by Inc. Publishing Corporation, all rights reserved, adapted with permission.

THE WALL STREET JOURNAL

*T*he *Wall Street Journal* is the most authoritative and widely read daily business publication in the United States. But *Wall Street Journal* readers are not all found on Wall Street. Far from it. *The Journal* sells more copies in California than in New York, and only 12 percent of its readers work in finance. If you picture *The Wall Street Journal* only in the hands of big-business executives, look again: 45 percent of the readers work in companies with fewer than 100 employees, and 42 percent are under 45 years old.

This text has used *The Wall Street Journal* (WSJ) extensively to bring in real-world examples of management principles put into practice. If you look at the endnotes of the chapters you will see numerous citations of *Wall Street Journal* articles. Read on a daily basis, it will continue to reinforce the relevance of classroom concepts in the business world, which can make both the class and life more interesting.

While *The Wall Street Journal* is a business newspaper covering all apsects of business and finance, several regular features are particularly relevant to management. It is very likely that you will be required to do some outside research for a term paper or project, and *The Wall Street Journal* is one of the major resources available to you. This appendix is a guide to using *The Wall Street Journal* in your management class either on a daily basis or for such projects.

THE FIRST SECTION

The *first section* reports on the most important corporate, national and international news stories.

What's News, the 2nd and 3rd columns from the left on the front page (see p. WSJ _4_), is almost like an annotated table of contents of the day's business and world news. A quick read is sufficient to keep abreast of both business and world news. Each item in the left column on Business and Finance conveys the major points of the key business articles in that day's *Journal.* There is a referral to the appropriate inside page if the reader wants more details. The World-Wide column aims to be self-contained with bold-faced "handles" that start each item. An italicized paragraph of analysis and/or background closes many of the items. Usually these items are larger and more detailed than those in the Business and Finance column. If there is an inside story the page number will be given.

Columns 1 and 6 of the front page are called "*leders*" (see p. WSJ _5_), a British term for a story that "led" the paper. These leders have evolved away from hard news articles into comprehensive stories which often require weeks and even months to develop: in-depth looks at industries and companies; profiles of leaders, businesses and trends. This article is on the "Oil Industry's Inability to Contain Spills at Sea" from June 20, 1989. You will note that there are several references in the text to the Exxon Valdez oil spill, such as the case at the end of Chapter 3 on Social Responsibility and Ethics in Management, and the Global Trends box, Exxon: How to Prevent Another Valdez Disaster, in Chapter 16 on the Controlling Function. *The Wall Street Journal* has followed the story closely, and will continue to do so. Reading the *Journal* can keep you updated in a way that both relates to and goes beyond the text.

The 4th column starts off with a *graph* (see p. WSJ _6_) which presents statistical information visually. Information often has much more impact when it is reported this way. This is important for you to keep in mind when preparing reports and presentations (see Chapter 15 on Effective Communication). This particular graph

from July 19, 1989 depicts average weekly pay of factory workers since mid-1986, which is relevant to Chapter 12 on Staffing.

The graphs can be on any number of business topics, but *Column 5* presents a rotating series of reports each week day. Tuesday's is a "Labor Letter" (see p. WSJ _6_). The *Journal* uses the term "labor" here broadly as the newsletter covers both union and non-union employment topics. Each letter carries 10–12 items. Because many laws affect employment practices and the laws change continually, *The Wall Street Journal* tries as much as is possible to use court case developments in human resource management as the bases for these items. *The Wall Street Journal's* Washington Bureau has ready access to and provides information from the many government departments involved in gathering "labor" statistics, congressional senate committees and lobbying groups. This column is an excellent resource for keeping updated on the material in Chapter 12 on Staffing and Effectively Managing Human Resources.

One of the major developments in management is the increasingly global nature it has taken on. Each day *The Wall Street Journal* has a page and often a two page spread on *International News and Reports* (see p. WSJ _7_) from its foreign bureaus. One page usually covers important overseas business news while the other page focuses on political and economic developments. This August 15, 1989 article discusses Shanghai and Beijing after the confrontation between the pro-democracy movement and the government in the summer of 1989. The future of China as an economic power is discussed in Chapter 20, International Management.

THE MARKETPLACE

This section of *The Wall Street Journal* emphasizes how companies compete and how consumers respond. This section also offers material that relates to the reader's career.

The two left-hand columns on "the second front" offer a rotating column which, like column 5 of section one's front page, changes themes daily. One such column is on *Managing* (see p. WSJ _8_) which covers a variety of management topics. This one from July 12, 1989 shows several examples of how, despite much talk about and attention to important changes in the world which should affect management, things change slowly. You are the future of the world—keeping your eyes and ears open about what's really going on around you will make you better prepared to do something about it.

If you are following a particular company for an assignment, turn to the *Index to Business* (WJS p. _9_). This is another great help *The Wall Street Journal* provides in finding information you need very quickly.

Usually on the same page as the Index, you will find *Enterprise* (see p. WSJ _10_), a feature devoted to the changing world of new and smaller businesses. The article may profile a company or discuss a variety of topics which will help the small business owner or enterpreneur manage more effectively: tax law changes, trends—franchise law, government regulation and staff efforts to stimulate the creation and growth of small business, etc. This August 31, 1989 article points out how difficult it is for managers of small firms to think about strategy and innovation. This text specifically addresses enterpreneurship and small businesses in Chapter 21. Innovation is discussed in Chapter 4, and Strategic Planning is presented in Chapter 6.

Who's News, also in the second section, profiles new and established business leaders. This Who's News article from July 3, 1989 contains information about the Chief Executive Officers of three large corporations. Several things mentioned in the articles are discussed in the text: managerial responsibilities and roles—Chapter 1; developing strategies—Chapter 6; leadership—Chapter 14; and organizing—Chapter 8.

MONEY AND INVESTING

While much of this third section of the *Journal* might be more thoroughly read by those in finance courses than those in a management course, *Money and Investing* at least relates to management in so far as financial control is concerned. You will note that Chapter 16 has a section on financial controls in which we discuss using *The Wall Street Journal*. The text uses Campbell's Soup as an example. The August 11, 1988 column on which that part of the text was based is on p. WSJ _12_. The decline in pretax earnings as a percentage of revenue sends a signal that the company does not seem to be performing as well as it should. However, other ratios for the company, the industry and competitors would have to be studied before reaching conclusions.

The financial section of the *Journal* uses quite a bit of industry jargon such as blue chip, churning, golden parachute, insiders, and penny stocks. If you want to learn more about understanding financial data in the *Journal,* the Educational Edition of *The Wall Street Journal,* which is available through the *Journal,* has a five-page (newspaper size) users' guide on this topic. The Educational Edition also explains an efficient and effective method of finding the news that is important to you in the *Journal.*

The author of this text, Prentice Hall's editorial staff, and the Educational Service Bureau of *The Wall Street Journal* are convinced that the best education comes from a strong command of the book, classroom learning, and being aware of the real-world, current business news such as is found in *The Wall Street Journal.* We hope this guide has given you a way to see how management principles are—or can be—practiced in the real world.

What's News—

* * *
Business and Finance

STOCK PRICES SOARED as dwindling recession fears prompted investors to shift their strategies. The Dow Jones industrials jumped 41.54 points, to 2694.99, a post-crash high and less than 28 points short of the record. Still, traders questioned how long the stock market rally will last. Bond prices finished unchanged, while the dollar had modest gains.

(Story on Page C1)

* * *

UAL's stock rocketed $46.25, to $210.75, after United Air's parent confirmed receiving a takeover bid from investor Marvin Davis. Other airline stocks surged, pushing the Dow Jones Transportation Average up a record 94.06, to a new high of 1344.06.

(Stories on Pages A3 and C1)

* * *

USAir sold Berkshire Hathaway $358 million of preferred stock convertible to a 12% stake, possibly to ward off unwanted suitors. It is the first major airline investment by Berkshire's chairman Buffett.

(Story on Page A3)

* * *

Banking regulators approved Prudential Insurance's acquisition of an insolvent Georgia thrift. The deal is likely to be among the first to take advantage of broader marketing activities allowed in the S&L bill.

(Story on Page A2)

* * *

Civil insider-trading charges were filed by the SEC against two Merrill Lynch ex-employees and a New York lawyer whose 1985 stock transactions led to the unraveling of Dennis Levine's stock-trading scheme.

(Story on Page A2)

* * *

Hewlett-Packard plans to announce today an alliance with South Korea's Samsung. The move is likely to fuel competition among makers of computer workstations and to speed the arrival of low-cost models.

(Story on Page B1)

* * *

AT&T accused MCI of giving special discounts to several big clients without filing details with the FCC. The unusual complaint could prompt a policy review by the agency.

(Story on Page A4)

* * *

Warner-Lambert said earnings prospects have improved further. The company also is seeking acquisitions and isn't interested in a merger despite continued takeover rumors.

(Story on Page A4)

* * *

Mutual funds may be required by the SEC to disclose who is managing the portfolio and to notify investors of any change in managers, agency staffers say. The plan is certain to be strongly opposed by the industry.

(Story on Page C1)

* * *

Jerrico agreed to be acquired by a New York investment group for $24.25 a share, or $620 million. The operator of Long John Silver's restaurants was a long-rumored takeover candidate.

(Story on Page B8)

* * *

IBM plans to meet with clients and consultants today to provide details of some new telecommunications equipment, industry executives said.

(Story on Page B5)

* * *

Reebok agreed in principle to buy CML Group's Boston Whaler unit for $42 million, signaling a major broadening of Reebok's product base.

(Story on Page C9)

* * *

Markets—

Stocks: Volume 197,580,000 shares. Dow Jones industrials 2694.99, up 41.54; transportation 1344.06, up 94.06; utilities 221.52, up 3.34.

Bonds: Shearson Lehman Hutton Treasury index 3323.09, up 1.14.

Commodities: Dow Jones futures index 128.57, off 0.36; spot index 127.94, off 0.25.

Dollar: 140.05 yen, up 0.15; 1.9162 marks, up 0.0092.

* * *
World-Wide

CENTRAL AMERICAN LEADERS SET a 90-day timetable to disband the Contras.

The presidents of five Central American nations, concluding a three-day summit at the Honduran resort of Tela, announced an agreement for demobilizing and repatriating 11,000 Nicaraguan rebels based in Honduras. The plan calls for the U.S-backed guerrillas to surrender their arms to a force of Spanish, West German and Canadian soldiers within three months. The accord also calls for talks to end El Salvador's civil war.

The Bush administration had lobbied to keep the Contra rebels intact at least until elections are held in Nicaragua. Such voting is scheduled for February.

* * *

A U.N. ENVOY EXPRESSED optimism about freeing hostages in Lebanon.

The U.N.'s undersecretary-general for peacekeeping operations, after five days of meetings in Lebanon and Syria, said current circumstances "might be more conducive" to getting Western hostages released but predicted "a long process" of diplomacy. Israel, meanwhile, rejected a demand to free an abducted Shiite cleric, saying three Israeli soldiers had to be included in any swap of hostages and Arab prisoners.

The FBI's forensic experts believe a videotape of a hanged man showed Higgins. The agency didn't offer a conclusion on the cause or time of death.

* * *

The U.S. and Soviet Union concluded a round of talks on reducing long-range nuclear arms. It was the first such round since Bush took office. Both sides to the seven-week meeting in Geneva cited progress over inspection procedures, but said obstacles remain, including a dispute over U.S. plans for a space-based anti-missile system.

* * *

Walesa called for a coalition government in Poland that would exclude the Communist Party. Intensifying his objections to Prime Minister Kiszczak's government, the Solidarity leader urged two small political parties allied with the Communists—the Peasants and the Democrats—to switch their allegiance to his independent movement.

* * *

A Tennessee court opened a divorce trial in which the judge must decide whether seven frozen embryos should go to a husband who currently doesn't want children or to his wife, who can't conceive naturally. The case, thought to be the first in the U.S., is to focus on whether the fertilized eggs deserve consideration as a potential child.

* * *

The State Department said a plane carrying Rep. Leland of Texas failed to arrive at a refugee camp near the Ethiopian-Sudanese border, raising concern about the safety of the Democrat and his group. The aircraft was said to be Ethiopian. The congressman has been traveling in Africa, visiting areas hit by famine and civil war.

* * *

U.S. officials said the Bush administration will urge Mexico to join in tougher joint action against drug traffickers by making money laundering an extraditable offense. Meanwhile, Secretary of State Baker, leading a high-level team in talks with Mexican officials, said Mexico had become an economic model for other debtor nations.

* * *

The EPA said indoor air pollution makes up a major portion of the public's exposure to dirty air and may pose acute and chronic health risks. In a report required by Congress, the agency called for expanded research on various topics, including the health effects of chemical contaminants found indoors and ways to cut exposure.

* * *

New Zealand's ruling party elected Deputy Prime Minister Palmer to succeed Lange as prime minister. Lange, who cited health reasons, announced his resignation Sunday after a year of Labor Party wrangling over economic policies. The U.S. has expressed hope that Wellington's anti-nuclear policy would be reassessed.

* * *

A U.N. delegation arrived in Cambodia to investigate the feasibility of forming an international body to monitor a pullout of Vietnam's troops, scheduled to be completed next month, Phnom Penh's official news agency reported. The fact-finding team was sent by an international conference on Cambodia that opened July 30 in Paris.

* * *

Firefighters battled dozens of blazes on 182,000 acres in seven states in the West. More than 220,000 acres have been scorched by wildfires that began last month, and thousands of "dry lightning" strikes raised fears of new forest fires in the region.

Credibility Gap

Oil Industry's Inability To Contain Spills at Sea Poses Political Trouble

Legislators May Seek to Slow Offshore Drilling Until Safety Measures Improve

Did Big Oil Tell a Big Lie?

By KEN WELLS

Staff Reporter of THE WALL STREET JOURNAL

The collision of an oil-carrying barge with a freighter on Friday night sent 250,-000 gallons of crude oil spewing into the ocean outside the Houston ship channel. Bad weather foiled attempts to contain the relatively modest spill.

Earlier that day, a Greek tanker ran aground on a reef near Newport, R.I.,

Congressional Pressure

The groundings of the oil tankers increase pressure on Congress to require double hulls on the ships. One industry adviser said he will call for oil tankers to be built to chemical industry standards. Story on page A4.

sending an estimated 600,000 gallons of refined oil into Narragansett Bay. Despite encircling the ship with oil-containment booms in less than four hours after the spill, emergency crews were unable to contain the slick, which now threatens rich fishing and shellfish grounds.

On the same day 300 miles away, a Uruguayan tanker ran aground in the shallows of the Delaware River near Claymont, Del., dumping an estimated 800,000 gallons of heating oil that rapidly spread into a splotchy ribbon some 20 miles long.

And as for America's worst oil spill, the 11-million-gallon Exxon Valdez disaster in March that despoiled Alaska's scenic Prince William Sound, the slick eventually spread over a 1,300-square-mile area. Oil-company equipment didn't reach the scene for 36 hours.

All of these spills were accidents. But the inability to contain them wasn't, a fact that has ominous political implications for Big Oil. Despite numerous promises to the contrary, the oil industry's recent performance has shown it has had neither the technology nor the level of commitment necessary to control these major hazzards. It is a situation that that may lead previously quiescent legislators to take a hard look at limiting future development of offshore drilling sites.

Past Claims

For at least the past decade, the industry has claimed that technological advances make it possible to mop up most oil spilled in offshore incidents. As early as 1981, Sohio Alaska Petroleum Co., in commenting on a federal proposal to lease offshore tracts for oil drilling, stated emphatically that "the risk of a major oil spill based upon past industry experience in Alaska and the Lower 48 is extremely low," adding that "oil-spill technology and techniques exist and would result in cleanup of most oil spilled."

The same claim of spill-containment prowess has been repeated over and over in the 1980s, mainly to justify new oil exploration and development in environmentally risky areas. Just a week ago, Richard M. Morrow, the chairman of the American Petroleum Institute, maintained that the industry has a "good record in responding to non-catastrophic spills," meaning those spills of less than 10,000 barrels. But government research, interviews with oil-spill experts and the industry's own performance indicate that its record is, in fact, abysmal, whether dealing with large spills or small.

Falling Short

Over the past 22 years, "I've done a post-mortem on just about every spill over 1,000 barrels, and there are some very common threads," says Ed Tennyson, a spill research scientist for the federal Minerals Management Service (MMS), overseer of the nation's offshore oil leasing program. "Ninety-nine percent of the time there isn't enough equipment on the scene within the first critical four to eight hours, and when recovery finally starts there is almost never sufficient storage for recovered oil."

"It is a myth that industry now possesses the technology to reign in spills in open water," adds Richard Golob, editor of Golob's Oil Pollution Bulletin, a Cambridge, Mass., trade publication. "That ability doesn't exist." Mr. Tennyson agrees: "The current technology amounts to having a quarter-inch lawnmower working on a 40-acre field."

The technology for corralling a big spill is, in fact, primitive and remarkably ineffective, and neither the government nor Big Oil has spent much on improving it. Oil skimmer boats and containment booms can handle only small amounts of oil.

Chemical dispersants, much ballyhooed by the industry, fail 94% of the time, according to an unpublished government study of 107 small spills over the past 20 years. They may also be more toxic than the oil they are supposed to disperse. Dispersants also appear ineffective in calm seas, and skimmers and booms don't work in rough seas. Usually, adequate amounts of equipment and chemicals aren't anywhere near a spill site.

Despite a major but belated effort, Exxon Corp. recovered from the water only perhaps 5% of the 11 million gallons spilled by the Exxon Valdez. (Exxon, however, claims that including oil mopped off of beaches, it has recovered as much as 25% of the oil spilled, a figure that the state of Alaska says is more than double its own unofficial estimate.)

As poor as this performance is, it's about average for the industry. For the past two decades, the normal range of recovery for open-sea spills hasn't changed—at 2% to 10% —according to Karen Fine Coburn, publisher of Oil Spill Intelligence Report, an industry newsletter.

Last week, while asserting the industry's record for smaller spills was "good," Mr. Morrow, who is chairman of Amoco

Corp. as well as the American Petroleum Institute, did concede that "the industry has neither the equipment nor the response personnel in place and ready to deal with catastrophic tanker spills." Mr. Morrow announced a plan by API members to spend up to $250 million over five years developing standby regional response centers and funding research.

But given the "extreme difficulties" in fighting such spills, Mr. Morrow said the industry can't guarantee success, but can "only promise its very best efforts." Given its most recent efforts, that statement isn't apt to fly very well in Congress or state legislatures. They had been told by the oil industry that big spills could be significantly contained and cleaned up. Now, the industry is in effect telling them major spills aren't containable, but that risk is the price of developing new oil fields. Some politicians and government officials find the new position discomforting. And while they tend to be the same Democratic politicians who have opposed offshore drilling in the past, some also angrily charge that Big Oil told a big lie.

"What the Valdez spill has done is expose the soft underbelly of the industry—that it has no actual capability of handling a spill this size and, in fact, looking at the track record, a spill half, a quarter or even 10% as large," says U.S. Rep. George Miller, a San Francisco-area Democrat. The failure to contain the spill "held up to the public, in very dramatic fashion, what it means when we say there are some very real trade-offs and risks to oil development in sensitive marine ecosystems."

"The only solution, in areas like the Arctic or [Alaska's] Bristol Bay is to not take the chance, to put these areas off limits to development," maintains Jack Hessian, director of the Alaska chapter of the Sierra Club.

Alaska Acts

The state of Alaska itself has called upon the federal government to withdraw leases and ban drilling in the Bristol Bay region of the southern Bering Sea, arguing that a large spill could wreak long-term damage on the bay's renewable $1 billion salmon fishery. Conservationists are even using these concerns to press for an outright drilling ban in the onshore Arctic National Wildlife Refuge on Alaska's North Slope.

In California, a coalition of 29 congressmen led by Rep. Mel Levine and Sen. Alan Cranston, both Democrats, has asked President Bush and Interior Secretary Manuel Lujan Jr. to permanently ban drilling off the scenic Northern California coast and cancel several other coastal California lease sales pending re-evaluation of industry spill-response ability.

"We cannot accept at face value that impacts can be avoided, or that clean-up capability is both effective and deployable," Rep. Levine said bluntly in a letter to President Bush. "Indeed nothing could be further from the truth."

Rep. Miller says "we sense a dramatic change in the politics." He notes a unanimous bipartisan decision by the Florida

congressional delegation to seek a drilling ban off that state's coast. And similar movements to ban or slow down drilling have sprung up in Massachusetts, Oregon, Washington, North Carolina and South Carolina. "A year ago, you couldn't get a discussion going in Congress on these trade-off issues. But now the chances have substantially increased" that some of these efforts to stop development will ultimately succeed, he says.

The main response of the oil industry and its supporters to the shift in political winds is to point to its past safety record, and to promise to spend more money on oil containment efforts. The industry says that in the U.S. there have been no major offshore oil rig-related spills since 1971, and world-wide, the spill of the Exxon Valdez is one of only a dozen tanker spills greater than 10.5 million gallons since the 1967 wreck of the Torrey Canyon off the British Coast.

Furthermore, the API says its members will finance a new Petroleum Industry Response Organization that will operate five regional response centers "prepared to act quickly in any future major spill."

Spending Plans

The institute said the new PIRO will cost $70 million to $100 million to establish, and about $30 million to $35 million yearly to operate. In addition, the institute plans to support research into spill control and mitigation, costing an estimated $30 million to $35 million over a five-year period. The institute also plans to support improvements in tanker safety and operation.

Alyeska Pipeline Service Co., the consortium that operates the Trans-Alaska pipeline terminal in Valdez, has already agreed to spend many millions of dollars to upgrade its response capability. It has chartered or purchased six new large vessels, from tugs for hauling equipment to skimming vessels to big barges for storing skimmed oil. It has reestablished a 12-person emergency response team that will do nothing but train for and respond to spills. Tankers eventually will be accompanied by 210-foot vessels loaded with oil-spill gear. Emergency equipment also will be kept at Knowles Head deep in Prince William Sound.

Federal Reaction

The Bush administration is expected to point to these efforts as proof the oil industry is sharply enhancing the safety of offshore tanker and drilling-rig operations, and that development in environmentally-sensitive areas should thus proceed.Frank Murkowski, a pro-oil Alaska senator, is seeking a one-year delay in drilling in the Bristol Bay—rather than a ban—in hopes the government and industry can improve oil-spill response.

Certainly the oil industry's new position contrasts sharply with the past, when it consistently opposed spending more money on spill response or tanker safety. Alyeska, for instance, once had a full-time spill-response team, but disbanded it in 1982 to cut costs. It even rejected a later offer by the town of Valdez to help in financing a beefed up response capability.

Labor Letter

A Special News Report on People And Their Jobs in Offices, Fields and Factories

DRUG TESTING by private employers gets chilly reception in some courts.

The U.S. Supreme Court rules the federal government may test workers in sensitive or safety-related jobs. But a New Jersey court decides a private employee can sue for wrongful discharge if fired merely because of a random drug test, says Howard Lavin of Stroock & Stroock & Lavan, a New York law firm. A California court awards $480,000 to an office worker fired after refusing such a test, says David Bacon of Adams, Duque & Hazeltine, Los Angeles. Both decisions are being appealed.

Alaska's supreme court, though, rejects a challenge to an airline's random drug tests, Mr. Bacon says. And Mr. Lavin notes a federal court in New York says a worker who tests positive can't claim he is a handicapped worker whose job is protected unless he has sought treatment. A New York court, however, rules that a worker testing positive is perceived to be disabled and can't be fired or refused work unless the company demonstrates he can't do the job.

A dozen states and cities have regulated testing, Mr. Lavin says. Utah limits employer exposure to suits.

CRY FOR HELP! Lifeguards are in short supply at some beaches and pools.

Swimming areas around metropolitan Boston are shy 100 guards this summer, forcing curtailed protection at some outlying beaches. A new state regulation requires candidates to pass a $90 course, and some students can't afford the fee. The Red Cross lifeguard course has been increased to 27 hours from 21, says Jim Kelsea, aquatics director in Corpus Christi, Texas. "Students find it hard to work in the time," he says.

Inner-city pools are especially hard to staff. "We try to train kids who have grown up at the pool so everybody knows them," says Lonnie Walker, a Dallas parks official. But there's no problem at Oak Hills Country Club in San Antonio. Nor at Los Angeles County beaches, where the base pay is $12.06 an hour. "We're more aquatic minded out here," an official explains.

SAFETY EMPHASIS grows—in part under prodding—at major employers.

Mounting accident claims and tightened federal regulation, plus the recognition that good safety is good business, prompt companies to devote more attention and money to worker safety. At LTV Corp.'s aircraft products division, spending jumps 25% this year, to $2.6 million, in large measure because of a 27% rise in workers' compensation payments, to $6.5 million last year. Allen Group's safety-related spending has soared 50% over five years.

Du Pont Co. says it re-emphasizes safety after a lapse a couple of years back, when the stress was on productivity and quality. "We erroneously thought we would continue to do well without day-to-day attention," Bruce Karrh, a vice president, says. Now the accident rate is half of what it was in early 1987. Scott Paper Co. views a safe workplace as one precondition of being a "pre-eminent company," its goal.

"People ought to come to work and go home in the same condition," Coleman Co. says.

THE IRS signals it's OK to use tax-deductible Section 401(h) arrangements to pre-fund retiree health costs even when a company's pension fund is fully funded. Fred Rumack of Buck Consultants says the IRS tells employers they can get the necessary blessing from local IRS offices.

OVER 10 MILLION workers by year end will own a stake in their companies through employee stock ownership plans or similar stock bonus plans, the National Center for Employee Ownership estimates. Some 865,000 employees were added last year.

LEFT-HANDED MEN are one-third more likely to have accidents on the job than right-handers, finds Stanley Coren, a University of British Columbia psychologist. A principal suspect: the right-handed bias of the equipment they use.

POOR WORKER SKILLS force one in three banks to offer basic training in reading, writing and arithmetic, the American Bankers Association says. The programs cost the industry $32 million a year.

STOCK FOR DIRECTORS: As more firms use incentive, questions are raised.

Some 40% of the nation's 100 largest companies use stock or stock options to lure and hold on to outside directors, consultant Towers Perrin says. That's up from 7% in 1985. Consultant Sibson & Co. finds stock packages at 13% of 275 companies studied, up from 3% in 1983. In most cases, the stock is thrown in as an added incentive atop annual cash retainers that can run to $25,000 and meeting fees of as much as $1,000.

Owning stock "encourages directors to identify far more closely with the concerns of shareholders," declares Michael Halloran of Towers Perrin. Sibson's Jude Rich agrees. But Mr. Halloran sees a potential conflict if directors share in stock plans while judging management stock-based incentive programs. And Mr. Rich argues that stock should be paid instead of cash, not as extras beyond regularly rising fees.

At some companies, stock awards can add as much as 40% to a director's total compensation.

THE CHECKOFF: Prof. Henry Higgins would be shocked. A New York company, Communispond Inc., is opening an office in London to teach the English how to speak. ... Thank goodness it's Tuesday. There never is a good day to fire anybody, human-resource managers say, but if they've got to make a choice, most pick Friday, with Monday second, Adia Personnel Services finds.

—SELWYN FEINSTEIN

Shanghai Offers Sharp Contrast to Beijing

City's Spirit of Post-Rebellion Resentment Lingers Openly

By JEREMY MARK
Staff Reporter of THE WALL STREET JOURNAL

SHANGHAI, China—China's largest city remains uncowed by the throttling of the country's pro-democracy movement 10 weeks ago.

Both in the seedy 1930s-style business district and in overcrowded back alleys, a visitor finds that, unlike Beijing's subdued populace, many Shanghainese openly express resentment against the government and wonder where their lingering spirit of rebellion will lead them.

Outside a twin-screen downtown theater, scalpers are doing a thriving business for a sold-out afternoon movie. Most posters for the day's offerings portray a young Deng Xiaoping on horseback in a striped jacket, leading his army into battle. "Baise Uprising," named after a town in Guangxi province, has top billing, but it is hardly the main attraction. The young men buying the scalpers' tickets aren't interested in the film about the Chinese Communist revolution. They are here, a tout explains, to see an Italian thriller. "Look, this is an action movie," one says. "'Baise Uprising' is a political movie. No one wants to see it."

Typically Shanghai

The disdain for propaganda and the willingness to state this openly are typical of this outspoken city of more than 12 million people. A visitor walking Shanghai's hot, crowded streets hears strong opinions on plenty of other subjects as well: democracy, corruption, sky-high inflation, unemployment, even honest praise for the city fathers.

Barely 10 weeks after the Shanghai government used tough talk and worker brigades—not tanks and automatic weapons—to clear tens of thousands of young demonstrators from downtown streets, the city carries on as before. Just about the only people here who don't want to talk these days are the foreign businessmen. The city's foreign community is back in force, but traders and joint-venture managers have little desire to talk with a reporter. Wary of angering the Chinese government, and concerned about attracting attention back home while China's crackdown remains in the news, most decline to be interviewed.

Shanghai's openness contrasts sharply with Beijing under martial law, where troops still guard key intersections around the clock. A stranger wandering the capital's streets by day finds that nobody will speak his mind, and even at night the fears that spring from the early-June bloodshed choke most conversations.

"There was confrontation in Beijing, so the government dealt the people a hard blow," a university professor in Shanghai says. "Here the blow wasn't so hard, so our spirit is good."

The government certainly struck some blows in Shanghai. Demonstrators accused

Beijing

CHINA

Shanghai

VIETNAM

TAIWAN

LAOS

0 200
Miles

of violence in the streets have received long prison sentences, and there have been executions, including three young men shot to death for burning a train. Arrests of student activists are rumored, though none has been announced. Some well-known intellectuals have disappeared or been placed under house arrest. The city's most outspoken newspaper, the World Economic Herald, was shut down.

But some here wonder how long Shanghai will remain quiet. The college campuses are deserted, but students will begin returning next week for several days of political study. The anger felt by other young people hasn't subsided. The searing August heat brings this city out into the streets at night in search of relief.

In a neighborhood of narrow alleys near Shanghai's waterfront, hundreds of people relax in bamboo-slatted deck chairs by the curbside. It is impossible to walk more than a few blocks without being invited to share cigarettes, beer or even a meal. Discontented young men clad in shorts and sandals gather at every stop to air the same complaints over and over.

"Shanghai is no good," one declares loudly. "There's no freedom. There's no democracy. There are no jobs. Our work is what we can find in the streets, what we can split among ourselves."

After the young men move on, a 35-year-old man named Liu, who works as a government researcher, leans back in his chair and sighs. "They are unhappy because they have no work," he says. "There's a great distance here between the unemployed and the government."

A constant refrain to Shanghai life is that inflation—currently in double digits—has placed many goods out of reach. In a quiet tree-lined street that once housed this city's European elite before the revolution, the proprietor of a small bar ticks off the things that are no longer easily affordable for workers: fish, meat, chicken and eggs. "You used to be able to buy everything cheap, even though you made less

money," she says. "Now you can't."

Shanghai witnessed several large pro-democracy demonstrations in May, though none came near the size of the million-strong rallies that filled Beijing's Tiananmen Square. After the killings in Beijing, young demonstrators in Shanghai hijacked buses and trucks and paralyzed the city for several days before dispersing. Unlike in Beijing, where people of all ages joined the movement, Shanghai's protesters were primarily young people.

Workers with jobs and families largely stayed on the sidelines. "It's like this," says a 26-year-old taxi driver, who owns his own dilapidated Eastern European-made cab. "If you had money, you didn't participate. If you had no money, you were the movement. Those people with no place in society were there. Me? I was there, but I only watched. I have a wife."

The Shanghai government took advantage of this hesitancy to end the blockades after about five days. Mayor Zhu Rongji went on television on June 8 to announce that the city government had never considered sending in the army and declared it was time to go back to work. Late that night, the government dispatched tens of thousands of factory workers to clear the streets. Some analysts believe that Shanghai's party secretary, Jiang Zemin, was promoted later that month to general-secretary of the Chinese Communist Party because of the effective way the Shanghai rebellion was quelled.

Pragmatic Approach

But it is Mayor Zhu who has won respect in the streets. His approach "was very pragmatic, and Shanghai people respond to pragmatism," a Western diplomat says. "He came out looking great."

In effect, the mayor, who earlier this month also was appointed general-secretary of the party in Shanghai, bought the government time. Older Shanghainese recognize that many of China's problems can't be easily solved, yet everyone is demanding results soon. They most want results from the government in dealing with official corruption. Popular resentment can only grow if the government fails to tackle the problem.

Some Shanghai residents looked skeptically upon the student movement's demands for democracy, believing that the Communist Party was little inclined to loosen the reins. But the demands for an end to corruption struck a common chord because of the widespread resentment against officials at all levels who engage in profiteering and influence-peddling.

"Party officials have power, so they can do the things they want," says a 43-year-old man, who sympathized with the students but didn't join them. "We working people have no power, so there's nothing we can do. If the government doesn't deal with corruption, then we'll be upset."

Answering Systems Retain Feminine Touch

TECHNOLOGY MAY be transforming the job of receptionist, but tradition still counts for something. If a phone call is answered by a machine these days, chances are the recording will be a woman's voice.

An unscientific survey of "automated attendants" and "voice-processing" systems shows that almost all use a female voice. When system providers and users are asked why, the typical answer is, "I never thought about that."

Robert Yellowlees, president of **American Telesystems,** says many customers "instinctively" choose a female voice. When **Spiegel** wanted to tape messages, it went to its own operators, "who happen to all be female," says Michael Zivich, telecommunications manager.

The company also uses women because it doesn't want to confuse callers. When it adds its own taped instructions to a recording, it wants to match them with the "canned" voices already in the automated systems it buys. And they're always female.

Using women's voices may seem harmless, but Margaret Hennig, dean of Simmons College Graduate School of Management, says that, however "unconscious, it simply perpetuates stereotypes." The "cumulative effect" of such small signals, she adds, is to slow women's progress.

Voice-system users of the future, Mr. Yellowlees believes, will be more sophisticated about the image they project, paying more careful attention to gender and tone, just as some advertisers do with voice-overs in commercials.

But for the moment, companies are "trying to simulate what the caller has experienced," he says. With many callers annoyed about a machine answering calls, voice-system users are eager to avoid backlash with any more surprises—like a male voice.

More Firms Claim The Customer Is King

WHAT DO Pan Am, Cincinnati Milacron and **Ford Motor** have in common? Like every self-respecting company these days, they've declared themselves customer-driven.

Pan Am wants fliers to think of it that way rather than "having a transportation operations mindset." Milacron eschews a "technology-driven" past for customer-driven. And Ford not only puts customers behind the wheel; it calls itself customer-driven.

Customer-driven is a strategy of deeply satisfying the customer, under the theory that this will end up satisfying other important groups, like shareholders, down the line. Bank of Darien, for ex ample, makes money by keeping its drive-through window open from 7 a.m. to 7 p.m. weekdays.

According to Gregory Asvestas, a San Antonio-based consultant, customer-driven evolved from other drives. Henry Ford, he says, immortalized its antithesis—product-driven—with his promise "I'll paint your car any color you want as long as it's black." Next came market-driven, now equally taboo, which suggests a response to the mass market, not individuals.

But Carnegie-Mellon University Prof. Robert Kelley says that for too many companies, customer-driven is "just another buzzword." He and his students collect horror stories of companies that boast of being customer-driven but actually put management convenience first.

"The only way they're customer-driven," says Mr. Kelley, "is that they're driving the customers away."

U.S. Managers Still Focus on Home Front

THE GROWING rhetoric about the need for "global managers" seems to be falling on deaf ears in the U.S.

Querying 1,500 managers world-wide, Columbia University and Korn/Ferry International, a search firm, found "insularity" among American CEOs. The study partly blames the U.S. history of "economic preeminence."

Executives seem to realize they face more foreign competition, says Donald Hambrick, a Columbia professor, but they "skip a beat" when it comes to anticipating the experience and skill a global market demands.

Ranking skills important to CEOs in the 21st century, 35% of Americans thought "experience outside the headquarters country" was very important, compared with 73% to 74% of foreign counterparts. Some 62% ranked an "international outlook" very important, compared with 81% of Europeans, 87% of Latin Americans and 100% of Japanese.

Asked to rank the impact of international events, 18% of Americans called the 1992 unification of Europe "substantial," compared with 34% of Latins, 52% of Japanese, and 55% of Europeans.

Some companies are making progress, says Mr. Hambrick, citing **International Business Machines** and **Coca-Cola,** which make foreign postings critical for top-level promotions, and **Bristol-Myers,** where executive training includes trips abroad. But he said the study showed a broad "parochialism" that might have been expected in 1980, but not in 1989.

Odds and Ends

HAVING A TEMPER was rated "an effective management style" by 23% of top executives in a survey by Fred Bergendorff, a professor at San Diego State. . . . **Thrift woes helped trim** pay raises last year for chief executives in the savings and loan business. Mercer Meidinger Hansen, a consulting firm, says salaries rose 9%, down from 15% in 1987. That was still in line with corporate salaries generally but lower than for other financial services. Meanwhile, the number of thrifts offering executive employment contracts jumped to 82.6% from about 50%. . . . **Parent tracks** would be a popular option. About 82% of women and 74% of men in a Robert Half survey said they'd accept slower career progress for more time with family.

Photo Credits

Chapter 1

page xxxii—Jim Feingersh/The Stock Market; page 4—Robert Frerck/The Stock Market; page 8—Melloul-Rancinan/Sygma; page 15—Owen Franken/Stock, Boston, and Cary Wolinsky/Stock, Boston.

Chapter 2

page 34—Courtesy of General Motors Corporation; page 39—Joe McNally; page 46—Ken Straiton/The Stock Market; page 53—Mike Ballai/The Stock Market; page 54—James Schnepf.

Chapter 3

page 62—Culver Pictures; page 64—Courtesy of Pepsi-Cola International; page 68—Courtesy of Hewlett-Packard; page 77—Courtesy of Taylor Corporation; page 84—Stacy Pick/Stock, Boston.

Chapter 4

page 98—Art Resource; page 104—Michael L. Abramson; page 114—Brett Froomer/The Image Bank, Susan McCartney/Photo Researchers, and David Strick/Onyx; page 117—Tom Zimberoff/Sygma.

Chapter 5

page 132—Courtesy of Hyundai; page 135—Gail Greig/Monkmeyer Press; page 140—Sun Microsystems, Frito Lay, and Levi Strauss & Company; page 153—Hans Neleman.

Chapter 6

page 172—Brunswick Corporation; page 179—Steve Dunwell/The Image Bank, and A. M. Rosario/The Image Bank; page 188—Ben Simmons/The Stock Market; page 193—US Sprint.

Chapter 7

page 209—Photoreporters, Inc.; page 211—Teri Stratford; page 214—John Elk III/Stock, Boston; page 217—Tod Merritt Haiman/The Stock Market; page 224—Teri Stratford; page 238—Teri Stratford.

Chapter 8

page 246—Courtesy of AT&T; page 251—Jeff Albertson/The Picture Cube; page 255—Kashi; page 261—Bob Sacha; page 270—Resnick.

Chapter 9

page 282—Louie Psihoyos/Matrix; page 290—Yoram Kohama/Shooting Star; page 294—Lee Balterman/The Picture Cube; page 297—Dick Durrance II/West Light; page 309—Lawrence Migdale/Stock, Boston.

Chapter 10

page 316—Courtesy of Scott Paper Co.; page 321—Herman Miller, Inc.; page 323—Steve Hansen/Stock, Boston; page 328—Walter Urie/West Light.

Chapter 11

Chapter 12

Chapter 13

Chapter 14

Chapter 15

Chapter 16

Chapter 17

Chapter 18

Chapter 19

Chapter 20

Chapter 21

Endnotes

Chapter 1

1. S. Prakash Sethi, Nobuaki Namiki, and Carl L. Swanson, *The False Promise of the Japanese Miracle* (Boston: Pitman Publishing, 1984), pp. 276–77.

2. Harry Levinson, "You Won't Recognize Me: Predictions About Changes in Top-Management Characteristics," *Academy of Management Executive*, Vol. II, No. 2 (1988), pp. 119–125.

3. "Productivity Trends and Perspectives," *Innovation Policies* (Paris, France: Organisation for Economic Co-operation and Development, 1988), pp. 3, 7, 38. Also, "The Revival of Productivity," *Business Week*, February 13, 1984, pp. 92–100.

4. John Naisbitt, *Megatrends: Ten New Directions Transforming Our Lives* (New York: Warner Books, 1982), pp. 11–14.

5. Robert W. Rice, Dean B. McFarlin, Raymond G. Hunt, and Janet Near, "Organizational Work and the Perceived Quality of Life: Toward a Conceptual Model," *Academy of Management Review*, Vol. 10, no. 2 (1985), pp. 296–310.

6. Michael H. Mescon, Michael Albert, and Franklin Khedouri, *Management: Individual and Organizational Effectiveness*, 2nd ed. (New York: Harper & Row, 1985), p. 10.

7. Peter F. Drucker, "We Have Become a Society of Organizations," *Wall Street Journal*, January 9, 1978, p. 12.

8. George A. Steiner, *Top Management Planning* (New York: Macmillan, 1969), p. 7.

9. Henry Mintzberg, "The Manager's Job: Folklore and Fact," *Harvard Business Review*, Vol. 53, no. 4 (July–August 1975), pp. 49–61.

10. Fred Luthans, "Successful vs. Effective Real Managers," *Academy of Management Executive*, Vol. II, no. 2 (1988), pp. 127–32.

11. "Can Chrysler Keep Its Comeback Rolling?" *Business Week*, February 14, 1983, pp. 132–36. See also "GM Moves into a New Era," *Business Week*, July 16, 1984, pp. 48–54.

12. Pradip N. Khandwalla, *The Design of Organizations* (New York: Harcourt Brace Jovanovich, 1977), pp. 2–4, 109, and 515–16.

13. Michael W. Miller and Paul B. Carroll, "Vaunted IBM Culture Yields to New Values: Openness, Efficiency," *Wall Street Journal*, November 11, 1988, pp. A1, A9.

14. John Naisbitt and Patricia Aburdene, *Reinventing the Corporation* (New York: Warner Books, 1985), pp. 12–13.

15. Robert H. Schappe, "The Production Foreman Today: His Needs and His Difficulties," *Personnel Journal*, July 1972, pp. 156–72.

16. Lester R. Bittel, *What Every Supervisor Should Know*, 4th ed. (New York: McGraw-Hill, 1980), pp. 7–8.

17. Sethi, Namiki, and Swanson, *The False Promise of the Japanese Miracle*, pp. 11–12.

18. Peter F. Drucker, "The Coming of the New Organization," *Harvard Business Review*, Vol. 88, no. 1 (January–February 1988), pp. 45–53.

19. Robert L. Katz, "Skills of an Effective Administrator," *Harvard Business Review*, Vol. 52 (September–October 1974), pp. 90–102.

20. Luthans, "Successful vs. Effective Real Managers," *Academy of Management Executive*, pp. 127–32.

21. *The State of Small Business: Report of the President 1987* (Washington, D.C.: Government Printing Office), p. xi, Appendix A.

22. Israel M. Kirzner, *Perception, Opportunity, and Profit: Studies in the Theory of Entrepreneurship* (Chicago: University of Chicago Press, 1979), p. 39.

23. Brett Kingstone, *The Dynamos: Who Are They, Anyway?* (New York: John Wiley & Sons, 1987), pp. 45–60. See also Eileen Davis, " 'Small Caps' Tough It Out," *Venture*, April 1988, pp. 34–35, 37.

24. David P. Rutenberg, *Multinational Management* (Boston: Little, Brown, 1982), p. 5.

25. "Productivity Growth Lags Normal Pace," *Wall Street Journal*, p. 1. See also "Productivity Trends and Perspectives," *Innovation Policies*, p. 3.

26. J. M. Juran, and Frank M. Gryna Jr., *Quality Planning and Analysis*, 2nd ed. (New York: McGraw-Hill, 1980), p. xv.

27. William H. Newman (ed.), *Managers for the Year 2000* (Englewood Cliffs, N.J.: Prentice Hall, 1978), pp. 32–33.

28. Joel Dreyfuss, "Victories in the Quality Crusade," *Fortune*, October 10, 1988, pp. 80–88.

29. Roy Rowan, "America's Most Wanted Managers," *Fortune*, February 3, 1986, pp. 18–25.

30. John Huey, "Wal-Mart: Will It Take Over the World?" *Fortune*, January 30, 1989, pp. 52–56, 58, 61; Keith F. Girard, "Profiles in Power," *Business Month*, May 1989, p. 38.

Chapter 2

1. Jacob M. Schlesinger and Paul Ingrassia, "GM Uses Employees by Listening to Them, Talking of Its Team," *Wall Street Journal*, January 12, 1959, pp. A2, A6.

2. Harold Koontz, "The Management Theory Jungle Revisited," *Academy of Management Review*, Vol. 5, No. 2 (1980), p. 186.

3. Peter F. Drucker, *People and Performance: The Best of Peter Drucker on Management* (New York: Harper & Row, 1977), p. 19.

4. Adam Smith, *An Inquiry into the Nature and Causes of the Wealth of Nations*, 5th ed. (Edinburgh, Scotland: Adam & Charles Black Publishers, 1859), p. 3

5. Edwin A. Locke, "The Ideas of Frederick W. Taylor: An Evaluation," *Academy of Management Review*, Vol. 7, No. 1(1982), pp. 14–24.

6. Frederick Winslow Taylor, *Scientific Management* (New York: Harper & Row, 1947).

7. Daniel A. Wren, *The Evolution of Management Thought* (New York, Ronald Press, 1972), pp. 158–68.

8. Stephen P. Robbins, *The Administrative Process*, 2nd ed. (Englewood Cliffs, N.J.: Prentice Hall, 1980), pp. 194–95.

9. Warren G. Bennis, "The Coming Death of Bureaucracy," *Think*, Vol. 32 (November–December 1966), pp. 32–33.

10. Henri Fayol, *General and Industrial Management* (London, U.K.: Sir Isaac Pitman and Sons, 1949).

11. Chester I. Barnard, *The Functions of the Executive* (Cambridge, Mass.: Harvard University Press, 1938).

12. L. D. Parker, "Control in Organizational Life: The Contribution of Mary Parker Follett," *Academy of Management Review*, Vol. 9, No. 4 (1984), pp. 736–45. See also H. C. Metcalf, and L. Urwick. (eds.) *Dynamic Administration: The Collected Papers of Mary Parker Follett* (London, U.K.: Sir Isaac Pitman & Sons, 1941).

13. Elton Mayo, *The Human Problems of an Industrial Civilization*, 2nd ed. (New York: Macmillan, Inc., 1946). See also F. J. Roethlisberger and William J. Dickson, *Management and the Worker* (Cambridge, Mass.: Harvard University Press, 1946).

14. Wren, *The Evolution of Management Thought*, p. 313.

15. Abraham H. Maslow, *Motivation and Personality*, 2nd ed. (New York: Harper & Row, 1970).

16. Douglas McGregor, *The Human Side of Enterprise* (New York: McGraw-Hill, 1960).

17. Victor H. Vroom and Arthur G. Jago, *The New Leadership: Managing Participation in Organizations* (Englewood Cliffs, N.J.: Prentice Hall, 1988), pp. 3–4.

18. William Ouchi, *Theory Z—How American Business Can Meet the Japanese Challenge* (Reading Mass. Addison-Wesley, 1981).

19. Philip B. Crosby, *Quality Is Free: The Art of Making Quality Certain* (New York: Mentor Books, 1979). See also Thomas J. Peters and Robert H. Waterman, Jr., *In Search of Excellence: Lessons from America's Best-Run Companies* (New York: Harper & Row, 1982).

20. Ludwig Von Bertalanffy, "General Systems Theory: A New Approach to the Unity of Science." *Human Biology*, Vol. 23 (1951), pp. 302–61. See also Fremont E. Kast and James E. Rosenzweig, "General Systems Theory: Applications for Organization and Management," *Academy of Management Journal*, Vol. 15, No. 4 (1972), pp. 447–65.

21. Fred E. Fiedler, "Predicting the Effects of Leadership Training and Experience from the Contingency Model, A Clarification," *Journal of Applied Psychology*, Vol. 57, No. 2 (1973), p. 110.

22. Fred Luthans, *Introduction to Management: A Contingency Approach* (New York: McGraw-Hill Book Company, 1975). See also Fred Luthans and Todd I. Stewart, "A General Contingency Theory of Management" *Academy of Management Review*, Vol. 2, No. 2 (1977), p. 181.

23. Richard B. Chase and Nicholas J. Aquilano, *Production and Operations Management: A Life Cycle Approach*, 4th ed. (Homewood, Ill.: Richard D. Irwin, 1985), pp. 4–8.

24. Niv Ahituv, and Seev Neumann, *Principles of Information Systems for Management* (Dubuque, Iowa: Wm. C. Brown Company, 1982), pp. 5–6.

Chapter 3

1. "In Sherman We Bust, 1890," *Wall Street Journal*, January 11, 1989, p. 81.

2. Alvar O. Elbing, "On the Applicability of Environmental Models," in J. W. McGuire, ed., *Contemporary Management* (Englewood Cliffs, N.J.: Prentice Hall, 1974), pp. 282–83.

3. John Naisbitt, *Megatrends: Ten New Directions Transforming Our Lives* (New York: Warner Books, 1982).

4. Manual G. Velasquez, *Business Ethics: Concepts and Cases*, 2nd ed. (Englewood Cliffs, N.J.: Prentice Hall, 1988), pp. 18–19.

5. Allen H. Center and Frank E. Walsh, *Public Relations Practices: Case Studies* (Englewood Cliffs, N.J.: Prentice Hall, 1981), p. 360. See also Milton R. Moskowitz, "Company Performance Roundup," *Business and Society Review*, Vol. 53 (Spring 1985), pp. 74–77, and Kenneth Labich,

"The Seven Keys to Business Leadership," *Fortune*, October 24, 1988, pp. 58–64.

6. *Corporate Ethics: A Prime Asset* (New York: Business Roundtable, 1988), pp. 3–10.

7. *Business Conduct Guidelines*, Vol. 2 (The Boeing Company, August 1987); and *Corporate Ethics: A Prime Asset*, pp. 12–14.

8. "The 100 Largest Commercial Banking Companies," *Fortune*, June 6, 1988, supplement D, pp. 13–14.

9. "Chemical Bank Programs in Business Ethics and Corporate Responsibility," in *Corporate Ethics: A Prime Asset*, pp. 31–34.

10. R. Edward Freeman, and Daniel R. Gilbert, Jr., *Corporate Strategy and the Search for Ethics* (Englewood Cliffs, N.J.: Prentice Hall, 1988), pp. 90–91.

11. Joseph A, Raelin, "The Professional as the Executive's Ethical Aide-de-Camp," *Academy of Management Executive*, Vol. 1, No. 3 (1987), pp. 171–82. See also Marcia Parmarlee Miceli and Janet P. Near, "The Relationship Among Beliefs, Organizational Positions, and Whistle-Blowing Status: A Discriminant Analysis," *Academy of Management Journal*, Vol. 27, No. 4 (1984), pp. 687–705.

12. Myron Peretz Glazer and Penina Migdal Glazer, "Whistleblowing," *Psychology Today*, August 1986, pp. 37–43.

13. Felix Kessler, "Tremors from the Tylenol Scare Hit Food Companies," *Fortune*, March 31, 1986, pp. 59–62. See also John Bussy, "Gerber Takes Risky Stand as Fears Spread About Glass in Baby Food," *Wall Street Journal*, March 6, 1986, p. 21.

14. Archie B. Carroll, "A Three-Dimensional Conceptual Model of Corporate Performance," *Academy of Management Review*, Vol. 4, No. 3 (1979), pp. 497–505.

15. Richard L. Daft, Juhani Sormunen, and Don Parks, "Chief Executive Scanning, Environmental Characteristics, and Company Performance: An Empirical Study," *Strategic Management Journal*, Vol. 9, No. 2 (1988), pp. 123–39. See also Marc J. Dollinger, "Environmental Boundary Spanning and Information Processing Effects on Organizational Performance," *Academy of Management Journal*, Vol. 27, No. 2 (1984), pp. 351–68.

16. Maynard M. Gordon, *The Iacocca Management Technique* (New York: Ballantine Books, 1985), pp. 116–17.

17. Victor Kiam, *Going for It! How To Succeed as an Entrepreneur* (New York: William Morrow, 1986), pp. 207–8.

18. Peter F. Drucker, "The Job as Property Right," *Wall Street Journal*, March 4, 1980, p. 8.

19. Richard Tanner Pascale and Anthony G. Athos, *The Art of Japanese Management: Applications for American Executives* (New York: Warner Books, 1981), pp. 28–35.

20. John A. Pearce III and Richard B. Robinson, Jr., *Strategic Management, Strategy Formulation and Implementation*, 2nd ed. (Homewood, Ill. Richard D. Irwin, 1985), pp. 625–43.

21. Kaleel Jamison, "Managing Sexual Attraction in the Workplace," *Personnel Administrator*, Vol. 28, No. 8 (August 1983), pp. 45–52.

22. Joe R. Feagin and Clairece Booker Feagin, *Discrimination American Style* (Englewood Cliffs, N.J. Prentice Hall, 1978), pp. 19–20. See also U.S. Equal Employment Opportunity Commission, *Affirmative Action and Equal Employment: A Guidebook for Employers* (Washington, D.C.: Government Printing Office, 1974), Sec. D, p. 28.

23. Colin Leinster, "Black Executives: How They're Doing," *Fortune*, January 18, 1988, pp. 109–14.

24. "Corporate Women: They're About to Break Through to the Top," *Business Week*, June 22, 1987, pp. 72–76.

25. Albert Seelye, "Societal Changes and Business-Government Relationships," *MSU Business Topics*, Autumn 1975, pp. 5–13.

26. Michael E. Porter, *Competitive Strategy: Techniques for Analyzing Industries and Competitors* (New York: Free Press, 1980).

27. Burt Scanlan and Bernard Keys, *Management and Organizational Behavior*, 2nd ed. (New York: John Wiley, 1983), p. 59.

28. "Computer Security: What Can Be Done," *Business Week*, September 26, 1983, pp. 126–30.

29. Bruce G. Posner, "In Search of Equity," *Inc.*, April 1985, pp. 51–60. See also Steven Flax, "How to Snoop on Your Competitors," *Fortune*, May 14, 1984, pp. 28–33.

30. James Ledvinka, *Federal Regulation of Personnel and Human Resource Management* (Boston: Kent Publishing Company, 1982), pp. 4–14.

31. Saul W. Gellerman, "Why 'Good' Managers Make Bad Ethical Choices," *Harvard Business Review*, Vol. 86, No. 4 (July–August 1986), pp. 85–90.

32. Thomas Donaldson and Patricia H. Werhane, *Ethical Issues in Business: A Philosophical Approach*, 2nd ed. (Englewood Cliffs, N.J.: Prentice Hall, 1983), pp. 19–24.

33. Rich Stranel, "A Systems Paradigm of Organizational Adaptations to the Social Environment," *Academy of Management Review*, Vol. 8, No. 1 (1983), pp. 90–96. See also Keith Davis and Robert L. Blomstrom, *Business and Society: Responsibility*, 3rd ed. (New York: McGraw-Hill, 1975), pp. 23–25.

34. Robert W. Crandall, "Environmental Ignorance Is Not Bliss," *Wall Street Journal*, April 22, 1985, pp. 1, 28.

35. "The Productivity Crisis," *Newsweek*, September 8, 1980, pp. 50–69. See also James Fallows, "American Industry, What Ails It, How to Save It," *The Atlantic*, September 1980, pp. 35–50.

36. Keith Davis, "The Case For and Against Business Assumption of Social Responsibilities," *Academy of Management Journal*, Vol. 16, No. 2 (1973), pp. 312–22.

37. Anne B. Fisher, "What's Left of Reaganomics?" *Fortune*, February 20, 1984, pp. 42–46. See also "A Mandate That Will Have Its Limits," *Business Week*, November 19, 1984, pp. 36–42.

38. Joseph A. Raelin, "The Professional as the Executive's Ethical Aide-de-Camp," *Academy of Management Executive*, Vol. 1, No. 3 (1987), pp. 171–82.

39. Rogene A. Bucholz, *Business Environment and Public Policy: Implications for Management* (Englewood Cliffs, N.J.: Prentice Hall, 1982), pp. 8–12 and 524–25.

40. "In Sherman We Bust, 1890," *Wall Street Journal*, January 11, 1989, p. B1.

41. Wayne E. Green, "Courts Skeptical of 'Non-Compete' Pacts," *Wall Street Journal*, January 11, 1989, p. B1.

Chapter 4

1. "Trade Bill Highlights," *Wall Street Journal*, April 1, 1988, p. 12.

2. E. R. Archer, "How to Make a Business Decision: An Analysis of Theory and Practice," *Management Review*, Vol. 69, No. 2 (1980), pp. 30–37.

3. Herbet A. Simon, *The New Science of Management Decisions*, rev. ed. (Englewood Cliffs, N.J.: Prentice Hall, 1977), pp. 44–49.

4. Harold Koontz, Cyril O'Donnell, and Heinz Weihrich, *Essentials of Management*, 4th ed. (New York: McGraw-Hill Book Co., 1986), p. 143.

5. Nelson W. Aldrich, Jr., "Lines of Communication," *Inc.*, June 1986, pp. 140–144. See also "The Franchise 100," *Venture*, December 1988, pp. 35–47.

6. Henry Mintzberg, *The Nature of Managerial Work* (Englewood Cliffs, N.J.: Prentice Hall, 1980), pp. 54–94.

7. "Face-to-Face with '1-2-3' Creator Mitch Kapor," *Inc.*, January 1987, pp. 31–38.

8. Manuel G. Velasquez, *Business Ethics: Concepts and Cases*, 2nd ed. (Englewood Cliffs, N.J.: Prentice Hall, 1988), pp. 3–6.

9. Thomas V. Busse and Richard S. Mansfield, "Theories of the Creative Process: A Review and a Perspective," *Journal of Creative Behavior*, Vol. 4, No. 2 (1980), pp. 91–103.

10. "100 Ideas for New Businesses," *Venture*, November 1988, p. 62.

11. *The Entrepreneurs: An American Adventure*, PBS Documentary, Vol. 1 (Boston: Enterprise Media, and Martin Sandler Productions, 1986).

12. Organisation for Economic Co-operation and Development, "Trends and Perspectives," *R&D, Invention, and Competitiveness* (Paris, France: OECD, 1987), pp. 51–55; and Organisation for Economic Co-operation and Development, "Technology Indicators," *Innovation Policy* (Paris, France: OECD, 1988), pp. 48–57.

13. Gifford Pinchot III, *Intrapreneuring* (New York: Harper & Row, 1985), pp. 7–9.

14. Kenneth Labich, "The Innovators," *Fortune*, June 6, 1988, pp. 50–53, 56, 60. See also Ellen Schultz, "America's Most Admired Corporations," *Fortune*, January 18, 1988, pp. 32–39.

15. Thomas J. Peters and Robert H. Waterman, Jr., *In Search of Excellence: Lessons from America's Best-Run Companies* (New York: Harper & Row, 1982), pp. 29–30.

16. Myron Tribus, "Managing to Survive in a Competitive World," reprint from the Center for Advanced Engineering Study, M.I.T., Cambridge, Mass., March 2, 1983.

17. Gary Reiner, "Cutting Your Competitor to the Quick," *Wall Street Journal*, November 21, 1988, p. A16.

18. Laura Gardner, "Sludging Toward Profits," *Venture*, March 1985, pp. 85–86.

19. Mike Connelly, "Hospitals Try Franchising to Cut Costs, Add Services," *Wall Street Journal*, October 14, 1988, p. B1.

20. John Helyar and Bryan Burrough, "Buy-Out Bluff: How Underdog KKR Won RJR Nabisco Without Highest Bid," *Wall Street Journal*, December 2, 1988, p. A1.

21. "The Chairman Doesn't Blink," *Quality Progress*, March 1987, pp. 19–24.

22. "Water: Shortage Effects and Resources," *MacNeil/Lehrer News Hour*, transcript of October 17, 1988 (New York: WNET-TV, 1988).

23. Ronald N. Taylor, *Behavioral Decision Making* (Glenview, Ill.: Scott, Foresman, 1984), pp. 41–42.

24. A. F. Osborn, *Applied Imagination*, 3rd ed. (New York: Scribner's 1963), pp. 154–63.

25. T. J. Bouchard and M. Hare, "Size, Performance and Potential in Brainstorming Groups," *Journal of Applied Psychology*, Vol. 54 (1970), pp. 51–55.

26. Taylor, *Behavioral Decision Making*, pp. 44–45.

27. Marvin D. Dunnette, John P. Campbell, and K. Jaastad, "The Effect of Group Participation on Brainstorming Effectiveness for Two Industrial Samples," *Journal of Applied Psychology*, Vol. 47 (1963), pp. 30–37.

28. Andre L. Delbecq and Andrew H. Van de Ven, "A Group Process Model for Problem Identification and Program Planning," *Journal of Applied Behavioral Science*, Vol. 7, No. 4 (1971), pp. 466–92.

29. Taylor, *Behavioral Decision Making*, pp. 181–82.

30. Christopher Knowlton, "What America

Makes Best," *Fortune*, March 28, 1988, pp. 44–54.

31. Robert I. Benjamin and Michael S. Scott Morton, "Information Technology, Integration, and Organizational Change," *Management in the 1990s*, reprint by the Sloan School of Management, Massachusetts Institute of Technology (April 1986).

32. Kevin Crowston and Thomas W. Malone, "Information Technology and Work Organization," *Management in the 1990s*, reprint by the Sloan School of Management, Massachusetts Institute of Technology (October 1987).

33. Robert A. Portnoy, *Leadership: What Every Leader Should Know About People* (Englewood Cliffs, N.J.: Prentice Hall, 1986), pp. 114–15.

34. Vilma Barr, "The Process of Innovation: Brainstorming and Storyboarding," *Mechanical Engineering*, November 1988, pp. 42–46.

Chapter 5

1. Joel Dreyfuss, "What Do You Do for an Encore?" *Fortune*, December 19, 1988, pp. 111–19.

2. George A. Steiner, *Top Management Planning* (New York: Macmillan, 1969), p. 7.

3. Henry Mintzberg, "The Manager's Job: Folklore and Fact," in Arthur A. Thompson, Jr., and A. J. Strickland III (eds.), *Strategy Formulation and Implementation* 5th ed. (Plano, Tex.: Business Publications, 1980), pp. 35–36.

4. Fred Luthans, "Successful vs. Effective Real Managers," *Academy of Management Executive*, Vol. II, No. 2 (1988), pp. 127–32.

5. Echo Montgomery Garrett, "My Catalog Is My Showroom," *Venture*, November 1988, pp. 32–33.

6. Arthur A. Thompson, Jr., and A. J. Strickland III, *Strategic Management: Concepts and Cases*, 5th ed. (Plano, Tex.: Business Publications, 1987), pp. 6–7.

7. Joel Kotkin, "The Innovation Upstarts," *Inc.*, January 1989, pp. 70–76.

8. Jeff Bailey, "Sears Is Discovering Discover Credit Card Isn't Hitting Pay Dirt," *Wall Street Journal*, February 10, 1988, pp. 1, 12.

9. Henry Mintzberg, *Power in and Around Organizations* (Englewood Cliffs, N.J.: Prentice Hall, 1983), pp. 136–37.

10. Brenton R. Schlender, "Apple Unveils New Macintosh, Hints at Closer Unix Link," *Wall Street Journal*, January 19, 1989, p. B1.

11. "Home-Computer Field Baffles Manufacturers and Many Buyers Too," *Wall Street Journal*, July 26, 1983, pp. 1, 18.

12. Dale H. Besterfield, *Quality Control* (Englewood Cliffs, N.J.: Prentice Hall, 1979), p. 1.

13. Kenneth R. Andrews, "Ethics in Policy and Practice at General Mills," in James Keogh (ed.), *Corporate Ethics: A Prime Business Asset* (New York: Business Roundtable, 1988), pp. 41–52.

14. "Heinz Squares Off Against Its Archrival," *Business Week*, December 12, 1988, p. 58.

15. *Annual Report*, International Business Machines Corporation (1987), pp. 6–7.

16. Russell L. Ackoff, *A Concept of Corporate Planning* (New York: John Wiley, 1970), p. 4. See also Steiner, *Top Management Planning*, pp. 37–39.

17. "Heinz Squares Off Against Its Archrival," *Business Week*, December 12, 1988, p. 58.

18. Thompson and Strickland, *Strategic Management: Concepts and Cases*, 5th ed., p. 8.

19. Bernard Avishai, "A CEO's Common Sense of CIM: An Interview with J. Tracey O'Rourke," *Harvard Business Review*, Vol. 89, No. 1 (January–February 1989), pp. 110–17.

20. Steiner, *Top Management Planning*, p. 26.

21. Peter F. Drucker, *The Practice of Management* (New York: Harper & Row, 1954), pp. 128–29.

22. Gary T. DiCamillo, "Winning Turnaround Strategies at Black & Decker," *The Journal of Business Strategy* (March–April 1988), pp. 30–33.

23. *Monsanto Corporation Social Responsibility Policy Statements*, Monsanto Corporation, revised January 1980, p. 4.

24. Stew Leonard, "Love That Customer," *Management Review*, October 1987, pp. 36–39.

25. Neil Barsky, "Does This Mean All the Fights Will Now Take Place on the Ice?" *Wall Street Journal*, January 27, 1989, p. B1.

26. Glenn A. Welsch, *Budgeting: Profit Planning and Control*, 5th ed. (Englewood Cliffs, N.J.: Prentice Hall, 1988), pp. 3–4.

27. Kathy Williams, "The Magic of Management Accounting Excellence," *Management Accounting*, February 1986, pp. 21–27.

28. Michael Gilchrist, Diane D. Pattison, and Ronald J. Kudla, "Controlling Indirect Costs with Headcount Forecast Algorithms," *Management Accounting*, August 1985, pp. 47–48.

29. Jim Jubak, "Think Like a Bee," *Venture*, January 1989, pp. 48–52.

30. William P. Tavoulareas, "Remarks by the President of Mobil Oil Corporation Before the New York Society of Security Analysts," *Mobil Oil Speeches*, reprint courtesy of Mobil Oil Corporation, November 5, 1979.

31. Toyohiro Kono, "Japanese Management Philosophy: Can It Be Exported?" *Long Range Planning*, Vol. 15, No. 3 (1982), pp. 90–102. See also Mike Mansfield, United States Ambassador to Japan, "The Situation as I See It: Perspectives from a Decade as U.S. Ambassador to Japan," *Speaking of Japan*, Vol. 8, No. 84 (December 1987), pp. 1–3.

32. Dean M. Schroeder and Robert Hopley, "Project Development Strategies for High-Tech Industries," *Journal of Business Strategy*, May–June 1988, pp. 38–43.

33. Robley D. Wood and Lawrence R. LaForge, "The Impact of Comprehensive Planning on Financial Performance," *Academy of Management Journal*, Vol. 22 (1979), pp. 516–26.

34. Richard M. Hodgetts, *Management: Theory and Practice* (Philadelphia: W. B. Saunders Company, 1979), p. 99. See also Thompson and Strickland, *Strategic Management: Concepts and Cases*, 5th ed. pp. 12–15.

35. Lester R. Bittel and Jackson E. Ramsey, "The Limited, Traditional World of Supervisors," *Harvard Business Review*, Vol. 82, No. 4 (July–August 1982), pp. 26–37.

36. Mintzberg, *Power in and Around Organizations*, pp. 137–39. See also Victor H. Vroom and Arthur G. Jago, *The New Leadership: Managing Participation in Organizations* (Englewood Cliffs, N.J.: Prentice Hall, 1988), pp. 11–12.

37. George A. Steiner, John B. Miner, and Edmund R. Gray, *Management Policy and Strategy: Text, Readings and Cases*, 2nd ed. (New York: Macmillan Publishers, 1982), pp. 182–83.

38. "The New Breed of Strategic Planner," *Business Week*, September 17, 1984, pp. 62–68.

39. Steiner, Miner, and Gray, *Management Policy and Strategy: Text, Readings and Cases*, p. 186.

40. Dreyfuss, "What Do You Do for an Encore?" p. 116. See also Brian Dumaine, "A Humble Hero Drives Ford to the Top," *Fortune*, January 4, 1988, pp. 23–24.

Chapter 6

1. Jack F. Reichert, "Brunswick's Dramatic Turnaround," *Journal of Business Strategy*, January–February 1988, pp. 4–8.

2. Carol Kennedy, "How Marriott Corporation Grew Five-fold in Ten Years," *Long Range Planning*, Vol. 21, No. 2 (1988), pp. 10–14.

3. Carol Kennedy, "Planning Global Strategies for 3M," *Long Range Planning,* Vol. 21, No. 1 (1988), pp. 9–17.

4. James Brian Quinn, Henry Mintzberg, and Robert M. James, *The Strategy Process: Concepts, Contexts, and Cases* (Englewood Cliffs, N.J.: Prentice Hall, 1988), pp. 14–15. See also Charles E. Summer, *Strategic Behavior in Business and Government* (Boston: Little, Brown, 1980), p. 3.

5. Thomas J. Peters and Robert H. Waterman, Jr., *In Search of Excellence: Lessons from America's Best-Run Companies* (New York: Harper & Row, 1982), p. 31.

6. Ibid., p. 29.

7. Eric Rolfe Greenberg, "Downsizing and Worker Assistance: Latest AMA Survey Results," *Personnel,* November 1988, pp. 49–53.

8. John Naisbitt and Patricia Aburdene, *Reinventing the Corporation* (New York: Warner Books, 1985), pp. 12–16.

9. Henry Mintzberg, "The Manager's Job: Folklore and Fact," *Harvard Business Review,* Vol. 53, No. 4 (July–August 1975), pp. 49–61.

10. Peters and Waterman, *In Search of Excellence: Lessons from America's Best-Run Companies,* p. 260.

11. Jacob M. Schlesinger and Joseph B. White, "The New-Model GM Will Be More Compact But More Profitable: Over Next Five Years, Firm May Close Six Factories, Lay Off 100,000 Workers," *Wall Street Journal,* June 6, 1988, pp. 1, 6.

12. "Cincinnati Milacron, Mainly a Metal-Bender, Now Is a Robot Maker," *Wall Street Journal,* April 7, 1983, p. 1.

13. Amal Kumar Naj, "Clouds Gather Over the Biotech Industry," *Wall Street Journal,* January 30, 1989, p. B1.

14. Summer, *Strategic Behavior in Business and Government,* pp. 205–06.

15. Antony V. Trowbridge, " 'Titanic Planning' in an Uncertain Environment," *Long Range Planning,* Vol. 21, No. 3 (1988), pp. 9–17.

16. Ronald Henkoff, "Deals of the Year," *Fortune,* January 30, 1989, pp. 162–64.

17. Summer, *Strategic Behavior in Business and Government,* p. 203.

18. Peter F. Drucker, *Management: Tasks, Responsibilities, Practices* (New York: Harper & Row, 1974), p. 455.

19. John Huey, "Wal-Mart: Will It Take Over the World?" *Fortune,* January 30, 1989, pp. 52–61.

20. Arthur A. Thompson, Jr., and A. J. Strickland, III, *Strategic Management: Concepts and Cases,* 4th ed. (Plano, Tex.: Business Publications, 1987), pp. 253–55, 260–61.

21. "Executive Summary," *The State of Small Business: A Report of The President* (Washington, D.C.: Government Printing Office, 1988), pp. xv–xvi.

22. William H. Newman, James P. Logan, and W. Harvey Hegarty, *Strategy: A Multi-level, Integrative Approach* (Cincinnati, Ohio: South-Western Publishing Co., 1989), pp. 7–15.

23. James E. Ellis, "Sam Johnson Is 'Going Public to Stay Private,' " *Business Week,* December 5, 1988, pp. 58–60.

24. Leslie W. Rue and Phyllis G. Holland, *Strategic Management: Concepts and Experiences,* 2nd ed. (New York: McGraw-Hill, 1989), p. 57. See also Richard B. Robinson, Jr., and John A. Pearce II, "Planned Patterns of Strategic Behavior and Their Relationship to Business-unit Performance," *Strategic Management Journal,* Vol. 9, No. 1 (1988), pp. 43–60.

25. Richard F. Vancil, *Decentralization: Managing Ambiguity by Design* (New York: Financial Executives Research Foundation, 1979), p. 5.

26. "IBM Unhooks Rolm," *Fortune,* January 16, 1989, p. 16.

27. Thompson and Strickland, *Strategic Management: Concepts and Cases,* p. 29.

28. Ibid., adapted from Chapter 1.

29. Control Data Corporation, *Annual Report of CDC, 1987.*

30. Hart, Schaffner & Marx, *Annual Report, 1986.*

31. Thompson and Strickland, *Strategic Management: Concepts and Cases,* pp. 8–9.

32. Zachary Schiller, "Goodyear's New Boss Faces a Rough Road Test," *Business Week,* December 12, 1988, p. 90.

33. Thompson and Strickland, *Strategic Management: Concepts and Cases,* p. 61.

34. Eric N. Berkowitz, Roger A. Kerin, and William Rudelius, *Marketing,* 2nd. ed. (Homewood, Ill.: Richard D. Irwin, 1989), pp. 235, 298–99.

35. Michael E. Porter, *Competitive Strategy: Techniques for Analyzing Industries and Competitors* (New York: Free Press, 1980), Chapter 1, See also Michael E. Porter, *Competitive Advantage* (New York: Free Press, 1985), Chapter 2.

36. Lindley H. Clark, Jr., "Adventures and Joint Ventures in China," *Wall Street Journal,* May 12, 1988, p. 22.

37. Berkowitz, Kerin, and Rudelius, *Marketing,* p. 357.

38. Porter, *Competitive Strategy: Techniques for Analyzing Industries and Competitors,* pp. 27–28.

39. Thompson and Strickland, *Strategic Management: Concepts and Cases,* pp. 97–99.

40. Newman, Logan, and Hegarty, *Strategy: A Multi-level, Integrative Approach,* pp. 106–12. See also Thompson and Strickland, *Strategic Management: Concepts and Cases,* pp. 159–64.

41. Sally Saville Hodge, "Chicago's Unabashed Centimillionaire," *Forbes,* May 30, 1988, pp. 252–60.

42. Anheuser-Busch Companies, Inc., *Annual Report to Stockholders, 1987.* See also Charles G. Burck, "While the Big Brewers Quaff, the Little Ones Thirst," *Fortune,* November, 1972, p. 107.

43. Martin Love, "The Man in the Doubleknit Suit," *Forbes,* October 24, 1983, p. 100.

44. Statford P. Sherman, "Who's in Charge at Texaco Now?" *Fortune,* January 16, 1989, pp. 68–72.

45. "A Drive to Put Quality Back into U.S. Goods," *U.S. News & World Report,* September 20, 1982, pp. 49–50.

46. Rue and Holland, *Strategic Management: Concepts and Experiences,* pp. 45–47.

47. Thompson and Strickland, *Strategic Management: Concepts and Cases,* pp. 167–170.

48. The Continental Group, *Annual Report to Stockholders, 1987.*

49. Maynard M. Gordon, *The Iacocca Management Technique* (New York: Ballantine Books, 1985), pp. 153–54, 172–77.

50. Victor Kiam, *Going for It! How to Succeed as an Entrepreneur* (New York: William Morrow, 1986), pp. 207–26.

51. Pat Baldwin, "Smart Pricing Pays in Profits," *Dallas, Inc.,* March 21, 1988, p. 17.

52. Thompson and Strickland, *Strategic Management: Concepts and Cases,* pp. 13–14.

53. Reichert, "Brunswick's Dramatic Turnaround," pp. 4–8.

54. Robert M. Donnelly, "Exxon's 'Office of the Future' Fiasco," *Planning Review,* July–August 1987, pp. 12–15.

55. J. M. Malloy and D. B. Skinner, "Medicare on the Critical List," *Harvard Business Review,* Vol. 62, No. 6 (1984), pp. 122–35.

56. A. A. Lee and R. Sandroff, "How DRG's Will Affect Your Hospital—and You," *RN,* May 1984, pp. 71–81.

57. R. H. Egdahl, "Should We Shrink the Health Care System?" *Harvard Business Review,* Vol. 62, No. 1 (1984), pp. 125–32.

Chapter 7

1. Dennis Kneale, "Zapping of TV Ads Appears Pervasive," *Wall Street Journal,* April 25, 1988, p. 21.

2. "Sweet-Talking the Public," *Newsweek,* January 28, 1985, p. 57.

3. Alix M. Freedman, "New Sweeteners Head for the Sugar Bowl," *Wall Street Journal,* February 6, 1989, p. B1.

4. Eric N. Berkowitz, Roger A. Kerin, and William Rudelius, *Marketing,* 2nd ed. (Homewood, Ill.: Richard D. Irwin, 1989), p. 171.

5. "Sneakers That Don't Specialize," *Business Week,* June 6, 1988, p. 146.

6. Bertkowitz, Kerin, and Rudelius, *Marketing,* pp. 44–46.

7. "Marketing's New Look," *Business Week,* November 2, 1987, pp. 64–69.

8. "The Major Players: Companies You Should Know About," *Inc. Office Guide, 1987* (New York: *Inc.* Magazine, 1987), pp. 36–47. See also Ken Greenberg (ed.), "The Shape of Things to Come," *PC World,* January 1986, pp. 143–51.

9. Al Ries and Jack Trout, *Marketing Warfare* (New York: McGraw-Hill, 1986), pp. 167–86.

10. Ibid., pp. 184–85.

11. Carl R. Anderson and Carl P. Zeithaml, "Stages of the Product Life Cycle, Business Strategy, and Business Performance," *Academy of Management Journal,* Vol. 27, No. 1 (1984), pp. 5–24. See also David R. Rink and John E. Swan, "Fitting Marketing Strategies to Varying Product Life Cycles," *Business Horizons,* January–February 1982, pp. 72–76.

12. Steven Flax, "The Christmas Zing in Zapless Toys," *Fortune,* December 26, 1983, pp. 98–103.

13. Ann Hughey, "Sales of Home Movie Equipment Falling as Firms Abandon Market, Video Grows," *Wall Street Journal,* March 17, 1982, p. 25.

14. David S. Hopkins, *The Marketing Plan* (New York: Conference Board, 1981), pp. 24–25.

15. "Downsizing Detroit: The Big Three's Strategy for Survival," *Business Week,* April 14, 1986, pp. 86–87.

16. Walter Guzzardi, Jr., "The U.S. Business Hall of Fame," *Fortune,* March 14, 1988, pp. 142, 145.

17. "Corporate Antihero John Sculley," *Inc.,* October 1987, pp. 49–59. See also "Apple's Lisa Spurs Software Makers to Duplicate Its Integrated Features." *Wall Street Journal,* July 8, 1983, p. 23.

18. Thomas J. Peters and Robert H. Waterman, Jr., *In Search of Excellence: Lessons from America's Best-Run Companies* (New York: Harper & Row, 1982), pp. 115–16, 141.

19. Donald D. Boroian and Patrick J. Boroian, *The Franchise Advantage: Make It Work for You!* (Schaumburg, Ill.: National BestSeller Corporation, 1987), pp. 28–34.

20. Glenn A. Welsch, Ronald W. Hilton, and Paul N. Gordon, *Budgeting: Profit Planning and Control,* 5th ed. (Englewood Cliffs, N.J.: Prentice Hall, 1988), p. 210.

21. "Facing the Rural Challenge," *Dominion Bank Review* (Roanoke, Va.: Dominion Bank, 1988), p. 1.

22. D. M. Warner and J. Pranda, "A Mathematical Programming Model for Scheduling Nursing Personnel in a Hospital," *Management Science,* Vol. 19, No. 4 (1972), pp. 411–22.

23. Welsch, Hilton, and Gordon, *Budgeting: Profit Planning and Control,* pp. 216–18.

24. J. M. Juran, *Juran on Planning for Quality* (New York: Free Press, 1988), pp. 5–7, 283–84.

25. "Report to the Chief Executive Officer," *Purchasing,* February 7, 1983, pp. 69–77. See also Ted Kumpe and Piet T. Bolwijn, "Manufacturing: The New Case for Vertical Integration," *Harvard Busi-*

ness Review, Vol. 88, No. 2 (March–April 1988), pp. 75–81.

26. Loy A. Singleton, Telecommunications in the Information Age, 2nd ed. (Cambridge, Mass.: Ballinger Publishing Company, 1986), pp. 175–84.

27. Richard J. Schonberger, Japanese Manufacturing Techniques: Nine Hidden Lessons in Simplicity (New York: Free Press, 1982), pp. 34–38.

28. Donald F. Ephlin, "Revolution by Evolution: The Changing Relationship between GM and the UAW," Academy of Management Executive, Vol. II, No. 1 (1988), pp. 63–66.

29. Amar Bhide, "Why Not Leverage Your Company to the Hilt?" Harvard Business Review, Vol. 88, No. 3 (May–June 1988), pp. 92–98.

30. Paul Preston and Thomas W. Zimmerer, Management for Supervisors, 2nd ed. (Englewood Cliffs, N.J.: Prentice Hall, 1983), p. 311.

31. Sud Ingle, In Search of Perfection: How to Create/Maintain/Improve Quality (Englewood Cliffs, N.J.: Prentice Hall, 1986), pp. 1–14.

32. Preston and Zimmerer, Management for Supervisors, pp. 33–36.

33. Robert Landel, Managing Productivity Through People: An Operations Perspective, p. 11. See also Lester R. Bittel, What Every Supervisor Should Know, 4th ed. (New York: McGraw-Hill, 1980), pp. 117–18.

34. Kneale, "Zapping of TV Ads Appears Pervasive," p. 21. See also "Coke vs. Pepsi: Cola War Marches On, Wall Street Journal, June 3, 1987, p. 29.

35. William M. Bulkeley, "Computers Failing as Teaching Aids," Wall Street Journal, June 6, 1988, p. 23.

36. "Alfa-Laval: Updating Its Know-How for the Biotechnology Era," Business Week, September 19, 1983, pp. 80, 84–85.

Chapter 8

1. Brian Dumaine, "How Managers Can Succeed Through Speed," Fortune, February 13, 1989, pp. 54–59.

2. Mark L. Goldstein, "Tomorrow's Workforce Today," Industry Week, August 15, 1988, pp. 41–43.

3. Ernest Dale, Organization (New York: AMA, 1976), pp. 9–10. See also Howard M. Carlisle, Management Concepts, Methods, and Applications, 2nd ed. (Chicago, Ill.: Science Research Associates, 1982), p. 478.

4. Adam Smith, Wealth of Nations (New York: Modern Library, 1937), pp. 3–4.

5. Henry Mintzberg, Structure in Fives: Designing Effective Organizations (Englewood Cliffs, N.J.: Prentice Hall, 1983), pp. 36–37.

6. Paul L. Blocklyn, "Making Magic: The Disney Approach to People Management," Personnel, December 1988, pp. 28–35.

7. Chris Argyris, Personality and Organization (New York: Harper & Row, 1957); Warren G. Bennis, "The Coming Death of Bureaucracy," Think Magazine (November–December 1966), pp. 30–35; Frederick Herzberg, Bernard Mausner, and Barbara Snyderman, The Motivation to Work, 2nd ed. (New York: John Wiley, 1959); Rensis Likert, New Patterns of Management (New York: McGraw-Hill, 1961); and Douglas McGregor, The Human Side of Enterprise (New York: McGraw-Hill, 1960).

8. Victor K. Kiam, "Growth Strategies at Remington," The Journal of Business Strategy (January–February 1989), pp. 22–26.

9. Bill Saporito, "Cutting Costs Without Cutting People," Fortune, May 25, 1987, pp. 26–32.

10. Mintzberg, Structure in Fives, pp. 28–29.

11. Gordon Stewart, "Cardiac Rehabilitation," Heart Association World Congress, Proceedings (London: World Health Association, 1975), pp. 16–18.

12. Mintzberg, Structure in Fives, p. 31.

13. Ibid., p. 30.

14. Max Weber, The Theory of Social and Economic Organization, trans. A. M. Henderson and H. T. Parsons (New York: Free Press, 1974).

15. Mintzberg, Structure in Fives, pp. 35–36.

16. Paul D. Collins and Frank Hull, "Technology and Span of Control: Woodward Revisited," Journal of Management Studies, Vol. 23 (March 1983), pp. 143–64.

17. Bennis, "The Coming Death of Bureaucracy," pp. 32–33.

18. Tom Burns and George M. Stalker, The Management of Innovation (London: Tavistock, 1961).

19. Mintzberg, Structure in Fives, pp. 37–38.

20. Saporito, "Cutting Costs Without Cutting People," pp. 26–32.

21. Mintzberg, Structure in Fives, pp. 121–49.

22. Kiam, "Growth Strategies at Remington," pp. 22–26.

23. Mintzberg, Structure in Fives, p. 128.

24. Joan Woodward, Industrial Organization: Theory and Practice (London: Oxford University Press, 1965).

25. James Cook, "Where's the Niche?" Forbes, September 24, 1984, p. 54.

26. Mintzberg, Structure in Fives; p. 134.

27. "Gillette Finds World-Brand Image Elusive," Advertising Age, June 25, 1984, p. 50.

28. Fred Luthans, Barbara Kemmerer, Robert Paul, and Lew Taylor, "The Impact of a Job Redesign Intervention on Salespersons' Observed Performance Behaviors," Group & Organizational Studies, Vol. 12, No. 1 (1987), pp. 55–72.

29. John Paul Newport, Jr., "The Stalking of Gillette," Fortune, May 23, 1988, pp. 99–101.

30. John Helgar and Bryan Burrough, "Buy-Out Bluff: How Underdog KKR Won RJR Nabisco Without Highest Bid," Wall Street Journal, December 2, 1988, p. Al. See also Alfred A. Marcus, "Responses to Externally Induced Innovation: Their Effects on Organizational Performance," Strategic Management Journal, Vol. 9 (1988), pp. 387–402.

31. Mintzberg, Structure in Fives; p. 134.

32. "1-2-3 Creator Mitch Kapor: The Young Founder of One of the World's Leading Software Companies Gives Some Provocative Reasons for Walking Away from It All," Inc., January 1987, pp. 31–38.

33. Patricia Galagan, "Work Teams That Work," Training and Development Journal, November 1986, p. 35.

34. "Everybody's a Boss," Industry Week, February 23, 1987, pp. 16–17.

35. Bernard M. Bass, "Leadership: Good, Better, Best," Organizational Dynamics, Vol. 13 (Winter 1985), pp. 29–40.

36. Executive Summary, The State of Small Business: A Report of The President, (Washington, D.C.: Government Printing Office, 1988), pp. xv–xxi.

37. Larry E. Greiner, "Evolution and Revolution as Organizations Grow," Harvard Business Review, Vol. 50, No. 4 (July–August 1972), pp. 37–46.

38. Jack Cavanaugh, "When the Cheering Stops," Venture, February 1989, pp. 23–28.

39. "Publishing Magnate Pat McGovern," Inc., August 1988, pp. 27–33.

40. James M. Higgins, "The Decline and Fall of W. T. Grant," in Melvin J. Stanford, Management Policy, 2nd ed. (Englewood Cliffs, N.J.: Prentice Hall, 1983).

41. Tadd C. Seitz, "Why I Bought the Company," The Journal of Business Strategy, January–February 1989, pp. 4–8

42. Victor H. Vroom and Arthur G. Jago, The New Leadership: Managing Participation in Organizations (Englewood Cliffs, N.J.: Prentice Hall, 1988), pp. 5–14. See also Ellen Schultz, "America's Most Admired Corporations," Fortune, January 18, 1988, pp. 32–37.

43. John Naisbitt, Megatrends: Ten New Directions Transforming Our Lives (New York: Warner Books, 1982), pp. 20–26. See also John Naisbitt and Patricia Aburdene, Re-inventing the Corporation (New York: Warner Books, 1985), pp. 9–43.

44. Executive Summary, The State of Small Business: A Report of the President, pp. xvi–xvii.

45. "The Fortune Service 500: More Woes Than Winnings," Fortune, June 6, 1988, pp. D3–D7.

46. Walt Bogdanich and Michael Waldholz, "Hospitals That Need Patients Pay Bounties for Doctors' Referrals," Wall Street Journal, February 27, 1989, pp. A1, A4.

47. James A. Fitzsimmons and Robert S. Sullivan, Service Operations Management (New York: McGraw-Hill, 1982), pp. 221–27.

48. James A. Fitzsimmons and Robert S. Sullivan, Service Operations Management (New York: McGraw-Hill, 1982), pp. 221–27.

49. John J. Keller, "AT&T's Bob Allen Is Pushing All the Right Buttons," Business Week, November 28, 1988, pp. 133, 136.

50. Susan Fraker, "High-Speed Management for the High-Tech Age," Fortune, March 5, 1984, pp. 62–68.

51. Ibid., p. 63.

Chapter 9

1. Kathleen Deveny, "Can Ms. Fashion Bounce Back?" Business Week, January 16, 1989, pp. 64–70. See also Jeffrey A. Trachtenberg and Teri Agins, "Can Liz Claiborne Continue to Thrive When She Is Gone?" Wall Street Journal, February 28, 1989, pp. A1, A11.

2. Pradip N. Khandwalla, The Design of Organizations (New York: Harcourt Brace Jovanovich, 1977), p. 489.

3. "GM Moves into a New Era," Business Week, July 16, 1984, pp. 48–54.

4. Rosabeth Moss Kanter, "Power Failure in Management Circuits," in Robert W. Allen and Lyman W. Porter (eds.), Organizational Influence Processes (Glenview, Ill.: Scott, Foresman, 1983), pp. 87–104.

5. M. Dalton, "Conflicts Between Staff and Line Managerial Officers," American Sociological Review, Vol. 15 (1950), pp. 342–51.

6. Leonard R. Sayles, Managerial Behavior: Administration in Complex Organizations (New York: McGraw-Hill, 1964), pp. 48–49, 108–10. See also Mariann Jelinek, "Organization Structure: The Basic Conformations," in Mariann Jelinek, Joseph A. Litterer, and Raymond E. Miles (eds.), Organizations by Design: Theory and Practice (Plano, Tex.: Business Publications, 1981), pp. 293–302.

7. Robert Duncan, "What Is the Right Organization Structure?" in David A. Nadler, Michael L. Tushman, and Nina G. Hatveny (eds.), Managing Organizations: Readings and Cases (Boston, Mass.: Little, Brown, 1982), pp. 302–18.

8. Kenneth Labich, "The Innovators," Fortune, June 6, 1988, pp. 50–58.

9. "ITT Chief Emphasizes Harmony, Confidence, and Playing by Rules," Wall Street Journal, September 13, 1984, pp. 1, 22.

10. "The Chief's Personality Can Have a Big Impact—For Better or Worse," Wall Street Journal, September 11, 1984, pp. 1, 12. See also C. G. Burck, "A group Profile of the Fortune 500 Chief Executives," Fortune, May 14, 1986, pp. 173–77, 311–12.

11. Peter Nulty, "America's Toughest Bosses," Fortune, February 27, 1989, pp. 40–43.

12. Thomas Moore, "Make-or-Break Time for General Motors," Fortune, February 15, 1988, pp. 32–35, 38–39.

13. Ross Perot, "How I Would Turn Around GM," Fortune, February 15, 1988, pp. 44–46.

14. John J. McCarthy, "Sales Teams: The Powerful, Underused Selling Tool," Boardroom Reports, Vol. 13, No. 19 (October 1, 1984), pp. 2–4. See also Alex Taylor III, "Tomorrow's Chief Executives," Fortune, May 9, 1988, pp. 30–36.

15. Ross Perot, "How I Would Turn Around GM," p. 48. See also Susan Fraker, "High-Speed

Management for the High-Tech Age," *Fortune,* March 5, 1984, pp. 62–68.

16. Rosabeth Moss Kanter, "Quality Leadership and Change," *Quality Progress,* February 1987, pp. 45–51.

17. Carla O'Dell, "The American Work Place: Issues and Innovations," *Productivity Brief,* No. 32 (January 1984), p. 2.

18. Brian Dumaine, "Donald Petersen: A Humble Hero Drives Ford to the Top," *Fortune,* January 4, 1988, pp. 22–24.

19. O'Dell, "The American Work Place: Issues and Innovations," p. 2.

20. Christopher K. Bart, "New Venture Units: Use Them Wisely to Manage Innovation," *Sloan Management Review,* Vol. 29 (Summer 1988), pp. 35–43.

21. Christopher K. Bart, "Product Strategy and Formal Structure," *Strategic Management Journal,* Vol. 7, No. 4 (1986), pp. 293–312.

22. John L. Cotton, David A. Vollrath, Kirk L. Froggatt, Mark L. Lengnick-Hall, and Kenneth R. Jennings, "Employee Participation: Diverse Forms and Different Outcomes," *Academy of Management Review,* Vol. 13, No. 1 (1988), pp. 8–22. See also Fraker, "High-Speed Management for the High-Tech Age," p. 63.

23. David J. Kautter, *Benefit Planning* (Washington, D.C.: Arthur Young and Company, 1984), pp. 11–12.

24. "RDLPs and Consortiums: The New Wave in R&D," *Compressed Air Magazine,* March 1984, pp. 20–27.

25. D. Bruce Merrifield, "The Measurement of Productivity and the Use of R&D Limited Partnerships," U.S. Department of Commerce Publications, Office of Productivity, Technology, and Innovation, Summer 1984.

26. Jacob M. Schlesinger and Joseph B. White, "The New-Model GM Will Be More Compact but More Profitable," *Wall Street Journal,* June 6, 1988, pp. 1, 6. See also Moore, "Make-or-Break Time for General Motors," p. 38.

27. Bruce Kogut, "Joint Ventures: Theoretical and Empirical Perspectives," *Strategic Management Journal,* Vol. 9 (1988), pp. 319–32.

28. Robert Bartlett, "Tomorrow's Retailing to Change All Business," *Boardroom Reports,* Vol. 13, No. 10 (May 15, 1984), pp. 9–10.

29. "Doctors Are Entering a Brave New World of Competition," *Business Week,* July 16, 1984, pp. 56–57, 59–61.

30. Erik W. Larson and David H. Gobeli, "Matrix Management: Contradictions and Insights," *California Management Review,* Vol. 29, No. 4 (Summer 1987), pp. 126–38.

31. Harvey F. Kolodny, "Evolution to a Matrix Organization," *Academy of Management Review,* Vol. 4, No. 4, (1979), p. 548.

32. Ibid., pp. 549–50.

33. Paul R. Lawrence, Harvey F. Kolodny, and Stanley M. Davis, "The Human Side of the Matrix," *Organizational Dynamics,* Vol. 6, No. 1 (1977), pp. 43–61.

34. Ibid., pp. 46–48.

35. Kolodny, "Evolution to a Matrix Organization," p. 547.

36. Stanley M. Davis and Paul R. Lawrence, *Matrix* (Reading, Mass.: Addison-Wesley, 1977).

37. Rosabeth Moss Kanter, *The Change Masters* (New York: Simon & Schuster, 1983). See also Kanter, "Quality Leadership and Change," p. 48.

38. "Allied Unit, Free of Red Tape, Seeks to Develop Orphan Technologies," *Wall Street Journal,* September 13, 1984, p. 31; "Competition Leads Security Pacific to Form Unusual Investment Unit," *Wall Street Journal,* September 14, 1984, pp. 31, 57; "Tektronix New-Venture Subsidiary Brings Benefits to Parent, Spinoffs," *Wall Street Journal,* September 18, 1984, p. 33; and "Keeping the Fires Lit Under the Innovators," *Fortune,* March 28, 1988, p. 45.

39. Andrall E. Pearson, "Tough-Minded Ways to Get Innovative," *Harvard Business Review,* Vol. 88, No. 3 (May–June 1988), pp. 99–106.

40. Deveny, "Can Ms. Fashion Bounce Back?" p. 65. See also Trachtenberg and Agins, "Can Liz Claiborne Continue to Thrive When She Is Gone?" p. A11.

Chapter 10

1. Michael J. Milne, "Scott Paper Is on a Roll," *Management Review,* March 1988, pp. 37–42.

2. Rosabeth Moss Kanter and Barry A. Stein, *Life in Organizations: Workplaces as People Experience Them* (New York: Basic Books, 1979), pp. 259–60.

3. Bro Uttal, "The Corporate Culture Vultures," *Fortune,* October 17, 1983, p. 66.

4. Carol Davenport, "America's Most Admired Corporations," *Fortune* January 30, 1989, pp. 68–69. See also Daryl R. Conner, Byron G. Fiman, and Ernest E. Clements, "Corporate Culture and Its Impact on Strategic Change in Banking," *Journal of Retail Banking,* Vol. IX, No. 2 (Summer 1987), pp. 16–24.

5. Schultz, "America's Most Admired Corporations," p. 35. See also Ellen F. Jackofsky, John W. Slocum, Jr., and Sara J. McQuaid, "Cultural Values and the CEO: Alluring Companions?" *Academy of Management Executive,* Vol. II, No. 1 (1988), pp. 39–49.

6. Gene Bylinsky, "American's Best-Managed Factories," *Fortune,* May 28, 1984, pp. 16–24.

7. Ibid., p. 18.

8. William R. Torbert, "Pre-Bureaucratic and Post-Bureaucratic Stages of Organizational Development," *Interpersonal Development,* Vol. 5 (1975), pp. 1–25.

9. John R. P. French and Bertram Raven, "The Bases of Social Power," in Dorwin Cartwright (ed.), *Studies in Social Power* (Ann Arbor, MI: University of Michigan Press, 1959), pp. 150–67. See also Jay A. Conger and Rabindra N. Kanungo, "The Empowerment Process: Integrating Theory and Practice," *Academy of Management Review,* Vol. 13, No. 3 (1988), pp. 471–82.

10. Peter F. Drucker, "The Job as Property Right," *The Wall Street Journal,* March 4, 1980, p. 18.

11. Chester I. Barnard, *The Functions of the Executive,* 30th Anniversary Edition (Cambridge, Mass.: Harvard University Press, 1968), pp. 164–67.

12. Harold J. Leavitt, William R. Oill, and Henry B. Eyring, *The Organizational World* (New York: Harcourt Brace Jovanovich, 1973), pp. 32–39.

13. E. Dale and L. F. Urwick, *Staff in Organizations* (New York: McGraw-Hill, 1960).

14. J. A. Bealasco and J. A. Arlutto, "Line and Staff Conflicts: Some Empirical Insights," *Academy of Management Journal,* Vol. 12, No. 3 (1969), pp. 469–77.

15. Bart Victor and Richard S. Blackburn, "Interdependence: An Alternative Conceptualization," *Academy of Management Review,* Vol. 12, No. 3 (1987), pp. 486–98. See also Arnold O. Putnam, "A Redesign for Engineering," *Harvard Business Review,* Vol. 63, No. 3 (May–June 1985), pp. 139–44.

16. Otto Forchheimer, "Accountability for Functional Executives," *Advanced Management Journal,* April 1972, pp. 15–20.

17. William H. Newman, Kirby E. Warren, and Jerome E. Scnee, *The Process of Management: Strategy, Action, Results,* 5th ed (Englewood Cliffs, N.J.: Prentice Hall, 1982), pp. 221–23.

18. French and Raven, "The Bases of Social Power," pp. 607–23. See also Dale McConkey, *No Nonsense Delegation* (New York: AMACOM Books, 1974).

19. Ramon J. Aldag and Arthur P. Brief, *Task Design and Employee Motivation* (Glenview, Ill.: Scott, Foresman, 1979), pp. 44–48.

20. Peter F. Drucker, *Management: Tasks, Responsibilities, Practices* (New York: Harper & Row, 1974), pp. 494–95. See also Gerald G. Fisch, "Toward More Effective Delegation," *CPA Journal,* Vol. 46, No. 7 (1976), pp. 66–67.

21. Noel M. Tichy and David O. Ulrich, "SMR Forum: The Leadership Challenge—A Call for the Transformational Leader," *Sloan Management Review,* Vol. 26, No. 1 (Fall 1984), pp. 59–68.

22. Peter F. Drucker, "Behind Japan's Success," *Harvard Business Review,* Vol. 59, No. 3 (May–June 1981), pp. 83–90. See also Gary Jacobson and John Hillkirk, *Xerox: American Samurai* (New York: Macmillan, 1986), pp. 4–6, 37. See also Peter F. Drucker, "The Coming of the New Organization," *Harvard Business Review,* Vol. 88, No. 1 (January–February 1988), pp. 45–53.

23. Robert A. Portnoy, *Leadership! What Every Leader Should Know About People* (Englewood Cliffs, N.J.: Prentice Hall, 1986), pp. 3–5, 21.

24. Ronald N. Taylor, *Behavioral Decision Making* (Glenview, Ill.: Scott, Foresman, 1984), pp. 3–10. See also Herbert Simon, "Rational Decision Making in Business," *American Economic Review,* Vol. 4, No. 4 (1979), pp. 493–511.

25. William Ouchi, *Theory Z—How American Business Can Meet the Japanese Challenge* (Reading, Mass.: Addison-Wesley, 1981). See also B. J. Reilly and J. P. Fuhr, "Productivity: An Economic and Management Analysis with a Direction Towards a New Synthesis," *Academy of Management Review,* Vol. 8, No. 1 (1983), pp. 108–17.

26. Ann C. Seror, "A Contingency Framework for the Comparative Analysis of Japanese and U.S. Organizations," in Sang M. Lee and Gary Schwendiman (eds), *Management by Japanese Systems* (New York: Praeger, 1982), pp. 239–55.

27. Bylinsky, "America's Best-Managed Factories," p. 24.

28. Milne, "Scott Paper Is on a Roll," pp. 37–42.

29. Charles C. Harwood, "The View from the Top," *Quality Progress,* October 1984, pp. 26–30.

Chapter 11

1. Mark Hendricks, "Banking on Kids," *Venture,* March 1988, p. 12.

2. Bruce D. Merrifield, "The Measurement of Productivity and the Use of R&D Limited Partnerships," *U.S. Department of Commerce Papers,* Office of Productivity, Technology, and Innovation (Washington, D.C.: April 1984).

3. Joseph Luft, *Group Processes: An Introduction to Group Dynamics,* 3rd ed. (Palo Alto, Calif.: Mayfield Publishing Co., 1984), pp. 151–52.

4. Paul R. Ehrlich, *The Population Bomb* (San Francisco, Calif.: Sierra Club, 1969).

5. M. W. Thring, *Robots and Telechirs: Manipulators with Memory; Remote Manipulators; Machine Limbs for the Handicapped* (Chichester, U.K.: Ellis Horwood, 1983).

6. Joseph A. Raelin, "The '60s Kids in the Corporation: More Than Just 'Daydream Believers,'" *Academy of Management Executive,* Vol. I, No. 1 (1987), pp. 21–30.

7. Albert Shapero and Lisa Sokol, "The Social Dimensions of Entrepreneurship," in Calvin A. Kent, Donald L. Sexton, and Karl H. Vesper, eds., *Encyclopedia of Entrepreneurship* (Englewood Cliffs, N.J.: Prentice Hall, 1982), pp. 72–98.

8. Richard J. Schonberger, *World Class Manufacturing Casebook: Implementing JIT and TQC*

(New York; Free Press, 1987). See also Robert Landel, *Managing Productivity Through People* (Englewood Cliffs, N.J.: Prentice Hall, 1986), pp. 90–95.

9. John F. Krafcik, "Triumph of the Lean Production System," *Sloan Management Review,* Vol. 30, No. 1 (Fall 1988), pp. 41–52.

10. Jan P. Muczyk and Bernard C. Reimann, "The Case for Directive Leadership," *Academy of Management Executive,* Vol. 1, No. 3 (1987), pp. 301–11. See also Charles L. Hulin and Milton R. Blood, "Job Enlargement, Individual Differences, and Worker Responses," *Psychological Bulletin,* Vol. 69 (1968), pp. 41–55.

11. Frederick Herzberg, "One More Time: How Do You Motivate Employees?" *Harvard Business Review,* Vol. 87, No. 5 (September–October 1987), pp. 109–17.

12. Frederick Herzberg, Bernard Mausner, and Barbara B. Synderman, *The Motivation to Work,* 2nd ed. (New York: John Wiley, 1967).

13. Michael Fein, "Job Enrichment: A Reevaluation," *Sloan Management Review,* Vol. 15 (1974), pp. 68–88. See also Frederick Herzberg, "Retrospective Commentary," *Harvard Business Review,* Vol. 87, No. 5 (September–October 1987), pp. 118–20.

14. Richard E. Walton, "How to Counter Alienation in the Plant," *Harvard Business Review,* Vol. 50 (November–December, 1972), pp. 70–81.

15. Noel M. Tichy, "Organizational Innovations in Sweden," *Columbia Journal of World Business,* Summer 1974, pp. 18–27.

16. Bowen Northrup, "Auto Plant in Sweden Scores Some Success with Work Teams," *Wall Street Journal,* March 1, 1977, p. 1.

17. J. Richard Hackman, Greg Oldham, Robert Jansen, and Kenneth Purdy, "A New Strategy for Job Enrichment," in Barry M. Shaw, ed., *Psychological Foundations of Organizational Behavior,* 2nd. ed. (Glenview, Ill.: Scott, Foresman, 1983), pp. 64–79.

18. Arthur N. Turner and Paul R. Lawrence, *Industrial Jobs and the Worker* (Cambridge, Mass.: Harvard University Graduate School of Business Administration, 1965).

19. J. Richard Hackman and Edward E. Lawler III, "Employee Reactions to Job Characteristics," *Journal of Applied Psychology,* Monograph 55 (1971), pp. 259–86.

20. A. Nicholas Komanecky, "Developing New Managers at GE," *Training and Development Journal,* June 1988, pp. 62–64.

21. Patricia A. Galagan, "IBM Gets Its Arms Around Education," *Training and Development Journal,* January 1989, pp. 35–41.

22. J. Richard Hackman and Greg R. Oldham, *Work Redesign* (Reading, Mass.: Addison-Wesley, 1980), pp. 135–42.

23. Ramon J. Aldag and Arthur P. Brief, *Task Design and Employee Motivation* (Glenview, Ill.: Scott, Foresman, 1979), Chapter 4.

24. *IBM Management Development Policies,* a company manual for new managers (International Business Machines, 1987). See also John Marcom, Jr., "Behind the Monolith: A Look at IBM," *Wall Street Journal,* April 7, 1986, p. 15.

25. Ernest McCormick, "Job and Task Analysis," in Marvin Dunnette, ed., *Handbook of Industrial and Organizational Psychology* (Chicago, Ill.: Rand McNally, 1976), pp. 651–96.

26. Kenneth N. Wexley and Gary A. Yukl, *Organizational Behavior and Personnel Psychology* (Homewood, Ill.: Richard D. Irwin, 1977), pp. 126–28.

27. Luft, *Group Processes,* p. 167.

28. Arthur K. Rice, *The Enterprise and Its Environment* (London: Tavistock Institute, 1963).

29. Kichiro Hayaski, "The Internationalization of Japanese-Style Management," *Japan Update* (Tokyo: Japan Institute for Social and Economic Affairs, Autumn 1987), pp. 20–23.

30. Norman R. F. Maier, "Assets and Liabilities in Group Problem Solving," *Psychological Review,* Vol. 74 (1967), pp. 239–49.

31. David B. Cowfer and Joanne Sujansky, "Appraisal Development at Westinghouse," *Training and Development Journal,* July 1988, pp. 40–43.

32. Dorwin Cartwright, "Determinants of Scientific Progress: The Case of Research on the Risky Shift," *American Psychologist,* Vol. 28, No. 3 (March 1973), pp. 222–31.

33. Rebecca Rolfes, "The ITT Class of '86," *International Management,* March 1989, pp. 34–36.

34. Mary E. Settle, "Developing Tomorrow's Managers," *Training and Development Journal,* April 1988, pp. 60–64.

35. Cartwright, "Determinants of Scientific Progress," p. 337.

36. Ikujiro Nonaka, "Toward Middle-Up-Down Management: Accelerating Information Creation," *Sloan Management Review,* Vol. 29 (Spring 1988), pp. 9–18.

37. Irving L. Janis, "Groupthink," *Psychology Today,* November 1971, pp. 43–46. See also Ann Reilly Dowd, "Learning from Reagan's Debacle," *Fortune,* April 27, 1987, pp. 169–72.

38. Luft, *Group Processes,* pp. 170–71.

39. Ibid., p. 154.

40. S. Prakash Sethi, Nobuaki Namiki, and Carl L. Swanson, *The False Promise of the Japanese Miracle: Illusions and Realities of the Japanese Management System* (Boston, Mass.: Pitman Publishing, 1984), pp. 128–30, 136–38.

41. Peter F. Drucker, "The Coming of the New Organization," Harvard *Business Review,* Vol. 88, No. 1 (January–February 1988), pp. 45–53.

42. Mark Hendricks, "Banking on Kids," *Venture,* March 1988, p. 12.

Chapter 12

1. Virginia Breen, "The 10 Best Resorts for Meetings," *Corporate Meetings & Incentives,* June 1988, reprint pp. 1–4. See also "Pinehurst Wins Prestigious Grounds Award," *The Putter Boy,* Vol. 1, No. 4 (Winter 1989) p. 4; and "Pinehurst Bellman Named Tops in North Carolina," *The Putter Boy,* Vol. 1, No. 4 (Winter 1989), p. 4.

2. Gary Dessler, *Personnel Management,* 4th ed. (Englewood Cliffs, N.J.: Prentice Hall, 1988), pp. 2–6.

3. Andrew F. Sikula, *Personnel Administration and Human Resources Management* (New York; John Wiley, 1976), pp. 7–8. See also Jack English, "The Road Ahead for the Human Resources Function," *Personnel,* Vol. 57 (March–April 1980), pp. 35–39.

4. James Morris, "Those Burgeoning Worker Benefits," *Nation's Business,* February 1987, pp. 53–54. See also Arthur A. Sloane, *Personnel: Managing Human Resources* (Englewood Cliffs, N.J.: Prentice Hall, 1983), pp. 21–22.

5. William F. Glueck, *Personnel: A Diagnostic Approach,* 3rd ed. (Plano, Tex.: Business Publications, 1983), p. 89.

6. Thierry Wils, Christiane Labelle, and Jean-Yves Le Louarn, "Human Resource Planning at Quebec-Telephone," *Human Resource Planning,* Vol. 11, No. 4 (1988), pp. 255–69.

7. Eric Vetter, *Manpower Planning for High Talent Personnel* (Ann Arbor, Mich.: University of Michigan Press 1967); pp. 14–15.

8. Max Bader, "Attitudes Harden Before Arteries When Hiring the Elderly," *Wall Street Journal,* June 6, 1988, p. 20.

9. Dessler, *Personnel Management,* pp. 701–03.

10. Brian D. Steffy and Steven D. Maurer, "Conceptualizing and Measuring the Economic Effectiveness of Human Resource Activities," *Academy of Management Review,* Vol. 13, No. 2 (1988), pp. 271–96. See also Richard B. Frantzreb, "Human Resource Planning: Forecasting Manpower Needs," *Personnel Journal,* Vol. 60, No. 11 (1981), pp. 850–57.

11. "Retraining of Workers for Automated Plants Gets Off to Slow Start," *Wall Street Journal,* April 13, 1983, p. 1. See also "Manufacturers Press Automating to Survive, But Results Are Mixed," *Wall Street Journal,* April 11, 1983, p. 1.

12. Arthur R. Pell, *Recruiting and Selecting Personnel* (New York: Regents Publishing Company, 1969), pp. 21–23. See also Stephen P. Robbins, *Personnel: The Management of Human Resources* (Englewood Cliffs, N.J.: Prentice Hall, 1982), pp. 115–16.

13. Roger Ricklefs, "Victims of AIDS-Related Discrimination Are Fighting Back—and Getting Results," *Wall Street Journal,* July 15, 1988, p. 17. See also David Ritter and Ronald Turner, "AIDS: Employer Concerns and Options," *Labor Law Journal,* Vol. 38, No. 2 (1987), pp. 67–83.

14. Irwin L. Goldstein, "The Application Blank: How Honest Are the Responses?" *Journal of Applied Psychology,* Vol. 55, No. 5 (1971), p. 491.

15. Cabot L. Jaffee and Stephen L. Cohen, "Improving Human Resource Effectiveness Through Assessment Center Technology: Emergence, Design, Application and Evaluation," in Edwin L. Miller, Elmer H. Burack, and Maryann Albrecht (eds.), *Management of Human Resources* (Englewood Cliffs, N.J.: Prentice Hall, 1980), p. 360.

16. G. C. Thornton and William C. Byham, *Assessment Centers and Managerial Performance* (New York: Academic Press, 1982), pp. 3–5, 32–36.

17. Richard Neidig and Manela Neidig, "Multiple Assessment Center Exercises and Job Relatedness," *Journal of Applied Psychology,* Vol. 69, No. 1 (1984), pp. 182–86. See also Craig Russell, "Individual Decision Processes in an Assessment Center," *Journal of Applied Psychology,* Vol. 70, No. 4 (1985), pp. 737–46.

18. Meryl Reis Louis, "Surprise and Sense Making: What Newcomers Experience in Entering Unfamiliar Organizational Settings," *Administrative Science Quarterly,* June 1980, pp. 226–51.

19. Walter St. John, "The Complete Employee Orientation Program," *Personnel Journal,* Vol. 59 (May 1980), pp. 373–78. See also Joan P. Klubnik, "Orienting New Employees," *Training and Development Journal,* April 1987, pp. 46–49.

20. Sikula, *Personnel Administration and Human Resources Management,* pp. 227–228.

21. Patricia A. Galagan, "IBM Gets Its Arms Around Education," *Training and Development Journal* (January 1989), pp. 35–41.

22. Dessler, *Personnel Management,* pp. 272–80.

23. Ibid., pp. 330–31. See also Richard Henderson, *Compensation Management* (Reston, Va.: Reston Books, 1980), pp. 88–89, 103–104.

24. Jai Ghorpade, *Job Analysis: A Handbook for the Human Resource Director* (Englewood Cliffs, N.J.: Prentice Hall, 1988), pp. 6, 96, 141. See also Sloane, *Personnel: Managing Human Resources,* pp. 210–28.

25. Donald P. Schwab and Herbert G. Heneman, III, "Behaviorally Anchored Rating Scales," in Herbert G. Heneman III and Donald P. Schwab (eds.), *Perspectives on Personnel/Human Resource Management* (Homewood, Ill.: Richard D. Irwin, 1978), pp. 65–66.

26. Uco Wiersma and Gary P. Latham, "The Practicality of Behavioral Observation Scales, Behavioral Expectations Scales, and Trait Scales," *Personnel Psychology,* Vol. 39, No. 3 (Autumn 1986), pp. 619–28.

27. Joane Pearce and Lyman Porter, "Employee Response to Formal Performance Appraisal Feedback," *Journal of Applied Psychology,* Vol. 71, No. 2 (1986), pp. 211–18.

28. Patrick J. Montana, *Retirement Programs: How to Develop and Implement Them* (Englewood Cliffs, N.J.: Prentice Hall, 1985), pp. 3–5.

29. Personal Interviews, March 1989, with Jackie Hayter, Senior Sales Manager, Norma P. Stilwell, Public Relations Manager, and resort personnel at Pinehurst Hotel and Country Club.

30. F. Lee Van Horn, international consultant, quoted in *Vista*, July–August 1989, p. 58.

31. "OSHA Training Guidelines (Part II): Developing Learning Activities," *Personnel Manager's Legal Report*, February 1984, pp. 7–8.

Chapter 13

1. Howard Banks, "Is Delta Too Nice for Its Own Good?" *Forbes*, November 28, 1988, pp. 91–94.

2. Ibid., p. 94.

3. Craig C. Pinder, *Work Motivation* (Glenview, Ill.: Scott, Foresman, 1984), p. 8.

4. Edward E. Lawler, III, *High-Involvement Management: Participative Strategies for Improving Organizational Performance* (San Francisco, Calif.: Jossey-Bass, 1986), pp. 5–8.

5. Matt M. Amano, "Motivation Orientation Differences Between Japan and the United States: The Key to Worker Productivity Successes and Problems," in Sang M. Lee and Gary Schwendiman (eds.), *Management by Japanese Systems* (New York: Praeger, 1982), pp. 273–87.

6. Edward E. Lawler, III, "Job Design and Employee Motivation," *Personnel Psychology*, Vol. 22 (1969), pp. 426–35.

7. Douglas M. McGregor, "The Human Side of Enterprise," in Louis E. Boone and Donald D. Bowen (eds.), *The Great Writings in Management and Organizational Behavior* (New York: Random House, 1987), pp. 126–38.

8. Victor H. Vroom and Arthur G. Jago, *The New Leadership: Managing Participation in Organizations* (Englewood Cliffs, N.J.: Prentice Hall, 1988), pp. 7–14.

9. Thomas L. Daniel and James K. Esser, "Intrinsic Motivation as Influenced by Rewards, Task Interest, and Task Structure," *Journal of Applied Psychology*, Vol. 65, No. 5 (1980), pp. 566–73.

10. Abraham H. Maslow, *Motivation and Personality*, 2nd ed. (New York: Harper & Row, 1970).

11. Howard S. Schwartz, "Maslow and the Hierarchical Enactment of Organizational Reality," *Human Relations*, Vol. 36, No. 10 (1983), pp. 933–56. See also Vance Mitchell and Pravin Moudgill, "Measurement of Maslow's Need Hierarchy," *Organizational Behavior and Human Performance*, Vol. 16, No. 2 (1976), pp. 334–49.

12. Frederick Herzberg, "One More Time: How Do You Motivate Employees?" *Harvard Business Review*, Vol. 87, No. 5 (September–October 1987), pp. 109–17.

13. John W. Atkinson, *An Introduction to Motivation* (New York: Van Nostrand, 1961).

14. David C. McClelland, *The Achieving Society* (Princeton, NJ: Van Nostrand, 1961). See also David C. McClelland, *Power: The Inner Experience* (New York: Irvington Publishers, 1975).

15. Robert H. Brockhaus, Sr., and Pamela S. Horwitz, "The Psychology of the Entrepreneur," in Donald L. Sexton and Raymond W. Smilor (eds.), *The Art and Science of Entrepreneurship* (Cambridge, Mass.: Ballinger Publishing Co., 1986), pp. 25–48.

16. David C. McClelland, "Toward a Theory of Motive Acquisition," *American Psychologist*, Vol. 20, No. 5 (1965), pp. 321–33.

17. David C. McClelland, "That Urge to Achieve," in Boone and Bowen, *The Great Writings in Management and Organizational Behavior*, pp. 384–93.

18. Victor H. Vroom, *Work and Motivation* (New York: John Wiley, 1964). See also Vroom and Jago, *The New Leadership: Managing Participation in Organizations*, pp. 121–27.

19. David A. Nadler and Edward E. Lawler, III, "Motivation: A Diagnostic Approach," in Barry M. Staw (ed.), *Psychological Foundations of Organizational Behavior*, 2nd ed. (Glenview, Ill.: Scott, Foresman, 1983), pp. 36–45.

20. J. Stacy Adams, "Toward an Understanding of Inequity," *Journal of Abnormal and Social Psychology*, Vol. 67, No. 5 (1963), pp. 422–36. See also Steven Kerr, "On the Folly of Rewarding A While Hoping for B," *Academy of Management Journal*, Vol. 18, No. 4 (1975), pp. 769–83.

21. W. E. Craighead, A. E. Kazdin, and M. J. Mahoney, *Behavior Modification* (Boston, MA: Houghton Mifflin, 1976), pp. 134–48. See also Fred Luthans and Robert Kreitner, *Organizational Behavior Modification and Beyond: An Operant and Social Learning Approach* (Glenview, Ill.: Scott, Foresman, 1985).

22. B. F. Skinner, *Science and Human Behavior* (New York: Macmillan Publishing Company, 1953). See also B. F. Skinner, *Beyond Freedom and Dignity* (New York: Alfred Knopf, 1971).

23. E. L. Thorndike, *Animal Intelligence* (New York: Macmillan Publishing Company, 1911). See also Pinder, *Work Motivation*, pp. 187–208.

24. W. F. Dowling, "At Emery Air Freight: Positive Reinforcement Boosts Performance," *Organizational Dynamics*, Vol. 2, No. 1 (1973), pp. 41–50.

25. W. Clay Hamner, "Using Reinforcement Theory in Organizational Settings," in Henry L. Tosi and W. Clay Hamner (eds.), *Organizational Behavior and Management: A Contingency Approach* (Chicago, Ill.: St. Clair Press, 1977), pp. 388–95.

26. Fred Luthans and Robert Kreitner, "The Management of Behavioral Contingencies," *Personnel*, Vol. 51, No. 4 (1974), pp. 7–16.

27. Pinder, *Work Motivation*, pp. 229–32.

28. Banks, "Is Delta Too Nice for Its Own Good?" p. 94.

29. Laurie Baum, "Corporate Women: They're About to Break Through to the Top," *Business Week*, June 22, 1987, pp. 72–78.

Chapter 14

1. Stephen Kindel, "The 10 Worst Managed Companies in America," *Financial World*, July 26, 1988, pp. 28–39.

2. Ibid., p. 29.

3. Robert R. Blake and Jane S. Mouton, *The Versatile Manager: A Grid Profile* (Homewood, Ill.: Richard D. Irwin, 1981), p. vi.

4. Ralph M. Stogdill, *Handbook of Leadership* (New York: Free Press, 1981), pp. 6–8, 14–17. See also Karl W. Kuhnert and Philip Lewis, "Transactional and Transformational Leadership: A Constructive/Developmental Analysis," *Academy of Management Review*, Vol. 12, No. 4 (1987), pp. 648–57.

5. Ralph M. Stogdill, "Personal Factors Associated with Leadership: A Survey of the Literature," *Journal of Psychology*, Vol. 25, No. 1 (1948), pp. 35–71.

6. Robert A. Portnoy, *Leadership! What Every Leader Should Know About People* (Englewood Cliffs, N.J.: Prentice Hall, 1986), pp. 12–20. See also Paul Hersey, *The Situational Leader* (Escondido, Calif.: Center for Leadership Studies, 1984), pp. 13–14.

7. David C. McClelland, "N-Achievement and Entrepreneurship: A Longitudinal Study," *Journal of Personality and Social Psychology*. Vol. 1 (1965), pp. 389–92.

8. Gary A. Yukl, *Leadership in Organizations* (Englewood Cliffs, N.J.: Prentice Hall, 1981), p. 10.

9. Ralph M. Stogdill and Alvin E. Coons, eds., *Leader Behavior: Its Description and Measurement*, Research Monograph No. 88 (Columbus: Bureau of Business Research, Ohio State University, 1957); see also Chester C. Schriesheim and Steven Kerr, "Theories and Measures of Leadership: A Critical Appraisal of Current and Future Directions," in James G. Hunt and Lars Larson, eds., *Leadership: The Cutting Edge* (Carbondale, Ill.: SIU Press, 1977), pp. 9–21, 51–56.

10. Rensis Likert, *New Patterns of Management* (New York: McGraw-Hill, 1961). See also Rensis Likert, "An Integrating Principle and an Overview," in Louis E. Boone and Donald D. Bowen, eds., *The Great Writings in Management and Organizational Behavior* (New York: Random House, 1987), pp. 216–38.

11. Rensis Likert, *Past and Future Perspectives on System 4 and Appendices A and B* (Ann Arbor, Mich.: Rensis Likert Associates, 1977), pp. 3–5, 9.

12. Blake and Mouton, *The Versatile Manager: A Grid Profile*, pp. 239–61.

13. Dean M. Ruwe and Wickham Skinner, "Reviving a Rust Belt Factory," *Harvard Business Review*, Vol. 87, No. 3 (May–June 1987), pp. 70–76.

14. Robert Lange, "Participative Management as a Reflection of Cultural Contingencies: A Need to Reevaluate Our Ethic," in Sang M. Lee and Gary Schwendiman, eds., *Japanese Management: Cultural and Environmental Considerations* (New York: Praeger, 1982), pp. 117–37.

15. Robert Tannenbaum and Warren H. Schmidt, "How to Choose a Leadership Pattern," *Harvard Business Review*, Vol. 36, No. 2 (May–June 1973), pp. 95–101.

16. Jeffrey Pfeffer and Gerald R. Salancik, "Determinants of Supervisory Behavior: A Role Set Analysis," *Human Relations*, Vol. 28 (1975), pp. 139–53. See also Jeffrey Pfeffer, "The Ambiguity of Leadership," in M. W. McCall, Jr., and M. M. Lombardo, eds., *Leadership: Where Else Can We Go?* (Durham, N.C.: Duke University Press, 1978).

17. Bruce G. Posner, "Right from the Start," *Inc.*, August 1988, pp. 95–96.

18. Blake and Mouton, *The Versatile Manager: A Grid Profile*, pp. 10–26.

19. Sherman, "The Mind of Jack Welch," pp. 39–50.

20. Blake and Mouton, *The Versatile Manager: A Grid Profile*, p. 5.

21. Fred E. Fiedler, "Engineer the Job to Fit the Manager," *Harvard Business Review*, Vol. 43, No. 5 (September–October 1965), pp. 115–22. See also Fred E. Fiedler, *A Theory of Leadership Effectiveness* (New York: McGraw-Hill, 1967).

22. Blake and Mouton, *The Versatile Manager: A Grid Profile*, pp. 252–58.

23. Robert J. House, "A Path Goal Theory of Leader Effectiveness," *Administrative Science Quarterly*, Vol. 16, No. 5 (1971), pp. 321–28.

24. House, "A Path Goal Theory of Leader Effectiveness," p. 324.

25. Robert J. House and Terence R. Mitchell, "Path-Goal Theory of Leadership," in Boone and Bowen, *The Great Writings in Management and Organizational Behavior*, pp. 341–53.

26. Yukl, *Leadership in Organizations*, pp. 151–52. See also Blake and Mouton, *The Versatile Manager: A Grid Profile*, p. 153. For a response, see Robert J. House, "Retrospective Comment," in Boone and Bowen, *The Great Writings in Management and Organizational Behavior*, pp. 354–64.

27. Victor H. Vroom and Phillip Yetton, *Leadership and Decision Making* (Pittsburgh, Pa.: University of Pittsburgh Press, 1973). For a revised analysis of the original work with new implications, see Victor H. Vroom and Arthur G. Jago, *The New Leadership: Managing Participation in Organizations* (Englewood Cliffs, N.J.: Prentice Hall, 1988), pp. 49–77.

brainstorming Associated with group decision making and creativity, it is a technique for generating many diverse ideas in an atmosphere free from criticism and explicit boundaries.

break-even analysis Also called *cost-volume-profit analysis,* it is a mathematical relationship among revenues and fixed and variable costs that determines profits at various levels of sales.

budget A plan transformed into quantitative terms (such as money or units) to allocate resources, articulate performance expectations in measurable terms, and provide control documents for monitoring progress.

bureaucracy A model of organization based on defined positions, formal authority, and a regulated environment that includes well-documented rules, policies, and procedures.

business plan A carefully prepared document that describes services and products, identifies customers, markets, and competition, evaluates capabilities, and provides supporting data for financing a new venture.

business-level strategies Managers focus on well-defined business lines or divisions of services to determine how to compete in their respective industries.

C items Materials and parts that have many substitutes and are usually inexpensive to purchase and store; C items are not closely controlled.

centralized Concentrating decision-making authority at top levels of management with little delegation to others.

certainty Certainty exists when managers know the outcomes under each set of alternatives.

chain of command A vertical line of authority between successively higher levels of management, unbroken and direct, linking each stratum in the hierarchy of management.

clarity Managers must be explicit about how they expect subordinates to make decisions and the extent to which they have authority to make decisions.

closed system From system theory, a system that does not interact with other systems within the environment.

coercive power The capability to punish, rather than reward, or to withhold rewards to influence preferred behavior; power based on fear and force.

comparative advantage The economic strength one nation has relative to others based on natural resources, industrial technology, or cost-effective production. This strength permits favorable trade in gaining needed goods and services.

compensation management The management of wages and salaries, including raises, bonuses, and monetary incentives, by operating managers who deal directly with their subordinates and specialists who deal with compensation systems.

competition A contrast between two or more parties to attain a singular reward or to secure advantages and resources, but not to the extent of deliberate interference by contenders.

completeness of information The degree to which information is sufficient to support decisions, addressing issues without omissions.

comprehensive planning The total involvement of an organization in systematic planning at all levels to integrate objectives and coordinate formal planning processes.

computer-integrated manufacturing (CIM) The combination of design and production computer-assisted systems, commonly called CAD/CAM.

concentration strategy A strategy of trading on a distinctive competency to prevail in one product market, or technology.

concentric diversification A growth strategy achieved by developing new products or services that complement the company's existing line of business.

conflict An effort by one party to purposely interfere with another's ability to perform or attain objectives, thereby creating tension and discord.

conglomerate diversification A conscious effort to develop or acquire unrelated products, services, or technologies, thereby reducing the risk of being in one business subject to economic cycles or industry competition.

content theory The management theory usually associated with motivation that focuses on individual needs and improved performance through behavioral techniques and enhanced job satisfaction.

contingency leadership An approach to leadership that suggests the most effective management behavior depends on adaptation to circumstances in a variety of situations.

contingency management An approach to management that suggests leadership behavior should be adapted to accommodate different situations, or, alternatively, leaders should be assigned to situations that best fit their leadership styles.

contingency plan A conscious effort to develop alternative plans to be prepared for future conditions.

control points Designated places or times during operational activities to measure progress, sample results, or test products.

controlling The management function of monitoring performance and adapting work variables to improve results.

corporate responsiveness Public perception of how a company reacts to protect the public interest or resolves questionable practices, not what the company does in absolute terms.

corporate-level strategy Also called a portfolio-level strategy, it concerns board-level decisions for acquisitions, mergers, major expansions, or divestitures that add to or reduce product lines.

corporation A legal entity created by statute, subject to commercial laws, but a form of ownership in which investors have limited liability through stock ownership.

cost-volume-profit analysis A refinement of break-even analysis using the same variables to examine relationships between different cost components, revenue and costs, and profit changes due to changes in costs, prices, or sales volume.

critical path method (CPM) A network scheduling technique for planning and controlling operations (usually projects) based on critical time increments to complete defined tasks.

culture A shared set of values and beliefs that determine patterns of behavior common to groups of people; corporate culture refers to patterns of behavior based on shared values and beliefs within a particular firm.

customer pattern An approach to departmentalization based on well-defined customer groups whereby people and activities are focused on unique needs of clientele.

customer scenario A customer scenario describes a group of prospective buyers with common needs who are expected to respond similarly to a marketing program.

data Raw information and facts, figures, and results which become source inputs for analyzing activities, events, and circumstances.

data base A pool of raw data stored in such a way that parts of it can be selected, changed, used in calculations, and transformed into useful information for end-users.

decentralized Dispersing of authority through delegation that gives successively lower-level managers greater decision-making responsibility.

decision support system (DSS) An interactive computer information system coupled with decision-making software models that can be readily accessed by managers to enhance problem solving and analysis.

deficit principle A crucial aspect of Maslow's theory of motivation based on human needs that suggests an unsatisfied need becomes a focal motivator while a satisfied need no longer influences an individual's behavior.

delegation The process of partially distributing authority to subordinates for making decisions or performing tasks.

Delphi technique Used in forecasting, problem solving, and creative processes, the Delphi technique surveys experts through several rounds of investigation to develop a profile of information, ideas, or solutions.

democratic leadership An approach to leadership that involves employees in decisions through group efforts and team-building techniques.

departmentalized Logically grouping work activities based on expertise, products, markets, customers, or projects to enhance planning, leading, and controlling.

development Programs for long-term improvements focused on leadership, productivity, and organizational issues, often associated with management.

distress The destructive dimension of stress, which exceeds the normal tension associated with healthful living and threatens an individual physically or psychologically.

diversification By diversifying, a company can deploy its assets more effectively through new products, markets, or technologies.

divestiture The process of selling off divisions or subsidiaries that are either poor performers or do not fit well with the company's long-term strategic objectives.

economic order quantity (EOQ) A mathematical model for determining the optimal quantity of materials or inventory to purchase based on inventory usage, carrying costs, and purchasing costs.

effectiveness The result of making decisions that lead to doing the right things which help fulfill the mission of an enterprise.

efficiency The result of making decisions that lead to doing things right, which helps to achieve objectives with fewer resources and at lower costs.

employee orientation A style of management that emphasizes motivation, social cohesion, and a concern for employees.

employee stock ownership plan (ESOP) A program designed to transfer stock ownership to employees through a formula based on productivity or profit sharing to transform a company into an employee-owned corporation.

entrepreneur An individual who assumes the risk of starting a new business, creating a new commercial product or service, and consequently seeking profitable rewards within a free enterprise system.

entrepreneurship The process of creating a new venture as an independent business endeavor, usually positioned to grow and be profitable for the founders.

equity positions An equity position is created by buying a significant share of another company's stock, thereby generating a form of corporate partnership with the intent to pursue mutually beneficial commercial activities.

equity theory A theory of motivation that suggests individuals modify their behavior based on perceptions of fair treatment and equitable rewards.

ethnocentric multinational An approach to managing a global company whereby the home-office executives impose standards, ethics, and values on subordinates—behavior that is derived from *ethnocentrism*, the belief in the superiority of one nation, race, creed, or culture over others.

eustress The constructive dimension of stress, which is essential for a healthy mind-body response to life.

expectancy theory A theory concerned with motivation that suggests people make conscious decisions about behavior based on expectations of outcomes.

expert power The ability of managers to lead others and influence behavior through acceptance of their expertise or special knowledge.

expert system (ES) A recent term applied to the concept of artificial intelligence and fifth-generation com-

puter programs that provide managers with enhanced decision-making tools within decision support systems.

exporting A strategy of selling domestic goods or services overseas through international brokers or distribution centers.

family enterprise Legally defined as a company controlled by family members who hold a majority-owner interest through stock or other investments. Conceptually, an enterprise owned and operated by family members.

financial ratios Computations of selected data used to analyze performance, track company results over time, and compare companies with one another.

finished goods Products ready for sale to consumers and warehoused for future shipments.

five forces model of competition A systematic approach to evaluating a company's competitive position relative to its industry and economic power in society.

formal group Created with authority and responsibility for work-related results, formal groups have defined purposes and reporting relationships within organizations.

formal organization Two or more people involved in a mutual effort with formal authority for creating tangible benefits.

formal planning The process of using systematic criteria and rigorous investigation to establish objectives, decide on activities, and formally document organizational expectations.

formulating strategies Managers formulate strategies through their planning efforts to explain how the company will achieve its objectives.

franchise A form of business ownership created by contract whereby a company sells the rights to a business concept, providing products and services to the buyer in exchange for a royalty or share of profits.

franchising A special form of licensing based on a contract in which the franchisor provides a complete business concept, together with support products and services, in exchange for a royalty or percentage of profits from the franchisee.

functional management A definition of management authority based on expertise and specialization.

functional pattern An approach to departmentalization based on grouping people according to their skills and expertise, giving them authority within their areas of expertise.

functional perspective An approach that explains managers' responsibilities and activities according to general principles of management for planning, organizing, leading, and controlling.

functional-level strategies Carried out by executives in functional areas, these strategies support business-level decisions to introduce new technologies, develop new products, open new markets, or implement functional action plans to help the firm compete effectively.

gainsharing A method of bonus compensation based on a formula that shares profits or productivity gains among investors and employees.

Gantt chart A graphic illustration (usually a bar graph or diagram) that indicates time allocations for sequential operations and traces progress, routing, scheduling, and tasks in time intervals.

general adaptation syndrome (GAS) The psychophysiological (mind-body) reaction that is a natural mobilization and recovery process to stress stimuli.

geocentric multinational A company with diversified global operations but controlled through decisions made by a centralized cadre of executives at the home office.

geographic pattern An approach to departmentalization based on territorial control and localized decision making, with functional activities subordinated to geographic divisions.

go, no-go controls Another term for "yes/no controls," go, no-go controls have fail-safe standards dictating absolute corrective action or no action.

goals and objectives Performance targets or the end results that managers seek to attain through organized effort.

group A group consists of two or more individuals who regularly interact with one another to pursue one or more common goals.

group cohesiveness Group cohesiveness is the extent to which employees feel attracted to their work group and compelled to stay in it, adhering to group norms and standards of conduct.

group norms Informal standards of conduct that evolve within work groups that influence behavior everyone within the group is expected to follow.

growth A growth strategy is the expansion of sales achieved either through new products or new markets.

hardware The physical equipment employed to input, store, retrieve, and output data.

Hawthorne Studies Social and psychological experiments concluded at Western Electric Company during the 1920s that revealed how human relations affected productivity.

heuristics A process of "learning" through which decision makers analyze ideas and "progress" toward a solution as ideas unfold.

hierarchy of needs The progressive system of needs set forth by Maslow that he suggested motivated human behavior when needs were deemed unfulfilled.

horizontal integration An effort to consolidate the industry, reducing substitutes or competitors or to improve the firm's product mix or market coverage.

horizontal job specialization The result of dividing complicated tasks into simpler jobs or operations, reducing the scope of tasks.

human resource forecasting The process of estimating future demand for employees based partially on esti-

mated demand for products and services and partially on productivity, technological changes, and social changes.

human resource management The sum of activities required to attract, develop, and retain people with the knowledge and skills needed to achieve an organization's objectives.

human resource planning Planning for future personnel needs, skills, labor changes, and related issues (such as compensation and retirement) based on strategic evaluation of internal factors and external conditions.

hygiene factors In Herzberg's two-factor theory, those potential dissatisfiers that can be troublesome if not properly managed, yet are factors having little motivation potential.

idea generation A stage of creative thinking when a person recognizes a problem or opportunity with no obvious solution.

implement With respect to a creative idea, the action taken to pursue an idea to fruition.

income statement Also called a "profit and loss statement," the income statement is a financial summary of revenues and expenses with calculations for profits (or losses) and resulting taxes on operational income.

incubation A stage of creative thinking when a person allows an idea to formulate by "mulling it over."

informal group Informal groups evolve spontaneously through social or personal interactions without authority or formal responsibility for pursuing organizational objectives.

informal planning A process of intuitively deciding on objectives and activities needed to achieve them without rigorous and systematic investigation.

informal structure A shadow structure that exists apart from the formal organization, resulting from personal interactions, sentiments, and social activities.

information In systems terminology, the result of thoughtful analysis and communication of data in a form useful to recipients.

information procedures Guidelines for using a system and providing required information that is accurate, verifiable, complete, timely, and relevant.

information system A group of interrelated hardware, software, people, procedures, and data combined to provide useful information to decision makers.

initial controls Preventive control measures to guide managers in resource allocations and other decisions such as hiring, purchasing, and capital funding.

innovative Finding new ways to use or combine resources to create new products, services, processes, or technologies.

integration strategies Companies integrate either backward or forward to stabilize supply and distribution lines, often reducing costs or securing raw materials or markets related to the firm's products.

integrationist A theorist who integrates concepts of several schools of management thought to suggest improved management practices.

internal consolidation A form of retrenchment in which a company retreats to a more realistic operational position, reducing its costs and risks.

international business Global transactions of a commercial nature that involve companies operating outside their home country.

international management Managing overseas offices, branches, or subsidiaries of a multinational organization.

intrapreneurship A term applied to corporate entrepreneurship (literally "intracorporate entrepreneurship") suggesting innovation and new venture creation from within established organizational boundaries.

job A defined set of tasks that a person performs in relation to organizational objectives.

job analysis A formal method of identifying tasks, skills, physical requirements, and duties specific to an individual job.

job characteristics model An approach to job redesign that identifies core job dimensions and critical pyschological states that affect job performance and, when coupled with an employee's need for personal growth, will influence job redesign decisions.

job description A written statement of expectations and duties related to a specific job. An expanded view would also include how responsibilities are tempered by the person assigned to the job.

job design A process through which jobs are defined and tasks are allocated.

job enlargement An organizational development technique for combining two or more tasks into one, usually at one level of skill, to improve variety, reduce boredom, or improve efficiency in work.

job enrichment The vertical combination of tasks that increases one's duties and responsibilities; job depth is enhanced to improve job satisfaction.

job inventory The result of a job analysis, the inventory describes tasks and attributes related to each job.

job redesign The conscious process of changing an existing job to improve performance and conditions of work for an employee.

joint venture A contractual arrangement between two companies to contribute resources to a third organization created by the contract for a new commercial endeavor.

just in time (JIT) A technique derived from Japanese management practice that seeks to minimize inventory by purchasing raw materials just in time for production, producing just in time to meet orders, and delivering just in time to eliminate finished goods warehousing.

leadership The management function of influencing others to strive toward performance that achieves organizational objectives; also called *directing*.

legitimate power Also called *formal authority,* it is the right to manage derived from delegation based on ownership or property rights.

licensing In international business, the process of contracting with foreign companies and selling them the rights to employ technology, market products, or use patents, copyrights, and trademarks.

life cycle model An approach to leadership in which managers adopt behavior to coincide with the maturity of subordinates; four behavior modes include delegating, participating, selling, and telling.

line manager A person who has direct control over primary operations of an organization such as production.

liquidation The "final" option, liquidation is the decision to terminate business in a systematic way through bankruptcy or a complete sale of the company.

local area network (LAN) A system of interconnected hardware, software, and communication devices, linking various work centers or departments together within an organization so that information and data bases can be shared.

management The process of planning, organizing, leading, and controlling that encompasses human, material, and financial resources in an organizational environment.

management audit A method of appraising leadership behavior through surveys, interviews, and observations of management, often employing evaluation teams of peer managers, consultants, and employees.

management by objectives (MBO) A technique used in planning and controlling in which subordinates determine their objectives jointly with superiors and evaluation follows periodic monitoring and performance reviews.

management information system (MIS) A term applied to a total information system used to enhance managerial decisions, provide feedback, and track and record data from both internal and external sources.

management science An approach to management also called the *quantitative school* that relies on models and mathematical analysis to improve decision making; alternatively called *operations research.*

Managerial Grid An organizational development model created by Robert Blake and Jane Mouton that is based on a matrix of values between 1 and 9 for two primary variables explaining a manager's orientation, concern for tasks and concern for people.

manufacturing resource planning (MRP II) A comprehensive planning system that encompasses production resources and activities of MRP plus financial, capital, and marketing resources and activities.

market diversification A method of growing by positioning existing products or services in new markets or for sale to new customers.

marketing plan Managers develop market plans to support strategic objectives using customer scenarios to position products or services into markets according to well-documented sales forecasts.

marketing program A marketing program addresses specific activities to include product characteristics, pricing decisions, promotional activities, and distribution channels.

master strategies Also called grand strategies, these define in broad terms the long-term direction of an organization.

material requirements planning (MRP) A computer-integrated process of coordinating master production schedules, purchasing, inventory control, and resource allocation based on projected orders.

matrix organizations An approach to organizing work based on forming temporary teams from the ranks of existing employees who are responsible for completing well-defined projects.

motion study The study of physical actions required to perform a task in the most efficient way possible.

motivation The concept of behavioral change or result of influence that alters an individual's performance.

multinational corporation (MNC) A corporation that operates on a global scale with branches, outlets, distribution centers, facilities, or sales in foreign countries.

needs assessment review A process of matching projected activities with projected employment requirements.

new venture unit (NVU) A team, division, or subsidiary created specifically to initiate new business ideas, bringing them to fruition through commercial endeavors.

nominal group A panel established to develop ideas independently for resolving a particular problem, then through an exchange of ideas, refining those ideas until a group consensus emerges.

nominal group technique (NGT) A group decision-making process in which members independently identify solutions to a problem or alternative opportunities. Then after options are fully articulated and discussed, members vote confidentially for preferences.

nonprogrammed decisions Decisions derived from unstructured analysis or generated from individual evaluation of nonroutine situations; decisions that lack clear analytical parameters or substantial precedent.

office automation system (OAS) Designed to improve productivity, an OAS is meant to reduce clerical work and increase the efficiency and effectiveness of office administration.

on-the-job training (OJT) Training accomplished within the context of work and while actual work is taking place.

open system A system that interacts with the external environment. In terms of controlling, an open system is one in which managers intervene to alter system processes rather than relying on automatic controls (closed system).

operant conditioning The process of reinforcing behavior through positive or negative consequences to condition future behavior.

operational objectives Immediate short-term performance targets for daily, weekly, and monthly activities that, when attained, will reinforce tactical planning objectives.

operational planning Operational planning occurs at the lowest management levels and focuses attention on specific performance objectives for immediate results.

operations management The application of quantitative techniques in production and operations control using analytical models to improve organization activities.

optimal choice An optimal choice is one that generates the greatest possible benefits with the fewest negative consequences.

organization The structure of relationships that exists when two or more people mutually cooperate to pursue common objectives.

organizational behavior modification (OB Mod) The process of changing human behavior by influencing individuals through such methods as operant conditioning.

organizational development (OD) The process of changing organizations through behavioral science techniques, such as consulting intervention to improve performance, leadership, or decision-making systems.

orientation A formal program of indoctrination to introduce new employees to their job responsibilities, coworkers, company policies, and work environment.

participative change A strategy of implementing change through cooperative efforts, team decision making, and group initiatives.

partnership Two or more individuals with joint responsibility and investment in a business.

path-goal theory A contingency approach to leadership that holds managers responsible for influencing employees to work for rewards linked to specific tasks.

performance evaluation The process of appraising subordinates' behavior and providing feedback to help them improve their performance.

personal service firm A form of small business that provides services to customers though the skilled activities of its owners or employees.

personal staff Expert advisors who provide special services or advice related to unique responsibilities such as legal affairs, economic consulting, or affirmative action.

piece rate An approach to compensation whereby employees are paid for each unit of work completed.

planning One of the four major functions of management. It is the process of defining organizational objectives and then articulating strategies, tactics, and operations necessary to achieve those objectives.

planning premises Those considerations taken into account by managers that will likely affect plans or activities.

policy A standing-use plan that provides a general framework for decision making.

polycentric multinational A company with diversified global operations in which authority is decentralized, giving managers overseas broad-based authority for making decisions.

positioning The act of targeting specific products or services to specific markets.

power The ability to influence others by modifying behavior to accomplish preferred results.

proactive response A self-initiated action by a company to resolve, or protect against, unethical behavior.

procedure An explicit set of actions, often sequential in nature, required to achieve a well-defined result.

process theory The motivation theory that focuses on individual attitudes, thoughts, and preferences to understand and influence personal performance.

product control Product control is concerned with reducing costs associated with poor quality and unreliable products.

product diversification A specific choice of growing by adding new products, either through internal development or acquisitions.

product life cycle A product life cycle describes the stages a product goes through in the marketplace from introduction to decline.

product pattern An approach to departmentalization based on grouping people according to an organization's products or services, with functional activities relocated under product or service divisions.

production control Production control is concerned with controlling the manufacturing process.

production plan A formal production plan specifies that planned volume of each product to be manufactured consistent with marketing plans for projected sales during a planning period.

production planning Managers in product planning are concerned with manufacturing quality products in the right quantities for delivery to customers at the right time.

productivity The relationship of combined inputs such as labor, materials, capital, and managerial verve to outputs such as products or services. It is the summation of quality performance that results in more efficient utilization of organizational resources.

productivity planning The conscious attention to quality, costs, and work processes to improve resource allocation while achieving higher total company performance.

program A single-use plan with multiple activities that can be orchestrated to achieve one important objective.

program evaluation and review technique (PERT) A network model that identifies sequential events necessary to complete a project while defining activities that individually lead to the next event.

programmed decisions Decisions that have been made so often under similar circumstances that past experience provides clear guidelines for managers.

progression principle Abraham Maslow's concept that successively higher order needs in his hierarchy of human needs are not active motivators until lower order needs are fulfilled.

project A single-use plan with a specific short-term objective that is seldom repeated.

purchasing The acquisition of needed goods and services at optimal costs from competent, reliable sources.

purpose The reason a company exists; it is the fundamental rationale for being in business.

quality The concept of doing things better, not just more efficiently.

quality of work life (QWL) The concept of making work meaningful for employees in an environment where they are motivated to perform and satisfied with their work.

quantitative management An approach to management based on decision theory, use of statistical techniques for problem solving, and application of mathematical models to organizational processes.

rational decision making A systematic process of evaluating a problem and deriving an optimal solution.

raw materials The physical ingredients, parts, and supplies needed for manufacturing.

reactive response A forced action by a company, to resolve problems or unethical behavior, brought about by external pressure groups or through government intervention.

recruitment The process of attracting qualified applicants to an organization through activities such as advertising and campus visitations.

referent power One of the five power bases which stems from individual preferences to be identified with a leader; often associated with charisma.

reinforcement theory A theory of motivation that explains behavior in terms of consequences learned from past experiences so that individuals learn what to do to avoid pain and to incur pleasure.

relevancy of information Appropriate information that helps managers make decisions without creating an overload.

reorder point The critical point when a depleted level of inventory triggers an order for replenishment.

requisite task attributes (RTA) A model that describes categories of elements common to all jobs, which include tasks, interaction with others, and mental states of employees.

research and development (R&D) The formal scientific and engineering function of designing new products, improving existing ones, or developing new processes within an organization.

research and development limited partnerships (RDLP) A legal partnership that allows public and private organizations to contribute resources to a separate organization with a specific purpose and a limited life to benefit the organizations involved as partners.

resource allocation The planned used of facilities, equipment, material, energy, cash, and supplies during a company's budgeting period.

retrenchment A strategy of "regrouping," usually through consolidation, to retreat from an overexpanded position.

reward power One of the five power bases whereby managers can influence behavior by controlling rewards in a positive, motivating way.

risk The situation of not being certain about the outcome of a decision while also having some information to sense probabilities; not a condition of total uncertainty.

risk averse An aversion to taking perceived risks, preferring instead to make decisions with a high degree of clarity.

risk takers A propensity to pursue risks by those eager to resolve problems with uncertain outcomes.

rule A statement that tends to restrict actions or prescribe specific activities with no discretion.

sales forecast A sales forecast is an estimate of expected sales for a specific time period related to target markets.

satisfice A decision-making behavior in which an individual chooses a satisfactory alternative, one thought adequate but not necessarily the best.

satisfier factors Motivating factors associated with job content, achievement, recognition, and intrinsic rewards, including promotion.

scalar chain The concept of a clear, unbroken line of authority derived from unambiguous delegation throughout the management hierarchy.

schedule A commitment of resources and labor to tasks with specific time frames.

scientific management A major approach to management advocated by Frederick W. Taylor that focuses on standardized work methods and rational selection of employees coupled with training and job development.

selection The process of choosing and hiring employees from among those candidates recruited for the organization.

single-use plans Plans developed for unique activities and seldom repeated exactly, such as programs, projects, and budgets.

situation analysis An examination of industry structure, economics, competitive forces, and other external factors and internal conditions essential for strategic planning.

skills inventory A data base detailing each employee's qualifications, education, interests, and career aspirations.

skunkworks Small autonomous teams insulated from corporate activities to informally pursue new ideas, products, or services with potential commercial applications.

small business Conceptually, an enterprise that does not dominate its industry, has few employees, and generates limited income. The SBA has defined a small busi-

ness for qualifying loans as one with fewer than 1,000 employees and less than $10 million in annual sales.

social audit Evaluation of organizational activities that have a significant influence on social responsibility and external relationships.

software The means for driving hardware and controlling an information system.

sole proprietor A person who conducts business as an independent and unincorporated owner. Legally, a form of business that has no other investors beyond the independent owner.

span of control Also called the span of management, it is the number of subordinates that can be effectively supervised given the type of task, technology, and environment of work.

specialization Defining tasks that relate to expertise and then horizontally separating jobs for formal activities.

staff assistant Assistants and advisors to line managers who directly support operational activities but do not become involved in those decisions.

staff managers Managers concerned with the support and advising activities that reinforce line operations but without direct authority for operational results.

standardization Making work uniform through repeated use of similar methods, machines, and materials to achieve similar and predictable results over time.

standing-use plans Plans used on a continuous basis to achieve consistency in organizational activities; they include policies, procedures, and rules that can be repeated.

steering controls Controls used to adjust behavior or operations, such as correcting speed and direction of a car.

strategic business unit (SBU) A major subunit or group at the strategic level of a large, complex firm. SBUs provide a focus on related services, products, markets, customers, or technologies to improve management and decision making.

strategic implementation The deliberate execution of strategies that achieve objectives through incremental activities defined in policies, programs, projects, budgets, procedures, and rules.

strategic management The senior management responsibility for defining the firm's mission, formulating strategies, and guiding long-term organizational activities consistent with internal and external conditions.

strategic objectives Performance targets relating to long-term endeavors, such as growth, profitability, and the position of a firm in its industry.

strategic planning A disciplined effort to produce the fundamental decisions and actions that must be taken today to shape the long-term direction of an organization.

stress Associated with tension and anxiety, stress can be destructive both physically and psychologically, but it is also essential for life.

subsidiary In international business, a wholly-owned foreign affiliate that has been established through acquisition or direct investment.

sufficiency Subordinates can only be held accountable if they have sufficient authority to make decisions relating to activities for which they are responsible.

supportive leadership A style of leadership that encourages employees through motivation techniques and acceptance.

SWOT A situation analysis that examines external factors and internal conditions of an organization to identify strengths, weaknesses, opportunities, and threats.

system A collective association of interrelated and interdependent parts; organizations are systems of divisions, departments, and specialized activities.

System 4 management Developed by Rensis Likert, it is a description of four approaches to leadership taken by managers, ranging from autocratic to participative. Likert believes the one best way to lead is through "System 4 participation."

tactical objectives Medium-term performance targets for achieving limited results, such as annual sales, quarterly profits, or incremental changes in products or services.

tactical planning The transformation of strategies into medium-term objectives and activities usually implemented by middle managers in functional roles.

task orientation Management style emphasizing control of rather than encouragement of employees' work, focusing on work results, task responsibilities, and work standards.

team planning A participative approach to planning whereby planning teams comprised of managers and staff specialists initiate plans and formulate organizational objectives.

technical contracting In effect, technical contracting is the export of expertise and knowledge through consulting and assignment of personnel to overseas projects.

technological imperative The concept that an organization's structure and relationships among its members are often dictated by the technology employed.

technology The total accumulation of tools, systems, and work methods used collectively to transform inputs to outputs.

termination Employees are terminated when they are formally severed from the organization through retirement, death, resignation, or dismissal.

Theory X A set of assumptions that employees are lazy, unambitious, and must be coerced to work; hence, a managerial approach based on fear tactics.

Theory Y A set of assumptions that employees are generally responsible, want to have meaningful work, and are capable of self-direction; hence a managerial approach based on conciliatory behavior.

Theory Z A reference to Japanese management practices of consensus decision making, quality circles, and employee participation to enhance productivity.

Subject Index

Internal consolidation, 199
Internal recruitment, 394–95
Internal Revenue Code, 694
Internal Revenue Service, 83
International management, 21, 647–75
 case studies, 22, 671–75
 changing global environment and, 648–50
 culture and, 664–65
 defined, 650–51
 economic systems and, 668
 international business and, 650–51
 international relations and, 659–64
 head-to-head, 661–62
 home-country, 662–64
 host-country, 659–61
 legal systems and, 668
 multinational corporations and, 651–54
 perspective for, 650–56
 political systems and, 665–67
 rationale for international operations and, 654–56
 religious, ethnic, and sex biases and, 667–68
 skills and technology and, 667
 types of ventures and, 656–59
International Monetary Fund, 155
International trade, 485
International ventures, types of, 656–59
Interpersonal communication, 488
Interpersonal differences, resolving, 631–32
Interpersonal role of manager, 11
Interstate Commerce Commission, 83
Intervention
 organizational development, 623–24
 techniques for, 573–74
Intervention consultants, 623
Interviews in selection process, 398–99
Intrapreneurship, 104, 686
 defined, 105
Intrinsic factors of motivation, 423
Introduction stage of product life cycle, 217
Intuition, 28, 115
Invention, 686
Inventory
 finished goods, 222
 job, 362
Inventory control(s), 525, 527, 559–66
 economic order quantity (EOQ) and, 557, 560–61, 566
 just-in-time (JIT), 226, 547, 557, 565–66, 569, 574, 608–9
 manufacturing resource planning (MRP II), 564–65
 materials requirements planning (MRP) and, 557, 562–64, 566, 569
 poor, 551
 statistics in, 562
Investment(s)
 return on (ROI), 536–37
 subsidiary, 659
Invoice statistics, 558

Japanese firms
 concept of organization, 74
 financing of, 666–67
 productivity of, 2, 24
 technological advancement of, 155
 trade relations with U.S., 661–62
 zaibatsu, 296
Japanese management
 conflict and, 626
 contrasts between American and, 47–48
 current state of, 370–71

decision-making philosophy, 337, 338, 339, 368–69
facilities for inventory and, 560
imitative entrepreneurship in, 687–88
JIT system and, 547, 557, 565–66
leadership style, 457
selection process, case study of, 414–16
shared responsibility approach of, 620
Theory Z, 47–48
Jargon, 490–91
Jaundiced viewpoints, 495–96, 497
Job(s), 349–64
 core dimensions, 359–61
 defined, 349
 elements of, 356–58
 nature of, 349–51
 as property right, 324
 specialization of
 horizontal, 251
 vertical, 252
 two-factor theory of motivation and, 352–56
Job analysis, 38, 362
Job depth, 252–53, 351
Job descriptions, 394, 395
Job design, 356–59, 389
Job enlargement, 252–54, 351
Job enrichment, 253, 351, 353–56, 359
 shortcomings of, 356
Job expectations of new employees, 400
Job inventory, 362
Job involvement, 620
Job redesign, 354, 356, 359–64
 case studies, 374–77
 defined, 361
 job characteristics model of, 359–61
 strategy for effective, 361–64
Job rotation, 404
Job satisfaction, 43, 351, 356
 role of informal groups in, 366
Joint decision making, 334
Joint ventures, 304, 647–48, 658
J-type firms (Japan), 47–48
Just-in-time inventory control, 226, 547, 557, 565–66, 569, 574
Just-in-time (JIT) vendor, 608–9

Knowledge, 358
Knowledge-based systems, 597
Knowledge workers, 470
Korean chaebols, 296

Labor
 costs of, 531
 international operations and, 656
 division of, 248–54
 vertical and horizontal, 18
 supply of, forecasting and, 393–94
Labor-hours as productivity measure, 23
Labor-management councils, 300
Labor relations, 228, 229, 412
Labor union contracts, 393
Lagged production model, 223–25
Language, 480
Lateral communication, 486
Later growth stage of new venture, 690–91
Law of effect, 437
Layoffs, 229, 412
Leader-member relations, 461
Leadership, 8, 449–77. See also Authority; Power
 case studies, 473–75
 change and, 612
 communication and, 480
 contingency, 52, 461–68
 Fiedler's theory of, 461–62, 471–72

life cycle model of, 466–68, 472
 path-goal theory of, 462–64, 472
 Vroom-Yetton theory of, 464–66, 472
covenantal, 321, 501
crisis in, 269–70
decentralization and, 295
defining, 9, 450
in era of transformation, 468–70
as function of management, 9
interpersonal role of manager and, 11
local, 469–70
motivation and, 472–73
nature of, 450–51
in new ventures, 694–95
reciprocal processes of, 453–54
relation-oriented, 462
styles of, 454–60, 471, 501
 achievement-oriented, 463–64
 basic model, 454–56
 choosing, 457–59
 conflict and, 630
 directive, 463
 Managerial Grid model, 459–60, 471, 472
 participative, 463
 selling, 467
 supportive, 463
 System 4 management model, 456–57, 471
 telling, 467
 task-oriented, 461–62
 traits of, 451–53, 471
Leadership in the New Company—Managing the Transition, 482
Learned traits, 500
Learning
 avoidance, 438
 error, 598
 operant conditioning and, 437
Legal environment
 international management and, 668
 organizational structure and, 265
Legislation, 108
 consumer protection, 80
 selected business, 82
Legitimate power, 323–24
Less developed countries (LDCs), 654, 659, 675
Level production model, 223–24
Leverage ratios, 536
Liabilities, 534
Liaison, managers acting as, 11
Licensing, 657–58
Life cycle theory, 466–68, 553
Limited partnerships, 694
 research and development (RDLP), 303–4
Linear analysis, 538
Line assistants, 332
Line authority, 331–33
Line departments, 292–93
Line managers, 290, 330–31
 communication between staff managers and, 486
 defined, 18
Line operating managers, 333
Lines, number of, 225
Liquidation, 196
 defined, 199
Liquidity ratios, 536
Listening, 493, 498
 adaptive, 497
 poor, 497
Listening curve, 493
List (magazine), 510–11
Local area networks (LANs), 595–96, 602

Location, production planning and, 225
Long-range plans, 160
Lotus 1-2-3, 585
Love Canal, 69

Machine bureaucracy, 260
Madison Square Garden, 151, 152
Mail, electronic, 499, 599
Maladaptive behavior, 635
Maladaptive reactions, avoidance of, 639
Management. *See also* Strategic
 management
 changes affecting, 26
 classification of, 16–17
 defined, 3
 emerging concepts in, 10
 Fayol's principles of, 42
 functions of, 7–10
 decision implementation and, 111
 hierarchy of, 14–18 ✓
 international dimensions of, 21
 involvement in planning, 159–60
 process of, 7–10
 productivity and, 23–25
 responsibilities of
 division of, 14–16
 social, implications for, 86–88
 short-term vs. long-term objectives, 78
Management audits, 570–71
Management by objectives (MBO), 146–
 47, 266, 409–10, 570, 572–73
 for bank quality control, 577–78
 defined, 146
Management development, 404–5, 574
Management information network,
 computer-aided, 473
Management information system (MIS),
 50, 52, 54, 589–93
 defined, 54
 departments, 602
 management of, 592–93
 nature of, 589–90
 as service, 590–92
Management science, 52–54, 120–21
 defined, 52, 120
Management theory and practice, ✓
 evolution of, 35–55
 behavioral approach, 43–49
 case studies, 53, 56–59
 changing perspectives, 49–52
 classical approach, 37–42
 contingency views, 49–52
 historic legacies, 36–37 ✓
 model, 37
 quantitative, 52–54
"Management Theory Jungle, The"
 (Koontz), 491
Manager(s)
 accountability of, 330–31
 attributes of, 28–29
 autocratic, 455, 456
 charismatic, 325
 line, 290, 330–31
 line operating, 333
 managing productivity and innovation,
 24–25
 MIS, 333
 personal attributes of, 265–66
 personnel, 291
 planning roles for, 144–45
 purchasing, 291
 real vs. successful, 13
 roles of, 10–12
 decisional, 12
 informational, 11–12
 interpersonal, 11

 perceptions of, 13
 selection of, 399–400
 skills of, 18–20
 staff, 290–91, 330–31
 strategic planning dilemmas for, 180–81
 task-oriented vs. employee-oriented, 455
 use of time, 12–13
 women as, 445–47
Managerial Grid, 459–60
Managerial relationships, 71–82
 to competitors, 80–82
 to customers, 72, 73
 to employees, 74–78
 to stockholders and owner interests, 78
 to suppliers, 79–80
Manipulation, change through, 621–22
Manufacturing, 4
 computer, controls in, 576–77
 computer-aided (CAM), 298–99
 computer-integrated (CIM), 569, 599–600
 systems view of, 50
Maquiladora program, 673–74
Market, growth, 232
Market diversification, defined, 198
Market expansion, 196
Marketing, tactical, 212–20
Marketing controls, 533–34
Marketing plan
 defined, 213
 development of, 213–18
 elements of, 213
Marketing program, 218–20
 defined, 213
 elements of, 218–20
Market share, 196
Market share objectives, 139
Marxism, 665, 672
M*A*S*H (TV series), 290–91
Mass production, 260
Master production scheduling, 222, 235,
 563–64
Master strategies
 classification of, 194–96
 defined, 194
 strategic alternatives to reinforce, 196–
 200
Matched production model, 223–24
Material(s)
 bills of, 564
 poor-quality, 551
 raw, 559
Material management, production planning
 and, 225
Material requirements planning (MRP),
 557, 562–64, 566, 569
Materials control, 530–31, 553, 557–59
Materials requirements plan, 222
Matrix organization, 284, 305–10
 in aerospace industry, 312–13
 behavioral implications of, 307–8
 potential problems of, 308–9
 reassignment in, 306
Maturity stage of product life cycle, 217
Mechanization, level of, 358
Medical benefits, case study on, 406
Medicine, organizational changes in, 305
Medium of communication, 482
Meeting, quality circle, 578–79
Megatrends, 176
Megatrends (Naisbitt), 66, 592
Mental states of employees, 357
Mentoring, 400, 404
Merit pay systems, 435–36
Message, encoding of, 481–82
Mevacor, 319
Mexico, 673–74, 684

Middle management, 16–17
 centralization trend in, 297–98
 departmentalization and, 293
 planning role of, 145
 tactical decisions, 584
 tactical planning and, 210
 tactical planning by, 143–44
 technical skill of, 20
Mind-scaping, 705–6
Ministry of International Trade and
 Industry (Japan), 667
Minorities, equal employment opportunity
 for, 75–78
Mismanagement, zone of acceptance and,
 327
MIS managers, 333
Mission of corporate planning, 142
Mission statement, 158, 184–86
Model building. *See* Management science
Monitor, manager as, 11
Monitoring system for human resource
 planning, 392
Monopolies, 63–64
Monthly usage, 560
Morals, 64–65. *See also* Ethics, business
Motion study, 39–40
 defined, 39
Motivation, 421–24
 basic behavior sequence in, 423
 behavioral science research
 emphasizing, 44–45
 case studies, 426, 434–35, 442–45
 defined, 44, 422–24
 intrinsic and extrinsic factors of, 423
 Japanese vs. American sources of, 337–
 39
 nature of, 422–24
 values and, 426
Motivation theory, 424–41
 assumptions of, 424–25
 content theories, 425–30
 defined, 425
 Herzberg's two factor theory, 352–56,
 428–29
 McClelland's acquired needs theory,
 429–30
 Maslow's hierarchy of needs, 44–45,
 427–28
 process theories, 430–36
 defined, 425
 equity theory, 433–36
 expectancy theory, 431–33
 reinforcement theory, 436–41
 defined, 425
Multifunctional project team, 310
Multinational corporations (MNCs), 651–
 54. *See also* International
 management
 ethnocentric, 653–54
 European operations, 188–89
 geocentric, 651–52
 polycentric, 652–53
Mutual cooperation in organizations, 3
Myopic behavior, 287
Myopic objectives, 309

NASA, 151, 599
 space shuttle launch decision by, 125–28
National Association of Accountants, 273
National Association of Manufacturers, 67
Nationalization, 665
National Science Foundation, 273
Need(s)
 acquired, 429–30
 affiliation, 429, 430